ART
IN
SOCIETY

Consultant Editor
Michael W L Kitson, MA
Professor of the History of Art
University of London;
Deputy Director
The Courtauld Institute of Art
University of London

Advisory Editors
C K Green, PhD
Lecturer
The Courtauld Institute of Art
University of London

Peter Kidson, PhD, FSA
Reader in the History of Art
University of London

Philip Rawson, MA
Dean of he School of Art and Design
Goldsmith's College
University of London

The Contributors

David Anfam
Daniel R Barrett
Penny Bateman
Alan Brodie
Roderick Brown
Trewin Copplestone
Diana Dethloff
Lindy Grant

Peter Kidson
Professor Michael Kitson
John Mack
Judy Martin
Susan Morris
Philip Rawson
Richard Schofield
Robert Stewart

ART
IN
SOCIETY

A guide to the Visual Arts

General Editor
TREWIN COPPLESTONE

Prentice-Hall, Inc., Englewood Cliffs, N.J.

First published in the United States of America 1983 by
Prentice Hall Inc.
Englewood Cliffs, N.J.

Created, designed and produced by
Applecraft Limited, London

Design Consultants Groom and Pickerill

ISBN 0-13-047712-5 (soft back)
ISBN 0-13-047720-6 (cased)

Phototypeset by SX Composing Ltd, Rayleigh, Essex

Separations by County Repro

Printed in Spain by Mateu Cromo Artes Graficas SA

Contents

Suggestions for Further Reading

General Works
The McGraw Hill Encyclopedia of Art (15 vols)
The Pelican History of Art (20 vols)
T. Copplestone (ed): World Architecture
E. H. Gombrich: The Story of Art
E. H. Gombrich: Art and Illusion
A. Hauser: Social History of Art
H. W. Janson: A History of Art
H. W. Janson: Key Monuments of the History of Art
H. A. Millon: Key Monuments of the History of Architecture
B. S. Myers: Art and Civilization
N. Pevsner: An Outline of European Architecture
H. Read: The Art of Sculpture

Early Civilizations
L. Adam: Primitive Art
H. Bandi: The Art of The Stone Age:
J. Boardman: The Art and Architecture of Greece
S. Giedion: The Eternal Present:
J. Harris: Egyptian Art
R. A. Higgins: Minoan and Mycenean Art
S. Lloyd: The Art of the Ancient Near East
G. Richter: A Handbook of Greek Art
M. Wheeler: Roman Art and Architecture
C. L. Wooley: Mesopotamia and the Middle East

The Christian Era
J. Beckwith: The Art of Constantinople
J. Harvey: The Medieval Architect
P. Kidson: The Medieval World
J. Pope-Hennessy: Italian Gothic Sculpture
M. Schapiro: Romanesque Art
D. Talbot-Rice: The Art of Byzantium
McKenzie Wilson and Klindt-Jensen: Viking Art
G. Zarnecki: Art and the Medieval World

The Islamic World and Asia
Ashton and Grey: Chinese Art
O. Grabar: The Foundation of Islamic Art
E. J. Gruber: The World of Islam
P. Rawson: The Art of South-East Asia
P. Rawson: Indian Art
G. H. S. Bushnell: Ancient Arts of the Americas
Siebert and Forman: North American Indian Art
J. Soustelle: Arts of Ancient Mexico

Africa
W. Fagg: African Tribal Images
Ferman and Dark: Benin Art
Leiris and Delange: African Art

The Renaissance to the Nineteenth Century
J. S. Ackerman: The Architecture of Michelangelo
J. S. Ackerman: The Architecture of Palladio
B. Berenson: The Italian Painters of the Renaissance
A. Briggs: The Nineteenth Century
J. Burckhardt: The Civilization of the Renaissance in Italy
A. Chastel: The Age of Humanism
S. Giedion: Space, Time and Architecture
C. Gould: An Introduction to Italian Renaissance Painting
H. Honour: Neo-Classicism
Hughes and Lynton: Renaissance Architecture
M. Kitson: The Age of Baroque
F. D. Klingender: Art and the Industrial Revolution (ed Elton)
J. Maas: Victorian Paintings
J. Rewald: The History of Impressionism
J. Rewald: Post-Impressionism from Van Gogh to Gauguin
A. Scharf: Art and Photography
R. Schmutzler: Art Nouveau
J. Shearman: Mannerism

R. Wittkower: Architectural Principles in the Age of Humanism

The Modern World
R. Banham: Theory and Design in the First Machine Age
J. Barr: Cubism and Abstract Art
A. Bowness: Modern European Art
J. Charlot: The Mexican Mural Renaissance
M. Compton: Pop Art
S. Giedion: Mechanisation takes Command
C. Gray: The Great Experiment: Russian Art, 1863–1922
S. Hunter: American Art in the 20th Century
C. Jencks: Modern Movement in Architecture
G. Kahnweiler: The Rise of Cubism
N. Lynton: The Story of Modern Art
H. Read: Art Now: An Introduction
B. Rose: American Art since 1900:
L. M. Roth: A Concise History of American Architecture
J. Russell: The Meanings of Modern Art
M. Schapiro: Modern Art, 19th and

Methods and Materials
Harris and Lever: An Illustrated Glossary of Architecture, 850–1830
R. Meyer: A Dictionary of Art Terms and Techniques
W. Verhelst: Sculpture: Tools and Techniques

World History
J. Bronowski: The Ascent of Man
K. Clark: Civilization
A. Toynbee: A Study of History
J. M. Roberts: The Pelican History of the World
W. & A. Durant: The Story of Civilization (11 vols)

Reference
The Cambridge Ancient History
The Cambridge Mediaeval History
The New Cambridge Modern History

Introduction

This book is intended, firstly, for those people who have at some time wished that the visual arts of architecture, sculpture and painting meant more to them than they do, who are interested and would like to become involved but are deterred by a daunting suspicion that there must be something in the arts, some quality, that is beyond their appreciation or comprehension. More, perhaps, than anything they feel that they will never have the time to come to terms with the enormous and continually proliferating volume of work that exists: architecture in a bewildering varied profusion of styles and size surrounds them, and the museums and galleries around the world are stuffed with works of art, even more in the cellars than on view. A large number of them will have tried – will have visited what they take to be great buildings, galleries and museums, will have read histories of art and architecture, will have looked at reviews in magazines and have kept up with notices in the newspapers. For many the forms of contemporary art, unfamiliar and seemingly outside the whole pattern of the past, will have created a guarded suspicion that they are being "conned". Others may have concluded that there is a language of understanding – a jargon – that will inevitably remain closed to them.

There will, it is hoped, also be younger readers who are fired with an uninhibited and undirected enthusiasm to make sense of the prolific confusion of both art and life, and would like a guide that informs and excites rather than deflates them.

I do not claim that this book will resolve all the problems or answer all the questions that might be asked and I believe that no sensible reader will expect as much within a single volume of this kind. The book covers such a wide range – presents indeed a world picture – that necessarily it cannot be other than introductory. Nevertheless, its intention is to open what are called the "visual fine arts" of architecture, sculpture and painting to what I believe will be a rewarding approach to their understanding and enjoyment.

This, of course, is not to suggest that everything is made simple. Art is not simple and demands much of the viewer, as it demands as much or more from its creator. In fact, it is these demands of observer and creator and the relationship to the work that form the central theme of this introduction and of the subsequent text. This introduction also considers a number of the problems that almost everyone encounters as well as offering some information to aid study.

One basic question, and one which you might suppose can readily be answered in a generally acceptable form, has presented great difficulties and has never been answered to universal satisfaction. The

deceptively simple "What is Art?" has engaged art historians, critics, artists, philosophers, aesthetes and others throughout history. There is a general agreement on what it is about but not what it is. The early 19th-century painter J. M. W. Turner's comment that art is "a rum thing" is the shortest and most succinct observation on the subject but represents the same failure as much longer written works. The reader will therefore not be surprised to learn that we shall not be offering an answer here, but in showing throughout the book what art is about it may be that the reader will arrive at his own conclusion as to what it is.

There are those, to compound confusion with confusion, who would say that there is no such thing as art, only works of art; that art as a term is only a useful abstraction for a general category of human skills. A further postulation is made by Suzanne Langer in her book *Philosophy in a New Key*, to the effect that to be an artist is to be capable of producing art, not of actually doing so – the chicken definitely preceding the egg! Since it can be argued that the capacity to produce most things must pre-exist their production, there is some force in her point. While this is not the place to develop the theme, it has a bearing on such 20th-century manifestations as "action painting", "abstract expressionism" and "minimalism".

Not the least of the difficulties to be absorbed in reflecting upon our subject concerns the terminology and phraseology – the jargon – used by historians, critics and writers when trying to identify the nature of artistic intention or achievement. Of course, any attempt to translate one art form into another (in this case the visual arts into words), however evocative and exhaustive, will invariably fail, and all writing on art that attempts to do more than describe or inform can only be subjectively indicative of the writer's experience, of how he feels or has felt. Nevertheless, it is neither desirable nor possible to avoid all art terms; there is an advantage to be gained from a gradually extending familiarity with an art "language". When first used here such terms are explained and, where necessary, illustrated. Many will also be found in the glossary.

The value of history
There are a number of different ways of studying the visual arts and a number of different reasons for doing so. My own experience in teaching, lecturing and writing over many years convinces me that many people will find a refreshing stimulus in considering the subject from the viewpoint of history.

Of course, being visual, architecture, sculpture and painting must be

appreciated through being looked at, and there is no substitute for the direct experience of the works themselves. Indeed it is to encourage personal response that the book has been written. Although the illustrations included are certainly not intended as a substitute for the real thing, but only as a helpful reference, at the same time it must be recognized that the original works are not easily available to most people, and therefore as many and varied examples as possible are included.

Many books properly and effectively devote themselves to the work of one artist or school. Other books are devoted to a philosophical, psychological or aesthetic exposition of the subject. They examine the motivation, intellectual evidence, aesthetic nature, emotional inspiration, creative force that surround artists and works of art. Their studies have great value in deepening understanding of the extremely complex process that brings a work of art into being. Generally they demand of the reader some experience of the disciplines that they use (philosophy, psychology, etc.) and mostly they are not for the person approaching the subject for the first time.

Another valuable contribution to the literature of art comes from the art historian. His specialization will give him a deep understanding of the details of his area of study, he will be able to trace the course of development in the work of individual artists or periods, he will be able to make telling comparisons and draw significant and revealing conclusions. In a lifetime of devotion to the subject he is likely to enlarge knowledge and understanding of his chosen area. Although he may write more general books on the subject, his specialist studies will also be difficult and probably obscure for the uninformed. The general histories that the art historian undertakes are, of course, much more valuable to the general reader and such books as E. H. Gombrich's *Story of Art* and H. W. Janson's *History of Art* have made important contributions to public understanding. In both of these volumes and in most other similar works you will find some consideration of historical background, of the circumstances that surround the work and give them context.

The basis for this book and its framework is, precisely, history. It is not so much a history of art as about art in history. It is founded in the conviction, borne out by my own experience, that the arts of all periods are more easily comprehended, understood, related to and enjoyed within the framework of the events, movements and structure of history. The social conditions, the intellectual climate and the attitudes of mind that they sponsored make each work of art, as a

product of its own history and as a patent expression of its own cultural context, best known and loved in its specific historical setting.

All works of art have a specific and precise place in history. Every work from the earliest cave paintings to the latest one-man exhibition or completed building, whether in New York, Leningrad or Tokyo, has a place in time, its own artistic tradition in a single society and culture. The examination and emphasis of the historical context will provide the most fruitful approach for those first embarking on a consideration of this subject.

Traditionally, art has been used to illustrate and illumine history, because the historian recognizes that some arts may help him to identify and explain the nature of a society or period. Conversely, the study and understanding of man in history explains and illumines his activity as an artist as well as the works that he produces. It is through history that a real comprehension of the qualities and aspirations of the creative spirits – including the architects, sculptors and painters – may be discerned.

However, the generality of histories of art, while usually dealing chronologically with their subject and while treating the characteristics of a given period, age or style (with, wherever they are known, the works of individual artists, their inter-relationships and influences) in reference to historical periods, do not devote a great deal of attention to a clear exposition of the historical framework itself. And such historical framework as there is does not concentrate on the explicitly useful elements of the historical period.

This is unfortunate because, although it is assumed that they do, most people – for a variety of reasons – do not already have an established understanding of the flow and change in the history of mankind. The absence is often keenly felt since most people believe that they should have such an understanding. Some educational systems, under pressure, limit the teaching of history to the analysis of certain periods only (such as religious and dynastic problems of the 17th century or parliamentary politics in the 19th century), which do not necessarily coincide with the most compelling periods of artistic creativity. When a broader survey is undertaken, it is concerned with wars and dynasties, critical events, personalities and politics rather than the cultural developments even when, say, religious and social matters are examined. Furthermore, until recently, with the beginning of a world overview, Western teaching has concerned itself with the histories of non-Western societies only to the limited extent that they have affected directly some aspect of Western thought or culture. Rarely, for instance,

is the importance of Arab culture in the earlier creation of Western society acknowledged.

Since this is a book about the visual arts in history and not a history of art, a different approach from that which readers will usually encounter has been adopted. The book is structured in history, it includes a condensed historical survey and the main text is built within an historical rather than an art style framework. Thus art divisions going by names such as "Gothic" or "Baroque" do not appear in the section headings (although they are used and listed in the index). The illustrations include relevant historical and social material as well as examples of works of art.

In this way the close and revealing relationship between visual art and history will be made apparent. By history we mean the development of human societies; by visual arts we mean architecture, sculpture and painting, although some reference will be made to the "applied arts" of furniture, ceramics, etc.

The Nature of Creativity

I have already indicated that the basic and deceptively simple question of what art is will not be directly answered. Yet some comments may be offered that could help to indicate within what limits a resolution of the question might lie. We could start with a consideration of how the art process happens: how do we create art?

The first thing we must do is understand the distinction between certain aspects of the visual arts.

Architecture and the applied and decorative arts have an essentially practical base: they serve the physical needs of society before they supply anything in enjoyment, inspiration and aesthetic satisfaction. Buildings are made to shelter and protect and to provide a range of solutions to desired uses (temples, tombs, churches, palaces, stadia, factories, storage for a variety of products or materials and, in great variety of products or materials and, in great variety of scale and need, homes). They are made to be used, are justified by their use and their effectiveness in use is a part measure of their quality. In the same way the artifacts of society (furniture, ceramics, textiles, metalwork and, more recently, plasticware, etc.) are made to be used and justified in use. The forms of such artifacts are not always, or even usually, determined by their simple use (a chair for sitting on) any more than the forms of a building are.

Both buildings and artifacts have forms that are determined by other intentions; visual felicity, fitness for their context, relationship with

other examples and refined identification of use result in their being given a sense of internal unity – they are, in short, "designed". Design is intention; a designed object, whether architecture or furniture, is given an intended, precise form, which, to be effective, is concerned with the visual and practical.

The importance of architecture in the effective working of a complex civilization gives it a special position between the applied and decorative arts and the fine arts of painting and sculpture. For this reason architecture is sometimes called the "Mother of the Arts". The practical opportunities and limitations of architectural creativity make it peculiarly difficult to analyze but, its specific technology apart, it is subject to the same processes as the fine arts of painting and sculpture.

Painting and sculpture, on the other hand, have very little if any practical use. Their value depends on the emotive or intellectual effectiveness of their imagery and has almost nothing to do with their small cost in materials, in contrast to architecture and the materials employed in the applied arts.

When we consider the creative process we may see it as triangular: there are the creator, the work, and the observer.

Let us consider first the creator – the painter, sculptor, architect or designer. The quality of a work of art is, must be, determined by the quality of its creator, by his intelligence, his level of personal and social sensitivity, his energy, his dedication, his technical competence. These derive from his character and temperament, his education and his knowledge as well as from his social circumstances and the pattern and background of his life – from his human uniqueness. He *does* what he *is*. Of course, as we are all aware, life is not a straightforward progress. Health, personal relationships, financial constraints and many other minor factors all contribute to making one day, month or year happier or more successful than another. In different mental states we respond differently to the same or similar stimuli – and so does the artist. The particular form that his work takes arises from the direction in which his interests and abilities lead him, from sympathy with one technical mode of expression rather than another and, importantly, chance, opportunity and luck. A person becomes a painter, sculptor, architect or designer as the result of the fortuitous combination of a multitude of factors. The combination rarely amounts to genius, occasionally to real talent, and more usually to mediocrity.

That being said, the creator responds within terms of his creative method – architecture, sculpture or painting – and has an affinity with the elements of his art form. The architect challenged by the constric-

tions of mechanics and technology, inspired by scale, and socially alert will arrive at building solutions that at the same time reflect and create the character of his own society in a practical object. The demands on his abilities are far ranging and the pressures on his character often overwhelming. It is therefore not surprising that the constant demand for building results in a great deal of derivative work and the dominating genius of a Wren or Le Corbusier is rare.

The painter has an affinity to color, texture, line, tone, light, etc, and he is stimulated by the visible world into the use of these in drawing and painting. Each work is a special act of individual creativity. The form that it will take will arise from his affinity with materials and his desire to use them in a way that some form of stimulation has evoked in him. The painter in history has usually been inspired to use aspects of the natural world in a more or less representational image, but it is not necessarily the case in more recent work. The range of painting from intentional accuracy of transcription to determined abstraction in which no reference to the visible world is discernible will be encountered in any even cursory examination of examples of painting from the prehistoric to the present. This indicates that it is important to consider the role of representation in the fine art, and we shall do so later in this introduction.

Representation is also a factor in the work of the sculptor. Traditionally, the sculptor's primary subject has been the human form. Occasionally animal or plant forms are encountered but there are few if any sculptures of, for instance, trees or buildings – except perhaps in that form of sculpture known as "bas relief" (see page 377), which is in any case closely related to painting. In using the human form, because he is working three-dimensionally, the sculptor is creating an actual physical object that has a direct reference to its subject. It becomes in some measure an equivalent and any changes of scale or proportion between the original and the work, whether deliberate or inadvertant, will create a kind of visual dialogue – during the course of which the work will acquire or present its own identity. The sculptor works in wood, stone or metal traditionally and none of these materials has the same or similar character to the materials (flesh, textiles, etc.) that they represent. Neither do they have the color. For this reason the sculptor creates an identity in his work that, however referential, rarely evokes the same representational problems that seem often inherent in the appreciation and understanding of painting.

In recent years sculptors, like painters, have extended their range of subject and materials and, again like painters, turned to abstraction.

In considering the creative process it may be helpful to view the artist (in this book the architect, painter, or sculptor) as a specialist who, for a variety of indeterminable reasons, is driven by what Wassily Kandinsky, a 20th-century painter, has called an "inner necessity" to find a particular and unique shape for his understanding of and response to his life, society and place in nature. Since his own response is particular and unique, his choice and use of specific aspects of life, society and nature will be personal and unique – only he can paint his pictures.

It is, consequently, inevitable that the work is unique to him and could only have been produced by him, even though he may have been given the most precise instructions by a patron. Of course, forms of patronage are important determinants in the nature of the art of a period and since the patron, like the artist, has special and individual tastes (also derived from his view of life, society and nature), the work will reflect these also. The position and importance of the patron is discussed more fully in the section dealing with the Italian Renaissance – perhaps the greatest and wide ranged age of patronage.

It will be apparent from what has been said that creative activity is not an easy time-passing occupation and will engage, consciously or unconsciously, the whole personality and understanding of the creator. The amateur who paints or sculpts for pleasure is no less engaged than is the professional whose life is devoted to the arts. And the results will incorporate the actual rather than the wished for qualities of the creator. The necessities of creativity may, on the one hand, destroy his health and separate him from his fellows or, on the other, make him seem both to his contemporaries and to later observers to be a godlike and enviably privileged human being. When Raphael died, he was called "divine" and during his life had been followed by an adoring crowd much as a pop star is today.

The apparently easy genius of a Raphael may, however, be deceptive. The effort that works of art have frequently demanded for their realization are well known. Raphael's contemporary in Renaissance Italy, Michelangelo, is reported to have suffered eye strain in painting the Sistine Chapel ceiling to the extent that he could not read unless the reading matter was held above his head. And the intensity of the creative act can induce mental unbalance and even suicide. The tragic death of Van Gogh, who shot himself after completing one of the most intense landscapes in Western art, is a graphic witness to the strength of the "inner necessity".

Frustration and a sense of inadequacy (at its worst when justified – a circumstance marvellously expressed in the journals of Benjamin

Robert Haydon, an English artist of the 18th century and a better writer than painter), hypertension and intellectual strain, missed opportunity and baulked ambition, jealousy, envy, greed, hatred and sheer bad luck have all contributed to the death or despair of artists as much as to other human spirits.

While such a definite and conscious identification of motive is a particularly 20th century preoccupation – stimulated by, for instance, the influence of both Freud and Marx – the artists of earlier ages and different cultures might not have been conscious of such motives, and might even have denied them, it is, I believe, nevertheless true of all artists in all times and all places.

In the end, all having been said, the artist makes something and it can be experienced – it exists as a building, a sculpture or a painting and it has its own independent identity. As Paul Klee, a 20th century painter, said, a work is finished when it "looks back at you". Picasso thought differently, "Have you ever seen a finished picture? A picture of anything else? Woe unto you the day it is said you are finished! To finish a work? To finish a picture? What nonsense! To finish it means to be through with it, to kill, to rid it of its soul, to give it its final blow: the most unfortunate one for the painter as well for the picture. The value of a work resides in precisely what it is not." In the 19th century Delacroix wrote "Exactitude is not art . . . The so-called conscientiousness of the majority of painters is only laborious perfection in the art of being boring."

This directs us to consider the second point on the triangle: the work itself. To comprehend how a work of art stands on its own, divorced and separate from everything – even from the person who produced it, although it may mean more to him than to anyone else – we might describe it as intending the display of captured response. As such it stands as an object and embodies what the artist has, out of his temperament, experience and technical capacity, put into it. It may or may not incorporate the qualities that the artist intended – there is no absolute against which it may be measured. Neither the artist nor any observer can ever really know and opinions will differ and change. Of course, the considerations will change for the different forms of art. With architecture, complications of use, scale and context have to be included in any evaluation. With painting and sculpture, any propagandist (such as religious or political) purpose has to be reckoned with.

In the end, however, there it is, a relic of a long gone culture, an exotic evocation of an unfamiliar society, a nostalgic reminder of the recent past or the most present assault of the avant garde. Looking at

it will not change it, although time may change you and your valuation of it or affection for it: it may stimulate or repel you, grow or diminish for you, but, the natural decaying process apart, it will not itself change.

So the third point in the creative triangle is reached, the observer. The observer's "reading" of the work is the last act in the creative process and links him with the originator, the artist. Any comment on a work of art is also a comment on the commentator. In the last analysis (and in most cases, in the first) the artist is not concerned with the observer. This is true of all art at all times. The artist may anticipate the way in which the observer can participate in his expression of experience and, in producing the work as a commission at the instigation of others, he may precisely intend a response, but ultimately and inevitably he is alone in the creative process – only the mother can give birth. The artist makes a statement, which, as a statement, is not diminished by not being "read".

But whatever the statement, the "reader" or appreciator can only absorb what he can relate to, contribute in understanding only what he knows, offer his own sensibilities and intelligence to the comprehension of the work. Thus it is that the observer's response to a work of art is a measure of the observer's qualities and when transmitted to another, whose own sensibilities become involved in turn, will affect the second observer's response to the work and to the first observer. A process of evaluation and dissemination of multiple responses begins, which, involving many differing sensibilities, may lead to a consensus of value-acceptance or rejection. It is apparent that an absolute valuation makes no sense and is an impossible target.

It is also apparent why the artist cannot be concerned with the observer (who should not be confused with his patron, who will, independently, be an observer). It may be disturbing to some readers to realize that almost all architecture and a great deal of painting and sculpture is the result of interaction between patron and artist, since the prevailing concept of the artist today is of a free independent spirit, unconstrained and creative. So much has this notion come to be accepted that it is almost as if patronage promotes artistic prostitution and the patron is, if not sinister, at least ludicrous. It is as well to recall that throughout most of history this view so far from being accepted would have been incomprehensible. Historically, patronage from one source or another was the well-spring and inspiration of art.

The patron is, of course, one observer – or a group of observers – who is keenly interested. There are others with keen interest. The professional critic paid to appreciate, the fellow artist who may com-

prehend the problems and sympathize or be envious, the connoisseur, the collector, the amateur, the art historian and the "man in the street", who may have a long and concentrated experience and familiarity or be commonplace and prurient and for whom the nude in art may be merely cultural porn, may well be keen observers and have comments to make.

Do standards and criteria emerge from this wide-ranging interested group? Can we determine our own personal view from reference to any or all of these? As a new observer where do we start?

And so we have arrived at what is for me perhaps the most important point in this introduction. All the excitement and enthusiasm, curiosity, questioning and the beginnings of understanding and appreciation start here. Each of us is as sensitive, informed and intelligent as we are. Our responses are what they are – now! We might, of course, wish them to be other, but wishing will not make it so. So I urge every reader to try honestly, to start where you are, to assess where you are and to move from there.

The judge of quality is, *must be*, each individual observer; that is everyone who looks at and responds to a work of art. Its only importance is its importance to the viewer. It does not matter whether or how others value the work; it is the individual's valuation that is significant and if he finds that the work is empty, spurious, specious, ugly, beautiful, elevating, imaginative, moving, then it it is so. Other people's views, unless they really coincide with yours, do not help. Walking with someone when you do not know where they are going is not advancing.

Of course, since everyone is different, their responses will be different and no one will respond identically to everything – even the greatest works. No one likes everything. If you think Rembrandt painted boring and dreary Dutchmen in the dark and the effect is tedious and boring, then that is a critical judgment. Its greatest strength is that is the truth for you, and that is the best basis on which to re-evaluate your own value judgments.

The quality of human response, including that of both creator and observer, will be the result of innumerable influences. Background, heredity, environment are obvious factors, and there are others not so obvious but no less formative. Social attitudes, prevailing conventions of thought, accidental associations, minor events of great personal significance and the influence of other people through reading or contact are vital and unique elements in each person's makeup. One must also include unconscious responses, developed during growth.

Responses to color, shape, line, volume and visual detail cannot be the same for everyone; chance juxtapositions of color may recall to one observer events in his personal life that make them attractive or repulsive and lend them an importance that is special to him; and the same applies to all other visual stimuli. There is also the question of the exact color that each of us sees. Research has revealed an extraordinary divergence of color perception in different individuals – an extreme and obvious example is color blindness. In fact, the perception of objects and the significance that they may have to different observers makes even the commonality of vision itself uncertain. At the same time there are general or common responses to color, shape, etc, which will usually, although not universally, evoke similar responses from most observers. But, as the great Dr Johnson once observed, "When a butcher tells you that his heart bleeds for his country, he has, in fact, no uneasy feeling."

Two observers will never have *identical* responses. The communion between the work of art and the observer is as private and unique as that between the artist and his work.

This accepted, the appreciation of a work of art is a complex business, deeply and inextricably entwined with the cultural life of mankind. The artist and the observer are both part of the fabric of their society and, however minutely, an element in all succeeding societies – as is also the work of art.

In this situation the role of the art interpreter is of great importance. Although any attempt on his part to come between the artist and the "reader" and impose his notions is ultimately doomed to failure, he may – and as the "reader" becomes more involved with the subject, he most certainly will – have a profound influence on the range of knowledge, insight, and critical attitude that the "reader" has available and uses to relate to the works of art he is considering.

Like any other observer, the art critic and/or historian will bring the sum of himself to the analysis or examination of any work he discusses. He will be just as restricted and limited as any other human, although through developed sensibility and long study he may have and convey impressions of assurance and even omniscience. Historians, critics or artist-writers can only be of value to an observer insofar as they can supply what he, at that moment, needs and can use. This is not to diminish the historian, critic or artist, but only to emphasize the personal nature of artistic response. The most important art writers are sensitive and informed, and as an observer's needs change, reading such writers may offer a richer understanding to him.

With the passage of time everything changes. Creative acts and the responses to them change in value as society and individuals change. Although unchanging objects in themselves, works of art are a changing, flowing inspiration to succeeding generations of observers.

Architecture and the architect

Architecture is the most evident and long lasting of the visual arts. From the earliest civilizations to the present every society has created buildings for a great variety of uses. The forms that they have taken is a major consideration in this book. Even the most cursory examination of the illustrations will indicate the unending variety of forms, of scale, of decoration, of siting that constitute the character and nature of building. Most are as they are because someone or some group of people intended them to be so; they were "designed".

Design, although we can usually recognize it, is, like art, hard to define. Earlier we have described it as intention – the alternative to chance – which indicates that anything that is designed is thought about and conclusions are reached that result in a particular arrangement of the elements and a specific relationship of the parts. The design of buildings involves considerations of construction, materials, siting, function, etc. There is a further element in design, which is expressed by Professor Pevsner's distinction between building and architecture.

"A bicycle shed is a building; Lincoln Cathedral is a piece of architecture. Nearly everything that encloses space on a scale sufficient for human beings to move in is a building; the term architecture applies only to a building designed with a view to aesthetic appeal."

Pevsner suggests that in architecture design also must incorporate "aesthetic appeal". This certainly raises another common problem in the visual arts. Aesthetics is the study of beauty and ugliness, the philosophy of taste. From this we may conclude that amid all his practical decisions the architect must also consider the beauty or ugliness of his structure. Even just considering the matter will result in architecture, but whether it is good or bad architecture will depend upon the architect's sensitivity, his "taste" and, as the reader will now suppose, his success or failure will lie in the individual judgement of the observer.

The same considerations, of course, also apply to the other visual arts. Aesthetics, notions of beauty and ugliness, truth and falsehood, the pseudo and the real are the constant preoccupations of aestheticians and all other students of the arts. Value judgments are what appreciation and understanding are all about.

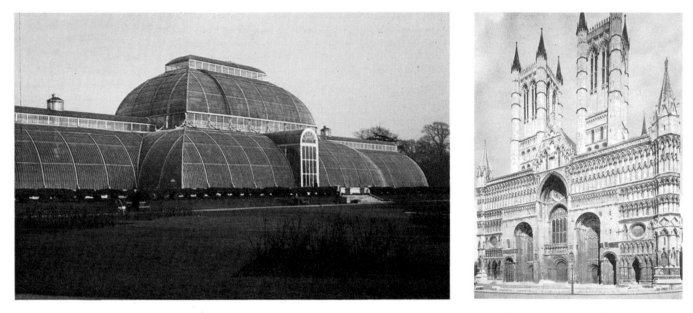

The Great Palm House, *1845*
Decimus Burton (1800–81)
Kew Gardens, London

Lincoln Cathedral, *England, begun 1256*

In considering architecture, however, there are complications that are not usually present in the arts of painting and sculpture. A building has necessarily to function effectively and elements of its design involve scale, the provision of services (heating, lighting, plumbing, etc.), aspect (what direction it faces), siting and location, structural method and building materials, building regulations and a variety of other specific requirements. The architect's concern with beauty must involve these practical matters, which in turn determine to some degree what the building will look like. Aesthetic considerations are here married to practicalities.

Architecture, then, may be described as the practical art of building. It is perhaps appropriate to note here the conjunction of science and technology and art. It is often supposed that science and art are polarities in human affairs, that never the twain shall meet, that where science is, art is not, that science concerns itself with fact and art with imagination – the description of the divergences is legion. In architecture there is a real combination of technology and art, and this in great measure accounts for the unique position of architecture as a revelation of the nature of any society.

It should be understood that the union is indissoluble. The art part of architecture is not an added decoration – although such a mistake is often made – but the whole structure in its entirety, its volume, its scale, its space provision, its surface textures, its decorative embellishments. Like sculpture, architecture is three dimensional; unlike traditional

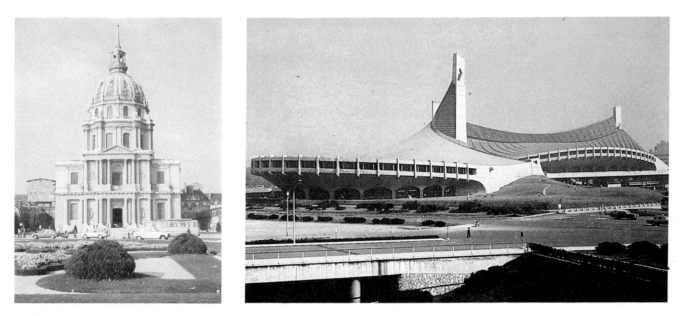

sculpture, it is experienced by being entered and seen internally as well as externally. Its physical relationship to human scale is part of its aesthetic nature. It is a common practice when considering architecture historically to identify its "style" – that is, its period attitudes in its forms of decoration as well as its generalized use. It is from this that the mistaken division of architecture into decoration and building-as-structure derives. The word style is nonetheless a useful one. With it one can encapsulate the common features of a period. It is the sort of shorthand that historians find useful and that, when understood, can be valuable to any observer, so long as one is careful not to substitute a stylistic descriptive label, such as Baroque or Rococo, for a direct response to the work.

Les Invalides, *Paris, 1680–91*
Jules Hardouin Mansart (1646–1708)

National Gymnasia for the Tokyo Olympics,
1961–64
Kenzo Tange (b.1913)

Painting and sculpture

A number of artists in the past have practiced architecture, sculpture and painting. For instance, in 16th-century Italy there was no feeling that it was improper to work in all three areas, and in the case of Michelangelo it would be difficult to determine in which discipline he was pre-eminent. Today such a thing would be almost impossible. It has become the common practice to specialize in painting or sculpture – occasionally to engage in both – but never to encompass all three disciplines. One of the obvious reasons is that the training in architecture now involves so much technical instruction that demands of time exclude other studies. Thus a historical link between the three arts had

Chartres Cathedral, *France 1194–1260*
Sculptural figures on Royal Portal

Age of Bronze, *1877*
Auguste Rodin (1840–1917)
Musée d'Art Moderne, Paris

been broken, with at least one unfortunate effect in that architecture is no longer automatically linked with painting and sculpture, which have become bought-in and often unrelated commodities. One further effect is that the architect, who is frequently the purchaser of painting and sculpture for an architectural setting, may have an undeveloped pictorial and sculptural sensitivity, which makes his choices less than appropriate.

The most significant effect of the separation perhaps has been that painting and sculpture have come to be regarded as different from architecture as art, and when the fine arts are considered, it is these arts that are usually referred to. But painting and sculpture are as different in kind from each other as both are from architecture.

Sculpture has a long history of close connection with architectural structures. The integration of the building with the external sculptures on, say, an Indian temple or the North door of Chartres Cathedral is immediately evident. Because sculpture, like architecture, is generally three dimensional, their relationship is easy and appropriate.

The three dimensional nature of sculpture lends it an actuality that differentiates it from painting. We have already noted its concentration on the human form and, although in this century that preoccupation has been broken down, most historical examples involve the presenta-

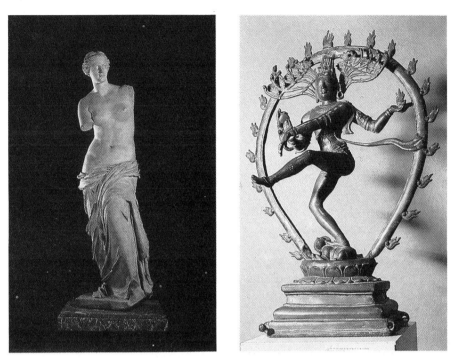

tion of the human form clothed or unclothed. The actual form of the sculpture-object relates to its subject in a physical sense. Whether larger or smaller than life, its volume is identified and created in relation to the subject; it exists as a human shape – it actually has a nose and other parts. It is not an illusion or construction in other terms than its actual form, as a painting of a human form is. But while in a painting sense of flesh, cloth, etc., may be created the surface of the sculpture is clearly the materials it is made of. Thus sculpture, while it creates form, usually does not suggest that it is the object it represents. Of course, in some instances the sculpture, particularly when made of wood, is colored to represent flesh and the materials that cover it, and this may have the effect of making the sculpture an object of reverence, fear, affection or familiarity. Sculptures of gods, priests or saints frequently have this effect. The coloring on some early sculptures from Greece and Rome has been weathered away, and this has had a profound influence on the idea of white marble as a proper material for carved sculptures. Most sculptures, however, are not to be confused with the subjects that they represent and the materials from which they are made have become an important and evident factor in their aesthetic nature. In some instances combinations of materials provide exciting or bizarre results.

Venus de Milo, *c.150 BC*
Marble height 80in (204cm)
Louvre, Paris

Shiva Nataraja *(Lord of the Dance),*
11th century
Bronze height 35in (88:9cm)
The Victoria and Albert Museum, London

Tactile, tactility, tactile values are terms often used in respect of sculpture and painting to indicate a quality that evokes a desire to, or sensation of, touch. In the case of sculpture, the observer wants to touch the material of which it is made, not the subject it represents. This tactile quality increases the observer's sense of physical involvement with the work. These tactile implications are part of the aesthetic attraction of sculpture.

There is one form of sculpture that is a sort of halfway house between sculpture and painting, and that indicates some of the significant differences between them. This form, known as relief, involves the use of a backing plane from which the sculptural elements rise, in some instances to be almost free of the plane – high relief – and in others standing only a few fractions of an inch above the surface – low, or bas, relief. There is a form of low relief, found for instance in Egyptian art, that is cut into and recedes backward from the surface plane and is known as intaglio relief. Even in high relief, such as the Parthenon horseman frieze, there is a pictorial element in that the backing plane forms a visual link, unifying what, without it, would be a series of images/objects unconnected except by understanding. When, as often happens, reliefs are colored, the pictorial effect is increased, and the backing plane may also be painted to create an effect of a location for the sculpted figures.

Apart from what may be found in this intermediate form, traditional painting is different from sculpture to the significant extent that in painting the image does not exist itself as an object of aesthetic concern. To experience sculpture, the observer must walk around it because its content cannot be experienced on only one plane or from only one viewpoint; differing viewpoints reveal different aspects of its nature. Thus a sculpture is understood in time and as the observer experiences the unfolding of its form. With a painting, a surface, which in the work has no validity in itself, has been adjusted with color, line, tone, etc. applied as paint, which itself has no meaning and minimal value. As Maurice Denis, an early 20th-century French painter, has commented, "A painting before it is a horse, a nude or some sort of anecdote, is essentially a flat surface covered with colors assembled in a certain order", and it is that "certain order", not the surface or the materials, that is important. This simplification, of course, ignores important pictorial elements such as paint texture, but it nevertheless indicates that in painting it is not the object but the effect of the object that is most important.

Throughout history the painter's range of subject matter has been

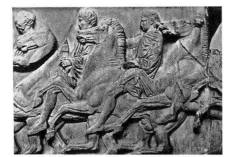

Parthenon Frieze, *detail of horsemen,*
in situ 447–32 BC
British Museum, London

wider than that of the sculptor. He has used the whole of visual experience, actual and imagined, from the human form to dream-inspired fantasy, from landscape to common objects. His range of treatment has also been wide, from careful apparent transliteration of what may be seen to arrangements of color or line that appear to have no direct visual external stimulus. His range of method has been equally different; an ever increasing availability of different materials offering almost no technical constrictions.

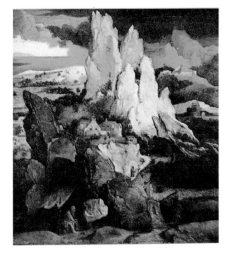

St Jerome in a Rocky Landscape,
date unknown
Joachim Patenir (d.1524)
Oil on wood 14¼×13½in (36×34cm)
National Gallery, London

Likeness and representation

We have noted that both painting and sculpture may be concerned with apparent visual fidelity to the subject. Throughout history painters and sculptors have been representing things that they have seen, believe or imagine that they have seen or that their imaginations can conceive. Even when they are not accurate – because, for instance, they are only reporting what they have been told and not personally experienced (as Dürer did in his engraving of a rhinoceros) – they paint or sculpt in such a way as to suggest correspondence with the object represented. A subject may be presented in so many different ways that a viewer may, if it is unknown to him, begin to question its actual appearance. The Netherlandish painter Joachim Patenir painted a number of landscapes containing great uprearing outcrops of rocks with unnatural geological structures, but with a powerful sense of conviction in the image. Since there is no such landscape in the flat Netherlands it might be supposed that Patenir went south into mountainous regions for his subject matter. However, we know that these landscapes were painted from models, made of shards of stone and other materials, that Patenir invented to satisfy his imagination. The resulting paintings, strange but authoritative, are a combination of knowledge, invention and observation. Again, no one living knows what the great 18th century actress Sarah Siddons looked like and she could not have looked as both Sir Joshua Reynolds and Thomas Gainsborough portrayed her – one or both of them got it visually wrong; the paintings are so different that one suspects a different factor than likeness is somewhere involved. Of course the probability is that Sarah Siddons did not look precisely like either portrait, and a photograph, had one been available, would not necessarily have resolved the question. And the portrait by George Romney adds another and perhaps more vivid interpretation, perhaps because of its incomplete and sketched directness.

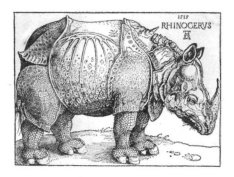

Rhinoceros, *1581*
Albrecht Dürer (1471–1528)
New York City Library

25

Indeed, likeness, "pure and simple" is rarely, if ever, an artist's sole or even primary concern; he is using the representation of objects as part of his creative means to reveal his experience and understanding. Patenir landscapes and Reynolds and Gainsborough portraits, as the main text reveals, say a great deal about the artists themselves, just as the observer's preference may reveal to him, and will reveal to others, something about the observer.

Two landscapes of similar subjects painted by Aelbert Cuyp and J. M. W. Turner reinforce the point. While it appears that both artists are concerned to show what the scene looked like, Cuyp emphasizes the sense of calm and aerial clarity, the relationship between the cattle, trees and river bank, while Turner is concerned with the dematerializing effect of the morning mist over the water and the increasing effect of the sun rising. What emerges is that while they both appear to be able to present the subjects as they wished, they treated them in a way that their different sensitivities, temperaments and societies inspired. Cuyp, as a 17th-century Dutch painter, loving the quiet peace of the country-side of Holland and aware of the newly won nationhood, was expressing a sense of security and stability as a hoped for presage of the future which would have been attractive to him and to his contemporaries in what were then troubled and insecure times. Turner, a 19th-century English Romantic, responded in his own way to the peace and evanescent light of the early morning scene. The result is two evocatively different works, which would not "work" if transposed in time and place.

There is another important, but perhaps not so immediately obvious,

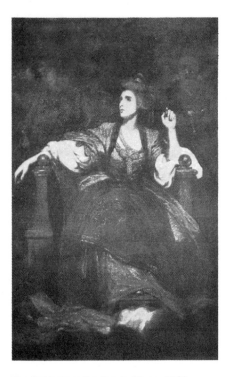

Mrs Siddons as the Tragic Muse, *1785*
Sir Joshua Reynolds (1723–93)
Oil on canvas 93×57½ (236×146cm)
Huntington Art Gallery, San Marino,
California

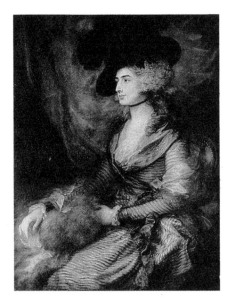

Mrs Siddons, *1785*
Thomas Gainsborough (1727–1788)
Oil on canvas 49½×39¼in (126×100cm)
The National Gallery, London

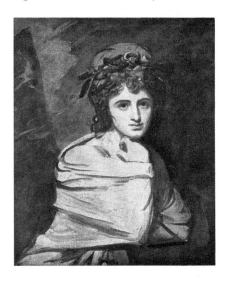

Mrs Siddons, *1785*
George Romney (1734–1802)
30×25in (75×62cm)
Private Collection

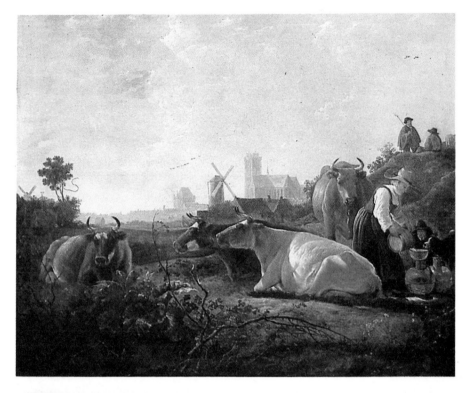

A Milkmaid and Cattle Near Dordecht,
c.1650
Aelbert Cuyp (1620–91)
Oil on canvas 62×77½in (157.5×196.9cm)
National Gallery, London

Norham Castle, c.1835–40
Joseph Mallord William Turner (1775–1851)
Oil on canvas 36×48in (91.5×122cm)
Tate Gallery, London

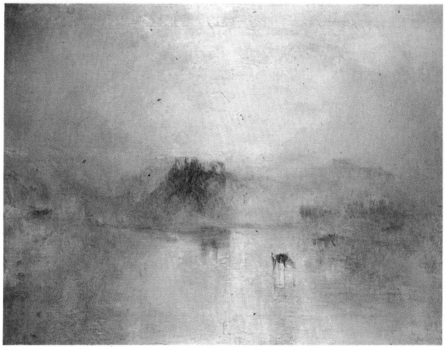

factor affecting our responses to representational art. Just as the perception of color varies considerably between individuals, as already mentioned, so does the perception of *what* we see, for we do not all see the same thing. Although the scene spread before us presents the same retinal image, what we observe is subject to processes of emphasis and suppression of which we are normally unaware. For instance, a child who is passionately interested in animals may show sudden excitement in a busy street because it has glimpsed the tail of a small dog and at the same time be oblivious to the people or traffic. Others viewing the same scene may at that moment see only an attractive girl, a coat in a shop window or a Rolls-Royce. Similarly, although you looked directly at the last door handle you turned, you could probably describe it in only the most superficial terms – all you may have registered in vision was the information that you needed to open the door. However, if you happened to be a collector of door handles you probably would be able to describe it much more precisely. This indicates that, to varying degrees, we all select from what is visually presented to us only sufficient information to meet our interests and needs, using vision mainly as a means of carrying out our daily activities.

Fraser's spiral, illustrated here, makes another important point about vision. Wat we say may not be what is there to be seen. Although the diagram appears to illustrate a spiral form surging to the center, it is actually constructed on a series of concentric circles. Even when we know this it is almost impossible to see it, so carefully has the spiral implication been set up. Human vision is, therefore, not only deceptively selective but it may also be subject to supplying misinformation.

A specialist may deliberately be selective in his vision, using it in detailed concentration on his specialization; a botanist will look for and see more in the heart of a flower – and, incidentally, understand more what he sees – than will an uninterested layman. In other respects his vision will be similar to the layman's when looking at, say, animals. The poet too may see or be inspired by different things in the heart of a flower. The English poet and artist William Blake encapsulated the effect of vision when he wrote "A fool sees not the same tree that a wise man sees."

And what of the artist's vision? He clearly depends on his visual perceptivity, which, traditionally, he has been at pains to train. His range of visual interest is likely to be wide, and he will also be sensitive to natural visual effects, such as colors, textures, etc. He may be interested in light and form, and all the elements that have traditionally gone into painting and sculpture. As a result, he will have, and so be

Fraser's Spiral

able to use, more visual information than a layman would. At the same time his visual selection and suppression will be as wide ranging and personal as anyone else's and for the same reasons.

We may then reflect upon what is offered in representational art. Is it what the artist actually sees or what he chooses to see? Is it what effects of light or distance have deceived him into believing he sees? Or is it what the observer is able to see, chooses to see, or is deceived into believing he sees? How far does the work coincide with the observer's own notions of what is there to be seen?

In practice accurate representation that could be used as a yard-stick for an objective evaluation is impossible. Perhaps the best that may be said is that each artist has produced a visual image that bears sufficient reference to an observer's experience that he may, at that moment, respond to it.

There is a further obstacle to accurate representation in painting. Even if we were able to make an objectively accurate mental transcription of what was presented to our vision in preparation for constructing on the picture surface, we would not be able to do so since the range of hue and tone available in color pigments and manufactured paints is not as wide as that encountered in nature. The tonal range from black to white (tone is the degree of light or dark on a black to white scale) in paints does not correspond to the range from natural brightness to deepest cellar dark. Place a white object against the light of the sky and the object will appear relatively dark. Which, if either, is to be painted white? Or take a painting that seems to represent a bright landscape into the open air and it will seem darker and more lacking in contrast than you will have anticipated.

All this establishes merely what the painter knows as soon as he begins to paint – that he has to compromise with vision, to make certain choices as, for example, whether to paint in a high key or low key.

There is a syllogism attributed to the ancient Greek philosopher Plato that bears upon the question. It goes "Imitation is bad; all art is imitative; therefore all art is bad." This often quoted comment by Plato bears upon the traditional view that pictorial art is essentially about appearance, but of course Plato is only condemning art as imitation and it is imitation, in his view, that is bad. But imbedded in the thought is the notion that *all* art is imitation and this perhaps demands, as a statement, serious reflection.

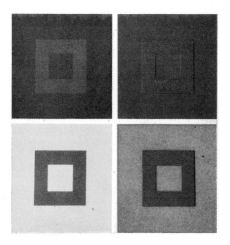

Red squares
Johannes Itten
From The Art of Color, 1961–70

The red squares in the center of each of the four different backgrounds are painted the same red, although through the effect of the background they appear different.

Vision and style

The artist's approach to his subject is affected by what has been called "period vision". Not only do we select what we want or need to see, but, in a sense, most of us usually also perceive only what our society and age encourage us to see – or, perhaps more accurately, what values and standards society holds and we embrace. When an artist looks at his subject matter, intellectually or visually, he is always to some extent searching for what his society expects of him. He is conditioned to share his society's interest and values, and what he chooses to see and use will be affected by the social values of his time. This is evident in the work of architects, sculptors, painters and craftsmen.

One effect of period vision is to affect the value that one society places on another. While we now value as magnificent achievements the great cathedrals and churches, the sculptures and paintings of Europe in the Middle Ages, so little value was placed upon them in the Renaissance – the period immediately after the Middle Ages – that the term "gothic" (crude and barbaric) was coined to identify them. The Renaissance mind was more attracted to the classical societies, preferring to find its inspiration in the great building of Greece and particularly Rome, from which medieval society had itself turned away.

Such differences may also be found in diverging attitudes existing at the same time. Two almost contemporary 17th-century portraits, one by Rubens, the other by Rembrandt, suggest the differences between Catholic Flanders and Protestant Holland. In Rubens we see a superficially brilliant elaboration of post-Counter-Reformation Catholicism and in Rembrandt serious, responsible soul-searching Calvinism. That is, of course, only my opinion, with which some readers might agree – but which may irritate others exceedingly. It is an interesting reflection upon the social values in Western society in our time that Rembrandt holds a position of artistic preeminence; it has not always been so since his death. Compare also Michelangelo's 16th-century David with Bernini's 17th-century version.

Period vision operates at two levels; firstly, it determines the view a period holds of itself and, secondly, it identifies a period for outside observers. The term usually adopted to characterize such identification of period is "style". It is a word somewhat out of favour at present, but it nevertheless has some value in providing convenient labels around which a useful shorthand can be constructed, and from which, in turn, perceptive conjunctions can be made. The advantage of some of these labels is that they do not describe but only identify; in this book they are used and their origins are considered.

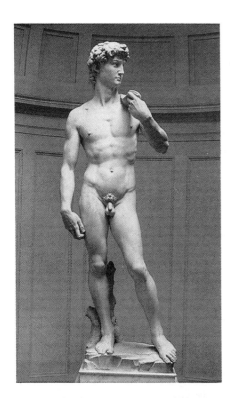

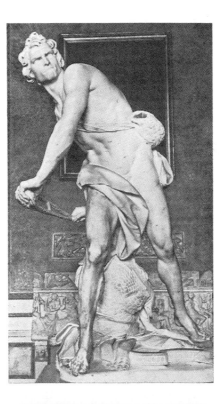

David, *1501–4*
Michelangelo Buonarotti
Marble height 16ft 10½in (410cm)
Accademia, Florence

David, *1623–4*
Gianlorenzo Bernini (1598–1680)
Marble height 67in (170cm)
Galleria Borghese, Rome

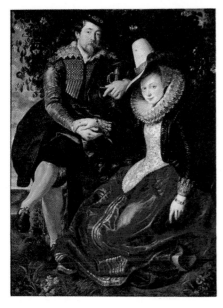

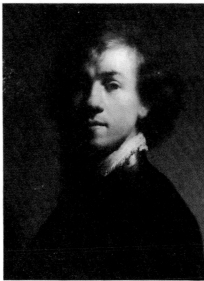

Rubens and Isabella Brandt, *1609–10*
Sir Peter Paul Rubens (1577–1640)
Oil on canvas 70½×53½in (174×132cm)
Alte Pinakothek, Munich

Self Portrait, *1629–30*
Rembrandt van Rijn (1609–69)
Oil on panel
Mauritshuis, The Hague

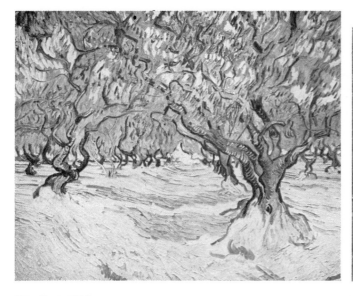

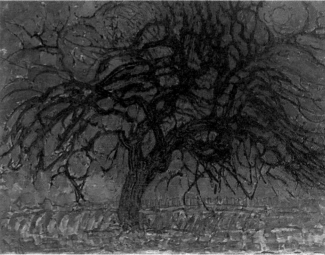

Olive Tree, *1889*
Vincent van Gogh (1832–90)
Oil on canvas
Kröller-Müller Museum, Otterlo

The Red Tree, *1908*
Piet Mondrian (1872–1944)
Oil on canvas 27½×39in (70×99cm)
Gemeentemuseum, The Hague

Abstraction

In considering representation we have been concerned with subject matter that, however presented, has its direct origin in the visible world. Even when deliberately distorted for imaginative or emotional effect the original source of the image is discernible. During the early years of this century a different and quite new preoccupation emerged in Western art (although it has a long history in non-Western art). This is a tendency towards abstraction. Abstraction covers the range of non-representational work; that is, work that does not appear to represent visible objects that we may recognize. The strength of this development is partly due to the increasing use of the photograph as a means of representing the visible world. Photography and cinematographyare discussed in the main text and here we need comment only that photography came as a rude shock to mid-19th-century painters. Its effect, for instance, on the Impressionists and its influence in directing their attention to color as distinct from form would be difficult to quantify. For other reasons, also discussed later in the book, during the last years of the 19th century artists began to be concerned with elements that were not explicitly visual, and as the 20th century advanced abstraction became a recurring, if not exclusive, preoccupation of painters and sculptors.

Some of the concerns of non-representational work have been

19th century photographic tableau, *with "artistic" pretensions*

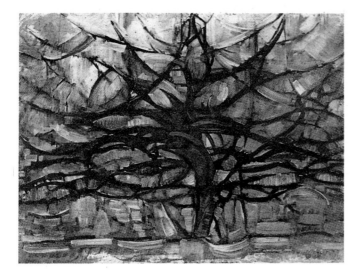

Gray Tree, *1911*
Piet Mondrian (1872–1944)
Oil on canvas 36½×30¾in (93×78cm)
Gemeentemuseum, The Hague

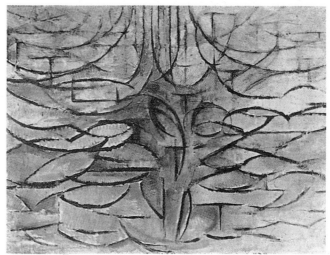

Flowering Apple Tree, c.*1912*
Piet Mondrian (1872–1944)
Oil on canvas 30½×41½in (78×106cm)
Gemeentemuseum, The Hague

touched on already; since, however, "abstract" and "abstraction" are terms allied to likeness and ones that the reader will encounter throughout the book, it could be helpful to examine them briefly here. They are most frequently used when discussing work of the 20th century and have become part of the battle cry for modernity.

To abstract has two general meanings; firstly to deduct or take away, and, secondly, to summarize, to reduce from a larger whole. In the first sense it describes works of art in which a particular subject – maybe a landscape, figure or still life – has been used for an arrangement, the shapes and forms having been extracted from the subject and altered to coincide with the need of the artist's intention. The stages and nature of this process can be seen in a series of paintings of trees by the 20th-century Dutch painter Piet Mondrian. In the first painting the form of the tree and the way in which it is painted relate very closely to similar paintings by his compatriot Vincent Van Gogh, although in the Mondrian there is the beginning of imposed order in contradistinction to the emotional attack in every brush-stroke of Van Gogh's painting. However, it is a directly related study with only the color providing a specifically non-naturalist note; one recognizes that it is a particular tree. In the second painting of a similar tree a

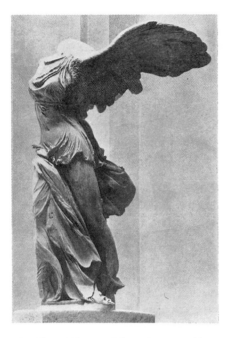

The Winged Victory of Samothrace, c.190 BC
Marble, height 96in (244cm)
Louvre, Paris

Unique Forms of Continuity in Space, 1913
Umberto Boccioni (1882–1916)
Height 43in (111cm)
Museum of Modern Art, New York

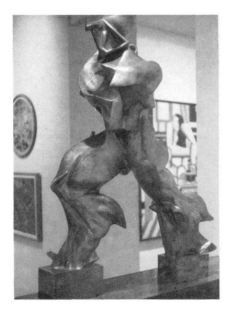

process of change has taken place. This painting is just over a year later than the first and plainly Mondrian has become absorbed in the idea of structure, of the thrust of branches, of growth and natural force arising from his earlier studies. But there is more in the second painting, for the artist appears to be concerned to relate the lines and forms to the surface plane of the canvas; he has abstracted the element of the tree to effect his composition.

There is, nevertheless, a residue of the volume and form of the tree in the second painting that has gone from the third painting, which is of the same tree. Lines and forms in the third are recognizable from the second, but they are less in relation to the form and appearance of the tree than to each other. Here a pattern is left of related tilted planes linked by and interlocked with heavy lines, which perhaps are the outcome of an exploration of relationships inspired by the particular tree but having only a residual and tenuous connection with it. In this form of abstraction we may say that the painter has abstracted from a given subject and that the work is abstractionist.

At this point let us consider the general and the particular. Mondrian starts with a particular tree and ends with a generalized image – could one say one is *a* tree and the other is "treeness". The question of what the observer receives is interesting; does he want a tree or treeness? In his *Principles of Art* R. G. Collingwood writes, "The patron who buys a picture of a fox-hunt or a covey of partridges does not buy it because it represents that fox-hunt or that covey and not another; he buys it because it represents a thing of that kind. And the painter who caters for that market is quite aware of this, and makes his covey or his fox-hunt a 'typical' one, that is, he represents what Aristotle called the 'universal'." In his quite different way Mondrian, as he says in his writings, is also concerned with the "universal".

Another illustration of abstractionist work is provided by a comparison of the great Classical *Winged Victory of Samothrace* with the striding figure called *Unique forms of continuity in space* by the 20th-century Italian sculptor Boccioni. Both figures express the energy of forward thrusting movement, the earlier work through the sensitive carving of a wind-blown fabric, the second through an abstractionist analysis of various stages of movement.

Two modern sculptural examples may be used to indicate how the distinction between the two forms of abstraction may be identified. Both are works by the 20th-century sculptor Constantin Brancusi, who was born in Rumania but worked mainly in Paris. The first, *Negro Head*, is a simplified refinement of interrelated forms derived directly

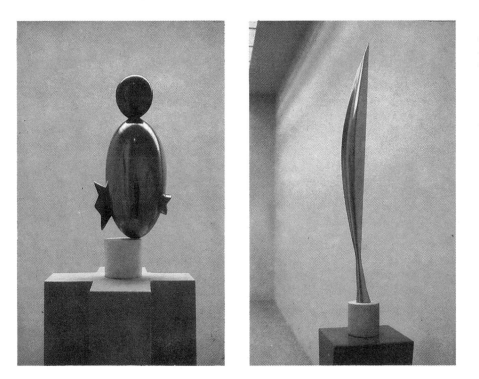

Negress Version II, *1933*
Constantin Brancusi -1876–1957)
Bronze and stone
Height 24in (61cm)
Museum of Modern Art, New York

Bird in Space, *1919*
Constantin Brancusi (1876–1957)
Bronze height 57in (137cm)
Museum of Modern Art, New York

from the form of the head. The second, *Bird in Space*, is a soaring, elegant form that does not directly derive from the appearance of a bird in flight but is an intended expression, in an abstract volume, of the subject. Although inspired by the idea of bird flight, the shape itself has, in its great subtlety of relationship between the parts, its own individual identity; its creation comes not through vision but through reflection, intuition, sensitivity and "inner necessity". Kandinsky's painting illustrated here is another example of the same form of creation. Work such as this is usually described as abstract rather than abstractionist.

Abstraction is, however, the method not the inspiration and it will only be employed if it is felt to be needed. The 20th-century artist has often considered varying degrees of abstraction valuable in expressing his disturbed discontent with, and distaste for, an increasingly de-personalized, science-based culture – or at least he has professed to do so.

Normal visual selection is to some extent abstraction and thus it may be said that abstraction has been a feature of all works of art. Conscious abstraction as a deliberate process is a modern development. Distortion of natural form for deliberate emotional effect, such as one en-

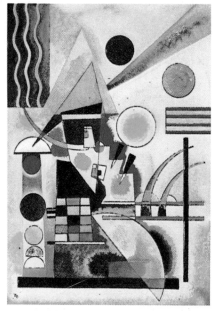

Swinging, *1925*
Wassily Kandinsky (1866–1944)
Oil on cardboard 27⅝ × 19⅝in (69 × 49cm)
Tate Gallery, London

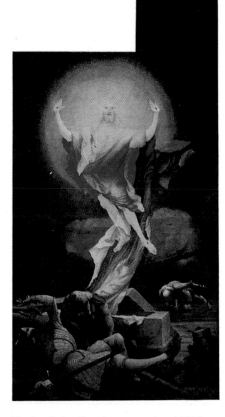

The Isenheim Altarpiece, *completed 1515*
The Resurrection
Mathis Neithardt-Gothardt, called
Grunewald (c.1470/80–1258)
Oil on wood panel 106×120in
(269×307cm)

counters in the 16th-century German artist Grunewald's Isenheim Altarpiece, is a more extreme example of such visual selection, as is the work that arises from fantasy, spiritual ecstasy, the occult and dream imagery. Such explorations are, of course, found in all the arts.

Fakes, frauds, forgeries

Art has become big business. With the beginning of the dealer industry in the 19th century, the support and promotion of the artist for money making purposes has become increasingly sophisticated and the realization that some of the baser emotions might be exploited through works of art has led to considerable ruthlessness in the art world. The desire to be "one up" on one's friends has prompted a collecting industry, in which the greed of dealers in art as a commodity, the limited production line from individual artists and the consequent rarity of their work have all contributed to a cutthroat competition. This has inevitably led to lies, exaggerations, forgeries, expediency, inflated reputations and dishonest dealing. Of course, this does not involve all dealers, galleries or collectors any more than it applies to all or most artists. But the rotten apple can affect the barrel, and the sad result is that a good deal of mistrust has been aroused in the mind of the interested public. At a time when modern works of painting and sculpture are generally found by that same public to be difficult to comprehend and enjoy, the commercialism of the art world tends to reinforce a belief that the whole of modern art is a "con".

The intellectual independence of the art historian, the serious remoteness of the aesthete, the fierce unconventionality of the artist do not appear to the public gaze, but the scandals that regularly crop up invariably occasion excitement, even hilarity, in the newspapers and among the public. There is a perhaps natural pleasure in the sight of an expert being, or appearing to be, confounded. The complexity of the observer's emotions, from envy to a sense of inferiority, usually express themselves in thoughtless glee.

Art fakes, forgeries and the great variety of frauds that are uncovered provide continuing opportunity for comic-serious analysis of the failure of critics, historians and others to have detected what, it is supposed, should have been obvious to them. While it is recognized that forgers are intelligent, informed and competent, it is claimed that they should not have been able to deceive real authorities – if we can't trust them, who can we trust? If you have read this introduction, you will know the answer to that one – trust yourself. Nevertheless, the fact that deceivers continue to get away with their deceit, at least for a

time, seems to establish that the technical knowledge and gathered experience of the art world is incapable of distinguishing good from bad, the spurious from the real. At the same time it is noted that the experts will elaborate freely on the qualities to be discerned in works of art from the distant past to the present day and from all parts of the world. It is a sport that the unthinking man may enjoy, but raised many problems for the thoughtful.

Since faking and forging are really big business, enormous sums of money are involved, and the successful passing off of a fake will be very rewarding. In consequence, a great deal of ingenuity is devoted to establishing the authenticity of a work of art. In many instances its provenance (place of origin) and its successive owners, in the case of an historical work, are known and its authenticity, if not its quality, is unchallengable. Many works in public galleries and private collections are of this order.

But, frequently, in the story of many works there are gaps – sometimes covering many centuries. In these circumstances the internal evidence in the work itself – its material, its finish, its condition, its similarity to other works by the same artist or from the same period – has to be considered and specialist expertise consulted.

It is, in fact, a tribute to the perception and disinterested determination of the "experts" that so few, not so many, forgers and deceivers succeed. Even where forgers are successful for a period of years, as for example in the case of Hans Van Meegeren's forgery in the 1950s of paintings supposedly by Vermeer, there are usually special factors surrounding success and exposure, as there were in Van Meegeren's case, which do not depend on the experts' judgment – and invariably not all experts concur. There were those who always doubted the "Vermeers" by Van Meegeren.

Nevertheless, sometimes forgers succeed and works that in fact are spurious appear to be, and are accepted as, genuine. A number of questions arise. If no one knows that the Vermeer they are looking at was not painted in the 1640s as they suppose, but in the 1940s, does it affect the quality of the response in the observer? Does he not receive the same message, the same satisfaction, the same pleasure whenever it was painted? And even if he knows, what is changed for him? What should be done with the uncovered forgery? It has given satisfaction and pleasure, and will the qualities discerned in it before not still be there? Should it not continue to be exhibited with a different authorship label? And if it is, will it command the interest that it would as a, say, Vermeer?

How may such questions be answered? First, let us remember that throughout this introduction we have been emphasizing the personal responsibility that everyone has for his judgments. Then, let us go further and assert that the only truth that has significance – that is to say, is true – is that which you individually accept and hold to be true. Your truth will have been arrived at through decisions you have made or through acquiescence in the judgment of others. Faced with any situation or evaluation, the action you take will, rationally or irrationally, result from what you think you should do. The truth and what you do about it is your decision.

So when we discover that something that we believed to be genuine is actually spurious, we must take what action we think we should. The decisions taken will differ from different motives. At this point I can only tell you what I think should be done with the spurious – it should be rejected. My own failure of sensitivity, my acceptance of the judgment of others as a result, the uncomfortable feeling that I would have in continuing to build on false foundations, my own pursuit of excellence, knowledge of the weaknesses of my character, my limited intellectual capacity, all these combine to make me say I am not secure enough to accept the spurious. It may be different for you. It may be that the power of the work when you believed it genuine is sufficient for you to continue to revere and enjoy it. So be it. You may change your mind.

As William Blake observed, "One law for the lion and the ox is oppression". This is what understanding and enjoyment is about – a personally expanding – or contracting – adventure. Is the ox superior to the lion?

Perhaps you may now approach this book with the following tail-piece in mind: "A creator needs only one enthusiast to justify him!"*

*Man Ray, 1963

Historical Survey

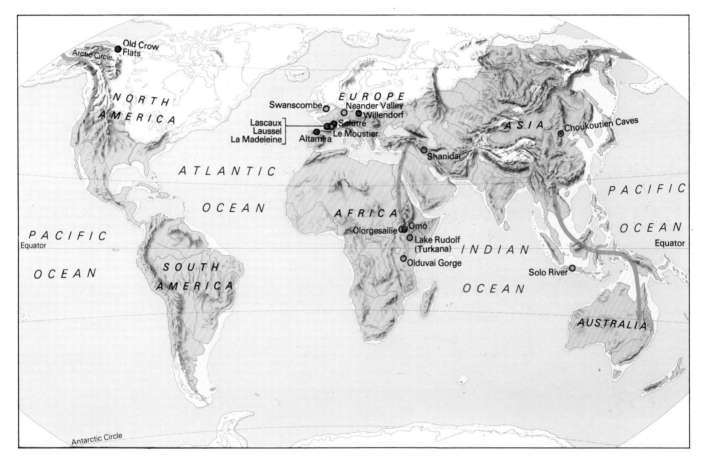

Early Man

Hominids – the group which includes human beings and their extinct close relatives – emerged from the Primate family during the epochs of earth history known as the late Miocene and early Pleistocene, some five or six million years ago. Most of our evidence of them comes from the Pleistocene, during which individuals walking on two legs, but with smaller than human-sized brains, were evolving towards modern forms. Dating the period when modern humans made their first appearance is still controversial, but it is being pushed back in time by scientists using ever more refined methods for interpreting the sparse finds of early fossil humans.

The clearest evidence of our ancestors which has so far been revealed is in the Rift Valley strata of East Africa. In particular, beds of sediment in the Olduvai Gorge in Tanzania hold sequences of fossils going back to the beginning of the Pleistocene. It is difficult to establish how true humans of completely modern type ('homo sapiens') then spread across the continents some 30,000 or 40,000 years ago. All we know is that their fossil remains, or evidence of their flint-tool-making industries, have turned up in China, India, Indonesia, Australia, Europe, and North, East and Southern Africa – all dated to this period, known as the Old Stone Age (Upper Palaeolithic).

The last Ice Age (85,000–10,000 years ago) kept early mankind somewhat on the defensive, restricting them to the areas where they could best survive the rigorous climate, but nature still provided great herds of game for the hunters, who could shelter under rocks or in caves. In the deeper recesses of some of these, they illustrated animals and hunting scenes in vivid paintings on the walls, where they may still be seen, 20,000 years later.

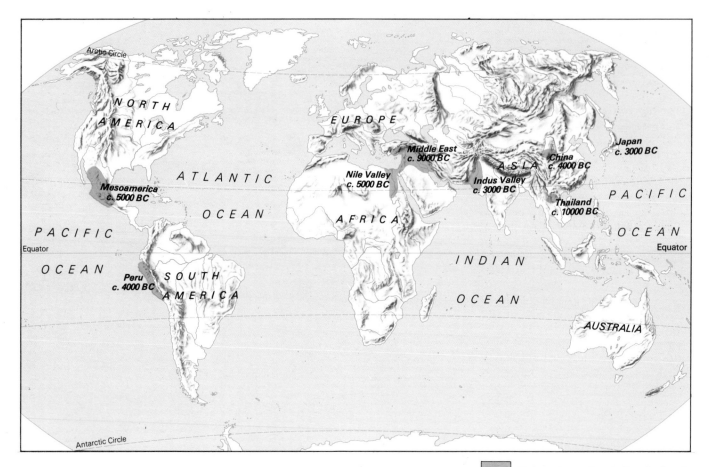

Regions where early agriculture developed

The Beginnings of Civilization

A life-style similar to that of the early hunters and gatherers can still be found in our own time in small communities tucked away in parts of South America, Africa, India, South-east Asia and Northern Australia. It is a life style which might have gone on for ever, for all of us, had it not been for the discovery, about 12,000 years ago, of farming. Planting vegetable and grain seeds and breeding dogs and goats may have seemed a relatively modest improvement to people at the time, but on it was to be built the whole of subsequent human civilization.

Being able to provide food at home without having to go out and find it in the wild meant the start of village life.

Farming began spontaneously, in mainly sub-tropical centers which were favourable for it, right round the world. From about 9000 BC, humans of the early Neolithic period took to the new way. In America the staple cereal was corn (maize), in western Asia, India and China it was millet – later wheat – and in South-east Asia it was rice. The resulting surplus production and population growth in villages went hand in hand with the creation of forms of social organization which made possible the storage of food reserves, the digging of irrigation systems, the construction of large ritual centers and the establishment of city-states.

During the late Neolithic period (from about 6000 BC onwards) this was happening quite quickly in the fertile areas of the great rivers, the Nile, Euphrates, Tigris, Indus and Hwang Ho. In America on the other hand, urban life developed in areas far from major rivers.

The tendency was for city-states to coalesce into larger units, as in pre-dynastic Egypt (5500–3500 BC), Sumeria (4000–3000 BC) and China (3000–1600 BC). Strong local administrators (sometimes priests, sometimes warriors) welded them into personal kingdoms, and set forth to dominate the others in that area.

The Early Empires

The reason the Near East is called the cradle of civilizations is that it was there, in the late Neolithic period, that the first urban developments took place, illustrated by the site of Çatal (pronounced Chattal) Hüyük in southern Turkey, a hill-top village that was inhabited between 6200 and 5400 BC. Settlements like Çatal Hüyük display the historical stage at which families of farmers living together began to have the needs of town-dwellers.

In the cities that grew up between roughly 5000 and 3000 BC, the arts of government were developed – especially the invention of writing. Taxation encouraged the use of number systems for calculations.

The use of copper, about 3000 BC, was soon followed by its more useful alloy, bronze. It brought with it better tools and sharper weapons and coincided, not surprisingly, with increased social organization. The two kingdoms of Egypt were joined together by an upper-Egyptian ruler about 3200 BC, who started the first of the thirty dynasties of ancient Egyptian history.

In lower Mesopotamia (Iraq today), the independent Sumerian cities of Eridu, Ur, Lagash and Uruk submitted, about 2350 BC, to the domination of Sargon I, the Semitic king of Akkad. In three or four centuries the city of Babylon on the Euphrates to the north of Akkad had become the political and cultural center of the entire region.

From this time, about 1500 BC, until the climax of Greek culture in the Aegean area some thousand years later, civilization was synonymous with the empires of the ancient Near East.

The power of Egypt swelled and shrank from time to time. Under the dynasties of the New Kingdom (c.1570–1000 BC) it asserted itself over Palestine and beyond.

Power in Mesopotamia passed to and fro between Babylonia in the center of the region and Assyria in the north. The Babylonians, as successors to the Sumerian civilization, had flourished first – their greatest ruler was the lawgiver Hammurabi (1729–1750 BC) – but their power declined about 1200 BC. The rise of the Assyrian state coincided with the introduction, c.1500–1000 BC, of iron in the Near East. Ashurnasirpal II (883–859 BC) raised Assyria to a power which reached its peak under Ashurbanipal (669–625 BC), who controlled the whole region from South-west Iran to Sinai and took war up the Nile valley itself.

The Hittites (an Indo-European-speaking people) had set up an important empire in the highlands of central Turkey, soon after 2000 BC.

The period c.1200 was one of turmoil in many parts of the Near East, and maritime invasions hit Egypt hard, devastating the coasts of Lebanon, Palestine and the Nile Delta.

Assyria	
Babylonia	
Egypt and Palestine	
Hittites	
Sumeria	
Trade routes	

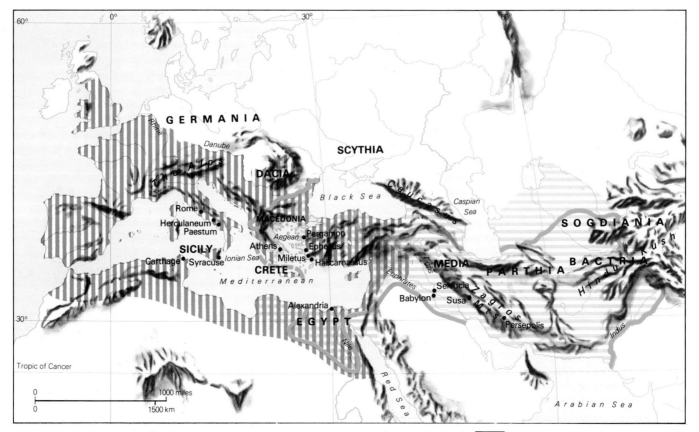

The Classical World

Between the Persian sack of Babylon (539 BC) and the death there of Alexander the Great (323 BC), the three-thousand-year-old heartland of civilization in the Near East was over-run by conquerors from beyond its borders.

By *c.*550 BC, an Iranian state had come into existence headed by a dynasty called the Achaemenids, who added Egypt and Asia Minor to an empire reaching from the Indus to the Aegean, and aspiring to the over-lordship of all Greece.

The Persian Wars lasted until the independence of the Greek cities was recognized in 449 BC.

Athens had ruled over the Aegean as an empire, but decline set in. The power base of the future lay even further away from the ancient centers: in Macedonia.

In 336 BC Alexander of Macedon succeeded his murdered father Philip II. A mere twelve years later, the entire Persian empire was in Alexander's hands, India had been invaded, and a world-state in which Greeks and Per-sians were to mix by marriage was in preparation. Western Asia became hel-lenized almost overnight, with Greek as the *lingua franca* of the civilized world.

The ripples of expanding civilization were at this time over flowing into the western Mediterranian, where in the previous four centuries, urban de-velopment had lagged behind that of the eastern Mediterranean. It was

Rome that was destined to constitute a focus of development and carry the most advanced civilization of the age to most of western Europe.

Established since *c.*750 BC, the Romans displayed the energy and resourcefulness to throw off Etruscan overlordship (474 BC), eclipse and absorb their culture, make themselves masters of most of Italy, and then (268 BC) take on Carthaginian military and naval power in a struggle which ended with the total destruction of Carthage in 146 BC.

Persian Empire c. 500 BC

Athenian Empire c. 500–450 BC

Conquests of Alexander the Great 336–323 BC

Roman Empire c. AD 200

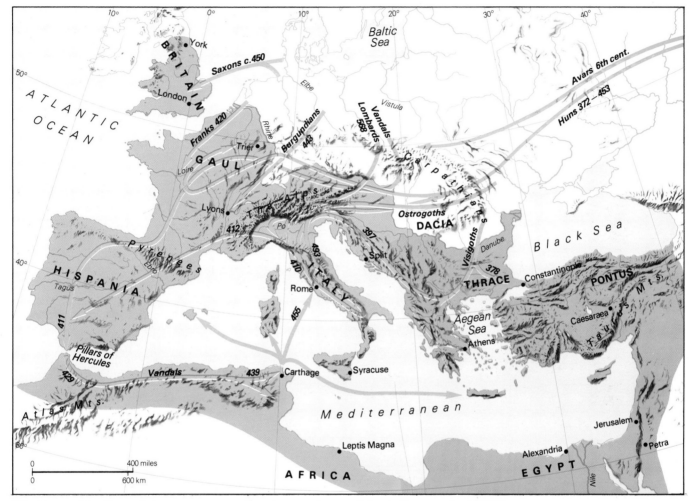
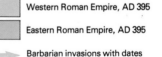

The Roman Empire and the Barbarian Invasions

By the end of the 2nd century AD, economic weakness and rapacious administration might have begun to bring about the break-up of the Empire even without the stress of barbarian attack. The non-Roman world beyond the Rhine-Danube frontier was making itself felt. Germanic tribes were on the move, hastened partly by population pressures on them by the Huns and others from inner Asia, partly by an appetite for good lands and Roman honours. The earlier migrants, having been settled by the government in frontier provinces of the Balkans and Gaul, were followed in the 4th century by larger contingents of Goths, Swabians, Franks, Alamanni and Vandals.

Early in this disturbed 4th century, two decisions made by Constantine the Great helped to shape the future: firstly, in 313, he lifted the official ban on the Christian Church; secondly, in 326, he moved the capital from Rome to the east, at Byzantium on the Bosporus. At the death of Emperor Theodosius I in 395, the split was consummated, with an eastern and a western Emperor from then on.

	Western Roman Empire, AD 395
	Eastern Roman Empire, AD 395
→	Barbarian invasions with dates

The Franks gave their name to the future kingdom of France, while the colonists in Britain changed a Romano-Celtic province into England. In 476, the Germanic mercenaries in Italy put an end to the shadowy western Roman Empire. It was to lie dormant until Pope Leo III crowned Charlemagne the Frank at Rome as Emperor on Christmas Day, 800.

The Christian World

The roots of modern Europe reach down to the 'Christendom' of the early Middle Ages. We can see, in the 10th-century realms of the West that replaced the crumbled Roman Empire, the shapes forming which are to become the nations of the modern world. The process draws the whole of the Continent (not just the Mediterranean and Atlantic portion) into the historical mainstream. Lost to Europe, however, are the once Roman provinces of North Africa, which the Muslim torrents of the 7th and 8th century submerged (along with most of Spain).

Viking domains

Viking routes

Invasions, 10th century

Muslim lands

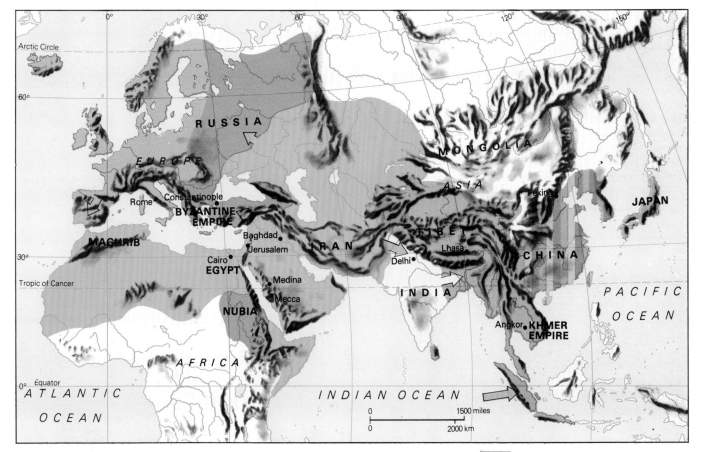

World Religions

Buddhism, c.500 BC, was the first organized system of beliefs to rise above the cults of place or race and to embrace believers from different cultures. It became an official religion in India when it was adopted by Ashoka (274–237 BC), and flourished there for a thousand years. By the 9th century AD, Buddhism had spread widely outside India. Even where it did not become permanently rooted, Buddhism permeated the culture of those areas.

The two other major world faiths spring from a single source: the ethnically-based religion of the Jews of Palestine, with its unique and exclusive God as creator and supreme judge of mankind, but Judaism itself did not

seek the conversion of the whole world. On the other hand, Christianity, though born within the framework of Judaism, went all out for universal conversion. Despite bitter controversies over doctrine, the Church continued to expand. In 484–519 a temporary split between east and west occurred, to be followed by the historic schism of the Church in 1054, which made permanent the division into Latin West and Greek East. While Latin Catholic Christianity spread northward, Greek Orthodox Christianity – including some 'heretical' variations – spread into India and China, Africa and most importantly among the Slav peoples. Muhammad (570–632) founded Islam in a corner of Arabia that had

never become part of the Greco-Roman world. Drawing on the traditions of both Jews and Christians, he spoke as the culminating prophet and 'final messenger' of the One God.

Legend:

- Buddhism
- Christendom: Latin
- Christendom: Orthodox and Coptic
- Confucianism
- Hinduism
- Islam
- Taoism
- Pagan and other religions
- ⟹ Direction of religious expansion

Renaissance and Reformation

The early Renaissance period in Italy coincided with the healing of one serious split in the Western Church (the 'Great Schism', 1378–1417) and closed with the opening of another and enduring one, the branching of Christians in the West into Catholics or Protestants (from 1517). A settlement of the 1378 schism was achieved through a series of Councils, the pressure for the holding of which contributed to the general desire for reform in the Church.

As the states of Europe gradually emerged from their medieval conceptions of Pope, Emperor, King and Christendom, there was intense political activity in every land. The leading powers, the kings of France and the Emperors, jockeyed for control of the papacy, fighting it out in the battleground of Italy. England under the first Tudors (Henry VII 1485–1509, Henry VIII 1509–1547) consolidated the royal power and the national interest. Spain, newly freed and united, became through the accident of Columbus' expeditions to America (1492–1504) a first-rank world power. The domains of the Habsburg Charles V (born 1500), who as king of Spain (from 1516) was master of America from Florida to Chile ('the Indies') and as Holy Roman Emperor (1519–1556) presided over the whole of what is now Holland, Belgium, Luxemburg, Switzerland, Germany, Austria, together with half of Czechoslovakia and large slices of France and Italy, were the largest European empire that had yet existed.

The Reformation was marked by progressively radical stages: Martin Luther's theoretical challenge to the Church authorities on the sale of indulgences (1517), his banning by Charles V (1520), the publication of his new translation of the Bible (1522), the Peasants' War (1524–1525) and the

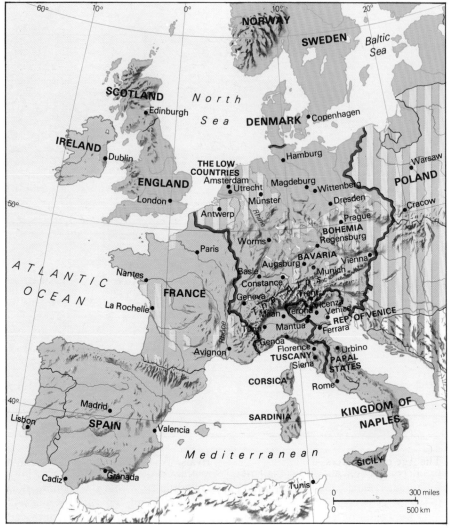

formation of opposing leagues of princes (1525) to fight for or against the reformed faith which was gaining ground in the German-speaking lands, the Low Countries, France, Scandinavia and the British Isles. After this time, political motives often compromised the religious issues on both sides. France split over reform, leading in 1562 to the Wars of Religion. The oppression of the Dutch by their Spanish rulers (1522 onwards) only strengthened the bond between Reform

	Catholic areas
	Protestant areas
	Areas penetrated by reformed faith
	Boundary of Holy Roman Empire, 150C
	Eastern Churches
	Islam

and Liberty, while for England the first fruit of Luther's stance on the Continent was the setting up of a state church (1534) rather than religious reform.

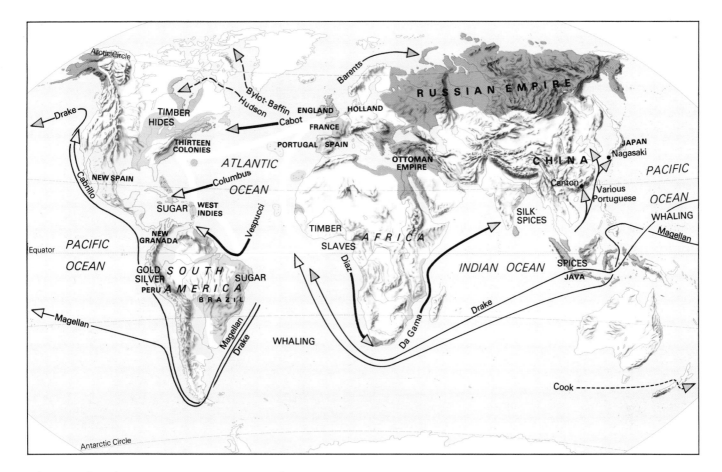

The Age of Explorers

In 1415 the Portuguese seized the Moroccan town of Ceuta, and the impetus of Portuguese exploration down the West African coast-line was launched. Organized and financed by Prince Henry the Navigator (1394–1460), seaborne expeditions systematically nudged their way southward. In the late 1480s things really began to move. Bartholomew Diaz went round the Cape of Good Hope into the Indian Ocean in 1483. Europe began to sit up. Printing had become widespread in the 1470s, and word got around.

It now being generally accepted that the Earth was a ball, the idea of beating the Portuguese to India and the Far East by the reverse route appealed to their rivals. A Venetian citizen, Giovanni Caboto (better known as John Cabot, 1450–98), sailing from Bristol in 1497, discovered Cape Breton (Nova Scotia) and, on a second voyage, Baffin Island – convinced he had reached Siberia.

Both Cabot and Da Gama were aware of what the Genoese Christopher Columbus (1451–1506) was up to. Backed by the court of Spain, he was extending his discoveries around the Caribbean on the expeditions of 1493–1500 and 1502–4, while the Florentine, Amerigo Vespucci, also in the service of Spain, was following the coasts of Guyana and Brazil (1499–1502). Vespucci, it seems, was the first to realise that this was truly a New World they had discovered.

Explorers:

— 15th cent.
— 16th cent.
---- 17th cent.
------ 18th cent.

Nationality of explorers and overseas possessions by mid-18th century

▷ Dutch
▷ British
French
▷ Portuguese
▷ Spanish
The Slave Trade 'Quadrilateral'

GOLD Source of commodities sent to Europe

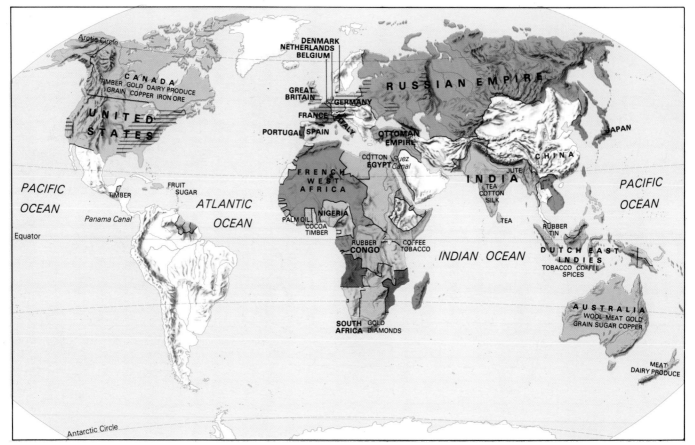

Industry and Empire

In 1700, European technology was not much more advanced than technology in China, but the principles of steam power were beginning to be applied. By the middle of the 18th century, modern iron-works were established in England (Coalbrookdale from 1709) and in 1800 workable steam-powered vehicles and locomotives were being demonstrated. The great coal-consuming industries of, firstly, England, and soon after, of France, Belgium and Germany, began to demand the raw materials of the whole world – iron ore, cotton, rubber, jute etc – for processing and, inevitably, to seek mass markets overseas for their products. The modern world economy came into being from the 1860s onwards, encouraging an accelerated race for colonies.

Wherever they went, Europeans built railways and raised the level of local productivity, thus feeding their economic system while at the same time undermining its long-term survival. The Suez Canal (opened 1869) and the Panama Canal (opened 1914) boosted sea-borne transport in its golden age.

The two super-powers of the future, Russia and the United States, filled out the available landmasses of Eurasia (Central Asia 1816–1900, Vladivostok founded 1860) and North America (see next map), while one non-European power, Japan (opened to the West after 1853), learned its lessons so well that it

Possessions and empires in 1914:

Belgian		Japanese
British		Portuguese
Danish		Russian
Dutch		Spanish
French		Turkish
German		U.S.A.
Italian		

Major industrial areas by 1914

COTTON — Sources of raw materials exported to Europe

embarked on overseas expansion of its own (Korea 1894, Taiwan 1895). By the First World War European world supremacy had reached its apogee.

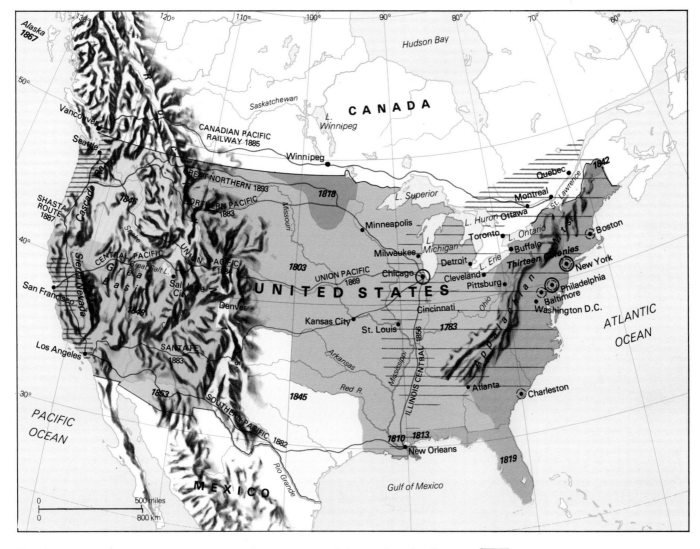

North America

The universal character of 20th-century civilization is clearly seen in America, the world's political and economic center of gravity since the 1940s. More than any other area on the American continent, the USA and Canada are a cultural replica of Europe.

About four million people lived in the United States at the time of the first census, and only 200,000 of these lived in towns. The present-day USA has over 226 million citizens, nearly three-quarters of them urban dwellers.

The prerequisites for this growth – the physical occupation and economic exploitation of the whole territory between the Atlantic and Pacific Oceans, and the means to transport people and goods across it – were achieved between the end of the war in 1865 and 1900. The basic railroad links were opened between 1869 and 1893. In all of this, the economy of Canada moved forward in parallel, despite a smaller population (nearly 25 million in 1983).

1783	Growth of the United States
	Area containing major industry by 1860
	Area containing major industry by 1900
	Area containing major industry by 1940
⊙	Cities with population over 10,000 at first U.S. census (1790)
⊙	Cities with population over 1,000,000 in 1910
•	Other towns and cities
——	Pacific Railroads

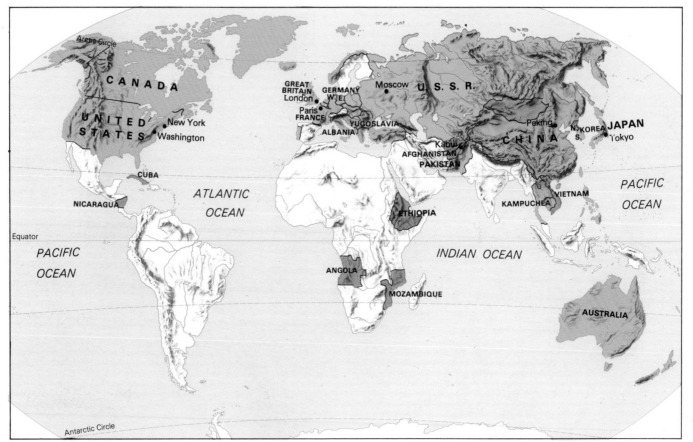

	North Atlantic Treaty Organisation and allies
	Warsaw Pact
	Pro-Moscow Communist states
	Other Communist states
	Non-aligned countries
	Principal borders, 1983

The Twentieth-century World

The Euro-centric civilization (see page 48) survived two world wars, but since the end of the latter (1945) it has been divided against itself in two great coalitions looking respectively to Washington and Moscow for leadership, and with much of the formerly colonial areas ostentatiously rejecting the tutelage of the advanced nations.

In 1917, late in the First World War, the Russian Communists (Bolsheviks) advanced in one stride from being a fringe group of leftist emigrés, within eight months of the overthrow of the tsarist system in February, to being in control of the revolution. Weak as it was, the Soviet government assumed a world political role from the beginning and has not ceased to act it out until the present day. The United States, on the other hand, endeavored to withdraw as far as possible from world leadership into a virtuous isolation, even after intervening decisively on the Allied side in the later phases (1917–18) of the First World War. Drawn (1941) into the Second World War, the United States found that the role of major power in the post-war alliance of non-Communist states was inescapable.

This polarization has, however, been far from neat. The power of China – Communist since 1949 – is not aligned with Moscow. China's neighbour and closest rival in the 20th century, Japan, has been, since 1945, integrated into the Western economic system.

The so-called 'Third' or 'Non-aligned' world consists mostly of countries which have either directly inherited the Old World's values (as in Latin America), or been given their statehood after a period of colonial rule (as in Africa, South Asia and South-East Asia) and therefore share outwardly many of the political, economic and social forms of the West.

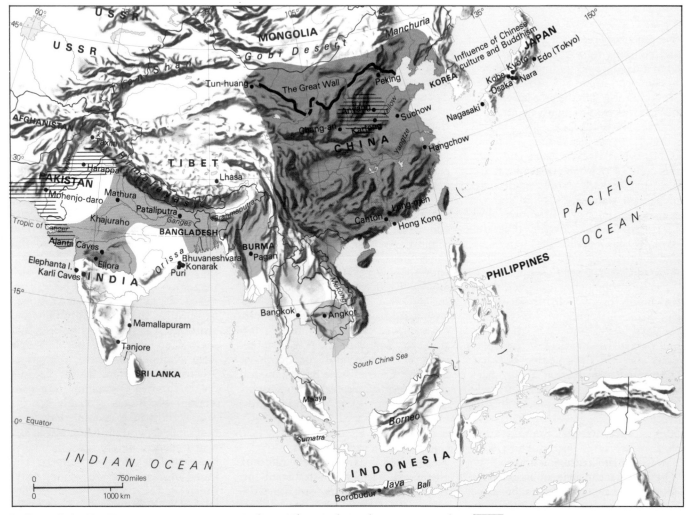

India and the Far East

Deeply rooted traditions of both the indigenous city culture that has been excavated in the Indus Valley, and the migration of the Aryans which swept over and obliterated it about 2000 BC are traceable all through India's subsequent history. Subsequent Indian empire-building energies focused in the Ganges region in the North-East, homeland of the Mauryas (319–185 BC) and the Guptas (320–470) – as well as of the Buddha (see page 45). From the Arab conquest of Sind (712) onward, Muslim invaders established themselves in India. The independent state of Pakistan (1947) consolidates this Muslim inheritance.

The source of the social and political structures of later Chinese dynasties is already recognizable in the Bronze Age culture of the Shang (c.1500–1000 BC) and Chou (c.1000–200 BC) periods in the middle reaches of the Yellow River. In the Tang period (618–906), the Chinese empire began its domination of the Far East which lasted, with many ups and downs, until the coming of the Europeans in the 18th–19th centuries.

The first civilisations, 2500–1000 BC

Greatest extent of Chinese empire

Gupta empire, c. AD 400

Other major civilisations:

Burmese, 11th–13th centuries AD

Khmer, 9th–14th centuries AD

Thai, 12th–15th centuries AD

Vietnamese, 11th–15th centuries AD

Present day borders

Influence of Chinese culture and Buddhism (T'ang dynasty, 6th cent. AD)

The Arts in History
Prehistoric Societies

Our practice of measuring time by years and counting forwards or backwards from a fixed point no doubt has much to commend it, but to historians, who are concerned with the passage of time, this has the effect of numbing our sense of time. The only way that we can give substance to the idea of time is in terms of our everyday experience, and from this point of view the events of a single day are perhaps more vividly apprehended than those of a year. A middle-aged man will have been alive for approximately twenty thousand days, yet only a million days ago Rome had not yet been founded. Two million days ago civilization – as opposed to what anthropologists call cultures – had hardly begun. Further back than this there is little point in even counting the days.

If we transfer our attention to generations and beg the question of what constituted a generation at any particular time, the evidence of toolmaking presented by anthropological archeologists suggests that there have been at least sixty thousand generations of creatures on this Earth who have some claim to be called human. As far as we can tell, art began only about twelve hundred generations ago. From this we may be tempted to conclude that our ancestors' need for art not only came late in their development, but that it represented a decisive stage in the process by which they separated themselves from the animal world.

Historical methods
Carbon-14 dating techniques have recently played havoc with many of the accepted beliefs of prehistoric chronology. It now appears that the traditional idea that early civilization at all of its stages was diffused outward from the Middle East is no longer valid. In terms of the art of these civilizations, not a single written word has come down to us from the remote times when it began to tell us what artists thought they were doing. To understand these civilizations, all we have to go on is the art itself. If we think we can make sense of it, that is because we are prepared to trust the promptings of our imaginations and experiences by saying to ourselves, if I had done that, what I probably would have had in mind was such and such.

Only a moment's reflection, however, will reveal that our confidence is unfounded. We have only to consider the chaos that descended upon history with the invention of written testimonies. Even when we consult those societies that seem to have survived unchanged from prehistoric times into out own, we cannot be sure that the analogies will support precise inferences if only because contemporary primitive societies have been static for generations, whereas the people who "invented" art were the avant-garde of mankind.

Understanding early societies
It was the 18th-century Italian philosopher G. B. Vico who formulated the proposition that whatever we ourselves create we can know, and showed how this could be used to elucidate what men did and the things they made long ago. In the 19th century the term "hermeneutics", originally a technique for clarifying obscurities in ancient texts, was extended to the wider science of interpretation. Since then it has become a dominant ingredient of archeology.

The idea that all human behavior is in principle intelligible and therefore capable of being understood by other human beings is one of the most seductive beliefs of recent times. As a device for penetrating the early history of the human race this idea succeeds within the range of familiar experience; a small piece of hard stone with sharp edges and a point, for example, is unlikely to happen by accident, and even less likely if several are found together. No one would question that such things were tools or weapons used for cutting and piercing. In the context of Paleolithic man, such objects can only infer the hunting of animals. And when we come to something like the so-called Venus of Laussel, we can be fairly sure that the artist had an eye for certain aspects of women. So far so good. But beyond that? Modern analogies might suggest erotic fantasies, but any such suggestion is not likely to be well received by serious scientists. It is assumed by scientists that life twenty thousand years ago was nasty and brutish, and sex was no laughing matter. If people were interested in sex for reasons of procreating children, it was because they associated copulation with conception, which was probably not the case. Fertility must certainly have been fashionable, but if the figure was in any way intended to promote fecundity, how could this possibly happen? The power of suggestion, we say; initiation rituals in the presence of a fertility symbol. Perhaps, but we do not actually know.

Nor can we say much more about the animals in the caves of southwest France and northern Spain, the acknowledged masterpieces of Paleolithic art. Probably the most astonishing thing about them is their wonderfully accomplished expression of an intuitive sympathy between artist and animal. Hundreds of generations later, similar paintings in Africa and elsewhere show hunters as well as animals, and here we may perhaps be confident that we are dealing with pictorial wishful thinking, again no doubt associated with rituals.

But earlier works conjure up an impression of more subtle or elusive purposes. This is where lively imaginations tend to run riot, and we begin to realize that an ability to devise possible explanations does not necessarily mean that we have hit upon the correct one. What we can deduce about these paintings, both from their artistic competence and location, is that they were bound with serious social activities that took place in seclusion, if not in secret. Like the frieze of the Parthenon, which was not easily seen from the ground, the viewing of the work does not seem to have been a major concern.

The function of art

It is difficult to avoid the usual conclusion that the people for whom the cave paintings were made thought they

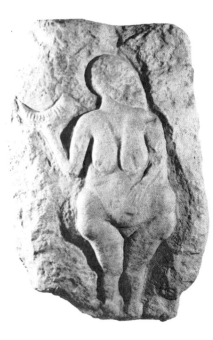

Venus of Laussel, *Dordogne, France, c.19,000 BC*
Musée de l'Homme, Paris

The so-called Venus of Laussel is the earliest surviving example representing two potent fertility symbols together, the nude female and the horn, in this case a bison horn. It seems that the head was believed to be the source of fertilizing fluids and that in the horn they were particularly concentrated. Horns were also thought to be the center of a creature's essence. The Venus of Laussel seems to have been a deliberate attempt at a realistic depiction of the human form. Like the Willendorf Venus it was colored with red ochre in an attempt at greater realism.

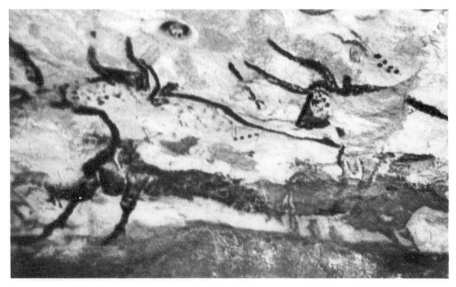

Hall of Bulls, *Lascaux, Dordogne, France, 15,240 BC*

The Halls of Bulls is part of a small complex of cave chambers, the other notable one being the Axial Gallery. They were only discovered in 1940, explaining their fine state of preservation. Because the cave was so well hidden, it has been suggested that the paintings were not just for decoration but had some ritual function, perhaps as a means of securing a successful hunt due to the occurrence of weapons in the paintings. The date of their execution was obtained by Carbon-14 dating techniques.

could achieve a power over the animals through the depiction of their forms. Put in this way it sounds like a naive form of magic, and so in a sense it may have been. At the time, magic must have constituted an important achievement, the first of which we have any intimation. Magic is an exercise of spiritual power in an attempt to alter or control the behavior of something in the physical world. For Paleolithic people, magic grew partly from an ability to understand their own behavior, and partly from a power to communicate with other people and carry out joint activities with them. The idea that everything that happened in the world, and especially the behavior of living

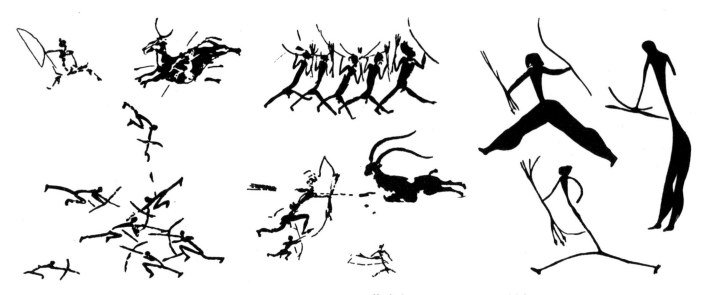

Hunters and quarry, *8000–3000 BC*
Castellón region, Spain
Redrawn examples

*These drawings, which include ibex and
wild ox, are examples of the so-called East
Spanish Hunter style of the Mesolithic era.
Predominant in this art is the portrayal of
movement achieved by treating figures and
animals as silhouetted, disjointed forms. This
is almost exactly the opposite approach to
that adopted at Lascaux where monumental,
multi-colored images were produced. At
Lascaux the image is an attempt to depict
reality while later in eastern Spain the image
consists of stylized forms representing
living, usually human, forms.*

creatures, was controlled by spirits akin to those that animated people was a plausible if erroneous inference.

However, the really daring flight of fancy of these early peoples was to assume that because the world was run by spirits, these were accessible to communication. The crucial question then became one of how to get in touch with them, make friends with them, appease them and, above all, persuade them to cooperate to the benefit and advantage of mankind. The answer once again seems to have been to put the desired idea or object into the "mind" of the spirit by enacting the hoped-for consequence in what were considered appropriate places.

That art in its earliest manifestations was part and parcel of a system of magic is generally agreed, but to go a step further and call these ideas to which magic belonged religious may be premature. There is no doubt that religion developed out of such attitudes, but there could be no religious art until artistic imagination shifted its attention from the desired effect to the effective cause – a god – and there is no evidence that anyone in Paleolithic times could imagine a god.

Social life

If hunting was the principal means of subsistence, human life must have been exciting as well as precarious, and among those who survived there must have been a disposition to see themselves in heroic terms. If this ever happened, however, it must have found expression in stories rather than art.

It can hardly be doubted that it was a man's world and things have never been worse for women. How long it took for change to occur is a question best left to experts in Carbon-14 dating, but it was obviously a slow, imperceptible process. While the men were out hunting, women evidently found time for some research of their own and discovered that by milking animals, for example, it was but a short step from hunting animals to keeping them, and cultivating grasses that could be eaten by humans as well as beasts. This culminated in man – the great hunter – pushing a plough and worshipping fertility images under innumerable guises.

In its earliest forms, farming required perhaps as much mobility as hunting or gathering, but when lands suitable for agriculture were discovered and

permanent settlements became possible, questions of property and its transference arose. Once there were goods to pass from generation to generation it became important to decide who qualified to inherit. Couples were anxious that their sons – as opposed to other couples' sons – should benefit, a distinction that came to be embodied in the idea of legitimacy and in turn gave a new significance to the status of marriage.

Neolithic society

All of these developments must have overlaid and merged with the primitive taboos and customs of earlier times, with the effect of extending and stabilizing the web of social relationships. No doubt it would be erroneous to present the transition from Paleolithic to Neolithic as a "just-so" story in which the wild man was tamed and brought under the yoke of the moral disciplines that make civilized life possible, but it will serve as a parable if not as history. Sexual tensions may have been kept out of sight beneath the surface of the social fabric over long periods of time but, then, as now, whenever constraints weakened, they were liable to reappear.

The most effective of these constraints was religion. It may have been some consolation for Neolithic farmers to feel a sense of contact with what were by then recognized as controlling divinities of the natural world, but the natural world, as the farmers understood it, was infinitely more complex and orderly than the world of the hunters; the possibilities of disaster were less capricious and therefore the occasions when the gods needed appeasement easier to calculate. In this sense religion was not just a matter of recognizing the existence of gods, but of observing an elaborate calendar of appropriate rituals. In such a context the opportunities for displays of imaginative skill must have been vastly increased.

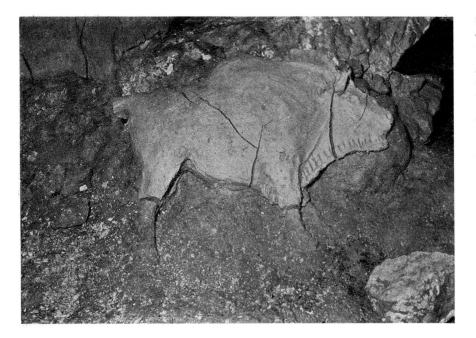

Bison, *Tuc d'Audoubert, Ariege, France, after 15,000 BC*
Clay

By virtue of its great depth, the cave system of Tuc d'Audoubert preserves five small animals in clay on the floor. Only Montespan (Haute-Garonne) contains comparable if rather inferior remains. The slightly flat quality of the animals and the strong silhouette may indicate a creator more used to working in relief than nearly in the round.

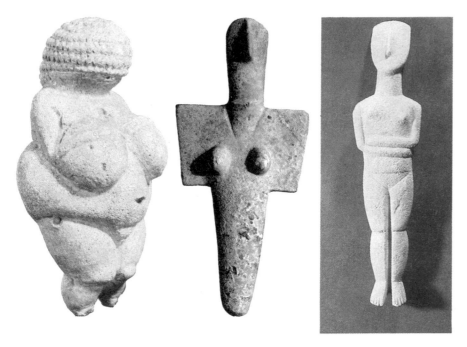

Willendorf Venus, *Willendorf Austria,*
c.39,000–28,000 BC
Limestone Height 4in (12cm)
Naturhistorisches Museum, Vienna

*This small nude female statue is a stylized
symbol of fecundity – a mother goddess.
The figure's female characteristics – the
breasts and stomach – have been heavily
emphasized and, in keeping with her
symbolic value, she has no features
whatsoever. Instead her entire head is
covered in waves of hair. One of a small
number of what are thought to be the earliest
examples of small-scale human statuary,
this type of figure may have been made to be
planted in the earth as a type of magical
icon. Particularly interesting, from the point
of view of technique, is the use of a pointed
tool – a burin and possibly even a drill – to
achieve the stylized hair. The entire figure
was finished by burnishing with scrapers.*

Senorbic Woman, *Sardinia, c.2000 BC*

*This figure is the largest and perhaps most
severe of around twenty such carvings
executed in local marble. Most were
discovered in tombs, but the example at
Senorbi was found in the open. Due to this
and its tapered base it has been suggested
that originally it was fixed into a type of
stand and stood in front of a tomb as a
memorial to the dead. Sardinia, unlike the
rest of the western Mediterranean, seems to
have had a flourishing sculptural art, relating
it more closely to Eastern Europe and the
eastern Mediterranean.*

Cycladic Figure, c.2500–2200 BC
White marble

*Figurines were produced throughout the
Aegean during the early Bronze Age. On
Crete and in Greece they were pottery, but in
the Cyclades, where the clay was poor, local
white marble was used. The island of Naxos
had an ample supply of emery, a mineral
second in hardness only to diamond, that
was used to shape and smooth the marble.
Most of the Cycladic figurines were female
and were discovered in graves suggesting
that they were ritual offerings to the dead or,
as in Egypt, companions for the dead.*

By comparison with what we can
postulate, however, what has actually
survived is disappointing. Almost every
newly excavated site seems to produce
its quota of figurines, most of which
were probably household objects, in-
dicating perhaps that religious ritual
was an everyday affair, as well as the
occasion for tribal ceremonies. The
ceremonies themselves might have been
performed above ground in buildings
that we would call temples, although
none has survived in a form that allows
us to recognize their function. For the
most part, however, the sacrifices and
offerings aimed at procuring a good
harvest would be made out in the fields
and the principal scope of art would be
in the invention of marvelously hideous
monsters, small enough to be portable,
to frighten away the evils that threat-
ened crops and men.

Neolithic societies seem to have been
greatly oppressed by anxieties and
superstition, and were much preoccu-
pied with death. Out of their graves
have come the objects and trinkets that
provide our only insights into the
conditions of their lives. Some of the
tombs were evidently grand. Presum-
ably their occupants were men of
distinction and we may deduce that
some ancestors were venerated, provid-
ing a means of ensuring tribal cohesion
and identity. Whether the practice of
adopting totems for the same purpose
was common it is impossible to say;
we know that some did, for they sur-
vived into recorded history.

To generalize about Neolithic art on
the basis of the meager items at our
disposal is not easy, although, such as
it is, it is at least consistent. It lacks the
vivid, impressionistic accuracy of the
early cave paintings. Forms are simpli-
fied and, like children's paintings,
everything is left out except what
matters. There are images from the
Cyclades in which so much has been
left out that we can barely recognize

human forms, let alone guess what function they were intended to perform.

Complementing this Neolithic disposition to abstraction are widespread manifestations of a highly developed sense of pattern. Spirals and wheels, diamonds and zig-zags appear on a great deal of pottery. No doubt it would be premature to deduce an instinct for geometry in the organization of this ornament, but it was certainly due to some such experiments with design that important aspects of mathematics owed their origins.

The transition from a society that revolved around survival to that of leisure is an important one. Breeding required stock-holding and crops required seasonal rotation, all of which indicates that at some point early peoples decided to stay put. The earliest examples of decorative art – the point at which a water-carrying vessel, for example, became more than a purely functional object – indicate a new element of leisure. Whether these peoples began to decorate their objects for magical or aesthetic reasons, they must have had the time to do so.

In the course of time the Neolithic Age passed into the Bronze Age. Metals were worked where they were easy to obtain, giving the Middle East a head start over Western Europe. By way of compensation, the West seems to have taken the lead in developing the possibilities of stone construction.

The Big Stone cultures

The megalithic (big-stone) cultures were spread via sea routes around the coasts of the continents where they erected monumental stone structures. Certainly some of the best surviving early stone structures, such as Avebury and Stonehenge in England, were produced in the West. What is impressive about both is the scale and monumentality of the component parts. To work and erect such huge pieces implies

an advanced command of technological devices, and the planning of such construction represents a high degree of sophistication. The stone from which Stonehenge is built is not of that immediate area but from Wales, some 240 miles (400 km) to the west. This also indicates that the builders of Stonehenge must have had sophisticated means of carving and transporting these huge pieces of stone over such an incredible distance.

At Stonehenge concentric rings of upright stones crowned by horizontal lintels were arranged in such a way as to focus attention on the moment of sunrise on midsummer's day. This preoccupation with events in the sky, as opposed to the Earth, introduced a new element into the pantheon of deities that provided early artists with their terms of reference. The movements of the Sun, Moon and stars, the seasons and the calendar – even the day to day sequence of the weather – combined to evoke a sense of another kind of divinity. If rain from the heavens brought forth the fertility of the Earth, and the Earth was the great mother, the sky gods should then be masculine. Moreover, the gods were powerful and violent, matching the authoritarian disposition of their worshippers.

We do not know what rites were performed at Stonehenge, but we can be fairly sure that they were focused on the interaction between cosmic and terrestrial powers. Such a religion embraced all aspects of life and, although it was fundamentally grounded in man's experience of the natural world, the social aspect of a perpetual encounter with all-powerful divinities must have had the effect of concentrating the conduct of human life into theocratically controlled communities. From this stage it was only one step to the organization of political structures and the transformation of art into a species of government propaganda.

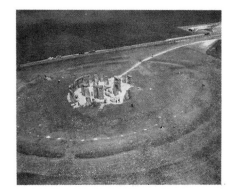

Stonehenge, *Wiltshire, England*
c. *second millenium BC*

The Stonehenge complex is of three dates: enclosing the whole is a ditch and bank with postholes from a wooden structure at the entrance and perhaps three standing stones (before 2000 BC). The ditch was partially filled and within it a double circle of stones from the Prescelly mountains in Pembroke was erected (2000–1500 BC). However, it is the latest work which is the most stunning (1500–1000 BC). The large bluestone circle was dismantled and the mammoth sandstone boulders were brought from Marlborough Downs. They were dressed and erected singly or constructed in lintel groups.

Early Civilizations

The Near East, Asia Minor and Egypt

Excavations at Çatal Hüyük in southern Anatolia and at Jericho have revealed the existence of urban settlements dating from approximately 6000 BC. The main civilizations of the ancient Middle East began several thousand years later. To judge from what has survived to our own day, the art and architecture of ancient Egypt, Mesopotamia and Anatolia were almost entirely concerned with gods and kings, who were either divine or scarcely less than divine. Everything followed from this central preoccupation: temples were built to tempt the gods to take up their abodes from which their earthly estates could be administered by bureaucratic priesthoods; palaces were erected where, in life, kings could emulate the style of the gods, and tombs where, in death, they could share the gods' immortality; images appeared that were theophanic, depicting the transfiguration of men through their encounters with the gods; and, not least, there was the important paraphernalia of everyday life that gave the gods an even greater physical reality.

To understand this art is not easy for people like ourselves who increasingly find it difficult to imagine anything of significance beyond our own material existence. We may pay lip-service to the idea that it was the task of the artist in those remote times to give substance and expression to hidden spiritual truths, but in the last resort we do not take it very seriously. Instead, we are content to stop short at the common denominator of supposed artistic quality shared by works of all times, which secures for them a place in our museums and galleries.

Only if we are prepared to make considerable efforts of historical imagination can we begin to appreciate the social contexts that gave these works their meaning, and even then it is not simply a matter of reconstructing believable notions of how ancient societies functioned. Although art history should not be approached as if it were part of archeology it is often in danger of such misapplication. What is required is the imagination that will allow us to understand how works of art actually succeeded in doing what they were supposed to do. We should begin by asking ourselves what it was like to be someone for whom such things were profound revelations and what was the right setting for what really mattered to these ancient peoples.

The reign of the gods

To identify the conditions under which the arts of the ancient Middle East came into being and flourished we should first note the transformation of small, separate groups of people into larger organizations, which, for want of a better word, may be called political. At the heart of this process was the invention of a new kind of authority, an authority that was no longer sanctioned by kinship but by favor of the gods, and extended deeply into the ways in which people lived their lives. While such authority may often have been imposed with violence, in the last resort, if it were to last, it depended upon a general consent of the people to the divine mandate claimed by aspiring rulers.

This new style of government was not only theocratic, it created an entirely new conception of the nature of its gods, and the fertility cults and totemistic rites that had served the religious needs of simpler forms of society were gradually developed into elaborate mythologies. To myths – whose origins lay in the recurrent patterns of human life and the agrarian calendar – were added epic stories of the deeds of great men that became the focal points for an historical identity. Primitive tribal deities, however, did not disappear entirely and some were considered models as well as protectors and promoters for the earthly kings who ruled in their name, acquiring characteristics appropriate to their role in a political society.

All of these factors made up the subject matter upon which artistic imagination worked. Art thus became a type of propaganda and, although its purposes were in a sense political, its language was entirely religious.

A home for the gods

Just how the momentous step was taken from the stage of recognizing the presence of a god through a fortuitous encounter with one of his sacred animals or plants, to that of the association of gods with particular places cannot be known. No doubt there were features of the landscape marvelous enough to conjure a sense of divine presence, but the crucial steps were those that brought the gods to where they were needed, and kept them there: the human settlements in the potentially fertile lands of the great river valleys. This was accomplished in two ways: by giving the gods a house in which to live, and by giving them an image with which to identify themselves.

Whatever other purposes they may have come to fulfill in the course of time, ancient temples were originally simple residential chambers, which is not to say that they were just elaborate versions of ordinary human homes. While the domestic requirements of the gods were few and unchanging, their presence required continuous reverence and attention, and to cater to these needs the art of architecture was born.

Because the gods were immortal it was expedient to build their temples of materials that would last a long time,

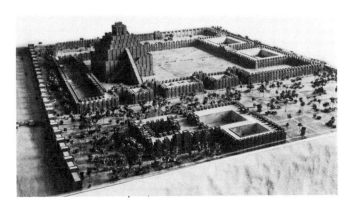

The City of Ur, *c.2125–2025 BC*
Reconstruction model

The model shows a large walled area of the original city with the dominating form of the Ziggurt. The complexity of the plan indicates the high degree of sophistication of early civilizations.

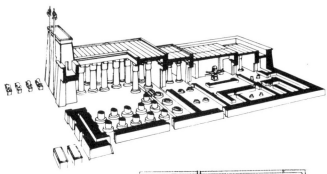

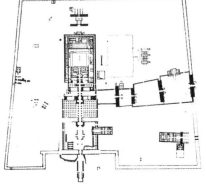

Temple of Khons, *Karnak, 1197–65 BC*
This temple was built by Ramses III to the moon god although its decoration was completed by Ramses IV, IX and Herikor. It has survived without any addition or enlargement apart from a gateway during the Ptolemaic period. Egyptian temple enclosures were entered through a gateway on to a long processional path lined with sculptures of lions, sphinxes or rams, symbolic of guardian spirits. The temple was entered through two towers wi·h a door between, followed by an open forecouft surrounded by colonnades within which festivals and rituals were enacted. Beyond this lay a series of columnar halls with the god's private sanctuary at the furthest point from the entrance.

Temple complex at Amarna, *from 1530 BC*
Plan of the Temple complex,
12th century BC onwards

if not forever. In the desert climates of Egypt and Mesopotamia the durability of the sun-dried clay bricks used to build these temples has been remarkable; fired brick was even more durable and had the advantage of being impervious as well. Wherever possible the logic of thinking in terms of immortality led to the use of cut stone, and the quarries of the Nile Valley produced some of the hardest building stone ever worked, with only centuries of neglect to explain the present ruined state of the monuments of ancient Egypt.

Another means of distinguishing temples from common buildings was the use of decoration: color in patterns or imagery; sculpture in relief or in the round; and architectural features such as columns, buttresses or moldings were all used to this end.

The temples were big and set apart. In Mesopotamia they were often built on the top of artificial hills called *ziggurats*, but even when located inside towns they were walled off. Access to a temple was restricted and admission to the presence of a god was carefully contrived to convey a series of intensified holiness. This was particularly true of the Egyptian temples of the New Kingdom, which were arranged along a single axis with the holiest placed at the end of a long sequence of gates, courtyards and great hypostyle halls. Each represented a stage of transition from the unconsecrated world outside of the temple to the sanctuary of the god himself. This idea has a long and varied history, and medieval cathedrals often reveal a similar ordered approach to the Real

Presence of the Sacrament.

This axial character of Egyptian and medieval temples reveals an attitude which is helpful in understanding the nature of the art of both periods. In an Egyptian temple, such as Khons at Karnak, the strongly directional axial construction not only of the temple but of the approach route, which consisted of a processional flanked by an avenue of sphinx sculptures, can be seen. Processions would move directly toward the last shrine without deviation. The control of mind and body that this indicates, the dominance of the priesthood in Egyptian life, reveals how unspeculative, or, as we might today say, conformist, the society was. This is also revealed in Egyptian sculpture, which was designed to be viewed from the front and not to be walked around.

Mesopotamia

In their earliest days the city-states of Sumeria were essentially theocratic, that is, they were presided over by a god and administered by his priesthood, whose management was meticulous. The temples of Mesopotamia were less formal than those of Egypt, but perhaps by way of compensation they were more functional. Thus, in addition to being the abode of a god, a temple would often include offices and storerooms. Architecturally this resulted in a proliferation of rooms and ruined sites extending from the Persian Gulf to Assyria that allow us today to trace the development of the single chamber temple into vast, irregular structures of labyrinthine complexity. The temples of Hattusas, the capital of the Hittite empire at Boghazköy in Anatolia, belong to this type and so, in a sense, do the palaces of Minoan Crete (a distinction between temples and palaces is not always easy to make, and perhaps not all that important).

The palace, however, performs a very different social function from that of the temple. As the home of the king or, in Egypt, the pharaoh, the palace was designed to enhance and protect the power and person of the ruler, like a spider at the center of his web of power. In Egypt this results in a nearly square building which, similar to Egyptian temples, has no outward facing windows, as seen in the North Palace at Amarna. The throne room is located not at the center of the palace but at the opposite end to the main entrance, in the middle of one end of the complex, creating a sense of axiality.

The palace complexes in Mesopotamia are much less consciously controlled and regular, suggesting what is perhaps borne out by the sculpture, that the social structure was less rigid and "blinkered" than in Egypt. Much later than Akhenaten's palace at Amarna, Sargon II built at Khorsabad,

the capital of the Assyrian empire, a palace on a vast scale covering over twenty acres (8 hectares) in a complex of courtyards and rooms whose relationship is not clear and requires the unifying authority of the king to justify. The palace expresses authoritarianism, a lack of logic and despotism, as do the reliefs.

In design if not in decoration Khorsabad conformed to ancient precedents; the kings of Babylon did likewise, as did the Achaemenid rulers of Persia. It was a tradition peculiarly well suited to a particular conception and practice of kingship, and echoes can be detected later in history whenever megalomaniac rulers sought to express their personality in the forms of monumental architecture.

The royal tombs

A second invitation to architectural enterprise was provided by the royal tombs that are especially conspicuous and well-preserved in the Nile Valley. Here, two considerations that were not always compatible were taken into account: the need for spectacular display, and the provision of adequate protection for the dead. Developments traced from the early mastaba tombs at Abydos, to the great pyramids of the IV Dynasty near Memphis show these two elements to have been nicely balanced. From time to time later pharaohs indulged in similar conceits of display, such as the colonnaded terraces under the cliffs of Deir el-Bahari overlooking the western band of the Nile at Thebes, which, when they were intact, must have been the most remarkable funerary monuments in Egypt.

Because the royal tombs were filled with treasures, hardly any escaped the attentions of grave-robbers and, in the hope of eluding such experts, the pharaohs of the New Kingdom had themselves buried deeper and deeper

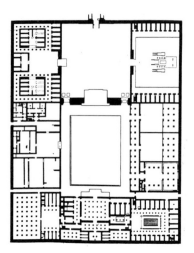

North Palace
El-Amarna, c.1350 BC
Plan

Amenhotep IV moved the Egyptian Empire's capital from Thebes to el-Amarna (ancient name Akhetaten) when he changed the state religion from the worship of Amon to Aten, and his own name to Akhenaten. The move of the capital occurred between the fourth and sixth year of his reign, by which time something must have been completed to move into. In the northern part of the city Akhenaten built a regularly laid out palace inside a rectangular closing wall. The central courtyard probably originally contained a pool, while in the center of the east wall was a throne room. A large courtyard in the northwest corner contained altars for the worship of Aten. Tutankhamen later moved the capital back to Thebes and reinstated the worship of Amon. Compare the controlled symmetricality of Akhenaten's plan with that of Sargon for Khorsabad

into the hillsides of the Valley of the Kings near Thebes. However, not only did these tombs offer little scope for architecture on a grand scale, they almost always failed to achieve their objective and only the tomb of Tutankhamen survived inviolate into modern times.

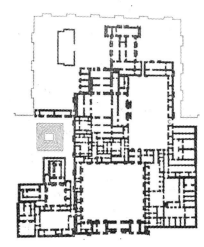

Palace of Sargon II
Khorsabad, 722–705 BC
Plan

*Sargon II of Assyria (721–05 BC) moved the
Assyrian capital to Khorsabad and built the
city, his successors however abandoning it
for Nineveh. Within the town walls on the
northwest border he built a citadel and
within that built a raised, walled enclosure
housing the palace and the temple complex.
In the temple were six sanctuaries, three
large and three small, each for one deity to be
worshipped in. A small ziggurat was included
in the complex.*

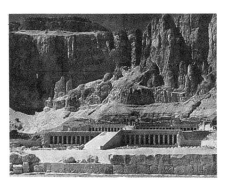

Queen Hatshepsut Funerary Temple,
Thebes' (Deir-el-Bahri) c.1480 BC

*This temple was dedicated to the supreme
god Amon with parts of it for lesser deities.
Its other important function was for the
Queen's and her parents' funerary rites. A
ramp led from an outer court up to a lower
terrace, another rose to a colonnaded area
behind which were the chambers of the gods.
Above this lay another, now destroyed,
colonnade, each column being a colossal
representation of the Queen. Within this
colonnade lay the great hall while the
chamber of Amon and the Queen's funerary
chapel were hewn out of the mountain
behind the Temple.*

Sculpture Court
Metropolitan Museum, New York

*Although large-scale Egyptian sculpture was
carved in the round, it was usually designed
to be appreciated frontally. Most large stone
statues were placed in front of pillars in
colonnades, hence long rows of these
imposing figures were often part of Egyptian
temples. To be truly effective in this role the
statues had to be designed frontally and
and carved in a bold, not wholly naturalistic
style. The sculpture court at the Metropolitan
Museum is one of the few places where the
original effect of Egyptian sculpture can be
appreciated.*

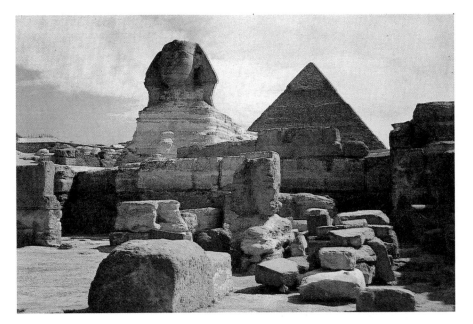

View of the Pyramids, *Gizeh, Egypt*

*In addition to the main pyramids, the area is
the burial place of the three most important
personages of the IV and V Dynasties. Each
pyramid complex was in four parts, laid out
east to west. It began with a temple from
which a covered walkway led to the funerary
temple in front of the tomb. The largest
pyramid was 475 feet (143m) high and
housed the tomb of Cheops. In the center is
Chephren's pyramid which was slightly
lower at 466 feet (140m) high. It retains the
upper part of its outer stone casing showing
that originally the pyramids had perfectly
smooth sides. The smallest pyramid is
Mycerinus's, originally 216 feet (129m) high*

Systems of defense

The cities of Mesopotamia had many enemies and needed permanent defense works. At first these took the form of simple mud-brick walls, but in the course of time they acquired considerable sophistication. Huge lumps of cyclopean masonry were skillfully piled high; secondary walls were positioned in vulnerable places; towers were placed at regular intervals; conspicuous gateways were erected and protected by magnificent monsters and secret tunnels were dug.

All of this testifies to the existence in the second half of the second millennium BC of highly developed techniques of siege-craft. These, with the formidable chariots that made the Hittite field armies perhaps the first effective striking force in the history of warfare, suggest that the Hittites gave much thought to the theory, as well as the practice, of warfare and in this respect they may have anticipated the better-documented Assyrians of the first millennium BC. If we may believe the remarkably vivid pictorial records illustrating the victories of Sennacherib, Ashurbanipal and the rest, the Assyrians and their enemies certainly knew about massive fortifications.

It was almost certainly in the context of military works that architects became engineers, applying themselves to the construction of arches and vaults, yet the interaction between practical and religious purposes in architecture was subtle and continuous. The idea of focusing attention on sacred objects by positioning or framing is fundamentally no different from using the framing effect of wall niches, arches or other architectural elements for the same purpose. These eventually acquired a symbolism of their own and were destined to become important, even indispensible, parts in the display of commemorative images.

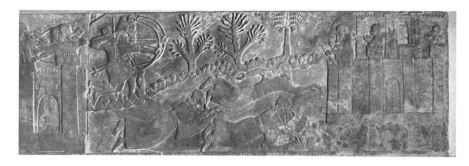

Relief panel, *showing fortified camps, from the Palace of Ashurnasirpal II at Nimrud, after 879 BC*
Height 33in (83cm)
British Museum, London

Ashurnasirpal II (883–59 BC) began the northwest palace at Nimrud in 879 BC which continued in use until Sargon (721–05 BC) abandoned it. Stone reliefs were carved as part of the decorative scheme for the official suite of rooms, their first use, in this context, being in Mesopotamia. In the throne room, reliefs of military campaigns adorned the walls in two levels. Between the two strips a two-foot (60cm) deep inscription praised the virtues and victories of the King. The reliefs nearest the throne showed Ashurnasirpal II's hunting campaigns in Syria and Assyria. These bas-reliefs are among the finest to survive and show the great subtlety of modeling that is possible with very little relief. The overall decorative effect of the scheme is of a high standard of visual sophistication despite the extremely formal and hierarchic nature of the subject treatment.

Hattusas plan and view of Lion Gate at Boghazköy, *Turkey*

Hattusas was the capital of the New Hittite Empire (c.1450–1190 BC). It was surrounded by a massive two-mile (3.2km) circuit of defensive stone walls topped with mud bricks and five temples have been uncovered inside. Within the city, enclosed in its own walls, is the citadel of Büyükkale, the chief residence of the rulers and the administrative center of the Empire. Around 3350 inscribed clay tablets were discovered in two locations in the citadel, the oldest libraries ever discovered. The citadel also contained a temple, the largest in the city, to the god of weather and the deity of Hattusas. The great stone blocks on either side of the Lion Gate at Baghazöy, estify in the massive masonry, to the great attention the Hittites gave to the appearance of effective defence.

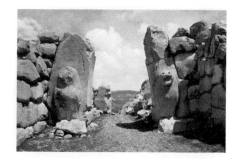

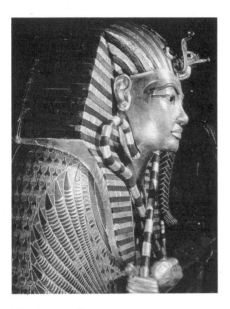

The human figure

More than any other, the central artistic preoccupation of the ancient Middle East was how to devise images appropriate to the relationship between men and gods; to express visually those special properties that set certain men apart from the rest and made them suitable vehicles for the exercise of divine authority. It can be stated immediately that whatever the answers may have been at the time, there was little or no room among them for what we today call directly representational art. For these ancient peoples, to render a person's shape or appearance correct in every physical detail was an exercise without significance and, indeed, to be avoided.

A basic assumption of the time was that by contact with a god a man was in some measure transfigured. To convey this by means of art involved a conscious alteration of what was actually seen by the use of stylization which ranged from delicate patterned adjustment to strong and expressive distortion. In Mesopotamia, for example, where the purpose of the exercise was often to stress the terrifying

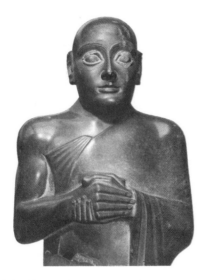

Tutankhamen, *Thebes, c.1340 BC*
Gold sarcophagus lid
lines of lapis lazuli-colored glass;
white calcite and dark obsidian eyes

Because Tutankhamen died at the unforeseen age of eighteen, his tomb was not ready and so he was laid to rest in the tomb of the priest who succeeded him. Splendid works of art adorned his mummy and tomb. The innermost of the three coffins was made of solid gold and weighed 250 pounds (113kg). His death mask was also of solid gold and his mummy was dressed in the state robes. (Dressing and mummification guaranteed a ruler's reincarnation as ruler of the Kingdom of the Dead.) An older belief identified with the sun god Re may explain the lapis lazuli-colored hair lines of Tutankhamen's mask because Re was believed to have lapis lazuli hair. The mask and coffins were probably made by goldsmiths at the Theban court.

Gudea, *22nd century BC*
Louvre, Paris

Gudea, a high-ranking religious and political figure of Sumeria, never adopted the title of king, but was responsible for a huge artistic outburst during his reign. Statues of Gudea were carved to decorate public buildings, temples and palaces. Around thirty of these survive and almost all are in the same form: plainly dressed, huge feet but delicate, clasped hands. Gudea had made Lagash a great cultural center and it was probably here that the figures were produced.

apparition of the god and the obsequiousness of his worshippers, eyes might be unnaturally enlarged and hands clasped in piety or reduced to tiny claws. Even the rulers of cities such as Gudea or Lapeah found it expedient to adopt poses more appropriate to suppliants than governors, while generations of invincible Assyrian warrior kings, secure in the approval of their protective deities, assumed a mask of complacent condescension.

It was in Egypt that the implications of these attitudes were most fully and consistently explored, and at an early stage a repertory of conventional attitudes was devised. For example the pharaoh might be depicted enthroned, standing equal among his gods, or smiting his enemies. Such postures were repeated dynasty after dynasty with only minor variations of gesture or expression, and as evocations of timeless, superhuman qualities they are remarkably effective; almost without exception the bland, mask-like faces of these pharaohs suggest an implacable, hierarchic dignity that is still positively hypnotic today.

These effects were devised quite literally by formula, with set rules prescribed for each subject, and a good deal of what made these images so effective was the fact that they conformed to a precedent. However, while the creative individuality of artists and craftsmen was rigidly curtailed, not all of the pharaohs looked alike because within these limitations a surprising degree of characterization was possible. The calm, untroubled majesty of the IV Dynasty Pharaoh Chepren is quite different from the haughty but intense Sesostris of the XIIth, yet the extent to which both fall short of being genuine portraits is clearly revealed when compared with the sculpted portraits of the royal family of the heretical pharaoh Akhenaten of the New Kingdom.

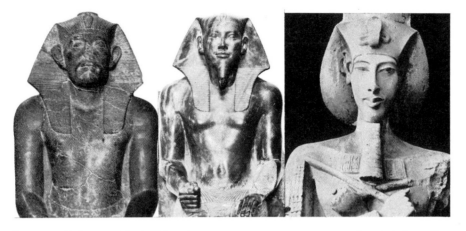

Chephren, *IV Dynasty (2680–2565 BC)*
Black diorite Height 66in (168cm)
Sesostris I, *XII Dynasty (1991–1786 BC)*
Wood, Height 24in (60cm)
Akhenaten, *XVIII Dynasty (1570–1345 BC)*
Sandstone, Height 156in (390cm) completed
Cairo Museum, Egypt

These three portraits of pharaohs show how
Egyptian sculpture developed during a
period of over one thousand years.

Chephren is depicted as the ideal of god-like
majesty by substituting elements of the
earlier naturalistic style for a more stylized
treatment. In the portrait of Sesostris I there
remains a highly naturalistic treatment of the
head, although the proportions and modeling
are still very stylized. Naturalism, however,
was apparently of no concern to the sculptor
who executed the portrait of Akhenaten in
which an expressive, powerful image of the
divine Pharaoh was sought that actuality
would have only impaired.

Whatever the aims of Akhenaten's religious revolution may have been, one effect was the suspension of the exclusive prerogatives of the traditional forms of official art. The art that took its place during the so-called Amarna period was not exactly naturalistic, but for once figures were drawn without respect for inherited pattern or formula. As a result, subjects were often sensuous, intimate and ephemeral, and the drawing itself self-consciously sensitive to the point of caricature. While this period did not last, it was important because it implied rejection of the beliefs on which ancient Egyptian art had been based.

One suspects that art played no great role in Akhenaten's religious philosophy and, if so, his position was only a step from the Hebrew prophets, whose perception of the nature of god seemed totally incompatible with any form of artistic expression. This dramatic conception, later to be reaffirmed by both strict Muslins, and the Greek Church, had the effect of confining art to ornament and the construction of patterns. However, not everyone who felt dissatisfied with the stylized imagery of the visual arts in the ancient world felt it necessary to go to such exclusive and puritanical solutions. For the Greeks it was not so much a question of the competence of the arts to penetrate to realities beyond the conscious senses as a concern with the precise nature of those realities. The Greeks willingness to reopen this basic issue launched the arts upon the next great chapter of their history.

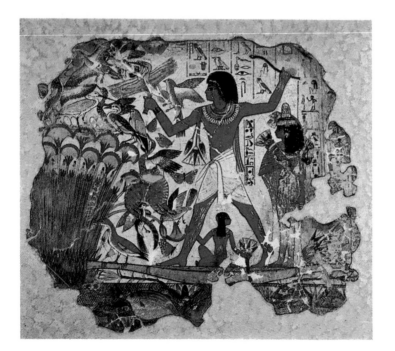

Fowling in the Marshes, *Tomb of Ay,*
Thebes (Deir el Bahri) 14th century BC

Paintings of Tutankhamen's and Ay's reigns
show a sketchy, free treatment which had
been a feature of art since Akhenaton's
reign. The subjects in Ay's tomb largely
follow earlier models in depicting scenes
of everyday life, such as hunting,
harvesting and fowling.

Greece and Rome

It would be difficult to overemphasize the significance and influence of the civilizations achieved by the Greeks and Romans – together called "Classical" – for the whole development of Western culture. These civilizations were not only significant in the arts but also for the whole basis of Western thought. Their philosophical and intellectual systems determined, as did no other society, except perhaps the Jews, the whole concept of life by which succeeding generations of people have lived.

In the West logical active thought tends towards creative action with tangible results; people make decisions and do things as a result of thinking. If you consider what you have done it leads you to think how you could do it better. It directs you towards competition and perfectibility; towards the idea of improvement, whether it is in athletics or the arts. Creative action sponsors a society of invention, the determining of standards and norms and a yearning for the excellent. These attitudes – the best and the worst – are in the nature of our modern Western society and have their origins in the Classical world.

Underpinning these attitudes is what may be called the social conscience – what is permissible and what is not. The Classical societies, and in particular the Greeks, had a view of life that encouraged the pursuit of pleasure but not to the point where it would interfere with the harmony of the individual or communal life. The Greeks believed that goodness and happiness were both necessary for a harmonious life.

The word "Classical" thus describes a new development in the history of Western society. From the time of the Greeks a view of life was adopted that provided a base for one expression of human maturity and "Classical" has become synonymous with specific qualities and standards in Western society and therefore has precise historical meaning. The "Classical world" is the period during which Greece developed its civilization and Rome absorbed, expanded, diluted and adapted Greek ideas and spread them through the then-known Western world. It has a span of approximately one thousand years from some time about 800 BC, when Greek society started to emerge from its Dark Age, to the 4th century AD, when the legalization of the Christian religion began to inspire a different direction for Western culture. The creative center of this Classical spirit can be identified with a short period of about fifty years in one city – 5th century BC Athens – enclosing the prime of its leader Pericles, who was responsible for the construction of the Parthenon and the rebuilding of the Acropolis. It is a measure of the genius of the Athenians that every subsequent Western society has measured itself against the Greek view of life.

Central to this view of life was a new and revolutionary concept. The earlier civilizations of Mesopotamia, Egypt and Asia Minor, powerful and long-lasting as they were, depended on authoritarian systems. They were unified under the domination of a kingly or priestly cadre, in which the ordinary citizen neither participated in government nor questioned its absolute right of life and death over him. Privilege was the rule of life and speculation on ideas was not approved of. The Greek political system depended on quite different ideas. It was the citizens who formed the Greek state; who the citizens were and how many there were in any particular city distinguished one city from another. Some were tyrannies, some aristocracies and some, such as Athens in the Age of Pericles, democracies. But, whatever this criterion, the state existed only in the citizens, for them and was in turn, through every member, sustained by them. The state was the city with its citizens. The good life was that to which they were all expected to contribute. The state involved every part of the citizens' lives, including their art, so everyone lived a "political" life.

In order to achieve such a quality of life it was necessary to create city-states that would allow for the participation by everyone in the daily business of city government and the administration of justice, the flowering of the arts and intellectual enquiry. It was in pursuit of the good life that the ideas of improvability and perfectibility were proposed, to be achieved through increasing wisdom, from which evolved the discipline now known as philosophy, introducing the concept of human progress.

The Roman contribution to the classical world is different from, but no less significant than the Greeks'. The origin of the word "Classical" itself derived from the Latin word for the classes, or levels, into which Roman society was divided and describes the ordering and regulation of things, or standards. Roman authors came to use the word to describe the highest order and it may be a reflection of the success of the Greek and Roman world that we use it to identify excellence today. "Classical" has a further important implication applicable to the arts. Because it is based on the idea of order and regularity it suggests no flights of fancy but rather obedience to rules and standards. This has been of sustaining support to the arts of the West and has enabled them to draw inspiration from the Classical world. Once the forms expressing these ideas had been established, they remained the source of inspiration for subsequent work.

The first Aegean civilizations

The Aegean Sea, thickly dotted with islands, lies east of mainland Greece, separating it from Asia Minor – modern-day Turkey – and at its northern end leading through the narrow neck of the Dardanelles into the Sea of Marmora. This connects, through the Bosporus, with Istanbul, for example Constantinople, to the Black Sea and the Balkans. Throughout Western history this area has had a momentous importance.

Located between Italy and Asia Minor, Greece was connected with the early Mid-Eastern civilizations and provided a route westward. With its back to Italy, it looked east with a long, irregular coastline that provided safe harbors and a backbone of rugged, inhospitable mountains. In the middle of the southern part, the Peloponnese, lay Sparta, one of the great cities of ancient Greece. Connecting the north with the south was Attica, with Athens as its capital in a strategic position.

About five thousand years ago, while the rest of Europe was still in the New Stone Age, an adventurous bronze-using culture began to emerge around the Aegean on the Greek mainland and the sea borders of Asia Minor. These ancient civilizations had had two significant factors in their locations: to the east and the south lay extremely difficult terrain and the Mediterranean, a navigable trading sea, was at their doorstep. Focus was towards the Mediterranean and at the hub lay the island of Crete, ideally located as a stepping stone out of the East and into the West. The Aegean basin, with Crete and mainland Greece, was the center of the first European civilizations and the forge of Western culture.

Called Minoan after the legendary King Minos, Cretan civilization began to develop about 3000 BC with a capital at Knossos. It is interesting to note that Knossos was an unfortified city, an indication of the security that its inhabitants must have felt. It was a peaceable society with an elaborate

Octopus Vase, *Palaikastro, Crete, c.1500–1450 BC*
Height 11in (27.5cm)
Heraklion Museum, Crete

A marked change occurred in Cretan pottery in about 1550 BC when dark on light replaced the old light pattern on a dark ground. After this change decoration was almost entirely confined to using floral and geometric patterns. Around 1500 BC Cretans looked to the sea for motifs to adorn their pottery and created the marine style, the Octopus Vase *perhaps being the finest surviving example. It is both naturalistic yet stylized to provide a suitable decorative effect. Other examples may be either more realistic or more highly stylized, but their overall effect is similar.*

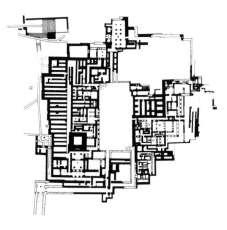

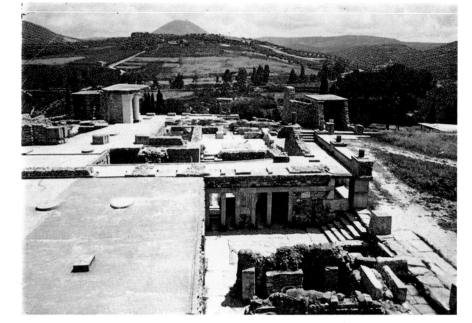

Palace of Minos at Knossos, *Crete, c. 1700 BC*
Plan and view

After a disastrous earthquake in about 1700 BC, all of the Cretan palaces were rebuilt. Knossos is the largest of these and still shows the type of layout employed. Around a large rectangular court the main chambers were arranged and the west wing divided by a corridor running from north to south into storage rooms on the west side and cult rooms on the east. An east-to-west corridor divided the east wing into living quarters on the south side and workshops on the north. The throne room, like the other cult-associated rooms, looked directly on to the central courtyard. As Cretan palaces had no outer defensive walls they could expand at will, which explains the sprawling plan of the Palace of Knossos.

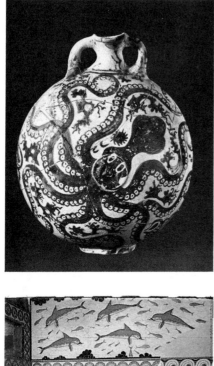

Dolphin Fresco, *c.1900/1800–1500 BC
Queen's Megaron, Palace of Minos,
Knossos, Crete*

*The frescoes of the Queen's Megaron are
largely 20th century restorations based on
fragmentary originals, some of which have
been removed to museums. Many different
styles of Cretan fresco are represented. The
earliest is c.1900–1800 BC but is very
fragmentary. To the period c.1700–1550 BC
belongs the highly naturalistic Dolphin
which was restored from remains found on
the floor. Around 1500 BC the Queen's
Megaron was extensively redecorated, the
spiral frieze in the bathroom, the floral motifs
and the elegant, half life-size "Dancing
Lady" all dating from this period. The
Queen's Megaron may be exceptional in that
its frescoes have survived, but elaborate
mural painting was probably standard in
Cretan palaces.*

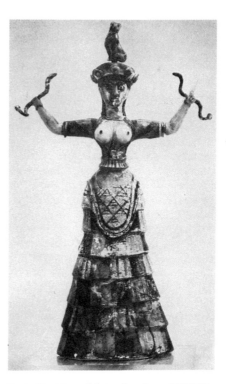

Snake Goddess, *faience figurine, c.1600 BC
Height 6in (16cm)
Heraklion Museum, Crete*

*The small number of snake goddesses
surviving are the only artifacts of Cretan
religion that have survived. The religion was
unusual in that it seems to have required no
temples and was centered around a supreme
female deity whose image as a snake
goddess was perhaps only one of her several
identities. The bared breasts indicate that
this female deity was perhaps a development
from ancient fertility rites, one element being
the use of snakes to symbolize masculinity.
Because all of the snake goddesses were
small, it is likely that they were offerings to
the deity rather than the focus of devotion.*

hierarchy of kings and priests. The bull
was important in both ritual and sport,
in paintings and mythology, the most
famous of the latter being the story of
the minotaur (*minos*, king; *taurus*,
bull).

Mycenae was the most important
city on mainland Greece. While we
have become accustomed to think of
the Mycenaeans as being indebted to
Crete for their notions of civilized life,
there is little to substantiate this view.
By the Greeks' own accounts, insofar
as they can be extricated from the
legends in which they have come down
to us, these early Greeks were quarrel-
some, belligerent and no doubt made
their living by fighting. From about
1500 BC the Mycenaeans were in con-
tact, perhaps in the role of mercenaries,
with Egypt and western Asia. It was at
this time that their beehive (*tholos*)
tombs were built and solemn and
aggressive decorative art emerged.

Between them, Minoan and Myce-
naean societies contributed much to
the subsequent civilization of Classical
Greece. In their arts were revealed a
sense of order and authority, and in a
sense the freedom and grace of Minoan
art found new life in the temples,
sculptures and paintings of the Age of
Pericles. But it would be rash to see
either of them simply as anticipations
of what came later; each, in its own
way, belonged to the Bronze Age world
of the second millenium BC and within
that world each developed its own
idiosyncracies.

The architecture of the two societies
was very different. The sites of Minoan
towns tell us a great deal: small houses
crowded together and spread over the
ground haphazardly with no con-
sidered limit and no walls to determine
their extent indicate a sense of careless
security that had no parallel in Myce-
naean planning. All Mycenaean cities
were walled and defensible, resulting
in massive building and heavy forms.

In like societies, such as Egypt, this containment reflects a containment of thought, quite different from the Minoan civilization.

Mycenaean architecture owed practically nothing to the sprawling palaces of Crete, but a great deal to the military constructions of the Hittites. The life styles of people who lived in the great halls of Tiryns and Mycenae were probably closer to that of the German warrior chieftains who entered history two thousand years later than to the elaborate, courtly ceremonials of contemporary Thebes or Babylon. Mycenaean society was based on fortified towns and was engaged in vendettas and piracy. It was a slave-based economy extolling physical heroism with a plethora of local gods who had no temples. The art remains are rich with gold masks, ivory caskets and sculptures showing that, unlike the Minoans, Mycenaean work was used to support the pretentions of the owner's status and power.

The plan of the citadel at Tiryns tells much. The first obvious element is the thick, heavy form of the outer wall defending and defining the limits of the citadel. The palace itself is simpler and smaller than at Knossos. At the center is a large rectangular hall (in Greek, *megaron*) that was both living quarters and reception area for the king, and was approached through a series of courtyards. In the *megaron* we can see the ultimate origin of Classical Greek temples.

In about 1500 BC, as the result of trade, a relationship developed between the Mycenaeans and the Minoans. The Minoans were not themselves Greek yet one of the scripts found in Crete, known as Linear B and deciphered only recently, was used for writing an early form of Greek. It is known that about 1450 BC Mycenaean rulers controlled Knossos, and by then Minoan civilization was in decline. All

of the other Minoan palaces had been destroyed. About fifty years later Knossos itself was destroyed and Minoan civilization was extinguished. The Mycenaean's turn was not long delayed. Tougher, rougher groups of Greek-speaking tribes came down from the mountains of northwest Greece. These newcomers were called Dorians and the ethnic distinction between them and other Greeks remained a feature of later Greek history. From about 1200 BC the Dorians raided and burned the central and southern Greek cities. Mycenae was destroyed in about 1125 BC and by 1100 BC Mycenaean culture had vanished. Only in Attica, the territory of which Athens was the capital, was a continuity of culture maintained. The Athenian upper city was never taken, and political and literary traditions were preserved which fed the reborn Greek civilization of Classical times. Nevertheless, some of the sophisticated techniques of the Mycenaeans were lost, never to reappear again.

From about 1100 to 800 BC, the period known as the Greek Dark Ages, earlier achievements were lost, writing difappeared and the oral tradition of the epics, myths and hymns were the only continuity, to be consolidated and written down in the 8th century BC, the age of Homer and Hesiod. During this period refugees from such colonies as Ephesus, Smyrna and others fled across to Asia Minor and eventually laid a foundation for the returning Greek culture in the 7th century BC. Little has remained from this period except a few artifacts. —

From about 800 BC the stirrings of Greek civilization that led to the Classical Age began. Conditions improved, iron replaced bronze as the chief metal, writing reappeared – derived from the letters the Phoenicians used – and in it the ancient songs and epics were recorded. This period,

Citadel of Tiryns, *Greece, in use 14th century BC–468 BC*

Like other Greek mainland citadels, Tiryns was heavily fortified. Their Cretan predecessors had no enclosing walls and could therefore be planned elastically but at Tiryns, the walls meant that the plan had to be tightly and regularly laid out. The ruler's palace was built in the upper terrace; the lower terrace contained buildings for storage, stalls for the horses and rooms for servants.

Geometric vase, *late 8th century BC National Museum, Athens*

This vase was used as a funerary monument and the hole in its base was to allow offerings to the dead to percolate to the ground. Before the mid-8th century BC, Greek vase painters showed no interest in representing the human form, motifs before this time being purely abstract. Even figures, when used, were treated in a pattern-like way although they were enacting scenes, such as a funerary procession and lamentation for the dead.

Black Figure and Red Figure pottery *British Museum, London*

Black-figure pottery was dominant from the late 7th century BC until about 500 BC. Animals and objects were painted on to red ceramic figures, and details were scratched out with a needle. Other colors could also be applied. This technique was limited, silhouettes being the only truly effective form and modeling being beyond the possibilities of a needle. Around 500 BC red-figure pottery replaced the black-figure form. It was more flexible because the background and details were painted black rather than the figures, hence modeling and frontal forms could be portrayed effectively.

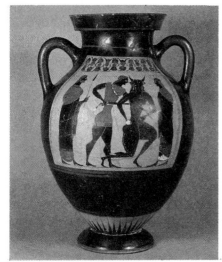

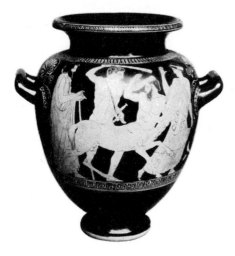

known as the Archaic, brought into being all those things in religion, politics, thought and the arts that we today recognize as distinctively Greek.

At this time the three best-known cities of ancient Greece began to emerge: Athens was an important trading center exporting ceramics, known as Geometric, that began the great tradition of Greek pottery design; Sparta built up its dominating militaristic society; and Corinth developed as the most important cultural center. Greek colonizing, both east and west, had begun before 700 BC and settlements in Sicily and southern Italy provided a base for the consolidation of Greek culture in the Mediterranean. Trade eastward introduced oriental influences, and colonies were founded on the shores of the Black Sea and North Africa. Thus before the appearance of the highest achievements of Greek civilization the ground was already prepared for their rapid dissemination and absorption throughout the extensive Mediterranean Greek world.

Other significant developments included the introduction of coinage, a useful gauge of trade and durable evidence for the archeologist. Cities codified their laws and settled societies under the rule of local aristocratic rulers. Although subject to occasional power struggles, these cities provided the base for the expansion of a culture. At this time the literary arts emerged with poetry of a personal and lyrical kind. The beginnings of Greek speculation about man and his place in nature first appeared in about 600 BC.

It is for the first time possible to see a pattern emerging, leading to what we know as the Classical Age. Before the Dark Age there was no specifically Greek culture, during the Dark Age it seems that almost all culture was lost, and as Greece emerged from it the strands came together. There are three

visual arts whose development out of the Dark Age we can effectively examine – pottery, architecture and sculpture – and each reveals an extraordinary and positive achievement.

From about 900 BC the Geometric style of pottery decoration evolved in the region of Attica. The ornamental repertory consisted, as the name implies, of mainly simple geometric elements arranged around the body of the vessel in a succession of horizontal bands. Color was limited to black or brown, but a new and wide range of vessel shapes developed. Some of the finest examples of this style are the large Attic vases of the 9th and 8th centuries BC that took the place of gravestones. During the 8th century BC stylized birds, animals and narrative scenes with stick-like human figures featured more and more often in vase decoration. This weakening of the abstract, geometric nature of decoration was accelerated by the increasing emphasis on representation and heralds the end of the style. The final breakdown of the late Geometric phase came in about 700 BC in Corinth, where more naturalistic influences from the East introduced new figure styles and floral motifs.

Although they were now organized into city-states, the control of which was everywhere in the hands of an aristocratic caste, Greek politics were unstable and there was already widespread antagonism between the social classes. When the Greeks were not at war or fighting among themselves, they expressed their aggressive tendencies through the athletic competitions that were part of their religious festivals.

The arts played an important part in the lives of the early Greeks, but these were the arts presided over by the Muses – singing, dancing and poetry – rather than the visual arts. Above all, the early Greeks loved the epic stories of their heroic ancestors that the poets

told and, insofar as the Greeks had a theology, it was in the hands of poets rathsr than priests. These epic tales became the focus of an aristocratic culture and were not integrated with the traditional cults and myths of everyday life.

The poetry of the early Greeks was magical and anonymous and available to everyone. With the so-called Heroic Age poetry was no longer intended for the masses but for the entertainment of heroes after battle, expressing the Greeks' desire for fame and recognition. The epic poems of Homer are the best known of these and illustrate the aristocratic nature of the time. Slowly, poetry lost its lyrical quality and grew to epic proportions; it was no longer the responsibility of one poet, but of a group. The gods and their mythologies also pervaded Greek cultures with each and every natural force and quality of life personified by a diety. These permeated the arts of Greece and such polytheism is still found today in the worship of saints.

The Greek temple

Perhaps the most important single development during this period is the beginning of temple building. It is a measure of the scanty information that we have of the period that the whole development of temple design is shrouded in speculation. It seems probable that the Minoans and Mycenaeans did not build temples, or, if they did, they have not been easy to recognize. There had been shrines and sacred places, but of the temples that are such a familiar expression of Greek architecture there is no clear origin of development.

Whether or not the Mycenaeans occasionally built temples, recognizable early Greek temples can be traced with certainty to the middle of the 9th century BC. Initially these were similar in construction to the great halls of the Mycenaean palaces, being situated in sanctuaries close to open-air altars, and the earliest examples found may well have been the deserted halls of Mycenaean palaces. By the 8th century BC a form with pitched roof, probably thatched, and a portico of wooden columns was widespread. The addition of a surrounding arcade gave the temple its characteristic appearance, and its original purpose may well have been to provide shelter from the sun. The first peripteral temple (peri, external; pteron, colonnade) is almost certainly the Temple to Hera on the island of Samos, a monstrously proportioned building, its length being out of relationship with its width.

Like all ancient temples, the early Greek temples were regarded as the residences of the gods, but these never developed the complicated layouts that had in the past signified elaborate ritual. Unlike the temples of Egypt and Mesopotamia, early Greek temples were seldom used for any purpose other than worship although, because of their sanctity, some were used as treasuries and banks.

In terms of religion, everything of importance occurred outside the temple at the altar and the building itself was merely a backdrop. Insofar as it is possible to talk about the evolution of Greek temple design, it was entirely a matter of what made a building worthy of being given the status of the abode of a god and what the most imposing object within the sanctuary happened to be; in other words, what the building looked like.

Within these limitations the sustained and concentrated attention that the early Greeks gave to the problem of what their temples should look like was quite astonishing. For example, the basic shape of the temple's hall could be altered by raising it upon an artificial platform and surrounding it by a fence or colonnade to set it apart and enhance its dignity. Sometimes the entrance to the temple was emphasized by additional colonnades, but for the most part an overall symmetry was preferred.

Perhaps the most fundamental innovation in Greek temple building was the decision to build temples entirely of cut stone instead of less durable materials such as wood and brick. This change occurred in the 6th century BC, but only after three centuries of experimentation – a sign that the Greeks were cautious rather than precipitate in following the example of oriental models. The motivation for this change was not confined to the durability of stone. Concern with the appearance of the temple had already focused the Greeks' attention on the area where the horizontal roof line and the vertical columns of the colonnade met. It was at this point that weight and dignity on the one hand, and lightness and delicacy on the other could most effectively be expressed; where the nature of weight and support were most clearly revealed. The different solutions expressed themselves in what have come to be called the Orders of Classical Architecture: the Doric, after the Dorians, who dominated most of mainland Greece; the Ionic, from Ionia, the coastline of Asia Minor that was colonized by refugees from Greece in the 11th century BC; and, later, Corinthian, from Corinth. The Doric column looks sturdier and heavier than the Ionic, being wider in proportion to its height. It is also less elaborate, with the capital at the top of the column being a simple cushion shape; the column has no base and stands straight on a platform. The Ionic column, slender and graceful with a curved volute capital, is generally more elaborate than the Doric. Doric was the more massive and monumental of the two styles but because scale was another factor, the Ionians took the

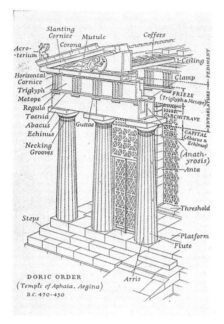

DORIC ORDER
(Temple of Aphaia, Aegina)
B.C. 470-450

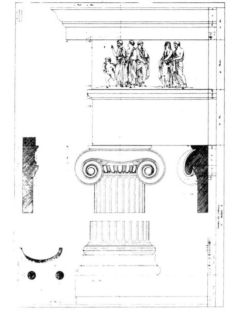

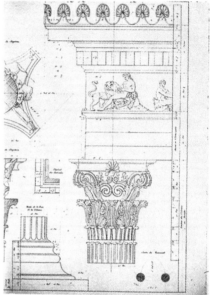

lead with a series of colossal temples. In either case, building in stone made available effects that could not be achieved in wood. New shapes that offered scope for further refinements were sought and, consequently, hitherto unexplored technical problems had to be confronted.

While stone temples could be huge by comparison with their wooden predecessors, they could not grow larger indefinitely because if the stone beams were extended over a certain length they eventually fractured under their own weight. Marble produced the smoothest surfaces but was expensive to transport, and so was often applied to rougher materials in the form of a fine plaster. Only rarely were temples built entirely of marble, which distinguishes the most famous of all Greek sites: the 5th century BC buildings on the Acropolis in Athens.

The search for the perfect material had its counterpart in formal building design. At every period of their history, Greek temples were composed of a combination of simple geometric shapes: rectangles, triangles, circles and cylinders. While barely perceptible curves were often imposed upon the straight lines of these shapes to create an impression of compact stability, such curves were refinements and in no way compromised the strictly mathematical character of the overall design of a building. The mathematical element used in the design of their temples may have been one idea that Greek architects gained from their precursors in Egypt and Mesopotamia, but, as with all foreign influences, the Greeks put this to use in a way that was entirely special to themselves.

All buildings have a formal and abstract quality but for superficial and expressive purposes the Greeks went far beyond the simple manipulation of shapes, with the result that their buildings were impregnated with mathematical relations linking the major dimensions one to another. In their preference for certain mathematical ratios the early Greek architects

The Architectural Orders

In its strictest sense the term "architectural orders" should be used only in reference to Greek architecture; in fact it is used frequently in connection with Roman and later Classically inspired buildings. When a particular order was used in Greek architecture, a specific result was expected; for example if the Doric Order was used the end result would be a Doric building. In Roman and later architecture the orders were mixed and varied to the extent that they no longer produced the result for which they were initially intended. The Doric Order was the earliest, being well established by c.600 BC. In a true Doric column, its height is eight times its diameter at the base, making it the least slender: Ionic and Corinthian are nine and ten times their diameters, respectively. Doric also differs from the others in that it uses no base for the columns and leaves the capital plain. The Ionic Order was probably first used in the 6th century BC and came to prominence in Athens in the mid-5th century BC. In the late 5th century BC the Corinthian Order was invented for interior decoration and first appeared on exteriors in the late 4th century BC. The Composite Order is a Corinthian Order with some Ionic features, particularly the spirals on the capitals.

71

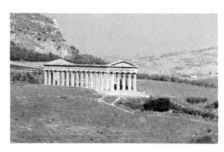

Segesta, *Doric temple, Sicily, 5th century BC*

In 426 BC the Sicilians formed an alliance with Athens. At some date soon after, once the Sicilians were sufficiently Hellenized, a Greek architect was imported to build a temple. Although in a well-preserved state, Segesta was never completed. The pteron is finished but in a rough state, the columns being left rough as fluting was to be added. Although Greek it employs un-Greek proportions: the columns are lower in proportion to their diameter and the height of the upper structure than usual in 5th century BC Greek mainland buildings.

The Temple of Zeus Olympios, *Athens 174 BC–131 AD*
Pentelite marble

This temple was one of the largest ever built, its stylobate measuring 134 × 616 feet (41 × 188m), the Parthenon being a mere 105 × 230 feet (32 × 70m). It employs the Corinthian Order, invented in the late 5th century BC for interior decoration but which first appeared on exteriors a century later. By the time of the Temple of Zeus Olympios it was a standard form. This temple shows clearly the trabeated construction of Greek temples in that any jointing of the architrave had to be placed above the columns for stability. Although mortar was not used by the Greeks, highly effective jointing was achieved by smoothing the underside of a horizontal and the edges of an upright while leaving the center of the vertical roughly scooped out. This system may sound inefficient but the high survival rate of Greek temples shows how effective it was.

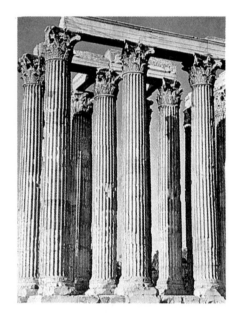

were closer than first realized by later admirers of Greek architecture to philosophers such as the Pythagoreans, who launched the first speculations about the nature of numbers and their place in cosmology.

In the absence of written evidence it is impossible to be sure, but we may at least wonder whether the Greeks were inspired to design their temples according to the same principles that they supposed the gods had used in designing the world. If so, the Greeks were responsible for a highly developed symbolism and their buildings should be counted among the intellectual as well as the aesthetic achievements of their time. Whatever the circumstances, it is beyond question that the Greeks took enormous trouble over shapes, both in general mass and in detail, one of their architecture's most distinctive characteristics.

The Greeks' intensely conservative respect for tradition was another distinct characteristic that was reflected in their architecture. It may seem a para-

dox that a people who were never satisfied and always tinkering with a desire to improve also insisted that in order for a temple to be a temple it should share at least a minimal similarity with every other Greek temple ever built. Even when the Greeks began to build in stone, they retained many apparently superfluous details to remind posterity that the earliest temples had had wooden frames.

While improvements were appropriate, capricious invention was not, and, gradually, from the incessant activity that led from simple boxes with thatched roofs to the Parthenon, the idea of an ideal temple became increasingly and precisely defined.

Sculpture

The Greek architect went about his business in much the same way as any other Greek craftsman: imposing preconceived forms onto a suitable raw material. This same philosophy can be applied in even more obvious ways to the Greek sculptor, but whereas the

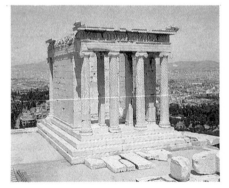

Temple of Nike Apteros, *The Acropolis, Athens, 427–4 BC*
Pentelite marble

According to the Greek geographer, Pausanias, in the second century AD this small Ionic temple housed a statue of Athena holding the attributes of victory, a pomegranate and a helmet. Because victory was usually depicted as a winged female, this temple became known as the Temple of Wingless Victory, or Nike Apteros. On three sides of the temple were reliefs of battles, probably carved by Callimachus. Its position beside the main entrance to the Acropolis proclaims the complex's function as a memorial to the final defeat of the Persians in 479 BC. Apart from the Erechtheum, it was the last building erected on the site.

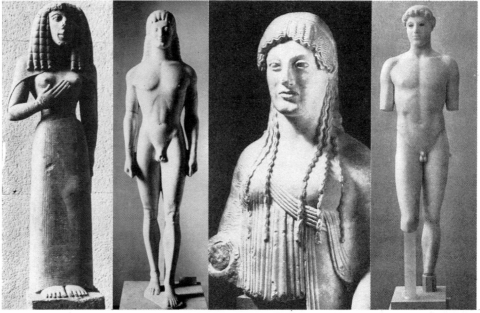

From left to right:
Figurine from Auxerre, c.650–600 BC,
Limestone, Height 24½in (62cm)
Louvre, Paris
Kouros from Tenea, c.560 BC
Cycladic marble, Height 5ft (152.5cm)
Antikensammlung, Munich
The Euthdikos Koré, beginning 5th century BC
Marble, Height 164in (415cm)
Acropolis Museum, Athens
Kritios Boy, c.480 BC
Marble, Height 33½in (85cm)
Acropolis Museum, Athens

The standing figures of the male kouros and the female koré were introduced into Greek art in the 7th century BC and became favorite sculptural forms, although their precise purpose is still obscure. The kouros is generally nude and the koré always clothed, the expressive potential of the drapery being fully exploited. Not until the Classical period is the female represented nude in sculpture. The Kritios Boy marks the transition from the archaic period of Greek art to the Classical. The formalized treatment of the hair, in ridged tresses, has been abandoned, and the features and facial expression are far more natural. The understanding of human anatomy — proportions and musculature — which is beginning to be noticeable in the Euthdikos Koré has deepened considerably. The figure has acquired a sense of movement; the head is slightly turned and the lower part of the body adjusted to conform with the position of the legs.

abstract nature of design and the technicalities of construction safely removed the architect from interfering patrons, Greek sculptors were exposed to pressures of a different order, namely those of philosophy and aesthetics.

It is perhaps most clearly in the development of sculptural form that the changes from the Dark Ages into the Classical achievement can best be seen. The subject of sculpture that dominates all others is the human figure and it has been the principal preoccupation of sculpture from the earliest societies. The blocked figures of Egyptian sculpture, reflecting a hierarchical, unmoving and immutable view of life, changed little over thousands of years, and achieved a degree of sensitivity that gives the work a sense of settled power reflecting the splendor of the society. Figures do not move; they step forward but not to go anywhere or do anything. In the early figures in Greece there is the same rigid, static pose and lack of facial emotion,

except a quizzical or secret smile, but generally the works lack any sensation of breath and life. From the early *kouros* or *koré* figures to the figures produced in the 5th century BC (now known largely from Roman copies) we see the metamorphosis from constraint to freedom, from chrysalis to butterfly, from the unformed and intellectually confined to that liberty of thought and inquiry achieved in the Classical period.

The Greeks began to show interest in the monumental sculpture of Egypt about the same time that they began building temples in stone. The first manifestation of this was a series of larger-than-life nude statues of young men, and in scale, anatomy, posture and details the debt to Egypt is obvious. It is tempting to suppose that the purpose of these statues was also inspired by the Egyptians because they were evidently votice offerings and celebrated the special occasion of man's transfiguration through contact with a god. For the Greeks, however, these occasions were not the same as they

had been for the Egyptians. As Greek society developed, the relationship of the gods to man changed. The myths of the gods and the history of the people became, as Greek society emerged from the Dark Age, intermixed. The ancient kings acquired god-like powers while the gods acted in human forms with human passions. Politically, with the overthrow of Mycenae, the Greeks had rejected the idea of divine rulers and what they knew about the dealings between gods and men was largely set out for them by Homer. Homer's heroes had moments in which they shone like gods, but it was a transitory glory achieved in victory or death in battle and was the special prerogative of vigorous young men at the height of their physical powers.

If these chosen were set apart from the rest of mankind it was not because they were spiritually or intellectually difference but because they were physically superior. It was obvious that the rules that governed Egyptian art to convey such a scale of values in visible form were not the right vehicles, yet it took the Greeks the better part of a century to realize this. During this time, like the architects with their temples, Greek sculptors experimented endlessly but did not question the basic formula. It is here that we encounter yet another paradox in Greek art: on the one hand a continuing tendency to subdue muscular exaggeration in the interest of anatomical perfection and, on the other, an apparent reluctance to break with the inhibiting straight-jacket of tradition.

Eventually Greek artists did break from their inherited restraints, and when they did they initiated not only a new phase in the history of their own art, but an alternative to an entire tradition of stylization. To call this art representational or naturalistic would be to miss the point of its origin. The Greeks were not interested in what

might be called photographic accuracy any more than any other society in antiquity. It was axiomatic that the business of art was to transform appearances and capture realities beyond appearances. Where the Greeks parted company with their predecessors was over the nature of these realities and the relationship between appearance and reality.

The pursuit of the ideal

By the end of the 6th century BC Greek sculptors were able to make large-scale, hollow bronze statues – an achievement they themselves recognized as an important event – and henceforth bronze statues were prized more highly than those cut in stone or marble. This was partly due to the finished surface of the piece, but also to a new freedom of composition.

To make a statue in bronze it was first necessary to make a clay model. The technique of making such figures was the exact opposite of that used for carving a figure from a block of stone. Instead of starting with an overall shape and working to details, the sculptor had to build his figure by adding detail to detail: finger to hand, hand to arm and so on. For such a method traditional rules were useless and new ones had to be invented. There was, however, more to this new method of sculpting than the discovery of a practical alternative because it involved questions concerning the relationships between the parts of the human body; inevitably these questions led to the essential one of how to define the ideal human form.

Two aspects of the Greeks' solution to this problem are known. The most famous of the new rules, presented by the 5th century BC sculptor Polyclitus and accepted by his contemporaries, was that relations between parts of the body could be expressed in numerical ratios. The second aspect was that ideal

forms were made of a collection of perfect details, as illustrated in the story of the painter Zeuxis, who, when called upon to paint a picture of the goddess Hera, chose seven girls as models and took the best features from each. Put in this way, an artist's conception of the ideal is apt to seem to be no more than a personal preference, but several eminent Greek philosophers were also involved in such ideas. The doctrine that the forms we see are but imperfect copies of perfect archetypes and that the perfection of forms could be expressed in mathematical terms was one of the most influential Greek philosophical traditions.

Whatever the Pythagoreans may have meant originally when they stated that all things are numbers, it was for the sculptor that this statement became a commonplace. It is certainly no coincidence that the man credited with inventing hollow bronze casting, Theodoros, lived on Samos and was a contemporary there of Pythagoras and Rhoikos, the architect of one of the huge early Ionic temples. Later, when philosophy and mathematics had made tremendous advances, Plato could afford to scoff at the presumption that artistic imagination could apprehend the essence of forms, but his teachings would have been pointless if some such claim had not already been made by the early Greek artists.

The Classical style

Artistically, the consequence of this monumental philosophical upheaval was the creation of what we today call the Classical style. Once the Greeks had recognized that perfection lay in the ratios between the various parts of the body, traditional postures no longer carried their former significance and figures could relax, adopt elegant stances, indulge in violent movement and enter into dramatic relations with other figures.

A more elusive aspect of this change was the Greeks' conscious cultivation of beauty. From its outset, the cult of the heroic young man was directed not so much at deeds performed as at the bodies that performed those deeds, and with the advent of the Classical style the emphasis upon the human form became even more explicit. In Greece the male form reigned supreme and male homosexuality was a recognized social practice. Greek women, on the other hand, were not generally regarded as suitable objects for higher human affections, were not prominent in social life and their beauty not rated as equal to that of men. This emphasis upon the male form bordered on the god-like and in fact led the Greeks to the novel and characteristic conclusion that formal, physical beauty was something that gods and men shared. To be beautiful was a mark not just of divine favor but of divinity and, conversely, this idea offered insight into what the gods themselves were like. In their exuberance over this discovery the Greeks felt empowered to refashion their deities in human form without impiety, and the Classical images of the Olympian gods – with the exception of Aphrodite – which lasted for the rest of antiquity, were all the work of the 5th century BC sculptors. In persuading themselves that beauty was an aspect of truth, the Greeks opened the way to a type of religious art that was entirely humanistic. While its subject matter remained unchanged – ancient tales of gods and heroes – it was now possible to present the characters in a far more vivid and direct manner.

More or less coinciding with the coming of the Classical style in the figural arts, Classical drama was launched upon an equally precocious career in Athens, and the two had many things in common. If statues could not move, their postures could suggest movement, and there were two theatri-

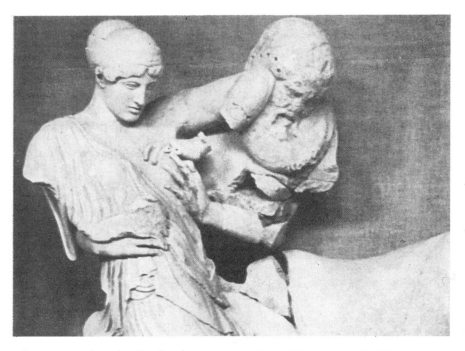

Lapith and Centaur, *Temple of Zeus, Olympia, 460 BC Marble Archaeological Museum, Olympia*

The Lapith and Centaur is one of the metopes on the Parthenon. Most of the metopes depict scenes of combat – gods against giants, Greeks fighting Amazons, or this example. The "good versus evil" theme depicted here may relate to the recent defeat of Persia by Athenian forces. The forcefully modeled figures, almost in the round, would have made a striking contrast to the flatter style of the entire frieze. There is a marked contrast between the violent expressions of the centaur and the serene, elegant Lapith.

cal resources that the Greeks chose to emulate towards this end: gesture and expression. It was some time before the artistic expression of human emotion was achieved. In the early days of the Classical style, when it was still important for the sculptor to get the anatomy of a figure correct, they were often shown posed in the extremes of violence yet with faces untouched by emotion. No lady ever faced a fate worse than death with greater calm and composure than the Lapith lady being carried off by a drunken centaur on the west pediment at the Olympia – and the centaur seems no less unconcerned about the prospects in store.

Clearly, a great deal of research was needed before such scenes of action could be made dramatically convincing. While in one sense this was merely a matter of experience and application, in another it touched upon the fragile nature on which the entire enterprise was based. Realism may have been dramatically desirable, but too much was liable to undermine aspirations toward the ideal, the entire justification for this type of art. In particular this put the gods at a disadvantage because they were not supposed to suffer or grow old. Therefore, while the rendering of pain and age inevitably became the *tours de force* of mimetic genius, greater discretion and skill were needed to maintain a subtle balance.

It was the large group compositions that proved the greatest challenge to the virtuoso skills of the sculptors and offered the most scope for theatrical

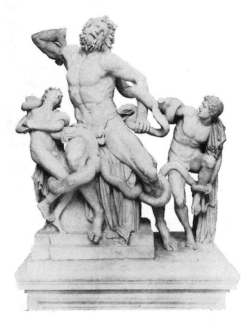

Laocoön, *c.2nd century or c.50–25 BC*
Hagesandros, Polyodoros and Athenodoros
Marble- Life-size
Vatican Museum, Rome

Until 1957 it was considered probable that the Laocoön was a late example of sculpture from Pergamum by three sculptors named in contemporary documents. In 1957, with the excavations of "the grotto of Tiberius", around 5000 sculptural fragments were uncovered similar in style to the Laocoön. An inscription bore the names of the three artists, the only occurrence of the three names together. It therefore seems likely that the Laocoön is in fact a Roman copy of a Pergamene original, now lost. Group sculpture was rare in Classical sculpture, but it was relatively common in Pergamum. Also suggesting a Roman copy is the sketchy quality of anatomy and the highly agitated yet convincing pose.

effects, and we may assume from surviving examples that the Greek sculptor made great use of writhing postures and contorted expressions. The artist to whom the ancient critics gave credit for discovering the means of conveying such violent emotions was the 14th century BC sculptor Skopas, and the few tantalizing fragments of whirling figures with rolling eyes attributed to him suggest a personality capable of truly dramatic frenzy.

We can perhaps obtain a better idea of what this art was capable of achieving from later works inspired by Skopas on Hellenistic originals such as the frieze around the great altar at Pergamum, or the Laocoön group. The latter, with its evocations of Virgil, pathos and anguished flamboyance perfectly embodies the Greek idea of the figural arts, allowing them a place alongside literature and rhetoric as the embellishments of a cultivated life.

The Acropolis

It is generally agreed today that the best of the Parthenon marbles, from the middle of the 5th century BC and either the work of Phidias or executed under his supervision, came closer than any other surviving work of art to fulfilling the Greek requirements of religious exaltation and theatrical credibility. So much attention has been given to to the Parthenon, however, that there

is danger of its being seen out of context. While the Parthenon was no doubt the most conscpicuous feature of the Acropolis, it was the Acropolis in its entirety that was the real work of art.

The entire cluster of buildings and statues of the Acropolis, with their position and scale carefully worked out in relation to one another, was intended by its promoter, Pericles, to embrace the full spectrum of Athenian life and history. Above all, memories of the Persian Wars were a focal point, expressed by the colossal statue of Athena Promachos standing guard over the ruins of a temple destroyed by the Persians in 480 BC, gazing out through the Propylaea to the narrows of Salamis, where the decisive victory was won.

The Parthenon was built primarily to house Phidias's new statue of Athena, the patron goddess of the city, and to stress the martial qualities that had helped create the Athenian empire.

The Acropolis, *Athens, Greece, after 479 BC*
Photograph of reconstruction model

The Acropolis, the sacred hill above Athens, had been a fortified site since Mycenaean times. In 480 BC the Persians destroyed almost all of the structures on it, but with their final defeat in 479 BC the Acropolis took on a new significance. During the next seventy-five years, all of the surviving buildings were erected and, although the relationships between individual elements seems arbitrary, they are in fact carefully planned. The Acropolis was rebuilt to commemorate the Persian defeat and buildings were carefully sited to provide views relevant to the Greek victories: the place where the naval battle of Salamis (480 BC) was fought is visible, and the valley leading to the battleground of Plataea (479 BC) and the pass leading from Marathon (490 BC) were also key points in deciding the position of buildings and the statuary they housed.

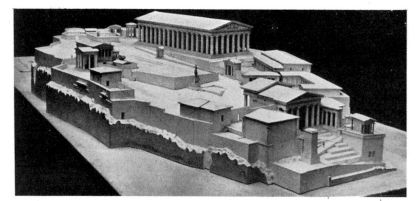

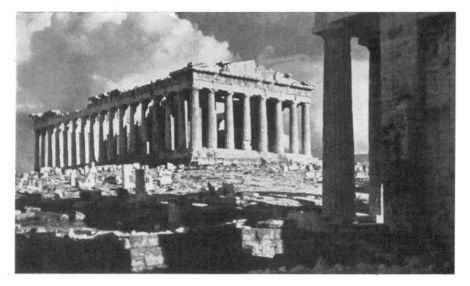

The Parthenon, *The Acropolis, Athens*
447–3 BC
Iktinos and Kallicrates
Pentelite marble with limestone foundations

The Parthenon is often cited as the classic example of the Greek Doric temple, yet in terms of proportion it differs from most other temples in being considerably less massive. By lightening the entablature – it is lower in proportion to its width and column height than was normal – the columns are slenderer and more widely spaced than was usual due to the decrease in the weight of the load to be carried. The Parthenon also differs in terms of plan from the standard Doric temple: across the east and west ends are eight columns instead of six, while along the sides are seventeen, a figure between twelve and sixteen being more usual. The careful siting on the Acropolis of the new temple to Athena when compared with the location of the old temple indicates how sophisticated the designers had become by the time of Pericles.

Other purposes were not excluded and traditional cults of a more pacific character were eventually housed in the small, exquisite Erechtheum, whose Ionic style complements the Doric style of the Parthenon. The entire conception of the Acropolis offered the citizens of Athens an ideal vision of their city and was both a constant reminder to market place and assembly alike of what had been achieved and an incentive to further efforts. It is an extraordinary testimony to the role that the arts played in the affairs of a small Greek state and, while they did not save the Athenian empire, they did procure immortality for Athens.

Agora, *Assos, Turkey, 2nd century BC*
Reconstruction drawing

The agora was the commercial and administrative center of a Greek city as the forum was of a Roman. It was also used as a trading center. Around the marketplace were stoas, or continuous colonnades, usually on three sides. At Assos, as in other congested cities, a two-storied stoa was built to provide extra space with Ionic Orders above the heavier Doric Orders at the ground level where there were two aisles with shops and offices behind, often two or three rows deep. In large Greek cities a number of agoras were often built one behind the other.

Urban art

Not every Greek city felt inspired to invest in art on the scale of Athens, yet almost everywhere in the Greek world the idea gradually came to be taken for granted that for a city to be a fit place in which to live, it should contain a certain number of imposing public buildings. These included at least one temple to the protecting deity, a theater, a gymnasium, a fountain and perhaps a council chamber. Further amenities were the colonnaded porticos called *stoas* that tended to be grouped around an open square, usually at the city center. Almost all Greek public buildings made use, to a greater or lesser extent, of the colonnades and entablatures that had been invented originally for temples, and through them architecture was extended from the temple to the city.

Thus the city itself came to be a medium for architectural design. In old cities that had grown piecemeal over the centuries, such as Athens, grandiose ideas often had to be tailored to existing street plans. But in places such as Miletus, which was totally rebuilt after its destruction by the Persians in 494 BC, a regular grid of new streets was laid out and the public buildings distributed among them with an eye to achieving the greatest effect. This became standard practice in subsequent centuries.

Segesta Theater, *Sicili, First century BC*
View and reconstruction drawing

The form of Greek theaters was established in the 4th century BC and remained basically similar until the first century BC. Segesta and Tyndaris, Sicily, are the earliest examples of Greek theaters showing a clear Roman influence. The seating no longer extends beyond the semicircle; Greek theater seating plans were horseshoe-shaped, and the proscenium seems no longer to have supported scenery but to have formed the backdrop itself. As the proscenium took on a new role its height was nearly double that of true Greek examples. In Greek theaters, most of the action occurred in the orchestra, the circular area between the proscenium and the seating as at Epidaurus, but as Segesta the plays were enacted on a raised platform in front of the proscenium.

Plan of the Theater at Epidaurus, *c.350 BC*

Reputedly built by Polyclitus the Younger and considered one of the finest and best preserved in Greece. Here the orchestra *was the place for the performances.*

As a result of the conquests of Alexander the Great, planned cities proliferated around the eastern Mediterranean and far beyond. Almost as soon as the Hellenistic kingdoms into which Alexander's empire fragmented had achieved a measure of stability, new cities were founded and old ones rebuilt with a view to attracting Greek settlers; and, wherever the Greeks went – even into the heart of central Asia – they took with them their expectations of what a city should be. Few, however, have left substantial remains and the greatest, Alexandria and Antioch, have disappeared almost without trace. Historians have some idea of the scale on which these cities were built from what is left of the greatest city of the western Greeks – Syracuse – which still has some of the most sophisticated fortifications ever devised for the protection of a Hellenistic city, showing the enormous destructive escalation of warfare introduced by the campaigns of Alexander.

But it is the more modest sites, such as Priene, that give us the best ideal of what ordinary Hellenistic cities were like. Rebuilt in the 4th century BC, Priene was the model for many new city foundations and, although politically insignificant, it had all the usual amenities. Quite a number of private houses have survived as well and these reveal simple rooms arranged around small enclosed courtyards. This was

the secluded world of women and children, as opposed to the town center where the men no doubt devoted their days to the principal business of Greek life, talking. Although its temple was the work of a celebrated architect, in the quality of its buildings Priene cannot compete with Athens, but whereas there was only one Athens, there were scores of Prienes; in this way architecture became less of an art and more of an industry.

As contributions to the conduct of civilized life, Hellenistic cities should command our considerable respect. They also correspond to an important change in Greek character and behavior. Politically, Greek cities were more or less autonomous, but the price they had to pay was the surrender of foreign policy and military initiative to the Hellenistic kings. In this they had no choice and it is not known whether the Greeks believed it better to live in an emasculated peace than to be free to destroy their neighbors, or to be destroyed by them. However that may have been, what Aristotle described as the good life made possible by the city became increasingly identified with the agreeable life, and among the things that contributed to making life more pleasant were the arts.

Portraiture

In a civilization such as Greece that was built around the idea of the great man, an art devoted to the commemorative image was indispensible; and portraiture, in our sense of the word, was one of the consequences of the Classical revolution. While archaic statues sometimes had names attached to them, they were generally as anonymous as the pharaohs of Egypt or the kings of Assyria. For the Greeks, however, just as it was discovered that the rules of perfect physical form could be applied to any posture or gesture, so there were categories of appearance that could be

applied to the endless variations of the human face.

The result was a discreet compromise between the ideal and an individual likeness that satisfied the commemorative expectations of the successful generals, politicians and rulers of the day. When in due course Greek artists turned their attention to lesser subjects, the result was not greater realism, but caricature. Even the well-known portraits of Socrates, based on Alcibiades's remark in the Symposium that Socrates resembled a satyr, were in a sense caricature.

The illustrious dead of long ago did not present the Greek portraitist with difficulty; the fact that no one knew what Homer looked like did not inhibit a proliferation of portraits, all depicting the noble poet visualizing the tales of Troy through sightless eyes.

The Greek critic
In the tidy way of compilers of encyclopedias, the Hellenistic writers who set about imposing order upon the history of art saw a systematic progression in which the various techniques of representation were successively mastered, each step being the individual achievement of one particular artist. This was a pattern of thinking that was to be resurrected by Vasari in the Italian Renaissance and provided the 18th-century art historian Johann Winckelmann with the framework for his reconstruction of the history of Greek art. While we need not question the accuracy of these Hellenistic judgements, most of them preserved for us in the works of Pliny and Quintilian, it is important to realize that the qualities that these ancient critics were prepared to recognize in works of art had little to do with what we today would call aesthetic merit. One important result is that by the time the Greeks began to reflect seriously on the idea of art, they were incapable of thinking of human

accomplishment other than in terms of great men. Every department of Greek history included an array of exceptional talents, so even if there had been no authentic candidates for the role of oustanding artist, reputations almost certainly would have been invented.

Although the artistic revolution represented by the advent of the Classical style remained the unquestioned basis of all Hellenistic art, the tensions between the religious and theatrical elements were soon stretched to breaking point. Exactly what happened to Greek religion during and after the 5th century BC is not easily summarized in a few sentences, but what is certain is that it changed. Socrates, the Sophists and other philosophers, and the experiences of the Peloponnesian War all contributed to the undermining of orthodox religion. Additionally, although the cults of the Olympian gods may have been adapted to meet the intellectual and aesthetic tastes of the upper classes, they were weak when it came to providing spiritual consolation for the common man, who sought spiritual fulfillment elsewhere. Phidias's great statue of Athena Parthenos was never more than a museum piece, but the crude wooden doll it replaced successfully retained its ancient religious status.

In such circumstances it is not surprising that the arts became the plaything of artists absorbed in the self-conscious exercise of their artistry. The hundred years or so that elapsed between the career of Phidias and the death of Alexander the Great included most of the great names in the history of art: Polyclitos, Scopas, Praxiteles and Lysippos in sculpture; Apollodoros, Zeuxis, Parrahasios and Apelles in painting. These were the men whom the Greeks, and later the Romans, chose to recognize as the masters – the men who brought their respective arts to the highest point of perfection.

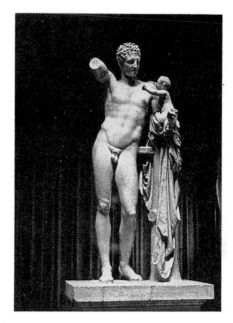

Hermes of Praxiteles, *Athens, c.350–30 BC Olympia Museum*

Praxiteles of Athens, along with Skopas of Paros and Lysippos of Sikyon, dominated Greek sculpture in the 4th century BC. There is some question whether this is an original work or by a 2nd century BC sculptor of the same name, or a Roman copy. A documentary reference, however, suggests it is an original by the great Praxiteles and its quality of execution means that it is unlikely to be a Roman copy. Hermes was the Greek messenger of the gods and the conductor of souls to Hades, the underworld. The identity of the small accompanying figure is disputed, although it is most likely the infant Dionysus.

Evaluating Greek art

Although we have been left the great names of Greek art, we have few of the works that made these artists famous and almost all of the masterpieces mentioned in ancient writings have been lost, including every painting. The Hermes by Praxiteles is one that has survived, although there are even doubts about this, and a few bronzes that were no doubt shipwrecked on their way to a new home, probably Rome, have been brought out of the sea.

While this shortage of original works makes it extremely difficult for us to judge the artistic achievements of Classical antiquity by our own standards, we are not wholly without clues. Because there were not nearly enough original works to supply the fine art market or later times, a new industry came into being – the reproduction of old masters – and it is upon the evidence of these Roman replicas that the opinions of most art historians have been based. Valuable as they may be to historians, however, these ancient copies were highly selective, representing the tastes and needs of Roman society and not, therefore, revealing the full range of original Greek art that existed at that time.

It is difficult for us to assess the cumulative impact of so much imagery. A good deal of it, including perhaps the more impressive pieces, was on public display where it merged with the religious and mythological themes of temple sculpture on the one hand, and contemporary political propaganda on the other. For the educated man the total effect was, perhaps, the establishment of an impressive sense of continuity with the past and the blurring of distinctions between fact and fiction, history and literature. The value of the contribution of these works to the atmosphere and flavor of city life was probably no less than that of the archi-tecture amid which it was set. The two were not distinct, but complementary and together they created an environment in which a man could, with confidence, cultivate public and private virtues; they offered him a context that in its own way, was as vivid and real as the legal status of his citizenship.

The Greek political system depended of an idea of the state unknown to earlier societies, which all cultivated Greeks regarded as "barbarian". What may be called the civic role of the visual arts in Greek life was perhaps an intangible achievement, but it was the one that lasted the longest. Not only did it survive the incorporation of the Hellenistic east into the Roman Empire, but also the transformation of the Empire from Roman to Byzantine. In fact, it continued to flourish as long as the cities themselves survived, and was one of the more deplorable casualties that attended the destruction of city life in the Byzantine Empire during the 7th century AD.

The Mediterranean world

The creation of the empire of Alexander and the kingdoms into which it was partitioned led to a colossal expansion of Greek influence, even if this was not quite what it had been in the days of the city-states. Initially the effect was the cultural unification of the eastern Mediterranean area. Then, with the rise of Rome, conditions were created that brought the western Mediterranean and much of Europe into the same cultural area.

The long-term effect of this in the development of Western society was two-fold. Firstly, it ensured the survival of an important part of the Greek achievement, among which were Greek art and literature; when new societies eventually grew out of the fragments of the Roman Empire, there were Greek as well as Roman materials out of which to create their own cultures.

Etruscan Sarcophagus, *Cerverteri, Italy mid-6th century BC*
Terracotta, length 6ft 7in (197.5cm)
Museo Nazionale di Villa Giulia, Rome

Terracotta seems to have been the medium that appealed most to Etruscan artists, while contemporary Greeks preferred stone. The earliest forms of large funerary monuments were house-shaped crematory urns molded in two parts. The portrayal of life-size reclining figures in terracotta on a couch developed in the mid-6th century BC when the many technical problems of using terracotta on a large scale had been overcome. These large sculptured sarcophagi held corpses rather than ashes, but with present knowledge it is impossible to say whether technical developments led to a change in funerary rites or vice versa. It is clear, however, that these developments occurred primarily in Cerverteri.

Etruscan wall painting, *6th century BC*

The decorative primality of the figures and geometric decoration show Greek influences, while a certain freedom of expression in the figures indicates the more childlike preoccupations of the society.

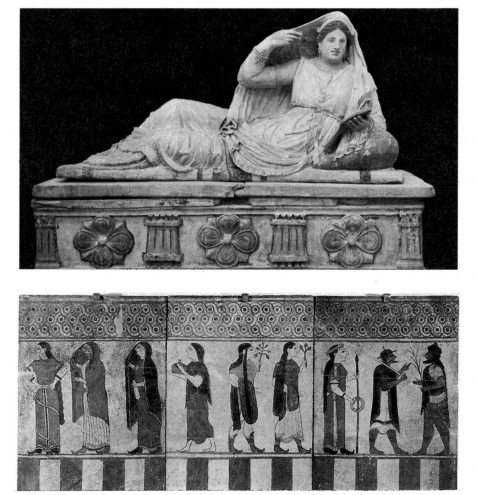

Roman art

Little of the art and architecture of the early kings and Republican Rome has survived, so it may be unfair to dismiss the Romans' achievements as negligible, but everything we know about the Romans during their first five hundred years suggests that they had little sense of beauty or use for art. The Romans' earliest temples were the work of Etruscan kings, and between the Etruscans and Romans there existed a considerable cultural gap. Although the Etruscans knew quite a bit about Greek art and were clearly sensitive to pictorial and architectural effects, the serious Hellenization of Roman art did not begin until after the second Punic War in the second century BC.

It was perhaps appropriate that the Romans, whose sense of destiny was sharpened by an almost unbroken dedication to the art of war, should have been taught they had much to learn from the Greeks by their encounter with Hannibal. Although not Greek himself, Hannibal practiced war in the manner of Alexander the Great and his marshals. He was eventually beaten by a careful study of his own methods, and within fifty years Rome became the only serious military power in the Mediterranean world. It was these campaigns that brought about the state of affairs in which Roman eyes were opened to the beauties of the Greek world.

At first, Roman interest in Greek works of art took the form of looting, with the victorious generals who captured Tarentum and Syracuse during the second Punic War sending home quantities of statuary. Many of their successors did likewise and henceforth there was a steady trickle of the spoils of war back to Rome, which must have made the city the greatest museum in antiquity. There were also peaceful travelers, and a trade in old masters and reproductions developed to cater to their tastes. Eventually Greek artists went to Italy to be commissioned by Roman patrons.

Imperial art

It is worth noting that in spite of their pretensions to divinity, neither the Roman emperors nor the Hellenistic kings on whom they modeled themselves resorted to the devices of stylization used by the ancient oriental monarchies. At home in Egypt it was accepted that all of the pharaohs were graced with divinity, but the kings and emperors of the Classical world needed visual expression of their superiority, and as a result a language of gesture was invented to convey the attributes of authority. As a practical solution this may have been acceptable, especially for the educated classes of the Greco-Roman world, whose ideas of divinity were based on philosophy rather than faith or supersition. The political and social history of the Roman Empire, however, was largely concerned with the detachment of government from this privileged minority. By the time this was accomplished in the 4th century AD the groundwork was laid for a different type of official art.

While the Empire prospered the

Arch of Constantine, *early 4th century AD*
Pentelite marble around concrete core
Rome

The arch, which was completed in 315 AD,
commemorates Constantine's victory over
Maxentius, and is an example of the
combination of sculpture with architectural
form in the creation of a large, but mostly
useless, architectural element. It follows the
form of the Arch of Severus and is more
impressive than the Arch of Titus. Such
triumphal arches are an indication of the
adoption of architectural form for sculptural
purposes.

Column of Marcus Aurelius,
Rome, 176 AD
Original of luna marble with bronze statues
Height 95ft (29.6m)

This column was erected to commemorate
Marcus Aurelius's victories in the first
Marcomanni War (167–75 AD) and in
emulation of Trajan's Column (106–113 AD).
Buildings were erected around the Column
to produce a setting comparable to that of
Trajan's, including later a temple to the
deified Marcus. The original height was
probably due to bronze statues of Marcus
Aurelius and his wife Faustina Junior at the
summit of the Column. On the Column war is
depicted as a hellish, brutal experience and a
dramatically disjointed style was employed
to heighten this effect. This is different from
Trajan's Column where battle still retains
some of the heroic spirit of the Greeks.

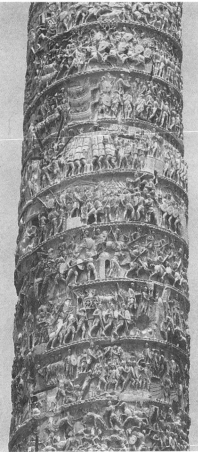

visual arts were largely employed as a public service to proclaim the majesty and generosity of the emperors. Much of this art, and especially the pictorial imagery, was simply propaganda, such as triumphal arches and victory columns covered with scenes of military success, altars showing the emperor punctilious in the performance of his religious duties, and reliefs proclaiming his imperial virtues of clemency and justice.

While much of Roman battlefield narrative has the vividness of eye-witness reports from intrepid war correspondents, the emperor depicted at peace inspired clichés, and as media manipulation such images were naive. Thus themes that were essentially ephemeral were given a permance by the skills and materials of art, while the occasions themselves receded quickly into the oblivion of popular indifference. From this point of view the public figural arts of Imperial Rome were little more than an interesting continuation of the inherited tradition of Greek art.

Painting and sculpture

The Bay of Naples was artistically an area of strategic significance where Roman patrons and Greek artists met, and there can be no doubt that the tastes and styles revealed from excavations in its vicinity were of more than local importance, although exactly what they reveal is by no means easy to assess.

Perhaps the most interesting manifestation of Rome's adoption of the Hellenistic world of art are the wall paintings of Pompeii, Herculaneum and Boscoreale. These provide us with the only substantial collection of Greek or Roman pictures to have survived and it would be rash to conclude that every house in the ancient world was painted in a similar fashion. In fact, special circumstances account for their

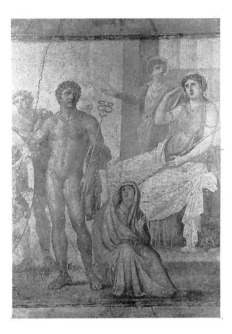

Hercules and Telephus, *Fresco from Herculaneum, c.70 AD*
National Museum, Naples

The state of Roman fresco painting in the first century AD is well known. When Vesuvius erupted in 79 AD it preserved many examples at Pompeii and Herculaneum. Mythological subjects were only one type of representation employed to decorate villas along with still lifes, landscapes and the depiction of pagan rites. Some frescoes are labelled "baroque" by art historians because, like some 17th-century painting they attempt to produce the illusion of a painted wall being part of the architecture. This shows that first century AD fresco painters had a supreme command of perspective while the treatment of figures, modeled in light and shade, demonstrates the high degree of naturalism possible at this date.

survival in a good state of preservation. On August 24, 79 AD Mount Vesuvius, the only live volcano on mainland Europe, erupted and buried the area surrounding it in many feet of volcanic ash. It was not until the 18th century that serious excavation began, and then it was discovered that the ash had protected the paintings as well as buildings, furniture and even the bodies of victims, providing a unique record of the rich Roman provincial society of the area.

It should be remembered that these paintings were the work of interior decorators rather than major artists, and the houses were neither grand nor exceptional. They offer a tantalizing glimpse into a world of private patronage well below the level of official art, which, to all intents and purposes, has disappeared from view. All that we can deduce today is that color must have played an incalculable part in the domestic lives of Hellenistic and Roman householders, and that there

The Statue of Augustus as a Veiled Priest, *63 BC–14 AD*

Augustus, first absolute ruler of the Roman Empire, was portrayed for official purposes in a large number of sculptures. This representation is as a Roman priest with head covered for the sacrifice and shows him in youth as a sensitive, if commanding, individual. The portrayal of draperies is somewhat loose and unorganized, but the work is a fine example of official portraiture.

Roman Husband and Wife, *1st century AD*
Marble, height 72⅞in (185cm)
The Louvre, Paris

The portrait busts and full length sculptures made during the late Republic and under the first emperor Augustus, represents one of the earliest atrempts at clear naturalistic portraiture and as such reflects that emphasis on individual personality, which subsequently reappears in the Renaissance, and remains an expression of a particular characteristic of western art.

was a stock of subjects, mostly mythological, that called for illusionistic presentation.

Even more equivocal was the effect of Greek ideas upon Roman portraiture. For the first time in antiquity realism was evidently prized for its own sake and the traditional Roman Republican was depicted as a sour and dyspeptic old man, side by side with his equally distasteful wife and hardly less forbidding children. This could be due to the fact that many portraits seem to have been made from death masks and the great families of Rome are known to have kept such masks from generations of their ancestors.

After the arrival of the Greeks, which coincided roughly with the conversion of the Republic into the Empire, in some statues Romans suddenly became handsome, noble and even beautiful, although the realistic strain in Roman art was never far below the surface. As far as it went the Greek ideal often enjoyed official approval, and the best-known statue of Augustus shows the youthful head of the Emperor on a torso that, in spite of its rich armor, is clearly borrowed from one of the most celebrated works of the 5th-century BC Greek sculptor Polyclitos. Later, it was common practice for emperors to have their own often grotesquely realistic heads placed upon bodies that everyone was to recognize as belonging to one of the gods.

Roman architecture

During the Roman Empire architecture underwent changes that extended the Classical tradition and prepared the way for totally new architectural forms. To some extent this was a matter of aesthetic experiment, but the more radical changes were due to a combination of factors, which included a range of new building styles, themselves a reflection of Imperial patronage, new building needs and, not least, the

inventiveness of structural engineers.

By the first century of the new era a remarkably propitious situation had come into being. Within the Empire the long established cities of the eastern provinces were in need of renewal and repair and the newly incorporated western provinces were due for urban development to bring them into line with the rest. Above all there was peace, which allowed capital to accumulate, and a substantial part was invested in new buildings.

The Roman buildings that most stimulated the new architecture were public amenities· theaters, amphitheaters, market halls, basilicas and baths. The Imperial palace on the Palantine included some of the most ambitious structures. Whereas the Greeks were content to carve a theater out of a hillside, the Romans constructed artificial banks of seats raised on tiers of arches, and the same principle made possible the great amphitheaters, such as the Colosseum. Greek *stoas* were essentially porticoes flanking open spaces while the Romans placed two such *stoas* together and roofed the space between to create vast halls, known as basilicas, in which various sorts of business could be transacted. These could be anything up to 85 feet (26m) across and 120 feet (36m) in length. Market halls employed the same formula, and Trajan's market in Rome was a forerunner of the modern shopping arcade and gallery.

Even more imposing were the concourses that formed the centerpieces of the great bath complexes. Roman baths were not just places where people washed; they offered a complete range of recreational facilities. Not least among the attractions of the baths was their opulence, which was often taken to a point where any Roman promenading through the baths of Caracalla or Diocletian might be forgiven for fancying himself the equal of the emperors

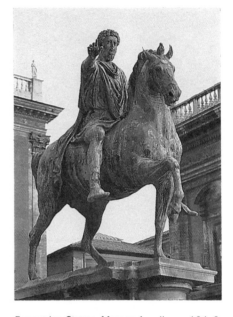

Equestrian Statue, Marcus Aurelius, c.164–6
Bronze with gilding. Over life-size
Capitol, Rome

Marcus Aurelius, in battledress, is here shown as the victorious emperor, and the bronze was probably cast to commemorate his defeat of the Parthians in Mesopotamia in 165 AD. This is not a depiction of how he rode into battle – he carries no sword – but rather an image symbolic of Roman authority and military power. Medieval texts mention the existence of a bound barbarian warrior below the horse's right hoof to prove this point. This equestrian portrait is the only surviving large Roman bronze and perhaps the only major piece of Roman art to have remained on show from its execution until the present day. Medieval accounts express a fascination with the piece and an awe in its technical achievement; the construction of a suitable mold and the casting process were so technically complex that no piece of this size could have been done in the Middle Ages.

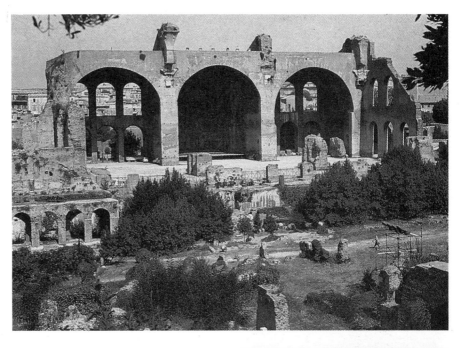

(Diocletian's hall, which never collapsed, was converted into the church of Santa Maria degli Angeli by Michelangelo in the 16th century, and now wears a veneer not at all inconsistent with the seductive purpose of its original ornament).

Almost every Greek theater was rebuilt to include a high screen wall behind its stage, which provided splendid opportunities for architectural conceits. So did fountains, gateways and triumphal arches. Even nominally sober buildings, such as the library at Ephesus, or tomb facades at Petra, adopted the prevailing fashion. What is interesting about some of these structures is that they were clearly designed to arrest the attention of anyone approaching the city or the city center.

Whatever their practical functions, what catches our attention is the visual attractiveness of these buildings that helped to make a city a pleasant place in which to live.

Basilica of Maxentius, *Rome, (c.312 AD)*

This massive basilica, begun by Maxentius and completed under his successor Constantine, was the last and bulkiest of the Roman Imperial basilicas. Three deep, barrel-vaulted spaces that open from the nave survive on the north side. These originally buttressed the nave which was probably covered by a groin vault that sprang from the entablatures above the fluted columns on either side. The design seems to be derived from the hall of the Baths of Diocletian, and both could be the work of the same architect.

Baths of Diocletian, *Rome, c.298–305/6*

The Baths were completed in 305 but dedicated in 306. The scheme follows generally the design of the Baths of Caracalla, but the elements of the plan are more evenly and regularly spread out and the overall conception is broader. The main vestibule was transformed from a domed rotunda into a rectangular space with four apses, one opening from each side. From 1563–6 the hall, vestibule and other parts were transformed by Michelangelo into the Church of Santa Maria degli Angeli, guaranteeing their survival until modern times.

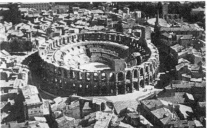

Amphitheater, *Verona, Italy, First century AD. Concrete core with stone dressing*

The amphitheater at Verona, used for gladiatorial combat, was one of the earliest to solve the problem of how to surround a rectangular space with a circular seating plan for spectators. The solution was to use an elliptical plan, as in the Colosseum (72–80 AD). This had not been a problem for the Greeks because they did not stage such games, and when building theaters for drama they used a semicircular form with a proscenium across the end. Verona would have held easily 25,000 spectators, the Colosseum around 50,000, and all would have had an equally clear view of the "entertainment". The basic structure, as with most amphitheaters, is concrete, while architectural features – columns, capitals and arches – are in stone.

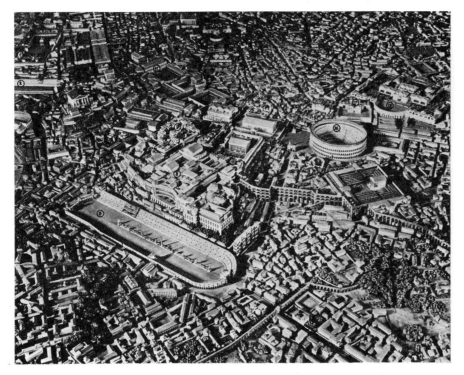

Model of Rome

Town and city planning, along with road building and water supply, all show one aspect of Roman Imperial thinking, namely the love of rigid regularity. Rome itself is perhaps not the clearest example of this as many emperors undertook large building projects not wholly compatible with earlier schemes. However, even in Rome the entire design revolves around certain main streets while housing is organized in blocks, a scheme originating probably in Egypt and still in use in modern-day New York City. The focal points of the city were the forums and their attendant buildings in the center.

Rome

The city of Rome set the architectural precedent, as expressed in Augustus' boast that he found Rome a city of brick and left it a city of marble, although, as with many grandiloquent claims, this was only partly true. The consistent aim was grandeur and opulence, and in this respect, while Rome may have set the pace, it was by no means the only city to indulge in such tastes. The cities of Asia Minor and the Middle East seem to have been particularly rich in large buildings that were as much an excuse for ostentatious display as for public amenities.

The transformation of the city center of Rome was started by the dictator Sulla fifty years before Augustus came to power and was continued by Julius Caesar. The temples and basilicas of the venerable *forum romanum* were rebuilt on a grand scale and the first of a series of Imperial forums laid out to the north. Further additions were made

by Vespasian and Trajan, and when the entire enterprise was completed by Hadrian it extended from the Capitol to the Colosseum.

No other complex of monumental buildings in any other city of the ancient world could match Rome in number, variety or scale. Only the Colosseum has survived in anything like its complete state, but fragments and foundations allow us to form some idea of the overall effect, which must have been very impressive. Most of the buildings made use of colonnades, entablatures and pediments, but their architects also felt free to take liberties with accepted proportions or to introduce elements for which there were no obvious precedents.

For the most part these buildings can be visualized only through the imagination because the ruins that remain are huge, gaunt and stripped of the marble, plaster, paint and mosaics that made them elegant. The interior decoration industry, which was such an indispensible aspect of Roman architecture, needs to be stressed again and again, not just because there is hardly anything left to appreciate, but because the final effects were as important in the design of these buildings as the structural engineering that made them possible.

Structural considerations

The most outstanding contribution of the Romans to the history of art was their competence in the handling of large structures. It is possible that the Romans acquired this ability through the construction of their roads and, more especially, bridges, because to build bridges required a knowledge of the behavior of arches, and from arches it was only a short step to vaults.

The Romans did not invent either arches or vaults, but they seem to have been the first to put them to use in monumental architecture, for which

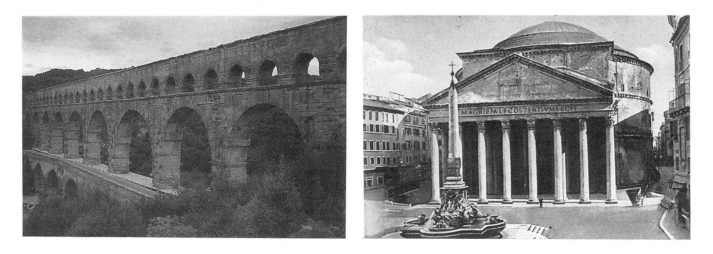

the great halls of their public buildings offered many splendid opportunities. It was perfectly possible to build basilicas on traditional lines by using columns and architraves, and many were in fact made in this way, but the Romans devised the first kind of architecture that gave precedence to internal effects, and the shaping of interior spaces became the principal business of Roman architectural design.

The three great arcades of the basilica of Maxentius, *c.*310 AD, which was completed by Constantine, cover nearly the same distance as the seventeen intercolumniations of the basilica Ulpia, *c.*100 AD, but the former's huge vault must have been infinitely more impressive than the horizontal roof-beams of the earlier building. Structures built on this scale required new materials as well as new technology. While it was possible to construct arches and vaults from cut stone, beyond a certain size the drain on cost and skilled labor became exorbitant and so the Roman alternative was to use concrete. By using concrete, masses of masonry could be built to great heights at great speed, and cheap, unskilled labor soon took the place of expert craftsmen. Once faced with marble, plaster or mosaic the structure

Pont du Gard, *Nimes, France (20–16 BC)*

A basic necessity for town life is a water supply; to provide water for Nimes the Romans brought it from thirty miles (48km) away in pipes. To cross the gorge of the river Gard, however, an aqueduct 967 feet (295m) wide was required. The Pont du Gard is 160 feet (48m) high and is symbolic of the sophistication of Roman engineering. Its harmonious appearance is due to the use of a proportionate system of design using the dimensions of the top row of arches as the basic units.

Pantheon, *Rome, c.118–128*

The Pantheon was rebuilt after a fire in 80 AD and was in turn badly damaged or destroyed in 110. The present building in its entirety dates from the rebuilding by Hadrian. It is in two parts – a domed, circular hall with an attached columnar porch – the clumsy junction of the two sections having led some to conclude that they are of different dates. The form of the hall has many precedents, but there is none for its huge size. An oculus at the summit of the dome may have been the only light-source, but the interior is light and airy. Writers have hailed the Pantheon as early architectural acceptance that interior space, rather than external appearance, was the dominant factor in the designing of architecture.

of a building played no part in the finished effect, except in its dimensions.

The return to religion

In a large Roman hall 120 feet (36m) high more than three-quarters of that space was, for most practical purposes, useless. The height was there to impress or symbolize; it was at the disposal of artistic imagination and, under changing conditions of the Roman Empire, the cooperation between art and engineering gradually focused upon religion.

The civic commissions that architecture had been expected to fulfill in the Classical world eventually contracted and largely disappeared, and the needs of religion came to provide the only regular and continuous architectual commissions. This shift of emphasis was part of the transfor-

Roman Floor Mosaic, c.*500 AD*
from Carthage
British Museum, London

The use of mosaic as a floor surface finish has early origins, but was most extensively exploited by the Romans throughout their Empire. Although there are examples of wall mosaics from this period, the use of mosaic as a wall decoration is most frequent in the Byzantine and medieval Christian world. Roman mosaics often depicted historical events and were used for propaganda purposes, though they also took the form of repeating geometric or floral motifs. These mosaics do not have the sharpness of color, or the rich luster of Byzantine examples, since the Roman constructions were of variously colored stones, not glazed or glass cubes.

Funeral Portrait, *Fayum, Egypt,*
first to 4th century AD

Fayum portraits were done from the first to the 4th centuries AD in Roman Egypt for a specific reason. The portraits were painted in fresco or encaustic on extremely thin wooden panels, sometimes covered with canvas. Once painted, the panels were placed over the face of the body being mummified so that the portrait projected through the layers of bandages. A suitably sized hole was left in the coffin so that the face of the deceased could be seen. This practice continued until the 4th century AD when mummification was abandoned in Egypt. The four centuries of Faiyum portraits show a gradual transition from highly naturalistic portrayals to stylized, flattened faces.

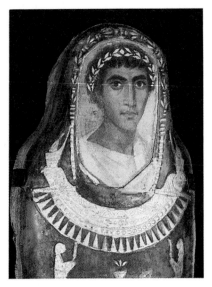

mation that eventually turned antiquity into the Middle Ages, and the change is not easy to describe in simple terms. People lived, worked and worshipped much as they always had, but while they did not suddenly become more religious, the significance of religion became all-embracing.

The crucial event was the conversion of the Emperor Constantine in 313 AD. A few years before a determined attempt had been made to wipe out Christianity by systematic persecutions. It failed, an edict of toleration was issued, and with imperial favor and protection Christianity soon began to flourish. Within a century the pagan temples were closed and their remains exploited as building materials for new churches.

Life was lived against the background of eternity, and eternity was understood not in terms of the abstractions of philosophers but emphatically defined religious beliefs. The state-sponsored cults of Classical antiquity did not cater to those who yearned for personal salvation and life everlasting, yet there were many sects that did offer such consolations, and these were the ones that prospered. Most of them, like Christianity itself, emanated from the East and insofar as they imposed any conditions upon architecture, these were unlikely to be met in the traditional forms of temples. The first Christian churches to be built in Rome were authorized and largely paid for by Constantine, the first Christian emperor. They were vast colonnaded halls rather like the basilicas of pagan times; but in spite of their size, they were simply constructed. Hardly any use was made of vaults except to cover the apse, where the main altar stood.

People interested in life after death thought it prudent to be buried rather than cremated; sarcophagi took the place of urns, cemeteries and catacombs proliferated on the outskirts of

towns, and tombs became more elaborate with the largest assuming the dimensions of full-scale buildings.

Preoccupations with God and death monopolized the visual arts as well as architecture and in this context beauty, as understood by the Greeks, became irrelevant. Once again it was the business of the arts to make visible realities that could be imagined but not seen and, as in Egypt and the Middle East, this was achieved by means of calculated simplifications, exaggerations and distortions; in a word, stylization.

As long as vestiges of the old educated aristocracy survived, wedded to the Classical past and its ideal of self-cultivation, there was still a market for Classical art. At the other end of the scale there were those for whom such art was entirely meaningless and who wanted to repudiate it along with all other aspects of the pagan past. It may be doubted whether such people had any serious use for art at all, but if they did we may find it in the simple paintings of the catacombs. Between these two extremes were those for whom art could still have a valuable part to play in religion, provided it was the right sort of art. The search for new styles of art, suitable to the specific purposes of the new dominant religion, Christianity, forms the positive side of the process that marks the end of the Classical Era.

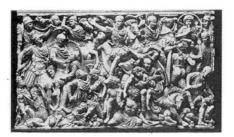

Catacomb Painting, *Rome, 3rd century AD*

Of great importance to the early Christian was a desire for a safe burial place so as to be sure of resurrection. It is only in the reign of Constantine the Great (324–337 AD) that Christians had a modicum of security in Rome and total control over Byzantium (Constantinople). Even after this time, Christian burial continued in catacombs, underground galleries and chambers with burial niches. No Christian art survives from before c.200 AD, and some catacomb painting is among the earliest. Although the subjects are Christian, the method is derived from the popular illusionistic mural painting style, best represented at Pompeii.

The Ludovisi Sarcophagus, *c.250 AD*
Marble with traces of gilding and purple underpainting
Museo Nazionale delle Terme, Rome; lid, Mainz Museum

Unlike most Roman and Greek sculpture, this example retains the original paint and gilding. It is likely that all ancient sculpture was painted, and to modern eyes, accustomed to bare marble, the effect would have been very different. The carved forms produce areas of deep shadow contrasting with lighter, projecting elements. The gilding of some features would have further enhanced this play of light and shade.

The Christian Era

What we think of as Western civilization had its origins in two broad traditions, both of which were transmitted to posterity in the form they received under the Roman Empire. The first element had its origins in that experience of citizenship and free enquiry in the Greek city-states during the 5th and 4th centuries BC. This experience, diluted but stabilized, provided the cultural context in which the educated classes of the Greco-Roman world lived their lives for the seven hundred years that lay between the conquests of Alexander and the collapse of the Roman Imperial political structure.

The other element that contributed decisively to the foundation of Western civilization was Christianity. For something like fourteen centuries Christianity supplied an essential spiritual and moral impetus to the processes through which Western civilization evolved, and for much of that time it provided the intellectual framework as well. The very first Christians were essentially a Jewish sect, which colored their attitudes toward art, specifically in the depiction of images. The religion of the early Christians who followed them, however, was universal rather than exclusive and because Christianity flourished in a world without real boundaries, it soon spread far and wide across the Roman Empire and beyond. Saints Peter and Paul were martyred in Rome in 64 AD and a Christian altar was found among the ruins of the city of Pompeii in 79 AD. It is not surprising that Christianity had reached this small provincial city within a generation of the death of Christ. The early Christians, however, were not evenly dispersed throughout the Empire: at the time of the persecutions in Rome under Julian in the beginning of the 4th century, Christians were a minority, but in other provinces, such as Syria and Asia Minor, they were probably a majority.

The success of Christianity was due to the fact that it fulfilled two needs not catered for by other religions of the ancient world: an optimistic view of the individual's immortal destiny expressed through the doctrine of the salvation of the soul, and an awareness of the individual's worth while alive. Both invited moral scruples and a code of conduct of a far higher order than that found in the Classical world. The official religion of the state had little to offer in this regard and its appeal was restricted to a small number of aristocrats who enjoyed the perquisites and privileges of government.

Because there were many alternative religions to that of the state, it took nearly three hundred years for Christianity to acquire official recognition and approval. Its final triumphs might have owed something to the element of chance in that the Emperor Constantine's adoption of Christianity in 313 AD was more a successful bid for power than a promotion of the religion.

When Christianity became the established religion of the Empire it provided an immediate and effective reason for putting an end to traditional forms of Classical art designed to perpetuate the myths and images of paganism. If Rome became Christian, however, then Christianity to some extent became Roman and this is nowhere more obvious than in early Christian art. The Christian Church not only found a use for art, but on occassion for Classical art. Some of the earliest representations of Christ, for example, bear a perceptible resemblance to Apollo; and Christian tomb-chests were carved by sculptors who probably supplied the pagan art market as well. This situation was not acceptable to all Christians and when the rhetorician Tertullian thundered "What has Jerusalem to do with Athens?", he may well have been thinking of theology but could easily have been referring to art. The Church had a need of art, but what was the right kind of art for the Church to promote and patronize? This question, once raised, had repercussions that echoed for centuries.

The circumstances in which this debate was conducted were affected strongly by the momentous shift of the Imperial capital away from Rome to Constantinople. In the west Rome ceased to be a center of political importance, being too far from the frontiers, and its place was taken first by Milan and then Ravenna. Rome went into a slow decline and became increasingly subject to its bishop. The prestige of St Peter, the first bishop of Rome, was exploited by his successors in their claims of preeminence over the entire Christian Church and henceforth the popes ruled Rome as the emperors had before them. In due course, although not for centuries, they contrived to exercise an authority over much of Europe not unlike that of their Imperial predecessors.

Justinian and his Court, 446–8
Mosaic
S. Vitale, Ravenna

This mosaic panel, Eastern in its naturalistic, unidealized treatment of the figures, decorates the side of the presbytery of S Vitale. The mosaics of Ravenna are perhaps the finest in the world. They were made chiefly of glass to decorate walls and vaults, whereas Roman mosaics had been predominantly floor decorations made of stone. The usual method of making a mosaic tessera, as the cube of glass was called, was to cover it in gold leaf or some other coloring and then to fire on top of it another very thin layer of glass. The effect created was one of ethereal lightness and richness of color almost impervious to the passing of time.

Byzantium and the Eastern Church

In 323 AD the Emperor Constantine decided to make a new capital for the Roman Empire and having chosen the site of the small Greek city of Byzantium on the Bosporus, renamed it Constantinople after himself. In so doing, whether by insight or coincidence, Constantine gave official recognition to a permanent shift in the balance of power within the Roman world. By and large the eastern provinces of the Empire had escaped the barbarian invasions that had brought havoc to the West and the Imperial Roman system, suitably modified to satisfy the doctrines of the Christian Church, survived in Constantinople for more than a thousand years.

At a time when cities everywhere else were in decline, Constantinople grew to become the greatest city in the world. Until 1204 its defenses held against attacks from all directions; it became one of the great centers of world trade and retained whatever vestiges of Classical culture had survived the city's conversion to Christianity. Although Constantinople's wealth and power eventually declined, it remained the spiritual capital for large parts of eastern Europe

and the Middle East. The present Greek Orthodox Church is the spiritual heir of the Byzantine Church.

Constantinople was therefore bound to become the focal point of the arts. As the residence of the emperors, it accumulated the fruits of artistic patronage to an extent that no other city could match. Its workshops were busy, if not continuously, at least often enough for traditions to be maintained. More importantly, perhaps, was the fact that art mattered in Constantinople, where it was a subject that could be discussed and criticized in the self-conscious manner that gives rise to new styles. In this respect, during the first three centuries of its history the city was perhaps not fundamentally different from other, older centers of artistic activity in earlier empires. By the 7th century, however, Constantinople was the only place that mattered and the art that developed there takes its name from the Greek alternative for Constantinople: Byzantium.

Byzantine art, however, should not be wholly identified with the art of the city of Constantinople since in its mature form it is not encountered until the 9th and 10th centuries. To a large

extent this is a consequence of a curious episode known as iconoclasm, during which, for a period of almost 150 years (726–842 BC), emperors forbade the production of religious images. No doubt the fact that the Muslims, now attacking the Empire in Asia, had, like the Old Testament, an austere approach to the subject of images, had something to do with this decision. The result was that almost no religious pictures were produced and almost all works of art made prior to iconoclasm were destroyed as well. This imperial edict did not, however, go unquestioned. The iconoclasts had again raised the fundamental issue presented by all religious art: whether it is possible to represent visually the spiritual significance of an object of worship. Because this question was eventually answered with an unequivocal "yes", iconoclasm is apt to seem only a brief interlude in the history of Christian art. Nevertheless, the verdict was a milestone for Christianity: it meant the relinquishing of whatever traces of inherited Jewish attitudes towards subject matter were left, and inspired the formation of an elaborate imagery that flourished in both East and West – with only isolated bouts of doubt and self-criticism – until the Protestant Reformation in the 16th century.

Whether the Byzantine art that immediately followed iconoclasm was something new or merely a revival of what had preceded it is hard to decide. The architecture of this period is the one art on which an opinion might be based, and here the impression of a fresh start seems to outweigh that of continuity. This, however, may be due to the extraordinary achievements some two centuries earlier of a single man – the Emperor Justinian (527–65 AD) who had scattered buildings throughout the cities of his empire the way other emperors left statues of themselves to posterity. He is best

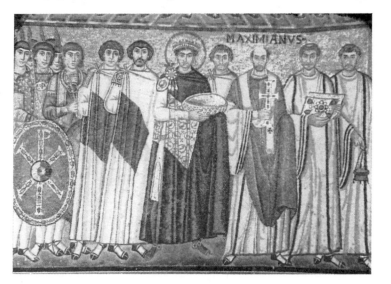

known to us as having a mania for building, thanks largely to a book written by a contemporary historian, Procopius. There is no doubt that he used these buildings as a kind of imperial propaganda and at San Vitale in Ravenna we can see that on occasion he used other arts for the same ends. Mosaics representing Justinian's imperial retinues and his empress Theodora adorn the walls of the chancel on either side of the altar, and figures are depicted on which costumes, rather than faces, convey the solemn grandeur of their spiritual pretensions.

But Justinian's building campaigns served practical ends as well and it might be argued that whatever demand there may have been for great churches was satisfied during his reign. So far as Constantinople was concerned, Justinian provided two spectacular monuments that, more than any others, sustained the architectural reputation of that city – St Sophia and the church of the Holy Apostles. Although the latter was destroyed after the Turkish conquest in 1453, we can form a rough idea of what it looked like from St Mark's in Venice which was designed to resemble it.

For centuries St Sophia was the largest Christian church in the world and its design was by far the most novel, complex and subtle. Without a doubt it was also the personal conception of Justinian. In many ways we are reminded that St Sophia was the work of a Roman emperor and that it belonged to a time when a determined effort was being made to recover some of the lost power and prestige of the Empire. For example, in St Sophia there exist references to the great buildings of Old Rome, most notably the Pantheon. From one point of view St Sophia was the last of the great vaulted halls of the ancient world, as well as the last flourish of the engineering skills that made them possible. This

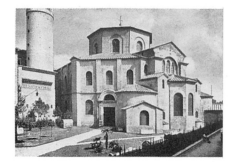

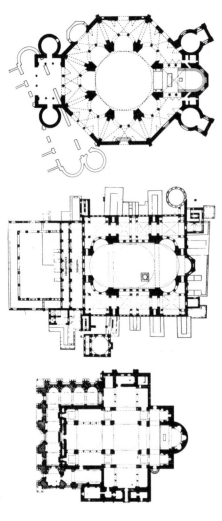

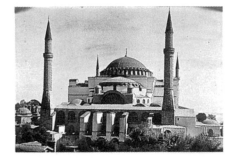

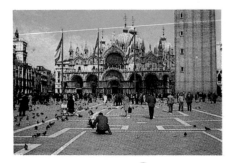

Dome with pendentives

The dome of Sta Sophia, Constantinople is supported by four gigantic pendentives – inverted, triangular concave segments formed in the corners of a rectangular room by four arches coming together to form a circle. Pendentives provide the most satisfying solutions to the problem of raising a circular roof, or dome, on a square ground plan. They were not, however, adopted universally. As late as the 13th century, the more primitive and less graceful squinches continued to be favored by some architects.

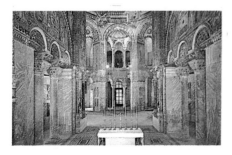

San Vitale, *Ravenna, 526–47*
Plan and two views
This church, consecrated by Justinian in 526 and completed twenty years later, is one of the outstanding examples of central-plan Byzantine architecture in the West and one of the finest monuments to the artistic and commercial supremacy of Ravenna in the 6th century. The ground plan is based upon two concentric octagons, around which are raised the vaulted aisles and galleries. The dome is a lightweight construction of clay pots.

Sta Sophia, *Constantinople, 532–37*
Isidorus of Miletus and Anthemius of Tralles (both active 6th century). Plan and view
When Justinian commissioned the building of this church in 532, no architect had ever before faced the daunting task of enclosing so much space. The finished church, one of the marvels of the age, was completed, remarkably, in only five years. It marks the change in taste which was then beginning to alter Classical traditions and raise a genuinely Byzantine style. Classical buildings had tended to concentrate on the exterior façades. Here the emphasis was shifted to the interior, a triumph of engineering. The full exploitation of the dome was thereafter copied throughout the Byzantine world.

St Mark's (San Marco), *Venice, completed 1071. Plan and view*
Generally regarded as next in importance to Sta Sophia, Constantinople, among surviving Byzantine monuments, this church is an extensive remodeling of the basilica built in 979. The original three-aisled, timber-roofed building was transformed into the present Greek-cross plan, surmounted by five masonry domes. The design is markedly Byzantine and it seems certain that Eastern architects and decorators worked with Italians to build the new church.

should perhaps warn us against supposing too readily that Byzantine art had already acquired its permanent character in the 7th century.

St Sophia was never copied nor even imitated on a smaller scale. When more churches were built in Constantinople, they were intended primarily to serve the spiritual needs of individuals and their families. Almost all were based on a central plan with a small dome over the center and compartments of varying sizes and shapes grouped around. Architecturally these were modest, but it would be a mistake to judge them solely on this because their architectural structures supported elaborate and often carefully thought out displays of imagery.

Christian art was organized and displayed in a variety of ways. Some of it took the form of scenes and episodes drawn from *The Bible* and *Lives of the Saints*; some of it was devotional and offered for veneration what were taken to be likenesses of sacred persons; some of it was designed to present the central doctrines of the Church. Inside a Byzantine church the first kind was usually expressed in the illustrations of service books; the second in the form of icons hung on a screen that divided the altar chamber from the rest of the church; and the third as large-scale decoration on the walls and vaults of the building. Image-making was not rigid not uniform, but neither was it capricious. The images were inspired by a strong sense of the hierarchy of the Trinity and the saints and with a spiritual importance that permeated from the dome to the smallest details. Ideally, when all of these elements were present, a Christian at prayer in his Byzantine church would be surrounded and his imagination fully absorbed by pictorial representations of his faith and the interpretation of the world that it entailed. In such a microcosm the size and shape of the

church played an important part: not only did it control the distribution and relationships of the individual items, but anything too large or long would defeat the overall effect.

The Byzantines devoted more energy to the visual presentation of their religious doctrines than anyone prior to the 15th century in Western Europe. The contrast between the developments of religious art in the West, on the one hand, and Byzantium on the other is both striking and instructive. To the German barbarians looking over the western provinces of the Roman Empire, finding uses for religious art lay at the heart of becoming civilized. In this way naive and untutored imaginations were gradually engaged with possibilities never before contemplated. This was a long, slow process in which the discovery of what the barbarian's elders and betters had done before them played a large part. Among these, the Byzantines were not the least important.

The authority of the Byzantine precedent was recognized in the West and many of their formulas filtered through both as iconographical themes and stylistic models. In the early days, when Byzantium was great and the West backward, this was to be expected. But the balance shifted. Between the battle of Manzikert in 1071, when the Byzantines suffered a disastrous defeat at the hands of the Turks, and 1204, when Constantinople was captured by Western Crusaders, the Empire contracted from a world power to a state of only local importance between Asia Minor and the Balkans. During the same period Western Europe launched a succession of offensives eastward and dabbled, even if without lasting success, in the affairs of the Middle East. Yet it was during these years of decline that Byzantium probably exercised its greatest influence on the arts of the

West. During the 12th century Byzantine faces and draperies turn up everywhere in art, from Spain and Sicily to Germany and England; and after the collapse of the Empire in 1204 the entire course of Italian art was deflected. Otherwise, the sacking of Constantinople by the Crusaders, which released a flood of relics into Western churches, had less effect than might be expected. The relics may have been Byzantine, but the churches receiving them were of a later period.

The outcome of this long encounter between the arts of Eastern and Western Christendom was as momentous as it was surprising. Despite its influence, Byzantine art did not capture the West; in fact it was firmly repudiated. When it came to making a choice, Western Europe decided that it was not really interested in what Byzantium had to offer because its own expectations of art had become somewhat different. Although pictures and statues no doubt helped Western Christians to brood upon the mysteries and doctrines of their faith, they increasingly focused their attention on historical details. Instead of asking what the images meant they asked what it would have been like to have been at the Nativity or the Crucifixion. The idea that one could become religious by dwelling upon events that were the objective framework of religion, if not exactly alien, was at least not central to the Byzantine temperament, and Byzantium could provide little guidance. It took some time for this distinction between the artistic aims of the East and the West to find expression in terms of a conscious preference, but when it did it became clear that what the West wanted was vivid realism and dramatic immediacy in its art; in other words, theatricality. For this the only artistic precedents available lay in the art of Classical antiquity, but it was not easy to untangle the formal quali-

ties of Classical art from its pagan subject matter.

Byzantine art was therefore not so much a model or goal for the West as a possible alternative; one that, although fascinating for a time, was eventually recognized as a distraction and passed over. Byzantine art served as a catalyst at a critical moment. The West was in the process of discarding its primitive preoccupations with ornament, pattern and expressive stylization and searching for a propaganda art of its own that would ensure the triumph of orthodoxy over heresy and encourage people to feel rather than think about their religion.

Although it was never to be again what it had been before 1204, the last two centuries of the Empire's history after its restoration in 1261 seem to have been dedicated to the illusion that nothing had changed. What is striking about the last flowering of Byzantine art in the 14th century is the effortless ease with which the conventions of the past were still used. Here, as in ancient Egypt, to conform with tradition meant not bondage but freedom to emulate the matchless excellence of the past.

Pala d'Oro, St Mark's, Venice, 10th to 14th centuries
Cloisonné enamel and precious stones

St Mark's houses the richest store of Byzantine enamel work done in the heyday of its importance, from the 9th to the 13th centuries, and of the numerous enamel works there the most resplendent is the altar screen known, from its glittering luminosity, as the Pala d'Oro. The screen has eighty-six cloisonné enamels, many of them depicting feast days in the Church calendar. Cloisonné, from the French cloison for "partition", means that the enamels are set in the metal outlines of the design. The screen was made for the Doge of Venice, Orseoli, in 976 by craftsmen of Constantinople. It was restored in the early 12th century and the mid-14th century. Some of the later additions were the work of Venetian craftsmen, but the art of Venice was then so deeply imbued with the Byzantine spirit that the screen retains its stylistic consistency.

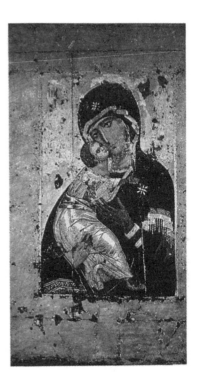

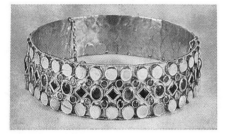

Crown of Theodelinda, *early 7th century*
Gold, pearls, sapphires and emeralds.
Circumference 27in (67cm), diameter 7½in
(19cm), height 2in (5cm)
Cathedral Treasury, Monza, Italy

Lombard rulers of this period did not wear
crowns but gave them as gifts, this example
having been given by Theodelinda to Monza
Cathedral. Inside the crown are three holes
used to house gold chains to suspend the
Crown in the Cathedral. It has remained at
Monza since its creation, apart from a short
time in Paris from 1798 to 1816 during
which all but one of the pearls which lined
the upper and lower rims were removed and
a number of artificial stones substituted.

Our Lady of Vladimir, *c.1125*
Icon painted on panel height 31in (78cm)
Tretyakov Gallery, Moscow

Although panel painting was done in the
Byzantine Empire from the 6th century,
especially in Egypt, not until the 12th
century (unless through accidents of history
earlier masterpieces have been lost) did it
achieve major importance. Perhaps, in the
wealthier days of the early Empire, panel
painting took second place to more
luxurious work in embossed metals, mosaics
and enamels. Certainly the new importance
of panel painting in the 12th century owed
nothing to fresh discoveries about painting
technique, for the method most frequently
used, tempera on a gesso ground rubbed
into canvas attached to a panel, was known
in Egypt in Greco-Roman times. Our Lady of
Vladimir, painted at Constantinople and
taken some time later to Moscow, is one of
the finest examples of the new Humanistic
tenderness with which religious painting
was beginning to be invested in the early
12th century, especially by artists working
in the capital.

Early Christian Society in the West

Along with the rise of Christianity, a fundamental factor that distinguished medieval Europe from Classical antiquity was the arrival of the barbarians. From the second century AD onward the movements of groups of peoples – some of them generated from as far away as central Asia – pressured the frontiers of the Roman Empire. These included the Ostrogoths and Visigoths beyond the Danube, who, with the Vandals, Burgundians and Lombards, made up the east Germanic groups. The west German tribes consisted of the Franks, Saxons and smaller groups. The Huns came from central Asia. Initially Roman defenses held, but they soon broke and were restored only with difficulty. Finally, in the west, they broke completely and Roman Imperial control of the western provinces was in effect, although not always in theory, relinquished to the newcomers.

In the folklore of later times the archetypal barbarian was Attila the Hun, who in 452 marched on Rome and threatened to sack it, thereby achieving a timeless notoriety celebrated in paintings and music. In fact, Attila was bought off by Pope Leo I, a service to the city that prompted the Romans to give Leo the title of "the Great". Other barbarians however, such as the Goths and the Vandals, did manage to occupy Rome, which was looted in 410 and again in 455. For these reasons the barbarians have become synonymous with wanton and mindless destruction.

However, to think of the barbarians as being only destructive would be unfair. The Huns were not typical and many other Germanic tribes had been long known to the Romans. These tribes were nomadic rather than settled farmers who continually required fresh pastures to support their livestock; they had trade links with the Roman army and their relationships with the Empire had been amicable for some time, even if Roman soldiers com-

plained of their antisocial habits, such as grooming their hair with rancid butter.

When the barbarians broke through Roman frontiers it was not to destroy the Empire but because they desired land on which to establish themselves in a settled, social order. They brought with them their own laws and customs, which mingled with those of the Romans. In due course all of the barbarians were converted to Christianity, although initially most made the mistake of remaining heretics, which kept them at a distance from their Christianized Roman subjects.

Some of the tribes that invaded the Empire were quite small: the eastern and western Goths, Burgundians and Vandals were so few in number that they displaced only the land-owning aristocracies of the provinces of Spain, Italy, southern France and north Africa. Being so few in number, they had comparatively little effect on the established lifestyle, and the transition from an ancient to a medieval world in such places was almost imperceptible. The Franks, however, who occupied what is now the Rhineland, Belgium and northern France, were numerous and their arrival largely displaced indigenous populations; the same was true of the Angles, Saxons and Jutes who swarmed over Britain. The long-term effects of these patterns of settlement led to an important cultural distinction between northern and southern Europe and left France a crucial zone where the two encountered one another with fruitful consequences.

By the end of the 5th century the first waves of barbarian invasions were exhausted except in Britain. Among the barbarian kingdoms, that of the Franks became the most powerful and this, together with the fact that the Franks had become good, orthodox Christians, gave them advantages over other barbarian settlements which had profound

effects on their subsequent history.

The nomadic lifestyle of the barbarian tribes meant that their possessions, and especially their treasures, had to be portable. Large-scale works of art had no place in their way of life and even when the tribes settled, their emphasis on small, portable treasure remained. The solution was found in finely wrought jewelry and the preferred art form of all the barbarian tribes was the work of the goldsmith. For these peoples gold and jewels were the ultimate symbols of worldly power, as seen in the crown given by Pope Gregory to the Lombard's queen Theodelinda. What could be more suitable for the adoration of the ultimate spiritual power than a potent combination of gold and gemstones? In this way the barbarian tribes introduced into European heritage a long-lasting and immensely fruitful passion for work in gold.

The barbarians arriving in the West brought with them a highly developed sense of ornament and pattern, and the skills needed to produce all manner of objects in which their tastes could be displayed. This appears to have been common among nomadic tribes from the earliest time. The patterns that they favored were almost entirely abstract designs of whorls and interlaced ribbons, which were ideally suited to beaten and filigree gold. Representations of humans were rare, but animals appeared often. Even these, however, are not easy to recognize, being incorporated into rigid, repetitive patterns.

Like the Egyptians and most early societies, the barbarians believed that they could take their treasures with them into the afterlife and in many barbarian cultures people were buried with the ornaments that had delighted them while alive. The marvelously intricate enamels of the Sutton Hoo treasure, for example, were part of the furnishings of a grave.

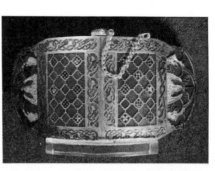

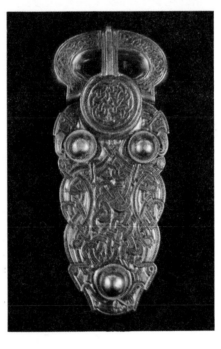

Sutton Hoo Ship Burial Treasure, *Suffolk, England, c.625–33*
British Museum, London

In the first half of the 7th century a pagan king of the Anglo-Saxons was buried with due honor at Sutton Hoo. His corpse and assorted treasures were placed within a 90-foot (27m) ship and the whole ship was buried beneath a mound of earth. It remained undiscovered until 1939 and now forms the richest collection of Anglo-Saxon metalwork. The Germanic roots of the Anglo-Saxons are clear in a love of abstract geometric ornament and interlacing animals, a taste perfectly in accord with the Celtic natives of England.

The influence of Rome

The eastern provinces survived the barbarian invasions better than those in the West and Constantinople developed rapidly as the alternative and, ultimately, the only capital city of the Empire. Rome went into decline and was for some time just one of many cities of the Empire. In the 5th and 6th centuries the bishops of Rome, conscious that their influence within the Empire was deteriorating, began to insist with increasing firmness on their special status as the heirs of St Peter. At the same time they began to turn their attention to the heretical barbarians established in the remaining western provinces, who were ripe for conversion. Pope Gregory the Great is said to have encountered some Anglo-Saxon slave boys in Rome and was struck by their blond hair and blue eyes. When he was told they were Anglo-Saxons, he replied "Not Angles, but angels" and promptly dispatched St Augustine to convert them to Catholic Christianity.

The missionary zeal of the popes was aided by a new phenomenon, the organization of Western medieval monasteries, begun by St Benedict in the early 6th century. From the start the Benedictine monastic movement had close links with the popes in Rome and its slow but sure spread across Europe meant also the growing influence of the papacy. Gradually the pretensions of the popes hardened into territorial ambition, with claims of representing the temporal and spiritual power of the Roman Emperor.

Nothing illustrates the hold that the idea of Rome exercised over the imaginations of the rulers of 6th century Europe better than their attempts to re-create the long-since defunct Roman Empire. The 18th century French philosopher Voltaire said that the Roman Empire was neither Roman nor an empire, and perhaps he was right.

Nevertheless, the idea was taken seriously at the time and the consequences were important.

The spread of Benedictine monastic, and thus papal, influence, however slow and tentative, meant the spread of Roman cultural influences into the lands settled by the barbarians. Links with the art of the Roman Empire had never been broken entirely and were strong in southern Europe, especially in Italy. The principal churches in Rome were still the great 4th- and 5th-century Roman basilicas. The large-scale figure sculpture and wall paintings of this period, although executed by the Lombards, attests to a continuing Roman tradition.

Roman artistic traditions gradually began to be prized in the north by settled, Christianized barbarians. The first dynasty of local Frankish kings, known as the Merovingians, built churches that, while not ambitious in scale, made use of marble columns and capitals that were clearly attempts to copy Roman prototypes, and much original Roman material was re-used. The magnificent Molsheim brooch is typical of Frankish goldsmith work, yet its central feature is a large, beautiful Roman cameo. Benedict Biscop, a 6th-century English abbot, imported Roman books, many of which were illustrated, for his monks to copy.

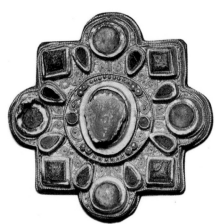

Molsheim Brooch, *early or mid-8th century*
Bronze, gold, gems and antique cameo
7¼ × 5¾in (18 × 11.8cm)
Hessisches Landesmuseum, Darmstadt

This brooch was the largest and latest of a group produced by Merovingian jewelers in the 7th and 8th centuries. All are constructed similarly with a thin sheet of gold laid over a bronze backing to which the pin was fixed. On to the gold sheet, gold filligree and real or artificial gems were attached. The Molsheim Brooch shows changes in form indicative of a late date, such as the very organized layout and the box-like settings holding the gems. Both features point to Byzantine influence, probably indirectly through northern Italy. The cameo in the center is an original Roman piece.

Book of Kells, *8th century*
The Chi-rho page from St Matthew's Gospel
Trinity College, Dublin

This manuscript was probably produced on the holy island of Iona, off the west coast of Scotland, and later found its way to the monastery of Kells in Ireland. It clearly shows the Celtic love of geometric ornament and interlacing. Within the decoration are small animals and heads to terminate the linear motifs. The source for some of the subjects depicted seems to have been an Eastern manuscript. However the figures were transformed into flat, decorative designs in keeping with a native taste for complex patterning.

The Irish Church

The Roman Church was not the first religious organization to reach the British Isles and when the Benedictines arrived in England they found the Irish Church already well established. The Church had been founded in the 5th century by St Patrick, who had spent some time in Provence at a monastery that had been founded by early Christian, or Coptic, monks from Egypt. The Irish Church therefore sprang from a type of Christianity with no direct links with Rome.

When St Patrick brought this tradition to Ireland, he brought it to a land that still had its own lively Celtic Iron Age traditions. Irish art shared its Iron Age origins with that of the invading barbarians and, not surprisingly, both had much in common: both used complex patterns rather than representation; both were interested in animal rather than human forms; both were ideally suited to, and had their roots in, goldsmiths' work. Like the Christianized barbarians, the Irish monks produced magnificent pieces of goldsmiths' work as church furnishings. They also used jewelers' designs and

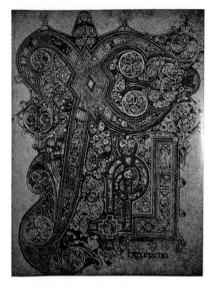

rich enameled colors for prayer book and Bible illumination.

The Irish monks had a missionary zeal equal to that of Gregory the Great, quickly establishing themselves in Scotland and northern England and founding and prestigious and artistically productive monastery at Lindisfarne in 635. Other missions penetrated into continental Europe as far as Switzerland and Italy. Wherever Irish monastic cells were established, their distinctive, decorative manuscript illumination flourished.

Because of its individual and independent nature, the Irish Church posed a serious threat to the Church of Rome's claims to be the sole representative of St Peter. There were also differences between the two churches: Irish monks were more reclusive than the Benedictines, the bishops of the Roman Church were more powerful than their Irish counterparts, and the two churches used different calendars. Benedictine monks established rival monasteries at Jarrow and Wearmouth to combat the Irish influence but at the Synod of Whitby (664) the Irish monks were forced to yield to the Church of Rome. During the power struggle Northumbria in northern England had been the main battleground and became something of an artistic melting pot, as seen in the Lindisfarne Gospels, that reveals the influence of Irish decorative design and representational Roman manuscripts.

Meanwhile, barbarian invasions were renewed spasmodically. Another tribe of Germans, the Lombards, arrived belatedly in Italy in 568, and the successes of the Mohammedans, or Saracens, brought the tribe across the full length of north Africa to Spain, almost all of which they occupied after 711. For a while it appeared that the Saracens would obtain total rule of Europe, but this was averted by the victory of Charles Martel, leader of the Franks and grandfather of Charlemagne, at Poitiers in 732. There followed a respite of a hundred years during which much of the West consolidated itself into the Frankensian Empire.

By the late 8th century the political situation in Western Europe was relatively stable: the Saracens had been turned back and the rapacious Lombards had calmed down; the Roman Church had overcome the opposition of the Irish Church and was now ready to turn its attention to the last of the pagan Germans. The popes, while powerful, were not always able to defend themselves and had to look for protection. In the 8th century the threat of Lombard domination drove the pope to seek the armed intervention of

Pippin, son of Charles Martel and King of the Franks. Pippin's reward was the transfer of the royal title from the Merovingian dynasty to himself and his family, subsequently known as the Carolingians. Thus began the momentous association between the Frankish kings, their actual and spiritual descendents, and the papacy to create the curious concept known as the Holy Roman Empire. It was Pippin's son Charles, better known in history and legend as Charlemagne, who was to reap the political and cultural harvest of this special relationship.

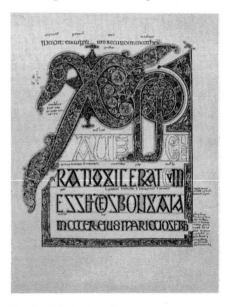

The Lindisfarne Gospels, *Detail of St Matthew's Gospel, 7th century Tempera on vellum 15 × 12in (38 × 30cm) British Library, London*

The monastery of Lindisfarne was founded in 635 at Holy Island off the Northumberland coast of England. Its most revered member was St Cuthbert, who ultimately retired to a hermitage in nearby Farne Island. His relics were returned to Lindisfarne in 698, eleven years after his death. It was in the period between these two events that the manuscript of the Gospels was written and illuminated by Eadfrith, a member of the community who became Bishop of Lindisfarne in 698.

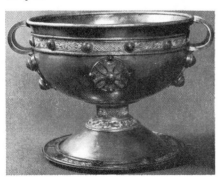

Ardagh Chalice, *8th century Bronze, silver, brass, gold filligree and enamel Height 7in (17.5cm) National Museum of Ireland, Dublin*

In 1868 this chalice and four brooches were uncovered in a field. It was a particularly important find because this is the only surviving, complete Irish chalice of this period. The widely and carefully distributed decorative elements point to an 8th century date. Irish metalwork of the 7th century differs in that it was used as decoration to try to cover every part of a surface, whereas much of the bronze surface is left bare on the Ardagh Chalice.

The Carolingian Renaissance

Charlemagne was a natural leader and is described as being unusually tall and commanding. He first made his mark with successful campaigns eastward and southward against the Saxons and the Lombards, by which he more or less united all of the continental Germans. Even Charlemagne's occasional military failures captured contemporary and subsequent imaginations. His renown spread widely and he received embassies and gifts from the Emperor in Constantinople and from Saracen kings. Such was Charlemagne's prestige and military might that he was crowned Emperor by Pope Leo III in Rome on Christmas Day, 800.

Charlemagne's early interests seem to have been – perhaps had to be – military. Yet as he grew older he seems to have developed a deep personal interest in the arts and learning, giving rise to what is known as the Carolingian Renaissance. Among the important innovations of Charlemagne's court was the invention of a neat, clear style of writing – used in preference to the nearly illegible Merovingian cursive – on which modern print forms are based. He attracted scholars from far afield to his court, such as Einhard, who rewarded Charlemagne's patronage with a biography, the first since Classical times. The motives for Charlemagne's generosity were not, however, entirely selfless: as a result of his conquests his empire was extraordinarily large and a new, more efficient and scholarly administration was required to govern it.

Charlemagne took his position as Roman Emperor seriously and one important aspect for him was the renewal of interrupted Roman cultural traditions. The design of his new coinage, for example, was based on Roman examples. Yet Charlemagne drew little distinction between Rome and Constantinople: his octagonal palace chapel at Aachen was partly Roman and undertaken to rival the pope's palace in Rome but also to invoke some of the splendor of the imperial palace at Constantinople.

Magnificent manuscripts produced in Charlemagne's royal scriptorium were produced to be enjoyed almost as "coffee table" books are today and were often illustrated in a way that reveals the use of Classical manuscripts as models. The style of some of the paintings suggests that Charlemagne employed Italian, and perhaps even

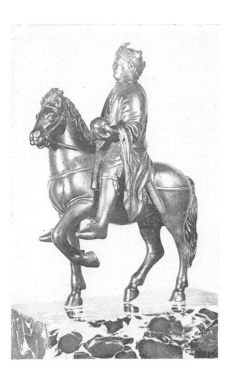

Equestrian Bronze of Charlemagne or Charles the Bold, *figure, 9th century; horse 16th century*
Bronze, height 9½in (23.8cm)
Louvre, Paris

This bronze was cast in the round in two pieces, a technically complex process that had been little practiced since the fall of the Roman Empire. Being so small however, it hardly ranks alongside the Roman equestrian bronzes, such as Marcus Aurelius. The model on which this bronze was based was probably an equestrian bronze of Theodoric the Ostrogoth (493–526), itself derived from Roman prototypes.

Palatine Chapel, *Aachen, Germany 792–805*
Stone and marble

The Palatine Chapel at Aachen is the most significant surviving monument of Carolingian architecture. It was designed by Odo of Metz for the Emperor Charlemagne. The chapel has always held the rank of cathedral; it was dedicated to the honor of the Virgin Mary in 805 by Pope Leo III. The octagonal plan of the chapel resembles that

of San Vitale at Ravenna. The central floor space was designed for public assembly and the chapel was connected at gallery level to the adjoining palace of Charlemagne, built at the same time but with a basilican rather than central plan. The chapel is still standing although alterations were made during two periods of restoration in 983 and 1881, giving the building Romanesque and Classical features. A sanctuary opposite the main entrance and two flanking chapels on a basilican plan were replaced by a Gothic chapel.

Plan for the Monastery of St Gall, c.820
Drawing on vellum
Stiftsbibliothek, St Gallen, Switzerland

The St Gall plan, presented to the Abbot of the Benedictine monastery of St Gall in about 820, shows a carefully thought out ideal for the complete rebuilding of the monastery complex. Monastic life centered on the church and this was the focus of the plan, with monastery buildings closely grouped around it to the south and east and having private access. A school, library, infirmary and cemetery were attached to the monastery; and spreading from these provision was also made for service areas, guest rooms, a farm and stables, all possibly walled off from the monastery's view. The church was planned with a cruciform layout, the long basilican nave having two apses at east and west, dedicated, respectively, to St Paul and St Peter. Lay members of the community, while not excluded from the church, had a separate entrance from the west end. When rebuilding began in 1830 the ideal plan was not followed precisely; modifications increased the number of altars to accommodate an expanding monastic population and the separation of laity and clergy was implied by the structural changes.

Gatehouse to the Monastery, *Lorsch,*
Germany c.800
Stone

This freestanding, three-arched gateway formed the entrance to the courtyard fronting the monastery church at Lorsch. It is reminiscent of a triumphal arch of classical style, but the basic plan possibly originates from the design of Old St Peter's Church at Rome. The arcade of pilasters at the upper level and Corinthian capitals of the lower half columns show the classical influence, while the ornamental stonework follows the traditions of early European masonry.

Byzantine, manuscript painters in his attempt to establish a true Classical style. For the first time Classical secular writings were copied and illustrated: Einhard's biography of Charlemagne, for example, was based on the Roman writer Seutonius's *Lives of the Twelve Caesars.*

The stable economic and political conditions created by Charlemagne were of great benefit to the Church, which flourished in the north as never before. Consequently monasteries became more substantial with large stone churches and other communal buildings grouped around a cloister, the standard monastic plan for the rest of the Middle Ages. Many features of the Carolingian church were inherited from early Christian basilicas. This unaccustomed scale of building must have caused many new problems and it was perhaps for this reason that the Abbot of Reichenau sent a plan of an ideal monastery to the Abbot of St Gall. This is the earliest surviving drawing of an architectural design and a document of incalculable importance; it is not, however, easy to interpret. A good idea of what these new monasteries looked like can be gained from the 17th-century engraving, based on an 11th-century drawing, of the long-since destroyed buildings of St Riquier.

An important new development in

architecture was the incorporation of towers as a main feature of the principal building. In early Christian buildings towers, when they appeared, were usually separate from the church. The origin of the use of towers is unclear, but they were a feature of churches of the eastern Roman Empire and the idea may have come from there. At all events, they introduced an important and recurring feature into European church architecture and the tradition lingered in Italy as the *campaniles*, or bell-towers, of Florence and Pisa Cathedrals suggest.

Charlemagne's empire was held together by the energy and personality of its founder. Under his successors it was divided into three separate parts: west and east Francia – which eventually became France and Germany – and Italy. After Charlemagne's death the French Carolingian dynasty degenerated with astonishing speed and consequently no art was forthcoming from the king or court. The political confusion remained until the late 12th century. In 987, when the by then impotent Carolingian line finally failed, Hugh Capet was elected king, founding the Capetian dynasty. The Capetian kings developed their power within their kingdom slowly but steadily, gradually insisting on their legal power over the great barons, the dukes of Normandy and the counts of Flanders, Blois and Champagne.

Unlike the Empire, the divisions proved remarkably durable and by degrees acquired the distinguishing characteristics of separate nations. Charlemagne's descendants, however, fought among themselves and proved unequal to the task of defending their heritage. Most importantly, the Carolingian rulers failed to protect their people from new threats to European society: the Magyars from the east and, more especially, the Vikings from the north.

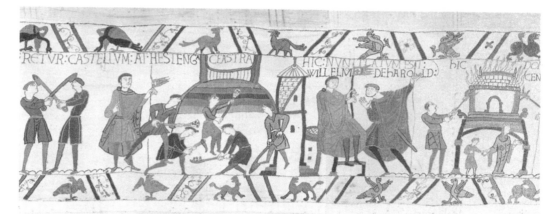

The Oseberg Ship Prow, *8th–9th century*
Carved oak
Viking Ships Museum, Oslo

In 1904 a large grave was found on the west coast of Oslo Fjord. The burial mound was 20ft (6.5m) high and 130ft (40m) long and covered a wooden ship 66ft (21.4m) long, equipped with mast and sail and space for thirty oarsmen. In a central chamber lay the body of a woman, thought to be a Viking queen, and another presumed to be that of a female servant. The chamber was richly decorated with tapestries and contained a number of items and utensils considered necessary for the transition to an afterlife. Also in the ship's prow were the skeletons of fourteen horses, three dogs and an ox, as well as a four-wheeled cart, four sledges, three beds, two tents and a chair. All the wooden objects were elaborately carved, including the prow and stern of the ship itself. There is some continuity of style in the carvings but they are thought to have been the work of several master craftsmen.

The Vikings

The Magyars and Vikings were new waves of nomadic barbarians. The Vikings were different from their predecessors in that their mobility was dependent upon ships rather than horses, and their exceptional navigational powers and ship-building techniques were sufficient to take Leif Ericson to the shores of America. Naturally their raids affected coastal areas and major river valleys; eastern England, the coast of France and the broad and fertile river valleys of the Seine and the Loire were subject to continual raids and monasteries established in the north and west of France were forced to migrate to safer areas.

Similar to the barbarian hordes who had appeared in the past, the Viking's art forms were ornamental, depicted animal images and were portable. Their dependency on and their respect for their ships is reflected in their custom of being buried in boats that were often carved with splendid and fearsome dragon-prowed decorations.

The Norsemen (northmen and Vikings) to some extent settled in Normandy, to which they gave their name, and northern England. Their settlements seem to have been even thinner than those of their barbarian forces. Even in England, where under Canute they married into and finally usurped the ruling Saxon dynasty, their artistic influence was not great, although there were complaints at the court of Edward the Confessor of Saxons sporting Viking hairstyles. In Normandy, Viking influence was not apparent, and they rapidly became more French than the Franks, although William the Conqueror's ships, as they appear in the Bayeux Tapestry with their dragon-headed prows and square sails, are certainly Viking in design.

The Bayeux Tapestry, *c.1067–70*
Details showing William's men constructing a fortress and reporting Harold's advance.
Wool on linen 230ft × 20in (69m × 50cm)
Bayeux, France

The Bayeux Tapestry is a long wall hanging and, in fact, is embroidered. (With tapestry the design is woven with the fabric whereas embroidery is stitched to the surface, as in this case.) It shows the events leading up to the Norman Conquest of Britain and the decisive Battle of Hastings in 1066. It was popularly believed for many years that the Bayeux Tapestry was the work of Matilda, wife of William the Conqueror, but its real origin was probably a commission from Bishop Odo of Bayeux, who was given charge of the English district of Kent in 1067. First official mention of the tapestry was made in the inventory of Bayeux Cathedral in 1476 and it was displayed annually in the Cathedral to celebrate certain holidays. The form of inscriptions on the Tapestry suggest that it was of English craftsmanship, possibly designed and made in the workshops of Canterbury, where old English traditions survived into the Norman period. It was a vast undertaking, probably divided between several groups of craftsmen. There are eight joined sections of embroidered linen and it is thought that two scenes, or perhaps one entire section, are missing from the end. The embroidery is in a form known as couch stitch with stem stitch details using only eight colors. There was no attempt to fill in the background and the figures stand out clearly against the plain linen base. The Tapestry contains over six hundred human figures and even more animal forms, as well as ships and buildings.

France, with an extended coastline and easily navigable rivers, suffered severely from Viking invasions. Central authority broke down almost entirely and the 10th-century French rulers were too poor to be effective artistic patrons. The cultural lead therefore passed to those courts still able to draw on considerable financial resources: the Anglo-Saxons in England and, in Germany, the Ottonians.

The Ottonians

The Ottonian dynasty came from Saxony and owed its name to its second ruler, Otto the Great. While Magyars and Normans were a constant threat to the Ottonians, they were in general able to put up an impressive and usually effective resistance, culminating in the defeat of the Magyars in 955. The greatest danger to the Ottonians came from within their own empire because the great German dukes – descendants of Charlemagne's hereditary officials – saw no reason to accept one of their own as having dominion over them. While internal rebellion was therefore endemic, the Ottonians were sufficiently secure in their rich base in Saxony – owing to the sound policies of Henry I, the founder of the dynasty – to remain in control in Germany and under three successive Ottos to extend their activity to Italy. All three Ottos found various pretexts to involve themselves in Italy; all three were crowned Emperor by the pope in Rome; and all three consciously emulated Charlemagne and his patronage of the arts.

In Ottonian art there is a complete absence of the copying of secular manuscripts that had distinguished the earlier Carolingian Renaissance. The substantial volume of Carolingian church building, however, continued, reaching a new scale in the cathedrals of the Rhineland. These were filled with shrines, altar canopies and crosses of glorious workmanship. There was also an immense output of high-quality manuscript illumination, often bound in covers with ivory and jewels.

Ottonian art was almost entirely religious which perhaps reflects the fact that the Ottonian emperors had to a large extent based their political power on the support of the Church and believed themselves to be, like the emperors of Constantinople, its heads. From its beginnings the German church was organized on missionary lines, and at the time of the Ottonians was attempting to convert Slavs, Magyars and Danes to Christianity. As a result its bishoprics were immense and its bishops correspondingly rich and powerful. All of the Ottonian rulers found it expedient to build the secular power of the bishoprics and the great monasteries at the expense of the dukes. They also ensured that the major ecclesiastical appointments went to men who would be loyal to them, often their relations. Bishops and abbots were also often important patrons of the arts. Bernward, Bishop of Hildesheim, as well as being tutor to Otto III, was the perfect ecclesiastical patron. The abbey of St Michael, which he founded, was embellished with bronze doors and candlesticks, conjuring the impression of a renaissance in church decoration.

Yet the Ottonians looked less to Classical Rome than to contemporary Byzantium. Trade with the eastern Empire was frequent, Otto II married a Byzantine princess, and Byzantine works, such as ivories and enamels, were set by Ottonian goldsmiths. The combination of Byzantine stylistic influence and the new religious seriousness encouraged designs that were stiff and formal and almost the opposite of the naturalism and illusionism of Carolingian art. It was this aspect of Ottonian art that looked forward to the next period in art, the Romanesque.

Ivory of Otto II and Theophanu
Musée de Cluny, Paris

The date of this ivory is fixed by the inscription in the top left corner: "Otto Imperator Romanorum Augustus". Otto II (973–83) only used the title of "Imperator Romanorum" after 982. The ivory shows the imperial ambitions of the Ottonians and its style points to an increasing importance of Byzantine art at the Ottonian court. It was probably carved by a Greek trained in the Byzantine style. The ivory was perhaps the first Byzantine carving to be mounted on a northern European book cover.

Ottonian Imperial Crown, *961–2*
Schatzkammer, Vienna

The crown was made by the papacy, rather than the emperor, probably for the coronation of Otto I (the Great) in Rome in 962. Its style is Italian with Byzantine influences, especially in the use of enamels, a particularly Byzantine feature. The use of green, translucent enamel decorated with gold, however, shows a continuing Carolingian style never used by Byzantine enamelers. The cross on the front of the crown is a later addition. Spanning the crown is an arch with an inscription in pearls which probably post-dates Conrad II's coronation in 1027.

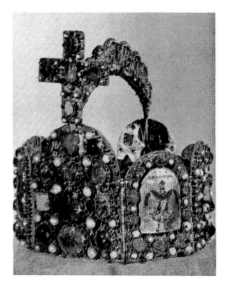

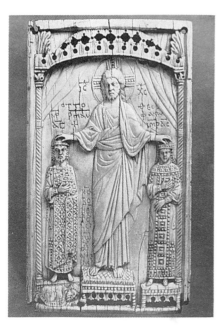

Hildesheim Cathedral, *doors, Germany, detail of Adam and Eve with the serpent c.1015*
Bronze, height 16ft (5m)

Each wing of the doors has eight scenes, those on the right from Genesis and those on the left from the New Testament. The doors represent a major technological revival: each wing was cast in one piece, the largest bronze casting since the collapse of the Roman Empire. (Bronze doors existed in the Byzantine Empire but were cast in small sections and attached to a wooden backing.) The idea of covering doors with Biblical scenes is probably derived from early Christian wooden doors in Italy. The doors were made for Bishop Bernward whose awareness of Classical forms is shown by the bronze column (1015–22) cast in emulation of Roman types, such as Trajan's and Marcus Aurelius's columns.

England

During the 9th century in England Viking raids occupied the northern and eastern parts of the kingdom. In the 10th century the Anglo-Saxon royal house – King Alfred and his successors – fought back and successfully incorporated the Vikings into the Anglo-Saxon kingdom. Their prestige was very high; they intermarried with the Ottonians in Germany and enjoyed the most efficient tax system in Europe. They gave generously to the Church and especially to the monasteries, which in the late 10th century were reformed and sometimes even refounded. The range of royal patronage was, however, much more limited than

Earls Barton, *Northamptonshire, England, tower 11th century*

This late Saxon tower shows clearly the poor state of Anglo-Saxon architecture before the Norman invasion. Buildings were conceived as boxes to which painted and sculptural decoration may have been applied internally and stone ornament externally. The stone pattern on the tower bears little relationship to the haphazard architectural features, and decorative elements, apart from the columns in the bottom and top stories, are wholly undeveloped strips of masonry.

that of the Ottonians. Architecture hardly got off the ground and the few buildings that remain consist of small boxes strung incoherently together, such as at Deerhurst, are reminiscent of the small churches of the early days of the Christian mission in England. While the impression may be misleading, symptoms of a new interest in architecture were eventually forthcoming.

The remains of the rotunda at St Augustine's Abbey, Canterbury, which was started just before the Norman Conquest (1066), suggest building on an ambitious scale and design. The idea of the Abbey came from Europe and when Edward the Confessor wanted to build a new abbey at West-

Deerhurst Priory, *Gloucestershire late 10th century or first half of 11th century*

Oswald, Bishop of Worcester (962–92) probably founded Deerhurst Priory as a consequence of the mid-10th century monastic revival in England. While Anglo-Saxon England can claim a fine production of manuscripts and minor arts objects, the same cannot be said of its buildings. Painted decoration probably covered the huge areas of bare wall and plain arches that were prevalent in Anglo-Saxon buildings and perhaps the architecture was seen only as a surface to carry paintings.

Utrecht Psalter, *816–35*
Brown bistre on parchment
University Library, Utrecht

The Utrecht Psalter was probably produced at Rheims. From the monumental treatment of the figures and architectural settings, it is clear thet Classical prototypes were known at the time. The drawing style resembles contemporary works of the palace school at Aachen and the Rheims scriptorium. The ultimate source, however, is a sketchy technique derived from late antique painting. The Psalter's composition is novel in that only occasionally are frames provided for the miniatures, otherwise they are left to mix with the three columns of text. By about 1000 the Psalter was in Canterbury where it was copied, which was in turn reproduced in the mid-12th century. Another version was produced in Paris in about 1200, showing the longevity of interest in this manuscript.

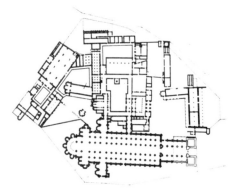

minster he looked to Normandy for its architectural design. Manuscript painting, on the other hand, was an Anglo-Saxon speciality. The style of the Benedictional of St Ethelwold, for example, although derived from Carolingian models, has a fluidity all its own. A Carolingian manuscript

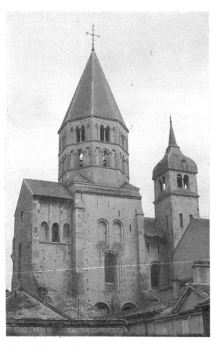

Cluny III, *south transept exterior and plan*
1095–1100

Hugh of Semur, Abbot of Cluny, initiated the construction of the giant third church at Cluny, but only the south transept survives. The church was intended as the symbolic and administrative center of the Cluniac Order and this explains why it was one of the largest churches ever built. The use of double aisles was probably inspired by Roman Imperial models, particularly Old St Peter's in Rome, as was the use of aisles of different heights. Details, such as fluted pilasters, Corinthian-like capitals and marble columns further point to Classical influences. These are blended with other influences, particularly contemporary Burgundian architecture and details that may have originated in Spain. A smaller version of Cluny III survives at Paray-Le-Monial, France.

known as the Utrecht Psalter, with its delicate, sensitive illustrations, was copied several times before the end of the 12th century and seems to have been responsible for establishing in England a long-lasting taste for expressive line drawing.

Whereas most of Charlemagne's artistic endeavors were directed toward providing himself with a fit imperial environment – his most important ecclesiastical commissions were for his palace chapel – the works produced under Ottonian and Anglo-Saxon patronage were intended to be used in church. In both cases, however, the art conformed to the expectations of the patrons. The great bishops and abbots were prominent members of the aristocracy, usually closely connected with the royal house, and therefore patronage was essentially aristocratic. The Church accepted what everyone who mattered liked; it did not put forward its own organized views about art and had no views of its own. But already the spirit of dissatisfaction was becoming apparent. Christians wondered why their prayers were not always effective and some suspected that it was because monks and clergy were not as pure as they were meant to be, and steps were taken to set this right. The abbey of Cluny was founded in 910 and later in the 10th century the first waves of reform reached England with Dunstan and Ethelwold. In Germany the reformers at first found sympathy in high places and with the support of the imperial family their influence spread from the monasteries to the Church. This coincided with what is known as the millenium in the year 1000, which some feared to be the Apocalypse. The passage of this momentous date may have brought relief and renewed confidence to the superstitious, but whatever its significance, the millenium marked a new phase in European history.

Medieval Societies in the West

The foundations for a new age were laid when the energies that had been used to counteract the barbarian invasions were released for more productive ends. The turbulence of the political and ecclesiastical affairs of the period that fill our history books has perhaps obscured the slow but steady progress in economic development that sustained this extraordinary output of energy. This was an heroic age; its quarrels between Empire and papacy and between the powerful families are epic; its religious aspirations, expressed in the Crusades and the reform of the Church, enormous. The great figures – William the Conqueror, Henry II, Abbot Suger, El Cid and Eleanor of Aquitaine – all possessed an energy and determination not found in their descendants, and this same energy and determination infused the arts.

Western society in the 11th century

When the barbarian invasions ended, the inhabitants of medieval Europe who had sought refuge in higher lands away from the river valleys began to descend to the more fertile coastal and river regions. While agriculture prospered, the population increased and with more mouths to feed the pressure to produce more food grew accordingly. The villages that had been abandoned during the invasions were resettled and new villages were founded in previously unpopulated areas. The population continued to increase and by the mid-11th century Europe was well into an economic inflation spiral which quickened appreciably in the 12th century and was carried over into the 13th.

The slow reconquest of lands from the barbarians was not fully achieved until the 15th century. During that time the reconquest provided ample opportunity for bands of French and Norman knights to gain fame and fortune, rival monarchs to extend their territories and the Church to extend its domain.

While the Church had always been well endowed, the control of its property had remained largely in the hands of the great families and it now began to reconsider these claims. According to the Church, if the world really existed as described by Christian doctrine then it was by far the most important of its institutions and should therefore have precedence over all secular powers. At the very least this meant that the Church should have control of its own wealth, and it was this new way of thinking that contained the seeds of wider conflicts.

The process through which this issue unfolded was devious and complex, and the early stages were bound up with the reform of the monasteries. While the idea that monks were the elite of Christendom died hard, the conviction emerged eventually that the salvation of the soul offered by the Church was not just for the few but for all baptized Christians. In doctrine this was expressed in the idea that redemption was available to all but the worst of sinners; in practice it meant a greater responsibility of the Church to its laity. Consequently, not only a more professional approach to religion was required but, for those who joined the Church, vocational alternatives to the monastery. In this way the Church became a vast, unified organization. At its head was the pope in Rome with provincial offices in every bishopric throughout Western Europe, and eventually the papal influence extended to every parish in every diocese. The Church was therefore a veritable empire and to many it seemed that the popes, not the German emperors, were the real heirs of the Caesars.

Papal claims to spiritual and secular dominance took advantage of the persistent demand of Christian society in the 11th and 12th centuries for improved and reformed religious life. This was first expressed in the foundation of new monasteries, and soon gathered impetus and adherents. The monastery at Cluny received substantial gifts from Alfonso VI of Castile and in return threw its weight behind the Spanish reconquest of Moorish Spain. Even William the Conqueror, not noted for his piety, promoted reform. William, however also knew of the advantages of having the Church on his side and when he invaded England in 1066 it was with the unlikely alliance of Pope Gregory VII, gained through William's promise to reform the Anglo-Saxon Church.

The impact of the reformed monasteries on the art and architecture of the period was immense. The Cluniacs, for example, liked large churches for their elaborate services and were responsible for the building and equipping of a vast number of these. In its size and design the great church at Cluny reflects its special relationship with the papacy to which it was subject, and was too large for any of its daughter houses to copy. Cluny was undoubtedly the most spectacular of the early reformed monasteries, but by the end of the 11th century attitudes had changed. Monks were expected to be either useful or ascetic, and Cluny represented neither. Therefore, those who answered the call joined either the already established orders that went out into the world and ministered to the laity, or the new orders whose austerities were often prodigious, such as the Cistercians who developed their own unique building style.

The Crusades

If at the beginning of the 11th century the continent had covered itself with what the monk Raoul Glaber called "a white robe of churches", by its end hordes of Christian knights were riding off in all directions against the infidel. The Crusades, a spectacular manifestation of papal power, were launched by

Urban II in 1096 and attracted members from Flanders, Normandy, Spain and France. The intention of the Crusades – to free the Holy Land from the Muslim infidel – was heroic, sincere and had the support of some of the most deeply religious men of the day.

In his attempt to gain support for the Crusades, Urban II dedicated not only finished churches but churches for which foundations were not yet laid, leaving art historians with the misleading impression that 1096 was an uncommonly good year for church building. Papal dedication, however, acted only as a spur to the already flourishing spate of church building.

The impact of the Crusades on the art of the West was less than might be expected. While the Crusades brought Westerners into close contact with the Byzantine and Muslim world, the art there already had too much vitality to require new blood. Nevertheless the Crusaders brought their own styles and preferences of art with them and there exists sculpture in the Holy Land that is stylistically similar to contemporary work done in France. Through the Crusades horizons were broadened and themes introduced that appealed to the Western imagination. The circular church of the Holy Sepulchre at Constantinople, for example, inspired a host of Western imitations, those of the military order of the Knights Templar in particular. It is possible that the domed churches of western France owe something to the influence of Byzantine domed churches. The influence worked the other way as well and in Spain the presence of the Saracens in contact with Western monastic artistic tradition made a strong impression on artistic production. Ribbed domes, such as those at Salamanca and Torres del Rio, owe much to Moorish design. Similarly, the finesse with which birds and beasts are carved on the cloister capitals at Silos reflect that the

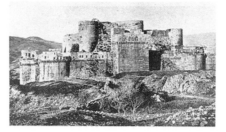

Kraak des Chevaliers, *Syria, 12th century*

Originally an Arab castle, the Kraak des Chevaliers was founded in 1031 and briefly occupied in 1099 by Raymond de St Gilles before Tancred of Antioch finally captured it in 1109. In 1112 it passed to the Counts of Tripoli and in 1142 Count Raymond II gave it to the Knights Hospitallers as a base for the protection of pilgrims and to attack the Arabs. The extraordinary site, in desolate barren landscape, which helped to protect its inhabitants shows how much the Crusader castles were sanctuaries for the pilgrims to the Holy Land. In 1271 it was captured by Sultan Baibars and was partly rebuilt starting in 1285.

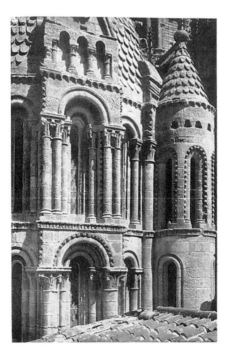

Salamanca Old Cathedral, *Spain c.1152–1200*

Due to the construction of a new Salamanca Cathedral in the 16th century, the old one has survived almost untouched. Although heavy in appearance and having small windows, the use of pointed arches and rib vaults formed the basis of the lighter, more elegant style of the 13th century. The inclusion of a lantern with a dome over the crossing in 1180 may have derived from Jerusalem, however the use of ribs points to a source in Islamic Spain.

Moors remained experts in carving marble, a skill that the barbarians lacked and that their descendents took a long time to learn.

Pilgrimage

Those whose tastes were devotional but not martial went on pilgrimages rather than the Crusades. While pilgrimages to the shrines and relics of saints, Apostles and Christ were not an invention of the 11th and 12th centuries – they were already known in early Christian Rome – they became popular during this period as never before.

There appear to have been three main pilgrimage sites – Rome, the Holy Land and Santiago de Compostela – yet most of the major abbeys and cathedrals possessed some crowd-attracting relics. The increase in population and an almost universal atmosphere of religious hysteria caused the crowds of pilgrims to become larger. Because pilgrims could be an important source of revenue, it was therefore worth some trouble for the Church to display its relics effectively. To help solve these problems around the end of the 10th and beginning of the 11th centuries churches were designed with ambulatories with radiating chapels to allow more pilgrims to see the relics. The idea seems to have originated in central France but was not confined to pilgrimage churches. The development of the aisled and double-doored tran-

sept also allowed large numbers of pilgrims access to the shrines without disrupting the continual daily services.

On occasion vast programs of painting were spread across walls and vaults to the same end. In all this the intention was clearly to instruct the ignorant and perhaps to overwhelm their sense of pattern. The production of illuminated manuscripts and carved ivory book covers of course did not cease; but here two traditional styles were affected by the new taste for the heroic and monumental. If the Church provided the ideals which inspired the energies of society, it saw itself, and presented itself, in the forms of art in terms of the prevailing mood.

Feudalism

The Church and the increasing strength of the kings and princes imposed a growing political cohesion on 11th- and 12th-century Europe, yet there were other strong forces at work in society. This was the age of feudalism, a system in which land was held in return for military service. There were lords and there were vassals. The obligations of the latter were legally defined, but the lords were not without their responsibilities in return. If a vassal was not treated justly by his lord, he had the right to disengage his loyalty and attempt to persuade his lord of the errors of his ways, often through the use of arms. Thus the entire feudal system was ripe for abuse. But when the system worked well, it gave cohesion to society, especially at a local level.

The steady development of primogeniture, by which the eldest son of the lord was heir to the entire estate, exacerbated the problem. Previously it had been the custom to divide the inheritance between all of the sons; thus had Charlemagne divided and fatally weakened his Empire. Henry I of England, on the other hand, felt

justified in fighting for both parts of his father's domain – England and Normandy – and consigned his unlucky brother to perpetual imprisonment once he had wrested Normandy from his grasp. The problem was eased by the fact that some landless younger sons could be persuaded to join the Church, the Crusades or other overseas enterprises.

The lord and his castle

The focal points of the feudal system were the castles. In many cases, particularly in the 11th century, it was an impermanent affair built of wooden stakes on top of an earthen mound. This type of castle could be built very quickly; the Bayeux Tapestry shows William the Conqueror's men building a castle immediately after landing on English soil. However, such castles could also be destroyed very quickly, and as the 11th century wore on more and more castles were rebuilt of stone in a simple design. Initially men de-

pended on the sheer strength of their castle walls for defense, but the development of seige technology in the 12th century resulted in even the most solid walls being felled. Gradually, castle design became more subtle. The main objective was no longer one of solidity, but the incorporation of sight lines that allowed the inhabitants to see enemy engineers at work.

Château Gaillard, *Les Andelys, France, 1197–8*

Richard I ordered the construction of this castle against Philip Augustus and to defend Normandy from attack along the Seine. His Crusading experience undoubtedly influenced the design which is based on Kraak des Chevaliers. The Château sits high on the north bank of the Seine on land acquired from the Archbishop of Rouen. It was built in a year, laying to rest the belief that medieval construction lasted decades or even centuries. Philip Augustus laid siege to the Chateau from September 1203 until it surrendered in March 1204 after an abortive attempt by King John to relieve it.

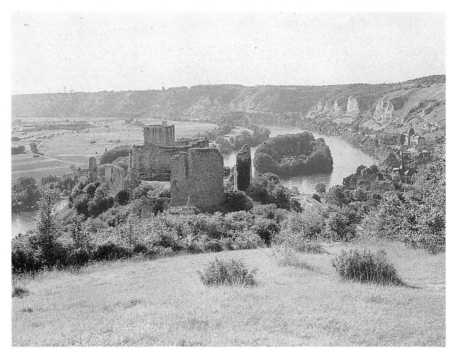

The castle was the center from which the lord administered his lands and became increasingly the symbol of lordship. It provided accommodation for officials who administered the estates; it was a hall of justice, a weatherproof storehouse for grain and a stronghold for treasures and money. The castle was also where the lord gathered his court and family about him to be entertained. In southern Europe short poems developed as a popular form, which in the later 12th century became the troubadour song. Their subject matter was sometimes derived from the legends of King Arthur or Charlemagne, but more often they celebrated a passionate but unconsummated love for a lady. In the north, and particularly in Normandy, the narration of recent history developed. A delight in narrative recitation was part of the heritage of the Viking saga and appears in visual form in the Bayeux Tapestry. The tradition of monastic chronicles gave a sense of permanence, and in the late 11th and 12th centuries an incredible industry of histories emerged. Biographies of contemporaries began to flourish as well as autobiographies.

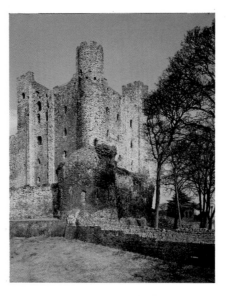

Rochester Castle, *Kent, 1123–32*

Castles not only reflect developments in ecclesiastical architecture, but show even more clearly the evolution of medieval warfare. When a siege occurred at Rochester Castle in 1215 it was clear that it could not be successfully defended: the square corner towers were prone to collapse when a tunnel was dug beneath. After one of the towers fell a replacement was built on a circular plan because this form was more difficult to undermine and was less vulnerable to destruction by catapulted stones.

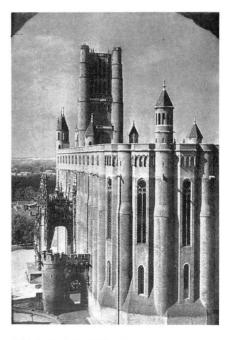

Albi Cathedral, *1282–14th century*

When Bishop Bernard de Castanet laid the first stone of this Cathedral on August 15 1282, the last of the southern French heresies had been destroyed but not entirely silenced, explaining the grand nature of the building and its fortress-like appearance. The internal layout follows the local style of a single large space, flanked by smaller spaces between aisles divided into single bays and areas between internal buttresses. The narrow windows recall slit windows in castles while the rounded buttresses are suggestive of corner towers. This fortress-like appearance is further indicated by the setting of the lowest windows high above the ground.

Exterior Walls of Aigues Mortes, *after 1272 Provence, France*

The town of Aigues Mortes, still in a remarkable state of preservation, is a fine example of one of a number of medieval new towns built with a defensible surrounding wall. Externally, it looks like a large castle.

Romanesque art

The term used by art historians to denote the styles of this period is "Romanesque". It is not easy to define, and other historians do not use it, preferring instead to stress the new economic, political and ecclesiastical circumstances which became evident during the middle years of the 11th century and which took anything up to two hundred years to work themselves out. But developments in art did not correspond exactly to other aspects of medieval life. "Romanesque" means roughly Roman-like, Roman with a difference, or even sub-Roman. It stresses the importance of the Roman contribution to this episode in medieval art, which was real enough. Rome could supply models of monumentality – grand buildings and figures engaged in dramatic action – but it would be wrong to suppose that there were no other factors. Roman remains were not equally distributed, and the character of Roman art was not always attuned to the emotional, indeed often hysterical, tone of medieval Europe. Ethnic temperament also affected the use that was made of Roman precedents, but we can distinguish between Italy and Provence on the one hand, where these influences were very great, and, on the other, England and Germany where it was stifled. In between, as it were, lay France, where all the elements in this situation came together to produce the richest and most varied display of artistic achievement.

It is not surprising that the Romanesque in Italy evolved along different lines from the rest of Europe. It persisted longer and the large Classical element which it contained gave it the character of a proto-renaissance. It was also to some extent mixed up with the political idea of a renewed Roman Empire. This was particularly true in the south of Italy where the Norman kingdom, as a result of an improbable

marriage and a series of deaths, fell into the hands of the German Hohenstaufen dynasty. Frederick II (1196–1250) deliberately used Imperial Roman themes in his propaganda war with the papacy. But even without such an incentive, artists, especially sculptors, found themselves drawn to the careful study of Classical models and the accurate reproduction of Classical ornament.

This attitude persisted well into the second half of the 13th century. By this time Italians were conscious of being different from the rest of Europe and their sense of identity was in some way bound up with feelings of direct continuity with the ancient world. It was entirely appropriate that the Renaissance should have occurred in Italy, or that Renaissance artists should have sometimes mistaken Romanesque works for genuine antiquities.

In Provence and adjacent districts this situation repeated itself on a smaller scale and within a shorter span of time. The unfinished church at St Gilles has a façade which was based on the stage structure of a Roman theater; and the statues that embellish it could only have been carved by someone familiar with high-quality Roman sculpture.

North of the Alps, where Roman remains were less impressive and also less numerous, something of the prestige of Rome was transferred to Italians who were presumed to know what Roman art was like. From the end of the 11th century onward, a steady stream of Italian craftsmen was lured to work in Germany, mostly for the German emperors. Some of them found their way as far as Lund in Sweden, to the Low Countries and even to England. But the Romanesque art at which the Germans excelled above all others was metalwork. Their skills in this field found expression in the objects which filled church treasures. By comparison, German church buildings with few

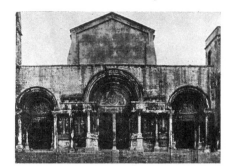

St Gilles du Gard, *west front, c.1140s–1150s near Arles, France*
Limestone, marble and dark granite

The west front of St Gilles shows clearly the 12th century Provençal interest in Classical art. Screen fronts of Roman theaters, of which examples survive at Lyons, Arles, Vienne, Orange and Vaison, inspired the general design while local Roman remains explain the treatment of details; the marble columns and capitals were probably extracted from a Roman building nearby. As well, abundant Roman sculpture must have survived to influence the 12th century treatment of figures and drapery.

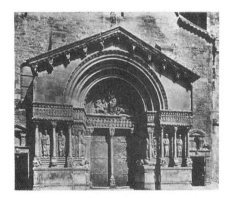

St Trophime, *west façade, portal, Arles, France*
c.1160s/early 1170s

Inspired by St Gilles du Gard, the existing façade was embellished by adding an impressive portal based on those of St Gilles. This is evident in the sculpted frieze, Cotinthian capitals and columns, and the disposition of the life-size statues. Also shown is the influence of Roman triumphal arches, particularly in the use of a gable.

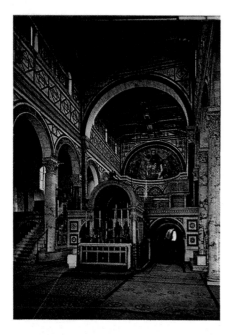

San Miniato al Monte, *nave, Florence, 1090 and 12th century*

San Miniato, along with other contemporary northern Italian buildings, clearly reveals an interest in Roman Imperial architecture. It follows the Roman basilican style of an aisled, rectangular building covered with a wooden roof, but with a stone semi-dome over the eastern apse. Inside, the main arcade, with a large area of blank wall below a small clerestory window, is also derived from Roman basilicas, such as Old St Peter's. This was also the inspiration for the marble columns and treatment of capitals.

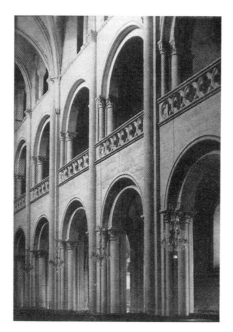

St Etienne, *Caen, France begun c.1068*

St Etienne was built as the church of L'Abbaye aux Hommes, founded by William the Conqueror to atone for the sin of marrying a kinswoman without papal permission. It is paralleled by La Trinité, also at Caen, the church of L'Abbaye aux Dames, founded by William's wife, Matilda. St Etienne is one of the largest French churches. The design of the twin-towered façade originated in Germany but quickly became a typical feature of Norman architecture. Also typical are the cruciform layout and three-story elevation. Several additions were made to the building during the 12th and 13th centuries. In the original plan the nave was roofed with wood, but in the 12th century sexpartite roof vaulting in stone was constructed. This feature added a Gothic style, although the vaults are set above round arcading separating the aisles and clerestory from the nave. The choir, ambulatory and radiating chapels of the church were rebuilt in the 13th century and the two western towers were finished with tall spires.

exceptions seem old-fashioned and even seem to stand apart from the mainstream of European architecture.

England was even more of a cultural borderland. Until the Norman Conquest of 1066 it was an open question whether England was to be part of Scandinavia or attached to the mainland of Europe. William the Conqueror decided the issue in favor of the latter and in terms of art the principal result was the construction of a series of enormous cathedrals and abbeys, collectively, perhaps, the most impressive achievements of Romanesque architecture. For a while the other arts languished. The Normans had little taste for the sensitive, small-scale drawings and carvings which had been a speciality of the Anglo-Saxons, and it was not until well into the 12th century that sculpture and painting of high quality began to appear again in England. Then a succession of superbly illustrated Bibles and psalters followed one another until the end of the century. These, too, belong to the great masterpieces of Romanesque art. The styles varied considerably and indicate connections with many far away places, no doubt a reflection of the high standing of the Anglo-Norman kingdom in the affairs of Europe at the time, but also of the extremely cosmopolitan character of the Romanesque artistic world.

To appreciate the full range of the possibilities of Romanesque art and architecture, however, it is necessary to travel across France in many directions. France in the 11th and 12th centuries was hardly more than a name. There was a king who ruled a small area around Paris, but the rest was in the hands of feudal lords, some of whom where probably more powerful than the king himself. These shared a common outlook, if not exactly a common culture. But beneath the surface of society there were differences,

Durham Cathedral, *1093–1133*
Exterior view from south
Durham, England

This cathedral, set on a magnificent raised site, is one of the most impressive on English cathedrals, the unified structure clearly identifying the crucifixion plan. It is evident that some of the structural innovations at Durham were amongst the earliest indications of the development of the Gothic, although the introduction of the rib vault does not constitute a Gothic feature. The unified nature of the structure itself, the abstract character of all the decoration, firmly identifies it as mainly Romanesque, though, in common with most cathedrals, elements of Gothic were introduced at a later date.

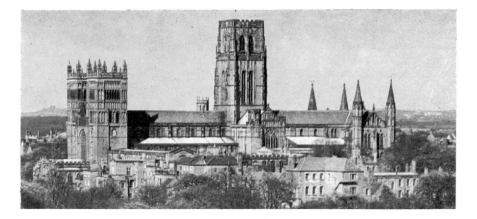

some of which went back to the beginning of the barbarian occupation of the Roman province of Gaul. Visigoths, Burgundians, Franks, Bretons, Normans – each made a distinctive mark on a part of the country, and each responded in a different way to the artistic opportunities of the Romanesque period. Norman churches were quite different from those of Burgundy or the Auvergne, and the sculpture of Burgundy, the west or Languedoc can easily be distinguished.

But it is not just the variety of Romanesque forms that sets France apart from the rest of Europe; the profusion of work is equally impressive. The English cathedral of Durham is probably the most outstanding single monument, but France has literally

Illuminated page from the Winchester Bible,
12th century
Cathedral Library, Winchester

This finely illustrated initial page from the Winchester Bible indicates the nature of 12th-century painting style that produced a series of Bibles and psalters among the finest in decorative sophistication in Europe at that time. In these works a new figure style first appears which owes something to Byzantine influence. It is likely that this style was also used in church murals, but little evidence of them now survives.

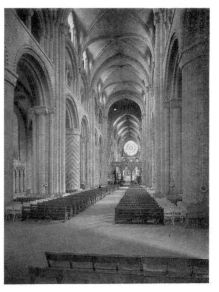

Durham Cathedral, *nave, England*
1093–1133

The great innovations in the choir (1093–1104) included the construction of rib vaults over the nave and their integration with their supports, the walls and buttressing in the gallery. The nave vaults show a perfection of ideas first employed in the choir: by making the transverse arch pointed, the diagonal ribs could be semi-circular, the most efficient solution. Durham's innovations in vaulting were taken up and developed in Normandy and the area around Paris but were largely ignored in England. Instead, it was the use of architectural decoration that influenced England in the 12th century.

hundreds of churches worthy of comparison. The impression of a society equipping itself with virtually all the churches it needed comes over strongly and every church was the focal point around which furnishings and ornaments accumulated. In this sense one can think of Romanesque as the first manifestation of French civilization and the basis on which the future cultural beginning of Europe was built.

In the last resort, however, the importance of French Romanesque art depends upon its quality. It may not include the best building, but it has by far the best sculpture. At Autun, Vezelay, Moissac and Chartres vast schemes of imagery can still be seen

which combine profound theological programs with extraordinary expressive power. The importance of these works was fundamental, for this was the moment when the figural arts took up once more the services and systematic task of conveying meaning through the human form. Essentially they belong to an ephemeral phase, no more than three decades – 1130–60. It soon became apparent that dynamic distortions, however graphic, were less suited to the ends the church wished to cultivate than bland accuracy; and when this happened Romanesque art gave way to something else; it needed the outlook of the 20th century to restore to it the credit it deserves.

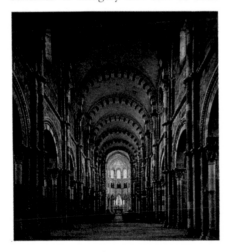

Vézelay Abbey, *Burgundy, nave*
c.1120–32

While the sculpture for the western doors of the Abbey was being prepared, the sculptors were carving capitals for the nave. The subject matter of the cycle was obviously carefully planned. Apart from the aim which all capitals in ecclesiastical buildings share, the glorification of God, the capitals were to illustrate two major themes: man positioned between the forces of good and evil, and how the New Testament fulfills the prophecies of the Old. Some of the nave capitals do not fit the cycle because they were earlier original capitals, most of which were carved c.1100 for another purpose.

Vézelay Abbey, *tympanum of the central west doorway*
Burgundy, c.1130

The major innovation at Vézelay was to spread sculptural decoration out from the tympanum to the arches, trumeau and jambs, foreshadowing St Denis and Chartres. There is dispute over the subject depicted on the tympanum: one view holds that the lines emanating from Christ's hands represents the blood linking Him with the Apostles; more plausible is the suggestion that Christ is sending forth His commands to the Apostles to convert the heathens, the peoples in the compartments around the tympanum. The sculptor probably was trained at Cluny and has a highly individual, expressive style.

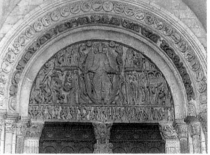

Autun Cathedral, *begun 1120*
Detail of capital (Fall of the Rebel Angel) and tympanum
Burgundy, France

The sculptures in Autun Cathedral, including the tympanum at the west end, are amongst the most powerful examples of such work in the Romanesque style. They are unique in being identified with the name of an individual sculptor Ghislebertus, who signed his name on the base of the tympanum.

The Gothic World

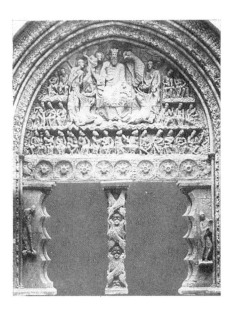

Moissac Abbey Church, *1120–50*
Portal, mid-12th century
Burgundy, France

Moissac is a key monument in the development of 12th century French sculpture: no longer was sculpture confined to the tympanum, but spread to the jambs, trumeau and the sides of the Porch. (At Vezelay a similar development is seen c.1130.) The theme of the huge tympanum at Moissac is of the Second Coming. Also found on the west door of Cluny III. Moissac's chief master and his assistants adorned the cusp-shaped trumeau and door jambs with figures of saints posed to fit the shape.

The term "Gothic" was coined by Italian artists in the Renaissance and originally was used in a derogatory sense, implying that it was the Gothic barbarian tribes – the Goths, Visigoths and Ostrogoths – who destroyed Classical art. When historians later became interested in the art of the Middle Ages and realized the importance of this period, the term lost its negative connotations.

Gothic art grew naturally and almost inperceptibly out of Romanesque art. Roman influences gave way to a new creative vitality, and regional diversity, so important and characteristic of Romanesque, to increasing governmental centralization. Slowly, European monarchs increased their administrative efficiency and as a result large areas came together into political units.

In this somewhat stable political situation the economy flourished and artistic undertakings on a more ambitious scale could be initiated. In the 11th century prosperity had been measured in terms of agriculture. In the 12th a new factor entered the picture. For the first time since antiquity towns became numerous and important. Lords realized that towns could be exploited to produce more concentrated wealth than in the countryside, and it was therefore worth their while to give the towns and cities generous corporate rights in return for protection. It was, however, the monarch who was in a position to be the most generous and could therefore gain the most; cities not only produced considerable revenue, they could also be used as royal power bases to counter the influence of local feudal lords.

While royal support of the towns was based in opportunism rather than political idealism, it had the effect of shifting the emphasis in Europe from an agricultural to an urban economy and with this came a shift in artistic effort. The monastery, essentially an agricultural phenomenon, was no longer the focus of patronage and its importance was usurped by the cathedral, the symbol of the urban community and the main cultural focus. Cathedrals were financed in part by local citizens who had to pay church taxes and might be persuaded to give substantial donations; the windows of Chartres Cathedral were paid for by the guilds of the town. Therefore the cathedral was a corporate effort and it encouraged corporate art: there are descriptions at both Chartres and Rouen of local citizens joining in construction work.

The building of the cathedral, with its large-scale sculpture and stained glass windows, was the artistic focus of the age. The role of the Church was no longer to inspire the contemplative monk nor overwhelm the layman with his unworthiness as in the Romanesque; instead it tried by the sheer size and beauty of its buildings to convey a sense of the all-embracing power of the Kingdom of God. The congregations were welcomed not by ferocious representatives of the Last Judgement but by portals depicting the Life and Coronation of the Virgin, the great intercessor. They entered a church not dark and austere but elegant and luminous, glittering with gem-encrusted shrines and chalices.

It was the abbey church of St Denis that first expressed this new attitude. Abbot Suger, while unquestionably pious, was very much a man of the world and acted as an able regent of France when his pupil King Louis VII was on crusade. In the 1130s he reformed his monastery at St Denis and began an extensive rebuilding program. Art for art's sake, art for God's sake and art for the sake of Suger's personal pride all coalesced into a magnificent, airy church flooded with light from large stained glass windows filled with

precious objects and adorned on its exterior with mosaics and sculpture of unprecedented complexity and richness.

St Denis was comparatively small, unlike most of the cathedrals of subsequent decades. But large or small, the essential feature was stained glass windows. Suger wrote extensively about the mystical analogy between light and the grace of God. In the uppermost level of the cathedrals the clerestory windows began to occupy more and more of the total height of the elevation. Windows were filled with representations of the saints, and colored light streamed through at a celestial angle, as if the architect sought to capture a vision of heaven in the net of the cathedral vaults. The range and variety of experiments to this end was impressive.

By the end of the 12th century however, general agreement was reached, in France at least, about the shapes cathedral churches should have. At Chartres in 1194, and at Bourges, perhaps a little earlier, colossal structures of breathtaking daring and beauty were successfully undertaken. These provided the models and starting points for many later buildings.

These developments were spread over a wide area; with each new undertaking the center of gravity shifted; and ideas seem to have moved with remarkable ease and rapidity. This may have had something to do with pilgrimages and trade. Towns that lay on important trade routes or boasted important fairs were open to influence from other centers. This was particularly true of cities that lined the important trade routes of 12th and 13th century Europe, linking the industrial centers of Flanders with those in northern Italy. Thus the cathedral of Lausanne seems to have been inspired by the choir at Canterbury, and the west front of Notre Dame at Dijon is a rare instance of Italian design blended with northern European architecture.

In many ways, one has the impression that northern France, which had not previously been an area of conspicuous activity, took on a new lease of life in the second half of the 12th century. Artistically it had been rather backward; but as so often is the case, this was a positive advantage when it came to the formation of new attitudes and new styles. The initiative once seized, was never lost. This is not to say that nothing similar happened elsewhere. Across the Channel England was almost as rich and productive and there was a good deal of cathedral building. But little of it matched the scale of the French. Where English cathedral building revealed bold aspirations, as at Canterbury, Lincoln, Salisbury or Westminster, this was nearly always some sort of response to French influence. In 1174 the monks at Canterbury, determined to be in the vanguard of architectural fashion, took the precaution of employing a French architect. At Westminster in 1245 another Frenchman took charge. French architects also went to Spain and perhaps Germany. On the other hand, Germans almost certainly went to France to learn about the new architecture for themselves as first hand.

Other parts of France, such as Burgundy and the south, which had made so important a contribution to the development of Romanesque architecture and sculpture, fell behind in the later 12th century. Even Italy, which had an abundance of flourishing cities – northern Italy was the most heavily urbanized area in Europe – showed little interest in the new ideas about architecture, perhaps because they were French. Eventually a kind of Gothic architecture did make its appearance in Italy; but it owed little to France, and it never entirely captured the Italian imagination.

Salisbury Cathedral, *England c.1220–66*

Apart from its spire, the whole of Salisbury Cathedral was built in one phase, a unique feature of English church building. This was because an entirely new site was chosen for the Cathedral, giving the architect the freedom to execute an entire scheme. For this reason the building is highly regular, the danger of monotony being warded off by the profusion of gables and turrets. The Cathedral would have appeared long and flat, but with the addition of the spire, the highest surviving one in England, a new vertical emphasis was created to counterbalance the horizontality.

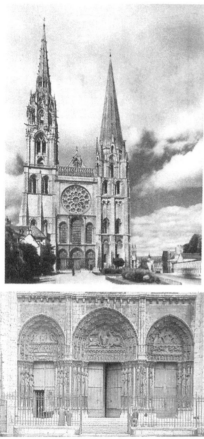

Chartres, *western rose window and north transept rose window* c.1200

Chartres Cathedral is the only large French cathedral that retains a large part of its original stained glass, allowing us today to see how architecture, sculpture and glass were knitted together for a total effect. The use of deeply colored glass produces diffuse internal lighting, softening and blending architectural features while the vaults of the nave are scarcely visible.

Chartres Cathedral, *1194–1260*
View of west front
Chartres, France

Chartres Cathedral exhibits many of the features which are the glory of French Gothic architecture, including great structural inventiveness and some of the finest remaining stained glass and sculptures. It also reveals in its somewhat surprising west front, the living nature of medieval church building. The early south tower, built at the time of the original church (1145–70), forms a strong contrast with the north tower (1506), which is constructed without regard for conformity or symetricality. The later tower (left in the illustration), is however, a fine example of late Gothic decoration. The sculptures on the south and north trancepts are most notable, and the detail of St Bartholemew (above) shows extraordinary sensitivity of carving.

After a disastrous fire in 1194, the reconstruction of Chartres Cathedral began. Because it was decided to retain and expand the 12th-century west front, any elaborate sculptural program had to be applied to the transepts. Accordingly, three portals were designed for each. The center and left portals were probably executed by the same workshop while the right was carved at a slightly later time by a workshop from Sens.

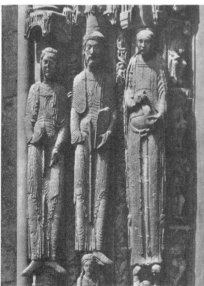

The rise of the university

The growing importance of the cathedral in the later 12th and early 13th centuries prompted a major change in education. Education had always been the special province of the Church because it was believed that only the clergy needed to be literate and those outside the Church had little need to read or write. Cathedral and monastic schools had been established as far back as Carolingian times. Up to the 12th century this education, such as it was, consisted of reading prescribed Latin authors and the Fathers of the Church. From the middle of the 12th century onward however, a much more intensive and systematic study of theological texts, and in particular the critical examination of their apparent inconsistencies, was ventured upon. Out of this was born the science of theology. At first this was centered at cathedral schools, such as Laon or Chartres.

At Chartres the presence of an important intellectual center had a tangible effect. Few of the schools in the smaller cathedral towns retained their preeminence for long, but that attached to Chartres was lucky to attract some unusually good teachers. But Paris was the place where the most famous teachers were to be found. By the late 12th century these teachers were sufficiently numerous to group themselves together and demand rights and privileges, including the sole right to grant degrees within the city. In this way the seed of what was to become the University of Paris was sown. Within a short time similar schools were established at Oxford and Cambridge in England. In Italy a different type of university developed where the central subject was not theology as in the north, but church law. Here the students were usually wealthier than the teachers and it was they who formed the dominant organization.

What effect the preeminence of Paris in theological studies may have had upon the arts is not easy to assess. It is true that students came to Paris from all over Europe. However, there is no doubt that the effective government of the Church was in the hands of men who had studied church law at Bologna and Padua, and there is little sign of that having much effect, at least before the 14th century. Yet Paris, unlike Bologna, was a great center of artistic activity; and however it happened, it is clear from the early years of the 13th century there was widespread agreement throughout Western Chrisendom that there should be a distinctive style of ecclesiastical architecture, and that the appropriate style was the one we call Gothic. Exactly how this was understood varied from place to place. The minimum requirement seems to have been pointed arches. Paris may well have been one of the places from which this conviction was put into general circulation. The unity of Christendom which the power of the Church made effective, had a decided French flavor.

The Church confronts heresy

The rapid growth of towns brought problems as well as benefits. Urban populations have always been more volatile than their rural counterparts. Relations between the townspeople and their cathedrals were often stormy because bishops and clergy, keen to embellish their buildings, pressed hard in their demands for taxation. Even at their richest and most successful, the cathedral clergy seemed to have found that their moral authority over the lower classes was in question.

The later 12th and early 13th centuries was a period of increasing discussion of the Christian faith. While the Church was at the height of its power, it was also profoundly disturbed by the spread of heretical sects that were unwilling to accept Church law and teachings. The Church had never been more organized or powerful and its cathedrals never more splendid, but because the papacy seemed more concerned with church law than the salvation of souls, it began to lose its grip on the loyalty of its flock. Heretical groups, centered in Languedoc, claimed to be able to fulfill ritual and pastoral functions and were, not surprisingly, unpopular with the clergy whom they repudiated.

One heretical group, the Albigensians, combined anti-clerical sentiments with their creed, which held there were two gods, one evil and of the real world, and one good and of the spiritual world. The Albigensians seem to have had a special attraction for townsfolk and aristocracy of southern France and, because the papacy could hardly allow them to succeed, a special order was founded by St Dominic to persuade the Albigensians out of their evil ways. Eventually the papacy announced a crusade against the Albigensions in which northern French barons and rootless knights seeking war and plunder in the south joined in, as did Louis VIII and Louis IX. The crusade became a war of exceptional violence and while the Albigensions were not stamped out immediately, the campaign left a legacy of hatred. The southern way of life had already lost much of its vitality by the end of the 12th century. The crusade destroyed what was left and new building in Languedoc from about 1250 onward was almost all of a nothern Gothic style.

There was another consequence of this growth of heretical sects. In 1207 St Francis of Assisi gave up his comfortable life as a rich, young knight to live in poverty and purity, with a group of like-minded companions, preaching to the underprivileged. Pope Innocent III, seeing the potential of this small

group of idealists, established them as the Franciscan Order. The Franciscans had shown every sign of becoming a subversive, anti-clerical element until Innocent brought them into the fabric of the Church. Innocent III also established the Order of the Dominican Friars. While neither Order restricted itself to the towns, it was there that they both found themselves catering for a particular need. Their role was to preach and teach, rather than to provide the sacraments of the Church; and their architecture reflected this purpose. Their churches tended to be large, bare halls, often in the form of what are called hall churches, where the aisles are as high as the nave. In Italy especially the friars churches were frequently bigger and more important than the cathedrals. Many private chapels, endowed by rich families, accumulated around them.

Heresy from below was not the only danger the Church had to face. In their extreme form, the claims put forward by the reformed papacy of the late 11th century implied serious threats to the power of secular rulers, who were themselves engaged in extending their authority and creating effective governments. This latent conflict erupted into violence on several occasions. In the 11th and 12th centuries the popes recognized their principal adversary in the German Emperors and so they found it expedient to keep on good terms with the Kings of France and England, especially France. In the 13th century the quarrel between Church and Empire reached a climax in what might almost be described as a war to the death between a succession of popes on the one hand and the Emperor Frederick II and his successors in the dynasty of Hohenstaufen on the other. At the heart of the matter was the personality of the Emperor: a remarkable man whose character and behavior seemed to surpass all accepted

medieval limits. He was called *stupor mundi* – the man who amazed the world. But to the popes he was the Anti-Christ. The task of exterminating this man and his children was deemed worthy of a veritable crusade. It was eventually successful. The last of the Hohenstaufen was executed at Naples in 1266.

But the Church paid heavily for this triumph. In defeating a worldly enemy, it lost in the eyes of society most of its other-wordly prestige. The popes became indistinguishable from the most ruthless and avaricious of secular rulers. They came to depend heavily on the support of the French royal family, and eventually they were forced into the humiliating position of becoming, in effect, clients of the kings of France when they left Rome for Avignon in the 14th century.

Not all secular rulers behaved like Frederick II. At a time when Frederick represented all that was bad and dangerous in kings, his near contemporary Louis IX of France (1226–70) was setting a new example of royal virtue. He became St Louis; but he probably did more damage to the pretensions of the Church by his worthiness than Frederick by his enormities. Louis' made secular government morally respectable. He also more or less completed the unification of France. These two achievements made France by far the most powerful kingdom in Europe, and the pattern for all other aspiring monarchies.

Part of St Louis's appeal to the imagination of European society was his perfect fulfillment of their ideal of chivalry. Gallantry in the conduct of war was in a sense an extension of the good manners imposed upon gentlemen by the notion of courtly living. Twelfth century warriors responded to the lure of plunder rather than damsels in distress. By the 13th century romantic aspirations had become incitements

to battle. Knighthood offered splendid occasions for display. Banners and heraldic devices became subjects for experts and acquired immense complexity. In the 14th century new orders of knighthood were founded, closer to Arthur and the Round Table perhaps than the severely monastic organizations which had fought in the Holy Land. The first of these was in fact the English Order of the Garter; but the idea was taken up with enthusiasm everywhere. It was not only in matters of government, but of social behavior that France set an example for the rest of Europe and stimulated imitations.

The mainstream of Gothic architecture in the early 13th century, represented by Chartres, Reims and Amiens, whose influence was felt so widely in the second half of the century, was in essence the architecture of the Ile de France in the region around Paris. The spread of this style in France, called *Rayonnant*, is not surprising. Like the government administrators, the bishops were Paris-educated men and they brought their Parisian architectural tastes with them to the provinces. Strasbourg and Cologne in Germany and Leon in Spain all tried to emulate French designs; the dasilica of St Francesco at Assisi attempted to combine French architectural ideas with Italian wall painting. It is also for good reasons sometimes called the "court style" because it enjoyed direct royal patronage. Henry III of England had Westminster Abbey rebuilt in a self-consciously French style and competition between the French and English kings became one of personal piety and the magnificence of donations to the Church rather than territory.

The new towns founded in the 13th century did not flourish as had those founded in the 12th century and economic stagnation quickly became apparent in church building. Beauvais was the last of the mammoth High

Gothic cathedrals and subsequent building was much smaller in scale. This was not only because the vaults of Beauvais fell down, although this was doubtlessly discouraging, but because there was less money available. Only in one or two areas still in economic expansion were immense buildings considered. Spain was one. The wealth of Catalonia, based on the cloth industry and sea trade is reflected in the 14th century cathedrals of Barcelona and Gerona while at Seville in the 15th century, a bold attempt was made to build a cathedral of a size to astonish the world, but either nerve of financial resources failed and the cathedral is almost certainly a reduced version of what was intended. So is its near contemporary at Milan in Italy.

The soaring heights and echoing space of the previous century were superseded by a passion for a new kind of decoration which grew out of window design. As windows increased in size to allow for more and more stained glass, it became necessary to divide them and as this became more complex, the masonry dividing the glass dwindled and became more delicate and decorative. The rose window, the large round window that often decorates the west front or façade of a church, also became more delicate and complex. Gradually, tracery stretched across walls as well as windows like a delicate, elongated spider's web. By this stage French architects were so technically confident that walls were reduced to an absolute minimum behind threads of tracery and were, as one such cathedral was described, "more glass than wall". Tracery was prodably cheaper to produce than other forms of decoration. It also lent itself to miniature forms where the entire scale of buildings was altered to give a sense of intimacy rather than grandeur. Sculptural details on capitals and archi-

La Sainte Chapelle, Paris c.1343–1246
Interior showing stained glass

On September 14th 1241 an official reception in Paris greeted the arrival of Holy relics from the Byzantine Empire. St Louis had brought the Crown of Thorns, a piece of the Holy Sponge, Robe, Shroud and part of the Holy Spear. To house these precious relics he built a reliquary, the Sainte Chapelle. It is a two-story building comparable in scale and design to the upper stories of a cathedral choir. Within it St Louis placed a reliquary so richly adorned that it cost two and a half times as much as the building itself. The identity of the architect is uncertain, but details resemble the ambulatory and radiating chapels of Amiens, both, perhaps executed by Thomas de Cormont.

volts were often very small and intended to be seen at close quarters.

A significant number of the great architectural works of the new court style were personal chapels. For example the Sainte Chapelle was Louis's private chapel, and the exquisite church of St Urbain at Troyes, built by Pope Urban IV, was a memorial to his power. Personal psalters, gospels and missals achieved a popularity not seen since the Ottonians. A passion for the gilded and ornate meant the rise of a new finesse in manuscript illumination for which Paris in the early 14th century had a veritable industry. In these illuminations complexity was prized for its own sake with figures placed against complicated backgrounds. Arches were surmounted by gables and gables were decorated with luscious growths of vine leaves, oak leaves and roses. Naturalistic foliage flourished particularly in England with fine examples at Southwell and York.

Along with this came a new attitude toward women. Around the end of the

12th century the cult of the Virgin had reached new heights along with new themes, such as the Coronation of the Virgin. On a less spiritual plane, in troubadour poetry the passionate idealization of women raised feminine charm to a level fit for artistic endeavor. By far the most sensitive and serious portrayals of women are found far from France among the statues at the

Chapter House, *Southwell Minster,
England, 13th century
Detail of capitals
Limestone*

*Naturalistic leaf decoration is found on the
capitals on the sides of the Chapter House
at Southwell Minster and in the gables and
tympanum of the corridor connecting the
Chapter House to the choir. Carved foliage
is a traditional decoration dating back to the
Roman Corinthian capital and the out-
standing quality of the sculpture at
Southwell is the sensitive realism and great
variety of the leaves, very different from the
accepted stylized forms of the period. The
many leaf types include maple, oak,
hawthorn, ivy and hops. Some are carved
with heavy undercutting creating spatial
depth, while others are arranged in lateral
designs, all with a persuasive naturalism
avoiding the simplified forms and symmetry
of stylized pattern-making found elsewhere.
Similar decorations occur in the Cathedral
at Rheims and it is possible that the work
at Southwell was carried out under a
French master sculptor or an Englishman
with a knowledge of France. Sculpture of
this type at York and Lincoln in England
indicates a group of craftsmen based in
that country.*

Cathedral of Naumburg, in what is
now East Germany. Here are ladies
who laugh and cry; elsewhere they
tend to be simpering and swaying
Virgins.

Realism on the grand scale had a
strong appeal in Germany and, to a
lesser extent, in Italy. Between 1230
and 1260 a remarkable series of statues
and reliefs were produced whose im-
pact is positively theatrical. Figures
behave like actors on a stage. Their
gestures are vividly expressive and

there is little if any sense of theological
significance. At their best they have
uncanny features and expressions that
come close to portraiture.

The work done in Germany at this
time goes far beyond the refined French
conventions. Social conditions in Ger-
many were rather different from those
in France: while princely courts were
numerous, they were not large enough
to follow the artistic lead that St Louis
had provided in France. In Germany,
as in Italy, the towns and their pros-
perous citizens continued to play a
substantial role in the development of
artistic taste. The work of the masters
can almost be seen as a middle-class
variation on the aristocratic styles
favored in France.

When St Louis died in Tunis in 1270
the path for the future had been firmly
established. Taste in art focused on
charm, craftsmanship, rich and exotic
materials, perhaps an element of fan-
tasy. But there was also a serious
element, an awareness of the pathos
embedded in the Christian narratives,
and if this was often treated senti-
mentally, the possibility of grand
tragedy was on occasion recognized.
At the heart of the matter was an
increasing recognition that religion
was an affair of individuals. It was the
fate of one's own immortal soul that
mattered; and investment in works of
art was part of an insurance policy to
secure favor and intercession at the
appropriate time. Not all religious art
became private; but tombs, chantries
and chapels, where specially endowed
priests could say mass for the benefit of
the dead, assumed greater and greater
prominence. Since art was essentially
at the disposal of the rich, and although
no doubt the aspect of class distinction
was not unduly stressed, it must have
contributed to the atmosphere in which
the Reformation eventually took shape.
If the teaching of the Church meant
what it said, the consolations of reli-

gion were for everybody, not just those
who had money with which to buy
them. It took 250 years for the ferment
to mature; but the special character of
Latin medieval art is inextricably
bound up with the special character of
Latin medieval religion.

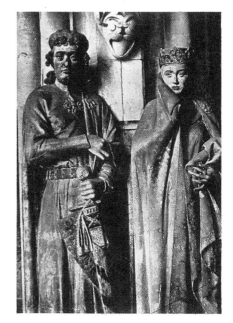

Eckhart and Uta, *c.1245
Sculptor unknown
Stone life-size
Naumburg Cathedral, Germany*

*A number of life-size sculptures in the west
choir of Naumburg Cathedral celebrate the
secular patrons of the Cathedral, among
them Count Eckhart and his wife, Uta. The
sculptures are unusual for the period in that
they successfully convey a sense of the
character and individuality of each subject.
The style is similar to that of surviving
fragments of sculpture forming part of a
choir stall in Mainz and to figures in a portal
in Meissen. These were possibly all the
the work of the same group of craftsmen
who traveled from place to place to take up
various commissions. A remarkable degree
of naturalism also exists in the foliage
decoration of the capital at Naumburg, a
development that occurred slightly later in
England at Southwell and in France at
Rheims.*

Emerging from the Middle Ages

The Middle Ages did not simply pass away like a change of administration, and the period of transition was one of uneasy tensions and many paradoxes. The economic stagnation which had set in at the end of the 13th century had become real recession in the 14th. Europe was overpopulated. There was simply not enough food to go around. In 1315 unusually bad weather brought unusually bad famine. The death rate began to climb; the birth rate began to fall (women were getting married rather later in life than previously; their fathers were finding it more difficult to provide an adequate dowry). The population, for the first time since the Dark Ages, began to fall. Still there was not enough food. In 1347, the year before the Black Death, people in Montpellier were reported to be eating rats and grass. The Black Death itself – bubonic plague – when it struck in 1348 and then again throughout the century, claimed easy victims. It was not the cause of the recession, but it greatly increased its impact. The plague was brought from the east, the carriers being infected fleas nestling in the fur of the brown rat, a newcomer to Europe. The rats arrived along with their fleas and the plague by ship, and the first place to be struck was the seaport of Messina in 1347. The plague spread rapidly and mortality was astoundingly high. In some places, whole communities – villages or monasteries – were wiped out. It is possible that the population of Europe was reduced by about a third.

The economic outlook was not, however, bleak for everyone. The recession, combined with the considerable fall in population, did tend to concentrate wealth. As so often in periods of economic disaster, the rich got richer and the poor got poorer. Land prices fell, and the baronage suffered badly. Some of the greater landowners, however, were in the long run able to take advantage of the situation. They were able to enclose the now unpopulated land and farm it more efficiently than before. There was a parallel development in the urban economy. Many concerns failed but there was room for enterprise, and many great merchants – the Medici family in Florence, or Jacques Coeur in France – emerged stronger than ever. Indeed, by the end of the 14th century, urban economy was in general beginning to flourish, and with it a new class of substantial, if not conspicuously rich, merchant.

Where there was money, there was cultural endeavor. The great rich landowners remained, as they had always been, considerable patrons. The richer they were the more lavish (though not necessarily the more adventurous) was their patronage. The richest of the great lords were those whose patrimony included not only land, but also towns – those who were able to draw on urban wealth. Thus the Visconti in Milan, and the Valois dukes of Burgundy and Berry (members of the French royal family), with taxable boroughs under their control were able to exercise a personal patronage on a scale hitherto unknown. None of the merchant princes sank money into art with quite such abandon, but their contribution as patrons was nevertheless considerable. When the Italian banker, Giovanni Arnolfini, married in 1434 he had his wedding portrait painted by the Duke of Burgundy's much prized court painter, Jan van Eyck.

The lesser merchant, the substantial burgher, also invested in art in various forms. This was not an entirely new phenomenon. The richer citizens had traditionally contributed to the building and fitting out of the local cathedral. Various guilds had, for instance, donated some of the magnificent windows at Chartres. But the gesture was often corporate, and the giver remained in effect anonymous. The richer citizen was not content with anonymity in the later Middle Ages and a whole range of new types of small-scale patronage developed to satisfy the demand. It became fashionable to establish small chapels between the buttresses along the flanks of cathedrals, each with an altar, and with stained glass windows in which the donation was often recorded. Endowment for small complete churches became popular. The friars, who were generally based in towns, benefited greatly from this. The large number of splendid English late medieval parish churches in both Wiltshire and East Anglia reflect the wealth of the local wool merchants. Another specifically English form was the memorial brass. It could be impressive enough on its own terms, and made a suitable economic alternative to the carved marble tomb.

The landed nobility, who had been so generous to the church and the monasteries of the earlier Middle Ages, could not compete. It was not just a question of wealth. The lord, hidden away in his drafty castle and struggling with his depleted estates, was too far from the center. The provinces became, as never before, provincial.

For the richest patrons of the late Middle Ages – the great territorial princes and their courts, and the very wealthiest merchants – art forms continued to be rooted in the court style of St Louis. Elegance, charm, richness of effect and a new and growing realism, had all been apparent in the Sainte Chapelle, and they were to continue very largely to dominate the arts of the later Middle Ages too. Indeed, designs become steadily more charming, more whimsical and more exquisite, as the century turned increasingly sour.

The chivalric ideal, too, developed as never before. Heraldic devices ac-

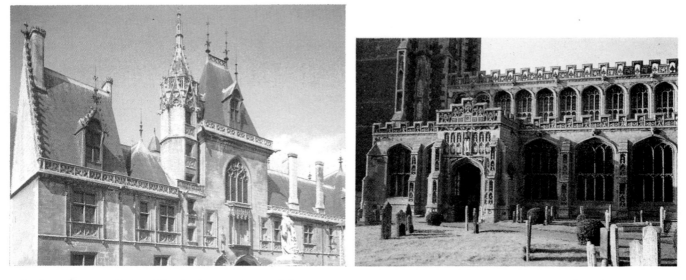

House of Jacques Coeur. *Bourges, 1443–51*

This house, built for an extremely rich moneylender of Bourges, is a symptom of the increased wealth and confidence of the urban middle classes in the later Middle Ages. The overall design reflects a light-hearted use of motifs originally intended for ecclesiastical architecture. Similarly, in the later Middle Ages sculpture was used in a more theatrical way than previously. The statue of Madame Coeur, dozing at a false window, shows this new dramatic quality and heightened realism.

Lavenham, *porch, Suffolk, England, c.1504–13*

Lavenham is an example of Perpendicular parish church building on a grand scale whose design is attributed to the notable architect John Wastell (d. c.1515). By the late 15th century the design of the naves of Winchester and Canterbury Cathedrals had permeated to parish churches, explaining the use of decorative paneling above the main arcade. The width of the nave, however, along with a lack of suitably skilled masons or finance, meant that it was given a wooden roof rather than a stone vault.

quired a new complexity. The devices were displayed on the knights' shields, which naturally became larger and larger, and rose in colorful crests from helmets. Armor, too, became extremely decorative. It was also extremely heavy: the richly caparisoned and heavily accoutered French knights sank into the mud at the battle of Crecy (1346) and were easy prey for the English foot-soldiers. The mounted and armored knight was becoming increasingly unsuitable for serious warfare, but tournaments seem to have been taken almost as seriously as war in the later Middle Ages. The tournament – a battle arranged as sport either between single knights or between quite considerable contingents – was not a new idea, but it became more popular than ever before. It was indeed, rather more than just a game to those who took part. Tournaments were rarely played to the death, but knights could capture their opponents and hold them to ransom. Accidental injuries could, needless to say, be horrendous. but they were also the excuse for a relatively harmless display of all the panoply of war, watched by the whole court and followed by a splendid feast.

Ceremonial became increasingly complex. Etiquette stiffened, officials became more numerous and court life became a fantasy world. The grand, extravagant gesture was much admired. The courtly life style reached its apogee with the Valois dukes: Philip the Bold, Duke of Burgundy, and Jean, Duke of Berry, the brother of Charles V of France. Both inherited vast lands and wealth. The Duke of Berry was not fired with much political ambition and such political activity as he indulged in was intended to do no more than to protect his own comfortable lifestyle. He surrounded himself with beautiful tapestries, jewels and books mar-

velously illuminated by the foremost painters of the day. He owned a large number of splendid castles – Poitiers, Etampes, Dourdan. He embellished them lavishly, adding, for instance, the magnificent chimneypiece which occupies a whole wall of the hall at Poitiers. He also built himself new castles, such as at Mehun-sur-Yievre, which seem to have been designed as decorative objects rather than as fortresses.

His brother, Philip the Bold, Duke of Burgundy, and his successors were still richer. They were also politically active and ambitious. Their ambitions were directed as much outside France as within it. From their Burgundian

base, they were able to absorb first Flanders, and then the rest of the Low Countries. The last Valois duke, Charles the Bold, tried unsuccessfully to persuade the Emperor Frederick to make him a king of the Holy Roman Empire. They remained dukes in name, but their territories, stretching from Switzerland to the English Channel and the mouth of the Rhine, and comprising the wealthy Flemish towns, made them in many ways the most powerful and richest rulers in Europe.

Their ambition and their wealth were both made manifest in the show and patronage of the Burgundian court. Court ceremonials reached new levels of pomposity, and major artists were paid to paint banners and to design tableaux for special occasions and elaborate, but totally edible, centerpieces for feasts. Fortunately the talents at the disposal of the Burgundian dukes were not always frittered away. When Philip the Bold founded the Carthusian house of Champmol at Dijon, he commissioned the portal and the cloister fountain from the Dutchman Claus Sluter (active 1380–d.1405), and the altar panel from Melchior Broederlam (active 1381–d.1409). Philip the Good's court painter was Jan van Eyck, who received a substantial annual salary and was required to fulfill a certain number of relatively practical commissions. He was, for instance, dispatched to Portugal to portray the prospective duchess, the Princess Isabella.

This conspicuous consumption in Burgundian courts of patronage of the arts and the provision of courtly magnificence (with not too fine a line drawn between the two) was echoed, if not surpassed, at the other European courts of the 14th and 15th centuries. Charles V of France (the brother of Jean de Berry and Philip the Bold of Burgundy) was in his own way a distinguished patron. He took his duties as king of France seriously and although France was already wasted by the first half of the Hundred Years War, and although he lacked the immense financial resources soon accumulated by his brother in Burgundy, he commissioned some fine manuscripts from Jean Bondol (active 1368–81) and others, which helped Paris to maintain its position as the most lively center for manuscript production.

Charles V's nephew, the Emperor Charles VI and king of Bohemia, did his best to emulate his royal French relatives. Under his influence, French artists were attracted to Prague. The Prague Cathedral choir was designed by Matthew of Arras (d.1352). The art form which benefited most from the French connection, though, was painting. Exquisite manuscripts were produced and Charles's castle at Karlstein was decorated with lavish wall paintings in which the artist's favorite color seems to be gold.

The English royal court continued to be, as it had become under Henry III, the focus of artistic patronage in the country. It is clear that the new architectural style, known as Perpendicular – of which the first surviving example is the cladding, completed by about 1350, of the Norman choir at Gloucester Cathedral – originated in court circles.

Painting, either on panel or manuscript, seems to have given rise to the most consistent achievement. The Westminster retable, of the late 13th century, shows precocious signs of Italian influence. Some exquisite psalters (the Queen Mary and the Tennison) were produced, and the Wilton diptych, painted around 1396 for Richard II, shows the introduction into England of the distinctive court style of the late 14th and early 15th century known as International Gothic in which fantasy and realism are strangely mingled. A flamboyant courtly chivalry

St Barbara, 1437
Jan van Eyck (active c.1422–41)
Drawing on panel
Musée Royal, Antwerp

St Barbara had been imprisoned in a tower by her pagan father to prevent her beauty from being spoiled. Her religious convictions were discovered only when she persuaded the builders to erect a chapel for her with three windows, symbolic of the Holy Trinity. St Barbara seemed the ideal subject for Van Eyck, a master of depicting delicate architectural forms, sweeping landscapes and elegant ladies. This picture is one of the first of his late "soft" style, resembling earlier works in the monumentality of the figure but differing due to the rejection of crisp, linear forms and sharply defined drapery folds. The delicate drawing of the great church in the background indicates how the churches and cathedrals dominate the surrounding countryside. Careful examination of the drawing also reveals a great deal about constructional methods.

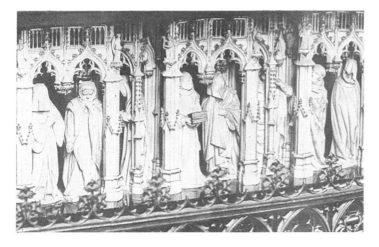

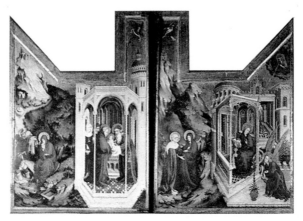

Champmol. The tomb of Philip the Bold
was begun by Marville in the monastery
chapel. It was left unfinished at his death,
and on the sudden death of Philip in 1404,
Sluter was commissioned to finish the work
by the Duke's successor, John the Fearless.
Museum. It was in 1395 that Duke Philip
had commissioned a large cross for the
central well of the main cloister in the
Chartreuse de Champmol and this was the
work now known as the Well of Moses.
It is the only surviving work known to have
been designed and executed entirely by
Sluter. The entire composition was originally
polychromed and gilded by painters of the
Burgundian court. Of the Well of Moses
only the base now remains and a few
fragments of the upper section, including a
damaged torso from the figure of Christ.

Tomb of Philip the Bold, *begun 1385*
Claus Sluter (c.1350–1406)
Alabaster and black marble
Musée des Beaux Arts, Dijon, France

The Well of Moses, *1395–1403*
Claus Sluter (c.1350–1406)
Stone height 126in (320cm)
Chartreuse de Champmol, Dijon, France

*Claus Sluter, a native of Haarlem, worked
from 1385 at the Chartreuse de Champmol,
the monastery founded by Philip the Bold
of Burgundy. At first Sluter was an
assistant to the master of the sculpture
workshop, Jean de Marville. He received
the highest salary of any of the assistants
and his work was very highly regarded. On
the death of Marville in 1389 Sluter was
given charge of the sculptures for*

Scenes From the Life of Mary *(Altarpiece of
the Chartreuse de Champmol), 1396–9*
Melchior Broederlam (active 1381–1409)
*Oil and tempera on wood panl wing panels
each of 65½×49in (167×124cm)*
Musée des Beaux Arts, Dijon, France

*Philip the Bold of Burgundy founded the
Chartreuse de Champmol, a Carthusian
monastery, in the late 14th century and for
its decoration enlisted the aid of the finest
painters andsculptors known at his court.
Melchior Broderlam, a painter from Yprès
attached to the Burgundian court from 1387,
was commissioned to paint the exterior of
the wing panels of a wooden altarpiece
carved by Jacques de Baerze, a Flemish
sculptor. Known as the Baerze Retable,
this is the more elaborate of two altar-
pieces established in the Chartreuse de
Champmol. Broederlam's represent
the Anunciation, the Visitation, the
Presentation and the Flight into Egypt.
These are the earliest examples of what has
become known as the International Gothic
style in painting. This is essentially based in
Franco-Flemish tradition, but shows the
influence of Italian work. Little else is known
of Broederlam's activities nor the origins of
his style.*

The Eleanor Cross, *1291–7*
Hardingstone, England

In 1290 Eleanor of Castile, Edward I's first Queen, died at Northampton, England. Over a period of twelve days her body was carried in state to its final resting place in Wes Westminster Abbey. Each night the procession halted and Eleanor's body was laid at the gates of a religious foundation and between 1291 and 1297 crosses were erected to mark where the cortège stopped. The idea was clearly derived from St Louis's funeral pageant from Tunis to St Denis in 1271. Three of the Eleanor Crosses survive. They were built by architects from Edward's Court and clearly show the influence that French Rayonnant architecture exerted there.

dominated the reign of Edward III, who undertook the Hundred Years War rather in the spirit of an extended tournament. Even Edward's grandfather, the unsentimental Edward I, had anticipated the new mood when he commemorated his much loved, if often deceived wife, Eleanor of Castile, with a series of stone crosses, placed wherever her bier had rested on its journey to London for burial. The importance of the English court as a center of patronage was interrupted by the outbreak of the civil war between two branches of the royal house (known as the Wars of the Roses) in 1455. Once the Tudors had settled in

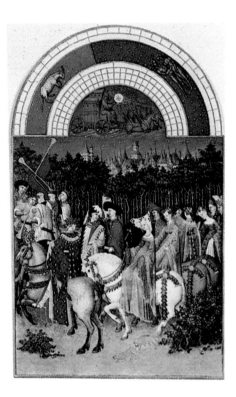

Très Riches Heures du Duc de Berry, *May*
begun c.1413
Pol de Limbourg (active c.1399–c.1416)
Illumination
Musée Condé, Chantilly, France

A "book of hours" was the term given to a prayer book for private use by a lay person. Such books were common in the 15th century and many were finely illuminated. The contents varied, but usual illustrations included scenes showing the different months of the year and events from the lives of Jesus and the Virgin Mary. The Très Riches Heures of the Duke of Berry were discovered in 1855 on sale in Italy and returned to France by the Duke of Aumale. Careful checking of old inventories revealed that the manuscript was the work of three brothers from Limbourg, nephews of Jean Malouel who was court painter to Duke Philip the Bold of Burgundy. The Duke of Berry was brother to Duke Philip and son of John II of France. An inventory of the Duke's possessions after his death gives the title by which the work is known: "Item, in a portfolio, many sections of a very rich Hours, which Pol and his brothers made, very richly illustrated and illuminated".

power in the 1480s, they re-established the tradition. They extended the palace chapel at Windsor, added a royal axial chapel to Westminster Abbey and founded King's College Chapel at Cambridge. Other artistically important courts were those of the Angevin Kings of Sicily, and the Visconti in Milan.

Court styles were inevitably lavish and expensive. Paintings were composed of the most expensive materials – gold and blue made of ground lapis lazuli. The life represented in the paintings and sculpture was all leisured, luxurious existence, nowhere better portrayed than in the Books of Hours of the Duc de Berry. It was, too, a decadent world. The courtiers inhabiting it wore ridiculously elaborate clothes, with shoes too long for their feet and hats far too big for their heads. The courtier was rarely actively involved in the administration of government (this was left to professional administrators). Unless there was a war to be fought, he was left with a lot of time on his hands. Apart from jousting, hunting was a popular way of occupying aristocratic leisure time and representations of hunting abound. They form the subject of innumerable tapestries, and range from the lively and well-observed depiction of fishing and birdcatching in the papal palace at Avignon to the elegant and sophisticated hunting party which represents the month of May in the *Très Riches Heures* of the Duke of Berry.

The proper occupation of the courtier had traditionally been war. Of war there was indeed more than ever. From 1337 to 1453 England, France and, after its creation, Ducal Burgundy, were locked in the struggle of the Hundred Years War. War flared intermittently in the German Empire as the Wittelsbachs, the Luxembourgs and the Habsburgs struggled for control. In the 15th century, England was torn by the Wars of the Roses. In Italy, the numerous

republics and principalities, all with conflicting economic or political interests, was in an almost permanent state of war and became the main market for the ambitious but rootless soldiers of fortune in the intervals of the Hundred Years War. If he were lucky, he could, like Francesco Sforza, become prince of a city-state, or like Sir John Hawkwood be immortalized in fresco by Paolo Uccello (1396–1475) as the *condottiere* Giovanni Acuto. In France itself, in the intervals of official war, unemployed soldiers, the freebooters, swarmed across the country, working on their own account. No one was totally safe. They even threatened the pope himself in his citadel at Avignon. Innocent VI on one occasion bought off the freebooters with 40,000 crowns, a good dinner and plenary remission of their sins.

The armies put into the field were still massive, consisting both of knights and mercenaries, as they had since the 12th century, but warfare was changing. The mounted knight, the backbone of most previous armies, was no longer an invincible force. Lighter armed, regular troops were proving more effective in the field than the so-called "flower of chivalry". Besides, the introduction from the East of gunpowder and the invention of the cannon in the 1320s began to alter the whole concept of warfare. Castles, the symbolic stronghold of the knight, were replaced by forts, ammunition stores and sturdy supports for heavy cannon. Although the engineer now eclipsed the importance of the knight, the ideal of chivalry lingered. It was still, if imperfectly, represented by the Black Prince (1330–76) whose knightly fame in the Hundred Years War was offset by his barbarities as Prince of Aquitaine (1362–72) and still less perfectly by Henry V of England, with his unchivalrous, although highly successful soldiering, including the slaughter of French prisoners at Agincourt (1415).

By the mid-15th century the knight and all that he represented had had his day. The sense of futility began to affect even the long-established tradition of the tournament. Jacques de Lalaing, a Burgundian courtier, waited for a whole year to take on challengers at the "Fountain of Tears" at Châlons, but very few responded. Nowhere does such impotent bellicosity receive better visual expression than in the wistful and absurdly armored knights painted by Pisanello (1397–1455).

War meant death; and by the mid-14th century the effects of war were reinforced by the onset of the plague. Death became as much an obsession as chivalry. Funeral rites became increasingly complex, culminating in the elaborate obsequies of Philip the Bold of Burgundy. New iconographies of death began to emerge. The tale of the three living and the three dead was depicted on the walls of the Camposanto in Pisa, along with the Triumph of Death, a specifically Italian form popularized by Petrarch's *Trionfi* and also illustrated in the Palazzo Sclafani at Palermo, Sicily. The Dance of Death, as represented in the transept of the church of St Robert at La Chaise-Dieu near Lyon (1460), appealed strongly to the northern imagination. Tomb design evolved considerably. A simple representation of the deceased on a bier was no longer enough. Canopies over the tomb became highly elaborate. In England, in particular, tombs as such were superseded by whole chantries (small chapels with their own altars for prayers for the souls of the departed), culminating in the enormous two-tiered and richly decorated chantry of Prince Arthur, elder brother of Henry VIII, in Worcester Cathedral. Immense chapels, intended entirely as tomb chapels were added to churches: Henry VII's chapel at Westminster and the Capella Reale at Granada to house the

Choir vault, St Barbara's, *Kutna Hora, Czechoslovakia, 1489–1506 Matous Rejsek*

Work began on St Barbara's in 1388 when a site was cleared outside the city walls, however no work was carried out during the first three-quarters of the 15th century. In 1481 Master Hanuš undertook the construction of the aisles and nave but died before the east end was completed. He was succeeded by Matous Rejsek who was wholly responsible for the choir vault. In Germany and eastern Europe late Gothic vaults were treated with great fluidity. Ribs had no structural role and served only to create a decorative pattern, in this case floral motifs. Visual logic and the functional aspect of ribs was abandoned, and instead they flow into their supports without capital or abacus and some end abruptly, as if cut off in mid-air.

tombs of Ferdinand and Isabella, the first monarchs of united Spain. Sometimes powerful families went so far as to adopt and rebuild a whole choir as their mausoleum. Thus the Despenser family occupy the choir of Tewkesbury Abbey. They had need of the prayers of the monks for their souls, since most of them had managed to cram a large

number of sins, both personal and political, into their relatively short lives, and many of them had come to some particularly medieval sticky ends. In France and French Burgundy, tomb design concerned itself increasingly with the human rather than the celestial aspects of dying. The grief of those left behind was expressed with increasing poignancy by the weepers surrounding the bier. The full agony of death was portrayed in the moldering and worm-eaten effigy which often accompanied, sometimes constituted, the stone memorial of the dead. Where the dead were represented as they had been in life, new care was taken to convey a genuine likeness. The French royal tombs in the Abbey of St Denis near Paris, and Claus Sluter's tomb of Philip the Good at Dijon established the new style. In the next century it was elaborated still further in the memorial at Innsbruck of the Habsburg Emperor Maximilian who died in 1519: so it was appropriate that he should inherit Burgundian artistic traditions, too.

The new expressiveness and realism of the dead in effigy both reflected and encouraged the development of portraiture. Charles V of France, with his distinctive, prominent upturned nose, is one of the first figures of whom we have convincing visual representations, both in painting, in the manuscripts of Jean Bondol, and in the sculpture for the chapel of the Quinze-Vingts in Paris, where he was portrayed as St Louis. Jan van Eyck painted many portraits of courtiers and other distinguished men living in the Low Countries. Even the reliquary of Charles the Bold, made of enameled gold and studded with gems, presents a relatively life-like, and recognizeable portrait of its donor. If realism was an increasingly important element, especially toward the end of the 14th century, it was not a new element. Its roots could be traced in the Parisian

The Belleville Breviary *(1323–6)*
Jean Pucelle (d.1334)
Bibliothèque Nationale, Paris

By about 1320 Pucelle was the head of a workshop in Paris and was responsible for a major revival in the capital's artistic life. He was an important innovator, most notably in the design of calendar pages in manuscripts, the treatment of margin decoration and the introduction of Italian schemes on perspective in painting. The Breviary was written for Jeanne de Belleville but by 1342 it was in the Royal collection. Pucelle was much influenced by the late 13th century Parisian illuminator Master Honoré who influenced Jean Bondol. All three artists were responsible for the revival in Parisian manuscript illumination.

Bible Historiale de Charles V
Jean Bondol (active 1368–81)
Museum Meermanno-Westreenianum, The Hague

Jean Bondol inscribed this manuscript in 1371, presumably to mark its completion, because in this same year it was presented to Charles V of France. During Bondol's active period in Paris he led a revival of Parisian manuscript illumination which had been at a low ebb since the early 14th century. The scene illustrated is accompanied by a long inscription praising the King's wisdom, one example of the monarch's program to convince his aristocracy of his fitness and right to govern.

styles of the early 13th century, particularly in the way that foliage sculpture was handled. In the art of French Burgundy, however, invariably the real world is invaded by, and merged with, a world of fantasy. John of Bavaria, bishop of Liège, has himself portrayed by Jan van Eyck in the presence of, almost on equal terms with, the Virgin and Child, in a modern room which

overlooks his episcopal city. The representation of the Mont St Michel in the *Très Riches Heures* of the Duke of Berry is minutely observed; but it is presided over by St Michael himself, clad as might be expected, as a model of chivalrous knighthood. This peculiar combination of realistic observation with courtly fantasy proved so popular throughout European courts

Reliquary of Charles the Bold, *1467*
Gerard Loyer (c.1466–95)
Gold, silver gilt, rock crystal, enamel and paint
Height 21in (53cm), length 12¾in (32cm),
width 7in (17.5cm)
Treasury of St Paul's Cathedral, Liège,
Belgium

*Charles the Bold, Duke of Burgundy
(1467–77), commissioned this reliquary to
present to the Cathedral in Liège after having
largely destroyed the city. Liège had always
been troublesome for the Duchy and this
reliquary can be seen both as a peace offering
and as a sign of the Duke's pleasure at his
success. Charles is shown kneeling in front
of Burgundy's patron saint St George with
a gold and rock crystal reliquary in his hands.*

in the late 14th and early 15th centuries
that it has become known as the International
Gothic style. The same delicate
balance of realism and courtly
fantasy had already been adopted in
the literature of the 14th century. It
dominates Chaucer's *Troilus and Criseyde*,
written in the 1370s for the court
of Edward III of England, while the
aching sensual passion of Petrarch
(1304–74) for Laura, a real woman who
was subject to eye infections and the
passing years, was very different from

Dante's idealization of his insubstantial
Beatrice, written by about 1293.

Italy was, indeed, the source of
certain sorts of realism, especially in
the field of painting. France and Burgundy
(which under its Valois dukes
was, culturally as well as politically, in
effect a French colony) retained their
artistic supremacy of Europe, but there
was more interaction with, if not yet a
real challenge from, Italy. Northern
Europe had always looked to Italy to
some extent as guardian of the heritage
of Rome. But gradually during the 14th
century the north began to be aware of
their Italian contemporaries. The delicate,
swaying, Byzantine style of Duccio
(*c*.1255–1318) and the Sienese painters
had already, at an early stage, reinforced
the northern Gothic development
in the direction of the exquisite.
It .is already apparent in the Westminster
retable (which might have been
produced in Paris); and it has been
shown that Jean Pucelle, the foremost
Parisian manuscript painter of the early
14th century, knew some of Duccio's
work well. The influence shows not
only in the arrangement of the figures
within the painting, but also in the
attempt to depict space in a realistic
manner. Italy had, at the same time, a
very different artistic tradition to draw
on. This was the tradition which had
never totally lost touch with its Roman
and Early Christian roots, a tradition
which had retained a certain realism,
and a strong narrative emphasis, and
a sense of solidity of bodies. It had
flowered at the turn of the 11th and
12th centuries with the sculptor Wiligelmus
of Modena (active 1099–1106),
and with the sculpture of Benedetto
Antelmi between 1178 and 1233, mainly
at Parma, and had continued in the
13th century in the work of Niccola
Pisano and in the 14th century with the
painter Giotto. Here again, the Italian
contribution was to encourage realism
in general and in the depiction of space

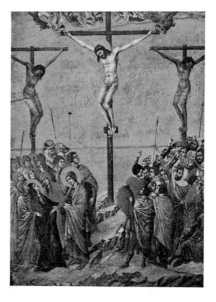

Crucifixion, *from the* Maestà, *1308–11*
Duccio di Buoninsegna (c.1255/60–
1315/18)
Tempera and gilt on wood panel 40×29in
(100×75.7cm)
Museo del Opera del Duomo, Siena

*Details of Duccio's life have been pieced
together from contemporary records, but the
attributions for the body of his work are
based on the two known master works, the
Rucellai Madonna (1285), for which the
commission is documented, and the signed
series of panels showing the life of Christ:
scenes from the life of the Virgin and the
large panel of the Virgin and Child
enthroned that gives the whole work the
title of Maestà. The separate paintings
formed one large altarpiece, decorated on
back and front. The altarpiece was
dismantled and about fifty-four paintings
survive from an assumed total of seventy.
The* Crucifixion *formed the central panel of
the back section, originally surrounded by
scenes from the Ministry and Passion of
Christ. Duccio's contract for the work,
drawn up in 1308, specified that he should
undertake no other commissions during the
period of its execution and for this he was
awarded a daily salary. There is
documentation of the date in July 1311
when the work was moved from Duccio's
studio and enshrined in the cathedral at
Siena.*

in particular. It is clear that some of the northern artists were well acquainted with some of the paintings of Giotto and his followers: De Limbourg's representation of the *Presentation of the Virgin* is, for instance, a copy of Taddeo Gaddi's (d.1366) Florentine fresco.

The influence was by no means all from south to north, indeed it was rather the opposite. Simone Martini's painting shows definite French influence, and in the early 15th century the International Gothic style had tremendous impact in Italy. This was only to be expected in the Viscontis of Milan (they had, anyway, married into the French royal house), but it was equally true in the great republican cities of Venice, where Pisanello was employed; and Florence, where the most expensive commission of the early 15th centuries must have been Palla Strozzi's for the *Adoration of the Magi* by Gentile da Fabriano (c.1370–1427). Where sculpture was concerned, French influence is apparent in the work of Niccola Pisano's son Giovanni. In architecture, France was more dominant still: Orvieto Cathedral, San Francesco at Assisi, and Milan Cathedral all owe much to French architectural design.

Italy was certainly more deeply involved in affairs north of the Alps than ever before. In 1309 the papacy moved its headquarters out of Rome – which had become unsafe due to the barbarity of its cut-throat nobility – and took up temporary residence at Avignon. This town did not at the time belong to the king of France (to whose bullying several popes had been subjected) and offered the popes a refuge which was strategically placed between the various powers. Here the popes were to remain for some seventy years. At Avignon they employed French masons and sculptors, but Italians, such as Simone Martini (c.1284–1344) and Matteo Giovanetti (active 1322–68), as painters, at least for the most important tasks. French taste is certainly apparent in the elegant figures and atmospheric gilded backgrounds of Simone Martini: but his influence in France seems to have been negligeable. Avignon, important bureaucratic center though it became as the papal political machinery grew more complex and all-embracing, was rather on the edge of the Franco-Flemish cultural sphere.

Italian traders and bankers seem to have been more important in the maintenance of relationships across the Alps. By the mid-13th century Italian merchants had replaced the Jews as the bankers of Europe. Their position was assured by the striking in 1252 of the first florin (named after Florence), which became the standard international coin of exchange in Europe. There were occasional disasters, like the crash of the firm of Peruzzi in 1339, and the Bardi in 1346, both causing international chaos; but in general the efficiency and extent of the Italian bankers differed from their northern counterparts, the Flemish merchants, in that they traveled. The Flemish towns did not extend their interests beyond industry to commerce in the way that the Italians did. The Italian merchants, many of them resident in Flanders and France, brought northern painting home with them.

There were signs of Italian consciousness of the Roman heritage quite early in the 14th century. Petrarch was important, not only for his enchanting vernacular love poems, but for his pioneering interest in the Roman past. While his contemporaries used medieval Latin, he modeled his prose on Cicero and had himself crowned poet laureate, after the Classical manner, on the Roman Capitol. By the later 14th century interest in the special nature of the Italian past was not restricted to poets and scholars. In 1347 there was unrest in Rome – as there was in many cities in the economic depression of the time. Cola di Rienzi (1313–45) announced the re-establishment of the Roman Republic and set himself up as tribune of the people. It was, needless to say, a short-lived disaster – Rienzi lived deeper in a dreamworld of chivalrous fantasy than any Burgundian knight – but the consciousness of Italian identity and of a special relationship with Classical Rome was abroad. In the end it helped to persuade the popes to bring their spiritual authority back to Rome in the 1370s.

The last flowerings of the Gothic style in the 15th century begin to reflect the development of some sort of national consciousness. In this Italy was not alone: it was a general European movement. The chapels produced for the early Tudors in England after 1485 are covered in tracery of unprecedented intricacy, but the buildings themselves are just boxes. The plateresque ("silversmith") ornamentation of late Gothic buildings in Spain was heavily over-wrought. In eastern Europe, especially in Poland and Bohemia, extraordinary vault formations, with ribs that disappear or suddenly stop, became fashionable. Self-conscious, weighed down by their own intricacy and elaboration, these are the designs of a dying style, but in them there are sometimes signs that the times were changing. The basic box shape of the Tudor chapels presaged the clarity, the emphasis on human-scaled rooms for living in, of the new age. The extraordinarily dense and intertwined sculptured details of the Portuguese style of architecture known as Manueline (after King Manoel I, 1495–1521) are newly drawn from the iconography of the sea – seaweed, sea anemones, nautical cables – and reflect the excitement due to the success of Portuguese navigators from 1415 on-

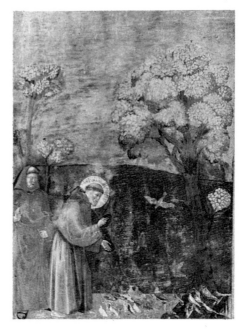

Pistoia Cathedral Pulpit, *1301*
Giovanni Pisano (c.1245–1314)
Marble and stone

Pulpit-making was in Giovanni's blood: his father Nicola carved pulpits for Siena Cathedral and Pisa's Baptistry. Giovanni's style seems to show an awareness of the Classical sculpture at Reims Cathedral and French court sculpture in general, as well as the native tradition of "classicizing" practiced by his father. He differed from his father, however, in separating his figures to allow the alteration of light and shade and to more fully suggest a background. Pisano was proud of his own abilities as the inscription on the pulpit indicates "Giovanni carved it, who performed no empty work. The Son of Nicola, and blessed with higher skill, Pisa gave him birth endowed with mastery greater than any seen before".

Scrovegni Presents the Chapel, *1303–6*
(Detail of the Last Judgement)
Giotto di Bondone (c.1276–1337)
Fresco wall size: 32½ × 27ft (10 × 8.4m)
The Arena Chapel, Padua

In 1303 the Scrovegni family began the building of a chapel attached to their palace to serve as a church for the religious order of the Cavalieri Gaudenti. Records show that gifts of money and materials were donated for the chapel, but the project was principally organized and carried through by Enrico Scrovegni. Giotto's reputation was already well established in Rome and through his work on the life of St Francis in the church at Assisi. He was entrusted with the large cycle of frescoes for the decoration of the Arena Chapel. The architectural framework of the interior was uncomplicated, allowing the painter a free hand in the arrangement of the frescoes The paintings show the stories of the lives of Joachim, the Virgin Mary and Christ. On the west wall of the Chapel is the large fresco of the Last Judgement. It is thought that the building of the Chapel was partly motivated by the need to atone for the sin of usury, an earlier practice of the Scrovegni family, and Scrovegni's humility is here recorded in the painting

Scene from the St Francis Cycle, *c.1300*
Giotto or followers
Fresco
Upper Church, Assisi, Italy

Giotto, the most highly paid painter of his time, is traditionally attributed with the execution of a cycle of frescoes in the upper church at Assisi although some think they were by his followers. The frescoes illustrate the life of Francesco Bernardone, St Francis of Assisi. After a wealthy upbringing in Assisi, St Francis rejected his family's affluence in favor of a life of total poverty. He soon acquired followers and the Franciscan Order was founded in 1209. The church at Assisi became the focal point for the Order and by c.1300 the poverty practiced by St Francis had been severely compromised by the splendid decoration in the church.

ward. By 1486, they had reached the Cape of Good Hope and their skills and experience were available to Christopher Columbus when preparing his great voyage of discovery in 1492 (although Portugal missed out on the sponsorship of the discovery of America, which was taken up instead by Spain). In 1497, Vasco da Gama set sail for India, and another squadron of Portuguese explorers reached Brazil in 1500. The New World had been irrevocably opened up to the Old.

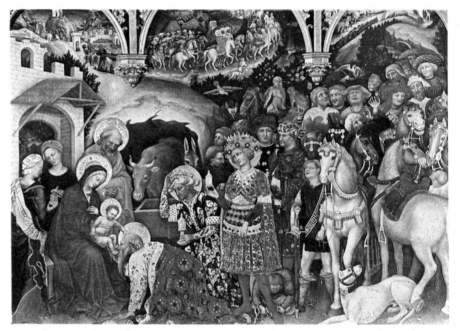

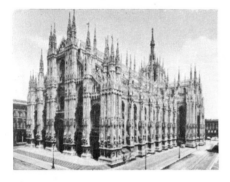

Milan Cathedral, *1386–1485*

The intention in 1386 seems to have been to build a cathedral to rival the largest found in France and in that same year a building council was set up to carry out the project. The local building tradition, however, was for simple, unadventurous structures that only rarely incorporated flying buttresses and problems arose almost immediately. The foundations of thr Cathedral had already been laid before a foreign adviser was called in and between 1389 and 1392 a French and two German architects were in turn consulted and then sacked. In 1391 the mathematician Gabriele Stornaloco was consulted on structural problems and three conferences were held in 1392, 1400 and 1401 to determine which proportional system should be used in the design of the elevation. The first scheme of 1392 was chosen and finally executed after fifteen years of wrangling.

The Adoration of the Magi, 1423
Gentile da Fabriano (c.1360–c.1427)
Panel 118×111in (300×282cm)
Uffizi, Florence

Gentile da Fabriano traveled a good deal in Italy during his lifetime. Evidence shows that he was working in Venice by 1408; by 1423 he had made his way to Florence but at the time of his death was at Rome painting frescoes in San Giovanni in Laterano. In the meantime he had also stayed at Siena and Orvieto. His influence on Italian painting cannot be fully assessed since so much of his work has been lost, but he certainly affected the styles of Fra Angelico, Sassetta, Gentile's pupil Jacopo Bellini, and Pisanello, who was responsible for finishing the frescoes in Rome after Gentile's death. The Adoration of the Magi *is considered one of the finest examples of International Gothic painting, exemplified in the complexity and delicacy of the detailed design. It formed the main panel of an altarpiece. In the predella were panels showing the* Nativity, the Flight into Egypt *(both still in Florence) and the* Presentation at the Temple *(Louvre, Paris). Vasari, the 16th-century artist and art historian, suggested that the* Adoration *contained a self-portrait by Gentile and this is taken to be the figure seen in full face directly behind the king standing at the center of the composition.*

The Cultures of Asia

Introduction to Islam, India and the Far East

The art of Western Europe is, generally speaking, much concerned with the present world of men and with a historical past conceived as continuity with the present. The Christian Church has been the major patron of the arts, and the greatest private patrons have been Christians. Christianity is a historically based religion; its central figure, as the incarnation of the Creative Word, lived a life defined by the New Testament within a specific time and place in a small world which was only a few thousand years old, and expected to end quite soon. Hence representations of the Christian legend in art were bound to emphasize the solid here-and-now value of their figures. While it is true that Byzantine tradition made much of transcendental aspects, this tradition was specifically rejected by the Gothic and Renaissance traditions. Both of those came to stress the idea of the present as part of a factual history punctuated by the central fact of the life of Christ. In art their personages were invested with a sense of individual weight and present reality. This led artists to a careful study of visual appearances, in the end for their own sake.

The arts of the East have quite different aims and intentions. Islam was also based on revelation which took place at a known time and geographical spot, but as it was a revelation to Muhammad of the transcendent God (Allah), there was no doctrine of incarnation, and so worldly reality was given no intrinsic value in Islam. Religious art in Islam is devoted first to transcribing the Word of God as recorded in the Q'uran; second to symbolizing the world of the archetypal and mathematical forms through which God's creation is mediated and which

is the furthest towards God that the perceptive intelligence of humans can reach. Hence what to the Western eye seems to be mere decoration, to the Muslim eye can seem the acme of perfection.

Whatever Muslim figurative art there is was made for personal pleasure. Poetic and scientific texts and stories were illustrated for connoisseurs. Historical miniatures were painted to satisfy the family pride of rulers. Religious scruples prevented these images from making any claim to "realize" an actual present. They preserve the Muslim character of finely crafted ornament.

The main religions of the further East, Hinduism and Buddhism, devalue the here and now. Since the earliest times they have offered a vision of the Cosmos as being vast beyond human imagining, and they have seen human life as an entanglement in the misery of repeated existences, from which, however, it was always possible to escape. The great religions taught the avenues of escape, and the iconography of the arts usually dealt, in one way or another, with an imagery of the beyond, the timeless and placeless, Hinduism centered on deities, to whom vast numbers of shrines were erected in India and Southeast Asia, decorated with illustrations of their mythologies. These deities represented in human shape the transcendent principles that create the worlds, sustaining them in existence and then destroying them over vast cycles of time. Partly by approaching the deities directly, individual beings might eventually achieve release from the prison of the here and now entirely.

Buddhism was founded by a teacher called the Buddha, meaning "the Enlightened One", who refused even to discuss any transcendent principle. He

demonstrated that release, *nirvana*, was to be obtained by totally abandoning all attachments to things, self, feelings, concepts, even to any idea of a transcendent principle itself. The tens of thousands of Buddha images which were made all over India, Southeast Asia, China and Japan thus embody a merely convenient teaching notion: each image symbolizes the nature of the Buddha in the condition of emptiness which an individual who reaches it may realize to be something like a cosmic radiance.

Japan assimilated Buddhism to its own native culture and social system, Shinto, and has remained nominally Buddhist to the present day. China accepted Buddhism, with its visions of vast bubble-like cosmoses, only intermittently. Chinese native traditions remained extremely powerful, notably in the form of Confucianism which taught a plain doctrine of the individual's filial responsibility to family and ruler, and which demanded an art that merely illustrated the exemplary behavior of men and women of the past. The more mystical tradition of Taoism taught the necessity of harmonizing one's behavior with the currents of change appearing ceaselessly within the whorls of a continuously changing and vanishing unity, called the Tao. The linear and calligraphic arts that expressed the Tao reached very high levels, and the characteristic vistas of immense cloudy landscapes which represent the highest achievements of Chinese painting are intended as comprehensive symbols for the working of the Tao through nature. The here and now, whenever it was represented, was never shown as a definitive and valuable present, but as only a moment in a shifting and vanishing panorama.

The Islamic Civilization

The word "Islam" means "submission". It is the name of a religion founded by one man, the prophet Muhammad, who declared that the One God had spoken to him the words of the book that is the focus of Islam, the Q'uran (Koran). Submission is to the word of Goc, Allah, and to the laws and customs that Muhammad and his earliest followers derived from the word of God. The followers of Islam are called Muslims.

Islam is also the name of a vast cultural empire, unified by religion, that was won almost entirely by force. Islam did not spread by religious conviction alone. Muhammad was not only a prophet and law-giver whose role was the re-establishment of the ancient religion of Abrahm; he was also a vigorous leader and a highly skilled general. His combative nature is reflected in many of the stories told of his life.

Muhammad

Muhammad was an Arab, born in around 571 AD in Mecca, of the Hashimite clan of the Q'uraush tribe. Although Arabia was populated mainly by nomadic desert people whose way of life was similar to that of the Bedouin today, there were also cities settled and populated by people of the same race. Arabia was crisscrossed by trade routes. Mecca lay at the intersection of two of the most important of these, one running north and south from Syria and Mediterranean Palestine towards the Yemen; the other from west to east from the Red Sea coast to the Persian Gulf. Of the two major powers that ruled the world at that time, the Byzantines, who dominated Syria, saw themselves as inheriting and continuing the Roman Empire, by then some thirteen centuries old. The other power was the Sassanian Empire. They ruled Iran and large parts of Mesopotamia and claimed to

be heirs of the ancient Achemenid empire of Persia that had dominated a large part of the ancient Greek world. A third major force was Abyssinia, whose Christian rulers made occasional forays from Africa into southern Arabia.

Between these powers lay the land of the Arabs, many of whose inhabitants were Jews and Christians, both Orthodox and Nestorian. The Nestorians shared with the Sassanians a belief in the creative forces of good and evil, but the Arabs worshipped a variety of deities. Some of these were the spirits of sacred places, and some versions of far older Mesopotamian and Syrian gods and, especially, goddesses. It was this multiplicity of deities that Muhammad aimed to eliminate and in their place establish the worship of the One God, Allah. Islam, however, shared the Old Testament with Jews and Christians alike and on the whole treated the followers of both of these monotheistic religions with the same tolerance. But it regarded both as inadequate: Judaism because it stopped with the Old Testament and Christianity because it failed to realize that, although Christ was a prophet recognized in Islam, his message had been superseded, or at least completed, by Muhammad.

Muhammad heard the voice of God in a lonely place near Mecca to which he used to retreat and recounted what was said to him to a small group of followers. At some point the word of God was written down in a series of disconnected chapters, called *Suras*, which constitute the Q'uran. The Q'uran was written in Arabic and every Muslim studied it in the original language, whatever his own might have been. This made the Q'uran a powerful unifying factor and it became the matrix of all Muslim culture. Because it was the vehicle of the word of God, calligraphy, handwriting in a variety of scripts, became the fundamental art form of Islam. Quotations from the

Muslim Calligraphy

From top to bottom:
Simple Kufic, *from an Egyptian tombstone, 790 AD. It has straight vertical strokes and angular letter-forms.*
Foliated Kufic, *from a tombstone at Kairouan, Tunisia, 952 AD. The vertical strokes end in leaf-like shapes.*
Floriated Kufic, *from an Egyptian tombstone, 848 AD. The letter-strokes terminate in elaborate floral shapes, the letters are framed in rectangular principal strokes, and some are trated as rosettes.*
Naskhi, *from an Egyptian tombstone, 1285 AD. A more cursive script. Words may be placed above each other in the same band of writing.*
Thuluth, *from the drum of the mausoleum of Princess Tughai (d.1348 AD) in Cairo. This is even more cursive than Naskhi, and emphasizes the varied shapes and lengths of the lower horizontal curves.*
Nastaliq, *from a manuscript of Sa'di's Gulestan, Bukhara, 1543 AD. The layout is as cursive as the strokes, with exaggerated rounded shapes and dots casually placed.*

Q'uran decorate a vast number of artifacts, from architecture to swords,

gems and ceramics; and every Muslim hears the rhythmic incantation of the Q'uran in Arabic every day of his life.

Muhammad gathered around him an increasing number of followers who promulgated his beliefs with increasing vigor. The rulers of Meccan society began to resent his influence and his objections to their reverence for their own gods and goddesses, in many of whom their tribal identities were rooted. At first Muhammad's followers were persecuted and, eventually, open conflict broke out with Muhammad and his followers besieged within Mecca. The city of Yathrib, now known as Medina, offered Muhammad refuge and in 622 he left Mecca. This journey is called the *hejira* and 622 is used throughout Islam as the base-date for Muslim chronology, just as the birth date of Christ is used in the Christian world.

From Medina Muhammad started a series of campaigns against Mecca, finally conquering it and making it the center of Islam. Its most holy object, the Black Stone, or *Ka'aba*, is still the goal of the pilgrimage that every Muslim is supposed to make at least once in his life; all other idols were destroyed. Muhammad began exerting pressure, backed by military force, upon the rulers of neighboring countries and when he died in 632 he was mounting a campaign against Syria.

After Muhammad's death, Islamic military expansion gathered extraordinary momentum with Arab leaders conquering and looting Palestine and Iraq; occupying Syria in 636, Mesopotamia in 637 and Egypt in 642. They went on to seize Iran, Afghanistan, western Turkestan, North Africa and southern Spain. In every country they converted the majority of the population to Islam by every possible means; within a century the Muslim empire extended from the Atlantic Ocean to the borders of China.

The Muslim invaders of these countries did not bring with them a fully developed artistic style to impose upon the conquered. Instead, they adopted and adapted the architectural and decorative styles of each region to produce what was needed within Muslim life. This generated quickly an extraordinary artistic uniformity over the entire Arab empire, although, of course, there were distinct stylistic differences within Muslim art. When, in later centuries, non-Muslim peoples, such as the Turks and Mongols, invaded areas previously Islamic they were converted to Islam and adopted Islamic arts, contributing major stylistic strands of their own.

The nature of Islam is to adhere closely to the original text of the Q'uran. It governs its entire social and domestic life according to the Hadith, the recorded sayings of the 7th-century prophet. Hence Islam has an inbuilt conservatism; the old and established is the criterion whereby the new is judged. For many centuries Islam had no interest in the non-Muslim world save in warfare at the frontiers between the two. Thus the general appearance of Muslim art, and the principles according to which it was produced, changed remarkably little after the earliest phases of regional assimilation.

This was also true of the general culture that Islam built with the work of its non-Arab predecessors. Byzantine engineering, Indian mathematics, Greco-Egyptian philosophy, all were enlisted into the structure of Islamic thought. Some were, of course, in need of more adaptation than others; but the criteria applied were all to do with absorption into the rigidly controlled Arab life-style.

There is one marked feature of Muslim culture and art: the art to some extent exemplifies the life. In addition to calligraphy, the other major component in Muslim art is its absolute reliance upon symmetrical geometric patterning. This is not accidental and can be explained only partly by reference to the older abstract ornamental styles of inner Asia. It is a cultural phenomenon in its own right and is intimately connected to Islamic ideas about God and His relation with His created world.

The works of Plato and Aristotle were well known by the Muslims in Arabic translation, as were other Greek authors, including historians, mathematicians and astronomers. It was from the Arabic of Muslim writers who had absorbed the heritage of the Eastern Roman empire that Western thought first learned the tests of Greek philosophy. Mathematical skills also reached Europe from India through the intermediary of Arabic, but once Islam had formulated its own cultural scheme by about 1000 AD it ceased to have any

Façade of the desert fortress of al-Mushattah. *The Jordan valley, south of Amman, early 8th century AD.*

This lavish cut-stone ornament is based upon Classical prototypes, but the design and some of the motifs are Oriental, illustrating the double origins of Ummayad art.

The Caliphate

By 1000 AD Islam embraced a multitude of small kingdoms focused upon great cities linked by a system of well-established trade roads. The custom of pilgrimage to Mecca ensured that every Muslim had at least some idea of the geographical extent of Islam, as well as its meaning. That meaning was brought home to him every day by the statutory periods of prayer he observed at set times, theoretically five, but sometimes in practice reduced to one, at sunset. This is still observed today. At that time of day Muslims assemble in their local mosque, the main focus of Islamic architecture. Essentially the mosque is a large enclosure, roofed in part or wholly, and may be decorated in a variety of styles, always including quotations from the Q'uran. The wall facing Mecca is called the *qibla* wall and is distinguished by a niche called the *mihrab*, before which hangs a lamp. At prayer times Muslims bow in unison towards Mecca and pray. There are no priests in Islam, but learned men who know the Q'uran and the laws by heart may lead the prayers. The basic Islamic declaration is, "There is no god but Allah, and Muhammad is his prophet."

Figurative representation was not always banished from Muslim art. It is true that icons of deities were forbidden and that in certain places at different times all but the most basic botanical figuration was eliminated, and in mosques no figuration is permitted. Through much of Muslim art, however, there runs a rich tradition of pictorial imagery. Wall paintings, miniatures, pottery and metalwork may be filled with human and animal figures. Low-relief may be used, but, except in the very earliest dynasties and occasionally in India, three dimensional figurative sculpture was not made. This may

have been because of the pronouncement in one of the Hadith that any maker of images will be severely punished on the Day of Judgement because he has attempted to imitate the one Creator.

All Islamic art tends to emphasize pure surface through decorative treatments that transform the object into an abstract order of reality; the world of art is not a reflection but a transformation of real objects. Order and tranquility go together and in this way Islamic art expresses the central idea of the Muslim religion. In Muslim art little religious iconography exists in the Christian sense, but there is a wealth of purely symbolic reference.

The first kingdom of Islam was in Syria-Palestine. After the death of Muhammad there was a struggle between factions to determine how the prophet's leadership should be passed on. Islam did accept that government should spring from the Prophet's lineage. But a split developed that has divided Islam ever since. The first caliphs were members of the family that emerged triumphant, the Ummaya, who moved their capital from Medina to Damascus. The Ummaya built their first major monument in Jerusalem, the city sacred to both Jews and Christians, as a direct challenge to those two faiths, which Islam claimed to supersede.

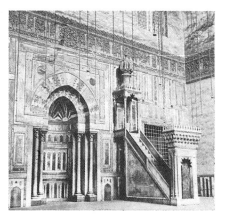

It is called the Dome of the Rock and is an octagonal shrine surmounted by a raised dome with interior colonnades and arcades. Although its ornament was altered substantially much later under the Ottoman Turks, it is basically a late Greco-Roman building clad in fine Byzantine mosaics. It illustrates the pattern followed by Muslims in the territories they occupied, that of taking and modifying to Islamic purpose the arts they found flourishing there.

The great Ummayad mosque of Damascus was actually built within the remains of a Roman temple between 705 and 715. It added to the original enclosure a three-aisled hall against the *qibla* wall. During the 8th century in the Jordan valley, the Ummayads also used Roman ideas for economic purposes. Large areas of what are now desert were brought under cultivation by means of a string of "desert palaces" modeled upon Roman frontier forts. Each formed the administrative nucleus for its area, organizing irrigation and the collection and distribution of produce. Both the mosque and the same palaces even contained Roman-type baths. The Oriental element appears in the elaborate geometric and curvilinear foliate ornament carried out in plaster and carved stone both inside and outside the main buildings. Other palaces in the region followed similar

Main hall of the tomb-madrasah of Sultan Hasan, *Cairo, 1356–1363.*

The Mihrab-niche is framed in pillars of Classical derivation. The pulpit is beautifully designed and the relief inscription around the walls is in Floriated Kufic script, with added scrollwork. This qibla wall achieves a fine unified design.

purposes and patterns.

The chief problem of the Ummayads was to conciliate and integrate the tribes of their empire; and the means chosen was continual wars of expansion, with the opportunity they offered for looting. The central authority was also consolidated, but internal conflicts eventually proved too much for the dynasty and by about 750 the caliphate dissolved. A branch of the family continued to survive in Spain, forming a nucleus around which gathered the remnants of Ummayad supporters. Spain thus remained to some extent integral and aloof from developments that followed elsewhere in the Muslim world.

In 750 the Abbasid dynasty took over the caliphate and moved their capital from Damascus and Syria to Iraq. In 792 the caliph al Mansur founded the first great city built entirely by Muslims at Damascus on an ancient Oriental plan and it was heavily fortified. The greatest of its rulers was the legendary caliph Harun al-Rashid (786–809). The Abbasids ruled in title until the middle of the 13th century, when their last caliph was killed by invading Mongols during their sack of Baghdad in 1258. The empire, however, had begun to break up long before. Early in the 9th century the Abbasid capital was

moved yet again to Samarra on the Tigris River. From the 9th century onwards, Turks gradually came to dominate the caliphate and large regions of the Asiatic Muslim world; thus the craftsmen of other races who worked for their vast courtly entourages were obliged to assimilate central Asiatic elements into their styles, including figural themes from Buddhist central Asia. This combination marks the Abbasid style.

According to literary descriptions, Samarra was probably the most magnificent city Islam ever built. Only two mosques survive and one of them, the al-Mutawakkil, is the largest known. Its great minaret, a circular tapering tower on a square plinth, is 89 feet (27m) high, and encircled by an external spiral staircase. The palace lay beside it, a huge complex covering over 432 acres (175 hectares). Its halls and courts were filled with fine decorations including both stucco and painted figurative work. Fragments of these have been excavated, and their quality is unmistakable. At Ukhaidir, 120 miles (193 km) south of Baghdad, a smaller palace survives, and with its geometrical stucco vaults is reckoned one of the most beautiful buildings of Eastern Islam. The Abbasid concept of the palace and of statehood were derived

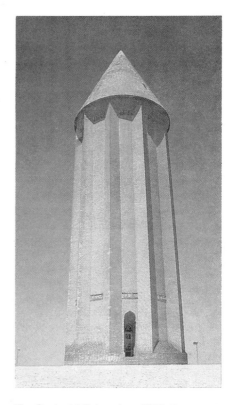

The Gunbad-i-Kabus, *Iran, 1006–7*
Erected by a minor king near Gurgan, this was a proclamation of royal command. He intended his sarcophagus to hang inside. It is over 200ft (67m) high, built of brick on a star plan, crowned by a massive cone. Similar towers were then common in Central Asia and Iran.

The al-Mutawakkil mosque, *Samara, Iraq, 9th century*

The largest mosque ever built, in the now-abandoned Abbassid capital. The court resembles a fortified enclosure, and the minaret from which the faithful were called to prayer stands separate, encircled by its external spiral staircase.

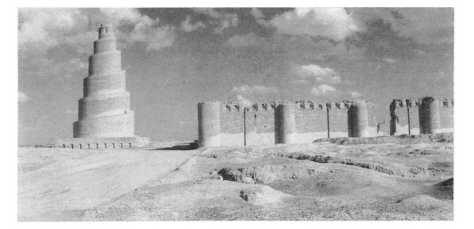

almost certainly from the pre-Muslim Sassanian empire of Iran. The fine early ceramics of Baghdad, Samarra and other cities, however, probably owe much to the arrival of Chinese potters, brought across Asia by the Turks. Lustered designs seem to have been a speciality during the 10th century.

During the high period of Abbasid culture at Baghdad, local dynasties in Iran, central Asia and Khorassan established cultural centers of their own. A unique building, the Gunbad-i-Kabus (1006–7), was erected by a minor king in north-east Iran. This is an extraordinary brick tower over 200 feet (60 m) high based on a star plan and crowned by a massive cone. It was intended purely as a declaration of royal command.

The principal motive behind most of the major arts of Islam was to proclaim the splendor of patron families, individuals and dynasties. Mosques, as religious buildings, testified by their magnificence to the piety of their founders. Tombs and cities testified to their power, while the lesser arts commanded the highest degrees of luxury and food for the imagination. Since the Muslim religion is sharply limited in

The Ummayad mosque, *interior and plan*
Córdoba, Spain,
founded 785 AD (subsequently enlarged)

The mihrab-chapel was erected in 965. The mosque-roof is supported by eighteen double-storied arcades decorated with carved plaster, marble and mosaic in lace-like designs.

its revelations, sayings and laws, the arts were, in one sense, bound to the service of anyone who could command them, rather than to the demands of an elaborate religious iconography decreed by a hierarchy.

Spain and Egypt

Probably the outstanding Muslim monument of the entire early epoch is the great mosque at Cordoba, Spain, built during the late era of western Ummayad rule when that city was their capital. The mosque represents the extraordinary culmination of a tradition that had begun in North Africa as early as the 8th century. At Kairouan,

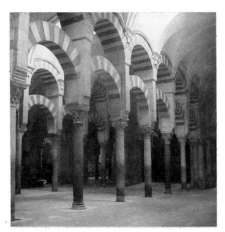

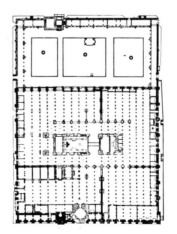

Tunisia, the great mosque, which still stands, had been built on the Arab court plan but had incorporated into its structure pillars and capitals from pre-Muslim Roman buildings. Its minaret is a massive square tower. In 1086 the rulers of Morocco invaded Spain to assist the Ummayad rulers against the Christian king of Castile. As a consequence, Andalusian administrators, architects, scholars and musicians came to refresh the cultural life of Morocco.

Gradually, however, Spain was lost to Islam. Its first major defeat by the Christian kingdoms was in 1212; but its greatest work of monumental art, the palace of the Alhambra, Granada, was built in the 14th century. The many courts, halls and corridors are roofed with fantastically elaborated stalactite vaults, its walls and slender pillars dissolving into a lacework of delicate ornament.

Even Sicily had been seized into the Egyptian empire and remained Muslim until the Norman reconquest of 1061. With the coming to power in Cairo of a dynasty called the Fatimids (969–1171), who claimed descent from the prophet's daughter, Fatima, a great era of splendid building was initiated. Unfortunately, nothing survives of the two vast Fatimid palaces that once faced each other across an open square in Cairo. The earliest Fatimid mosque, al-Azhar (1070–2), is of particular importance, being the university that set the pattern for universities of the entire Western world. It was preceded only by the Indian universities of Nalanda and Vikramashila.

A most important development was the increasing use of carved calligraphy applied to buildings. Al-Akhmar's façade, added in 1125, bears two bands of fine script, and thereafter most Cairene monuments are lavishly decorated with inscriptions, mostly quotations from the Q'uran, framing windows, spreading across façades,

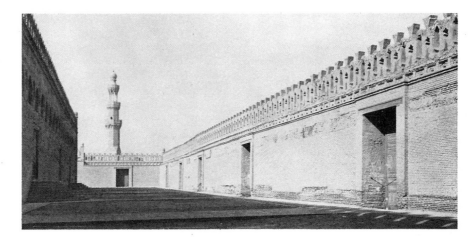

Mosque of Ibn-Tulun, *Cairo, completed 879.*

This view of the inside of the great surrounding wall shows the scale of the building. Ibn-Tulun was a ruler of the Fatimid dynasty, and the mosque is based upon those of Abbasid Samarra.

and banding minaret towers. Fatimid minor arts survive in relatively large numbers and mostly reflect the undoubted self-indulgence of rulers and the rich: splendid ivory casket panels, cut-glass, lustered ceramics, bronze utensils and silverware.

Egypt ruled the Holy Land and captured Jerusalem, but strife between the two sects of Islam eventually weakened the Fatimid empire. The last emperor was an eccentric who declared himself to be God and persecuted Jews and Christians, destroying the Church of the Holy Sepulchre in Jerusalem. This brought upon him the Crusades from Christian Europe. Jerusalem was taken in 1099 and an expedition against Egypt was mounted in 1118. The famous series of political murders carried out by the Assassins from mountain strongholds in Syria and Iran helped to demolish the empire. The survival of Egypt as a Muslim power was due largely to the efforts of Salah ad-Din (Saladin), a Kurdish officer sent by the Turks of Iran to co-ordinate resistance to the Crusaders.

The Seljuq Turks
A great era of elegance and refinement in the arts in western Asia took place under the Turkish dynasty of the Seljuqs (Seljuks).

The Turks were generally groups of ferocious tribal peoples, many of them nomadic, who had spread over large tracts of central Asia. They had first established a unified kingdom during the 5th and 6th centuries in the vast region between the Caspian Sea, the Pamir mountains and the Tarim river basin. In the 11th century the group now known as the Seljuqs saw political advantage in allying themselves with the merchant urban classes of the Muslim empires of inner Asia and associating themselves with the dominant religious sect. Towards this end they encouraged expansionist wars as a means of diverting the energies of other Turkish tribes with whom they were allied, particularly into Armenia and Anatolia, provinces of the Christian Byzantine empire. By this means they broke the power of Byzantium and captured the emperor. At the end of the 11th century the Crusaders came to the rescue of Byzantium in the name of Christianity, at the same time pillaging it without mercy.

The earlier Seljuqs were illiterate and relied heavily upon Iranian administrators and scholars. During the era of peace established under the protection of their military power, however, learning, the arts of Islam and the artistic creativity of the peoples they had

protected flourished, especially in the cities of Iran and Iraq. The architecture of the Seljuq mosque.was developed to provide for the accommodation of *madrasahs*, religious schools, as the basis for a high level of public education. One very famous scholar, al-Ghazzali (*c.*1111), a kind of Muslim St Thomas Aquinas, was a teacher in a *madrasah* in Baghdad. His theological works were revered for centuries and the influence of his teaching survives today. Also under the Seljuqs a reconciliation took place between strict orthodox Islam and the inspired mystical orders of Sufis, enabling Sufi missions for the first time to establish themselves not only in cities but in towns and villages of the countryside. The Sufi influence also spread across North Africa into Spain, where ibn 'Arabi (d.1244), another great teacher, grew up; he traveled widely, settling in Damascus. Many Muslim craftsmen and artists to this day owe their inspiration to the doctrines of Sufism.

The Seljuqs were great builders. During the period of their rule a vast number of mosques were constructed that established the pattern for later buildings to modern times. Earlier mosques in Iran had followed the Arab pattern of a simple open court, but under the Seljuqs the Iranian mosque

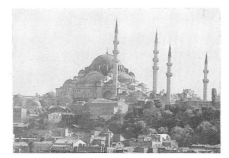

Mosque of Sultan Suleiman, *Istanbul, Turkey, c.1550*

This is the finest work by the Ottoman architect Sinan, built for the Sultan as the focus for a complex of religious buildings, hospitals and caravansarais. It is based on the Byzantine type of church represented by Santa Sophia, and follows a strict scheme of proportions.

was amplified by combining elements of the palace. Much of Seljuq architecture was executed in brick and builders developed extraordinary virtuosity in producing complex vaults, dome shapes, and elaborate squinches out of this simple material. Surfaces were either flat or continuous curves and all were originally covered with an elaborate skin of decoration, only some of which survives intact today.

Plasterwork, ornamental brick-coursing and patterns of applied brick had been used before, especially in central Asia, but it was only in Seljuq times that such techniques were used on a monumental scale in Iran. Large sweeps of wall, pilasters, vaults and domes were covered with shallow relief or flat ornament, banding, scroll-work, calligraphy and diapor patterns. The two most important ornamental media were plaster relief and color-glazed brick and tile. The glazed ceramic tiles

were the product of potters migrating from Egypt, who brought with them the technique of luster-glazing. In Kashan, guilds of skilled ceramists produced tiles in many colors and lusters to clad the walls of these new buildings. A large proportion of these were figurative. Designs were laid out in organized sequences of many tiles giving to a building an unparalleled effect of luminous sheen.

Such tilework also went along with a highly developed art of ceramic tableware. Potters developed new, refined ceramic bodies, relief designs and alkaline glazes that made possible true underglaze painting. The city of Rayy was in the forefront of the production of such figuratively painted wares. In a variety of color combinations, in copper luster and in the polychrome enamels, called *minai*, compositions of human figures, animals and birds were painted onto elegantly shaped plates and bowls. The human figures bear a notable resemblance to figures known in a few surviving wall paintings from Buddhist shrines of the 6th to 9th centuries along the caravan routes across the Tarim basin to China, an area long dominated by the Turks. A few pieces of plaster figure sculpture almost in the round are also known in a similar style.

Seljuq rule did not extend substantially into Africa. The dynasty was finally obliterated with horrible slaughter by the Mongol armies of Genghis Khan in 1258, about the time that the Mongols were establishing their Yüan dynasty in China. Baghdad was sacked and the last Seljuq ruler was killed. The Mongols moved into Syria and there they met their match: the professional army of the Mamluks, the formidable rulers of Egypt, who routed the Mongols in 1259 and pushed them beyond the Euphrates River.

The Mamluks and Ottoman Turks

The Mamluks were a slave dynasty who had come to power as a consequence of their military success in defeating the invasion of Egypt by the Crusades of Louis XI of France in 1250. Their military skills were based upon their rejection of the hereditary principle in that they maintained their number by selecting, purchasing and training slave boys as a military elite, from whom officers and rulers were supposed to be selected. Their formidable army mounted a series of vigorous campaigns against the Mongols, with whom they eventually made a treaty, and against the Crusader fortresses of the Syrian coastline; in 1268 they also overran the Latin kingdom of Antioch. The Mamluks ruled Egypt and most of Syria until the coming of the Ottoman Turks, early in the 16th century. They also contained a substantial Turkish element, and, like the Seljuqs, saw themselves as protectors of the old institutions of Islam. Mamluk wealth was based upon their Red Sea trade with the East, but in 1498 Portuguese men-of-war closed the Red Sea to them, and their conservatism and rigidity led to military and social decline. They even refused to adopt firearms and the Ottoman army, which did adopt them, defeated the archaic Mamluk military machine in 1517, and the Ottomans annexed all of their terrain.

Under Mamluk rule Cairo became a flourishing center of culture and the arts. Great mosques were built, with *madrasahs*, along with many convents for Sufi orders, and dynastic mausoleums with *madrasahs* attached; many of these still survive. Quantities of metalware – basins, trays, water ewers and candlesticks – are superbly inlaid with silver calligraphy. These became a Cairo specialty. Their surfaces, and the surfaces of the fine pieces of mosque furniture, are entirely covered with varied ornamental patterns, with blank spaces a rarity. This is also true of the superb Mamluk rugs that survive.

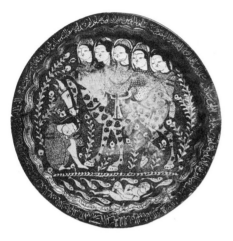

Ceramic dish *from Kashan, Iran, 1210 AD*

Signed by the painter Sayyid Shams-al-din al-Hasani, in the Seljuq period. Most Seljuq painting has vanished, so superb lustre-painted ceramics like this are vitally important. The scene illustrated is from a tale about a young groom, set to guard a horse, who sleeps and dreams of a mermaid. The Nastaliq script is from a Persian poem that refers to the subject.

The dynasty that took control of the Seljuq dominions in Anatolia after the Mongol catastrophe was that of the Ottoman Turks. In the middle of the 15th century the Turks seized Constantinople, ancient Byzantium, and renamed it Istanbul. It became the capital of their vast empire, dominating internal and external trade, which was extended by conquest far into the Balkans, the hinterland of Anatolia and, during the 16th century, into Egypt. Most of western Islam came to acknowledge Ottoman dominance, which was brought to an end only after

1918. In the west the Ottomans were in continuous confrontation with the European powers, especially the Habsburg empire. During the 17th century their impetus declined greatly after the exhausting "long war" from 1593 to 1605 with Habsburg armies.

Perhaps the greatest Ottoman achievements in the arts were their colossal roofed mosques, which were based upon the centrally planned pattern of the old Byzantine church of Saint Sophia. Enormous flat pointed domes roof the vast octagonal assembly courts, and tiers of half-domes roof the buttress arcades to cover further spaces that extend from the center. At each corner rise immensely tall and slender minarets. Such mosques were built at Edirne and an earlier capital, Bursa, as well as in Istanbul, by a great 16th-century architect called Sinan and his pupils and followers. Among their greatest works are the mosque of Sultan Suleiman in Istanbul, the mosque of Selim in Edirne, and the mosque of Sultan Ahmet I in Istanbul. All share the structural principles inherited from Byzantine architecture, although their plans vary.

Ottoman buildings are lined with tilework in dazzlingly brilliant colors, most of it based on floral patterns. The great palace Topkapi Saray in Istanbul contains the most brilliant work of all. The later tiles are stylistically and technically related to the ceramic wares produced at and around Iznik, which used characteristic opaque white tinglaze, an opaque red, and brilliant deep blue. All Ottoman decorative design is derived from the Seljuq tradition, but its characteristic is a thickness and solidity in the actual ornament that gives it an often gloomy strength. This is especially marked in the superb carpets and rugs that were made in large numbers at a number of different centers. The knotted rug technique is probably Turkish in origin, coming from Central

Asia with the Turkish peoples.

One aspect of Ottoman art little known in the West is book illustration. The fine volumes made for the emperors were preserved in the seclusion of the palaces and only relatively recently have they been on display in, for example, modern Istanbul's Topkapi palace museum. Very few are in Western collections. Although there appears to have been substantial exchange of influence with contemporary Iran, Turkish taste is distinctive. It favors a quality of fairly coarse-grained narrative realism in court and battle scenes, executed in blunt drawing and bright colors. Many of the illuminations exhibit an extraordinarily complex calligraphic invention that relates them closely to the script either in bands or framed *cartouches*, small or monumental, another major Ottoman artistic activity.

Iran, India and the Mughals

In the eastern Muslim world, the heritage of the Seljuqs developed along different lines, taking on a new lease of life after the decline of the empire of Genghis Khan's heirs. Another warrior of Turkish descent, Timur, known to the West as Tamerlaine, set the new era on its course. During the second half of the 14th century he established his power base among his own people, centered on Kesh and Samarkand. He then seized large tracts of northern Iran and Iraq, notably the cities of Shiraz, Tabriz and Baghdad, forced the Ottomans back into Anatolia and consolidated a defensible empire. He died in 1405 and was succeeded by his son, Shah Rukh, who died in 1447. The empire then began gradually to dissolve and was partly taken over with great destruction by the Uzbeqs and Turkomans.

Under both Timur and Shah Rukh new styles of art evolved based upon such pre-Mongol works as survived,

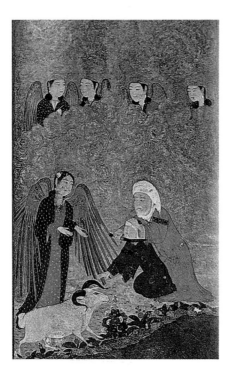

Miniature painting, *probably made in Herat, 1410 AD.*

It represents the Sacrifice of Isaac witnessed by Angels. The style embodies a magnificent calligraphic linear expression, and even the curls of color are full of varied invention.

but also incorporating substantial design influences from China, the northern part of which had formed part of the Mongol empire. It is most probable that the Mongols actually transported Chinese craftsmen from the eastern to the western parts of their empire. Certainly under their dynasty, called the Ilkhanids (1206–1353), Iran flourished commercially; trade relations were maintained with Italy, through the Black Sea port of Trebizond. Some

of the greatest poets in the Persian language lived during the Mongol period. This heritage of prosperity and art was received by Timur and his successors. Even after the break up of the Timurid empire had started, Shah Rukh's son patronized what became especially splendid schools of minature painting at Herat in Eastern Iran.

Timurid architecture is represented by few surviving buildings, many of them fragmentary and all in brick. It is clear that the old Muslim search for stupendous scale was a powerful inspiration. The base of one colossal gate structure of Timur's palace at Kesh gives some idea of the scale of the entire palace. It was seen in an incomplete state by the Spaniard Ruy de Clavijo, who went with an embassy to Timur's court between 1403 and 1406. He left a description of its magnificence and tells that a succession of gates led to a linked series of huge courts with water ponds and many domed halls. One especially beautiful late Timurid building is the Blue Mosque in Tabriz, built in 1465. It follows a somewhat unusual ground-plan in that it has no court and centers around a single large domed chamber surrounded by eight lesser domed volumes. It is also lined with dazzling blue faience glazed tilework, and supporting the decorative overlays is the virtuoso brick vaulting and dome construction that was the forté of Iranian builders.

The Timurids sponsored superb craftsmanship in metal and particularly in jade, which must have been imported from China. Their miniature painting, however, probably represents the dynasty's greatest surviving artistic heritage. In Baghdad, a series of sets of illustrations to a secular set of tales, the *Maqamat of al-Hariri*, give an extraordinary glimpse into city life, even though their compositions are somewhat cramped and conceptual and have late Byzantine overtones. They do,

however, deomonstrate how both rulers and wealthy city dwellers were beginning to patronize the pictorial arts.

From the period of the Ilkhanids the few paintings that we know show clear Chinese influence in their use of calligraphic drawing and a particular kind of ambiguous space, but under the Timurids what we recognize as the truly Muslim pictorial style was forged.

The Timurid style was begun in the Baisunghur workshop of the early 15th century and reached its apogee at the hands of perhaps the most famous

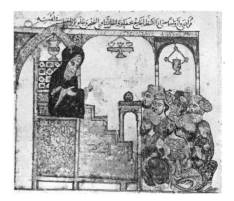

Miniature *from the Maqamat of al-Hariri, Syria, 1222*

This manuscript records and depicts episodes of city life. The script is Nastaliq, and the pictorial technique is derived directly from Christian Syrian manuscripts, inspired by Byzantine prototypes – an important strand of late Hellenic influence in the arts of Islam.

of all Iranian painters, Bihzad of Herat. During the second half of the same century, Bihzad worked directly for the library of the Sultan and had a host of pupils and close imitators.

Herat was captured in 1507 by the Uzbeqs, who carried off the leading craftsmen and artists to their own capital city, Bukhara. Three years later the armies of the Safavid dynasty took Herat and transported the remaining Herat craftsmen to their own capital, Tabriz. The Safavids were originally a Turkish brotherhood inspired by Sufi ideas, claiming descent from the ancient sacred heirs of the Prophet, known as Imams. For a short time they challenged Ottoman rule in Anatolia, but the Ottomans, by dint of massacres and their recently acquired firearms, repulsed them.

Practically nothing survives of the grandiose architecture with which the Safavids declared their imperial splendor in their first two capitals, Qasvin and Isfahan.

Isfahan is the only surviving city that was entirely replanned and organized according to specifically Iranian Muslim conceptions, giving it an extraordinary importance. During the 17th century a huge imperial complex was constructed at the heart of the old Seljuq city. It is centered on the Maidan-i-Shah, a vast elongated rectangle of open space intended as a polo-ground, running roughly north to south. This is surrounded by enclosing screens of wall decorated with the originally Seljuq double-story of niches shaped as pointed arches into which six main roads open.

Opposite the main gateway stands the jewel of Iranian Muslim architecture, the tiny mosque of Sheikh Lutfullah, built between 1616 and 1620. This is entered through a gateway and a darkish corridor running around two sides. Its central luminous walled square without arches rises into its pointed

dome, faced with an unbroken carpet of exquisite cut tilework that embodies bands of calligraphy. The overall design is superbly consistent. The dome is crowned with a centralized and radiating foliate design in blue and yellow and the lower walls are an intense blue.

The floors of such buildings and many houses were covered with carpets and rugs, which used fundamentally the same design techniques as the architectural decoration, but different imagery. Many splendid Safavid examples survive, some of them very large, made in several different centers. They use a wider range of color, including reds, browns, greens and blacks. Some designs seem to be purely arabesque, others contain figures of animals, and people; others only architectural references; but all are united by sharing the fundamental image of the garden. No Safavid gardens survive intact, but the idea and image of the constructed garden as paradise – with its grateful water led along geometric channels between geometric beds of geometrically planted flowers – had long haunted the imagination of Islam. Such gardens convey a sense of immense peace, and each carpet is the image of a garden.

The Safavids continued the long-standing Muslim love of books and learning, of calligraphy and superb ornament, to its apogee. The invention displayed in the illustrations to Muslim and Persian classical texts was extraordinary. All, of course, were handwritten. This enabled artists to devise varieties of page-division into linked cells that frame, in different ways, brilliantly colored figures with highly individualized faces that interact with each other from cell to cell; landscapes blossom into amazing curlicues of rock and burgeoning vegetation.

Superb calligraphic drawing became the speciality of some masters, many of them portraitists, the best known of whom is Riza-i-Abbasi, who worked

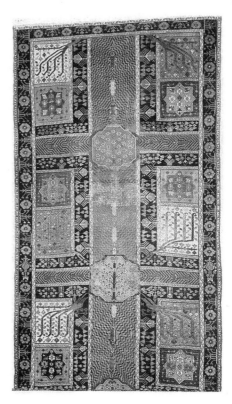

Woven carpet

The design presents the image of the garden, its beds filled with flowers, and its water-channels inhabited by fish. Such carpets were made in vast numbers at many centers in the world of Islam.

in the early 17th century. After a two hundred year interval there was a deliberate archaizing revival of the old Timurid style in Isfahan during the early 17th century, which probably reflected a certain nostalgia at the court for the heroic past. The finesse of their execution, however, fully matches the earlier masterworks.

The brilliant art of the Safavids had a profound influence on the arts in regions of India, another part of the world that only became Muslim in late medieval times. Arabs had made a few incursions into western India even in the 8th century, but without having

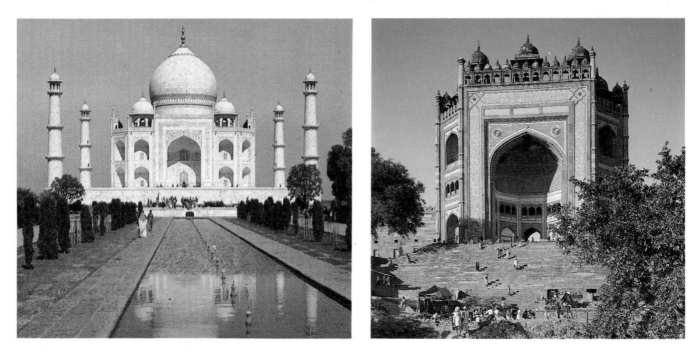

established more than trading contacts. During his reign, a ruler of Ghazna in Afghanistan, Mahmoud (998–1030), annexed a substantial part of north-western India to his kingdom. Neither he nor his successors, however, liked the heat of the Indian plains and pre-ferred to live in Afghanistan, treating their Indian provinces as a source at first of loot and then of revenue. In the 12th century, however, groups of Turkish nomads, the Guzz and then the Ghorids, occupied northwestern India and eventually made Delhi their capital, ruling as far as Bengal.

In 1192 Qutb-al-Din Aibak set up an empire of his own. By then the Muslims were already making substantial numbers of converts, a process that continued during succeeding centuries. In 1399 Timur sacked Delhi, after which two provincial dynasties ruled Delhi and large tracts of northern India.

At the close of the 14th century many provinces broke free from the domin-ance of the kingdom of Delhi and be-came independent Sultanates. Jaunpur

was one, where the Atala mosque was built, its massive forms reminiscent of aspects of Hindu architecture because, where the alien Muslim rulers needed to build afresh, they employed native builders.

In 1347 a sultanate was established by conquest in the Deccan, ruled by the Bahmanids, which towards the end of the 15th century broke up into smaller separate kingdoms that engaged in conflict with each other and neighbor-ing Hindu kingdoms.

By far the most important Muslim dynasty to rule the north of India were the Mughals, most of whose greatest buildings are intact. They claimed to be descended from Timur, and their name means "Mongols". The dynasty was founded by Babur (1526–31), who was a great soldier. He became heir at a very young age to Timurid Ferghana but was not strong enough to assert his claim. He therefore turned to India, where he carved out a kingdom for himself, "marching into Hindostan" in 1525. He reigned for only five years.

The Taj Mahal, *Agra, India, 1632–53*

It was built by the Mughal emperor Shah Jahan as a tomb for his wife, Mumtaz Mahal. He is also buried here. He intended to build a second, larger tomb for himself, but was deposed before the project could be realized. This is probably the most famous building in the Muslim world. Its white surfaces are adorned with cut-stone inlay, and its garden was originally magnificent.

The entrance gateway, Fatehpur Sikri, *near Agra, India, 1569–72*

This city was built by the emperor Akbar on a waterless site and needed to be kept supplied by endless trains of water carts. It was soon abandoned and stands as it was first built, a huge complex of courts, palaces, pavilions on varied levels, presenting profoundly impressive spatial images.

Babur had a low opinion of Muslim Indian craftsmanship, and so he sum-moned pupils of the great Ottoman architect Sinan from Istanbul, who built numerous buildings in Kabul, Agra, Delhi and elsewhere.

Babur's son, Humayun (1531–56),

spent a great deal of his reign in exile at the brilliant court of Shah Tahmasp, in Iran. His importance for art is that when he finally regained his throne he brought with him to Kabul a group of major Iranian painters, including Mir Sayyid Ali and Abd al-Samad. He and his successors were eager collectors of Persian books and miniatures. The first great corporate work of the studio set up at Kabul, later transferred to Delhi, was an immense set of illustrations of a Persian tale about the legendary Amir Hamza that took fifteen years to complete. Persian and native Indian artists worked side by side on the same pictures, establishing a pattern for Mughal art that was followed during the two successive reigns.

Akbar (1556–1605) was the greatest of the Mughals, and was succeeded by Jehangir (1605–28), Shah Jehan (1628–58) and the disastrous Aurangzeb (1658–66). Under Akbar the great wave of building palaces, tombs and mosques began which produced many of what we now recognize as the world's greatest monuments. Among them are the tomb of Humayun (c. 1560), the Pearl mosque at Agra (1646–53) and the Taj Mahal, Agra (1632–53), all in pure Muslim style, probably designed by masters from outside India. They are distinctive in being built in and surfaced with fine stone, without tiles, their principal ornament being sparse calligraphy and pattern in shallow relief and extremely refined cutstone inlay. The expense of building the Taj Mahal as a tomb for Jehangir's favorite wife is said to have ruined his empire's economy. The greatest building project of all was Akbar's extraordinary complete city, Fatehpur Sikri.

Akbar was a hard-headed soldier and diplomat who also believed deeply in the possibility of reconciling his Hindu and Muslim subjects in both cultural and religious spheres. He encouraged the search for common religious ground

by paying visits to distinguished Muslim and Hindu holy men. He also founded a monotheistic religion of his own, the Din Ilahi, which was meant to combine the best elements of both religons and ultimately supplant them. He invited Jesuits to participate in Din Ilahi assemblies in 1578–82 and 1591. This was not ultimately a success, but Akbar continued to welcome embassies from the West and opened trade relations with Western merchant companies through the Indian coastal ports. These were further developed under his son, Jehangir. The first Jesuit visitors reported that Akbar already had Western pictures in his palace, and they themselves brought to him gifts of European engravings, including a complete Bible published in the Netherlands.

Akbar deliberately expanded his studio of miniature painters as an instrument of his policy of reconciliation. Hindus and Muslims worked side by side and studied his collection of European art. He ordered illuminated manuscripts to be made of classic texts in Persian – the language of the Muslim court and dominant feudal princes – translated into native Indian languages, and classic Sanskrit texts into Persian.

Miniature from the Akbar-Nama, c.1590
13×10in (37×25cm)
Victoria and Albert Museum, London

This figure miniature painting was executed in the court workshop of the Mughal Emperor Akbar. It illustrates an event in his reign in 1565 – the reconciliation of the rebel Khan Zaman with one of Akbar's officers.

A Turkey-Cock, c.1612
8¾×6in (22.5×15.5cm)
Victoria and Albert Museum, London

This accurate representation of a turkey-cock was painted for the Emperor Jahangir, son of Akbar. Jahangir was passionately interested in botany and zoology and required his court artist to record interesting specimens of plants and animals.

These were then distributed to his Hindu and Muslim nobility to encourage mutual understanding. The Imperial artists were also expected to record in elaborate albums pictures of important and interesting events. Jehangir and Shah Jehan continued this custom, which encouraged the painters to develop a definite Mughal style going far beyond its Persian inheritance.

In 1658 Aurangzeb, a bigoted, religious conservative, usurped the throne. He spent his long life in arduous military and punitive campaigns that only served to intensify the opposition of his subjects. When he died in 1707 the Mughal empire was crumbling and continuous warfare had ravaged the north of India. The court artists were dispersed into provincial courts and the bazaars of the major cities to earn a living as best they could.

The Mughals never aimed to eradicate completely the Indian feudal nobility whom they had conquered, but the Hindu princes attempted in their palace fortresses to imitate the splendors of the Mughal court. Even in the 20th century these princes – Rajahs and Maharajahs – maintained an apparatus of state with costume, turbans, jewelry, swords, manners and palaces directly imitated from Mughal examples.

Islam entered Southeast Asia during the 13th through 15th centuries with Arab traders and expatriate merchants and refugees, mainly from India. Java has at present one of the largest Muslim population groups in the world, and Malaysia and Sumatra also have substantial Muslim populations; both Indonesia and Malaysia are officially Muslim. Unfortunately, those countries have produced almost nothing in the way of good quality Muslim art. The best works are mosque gateways of the 16th century at Sendangduwur and Kudus, which adapt the traditional Hindu ornamented gateway without its direct figurative imagery.

Religions and Empires in India and the Far East

India

India is a vast subcontinent, some 2000 miles (3200 km) from north to south, entirely covered with a network of agricultural villages. It has a wide variety of climates, ranging from continual snow in the Himalayas in the north to tropical lagoons in the southeast. Over most of the country the weather pattern is constant. Between November and May the weather is dry; in December in the north it can sometimes be cold enough to produce a frost on the plains. In spring the crops are ready to harvest, and by May the temperature is rising to a blazing heat that makes all activity impossible. By June the country is baked brown and a dust haze may fill the air. Then the first clouds of the great annual rainfall, the southwest monsoon, come rolling in from the sea, obscuring the sun. The clouds burst in huge thunderstorms, torrential rains blanket the landscape and the whole countryside is refreshed. People delight in the sudden drop in temperature and revel in the water.

If you fly over India just after the rains you will see a mosaic of glittering lakes. The small ones are quickly exhausted by use and evaporation, but here and there are huge ones. To build, maintain and keep in existence the irrigation systems that depend on these lakes was the chief business of the kings of India, and this necessity dominated the distribution of royal power and civilization.

India's greatest cities lie on continuous rivers such as the Ganges and Yamuna, and were founded long ago, probably by the 6th century BC. They were the ancient strongholds of Indian culture and art.

The water-unit was the basis of Indian politics. Princes and petty kings ruled all the habitable and cultivated parts of the land from their cities, jockeying for position and prestige, each coveting their neighbors' land and revenues and fighting continually over them. Major kings dominated clutches of lesser kings. Occasionally great rulers established dynasties that built up empires governing vast tracts of the subcontinent. When dynasties died out their large-scale administrative systems would unravel to leave lesser kings in control of their basic units of power. This happened many times over during the history of India.

The earliest city-empire in India was the Indus Valley civilization. It lasted about 1500 years from 2800 BC to 1330 BC. Two very large cities, Harappa and Mohenjo-daro, have been excavated, about 600 miles (965 km) apart along with several smaller towns and villages including a port spread over a wide area. They were built of unfired brick with fired brick facings. Each city had a citadel, on top of which was a bath-like structure with cells around it, suggesting that it could have been run by a ruling group similar to a college. For those 1500 years the streets kept their original strictly planned grid. There was a big granary with drying flues. The big houses, with several stories and bathrooms, were built around courtyards and the whole city had a brick-built sewer system. Implements and weapons of bronze were made and used.

The culture used writing, still undeciphered, that appears on thousands of tiny stamp seals made of stone and terracotta and on the fired clay stampings made by such seals. On these seals are a large number of visual images. The greatest number represent humped cattle, but some illustrate scenes of worship, strange mythological images, and one a bull-headed dancer. One explanation for the existence of such seals is that each represented a personal identification or authorization; sealings stamped by more than one seal on its sides may have constituted contracts or acknowledgements; but until the writing is deciphered we shall not know

for certain. Similar images appear on the painted pottery, some of it very large storage jars.

This Indian river-culture traded with Mesopotamia by sea and, perhaps, even Africa. It grew seemingly out of a long preceding series of village-based cultures in what are now Baluchistan and Afghanistan, and the implication is that the whole area was far more fertile and well-wooded than it is today.

With the end of the Indus Valley cities the people calling themselves Aryans appeared. The Aryans spoke Sanskrit, used chariots and horses and divided their population into four castes: Brahmans, the priests and professional theoreticians who served sacrificially a pantheon of major deities to whom they addressed hymns which survive; Kshatriyas, the warriors to whose ranks the kings and feudal princes belonged; Vaisyas, the merchants and artisans; and the Sudras, the remaining population. This last group may well represent the original population of India whom the Aryans conquered, about whom we know little, although there are groups of non-Aryans surviving today.

Sanskrit was the first language of Indian culture and there is still a vast literature – poetry, science, government, philosophy, religion – scarcely known in the West. Over the centuries Sanskrit evolved from its original pattern into separate spoken languages. These include Pali, the language of southern Buddhism; modern Hindi, Bengali, Gujarati, and others. By about the second century BC a special form of Sanskrit had developed at the courts that was a language used purely for scholarship, administration and literature. This literate complex was to prove very important not only inside India, but as the carrier of skills and culture to many Indian colonies around the coasts of Southeast Asia.

In South India another and probably older group of languages called the Dravidian group existed even before the coming of the Aryans and are still widely spoken. They have their own scripts and a huge literature, and on the whole did not travel much abroad.

Buddhism

During the 6th century BC two major religious personalities appeared in northern Sanskritic India: the Buddha and Mahavira, the founder of Jainism. Both taught doctrines of salvation through personal discipline and enlightenment; both were firmly based on the idea of reincarnation and the gradual achievement of ever higher social and moral status through a series of rebirths. Both the religions provided modes of social discipline. For their millions of followers the Buddha and Mahavira set a personal, social and metaphysical goal and demonstrated the stupidity of selfish and wicked acts.

Many Indian kings became Buddhists or Jains and some even abdicated their thrones to become wandering, homeless ascetics. Because both religions recognized that high birth in society was an index of high status on the reincarnation scale, a king was next to the enlightened. Rulers naturally identified themselves, at least in theory, with the metaphysical goals of Buddhism or Jainism.

India was a great trading country and internal trade thrived along the great navigable rivers and a well-marked pattern of roads. Buddhism especially spread along these trade routes, with its shrines and monasteries appearing wherever the religion was established. By the early 2nd century AD Buddhist colonies had been established in distant countries overseas such as Malaya, Burma, Thailand and Java, and along with them patterns of kingship evolved.

In Afghanistan, Khotan, and along the trade routes across the vast deserts of central Asia to China Buddhist monasteries served as stopping places for caravans; and Buddhist monks acted as the counselors of kings. Virtually the whole of Southeast Asia and Tibet eventually became Buddhist, as did China for a time, Korea and Japan. In fact, Buddhism and kingship went hand in hand. The first great example of this was set by the Emperor Ashoka (269–232 BC). As heir to his imperial grandfather, Ashoka conquered most of India in savage campaigns, but was then converted to pacific religion, probably Buddhism and he devoted the rest of his life to becoming the ideal Buddhist ruler. Ashoka's ceremonial religious center was at Sarnath, where the Buddha preached his first sermon. Ceylon was totally converted and, in the now widely dispersed Pali literature of Ceylon's Buddhism, Ashoka is remembered as the great pattern for kingship.

After Ashoka the Kushan dynasty (1st century BC–5th century AD) came to power in the northwest, ruling from the cities of Purushapura (Peshawar), Taxila and Mathura. The Kushans united these kingdoms to others in India and opened the major trade routes between India, the Roman Mediterranean and China. Vast numbers of Buddhist monasteries were built bearing stone and stucco images and decoration in two distinct styles. In the Indian areas around Mathura, rounded sensuously carved bodies set the pattern for later Indian sculpture; in the Afghan areas of Gandhara, a style strongly influenced by late Helleno-Roman art continued under the Roman Empire. The volume of trade across the whole of Asia was colossal. The wealth of the Gandhara monasteries reflected the wealth of the Buddhist merchants.

During the rule of the Kushans the rest of India was governed by many

smaller but significant dynasties. The chief of these were the Satavahanas, who bridged the Deccan from coast to coast, trading by sea to the west and to the east. Two large groups of monasteries flourished: one in painted and carved caves such as Karli, Ajanta and Bhaya between 100 BC and 600 AD, in the western Ghats. The eastern group spread in the fertile lands around the mouth of the Krishna River, between about 50 BC and 300 AD and included the famous site of Amaravati. Vast quantities of sculpture in white limestone were made to decorate these shrines, crowded with surprisingly sweet and sensuous figures illustrating Buddhist legend. =

By the end of the 4th century AD a major empire, the Gupta, had begun to grow in the middle Ganges valley. The Guptas were also Buddhists and the dynasty survived as an imperial power until the early 7th century AD, when the great king Harsha was ruling over a court of outstanding brilliance. Under the Guptas Sanskrit literature – drama, poetry and novels – flourished. The dance-drama, which is still India's leading art, became established at most of the royal courts. The figurative arts of sculpture and painting adopted the dance's language of posture and gesture as the basis of their own imagery, which itself became the common Indian visual expression of royal splendor.

Hinduism and Islam

The dominance of Buddhism as the royal religion was challenged by the development of new forms of Hinduism at other early medieval courts across the north and south of India. At the sacred centers of Hindu religion great shrines were developed and, because Hinduism focuses not on personalities but gods, deities little known in ancient Brahmanism were adopted by kings as divine patrons. The most important are Shiva, Vishnu, Surya and various

The Death of the Buddha, *2nd century AD*
Stone Panel, length 48in (120cm)
Victoria and Albert Museum, London

This stone panel once formed part of the decoration of a Buddhist shrine in Gandhara, now covered by parts of Pakistan and Afghanistan. The style is an amalgam of Indian and Greco-Roman styles and illustrates how the two cultures met and mingled as a consequence of the development of trade between India and the states of Hellenic eastern Mediterranean.

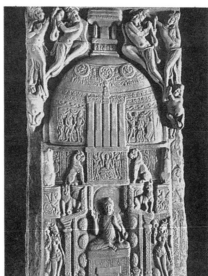

Panel from a shrine, *2nd century AD*
Amaravati, South-eastern India

This illustrated a stupa, in the entrance to which appears a figure of the Buddha preaching, flanked by lion-images and a couple of worshippers. It shows what stupas would then have looked like, and how such decorative panels were used.

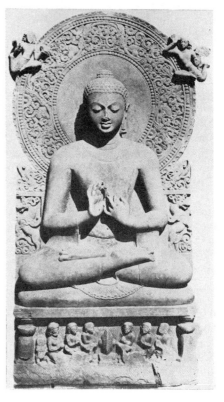

The Buddha preaching his first sermon,
Gupta period 5th century AD,
Sandstone from Sarnath, near Banaras, India

The Buddha is shown in radiant and beautiful form with a richly decorated halo that depicts his spiritual, not his physical, nature.

forms of the goddess such as Durga and Lakshmi.

These kings and members of their families built at their capital cities groups of temples dedicated to their patrons, usually next to the principal irrigation source. Each temple was centered on a cell containing an icon of the main god. The ritual consisted of offerings and prayers to the deity. A portico and one or more halls, including a many-pillared dance pavilion, were aligned with the cell and were used for public ceremonials. Some are modest structures, but some are immense and encrusted with sculpture representing Hindu legend. Perhaps the most famous temple in India is the Kailassanatha at Ellora. Dedicated to Shiva, it is a monolith cut out of a hillside by members of the Rashtrakuta dynasty of the Deccan during the 9th century AD. Other famous shrines of the Deccan are the cave temple on Elephanta Island (c.800 AD) and the cliff-faces carved at the Pallava dynasty capital of Mamallapuram (c.700 AD), also dedicated to Shiva.

There was one very important dynasty who were the last patrons of Buddhism in India. The Palas ruled in northeastern India from 750 AD and built large pyramidal brick and terracotta shrines such as Paharpur. Their immense contribution to the culture of Asia, however, was their sponsorship of large Buddhist universities, the most famous being Nalanda. These were the size of small cities and gave courses in the secular sciences as well as religion and literature. Students – not all of them Buddhists – came from many countries of the East to study and take back to their homes the learning of India.

The form of Buddhism that prevailed was called Vajrayana, which was transplanted entirely from the northeast to Tibet in the 8th century AD by missionary monks. There it became the

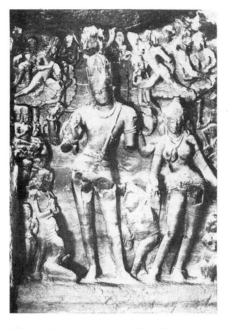

Shiva's Marriage to the Goddess Parvati, c.800
Rock-carved sculpture
Elephanta, India

This collossal rock relief was cut inside the cave temple of Elephanta on the island of Salsette, near Bombay. Shiva, to whom the shrine is dedicated, is attended at his marriage by his host. The entire interior is cut into the living rock and the surfaces of the sculptures were coated with fine lime plaster and painted. These immense images much impressed the first Portuguese travelers to encounter them.

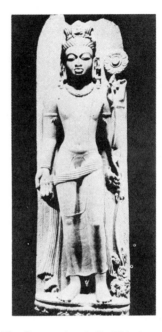

The Compassionate Boddhisatva Padmapani, c.850
Stone height 56in (1.42m)
National Museum of India, New Delhi

This image of "him who holds a lotus in his hand" (Padmapani) probably stood in a niche in a shrine of the Buddhist university of Nalanda, which was a major center of Buddhist learning. Nalanda art was much copied in the rest of the Buddhist world and versions of this image were made during the later middle ages in Nepal and Tibet especially.

dominating cultural influence, combining with the indigenous shamanic Bón culture. Its art was more purely iconic than dynastic and represented assemblages of deities who personify the psychological principles of this form of Buddhism. These were made on monumental and miniature scales primarily for meditative and magical rather than dynastic purposes.

With the death of the last Pala king, Buddhism disappeared from India and

Hinduism prevailed. In the South, which remained largely Hindu until modern times, a succession of dynasties balanced power among themselves, generating a series of temples at the major cities. The Colas (9th–13th centuries AD) succeeded the Pallavas with great temples at Tanjore, Kanchipuram and Chidambaram. They were followed by the Pandyas (12th–14th centuries), who developed older existing shrines by adding successive perimeters

of corridors and halls, pierced by gateways crowned with towers of ever-increasing size. Great Pandya shrines still flourish at Madurai and Shrirangam. Their halls and corridors, many hundreds of feet long, are supported by ranks of piers and columns carved with figures in relief or full round that illustrate events in dynastic history as well as encyclopedias of Hindu legend. In Mysore, the Hoyshala dynasty (1070–1315) built sets of temples carved in a distinctive, exuberantly ornate style at Somnathpur and Halebid.

In the north each of the Hindu dynasties developed its own style of temple building and sculpture, sometimes over centuries. From the 11th century onward, however, invading Muslim armies from Afghanistan repeatedly looted and destroyed, eventually setting up sultanates in previously Hindu states and ultimately a Muslim imperial dynasty, the Mughals, centered on Agra. The state of Orissa in eastern India was never conquered and its long series of Hindu temples culminated in two of the most sacred of Hindu shrines, that dedicated to a deity called Jagannatha, "lord of the universe", at Puri (12th century), whose devotees used to sacrifice their lives under the wheels of its immense chariot; and the Lingaraja (11th century) in the temple city of Bhuvaneshvara. At Konarak a ruined shrine (13th century) carved with the world's greatest collection of erotic sculpture stands by the seashore.

Most of the major Hindu cities of the northern dynasties suffered severely from Muslim destruction and the invaders have left accounts of strenuous efforts made to dismantle the temples and smash idols. Quite a number of devastated city-sites are known and at some a few shrines still stand, Deogarh and Osia for example, where modest dynasties once ruled. At the abandoned city of Khajuraho in central India, more than eighty temples once stood around the great water tank. Some are still in a good state with their wonderful sculptures of gods and heavenly pleasures intact, showing the quality of those immense quantities of medieval Indian art now lost to us. In western India a few remains of dynastic Hindu temples also survive, as at Modhera, but there are also a number of Jain centers where the wealthy mercantile Jain community has kept alive into modern times groups of temples modeled on Hindu shrines. Mount Abu has the most famous, carved out of a local white marble.

After the coming of Islam, Hindu dynasties continued to rule some of the northern states as vassals but, in imitation of their Muslim masters, they devoted their main architectural effort to fine palaces and fortifications as at Udaipur and Jaipur, and few temples of distinction were built. No less beautiful are the palaces of the Hindu maharajas in the capitals of other Hindu states of India, and there survive many fine city houses in a blend of traditional and Muslim styles.

Life in these palaces continued on traditional patterns until the 20th century social revolution. Most of the courtly finery adapted itself to the Persian prototypes imported by the Mughal emperors, among these being miniature album painting, which had a special incarnation at the courts of northern India.

We know little of the painting of pre-medieval (7th century) India save a few beautiful but fragmentary wall paintings as in Ajanta, Bagh and Badami cave shrines and temples, but small-scale illustrations to stories. painted hangings and scrolls existed at the medieval Hindu courts in large numbers. There are a few early illustrated books of Buddhist literature executed on palm leaves, the earliest dated c.1000; and both palm-leaf and paper Jain illuminated texts exist from later centuries.

In the mid-16th century native Indian painting succumbed to the powerful Persian influence which led to the establishment of court studios, usually staffed by families of painters. These were founded at many of the Hindu courts of central India, Rajasthan and the Punjab. The works they made were

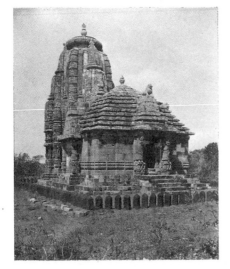

Raja Rani Hindu temple, c.1000 AD
Bhuvaneshvara, Orissa, India

This shows how the entrance hall is aligned with the principal shrine that houses the main image under the tower in the standard type of Hindu shrine.

sets of miniature illustrations of courtly life, devotional literature and Hindu legend. In sharply defined areas of brilliant color, they laid out their subjects with a passionate intensity. The pictures were probably made for the royal families to enjoy as they would poetry or music, and the artistic invention that went into them was substantial. They continued to be made well into the 19th century under British rule; although by then the artists were tending to migrate from the stagnant courts to the bazaars of the cities in search of a better livelihood.

A number of folk-painting styles survived from the Middle Ages into modern times, the best known being the Kalighat. In the temple of that name near Calcutta painters produced swiftly painted popular icons for the pilgrims who flocked to the shrine. They adopted European watercolors to paint with, and their work played an important part in the revival of Indian traditional art during the 20th century.

By the end of the 18th century the Mughal dynasty had declined because they could no longer maintain their power against the forces of native Hindu resurgence. The Sikhs in the Punjab and the Marathas to the south carved kingdoms out of the Mughal empire, and their armies migrated across large tracts of country. European mercantile powers also joined in and began to settle and seek to control the trade of India.

During the later 17th century trade with Europe had been conducted through coastal factories; only a handful of merchants and Jesuit missionaries had penetrated the interior. In the 18th century this changed and the East India trading companies of the Dutch, Portuguese, French and British sought to take command of the productive hinterland. The consequent warfare and political intrigue did great damage to the economy of India and altered the internal patterns of trade. By the 1820s the British were in substantial control and by 1860 had established the "Raj" under Queen Victoria, as Empress of India. This was based upon a system of administration that controlled the trade of India while maintaining Indian customs as far as possible.

The British also began the formal study of archeology in the 1850s, from which stems our modern knowledge of ancient Indian art. Universities were set up adopting the British pattern and art schools based upon British patterns were established, introducing Victorian standards into India. A few Indian painters had acquired European techniques during the 19th century and earlier from traveling artists, but it was not until the early years of the 20th century that the full pressure of an alien artistic tradition began to be felt. This prompted a substantial movement, led by the Tagore family in Bengal, which allied itself with political movements for Indian independence. Kalighat painting figured in this revivalism as a link with the artistic past.

Since Independence in 1947, Indian artists have sought to establish their identity both as Indians and members of the world-wide artistic community. Some have emigrated and earned substantial reputations in the West. Only recently, however, has the Western art market begun to take serious account of living Indian artists, among them Souza, Raza, Samant and Padamsee.

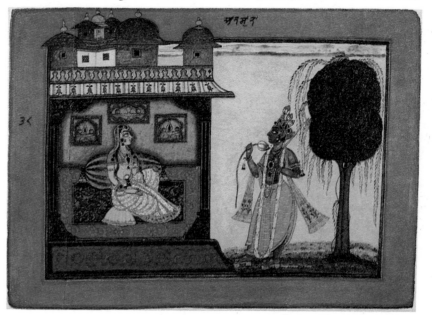

Rajput Miniature, c.1660–70
Victoria and Albert Museum, London

This miniature was painted at the court of the Rajput hill state of Basohli. It illustrates an episode in a poem called the Rasmanjari *of Bhanudatta. The vivid mood of the poem is captured in the brilliant colors used in the painting: the lady Radha weeps, sad because she realises her divine lover Krishna has been making love with another woman in the forest: he is given away by the mango blossom in his hair and the mango pollen in his ears.*

China before Buddhism

Like India, China is a country so vast that it must be considered a subcontinent. Its northern borders extend towards the coldest regions of the inhabited world and its southern into subtropical heat and humidity. It has a number of vast rivers that carry fertile silt down from mountains to the west to water the immense plains. The river gorges are spectacular and have provided Chinese painters with inspiration for thousands of pictures. Culturally, China has always been isolated by the mountains, deserts and vast steppelands of centra Asia, and other countries have looked on it as the outer limit of the known world. Again and again China has been invaded, occupied and ruled by dynasties of tribal nomadic peoples originating in central Asia, who coveted the wealth and civilization of its lands.

The cultural achievement of China was substantially original. Whereas India had access to the cultural worlds of Mesopotamia, Egypt and the Mediterranean, China's remoteness meant that it was able to develop its own culture and art patterns. It achieved political unification into a single empire by the 3rd century BC under the Ch'in dynasty, after which it is named. Following a hesitant start, China generally remained a single political unit with a central administration for the rest of its history.

The earliest recorded history and material remains of China belong to the Shang dynasty (c.1523–1028 BC), whose capital was at modern-day Anyang in Honan, near the Yellow River. After this came the Chou dynasty (1028–256 BC). Excavations have revealed the high and technically competent civilization of these dynasties. Their great artistic works were huge bronze vessels cast in an elaborate technique known as *cire perdue* and ornamented in deep relief with a repertoire of designs

Bronze vessel, *12th–11th century BC*

Such big bronzes, cast by the lost-wax process, were made for use in the rituals carried out at family tombs in ancient China. Many of them carry inscriptions giving information as to why they were made.

including stylized animals based upon squared-off C-curves and spirals. These vessels were used for cooking food and heating wine at ritual meals, reflecting the continuing basis of Chinese civilization – the cult of the family. Each family maintained the most magnificent ancestral tomb it could afford, and kept in touch with the world of the spirits through meals shared with its ancestors. Some of the greatest Chou bronzes bear inscriptions that inform the dead about the achievements of the individuals who had them cast.

The script of these inscriptions is syllabic and was invented in China. It is still used, modified over millennia, and was, perhaps, the single most important unifying factor in Chinese culture. The literature composed in this script, and its value for the administration of the empire, gave the Chinese their sense of cultural identity. Calligraphy, executed with the brush by the 2nd century BC became the most fundamental art form. The existence of written records, along with the constant striving to maintain dynastic

and imperial unity, enabled the Chinese to develop a sense of their own history unlike that of any other culture.

At the latter end of the Chou dynasty lived one of humanity's most famous men, Confucius (551–479 BC). During his lifetime the unified kingdom of Chou had split into warring states, and a major part of Confucius' work consisted of trying to establish a moral and metaphysical basis for unity. This was achieved under the Han dynasty (206 BC–220 AD) when the Chinese empire approached a scale which it maintained thereafter. Its military expeditions reached the frontiers of Gandhara in Afghanistan, the most important achievement of the Han was to establish a civil service that ruled the entire country ever after. Its members were recruited by public examinations from every corner of the empire and were therefore highly literate and scholarly. From their ranks were drawn the greatest number of China's major artists, as distinct from craftsmen. Among other achievements of the Han were vast engineering works, including the first phases of the Great Wall, designed to exclude nomadic invaders, and the immense canal system that linked the fertile plains with their cities to the great rivers and the sea.

Painting flourished under the Han, and paper was invented, although exact dates are unknown. Silk was made not only for domestic use but increasingly for export across the trade routes of central Asia to India and the Roman world. Fine painted lacquer wares were also exported. These, along with a few painted tomb tiles, are all of Han painting that we know. What we do have are relief sculptures that reflect the fluent linear styles of pictorial art, and objects of bronze, carved jade and other stones. We know that the Han court was a center for artistic work although fine lacquer was also made near the ancient site of Chang-sha.

From T'ang to Tatars

When the Han dynasty collapsed there followed the period of the Six Dynasties. These were mostly foreigners, and ruled in the north while the Chinese national empire retreated to the south. It took two and a half centuries for China to be reunited in 589 AD. In the north, however, one of the most historically important episodes took place: the establishment of Buddhism under the Wei (385–557 AD), a Turkic dynasty from central Asia that welcomed trade across central Asia from the West and also the Buddhism that came with it from Khotan and India. Their great monuments are huge rock-cut and painted cave monasteries, first at Yün-kang and then at Lungmen and Tun-huang. It is probable that the Wei were establishing metaphysical sponsorship for their alien rule in China, but the cult and art they imported survived well on into the next great native Chinese dynasty, the T'ang. The pantheon of figures in the caves crystallized for China the Buddhist concept of reincarnation together with a sense of the immensity of the cosmos, which the more rationalist culture of earlier times had not grasped. Among the works of Wei art are tomb *stelae* of individuals carved in linear relief with Buddhist scenes of extraordinary calligraphic beauty.

The great native T'ang dynasty (618–906 AD), also Buddhist at first and later Confucian, began by thinking of its capital cities Chang-an and Lo-yan as termini of the central Asian trade routes. The country became immensely prosperous and the dynasty pushed the borders of its empire far to the west, into central Asia. This was mainly to eliminate the constant threat to peace posed by the nomadic peoples, but partly also to ensure a continuing supply of the superb horses bred by those peoples on the central Asian steppes, which were essential for the Chinese military cavalry. The wealth of Chang-an in the 7th century also brought immigrants from Khotan and as far west as Iran. China in that period thought of itself as facing westwards along the desert trade routes. This attitude was reflected in the art of ceramics; in the many ewers, plates and bowls which refer to the forms of western Asiatic metalwares; but especially in the fired clay tomb figurines of horses, grooms, camels, musicians and beautiful girls that were used for display at funerals and buried afterwards with the dead.

We know T'ang painting principally through literary records and faithful copies. One of the greatest of all Chinese painters, Wu Tao-tzu, was a Buddhist monk who painted figures and

An anteroom in the cave-temple, *Yün-Kang, 5th century AD*
Shansi, China

The carved reliefs are based upon Indian patterns of Buddha and Bodhisattva figures, carried across the trade-routes of Central Asia. Such images were originally painted in bright colors.

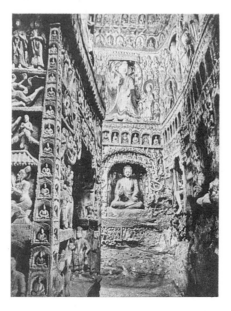

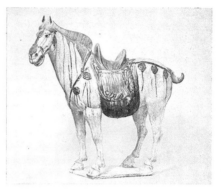

Tomb figure of a horse, *T'ang dynasty, 8th century AD*
Ceramic

Fine horses were bred in Central Asia, and eagerly sought by the Chinese. The tomb figure was displayed at the funeral, and buried with the dead to serve him in the spirit world.

landscapes that were the wonder of his time. Other painters dealt specifically with historical anecdotes, famous characters of the past, animals and political events. Yen Li-pen (d.673) painted a famous hand scroll representing a mission from Southeast Asia bearing tribute to the emperor. Han Kan was famous for the sense of life he conveyed in his superb paintings of horses. Most early T'ang painters drew with a vivid wire-like line strongly influenced by Buddhist painting of central Asia. Under this dynasty, the important fundamentalist Buddhist sect, the Chan, appeared and began to exercise an important influence on the arts. Later in the dynasty scholar-officials painted pictures that explored the wider resources of brush and ink and aimed to achieve poetic qualities reminiscent of those conveyed by the many great writers of the epoch.

The Five Dynasties (906–960) followed the end of the T'ang after a brief period of upheaval and division. Nevertheless, the court academy of one dynasty, the Southern T'ang, based on Nanking, produced a galaxy of great

artists who painted flowers, palace women, river scenes and landscapes that were the precursors of perhaps the greatest works of Chinese art, the landscapes of the Sung academy.

The Sung dynasty (960–1260) re-established a unified empire. Its reign is usually divided into two parts: the first, usually called the Northern Sung, from 960–1127, when the capital was in the northern city of Kaifeng; and the second, called Southern Sung, when the dynasty had been driven from the north by Tatar invasions and settled in the south at Hangchow. The dynasty maintained a group of painters who worked for the court, producing ceremonial seasonal paintings, and decorating the vast numbers of palaces and pavilions around the capitals. Some of China's most powerful landscape painters worked for the Northern Sung.

After the move south, the work of painters took on a more intimate and lyrical quality. Small hand scrolls and album leaves became popular. The pictures became permeated with misty spaces and sheer calligraphic power gave place to subtle reflections of the moist atmosphere of the south. The Southern academy's development culminated in the work of Hsia Kuei and Ma Yuan, but alongside the work of the academy there flowered schools of dedicated nonprofessional painters who painted for each other. They belonged to circles that included poets, seal-carvers, calligraphers and monks; indeed some, such as Su Shih, were poets, calligraphers and painters at

once. Mi Fu, the painter of rain-soaked mountains, was also a calligrapher and connoisseur of exotic stones. Among these scholar-artists, some of whom held quite modest official posts in the administration, there flourished that attitude of reverence for and involvement with the forces of nature which we recognize, as did the Japanese, as a unique Chinese spiritual achievement.

Under the Sung the art of ceramics developed to previously unknown heights. The court established officially recognized factories that produced a variety of beautiful glazed wares, not only for ceremonial use and as tableware in China, but also for export. The gray-green semi-translucent glazes known as celadons are the most famous. Fragments of celadon porcelains have been found all over the islands of Southeast Asia, the Middle East and even along the coast of East Africa.

Between 1260 and 1368 the Yuan dynasty dominated Chinese cultural life from their northern capital, Peking. They were a Mongol family, descended from the fabulous conqueror of Asia, Genghis Khan, and Kubilai Khan – the Kubla Khan of Western legend – was the founder. Some scholar-families re-

Left to right:
Incense burner, *12th–13th century Porcellanos ware Diameter including handles 7¼in (185mm)* **Bottle vase,** *early 15th century Porcelain height 12¾in (325mm)* **Flask,** *c.1730 Porcelain height 11⅝in (294mm) All three vessels in the Percival David Foundation, University of London*

These three fine pieces of porcelain illustrate the continuity of Chinese ceramic art. The first is greenish celadon ware made during the Southern Sung dynasty, and is reminiscent in its form of earlier bronze vessels. The second is decorated with birds on a branch, freely painted in underglaze enamel. It was made during the Ming dynasty. The third is a flask of white porcelain superbly painted in overglaze enamel of many colors.

fused to serve the alien dynasty and separated themselves from national affairs. Among them were several major artists who gathered in a reclusive and disaffected group south of the Yangtze River. Ni Tsan lived on a canal boat to paint his reserved and subtle landscapes; Wang Meng constructed mountain massifs running off into deep space; Huang Kung-wang touched in his profound landscapes in apparently simple calligraphy that kept alive the spirit of Sung. Among the native

Chinese who did serve the Mongols as high officials were two major painters, Chao Meng-fu and Kao K'o-kung.

From the Ming Dynasty to the Present

With the Ming dynasty (1368–1644), a native Chinese dynasty returned to rule the empire. The Ming set out to restore a sense of, and a pride in, native traditions. Their reign was marked by peace and prosperity, reflected in the arts as a sense of well-being combined with a lack of interest in experiment. At first few artists carried on the independent vein of the Sung scholar-painters, but a host of distinguished professional painters produced works in styles that rested securely in an understanding and knowledge of the work of their great predecessors.

In the late 15th and 16th centuries a fresh school of amateur scholar-painters arose in the south around Suchow, which included such major artists as Shen Chou and Wen Cheng ming. Also in Suchow at that time two strong professional artists, T'ang Yin and Ch'in Ying, earned reputations for their versatility as well as their technical mastery. Also during the Ming a series of woodblock print books were published of extraordinary beauty. They were intended purely as works of art, and were the result of private ventures by groups of aesthetically minded scholars and bourgeosie in certain southern cities. They provided prototypes for the far-better known woodblock prints of the Japanese Ukiyo-e.

The Ming was a great era for porcelain, well known in the West because the Chinese emperors encouraged its export, eventually in vast quantities. The kilns produced their wares under Imperial supervision and contributed to the overseas earnings of the empire. It was not until the 18th century that European kilns were able to make fine colored enamel porcelain in any quan-tity; and the Chinese products were looked on as intrinsically precious. The very best pieces from the kilns, however, were reserved for Imperial use.

The most famous Ming wares are the white porcelains decorated with under-glazed blue enamels in a variety of designs that were widely copied in inferior techniques and taste in the West. The underglazed red that the Chinese developed was inimitable, as was the range of monochrome wares also developed. But the best known, after the blue and white, are the San-tsai, three-color, and Wu-tsai, five-color wares, in which a wide range of designs were freely painted on the white porcelain surface of vases, plates, bowls and jars, in sets of brilliant enamel colors. One special achievement was a combination of layered green, yellow, blue and purple enamels, but simpler combinations of green and yellow, purple and yellow, and blue and red were developed to a high level of technical sophistication and aesthetic quality.

Under the following dynasty, the Ch'ing (1644–1912), the manufacture of these wares continued and attained extraordinary levels of technical refinement. Western aristocratic families became accustomed to ordering complete table services and the Chinese began to work to fulfill orders and even copy designs transmitted by the European East India trading companies. Around Canton, ordinary commercial, rather than Imperial, kilns began to flourish during the late 18th century and well into the 19th century there was strong mutual influence between Chinese and Western ceramics.

The Ch'ing were another alien dynasty, being Manchus from northern Asia, who imposed a severe regime upon the native Chinese. Into their capital, Peking, they imported a Tibetan type of Buddhism, complete with its monastic institutions and art. The great Lama temple was its center. Once again the more distinguished Chinese refused to serve the dynasty and, as a consequence, many of the greatest Ch'ing artists remained recluses or monks who worked primarily for each other in old provincial centers. Two of the greatest were Chu-Ta and Tao-chi, both Ch'an monks. The latter wrote one of the most important Chinese texts on the theory of art. The Ch'ing court attempted to follow the orthodox Chinese dynastic practice of maintaining a court atelier of painters, but this fell gradually into banal and highly decorative formulas that reflected both the alien taste and the corruption of the court.

By the end of the 19th century, after bitter conflicts in the trading cities, pressure from European trading corporations backed by naval and military force had imposed humbling treaties upon the Manchu emperors. The government was even obliged to consent to the sale of opium, by the British in particular, to the Chinese population. Many great Chinese merchant families made fortunes out of the general international trade that followed the opening of the ports to Europe.

The rule of the Ch'ing ended when the last Dowager Empress, who had retained the throne by the most unscrupulous intrigue and oppression, died. China then became more open to cultural influences from the West, partly mediated through Japan. Towards the end of the 19th century China had begun to introduce Western technology and methods of industrial production into some of its southern cities. In 1906 the first art school on Western lines was opened in Nanking and in 1912 another was opened in Kuantung, expressly to revitalize traditional styles by introducing perspective, shading and realistic illustrations of modern city life. By the 1920s there were many more such schools striving to emulate a second-hand, romantic

view of Parisian studio teaching. Art thus maintained its relationship with an increasingly industrialized Chinese urban society. Nevertheless, the strand of scholar-painting, the art of ink-painting as a private aesthetic activity based on traditional themes of landscape, birds, flowers and animals, did survive, and still survives today with modifications.

In the early 1930s Japanese pressure upon China increased, culminating in the attack on Peking in 1937. The war with Japan dragged on until 1945. During this time a new socially conscious and patriotic view of art flourished in the school of woodcut art founded by Lu Hsun in the 1920s. This was strongly Western in technique and became a potent weapon of socialist propaganda during the civil war after the Japanese had left, which culminated in the People's Government finally gaining power in 1950. Since then great efforts have been made to reclaim the traditional arts of the privileged for the people. Landscapes of traditional appearance, painted by individuals and groups and often turned into large woodblock prints with amazing skill, have been reinterpreted as settings for the everyday life of the workers and peasants. Versions of 18th-century ceramics, ivory and jade carvings are now made in huge numbers in specialized workshops for sale overseas, mainly through Hong Kong, to earn foreign exchange. Perhaps the most famous work of the entire epoch was made about 1965 at Ta-yi, Szechuan. Called *The Rent Collector's Courtyard*, it is a large collection of life-sized realistic plaster figures that illustrate the suffering and indignity imposed upon Chinese peasants under the corrupt old regime. It occupies a former landlord's mansion, and was executed cooperatively by a group of sculptors.

Japan

Japan consists of a string of volcanic islands curving from the arctic shores of Siberia almost down to Korea. The land is constantly plagued by earthquakes and the long coastlines are subject to typhoons and vast tidal waves originating in the Pacific Ocean. The mountain slopes are densely wooded and the landscapes of the sea inlets are exceptionally beautiful. The original inhabitants seem to have been of Siberian stock, but a great deal of the culture derives from that of other Pacific peoples in the islands further south.

There seems to have been no Paleolithic age in Japan and the oldest inhabitants were Neolithic hunters, fishermen and food-gatherers. They were probably the ancestors of the Ainu, who now live only in Hokkaido, the most northerly and coldest of the islands. They may well have been the people who produced the magnificent Jōmon pottery and terracotta figurines that we recognize today as major works of art. Ancestors of other Japanese seem to have entered later from Korea bringing with them rice cultivation and an administrative system. These people established what is known as the Yayoi culture. Their monuments consisted of many great tomb-mounds, known as tumuli, considered so sacred even today that few have been opened. The tombs that have been opened contained bronze swords and mirrors, iron swords, horse-trappings, gold and silver ornaments and a few wall paintings, all similar to the contents of tombs in Korea. The tomb-mounds were also surrounded with pottery known as *haniwa* – sometimes hundreds of them – in the form of tall cylinders crowned by brusquely modeled images of courtiers, servants and treasured objects. They were probably made to substitute for the actual people and objects buried with the dead in their tumuli in earlier times. The largest and the best

seem to have been made in the 5th century AD. Even at this time it seems that the country was ruled by a rigid feudal hierarchy, demanding absolute obedience.

The heritage of the Yayoi probably survives today in the pre-Buddhist state cult of Shinto, which has survived alongside Buddhism. The major shrine of Shinto is the famous Ise shrine dedicated to the sacred imperial spirits of Japan. Throughout its history one of the main features of Japanese culture has been its continuing reverence for spiritual forces in nature and people, which are thought of with affection, and not simply with awe. The landscape of Japan is scattered with sacred places, some very beautiful – rocks, hillsides, patches of coast – inhabited by spiritual presences called Kami, which to the Japanese are physical and spiritual realities. The Emperor of Japan embodies the most potent Kami of all.

It was during the Yayoi period that the concept of the emperor as divine head of his feudal state evolved. By that time the land of Japan had been divided under the domination of powerful local clans, whose feuds flared periodically into civil war. The Imperial family was the clan upon which divine status had fallen; and for the rest of its history the social organization of Japan was focused upon descendants of that family.

Sophisticated culture and art entered Japan with Buddhism during the Asuka period (552–645 AD). This came from Korea, which had assimilated Buddhism from China under the Six Dynasties, and had developed a high level of civilization. The first Buddhist missionaries arrived in Japan in 538 and were welcomed by Prince Shotoku of the Yamato clan. Shotoku fostered direct relations with China, imported Chinese techniques of administration, a code of laws and a calendar; he also organized a system of education and

set up a studio of artists. When Shotoku died in 623, there were already forty-six Buddhist temples in Japan. It is clear that the Prince saw himself as a ruler supported by the classic doctrine of the emperor as the good Buddhist.

Japan has protected and preserved her artistic heritage perhaps more thoroughly than any other country of the East, and so Shotoku's temple, the venerable Haryuji survives more or less in its original plan. Many fine Buddhist bronzes were cast and wooden images carved which have also survived. The process of assimilation during the Asuka period saw the original Korean influences even its script, superseded by the Chinese.

This Chinese link was fortified during the Nara period (645–793), the golden age of Japanese culture. Nara was chosen as the capital of the kingdom in 710, and the city was deliberately modeled on the Chinese T'ang dynasty capital, Chang-an. Under the Emperor Shomu (724–48), the great imperial temple, the Todaiji, was founded and the first of its many splendid sculptures installed. Many other great temples were built to accommodate the varied sects of Buddhism. They became vast and wealthy institutions, competing with one another for secular patronage and filled with sculpture and wall paintings used in public and state ceremonials.

The cultural influences of the Nara derived immediately from China. Emperors sent monks and ambassadors continually to Chang-an who returned with news of historical events, technical innovations and administrative improvements. Chinese monks and scholars were also invited to Japan.

One important Nara legacy was the storehouse of treasures that Shomu left to posterity, housed in his log-built treasury called the Shosoin. This consisted of Chinese T'ang dynasty robes, instruments, weapons and fine

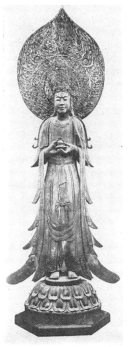

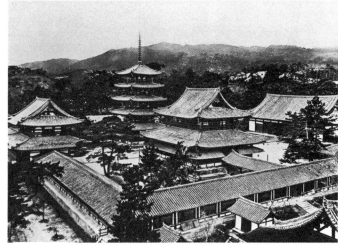

Main court of the Horyu-ji, *7th century AD*

The plan of Japan's oldest surviving Buddhist shrine is a transformation into wooden architecture of the layout of a shrine developed in India, the home of Buddhism.

The Compassionate Boddhisatva Kannon (Kuan-yin), *Asuka period, 552–645*
Carved and gilded wood height 6ft 5½in (1.97m)
Horyu-ji Temple, Nara, Japan

This life-size wooden image represents a type descended from the Indian Padmapani type. It is one of Japan's greatest early treasures, preserved in its oldest Buddhist temple. In style it is strongly Korean, which suggests it could have been carved by one of the Korean masters who worked in Japan at that time.

The Buddha Amida, *Heian period, 11th century*
Painting on silk
Reihokan Museum, Mt. Koya, Japan

This large painting represents the Buddha Amida (Sanskrit: Amitabha) borne on clouds from his western paradise, surrounded by celestial beings and musicians, to comfort his faithful worshippers. This illustrates the kind of cosmic vision which appealed so strongly to the imagination and emotions of Buddhist devotees during the Heian period.

furnishings and both building and collection survive to this day.

In 782 the current emperor, feeling that Nara had become too crowded with powerful monasteries and feudal palaces, moved his capital to Heiankyo, modern Kyoto. It, too, was built on the model of Chang-an, and T'ang influence on court and provincial life was paramount. It was during the Heian period that the first images of Shinto deities appear; they had been represented previously by abstract symbols, such as mirrors, swords or jewels.

At the Heian court the feudal nobility congregated. Leaving the management of their lands to retainers, they were far from what we know as the Samurai warriors, a creation of later times. The Heian court was an assembly of people such as poets and calligraphers who conducted aesthetic games by the use of subtle codes of allusion, according to strict rules of etiquette; the arts that arose from this environment were delicate and formal. We know of the inner life of this creative epoch from two works of prose literature; the diaries of a court woman called Sei Shonagon; and a novel by another court woman, Murasaki, called *The Tale of Prince Genji*. Both are concerned with love affairs.

The many Buddhist monasteries were gradually filled with gorgeous paintings of the deities and sects. Their altars were adorned with sensuous, overwhelming sculptures of the many personages of Buddhism, many on an immense scale, but with sweetness, gentleness and compassion as their keynotes. The custom also arose, probably in imitation of Chinese work that has long since vanished, of carving and painting likenesses of the teachers revered in the Buddhist sects. Most characteristically Japanese are a few surviving hand scrolls that mock, with sure calligraphy and great verve, the pretensions of conventional piety. Their

sense of fun and genius for caricature represent yet another side of the Japanese character.

Later ages criticized the Heian as a time when feminine influence upon court life grew. They claimed that the arts testified to this and that corruption was the inevitable result, with disastrous consequences for the country. In fact, it had gradually become customary for the wife of each emperor to be chosen from the same noble clan, the Fujiwara. To the great advantage of the clan the Fujiwara had taken over the office of court regent, transacting all state business, for 250 years.

The Heian period came to an end in 1156 amidst bloody civil wars. During its later years members of other clans who felt disadvantaged by the Fujiwara, especially the Taira and Minamoto, had been levying and training armies of tough, loyal and disciplined clansmen. They built ships and learned how to use them; they fought other clansmen and maintained defensive pressure against rebels and pirates from both within and beyond their borders. Imperial power had grown soft at its center and a dispute over the succession prompted an explosion of violence in the Hogen wars. These lasted three years and ended with the Minamoto crushed and decimated and the Taira in power. Their head, Kiyomori, built an immense castle-palace, organized an internal intelligence service and married his daughter to the emperor. He was thus able to make his own grandson emperor at the age of two. But in 1180 the surviving Minamoto rebelled; Kiyomori died and the Taira were expelled to the west of Japan, finally defeated as a force in 1185 AD.

The Minamoto placed at the head of their clan a cold-blooded and utterly ruthless tyrant, Yoritomo, who had himself proclaimed Shogun, or military dictator, ruling in the name of the emperor. Yoritomo established his own

court at Kamakura while the emperors remained at Kyoto, living in what became increasingly a cultural backwater. Thus began the Kamakura period (1185–1337). Yoritomo instilled into his followers a code of selfless obedience along with a dedication to military life and a code of honor stricter than any other known to history. This was the code of the Samurai, who lived and, all too often, died by the sword.

The art of Kamakura was not particularly original. There was one family of sculptors of genius, headed by Unkei, who were the last in Japan to work on a monumental scale. Once again the Japanese turned for inspiration to China – by now under the Sung dynasty – and Sung influence in the depiction of nature entered Japanese painting. Perhaps the most important artistic event was the introduction of sophisticated ceramics into Japan. In 1223 the monk Degen took with him to China a Japanese potter from Seto, known as Toshiro, who studied Sung ceramics and returned to work at Seto. Toshiro's wares were the first to be used in the Zen Buddhist tea ceremony, which was developing at that time even outside the great Zen monasteries as an austere and self-abnegating cult among the Samurai and clansmen of Japan.

After the death of Yoritomo the Minamoto continued to rule, often as regents of infant Shoguns, thus establishing the hereditary nature of the Shogunate, as well as the empire. Fortunately they continued to cultivate the military virtues; for in 1268 Kubilai Khan, the Mongol Yuan ruler of China, demanded the submission of Japan. The Shogun answered with an insult and the Mongols replied by sending two armadas – with disastrous results.

In 1319 an emperor came to the throne determined to reclaim the government from the Shoguns in the name of his infant son. Decades of war, plots and counterplots and a split dynasty

followed. In 1392 a great soldier and statesman, Yoshimitsu of the Ashikaga clan, effected a reconciliation between the emperors and the Shogunate. He ruled as Shogun and in turn sent monks and ambassadors to China, now ruled by the Ming dynasty, to bring back cultural and administrative ideas with which to fortify his military rule. Yoshimitsu's dynasty lasted until 1573. In its later years it declined into a life of luxury and corruption like the Heian, and it was eventually unable to control new inter-clan civil wars that became a permanent fact of Japanese life.

Yoshimitsu brought peace to Japan only for a period. He was both a statesman and a patron of the arts, building his sumptuous palace in the Muromachi quarter of Kyoto, hence this period is often called the Muromachi. Yoshimitsu retired from the palace to his own splendid Buddhist temple, the Golden Pavilion (Kinkaku-ji), which still stands, leaving the rule to his grandson. It was during this period that the tea-pavilion became a feature of Japanese domestic architecture and the Zen-inspired tea ceremony became widely established as the focus of art.

The leading painters of the period were the monks Shubun and Sesshu. Shubun followed Southern Sung styles of atmospheric landscape painting and served Yoshimitsu as head of the studio; his followers tended towards virtuosity. Sesshu, however, was a vigorous individual who went to the Ming capital in China for inspiration. On his return he made a career for himself as a Zen-inspired free artistic spirit, reclusive but much admired by the feudal aristocracy.

The last century of this Shogunate was plagued by unremitting civil war and tranquil periods were few. One event of major importance was the arrival of Portuguese ships and missionaries in 1542. A local lord, Nobunaga, welcomed the Christians as an afset in his own bid for power, which

he attained in 1567. European influence can be seen in the art made under Nobunaga, especially in lacquer and metalwork. Some Japanese envoys reached Rome and Madrid and goods were exported, but dissension among the missionaries proved catastrophic.

After Nobunaga's assassination, his general, Hideyoshi, continued to rule. Hideyoshi was a man of obscure origins but of boundless vigour who finally broke the power of the great monasteries and persecuted the Christians, being reluctant to tolerate any influences that would conflict with his own will. Twice he attempted to invade Korea and brought back Korean craftsmen. Some of these were potters, who set up kilns at Arita and made a further important contribution both to tea-wares and ceramics that, like China, Japan was later to export.

Hideyoshi began a vogue for building stupendous castles that were collections of tiered wooden palaces with curved wing-like roofs standing upon vast bases of cyclopean masonry. Their interiors were decorated with hanging scrolls and folding screens by members of the Kano family, who became virtually a Shogunal dynasty of painters. The Kano used a galaxy of traditional themes derived from Chinese and Japanese art and cultivated an immense pictorial skill by executing vast decor-

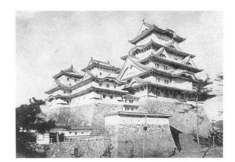

Himeji Castle, *late 16th century*
Hyogo Prefecture, Japan

This was built as a feudal fortress-palace during a period of ferocious civil wars. Its vast stone plinth was meant to resist the fire of the cannon which the Japanese had recently acquired from the West. Its towering wooden superstructure housed family and retainers in halls and rooms of the utmost splendor, their interiors lavishly decorated with paintings.

Eight Views of the Hsiao and Hsiang Rivers, *Muromachi period, 1334–1573*
Zosan
Folding screen
Museum of Fine Arts, Boston, Mass.

This superb screen was painted to furnish a pakace. Its subject is taken from the traditional landscape imagery invented in Sung-dynasty China and later adopted in Japan. The trees and rock pinnacles appearing from misty space invite the viewer to contemplate infinite time and change, while conveying an impression of great elegance. It summarises the aesthetic culture of feudal Japan.

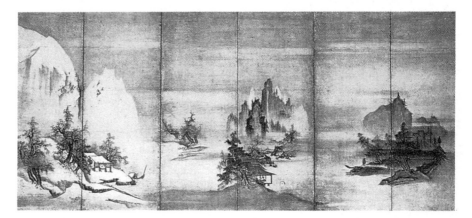

ative schemes at high speed. The greatest was Kano Eitoku. The Kano worked for both secular and religious patrons and also designed gardens.

After Hideyoshi's death there was once again a struggle for power, which was won by his right-hand man, Ieyasu of the Tokugawa clan, related to the Minamoto. In 1615 Ieyasu captured Osaka castle, founding a police state that lasted until 1868, longer than any other in history. Ieyasu chose Edo, now Tokyo, as his capital and the heads of feudal families were obliged to spend most of the year there, within reach of Hideoyoshi's arm; if they left they had to leave an important member of their family behind as hostage. Thus Tokyo became a city of rich but temporary residents. It also became the natural resort of those who could make a living from the rich: craftsmen, Samurai whose feudal masters had been killed and hucksters of every kind. In other cities, too, the new dictator induced prosperity and peace, if of a somewhat oppressive nature. Censorship of books and art was strict and official; secret police maintained constant watch; foreigners were rigorously excluded and only the Dutch were allowed access to the port of Nagasaki, through which a small trickle of imports was allowed to flow. Japanese ceramics, however, flowed out to meet the needs of the European market, many of them direct imitations of Chinese wares.

While the Kano family of painters continued to flourish, three other great painters – Sotatsu, Korin and Koetsu – worked in highly decorative styles for the wealthy. But the best known artistic phase was the Ukiyo-e print school, which flourished, from the second half of the 17th century to the late 19th century, as a part of the immense entertainment industry that grew up in Edo to amuse the new leisured population. Edo had become a metropolis full of pleasure-seekers with money to spend. The Yoshiwara, a region of the city in which courtesans and prostitutes of all grades lived, was the center of this culture. It was the center of fashion and Ukiyo-e painters worked to decorate its 'green houses', a poetic name for the brothels. The kabuki theater became popular, with its stars being the subject matter for the print artists, and block-printed novels were produced in large editions for a newly literate market.

The Ukiyo-e artists worked for a clientele who regarded art as amusement but could not afford original paintings. Prints were produced in large numbers by publishers with large workshops from designs by specialist artists. Many are now recognized as great masters, among them Harunobu, Koryusai, Utamaro, and Hokusai. The subject matter was primarily beautiful, fashionable girls and love, but every aspect of metropolitan life and Japanese legend could be depicted, from wrestlers to heroic battles and street fights. The prints were topical but subject to government censorship. Large numbers of small works of art, such as inro boxes to hang at the sash, and decorative sword guards were made.

In 1868, as a result of the opening of Japan to Western influence by Commodore Perry, the direct rule of the emperors was restored. This resulted in the swift and total industrialization of Japan, the consequences of which are with us today. Japan has demonstrated the immense vitality, adaptability and skill of its artists. Virtually every Western mode has been assimilated and exploited, and the country's own revivalist movements have been successful as well. The 20th century artists best known in the West are Shoji Hamada, the potter, designated a "living national treasure", and the woodblock master Munakata.

Katsura Imperial palace,
Kyoto

This is a detail of the 17th-century "detached palace", one of the crowning achievements of Japanese architecture. It was built as a retreat for the emperors and was designed expressly to refresh and nourish the spirits of its residents. The wooden pavilions of the dwelling interact with the beautifully designed garden by the subtle use of balconies and sliding wood-and-paper screens which can open the inner spaces to the outer environment. The pavilions symbolize what is human, the garden the changing universe.

Ukiyo-e Fan Painting
Utamaro (1753–1806)
Victoria and Albert Museum, London

Done in the 1760s, this fan painting depicts one of the most popular themes of the day, actors of Kabuki theater. As a piece of Ukiyo-e it was made for a member of the vast population of the city of Edo (now Tokyo).

Oceania

The vast cultural area of the South Pacific, called Oceania, can best be thought of in five major sectors, which interlock and have interacted over the course of millennia. First is Melanesia, which extends around New Guinea and the Solomon Islands, southward into the Australia of the Aborigines and northward as far as the Admiralty Islands and New Britain. Second is Micronesia, which embraces the Marianas, the Caroline, Marshall and Gilbert Islands. The third, and largest, includes the far-flung outposts of the Pacific, the Hawaiian, Fiji, Marquesas and Cook islands, Samoa, Tonga and Maori New Zealand. These different collections of islands appear to have been settled by different groups of peoples in an assumed order that can serve as a reasonable guide to the general history of the area. The groups probably migrated principally from the two remaining sectors of the South Pacific: Indonesia, including the large islands of Java, Sumatra and Sulawesi and adjacent areas of Southeast Asia; and Malaysia. These two were heavily Indianized during the earlier and later Middle Ages.

The first three groups seem to have continually produced a variety of arts in the different available materials. None of them knew a metal technology. On volcanic islands, plentiful supplies of hard basaltic rock gave them the axes with which to fell, trim and shape trees. Shell, bone, the teeth of animals and fish gave them other implements to shape the utensils with which they adapted themselves to each type of terrain. The arts were at one level closely connected with their methods of gaining their livelihoods in their different environments – fishing, hunting, animal rearing, planting and so on – and at another level with the variety of social and religious organizations they adopted. There is little overall con-

sistency about these. Indeed, in places such as New Guinea even the languages seem to have been multiplied and distinguished as part of a positive cultural process.

We can recognize that some arts that were at first practical later became concerned with perpetuating links between the human world of the present and the mythic world of ancestors and spirits from which supernatural power emanated. The peoples have therefore also interpreted the arts as practical magic, to gain benefits, to avert evil and to ensure the stability of their societies.

The earliest human settlers seem to have entered Oceania after 20,000 BC. They were Paleolithic food-gatherers and hunters, a mixture of negrito and ancient Caucasians in physical type. They spoke languages that were the ancestors of those now called Papuan. These peoples had dark skins, full beards and frizzy hair and may be related to the Veddas of Ceylon and vestigial groups in Malaysia. Some migrated into the immense deserts and steppe-lands of Australia to develop the powerful cultures known as Aboriginal. They appear to have been substantially resistant to malaria, the plague of Melanesia, and still populate the mountainous interiors clad in tropical rain forest of great islands such as New Guinea and Borneo. Substantially gardeners and pig-rearers, they promoted mobility in their social groupings by accumulating wealth through trade and competitive feasts. Until recently they were headhunters, with all that implies of belief concerning the nature and spirit of man. Their religion is centered on clubhouses that housed the male population and elaborate initiation ceremonies. The art produced in Melanesia is linked to these societies. Stupendous human figures are carved in dense, curvilinear designs to represent the spirits of the living and are then stored in houses as sources of

power when the subjects have died. Masks are made for elaborate dances and carved funeral standards are erected, some of immense size. These, as well as all of the other arts and implements throughout the islands, are dominated by the image of the human head as the vessel of ancestral and supernatural power.

Between about 3000 and 2000 BC other migrants with Neolithic tools and culture patterns, first from Indonesia and then perhaps from further north in Asia, began to infiltrate the islands of Micronesia. Some of these peoples belonged probably to distinctly Mongoloid types. Their habitation of the Micronesian islands produced a culture of coastal farming and fishing, relatively loose political federations and religions that were based upon socially unformalized family religion. The arts tended to be utilitarian and decorated with patterns. Mat-work, weaving and tattooing were their primary modes. These people also colonized the coastal areas of northern Melanesia, and interbred with the original Melanesians. Perhaps because they could not tolerate malaria, and perhaps reinforced and pressed by further waves of migration of Indonesian peoples, they began the vast sea voyages with which they populated all of the far-flung habitable islands of Polynesia. The sea-faring technology they needed for voyages of over 2000 miles (3200 km) was based fundamentally upon wood-working skills and seems to have promoted other important artistic developments. Everywhere they penetrated they had to adjust themselves to new environments: from low-lying coral atolls where there was no stone, to Easter Island, where there was little else. The variety of wood-carvings they executed on houses and canoes with all kinds of natural tools bears witness to their adaptability. They developed an immense variety of expressive patterns and images that

were based upon their cultural customs.

Polynesians were primarily fishermen and gardeners, cultivating the coconut palm for its natural attributes. They worshipped deities who embodied their social values, and family groups consolidated the efforts of both paternal and maternal lines of descent into joint enterprises. Their secular leaders were commonly the lineal descendants of deified ancestors and were supposed to serve both gods and humans. Hereditary aristocracies and elaborate social etiquette maintained the order of society and were served by poets and public orators whose skills were highly regarded.

These peoples expected their everyday utensils to be beautiful, be these food-pounders, stools, fish-hooks or wooden weapons. Bark cloth made from coconut palm and pandanus leaves, and hibiscus bast, was woven by the women into superb mats, sails, baskets and even house walls. These were dyed in brilliant colors. Featherwork was regarded as a major ritual art, red and yellow feathers being emblems of the divine. Shell was carved both for body ornament and for trade. But perhaps the most accomplished artists of all the Polynesian peoples were the Maori of New Zealand, whose elaborate, sinuous woodcarvings on houseposts and divine icons were also used to tattoo their faces. They also worked the rare local jade into axes and amulets.

The cultures of the islands of Oceania were devastated by the arrival of Europeans and the process still continues.

Indonesia

Indonesia, from which substantial elements of Polynesian culture originated, was populated by people who retained, unless they were Indianized, many cultural features in common with the Polynesians. Today, the Dayaks of northern Borneo, the Bataks

of Sumatra and the native peoples of Sulawesi preserve tribal and artistic customs that must have originated in a remote and common past. Their arts are chiefly connected with a ritualization of the family or tribal house, whose towering gables are adorned with elaborate carvings and references to ritual sacrifices. They were also headhunters who valued and sought to possess the spiritual powers believed to reside in the human skull. Their ancestor figures also emphasize the spiritual function of the head. In Borneo the Toucan bird plays a special role in funeral art. Its beak is especially treasured and images of the bird show the beak fantastically elaborated into curvilinear designs. Among the Batak of Sumatra the staves and ritual vessels of professional magicians were once adorned with emblems of power refering to human sacrifice.

The process of Indianizing much of Indonesia was begun at the end of the first century AD when traders from western India first settled in western Java and Buddhism was introduced. In fact, many islands remain to this day relatively untouched by Indian influence. At about the same time, Indian trade settlements, which developed into kingdoms, were established on the Malay isthmus of Kra and further north on the peninsula. These settlements were introduced into Neolithic contexts where bronze working was also known. Indeed, different layers of culture have long existed side by side in Indonesia. Megalithic monuments, some as recent as the 9th century AD, survive in Sumatra, Java and Nias Island. Stone circles are still used as sacrifice grounds in Sumatra. Old rectangular polished stone axe-heads following Neolithic types have been found at many sites in Malaya, Indonesia and on the mainland.

Major works in bronze were probably distributed around the coast of South-

east Asia and into the islands of Indonesia by a seaborne culture that appears to have been centered at Dongson on the coast of the Gulf of Tongking. The bronze objects are mainly large, hollow, cylindrical drums with surface decoration in relief. They were cast by the lost wax process. Small versions are today still used to "pay" for brides in certain parts of Indonesia.

Some time during the 2nd century AD a powerful Buddhist Indian colonial kingdom called Shrivijaya ruled large areas of modern Malaya and Indonesia from its strategically located power base at Palembang, commanding the Strait of Malacca. This center seems to have maintained close relations with the great Buddhist centers of southeastern India around Amaravati. The influence of their Buddhist imagery and style upon Shrivijaya art is clear. Many regions of Southeast Asia and Indonesia were ruled by kings who relied upon the skills of learned Buddhist monks for the administrative theory and practice. It is likely that there were other Buddhist settlements and petty kingdoms elsewhere in Indonesia of which we know nothing as yet; a superb bronze figure of the Buddha in southeast Indian style has been found, for example, in distant Sulawesi.

Indian-influenced kingdoms took root in Java between the 3rd and 6th centuries AD. Their rulers, who lived in fortified villages, relying upon Indian ideas and technology, competed among themselves for power. Eventually, in about 700, a central Javanese dynasty who had assimilated Hindu culture from southern India came to dominate the island and built the first major Indian-style temples on the Djieng plateau. They were succeeded by the Buddhist Shailendra (775–864), who set up irrigation systems to cultivate large areas of rice in central Java. They built several great Buddhist monuments that survive today. Hinduism con-

tinued to co-exist with Buddhism.

The greatest Shailendra monument is Borobudur (c.300), a huge, symmetrical Buddhist temple-mountain built of stone and covered with superb stone carvings in relief and in the round in a characteristicaly Javanese style. Other dynastic monuments in the same region and the same period, with similarly splendid sculpture, are Mendut, Pawon, Kalasan, and Sari. It seems probable that each was a spiritual power-center for a king of the dynasty, authenticating his rule by reference to the mythology and doctrines of Buddhism. The many fine precious metal wares and small bronze images excavated in the central Javanese heartland suggest that there were once substantial monasteries, perhaps of wood, associated with the major stone structures. The last great central Javanese temple was Hindu, at Prambanam (c.900). This was once an immense complex of 232 shrines centered on a central court containing eight shrines, with a focal shrine 120 feet (36 m) high. It, too, was covered with sculpture, much dealing with Sanskrit classical legend but including a major series devoted to the postures of Indian traditional dance. The latter testifies to the early establishment in Indonesia of the Indian dance which inspired the now well known dance traditions of Java and Bali.

These traditions were further developed under the East Javanese dynasty of Majapahit, which lasted from the 10th to the 16th century. It was in continual conflict with the other great Indianized cultures of Cambodia and Thailand for lands and trade. At one time it ruled substantial areas of what are now Malaysia and Thailand. Its capital was also moved for a time into the low rice and palm lands of Sumatra. Many great works of art have survived from East Javanese times, notably superb stone-cut icons of Hindu and Buddhist deities that once stood in vanished temples. It was the advance of Islam during the 13th to 15th centuries that brought the East Javanese kingdom to an end. But even in the nominally Muslim culture of present day Java many traditions from earlier times survive, built into the social and economic fabric of the farming communities. The best-known are Javanese dance and gamelan music, both of which are direct descendants of the court arts of Majapahit.

Perhaps the most important and interesting survival of East Javanese tradition is found in the small island of Bali, off the eastern end of Java, which resisted Islam through a series of bitter wars and has remained Hindu. Here dance, music and temple arts flourish, integrally woven into the life of the people, alongside versions made especially for Western and Japanese tourists.

Indo-China and Thailand

Across the South China Sea from Indonesia another major empire existed contemporary with the Central and early East Javanese periods. Its heartland was Cambodia. It was in continual conflict with the kingdom of the Cham in southern Vietnam (2nd to 15th centuries), whose dynasties produced a series of modest shrines in two capital cities. The Khmer peoples of Cambodia, however, produced a series of gigantic dynastic temples, some of which individually contain the largest masses of carved stone ever assembled by mankind. The focus of all this artistic effort was the city of Angkor, on the Mekong River. The imperial Khmer dynasty was founded by the rulers of two successive small, earlier kingdoms on the reaches of that river, called by the names by which they were known to the Chinese, Funan and Chenla (1st to 9th centuries AD). At early Funan sites, objects from the Roman world, Ptolemaic Egypt and Sassanian Persia have been found, giving an idea of the vast ramifications of the sea-borne trade in which they played a part. The influence of these kingdoms, especially Funan, seems to have extended a good way along the coasts of Thailand. Their wealth was founded upon wet-rice cultivation.

Angkor was founded in the 9th century. It was not only a city, but also the focus of a gigantic irrigation system containing reservoirs, canals and channels associated with the fresh water lagoon of Tonle-sap. Under the dominion and spiritual protection of the Khmer kings, Angkor controlled and protected an enormous area of irrigated rice-paddy whose crops were exported to the profit of the empire. Successive kings built a series of temple-mountains of gradually increasing size, in which they performed their traditional Hindu state ceremonials. The first was built by Indravarman II (877–889), the king who extended the boundaries of the Khmer empire far into Thailand. It is called the Bakong. The biggest is Angkor Wat, whose perimeter is four miles (6 km) in length (early 12th century). The last, the Bayon, was at the center of a new city built within the old called Angkor Thom, 7 miles (11 km) in perimeter. It is Buddhist (c.1200 AD) and was built by Jayavarman VII. He had embarked on a series of ferocious campaigns at the age of 60 both to repel the Cham, who had temporarily seized Angkor, and to extend once more the frontiers of the empire. All these Khmer monuments, including some at other sites, are splendidly conceived works of architecture. They are decorated with vast quantities of stone sculpture of exceptional beauty that deal with the mythology of Hindu and Buddhist divine royalty.

After the death of Jayavarman VII (c.1215–19) Angkor declined. The Thai populations whom the Khmer had ruled pushed them back towards the

Mekong delta, confining them to the terrain now known as Kampuchea. A Thai version of fundamentalist Buddhism became the religion of the people.

The large rice-growing country of Thailand was ruled during most of the 11th to 13th centuries by the Khmer, kin of the major population group in Thailand, the Eastern Mon. These people had adopted a form of Indian Buddhism as their state religion and sustained a major kingdom called Dvaravati (6th to 11th centuries) focused upon a group of major cities. Many monasteries contained Buddhist sculptures of direct Indian inspiration. There were artistic and, probably, political links with the kingdom of Shrivijaya. One major Dvaravati monument survives, the Wat Kukut at Lamphun, built probably about 1130 by a Mon king in Khmer style. When the Khmer captured the Mon territories they built a number of major provincial temples of their own using brick ornamented with stucco reliefs.

While the Khmer were ruling Mon Thailand a population group of non-Mon descent, the Tai, were steadily advancing in the north of the country, probably from the mountainous regions of South China. When Khmer rule was withdrawn they took command of all the great cities of Thailand but did not establish a unified imperial power. Dominance passed between their city-states centered on Chiengmai in the north and Ayutthaya in the south, with control of the great city called Sukhothai, at the focal point of important land trade routes, fluctuating between them. Sukhothai seems to have maintained direct contact with Ceylon, which remained the chief home of Buddhism after it had been expunged from India by the Muslims in the 12th century. At each of the great Thai cities large numbers of Buddhist shrines with tall *stupa* towers were erected. Today the remains of old

Ayutthaya's towers stand as an attraction for tourists. Elsewhere, major traditions of Buddha sculpture cast in bronze, often on a colossal scale, were the leading form of art. Modern Bangkok, a city that suffered invasion from Burma in the late 18th century and Burmanization of its art-styles, contains many Buddhist shrines decorated in extravagant and sometimes meretricious late Burmese taste.

Burma

Burma, another leading Buddhist country of Southeast Asia, was at first ruled by its earliest documented inhabitants, the Western Mon in the south, and the Pyu in the north. The latter spoke a Tibeto-Burman tongue and came probably from central Asia; they built enormous cities whose magnificence was recorded by the Chinese. In the 8th century one city was documented as over 50 miles (80 km) in circumference, containing one hundred painted and gilded Buddhist temples. One was over 150 feet (45 m) in height. The Pyu capital was at modern Hmawza and was larger than any later Burmese city until this century. Like Thailand, Burma was gradually overrun from the north by a group of Burmese racially kin to the Tai who may have come originally from near Tongking. They overcame the Pyu and the Mon, being converted to Buddhism. Their great and legendary king, Anawrahta, took the throne in 1056 and captured a Mon royal family, large numbers of Mon craftsmen and learned monks.

He gave orders for the elaboration of his own capital city, Pagan. Much of it still stands, the largest ancient city complex to survive in Asia. Its brick and stucco buildings – shrines, palaces and libraries – were once densely surrounded by wooden halls and houses. Its architecture, with the few surviving paintings and reliefs, is derived from eastern India. The most famous shrine

still in use is the great Ananda temple, dedicated in 1090. Pagan was abandoned after the Mongol conquest (1287).

As time went on, other Burmese cities evolved – Rangoon and Mandalay are the largest – that also contained large numbers of Buddhist temple complexes filled with pagodas. These are tall, tapering bell-shaped towers raised on ornate plinths, derived from the Indian *stupa*, surrounded by preaching halls, living accommodation and other facilities. Since the Burmese custom has long been to tear down the old and rebuild, or at least to re-clad it again and again, it is not possible to trace a consistent history of Burmese architecture.

The Philippines

The population of the Philippine Islands embraces a number of ethnic layers, who share the inheritance of the rest of Oceania. One group may well be equivalent to the Paleolithic Melanesian. The group known as the Moro were converted to Islam in the 15th and 16th centuries. The most important historical development for the arts was the Spanish conquest of the islands in 1571. The new bishopric of Manila, now the capital, and all of the island of Luzon became the focus for a major development of Spanish colonial ecclesiastical art. Major architects, sculptors and painters from Mexico and Spain worked on cathedrals and churches. After the transfer of rule to the United States in 1898, industrialization commenced, and the increasingly modernized commercial society adapted the arts to its own ends. Since the 1930s many artists have worked in idioms current in the West.

Pre-Columbian Civilizations

Although evidence is scarce, it is thought that the first wave of immigrants crossed the Bering Strait to the New World in several waves from 50,000 to 15,000 BC and there are indications that man was living in the Basin of Mexico about 20,000 to 18,000 BC and had reached Peru by 19,000 BC. For many thousands of years subsistence was based in hunting and gathering with an increasing concentration on plant foods and small game. This in turn led the way to the domestication of flora and fauna first evident in Mexico in about 7000 to 6000 BC and in Peru domesticated plants and animals appeared about 5500 to 4500 BC. With the advent of this food base a more sedantary way of life was possible and this led the way toward the development of the great pre-Hispanic cultures in the succeeding centuries.

Middle America

The Olmecs were the first great civilization to appear on the Middle American scene and their influence on the succeeding peoples who rose to prominence throughout the country was such that when we look at the last great civilization to hold sway before the Spanish Conquest, the Aztecs, we find many of the features of their culture already present with the Olmecs. Common to both cultures and to all those intervening were the use of obsidian for weapons, tools and jewelery; the great value placed on jade; a pantheon that included a rain-god and a feathered serpent; a counting system; the 52-year calendrical cycle; civic-ceremonial buildings and the ball-game; semi-divine rulers and a ranked society; and the centralization of authority.

The Olmec civilization lasted from 1200–400 BC on the Gulf Coast of Mexico. Ecological differentiation throughout Middle America was an important factor in the development of

inter-regional contact and establishing trade networks along which it was not only such highly-prized and difficult-to-obtain items as jade or iron-ore mirrors that passed, but trade also provided the vehicle for the diffusion of ideas and the Olmec model of society must have held strong appeal for the other less-developed centers with which it came into contact.

The principle Olmec site known to us so far is La Venta, Tabasco, which would seem to have been occupied between 800–400 BC. The site is characteristic of many in Middle America in that it is not urban or primarily residential. The peasants who built it and upon whom it depended for its existence lived some way off and the site itself was of the nature of a ritual center where lived a few priestly rulers with their attendants and specialist craftsmen; the massive architectural structures representing an impressive setting for their ceremonial.

Problematic in Olmec art is the significance of the pervasive "were-jaguar" face which combines infantine

Olmec ceremonial adze
Jadeite

The carving shows the characteristic cleft forehead and flaring lips of the baby-faced were-jaguar beings which frequently occur in Olmec art.

and feline features. A carving at the Olmec site of Portroro Nuevo which shows a jaguar and a woman in copulation suggests a mythological identity for these hybrid beings.

Olmec influence was widespread and small portable objects, such as jade figurines or plaques in the style are found on many Middle-American sites. It made itself felt in the southern region of Oaxaca, in the great center of Monte Alban, where stone figures carved in relief are accompanied by glyphs, an early instance of a stylistic device. Monte Alban was founded between 500–400 BC and it rose to prominence, as the centers of Olmec culture collapsed. The Zapotec sphere of influence was confined to Oaxaca, where their activity, as depicted on hundreds of stone carvings from Monte Alban (500–200 BC) appears to have been emphatically militaristic with frequent bloody sacrifices to the gods.

The exact relationship between Monte Alban and Teotihuacan after the latter became dominant in the Valley of Mexico is not known, but it appears to have been a friendly one and four stone monuments at Monte Alban, faithfully depicting regional variation in dress, record the visit of an important personage from Teotihuacan

at some time during 1–400 AD. Teotihuacan was a vast urban development, which was able to sustain so large a population (100,000–200,000 people) through intensive agriculture. Commercially, it exploited nearby obsidian quarries and established a wide network of trade in this basic Middle-American commodity that reached into distant Guatemala and Belize.

Teotihuacan has produced relatively little stone-carving and it has been suggested that demand for the decoration of the many public and private buildings was so great that this more laborious technique was replaced by wall-painting. With few exceptions, the theme in these murals is religious and the recurring motifs of butterflies, flowers or birds usually bear some relation to a god or a cult. Not unexpectedly for a people whose survival was intimately connected with an intricate irrigation system, agricultural fertility is frequently the subject matter of these murals and dramatically stylized depictions of the rain god with the beneficent gift of water falling from his hands appear in several.

Teotihuacan's busy trading activity brought it into contact with emerging Maya civilization east of the Isthmus of Tehuantepec. Around 450 AD, the Maya influence is apparent in the style of ceramics and murals at Teotihuacan and Teotihuacan-style artifacts are found in elite Maya burials.

Teotihuacan provided the elite among the Maya with a model of social stratification and ostentatious display of authority and power and had a profound effect on the means by which that elite consolidated and reinforced its leadership. A dynasty of rulers first emerges at Tikal, a southern Maya lowlands center, where, predictably, a complex of temples and places was built around squares and courts and the histories of the rulers are recorded on carved stelae, often attesting to

divine descent with a god-ancestor depicted in the heavens above, and because of the Maya absorption in calendrics, often very precisely dated in hieroglyphs.

The abrupt and unexplained interruption of the close trading relationship between Teotihuacan and Tikal c.540 AD began a period of instability and disorientation throughout the lowland Maya area, during which there is minimal building work or erection of carved monuments, and by the end of the 6th century BC, Tikal is having to share power with such other centers as Palenque and Copan. The subsequent 150–200 years have been called the Maya Renaissance. New buildings are erected and sculpted columns showing rulers and priests loaded with jewelery and elaborately costumed. Maya civilization is at its most brilliant in artistic and intellectual terms during this period.

In Northern Maya centers, such as Tajin and Chichen Itza, the ball-game was played with enthusiasm and raised to the level of a cult. Early evidence of the ball-game appears at the Olmec site of San Lorenzo. The rules and the significance of the game may have changed throughout succeeding centuries and from site to site, but ball-courts are usually located in temple precincts and as played in these later centers, it may have been a means of divining the outcome of future events and from the time of Monte Alban the carvings found in association with ball-courts leave little doubt that human sacrifice by decapitation or removal of the heart was a significant feature of the game. At Chichen Itza there were as many as thirteen ball-courts.

Teotihuacan's gradual decline was completed when it suffered a disastrous fire and its role of leadership passed to Tula, around 900 AD. Our picture of the Toltecs who lived there is obscured by subsequent Aztec mythologization of

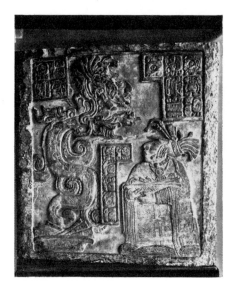

Maya lintel
Yaxchilan, Mexico

A divine figure emerges from the mouth of a huge serpent. Both this head and that of the worshipper before it shows the skull deformation practised by the Maya. Wooden boards were strapped to a baby's head to mold the lofty forehead the Maya considered beautiful.

the people they adopted as their cultural ancestors, in an attempt to dignify the less glamorous truth that they were descended from a mixed bag of itinerant northern immigrants. Ironically, the Toltecs themselves may have descended also largely from just such a group. The art of Tula has iconographic features in common with Chichen Itza, a major Mayan ceremonial site, and ideological parallels appear in the many ball-courts and the prevailing images of warriors.

Incursions of semi-nomadic barbarians continued from the north and Tula was destroyed most probably by one of these Chichimec chiefs in 1168 AD. The Aztecs were one such migrant people who wandered into the Valley of Mexico, hiring themselves as mercenaries to neighboring groups, before

establishing their capital, Tenochtitlan, on an island in the central lake of the Valley. The island in time was linked to the mainland by the construction of causeways and aqueducts and the Aztecs erected a city of such regularity and beauty as to excite the admiration of those few Europeans who saw it before its destruction in 1521. The center of the city was occupied by a sacred precinct which served as a stage for the sacrificial killing of large numbers of captives taken in battle. It was thought that their blood nourished the sun in its course across the sky.

From 1428, the Aztecs embarked on a program of expansion and conquest which resulted in vast amounts of tribute in the form of corn, beans, cacao and cotton flowing into the metropolis from subjugated peoples. Warfare was also an important means of gaining honors in a highly stratified society, through personal prowess in battle. The *pochteca*, or professional traders, traded far to the east and south, not only bringing back luxury goods to Tenochtitlan, but also important information about the wealth of these far-flung areas and their susceptibility to conquest. Religion was at the heart of Aztec life and in the quality and number of the sculptured representations of their gods we encounter some of the most powerful images in all Middle American art and witness the extraordinary religious preoccupation of a people for whom to be sacrificed to the gods was the greatest human glory.

South America

Perhaps one of the main achievements of the pre-Hispanic cultures who lived in the Andean region of South America was the effective exploitation of their extremely difficult environment. The area is divided into a barren coastal desert, precipitous mountain ranges and almost impenetrable tropical

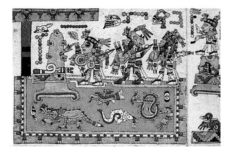

Page from a Mixtec manuscript

Warriors are attacking a town on a lake. The Mixtec people who lived in Oaxaca were most gifted craftsmen, and produced many exquisite works of jewellery and turquoise mosaic for the Aztecs. The Nuttall-Zouche Codex is largely a genealogy and deals with the life and exploits of the chief Eight Deer. It is believed to have been sent by Cortés to the Emperor Charles V in 1519.

forests on the eastern Andean slopes. On this terrain dozens of plants were cultivated and the Andean record for the domestication of flora and fauna is comparable to any other area of the world – the most important being the staple crop, the potato, and llamas and alpacas. This base and intensive method of cultivation permitted dense population growths in the coastal and valleys. By using coastal sea routes, river courses and constructing hundreds of miles of foot roads, important trade routes between different ecological areas were established to supply food and luxury goods to the developing civilizations. A number of common characteristics developed, the most important being the widespread prevalence of a sophisticated religion centering around a feline, or cat-like, mythological figure. Large structural complexes were built requiring advanced architectural and engineering skills. Textiles were also immensely important beyond their utility value. Accounts of Inca life relate how textiles were used to distinguish different social and regional

groups, to mark important ceremonial occasions, and were used as important economic commodities. Pottery first appeared in the first part of the third millenium in Colombia and Ecuador. Distinctive styles and designs serve as markers for individual cultures, but several basic forms are characteristic of the west coast of South America; for example, the stirrup-spout vessel of the north coast of Peru and Ecuador, and the double spout and bridge pieces on the Peruvian south coast. Metal-working, in gold, silver (and in Ecuador, platinum) reached a very high standard. Casting, soldering, hammering, repousée and false filigree were some of the techniques employed.

The first major South American civilization was already flourishing in the northern Peruvian highlands by 1000 BC. A number of impressive ceremonial centers indicate the existence of a structured society capable of mobilizing large numbers of people for their construction. The main motivating force was the cult of the "grinning" feline god which appears in many forms on both the monumental sculpture and lesser art forms. Of these, the site of Chavin de Huantar in Peru, was the most influential. Early Chavin art was already well-established, presumably the culmination of previous developing traditions. Its pottery, such as well-burnished stirrup-spout vessels decorated with felines and other animals modeled in relief, shows a high degree of sophistication, and the few fragments of textiles discovered indicate that the Chavin were fully conversant with the technology of weaving. It also was one of the first cultures to introduce to the central Andes the craft of gold-working. Fine hammered and repoussé gold ornaments have been found. The Chavin influence extended not only over a wide region of contemporary Peru but continued to affect the art and religion of the succeeding pre-Hispanic

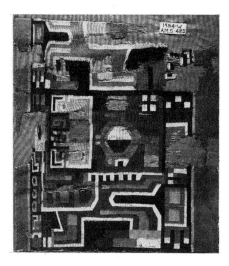

Tapestry fragment, c.*AD 500–1000.*
Coastal region of Peru, Tiahuanaco
influenced

The kneeling winged figure clutching a staff
is reminiscent of relief carvings on the
Gateway of the Sun, Tiahuanaco. A tear-like
projection extends below the eye, which
itself is in the form of an animal's head.

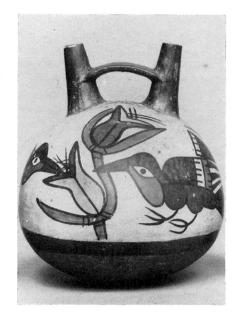

Polychrome vessel, c.*AD 100–300*
South coast of Peru

Many features of the earlier culture of
Paracas, including much of the
iconographic detail on pottery and textiles,
were adapted by the Nasca. A more
naturalistic style was used and illustrates
Nasca environment, daily life, mythology
and history. Its militaristic nature is revealed
by numerous representations of trophy heads
of fallen victims. Much of Nasca religion
seems to have focused on the observance
and successful maintenance of a subsistence
economy based on intensive agriculture. The
famous Nasca lines on the plains of Pampa
Ingenio in the form of geometrical patterns
and gigantic representations of animals and
plants may have been astrological signs
related to the integration of the agricultural
system.

cultures in South America until the Spanish conquest over 1500 years later.

With its decline in about 500 BC a number of local cultures emerged, which, although continuing to reflect the inheritance of the Chavin period, evolved in different distinct ways. On the south coast of Peru, early examples of pottery show clearly the feline god of Chavin but the style of vessels with incised designs, painting done after firing and additional iconography were innovations of the region itself. This style, known as Paracas, became famous mainly through the discovery of a large number of well-preserved textiles, covered in superb embroideries in rich vivid colors. Their production would have required the skill of specialist craftsmen, and this in turn suggest both a level of economy sufficient to support such a group and a clientele – an upper class – for which they were produced. The iconography of both the pottery and the textiles is extremely complex, with mythological figures of both human and animal form.

On the north coast, the Moche culture (1st to 5th century AD) cultivated the coastal desert by a complicated system of terracing, irrigation canals and aqueducts. Intervalley trade was facilitated by the construction of a good road system, still used several centuries later. This base supported a militaristic and stratified society with a strong religious orientation, indicated by the construction of ceremonial centers and immense adobe structures, such as the pyramids of the Sun and Moon in the Moche Valley. Of greatest benefit to us is the superbly painted and modeled Moche pottery. In the absence of written records it provides a detailed account of the Moche culture, including environment, religion, architecture, and craft and means of survival. Others show scenes of battles and conquest and may be clues to the political history of the area. Modeled pottery in the form of portraits of Moche people are some of the finest sculptures in pre-Hispanic art.

Around 500 AD, the regional development of the preceding centuries ended with the onset of a period of imperial expansion, the center of which was the site of Tiahuanaco south of Lake Titicaca. This was the center of a religion based on a staff-bearing god similar to one found at Chavin. The most well-known depiction is on the beautifuly carved frieze of the Gateway of the Sun flanked by a series of kneeling winged figures. These two features recur repeatedly on Tiahuanaco pottery, and textiles and their presence is one indication of the extent of its influence. Tiahuanaco is noted for its fine architecture with finished stonework, monumental sculpture of angular anthropomorphic figures, and stone relief carving.

While Tiahuanaco was in control of southern Peru and Bolivia, another culture was beginning to expand from its city of Huari in the central Andes. It was thought that the religion emanating out of Tiahuanaco was adopted by the Huari people and was the principle cause of conquest. The result was the creation of a vast empire that extended over most of northern and central Peru. Polychrome pottery, with Tiahuanaco-style motifs, are found throughout the empire. Also prevalent on the coast are brilliantly colored tapestries frequently decorated with depictions of the winged figures of Tiahuanaco or characteristically stylized felines with tearful eyes.

The reasons for the decline of the Huari culture is uncertain, but many local characteristics suppressed during the imperial period re-emerged and new regional states were created, urban in character but ethnically autonomous. One of the most important to develop was the Chimu Kingdom (c.1000–1500 AD), on the north coast of Peru with the immense adobe city of Chanchan as its capital. When the Inca finally conquered this kingdom they were impressed by the artistic level of the Chimu so much so that they transported many of the artisans to the Inca capital of Cuzco to continue their craft for the benefit of the Inca nobility. Most Chimu art gives a feeling of being mass-produced, such as their burnished mold-made blackware. They also wove fine textiles in large quantities. As opposed to earlier cultures, the scarcity of mythological representations suggests a more secular rather than religious trend in art styles. The craft of metalworking developed noticeably – hammered and repoussé beakers and jewel-encrusted ceremonial axes and staffs were produced, many in the form of anthropomorphic figures with the distinctive upward slanting eye form of the Chimu.

At the same time that the Chimu dominated the north coast, the Inca were establishing their small kingdom in the highlands of southern Peru. By the end of the 15th century they had created an empire extending from the Ecuador-Colombian border to the Bio-Bio River in Chile. By dependence on a hierarchial governing system and the establishment of good communication networks, the Inca were able to control such a vast area. The conquered populations were obligated to pay tribute to the Inca in the form of goods, labor and skills, thus maintaining the Inca's bureaucracy. Tribute also provided the necessary manpower to undertake the immense building projects for which the Inca are famous. Beautifully dressed and fitted stonework, such as is still evident in the streets of Cuzco, only hint at the splendor of Inca architecture. Apart from stonemasons, other specialists were employed to produce the luxuries of the elite. For example, some of the most finely hand-spun and woven textiles known were produced. Well-burnished pottery decorated with painted geometrical patterns was manufactured. The most distinctive form was the *aryballo* with long neck, flaring rim, and conical base. Another media for painting was a wooden cup known as a *kero*, covered with polychrome scenes of battles, ritual, and daily life.

Although deeply impressed with many aspects of Inca culture, the Spanish on their arrival were most obsessed with the wealth of material in gold and silver. Unfortunately, the majority of the ornaments were melted down into ingots and the few items remaining, such as small hammered and repoussé gold llamas, only suggest the extent of this Inca art form.

In just a century, the Inca rose to be a great imperial nation, only to be crushed by another empire from the Old World and with it much of the culture of pre-Hispanic South America was lost forever. Now we can only cherish and appreciate the art these cultures have left behind.

Sacsahuaman: part of the massive Inca structure

Remains of this fortress still dominate a hill overlooking the city of Cuzco. A series of walls were constructed of massive boulders expertly worked and fitted together without the use of mortar.

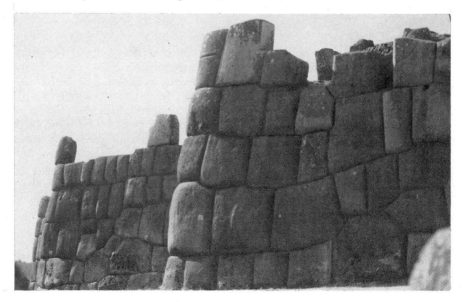

Africa

The great land mass of Africa carries within it some of the deepest secrets of the origins of man. The earliest evidence of man-like creatures dating from about three million years ago is found at Olduvai Gorge in Tanzania, and the earliest "civilization" of which we have record was in the north-east, in Egypt. The great gap in time between the two has yet to be filled, and the subsequent history of the peoples of the vast open areas and forests of the continent is little known.

Attempting to place African art in its historical context is a little like trying to do a jigsaw puzzle knowing that most of the pieces are missing. To a greater or lesser extent much of art history is handicapped in this way; yet until the latter half of the 19th century there were not even written records to guide and shape conjecture about developments over much of the continent. To add to this, the peoples of Africa, almost without exception, had no systems of writing of their own with which to record their histories before the advent of European influences.

Artwork from sub-Saharan Africa began to arrive in Europe in the 15th century, brought back by the Portuguese and later by other navigators. Such collections, like the documentary accounts accompanying them, were derived largely from peoples living along the coast rather than from interior regions. For example, the impressive southeastern settlement of Great Zimbabwe was established in about the 13th century. Its people dominated the gold trade in southern Africa and their subsequent wealth gave rise to stories in Europe that the settlement might be associated with the Queen of Sheba, King Solomon or even Prester John. Even so, the settlement was probably not visited by Europeans until 1871, despite the fact that it lies barely 250 miles (400 km) from the Indian Ocean seaboard.

There are additional problems in understanding African art. It is clear that in attempting to look at developments in the culture and arts of Africa we are not dealing with a single and distinct set of events. For instance, the constraints placed on human activity by environment are infinitely variable. Every gradation of vegetation and climate is found, from desert through open savanna grasslands to dense rain forest. Such conditions have caused some peoples to pursue a nomadic existence, while others are able to follow a more settled way of life.

Similarly, today as well as in the past, forms of social and political organization are diverse. Elaborate state organizations, whether under the rule of a single royal household or a number of chiefdoms, exist side by side with communities lacking centralized institutions and inherited political offices. For present purposes we may exclude Mediterranean influences in Africa, including Christianity and Islam, thus placing to one side those parts of the continent lying to the north and north-east of the Sahara.

The Coptic Church, whose tradition stretches back almost to the beginnings of Christianity itself, is centered in Egypt and Ethiopia. By the 6th century AD Christianity was the prevailing ideology of the Nubian kingdom in the Sudan, but its influence to the south of the Sahara, with the exception of a few coastal populations, is the product of the last two centuries of missionary activity. Muslim influence was not so readily contained by the Saharan barrier, and the Islamization of the savanna peoples immediately to its south is many centuries old, as is its adoption along the East African coast. In West Africa, however, the process has not led to the complete replacement of figurative art by the non-representational traditions of Islam which are associated with North Africa.

Glyptic art

The earliest evidence of figurative art in Africa is found in engraved or painted designs executed on rock surfaces, known as glyptic art. The distribution of these is extensive, ranging from the Tassili Mountains in southern Algeria, through East Africa, to the Drakensberg Mountains in South Africa. Rock paintings are usually associated with early hunting and gathering communities, of whom the Pygmies of Equatorial Africa and the Bushmen and Hottentot peoples of Southern Africa are surviving representatives.

The earliest dated rock sites in the Tassili area are from the second millenium BC. By 4000 BC their subject matter, although it includes the wild animals vital to hunters and gatherers also depicts a large proportion of herdsmen and domesticated cattle, indicating the pastoralist way of life then possible in the Saharan region. From about 1200 BC images recording the introduction of the horse and the wheeled chariot that brought Libyan forces on military expeditions over much of the Sahara began to appear. Only in the final phase of the Tassili occupation is the camel depicted, creating a picture more in keeping with the familiar view of what was by then desert life.

Southern Africa

It is often suggested that the Bushmen are the authors of rock engravings and paintings found in areas such as the Drakensbergs. Now restricted to the inhospitable environment of the Kalahari, the Bushmen were indeed living in more favorable areas where rock paintings are also found until the 19th century. However, the myth that they, and possibly the Hottentot, were in sole occupation of the region during the time when the decoration of the rock surfaces took place must be false.

Early Iron Age settlements, with an economy that included animal hus-

bandry and farming, have been dated to at least the 3rd century AD in South Africa. Such communities were probably the southernmost descendants of Bantu-speaking peoples believed to have spread from somewhere in the Nigeria and Cameroon area. It is accepted that at least some of these communities developed a tradition of figurative sculpture, of which the fragments of seven terracotta heads found at Lydenburg in the Transvaal are the most striking evidence. Dated to about 500 AD, these hollow ceramics with modeled human features remain the earliest examples of sculpted art discovered in Africa south of the Equator.

Western Africa

As in the south, the earliest sculptural forms discovered in West Africa are terracottas. These derive from the Nok culture, named after a small village in northern Nigeria. Nok is the first of a sequence of more or less distinct archeological and historical cultures found within the boundaries of present-day Nigeria. These provide the greatest concentration of ancient sculptures covering the greatest period of time yet to be found anywhere in Africa.

At Nok, a series of ceramics of human and animal subjects have been excavated, and fragments representing the human form suggest that the full figures were perhaps as much as four feet (1.2 m) in height. They are dated to between 500 BC and 200 AD. The discovery of grinding stones and parts of smelting furnaces, together with iron slag, indicate the authors to be of a culture that was, even at this early date, able to smelt iron.

Next, in chronological order, is the culture associated with Igbo-Ukwu, a site in southeastern Nigeria, that produced ornamental bronzes from the mid-9th century AD. Ife, in southwestern Nigeria, was for centuries a religious and political center of the

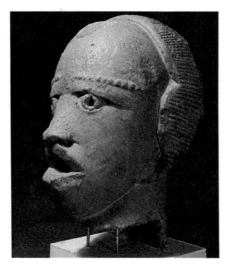

Terracotta head, *between 500 BC and 200 AD,*
Nok culture, Nigeria

This and other examples give few clues to the nature of the society that produced them. The fact that human beings are not represented realistically points to a culture with witchcraft beliefs and that the sculptures themselves may have been for use in a cult of the ancestors. Another feature of the Nok terracottas is the close attention paid to the hairstyle of each head and their variety, such details perhaps marking differing social status.

Yoruba peoples, and terracottas, brasses and bronzes from the 11th to the 15th centuries have been found here. Finally, the brass works from Benin – often erroneously described as bronzes – date as far back as the late 15th century and form an apparently continuous tradition that lasted until 1897 when British troops sacked Benin.

It is far from certain that all of the relevant archeological materials have been recovered. Nevertheless, continuities in style and the social and political circumstances in which such works were produced have emerged. The ceramic and metal-working traditions of Ife are regarded conventionally as a crucial historical crossroad, and local oral histories recount it as being a focal

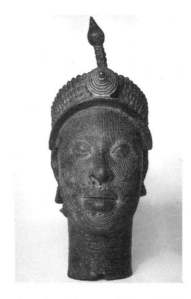

Zinc brass head, *between 12th and 15th centuries AD*
Ife, Nigeria

The head represents an Oni (or king) of the ancient Yoruba city-state of Ife with characteristic cap or crown. The row of holes at the base of the neck were probably for attaching to a wood body for use in royal funeral rites and those around the mouth to hold a moustache and beard of beads. The metal for such castings would seem to have been imported across the Sahara from a source in North Africa or possibly Europe.

point of Yoruba life and culture. It is at Ife that one of the Yoruba gods is said to have descended from the heavens to found a city-state and become its first king. Similarly, oral traditions from Benin record that the Benin kingship was established from Ife. It is related that upon his death, the head of the king was returned to Ife for burial and a brass head sent to Benin in its place for the ancestral shrine. At one point, usually identified as the end of the 14th century, a brass-caster was supposedly sent from Ife to establish a metal-working center at Benin.

With the exception of Igbo-Ukwu, a maverick in both stylistic and metalurgical terms, the jigsaw puzzle might seem to fit together neatly. A com-

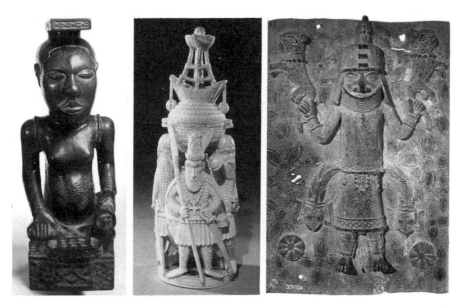

Ivory salt-cellar, *early 16th century
Benin, Nigeria*

*Such objects were made as luxury items for
the Portuguese Court. The figures at the
bottom are Portuguese dignitaries in military
attire which remained a stock image in Benin
art long after the fashion for such dress had
become obsolete in Europe. The lid shows a
ship's crow's nest with a figure peering out.*

Portrait of a king, *probably 18th century,
Kuba, Zaire. Wood*

*The figure commemorates Shamba
Bolongongo, the founder of the present
Kuba dynasty, who ruled in the early 17th
century. In theory such figures were carved
during the lifetime of the king portrayed, and
it is possible that this statue is a replacement
for an earlier one. The hat and other items of
royal regalia are distinctive of kingship, but
the emblem at the front of the carving – a
game board – is associated with Shamba's
reign and identifies him as the subject.*

Brass plaque, *probably mid-16th century,
Benin, Nigeria*

*The plaque form may be a result of European
influence, possibly derived from a book plate.
It shows the Oba (or king) sacrificing
leopards, a ritual act emphasising his powers
over the king of animals and by extension
over wild places in general. His legs are
depicted as mud-fish, indicating his
identification with Olokun, the god of the
waters and the source of riches.*

parison between the artworks at Ife and
Benin, however, reveals little in the
way of firm stylistic continuity. Indeed,
were it not for other suggestions of a
definite link, it might be difficult to
reconstruct such a close relationship
based upon the evidence of objects
alone. As a result, it has been suggested
that Benin must have possessed an
earlier tradition of representational art
in wood or ivory that influenced the
style of casting in metal.

Such an hypothesis is only necessary,
however, if the fragile evidence of the
oral accounts is accepted. The docu-
mentation of a brass-caster being sent
from Ife would have to have been
passed down by word of mouth over
the centuries – a scenario that else-
where in Africa has proved less than
credible. However that may have been,
as Benin developed into a cosmopolitan
center from the 14th century onward,
its contacts with the Yoruba states were
far from exclusive and, by the 15th
century, included the Western world.

The political context
The picture of African art is complex
because, just as the arts of the continent

as a whole are far from being a unitary
phenomenon, so those within a single
society may also be diversified. The
Kuba of Zaire, for instance, live under
one of several influential kingdoms
that have flourished over the past three
to four centuries in and on the fringes
of the Equatorial forest. Among the
best known objects from their past are
wooden portraits of kings, the earliest
surviving examples dating from about
the 18th century.

The making of such figures was
probably connected with the develop-
ment of the idea of the sanctity of the
royal person. As part of his inaugura-
tion each new king was required to
sleep in a room with the images of his
predecessors in order to incubate in
him the spirit of kingship. Stylistically,
these royal statues show remarkably
little variation and if they are to be con-
sidered portraits it is not because of
the carving of the figures but from the
forms of the emblems displayed in
front, which are identified with parti-
cular reigns.

Other objects associated with royalty
or with the holders of specific court
titles are similarly conservative in exe-
cution. Yet the Kuba tradition was
innovative and their experiments with
geometric patterns and the human
form were all part of an essentially
exploratory attitude to the visual arts.
Such virtuosity, however, was restrict-
ed to objects in private ownership –
boxes, embroidered cloths or drinking
cups – that may have been used as a
means of attracting prestige and in-
fluence.

Western influences
From the earliest periods of European
contact African artists were receptive
to external influences. It is, in fact, easy
to underestimate the extent to which
traditional African arts are, and have
been, open to innovation.

As long as the cultural forms in which the art was rooted remained un-impaired by external influence, receptivity to new ideas did not mean the replacement of artistic traditions.

Yet the balance of influence between Europe and Africa was almost entirely one-sided. For example, African art did not survive the enshipment of slaves to the New World. It was only in special circumstances, such as the escape of the so-called Bush Negroes of Surinam (first generation slaves in the South American Guianas), that anything approaching a distinctly African culture and with it, distinctively African art, was re-created.

Where African art did have a perceptible influence outside the continent, its African origin was almost incidental. Western modern art owes much to the encounter of artists such as Picasso and the Cubists with African sculpture. It is through an appreciation of the craftsmanship of African art that masks, figures and even domestic objects have come to be described as "art" rather than simply as "trophies" from the Dark Continent.

Ironically, the very quality that the Cubists admired in African sculptures – its aesthetic appeal – was often unimportant to the makers of the objects. The Kalabari of the Niger delta, for example, make screens and masks that have been much admired in the West, yet the Kalabari themselves regard them with a mixture of apathy and repulsion, necessary only as a means of gaining control of unruly spirits. Similarly, the Lega of Zaire carve small figures in ivory and wood that have attracted the interest of collectors, but in Lega society they are used to invoke proverbial and moral teachings to members of a secret society; aesthetic appeal is not one of their intentions. Furthermore, neither the Kalabari nor the Lega keep such objects in places favorable for viewing.

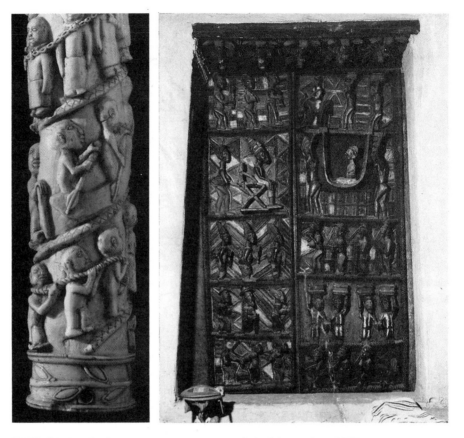

Detail of an ivory tusk

The spiral figures carved in high relief were distinctive of craftsmen working on the Loango coast close to the mouth of the Congo (now Zaire) River, especially around the turn of the century. They were usually made for a predominantly European clientèle and in addition to scenes of traditional life sometimes included rep representations of colonial administrators. One of the most familiar subjects was a group of slaves chained together, as here. The Congo estuary had been a major collecting point for slaves brought from the interior.

Pair of doors, *about 1915*
Wood
A palace of the Yoruba, Nigeria

The scenes displayed in each panel refer – in a manner relatively rare in Africa – to the historical experience of the makers. The central image in this instance shows the first British administrator, Captain Ambrose, being carried to his reception by the ruler of Ikere in eastern Yorubaland, an event which took place about 1895.

The Renaissance in Italy

The Background to the Renaissance

The word "renaissance" is so well known, particularly as an art historical term, that one tends to think that is has a precise and comprehensive meaning that can be attached to a particular period of time. The more we try to pin it down, the more it seems to escape to further implied meanings, periods of time or places. The term is commonly used to identify a period of Italian history from about 1400 to 1550; the transition from the Middle Ages to the beginning of the formation of the modern nation states. But the term has also much wider general uses. It may be used to describe the whole period from the Middle Ages to what is called the modern world, which is taken to begin somewhere in the 19th century – that is, a period of over 350 years – and implies changes in the intellectual, moral and religious attitudes of Western societies as a result of the emergence from the Middle Ages.

The word itself means rebirth (*rinascita* in Italian and *renaissance* in French) and was first used to identify the period from about 1400 to the middle of the 16th century in Italy by the Italian 16th-century biographer and historian Giorgio Vasari (1511–74) in the first serious attempt to write art history and biography in his famous book *Lives of the Most Eminent Painters, Sculptors and Architects* published in 1550. Following him it does not appear again until the 18th century in the *Encyclopédie* edited by the French intellectual Denis Diderot, and was later taken up by John Ruskin, English art writer and critic, in 1851 in his book *The Stones of Venice* on the early architecture in Venice. In this use it was exclusively related to Italy.

It is reasonable to ask of what it was a rebirth and this introduces yet another meaning to the word. It is used to cover the development of European society of what is called the Revival of Learning. During the 15th century there was, particularly in Italy, a revived interest, almost amounting to a passion, for Classical learning. By this is meant the study of the writings of the great figures from the first European cultures in Classical Greece and Rome.

The new philosophy came to be known as Humanism because in essence it places mankind at the center of human affairs – if not of the universe. Man and his capacities should become the measure of all things – as the church plan by the Sienese architect Francesco di Giorgio (1439–1501) graphically symbolizes. Although this seems to mark a great distinction between Medieval and Humanist attitudes, the process of change was not clearcut and it is impossible to determine when Humanism achieved ascendancy, but the beginnings of the new attitude were clearly laid in Italy during the late 14th century at a time when they were not present in the rest of Europe. For this reason the Renaissance, a term that can now be seen to have wide application, is often called Italian, which makes it seem as if it had not happened elsewhere. This is, of course, not so. The Renaissance was a surge of intellectual energy that forms a transition from the Middle Ages to the European culture that in its essence still remains the dominant influence in world affairs.

The reason that it is usual to examine the Italian Renaissance first is principally one of time. The first evidences of the transition appeared in Italy. Petrarch initiated the direction of Humanist studies and of the Latin Classics as well as suggesting the im-

Francesco di Giorgio *(1439–1501) Drawing of Church plan based on human proportions.*

portance of searching for Greek sources. Boccaccio (1313–75), an Italian scholar best known for his *Decameron*, a series of often bawdy tales written to entertain refugees from the plague in Florence, began the study of Greek texts. He was followed by other Italian scholars who visited Constantinople, where Greek texts could be traced, collected and brought back to Italy for study.

Students in the medieval period had possessed manuscripts of a great deal of the Roman Classics in Latin, but had not been able to make use of them, being concerned with Christian studies for which the pagan Classic texts had no relevance. Not only were they not appropriate to medieval studies but they were relics of a past that to Christians was suspect. They were therefore little studied in the Middle Ages. In Italy during the 14th century Petrarch (1304–74), the great Italian poet, became a leader of a new form of

learning, which became what is called Humanism. This lays an emphasis on man as a rational thinking and feeling being with choice and independence. When linked, as it was in the 15th century, with a study of Classic texts (the Revival of Learning) it provides the intellectual background to what we now call the Renaissance. To the Humanists themselves the word "humanitas", from which humanism derives, simply meant "culture", but it has since taken on a philosophical identity as being concerned with man and his works. The development of this new intellectual pattern of thought was not in keeping with the medieval concentration on spiritual rightness and on the physical buildings of the Church as the focus of society.

The course of the struggle of intellect and faith that began during the 14th century is graphically illustrated by the architectural example of Milan Cathedral. During the middle years of the 15th century while Brunelleschi was completing the first consistently Classical churches of San Lorenzo and Santo Spirito in Florence, as well as crowning the cathedral there with a dome surmounted by a Classical lantern, Milan Cathedral was being built in a highly decorated, late Gothic style. All of Brunelleschi's work had been completed, Leonardo was over thirty and Michelangelo was just ten when Milan Cathedral was finished in 1485. While the constructional ingenuity that Brunelleschi applied to the dome in Florence was part of the great heritage of medieval building craft, he nevertheless used the most up-to-date calculations of load and stress to find the solution.

A passion for antiquity and its learning began, collections of manuscripts were formed, Humanism both as a philosophy and a way of life came to dominate intellectuals in Italy and by the beginning of the 15th century

the setting for an extraordinary outburst of creative energy had been created.

Italy at the end of the 14th century was, fortunately for the establishment of the Renaissance, a divided country. There was no strong centralized government to determine a common culture, the Church, however influential, controlled only a band of Papal States that stretched like a garter across the leg of the peninsula and its influence elsewhere was opposed either intellectually by the rising passion for Humanism or by the political ambitions of other rulers in Europe, who began to want pieces of Italy. (By the end of the 15th century a series of invasions by French, German and Spanish armies had ravaged northern Italy.) This might not seem at first sight propitious ground for the development of a new and liberal culture but a closer examination shows that the lands north of the Papal States were peculiarly suited to cultural growth.

One of the most important developments during the 14th century had been the territorial expansion of a number of the more powerful and aggressive city-states. In Lombardy, Tuscany and the Romagna, the city-state had developed out of the medieval independent cities (communes), which were at that time republics governed by an elected council. They developed an individualism and local loyalty and their independence was, at least partly, guaranteed by either the Church party (called in the 13th century the Guelph faction) or by the adherents of the Holy Roman Emperors (the Ghibelline faction). Most city republics in the 13th century took either the Guelph or the Ghibelline side. The rival interests of these cities and then attachment to either Church or Empire led to internecine wars and by the beginning of the 14th century the more effective – and rich – had been able to absorb some

of the smaller, thus increasing their territorial possessions. As the 14th century advanced, these city states came increasingly under the dominance of particular families (such as the Visconti family in Milan). When, as in the important examples of Florence and Venice, they remained republics it was because their governments had proved effective in maintaining their authority.

Where, in the earlier 14th century, the city republics were generally dominated by a single family it was usually as a result of the latter's commercial success, enabling the local family, through connections, influence or corruption to gain effective control without nominally destroying the republic. Nearly always their ambitions eventually led them to declare themselves overlords. An exception is found in Florence, where the Medici family although dominant in political affairs were wise enough to support the continuance of the republic in its outward forms.

The city republics also nurtured seeds of their own destruction in the form of mercenary armies whom they employed either for protection or to carry out their expansive wars on other nearby cities. Since the citizens were either disinclined to fight or too busy making money to have the time, the commanders of the mercenary armies, which were composed of soldiers drawn from Germany, France, Spain, the Netherlands and England, were themselves usually Italian and conceived ambitions to control the cities that employed them. Turning on their employers and ousting the governments, they set themselves up as hereditary rulers. These leaders, called *condottieri* ("conductors"), were ruthless and rich and well able to feed their ambitions.

Thus during the 14th century in northern Italy a number of powerful

city-states established themselves with hereditary dukes, such as the Sforzas, who ousted the Visconti at Milan, the Gonzagas at Mantua, and the Estes at Ferrara. These city states proved to be powerful breeding grounds for the new learning. Each of these *nouveau* dukes had, as is the way of things, cultural as well as territorial and political ambitions. The first generation of *condottieri* dukes were crude, uneducated, fighting men with no knowledge of the new learning, but they wanted their courts to be "cultured" and particularly to rival the courts of the petty dukedoms in German territories in pageantry and pomp. They also had no strong allegiance to the Church or its teaching. They therefore gradually, but with accelerating enthusiasm and the envy of their rivals, set about creating courts to which they could attract scholars, writers, philosophers and artists. They were particularly attracted to artists and architects who could make their ambitions take a visible form.

While these ducal courts provided most of the main centers of Renaissance culture there were exceptions and perhaps not surprisingly it is in these that the greatest creative strength of the Renaissance is found. Florence, described as "the Athens of Italy", was dominated through the Renaissance by three generations of one family, the Medici, and had the most liberal and intelligent society, attracting scholars, artists and opportunities from all over Italy. Venice was one of the richest and most powerful cities in Europe and with a system of government that provided a stability that survived the whole Renaissance period and, although weakened in the 17th century, the Venetian Republic lasted until the French Revolution. In 1797 Napoleon handed Venice over to Austria and she was only incorporated into a united Italy in 1870.

Patronage and the artist

One result of this new artistic demand was a dramatic and permanent change in the position and status of the artist. As this changed, so did the role of the patron and his relationship with artists. It was during the 15th century that a new and fruitful partnership was forged.

Painting, sculpture and architecture in the Renaissance was almost always produced by artists at the specific request of another person, the patron, who may have been a king, a pope, a duke, a rich citizen, a religious confraternity, a guild or the representative of the civic authority of a town. Artists did not, on the whole, produce works of art in their workshops and wait for a buyer: the buyer came to them, told them what he wanted, and the artist then carried out his contractual instructions. Since patrons were typical representatives of the society in which they moved, the artists represented their needs and tastes to a very high degree. Renaissance art, therefore, almost invariably had a function – it might have been the expression of papal power, the aspirations of a community, the indication of the wealth of a ruler, or family, the republican stance of the Florentine city council, the expression of Venetian authority and so on.

The status of artists at the beginning of the 14th century was often much the same as that of stonemasons, carpenters, ironmongers and bricklayers. Legally they were part of the urban working proletariat, and as such locked into a professional guild, membership of which was compulsory and meant that only members could ply the trade. Guilds were at their most powerful as social institutions in the 14th century. We find guilds of painters being organized in Perugia in 1286, in Venice in 1290, Verona in 1303 and Florence in 1339. Guilds organized and over-saw almost all areas of the professional activities of their members. Their financial activities included lending

money to impoverished members, and buying work from poor master craftsmen to help them out. They appraised applicants for membership; they checked work and prices by using arbitrators if disputes arose between members and patrons. Predictably, restrictive practices were an integral protective function of the guilds' controllers. Challenges to the system occurred from time to time in the 15th century and there was throughout the the century, as we shall see, a growing and vociferous protest against the social position of artists implicit in their absorption into guilds.

There seems to have been almost no artist at all in the Renaissance who went to a university, an indication of the social stratum from which most of them came. The vast majority went straight to apprenticeship with little or no preliminary education. Many artists were illiterate, in the sense of not being to sign their own names, and their humble beginnings often made a good story after they were successful. It is no surprise that, given the educational background of the artist apprentices, it is exceptional for artists to have read widely.

The situation of the Renaissance artist is clear: a low social standing brought about by participation in a trade and all that that implies in the social hierarchy, and only an apprenticeship by way of education. But, beginning as early as the *Libro dell'Arte* by Cennino Cennini (written, before 1437, as a highly technical handbook on the painters' craft), we find notions that were to be exploited by later authors: painting is an intellectual activity like poetry; it is engendered by a lofty spirit, enthusiasm and exaltation; the painter should be ascetic like philosophers and theologians; the painter is free to compose according to his own imagination.

These ideas involve a social reloca-

tion of artists into the company of educated and intellectual people. The sculptor Lorenzo Ghiberti's *Commentarii* is the first autobiography by an Italian artist and he is the first to express a fundamental proposition that artists are the carriers of a long tradition founded on the old examples of the Classical world (all based, as it happens, on a totally inaccurate understanding of the position of artists in Greek and Roman society). He insists on the necessity of painters studying grammar, geometry, arithmetic, accountancy, philosophy, history, medicine, anatomy and perspective. Leone Battista Alberti (1404–72), one of the greatest figures in the early Renaissance in Florence, writer, painter and architect, in his book *On Painting* (1436) codified all this. The painter was to acquire the fame and renown of the celebrated painters of antiquity through continuous study and various technical skills, such as geometry, astronomy, perspective and the rules of composition. The painter's imagination must be familiar with poetry, rhetoric and other learned subjects. The comparison with the painters of antiquity is pressed home.

Another and famous illustration of this theme in artistic literature of the period comes from Baldassare Castiglione's handbook on the behavior of the ideal gentleman, *The Book of the Courtier* (*Il Cortegiano*) published in Venice in 1528 by Aldus Manutius, the first great Venetian printer. One of his characters talks at length about the high status of painters in antiquity, and he begins by saying that the courtier (the ideal hero of the book) should not neglect drawing and painting, "even if nowadays it may appear mechanical and hardly suited to a gentleman, for I recall having read that in the ancient world and in Greece especially, children of gentle birth were required to learn painting at school, as a worthy

and necessary accomplishment."

A number of the most successful artists did achieve high recognition: Sodoma (1477–1549) was knighted by Pope Leo X: Gentile Bellini (1427–1507) was created a count by the Emperor Frederick III; Andrea Mantegna (1428–1506) made a papal count. The Emperor Charles V ennobled Titian. Wealth, then as now, did not necessarily guarantee acceptance by noble society, but it helped. A number of artists through the whole course of the Renaissance were indeed very well off: including the sculptor Lorenzo Ghiberti (1378–1455), the painter Andrea Mantegna, the painter and architect Raphael (1483–1520) and especially the great Venetian painter Titian (*c.*1487–1576).

By the middle of the 15th century a shift of attitude about artists can be noticed in the minds of some patrons. In Florence, Giovanni Rucellai, a rich merchant and the patron of the Rucellai chapel in the Church of San Pancrazio, the Palazzo Rucellai and the façade of the Church of Santa Maria Novella (all built by Alberti), wrote a memorandum some time in the 1470s about his collection of works of art, in which he lists the names of Florentine and other Italian artists. Rucellai is not even particularly interested in the subjects of the works – he does not list them; he is interested in famous names.

Another indication of a shift in attitude towards art and artists is given by the way in which the system of payment altered. It seems that artists and patrons began to accept that not only the materials (wood, stone, colors and so on) concerned in making a work of art should be taken into account, but also the skill of the artist. Saint Antonio (1389–1459), a strict Dominican, and archbishop of Florence, wrote that "Painters more or less reasonably request to be paid the wage of their profession not solely according to the

quality of work, but more according to their industry and their greater expertness in the art." In March 1470 the great Ferrarese court artist Lorenzo Costa (1460–1535), wrote a petition to the Duke, in which he laments that he is now famous, studies much, and his skill deserves greater financial reward than the standard rate the Duke gives to "ordinary craftsmen".

In 1445 Piero della Francesca (*c.*1420–1492) contracted to paint the now famous altarpiece *Madonna della Misericordia*. Among the long list of requirements is one that "no painter may put his hand to the brush other than Piero himself".

By the middle decades of the 16th century this requirement increased in the cases of the great master and patron. For example, in 1530, Alfonso I d'Este, husband of Lucrezia Borgia and Duke of Ferrara, wrote to Michelangelo about the cartoon of Leda and the Swan, saying that he would make no suggestion as regards to price, but that Michelangelo should himself assess the work. Earlier, Isabella d'Este, Duchess of Mantua and great patron of art, had made an initial approach to Leonardo in 1501, marked by an undemanding attentiveness to the artist's character and status. She asks a go-between "to sound him as to whether he will take on a picture for our *studio* [a reading and writing chamber]. And if he is pleased to do this, we will leave both the subject and time of doing it to him."

These are indications that the standing of artists was raised in society but what was the patron's relationship to the artist? How much could the patron, who had absolute control in the Middle Ages, decide the form, subject and style of a work of art he commissioned? What freedom did the artist have in the atmosphere of the Renaissance?

It was a common practice for a contract between artist and client to be

drawn up by a notary, and these contracts often provide clues to the attitudes and expectations of both parties. They were concerned, where they were specific, with five main matters: cost, materials, color, size, and date of delivery. Sometimes the upper and lower limits of the expected price would be laid down, or a minimum price could be fixed with the understanding that more money would be forthcoming if needed. The final price could be established after the completed product had been appraised, a maximum price could be fixed in the initial contract, or a flat price could be indicated without the possibility of adjustment. Sometimes payment in kind was made. The Umbrian painter Luca Signorelli's (c.1441–1523) contract for the frescoes at Orvieto Cathedral allocated money, gold, azure, lodgings and a bed!

Another way of controlling the artist's activities was by means of time-penalty clauses. Patrons could even arrange for the work to be finished by someone else if the artist did not make the deadline. There are spectacular surviving examples of time limits being ignored: Michelangelo took three, not two, years over his *David*; Ghiberti's north doors of the Baptistry in Florence took twenty-one years, not ten.

Color, too, could be controlled by the patron, particularly when the painting was to include expensive items such as gold leaf or blue, which was made from the semi-precious stone, lapis lazuli. Finally, two other restrictions were sometimes applied: a master could be required to execute a work personally (*sua mano*), and artists sometimes agreed to guarantee that their work would last for a certain amount of time. Leonardo's *Madonna of the Rocks* was guaranteed by the artist for ten years.

The conditions controlling delivery date, price and materials of course affected the dimensions and color of paintings and statues but of themselves did not automatically govern style or subject matter. The question of subject control is crucial because it was the usual practice for patrons to tell artists what and how they were to paint or carve. In general, artists and their styles were extensions of a corporate, social aesthetic and dependent upon it. Patrons often delivered detailed instructions, yet artistic license in the question of style and subject matter did exist and certain innovations can be attributed to artists themselves.

It was often the case that a learned Humanist was interposed as adviser between the patron and the artist in order to help both, but especially the latter, to represent the required subject clearly. Titian's (now lost) *Allegories of Brescia* in the Great Hall of the Palazzo Communale in Brescia is an example where it is certain that either the patron or the patron plus an adviser helped the artist with the subject matter. When Benvenuto Cellini was contemplating the design of his celebrated salt cellar, he discussed its prospective decoration with two learned friends, who proposed a Venus with a Cupid or Amphitrite with some Tritons. Cellini took no notice of either suggestion and submitted the idea of reclining male [Neptune] for salt from the sea, and reclining female [Tellus] for pepper from the land, which he carried out.

The change in the status of the artist and the developing relationship between him and his patron is a major feature in the artistic character at the beginning of Renaissance painting and sculpture. While it was the patron who determined almost every aspect of the work of art, as the Renaissance advanced the artist became increasingly an independent and much respected figure. His role in society had been that of a craftsman; it became not only a profession but one which was seen increasingly as an important creative part of the new culture.

It is perhaps worthwhile to repeat a general point that has often been made. There are many indications, a number of which have already been noted, that the period in transferring its focus from spiritual to earthly matters, from God to Man, initiated what has ever since been a prevailing feature of Western culture and is now a part of world culture – that is the cult of personality. Like Rucellai mentioned earlier, we have ever since been concerned with the achievements of great men – history has been written in this way. For this reason, although we are concerned with art in history we now start to consider something of the individual works of artists, which we have not done in the previous sections. There is no possibility however that we could consider the lives of all the artists in such a prolific and creative period.

The Renaissance introduces another element into the lives of the artists which was not commonly present in the Middle Ages. Artists traveled widely for commissions in Italy and sometimes outside. The beginnings of an internationalism of culture can be seen in this but the first effect is in the breaking down of purely local traditions. Although artists in the early Renaissance most often lived and worked where they were born, by the end of the Renaissance artists of great reputation like Michelangelo or Leonardo were frequently called from one city to another by powerful patrons. Thus although Leonardo was a Florentine by birth, a great deal of his working life was spent in Milan. It is, however, to Florence as the first focus of Renaissance culture that we must look. Here, as we shall see, one family had a great influence in making of Florence a city of almost unique cultural greatness.

Florence

The fine Roman ideals of the Florentine Republic, based on the exhortations of Cicero and other ancient Roman conservatives, could not stand up to the reality of Florentine society. The city was a trading and manufacturing community of long standing, and conflicts between the artisan classes and the noble families, and especially among the nobles, deprived the city of the necessary unity of purpose for running a republic on the Classical model.

Florence was riven by feuds that had been played out in blood for centuries, but from 1434 onward the story of Florence is virtually the story of a single family – the Medici. Long established in the political life of the city, they came to the fore quite suddenly. In one of the Republic's many crises a government friendly to the influential merchant Cosimo de'Medici (1389–1464) was elected. He, and later his grandson Lorenzo, nicknamed "the Magnificent", proved to be men of outstanding ability, sophistication and political adroitness, but their memory is kept fresh above all by their patronage of some of the greatest artists of the Renaissance. From 1434, the Medici hardly looked back. A conspiracy against them in 1478 led by the Pazzi family failed (although Giuliano, Lorenzo's younger brother, was killed) and confirmed the power of the Medici, which lasted until 1484, when the family was expelled for a period of eighteen years.

Florence did not fair too well in the interregnum of its restored liberties. First there was the episode of Friar Girolamo Savonarola's strange theocratic regime (1494–8) – marked by the famous "burning of vanities" at carnival time, in which finery, lewd books and profane works of art were piled on the bonfire, and ending in savagery with the torture and hanging of Savonarola – and thereafter the city was occupied and squeezed for big indem-

nities by French and Spanish armies in turn. The restoration of the Medici between 1512 and 1527 also coincided with the reigns of two Popes who were members of the clan, Leo X (1513–21) and Clement VII (1523–34), and ended with a second, but equally impermanent, expulsion. The subsequent siege of Florence by an army of papal and imperial allies in 1529 – during which Michelangelo took charge of the city's fortifications – led to capitulation, and in 1531 the Medici were back for good as puppets of, at first, the Spanish kings and, later, the Austrian emperors.

We have seen how at the start of the Renaissance period, the work of artists was enmeshed in the system of guilds and how artists responded to the expectations of their patrons, both in the nobility and the Church. But with the kind of court with which the Medici dictators (for whatever their actual titles were, that is the term that describes them best), surrounded themselves, a new and grander kind of intellectual and artistic patronage was dispensed. Florence was embellished with art and architecture on a scale that reminded Humanists of Athens under Pericles, and aroused the envy and greed of the courts of Rome and Europe. The marble-carving talents of the boy Michelangelo were encouraged – and it must not be forgotten that, later on, it was a Medici Grand Duke who sheltered and protected Galileo. Academies for Humanists were set up in Florence (the Platonic and the Della Crusca), and the thinkers and writers Marsilio Ficino, Politian (Poliziano), Pico della Mirandola and Nicoló Machiavelli gathered there. Of these Nicoló Machiavelli (1469–1527) is the best remembered. He was a Florentine statesman and writer of genius. His play *Mandragola* is one of the most powerful of all Italian dramas and he wrote a critical *History of Florence* and a treatise on *The Art of War*. His

San Lorenzo, *1421–60*
View along nave
Filippo Brunelleschi (1377–1446)
Florence, Italy

This basilican church with aisles separated by Corinthian columns, contrasts strongly with the view along the nave of any medieval cathedral or church. The dominant classical elements testify to the Renaissance revolution in style, and San Lorenzo is the earliest consistent example of the use of such elements.

greatest fame, however, rests in his short book *The Prince* (1513) one of the most influential works of Renaissance literature. It is about the means by which an ambitious man may gain and retain complete power in a state in which he makes expediency dominate moral considerations. It is a charter for power-seekers whose only restraint is whether action is effective, not whether it is moral or humane. It is another reflective of the Humanist concern for man rather than God.

The strength of the Renaissance that was fostered by the Medici in Florence lay in the artists born and bred in the city or drawn into it from nearby. It was during the years of external crisis for Florence that Filippo Brunelleschi

The Tribute Money, *1425–8*
Tomaso di Mone, called Masaccio
(1401–28)
Fresco 98½×236in (250×600cm)
Santa Maria del Carmine, Florence

While all of Masaccio's work occupies an important place in the development of Italian painting, details of his brief life are scarce. He was born and brought up in San Giovanni Valdarno, a small town on the River Arno about forty miles (64km) from Florence. He completed his training in Florence in 1422 and in 1424 became a member of the Company of St Luke. His best works are the frescoes in the Brancacci Chapel at Santa Maria del Carmine, part of a large cycle showing the life of St Peter. Masolino (1383/4–1447) and Filippo Lippi (1406–69) also worked in the Chapel. About one-third of the full fresco cycle was lost in a fire during the 18th century. In The Tribute Money Masaccio employed the device of continuous narrative, in which the same figures sometimes appear more than once at different stages of the story, yet the perspective of the composition is fully realized. The Biblical reference to the work is from Matthew, Chapter 17, telling how Christ instructed Peter to look in the mouth of a fish to find silver for payment of a temple tax charged to them at Capernaum. The painting may also refer to a contemporary controversy, the levy of a property tax, known to have been opposed by the affluent Brancacci family.

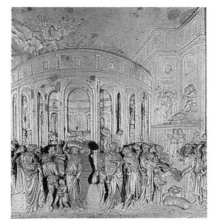

The Story of Joseph, *Baptistery doors, Florence, 1403–52*
Lorenzo Ghiberti (c.1378–1455)
Bronze chased in gold

Ghiberti won a famous competition (beating Brunelleschi among others) to make the bronze doors for the Baptistery of St John in 1401 and he worked on them for the rest of his life. The first set of doors were done in prevailing International Gothic manner and were completed in 1424. The merchants' guild of Florence then commissioned him to make another set and the later doors, from which this panel is taken, reveal the deepening influence of Roman antiquity on Ghiberti. The buildings in the panels, which illustrate tales from the Old Testament, are far more Classical in their central-plan shapes and also in their details – pilasters, Corinthian capitals, trabeated and arcuated porticos and façades – than any buildings which were actually yet being built in early 15th-century Italy.

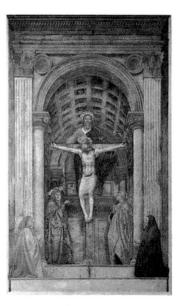

The Trinity, *1428*
Tommaso di Mone, called Masaccio
(1401–28)
Fresco 263½×126in (670×320m)
Santa Maria Novella, Florence

The fresco of The Trinity in Santa Maria Novella must have been one of Masaccio's last works in Florence, since he left in 1428 for a visit to Rome and died there at the age of twenty-seven. The commission is not recorded but the donors of the work are believed to have been the Florentine Lenzi family. The Trinity proves again Masaccio's mastery of perspective, based on the writings of Brunelleschi (1377–1446). The architectural structure in the painting is based on a central vanishing point that can still just be seen, scratched into the plaster. To separate the stages of the figure group, Masaccio showed the human donors at the eye-level of the spectator, the Virgin and St John in perspective from below, and the figures of Christ and God again from a frontal, eye-level view, although they are necessarily elevated by the height of the wall itself. The fresco was covered for many years by an altar. In 1861 it was rediscovered and cut away to be transferred to a different wall of the Chapel. In 1952 it was restored to its original place and cleaned thoroughly, and the lower part of the composition was seen again for the first time in three centuries.

(1377–1446) was called upon in 1418 to design the Church of San Lorenzo, followed in 1436 by the reconstruction of Santo Spirito. Together these two churches present quite new phenomena in Italian architecture. Brunelleschi used a rigorously uniform system comprising bases, columns with entasis, capitals, impost blocks and semicircular arches colored in such a way that the structural elements or those that purport to be structural are marked out in a gray stone, while the walls are left a creamy yellow color. The same newness of style is seen in Masaccio's *Trinity* (probably painted in 1426) in the Church of Santa Maria Novella, which displays a vigorous architectural frame consisting of pilasters with Corinthian capitals. The strict Brunelleschian architecture, the vigorous use of the new one-point perspective developed by Brunelleschi, the massively draped figures, the comprehensive use of a single light source, the total absence of incidental detail within the fresco frame, all mark the first systematic statement of a new style of painting. The break from the predominating style of his contemporaries can be illustrated by a comparison with the *Adoration of the Magi* by Gentile da Fabriano, painted in 1423.

The most important work of Masaccio, apart from the *Trinity* in Santa Maria Novella, is the series of frescoes in the Brancacci Chapel in the Church of Santa Maria della Carmine, also in Florence. The major single painting is *The Tribute Money*, in which, while treating the figures with more dramatic reality than any of his predecessors, he makes use of the medieval pictorial narrative tradition of showing a series of events in one apparently unified whole. Here Christ is seen commanding St Peter to pay the tax gatherer; St Peter is seen pulling the fish in which the tribute money will be found from the stream; and, on the

right, St Peter is paying the tax gatherer. The use of a conscious perspective and the considered relationship physically and emotionally between the figures as well as the accomplished drawing identify this as one of the seminal paintings of the early Florentine Renaissance.

Among the first important and successful figures in the early Florentine Renaissance, Lorenzo Ghiberti (1378–1455) is powerfully influential. He was a painter and sculptor and the author of the first artist's autobiography, *Commentarii* (1450), in which he tells us that the commission for the work that occupied much of his working life and employed many of his famous contemporaries, the bronze doors for the Baptistry of Florence Cathedral, was awarded to him unanimously by the judges. The earlier of his panels on the doors belong to the still pervasive International Gothic decorative style, while his later ones changed the Gothic quatrefoil shape to rectangular and carried Classical moldings, an indication of the growing Classical Renaissance spirit in his work. Sculptors were the first to adopt the new style, particularly Donatello and Nanni di Banco, and all their works were produced for public places, such as the Church of Or San Michele and the Cathedral (the Duomo). The decoration of these buildings was in the hands of the guilds which controlled Florence at the beginning of the century and in which the great Humanist scholars (who were active members of the government) and all artists were enrolled. Since 1339, fourteen niches had been assigned to various guilds for their church, Or San Michele, but by 1400 only two had been filled. In 1406, four years after the trauma of Gian Galeazzo's appearance and then sudden death at the gates of Florence, the city council told the guilds to fill the niches within ten years. Between 1399

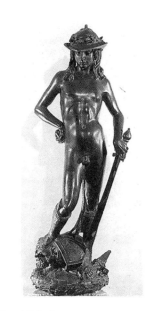

David, c.1430–2
Donato di Nicolo called Donatello
(1386–1466)
Bronze height 62½in (159cm)
Museo Nazionale, Florence

The marble David was probably commissioned from Donatello to form a pair with a carving of Isaiah worked by the Florentine artist Nanni di Banco (c.1385/90 –1421). The David, however, was not immediately installed in its intended position and was later reworked and erected at the Palazzo Vecchio in 1416. The date of the bronze David is uncertain, but there is some agreement that it may have been made in the early 1430s when Donatello visited Rome. There he worked with Brunelleschi (1337–1446) and had the opportunity to study antique sculptures. The assumption of the date is partly based on the Classical influence apparent in the pose of the David. The sculpture is mentioned in a contemporary account of the wedding of Lorenzo de'Medici in 1469, which described the arrangement of the wedding feast around "the beautiful column on which stands the bronze David" Both statues are also mentioned in the account of Donatello's life written by Giorgio Vasari. Vasari describes their positions in the Palazzo Vecchio and confirms that the bronze version had earlier been in the possession of the Medicis, but his biography sheds no further light on the origins of either work.

Gattamelata, 1443–8
Donata di Nicolo called Donatello
(1386–1466)
Bronze on marble and limestone base
Height 134in (340cm)
Piazza del Santo, Padua

Gattamelata, the "honeyed cat", was the nickname given to Erasmo da Narni, a commander in the army of republican Venice. It is not known whether the equestrian statue, commissioned after his death, was ordered as a public monument by the government of the Republic or as a private memorial for the family, although the latter certainly bore the cost of the work. Donatello practiced mainly in Florence through most of his career, but the Gattamelata was completed in Padua, where he lived for ten years from 1443. Donatello's work to that date shows the influence of the great Classical sculptures of Italy. Inspiration for the equestrian statue was drawn from the antique Marcus Aurelius at the Capitol in Rome, but probably also from Uccello's fresco of Sir John Hawkwood on horseback (1436) in the cathedral at Florence, where Donatello was frequently employed in the sculpture workshops. After his return to Florence from Padua, Donatello began to shed the Classical mold in favor of a more personal interpretation of his subjects; despite the overall style of the monument, many of the details are drawn from contemporary sources, skillfully combined with motifs from the older traditions.

and 1427, some fourteen life-size statues were installed, over the years increasingly naturalistic and Classical in style. Only after the terror inspired by Ladislaus in 1408 did Gothic give way to the Renaissance style. Donatello's *St George* comes in 1416–17, his *St Louis* in 1423, and Ghiberti's *St Matthew* in 1422. In the great statues produced for various parts of the Cathedral between 1399 and 1427 the stylistic shift from Gothic to Donatello's relentless realism is similarly marked. His marble *David* of 1408–9 was originally carved for a buttress of the Duomo and was regarded as a symbol of the tenacity of the Republic in the face of overwhelming odds.

Donatello, whose dates are uncertain (he was born about 1385 and died in 1466), was the contemporary of Brunelleschi and the close friend of Masaccio. They are the big three of the early Florentine Renaissance. Although it was already becoming common to practice all three of the arts, and Donatello made architectural designs while Brunelleschi sculpted, it is as sculptor and architect respectively that they are best known. In his short but influential life Masaccio worked exclusively as a painter. Florence was becoming a center of cultural development and Nanni di Banco and Ghiberti had already achieved reputations before Donatello, who appears to have been, in Renaissance terms, a slightly late developer. It is known that he was an assistant to Ghiberti for a short time and also that he visited Rome, but his most important work is in Florence. His uncompromising dedication alone cannot explain the extraordinary quality of strength with a tender humanity that gives his work a pathos unknown among his contemporaries. His strength – and Classical inspiration – is seen in his bronze equestrian statue of the *condottiere* Gattamelata in the square in front of the cathedral at

Padua. Andrea del Castagno (1423–57) shows the influence of Donatello, his contemporary in Florence, and his *Last Supper* is a powerful and dramatic expression of the scene set in a Roman interior. The careful picture-box space and the long unifying line of the table-cloth broken only by the figure of Christ makes this the most effective Renaissance presentation of the subject, its only peer in treatment and feeling being Leonardo's painting in Milan.

The menace of the Visconti gave a noticeable stimulus to the Florentines' commitment to ideals associated with the republican forms of government. Humanist authors were the chief public exponents of these values, particularly the interpretation of Florence as the natural extension of the original settlement founded by Sulla (i.e. when the Roman Republic still existed), rather than looking to the memory of Caesar, the incarnation of all that was opposed to republicanism. Civic virtues, such as an active and continuous participation in public life, were to be preferred to the lives of scholars and ascetics, and wealth was something that could be used to help learning, morality and edification, rather than a possession to be secretive about.

Leone Battista Alberti, although noted principally for his architectural designs, was not a practicing architect, but rather the first of the great "universal men" of the Renaissance. He wrote on painting, sculpture and architecture and set down the first principles from which subsequent Classically-inspired architecture was derived. His influence was considerable. A friend of popes and powerful rulers, his qualities were recognized early. In Florence he worked for Giovanni Rucellai, designing the façade of Santa Maria Novella and the Palazzo Rucellai for him. In the façade of Santa Maria Novella he introduced the scroll form, which was a simple and

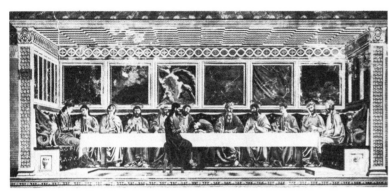

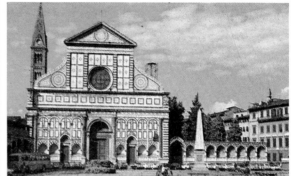

The Last Supper, *c.1445–50*
Andrea del Castagno (c.1423–57)
Fresco
Castagno Museum, S Apollonia, Florence

The biographer Vasari's account of Castagno's life established a poor personal reputation for the artist. It is possible that he was of a quarrelsome nature, but Vasari repeated and added invented detail to a report of an earlier biography that Castagno had murdered his friend, the painter Domenico Veneziano. This assumption persisted until the 19th century, when it was discovered that Domenico's death could be firmly dated at 1461, four years later than Andrea's own early death from plague. As an additional burden, Andrea acquired the nickname "Andreino degli Impeccati," Andrea of the Hanged Men, from his fresco showing the execution of participants in the Albizzi conspiracy against the Medici. In fact this was a relatively common type of commission and Botticelli carried out a similar task after the Pazzi rebellion. Vasari's biography of Castagno may be substantially true in its description of his earlier life. He worked initially as a herdsman and on seeing the work of a local painter, began to paint and draw at every opportunity. He was trained under the patronage of Bernardetto de'Medici, who owned an estate at Castagno and arrived in Florence in about 1436. The fresco of the hanged men established his reputation as an artist and he soon attracted other work. In 1442 he was in Venice but had returned to Florence by 1444. Thereafter no records are available until 1449, and it was probably during that period that he worked on the frescoes of the Passion at S Apollonia.

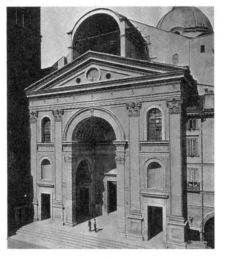

S Maria Novella (façade), *Florence, 1458–71*
S Andrea (façade), *Mantua, 1470–72*
Leone Battista Alberti (1404–72)

In c.1450 Alberti published ten volumes on architecture, De re aedificatoria, which established him as the earliest and most influential architectural theorist of the Italian Renaissance. Good building, he argued, could be designed only by wise men learned in mathematics and painting, so that they should reflect the mathematician's love of harmony and the painter's search for truth in nature, Perhaps Alberti's most profound contribution to Renaissance Classicism was his scholarly discussion of the principles of the ancient orders. He was not opposed to ornamentation, but architectural beauty was, above all, a matter of "correct" – that is to say, accurately Classical – proportions. "In all architecture," he wrote, "the fundamental ornament is undoubtedly the column."

direct means of unifying the façade, showing the ends of two aisles and a higher central nave. On the exterior of the Rucellai palace he used the pilaster with the traditional rusticated (roughly hewn) stonework that became characteristic of Florentine palaces and is seen again in the Riccardi Palace by Michelozzo, which became one of the Medici palaces. In Rimini, where he worked for the tyrant Sigismondo Malatesta, he undertook his first independent commission, the redesigning of the Church of St Francesco, and in Mantua he designed his greatest church, Sant'Andrea, for Ludovico Gonzaga. Although he died as the building work began, it was continued faithfully by the practicing architect, Fancelli, and work continued on the structure into the 18th century.

The Monastery of San Marco in Florence houses fifty frescoes painted, mostly in the cells of the Dominican friars, by one of their order, Fra Giovanni da Fiesole (*c.*1387–1455), known as Fra Angelico. He represents part of the transition from the late medieval to the Renaissance, and his expository religious intentions and deep faith shine through. The delicacy of his work combines a subtle feeling for color with a sense of serenity and innate goodness which goes well with his name. It was from San Marco that, from 1494 to 1498, Savonarola as prior

had so much influence on the course of Florentine history. The quiet, loving Christianity of Fra Angelico contrasts strikingly with the fierce zeal of the Prior.

Piero della Francesca (1410/12–92) was of the same generation as Alberti and, like him, interested in the science of art. His work is most demanding and yet apparently simple, seemingly scientifically constructed and yet pregnant with quiet poetic beauty, intellectual yet passionate. Piero was interested in perspective and proportion and wrote a treatise on painting as science. In his work this stillness, almost immutability, of the figures seems only to reveal an anticipatory sexuality. All this combines to make Piero not only a demanding but also a compelling painter. He was born in Sansepolcro in Umbria and was a follower of Masaccio and worked with Domenico Veneziano. Before 1444 he was working in Florence but later in his home town, and in Rimini, Ferrara and Urbino. His most important works are at Arezzo (the *Legend of the True Cross* frescoes) and at Sansepolcro, where his *Resurrection* is found.

The work of Antonio Pollaiuolo (1429–98) reveals another aspect of the Renaissance spirit, that of scientific enquiry. Pollaiuolo was interested in anatomy and the depiction of the human figure in realistic poses, to the extent that in his *Martyrdom of St Sebastian* the two foreground archers are mirror images of each other designed, presumably, to indicate his ability to draw the same form from different positions. There is a certain youthful intellectual naivety in this – and indeed in many other works of the time – which indicates both the insecurity and exhibitionism of the early Renaissance.

That same spirit of intellectual enquiry and naivety is present in Paolo Uccello's (1397–1475) paintings. In his *Rout of San Romano*, Uccello is less

The Annunciation, c.1450?
Fra Angelico (1387–1455)
Fresco 86½×126in (220×320cm)
San Marco, Florence

Fra Angelico was a member of the Dominican order of friars and originally joined a monastery at Fiesole. It is not known how or when he received training as an artist but in the tradition of his order, his paintings became a contribution to the service of religion. In 1437 the order moved to the monastery at San Marco in Florence, where fresco decorations were carried out throughout the building by Fra Angelico and his assistants. This version of the Annunciation, located at the top of the dormitory stairs, is thought to be later than the original cycle of works, which included a painting of the same subject, also by Fra Angelico, in one of the friars' cells.
Although Fra Angelico remained dedicated to the monastic life, he kept his interest in artistic developments in Italy and it is possible that the later Annunciation was completed after a visit to Rome, where he worked on frescos for the chapel of Pope Nicholas V in the Vatican. In the San Marco version of the Annunciation the figure poses are similar but the later composition seems more spacious and assured in the handling of figures and background.

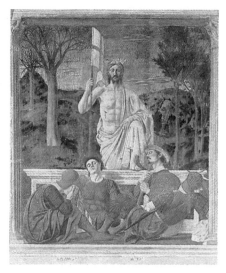

The Resurrection, c.1463
Piero della Francesca (c.1410/20–92)
Fresco 88½×78½in (225×200cm)
Palazzo Communale, Borgo San Sepolcro

There is only one recorded occasion of Piero's work in Florence, referring to his collaboration with Domenico Veneziano on frescoes for San Egidio in 1439. His subsequent paintings show that while in Florence he had studied Masaccio's frescoes and he also read Brunelleschi's treatise on painting containing the theory of perspective. During his lifetime Piero worked in Rome, Ferrara, Arezzo and Urbino but he lived for several years in his birthplace, Borgo San Sepolcro; he painted there and also took an active part in the community, becoming a town councilor in 1442. The fresco cycle of the Legend of the True Cross, of which The Resurrection is part, was painted in the Church of San Francesco at Arezzo. Piero was apparently a slow and deliberate worker and one difference between his work and Masaccio's, despite the shared understanding of perspective, is that Piero's compositions are more rigidly constructed, each element contributing to the spatial structure of the painting, but not necessarily to its naturalism.

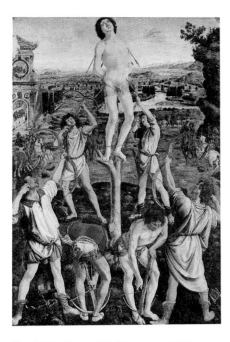

The Martyrdom of St Sebastian, *1475*
Antonio (c.1432–98) and Piero (1441–96)
Pollaiuolo
Tempera on panel 114×79in (290×200cm)
National Gallery, London

The brothers Antonio and Piero Pollaiuolo
frequently collaborated on paintings and
many efforts have been made to identify
each artist's contribution. From works
known to have been made separately, it is
agreed that Antonio was the more
accomplished of the two. Trained as a
goldsmith, he was one of the first artists to
study anatomy and perform dissections. His
surviving work includes some delicate
drawings and one very fine engraving. The
symmetrical poses in The Martyrdom of
St Sebastian may have been a device for
exhibiting some of his anatomical
knowledge, and it is possible that the
more romanticized figure of the Saint is
attributable to Piero. The background of the
painting shows Florence and the River Arno.
Both men went to work in Rome in 1483,
where they collaborated on designs for the
tombs of Popes Sixtus IV and Innocent VIII.
The tombs were completed by Antonio after
the death of Piero in 1496.

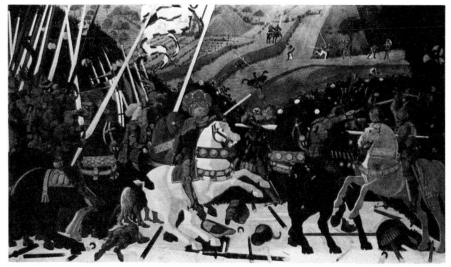

The Rout of San Romano, *after 1451*
Paolo Uccello (1397–1475)
Paint on panel 71½×125½in (182×319cm)
National Gallery, London

Uccello was trained in the workshop of the
sculptor Ghiberti in Florence, a center of the
International Gothic style. His activities after
leaving the workshop are not well
documented. In 1425 he went to Venice and
a record of 1432 suggests that he worked
there as a master mosaicist. Possibly the
formal dictates of such a craft proved
influential in his later style of composition.
After his return to Florence in 1431 he
completed a cycle of frescoes at Santa Maria
Novella showing the Creation myths and in
1436 executed his equestrian portrait of
Sir John Hawkwood, a replacement of the
original memorial and based on a statue of
Hawkwood. The three panels showing
scenes from the Battle of San Romano,
(other examples are found in the Louvre,
Paris and the Uffizi, Florence) were
apparently commissioned for the Medici
Palace. An inventory mentioned that they
formed decorations to the bedroom of
Lorenzo de'Medici. The battle of San
Romano had taken place in June 1432, but
the paintings are thought to be of
a considerably later date.

concerned with the emotional life of
his figures or indeed their solidity than
with perspective and the expression of
a "picture-box space". (This is the
space defined within the area of the
painting as that in which the action can
take place; the use of perspective
obviously constructed to define the
space in a box explains the term.) The
almost neat arrangement of the broken
and discarded weapons is a parallel to
Pollaiuolo's archers, in that it is a naive
exhibitionist display of the artist's
talents asking to be admired.

Andrea del Verrocchio (1435–88)
was born in Florence and his career has
some echoes of Donatello's, as can be
seen in his two best known works. The
first is a bronze *David* in a more relaxed
Classical pose than found in Dona-
tello's and with a soft charm rather than
the strength found in Donatello. The
second work parallels Donatello's
Gattamelata (1447) in front of the
Cathedral at Padua. This is the large
equestrian bronze of the Venetian
benefactor and *condottiere* Bartolomeo
Colleoni, which stands in front of the
Scuola San Marco in Venice, where
Verrocchio was working on the sculp-
ture when he died. This work shows
great power and less of the classical
Roman connections than Donatello's.

Although it was not finished, being only in "the clay" when Verrocchio died, it is essentially his work. Echoing the medieval knight at arms, it nevertheless contrives to epitomize the Renaissance *condottiere* in the figure's arrogant and self-conscious assumption of importance and in the symbolic dominance of the rider (man) over the horse (the physical world).

A reflection of the Humanist court of Lorenzo de'Medici is found in the work of Sandro Botticelli (*c*.1445–1510), whose mythological paintings are careful interpretations of texts by Classical authors. His *Primavera* (Spring), for example, has been considered by some authorities as interpreting ideas in the works of Ovid. His essentially Renaissance intellect is accompanied by a most beautifully taut and expressive linear style. He is not concerned with light and shade but with the bounding of form and a decorative charm that is rarely seen in Renaissance art. At the end of the century the revolution in Florentine life brought about by the mesmeric preaching of Savonarola appears to have influenced Botticelli late in life, and his taut and expressive line is used in his *Deposition* (*c*.1500) and his later Pietà to great emotional effect.

The enormous energy and enterprise of Domenico Ghirlandaio (1449–94) and his insatiate appetite for work (he is reputed to have expressed a desire to paint the entire walls of Florence), is allied to a fine sense of design and great craftsmanship. Like so many of his contemporaries, he was apprenticed in a craft, goldsmithing, but his abilities led him to painting. He was called to Rome with Botticelli and others to decorate the Sistine Chapel with a series of frescoes, only one of which survives. He was also recognized as a fine portrait painter, but few of his portraits have survived. His charming, sensitive and unusual portrait of a man with his grandson is

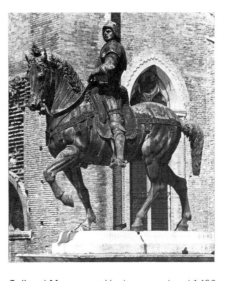

Colleoni Monument, *Venice, completed 1496*
Andrea del Verrocchio (c.1435–88)
Bronze

After a lifetime spent chiefly in Florence, Verrocchio moved to Venice in the early 1480s when he won a competition to sculpt a memorial to the late condottiere, *Bartolomeo Colleoni. It was his last important work, awesome in its larger-than-life size at 13ft (4m) it was 3ft (1m) higher than Donatello's* Gattamelata *monument. It is also much freer in its composition than the Donatello and, viewed with almost equal advantage from any angle, reflects the concern to suggest movement which was characteristic of the second half of the 15th century. Verrocchio died before the sculpture was cast (it was completed by one of his rivals in the original competition), but the work, vigorous in its rhythms and unyielding in its portrayal of a warrior's unsentimentality, is essentially his alone.*

An Old Man and His Grandson, c.*1475*
Domenico Ghirlandaio (c.1448–94)
Tempera on panel 14½×11in (37×28cm)
Louvre, Paris

Ghirlandaio was an accomplished fresco painter, the master of a large and popular workshop in Florence. In 1481 he started work on a fresco for the wall of the Sistine Chapel in Rome, in a scheme of decoration that included work by Botticelli and Perugino. Ghirlandaio's fresco, The Calling of the First Apostles, *contained many portraits of contemporary Florentines living in Rome. Throughout his work he exhibited this taste for applying local and contemporary detail, both in portraiture and in the general elements of a composition, and this may have been one reason for the popularity of his paintings. Michelangelo briefly trained at the workshop of Ghirlandaio and this probably gave him the knowledge of fresco technique that he later applied to the ceiling of the Sistine Chapel. Ghirlandaio also worked on smaller compositions in tempera, including portraits and altarpieces. There is no evidence that he ever practiced the recently introduced technique of oil painting. The subjects of this double portrait are unknown, but the painting is typical of the sympathetic observation brought to bear by Ghirlandaio.*

one, and the treatment of the view from the window recalls the Flemish painting of the time and the placid backgrounds in the paintings of Piero.

The great Florentines, Leonardo da Vinci and Michelangelo, remain to be mentioned. Both worked outside Florence – Leonardo in Milan and Michelangelo in Rome – and with Raphael they represent the High Renaissance; a fuller consideration of their work appears later. The Humanist Renaissance in Florence is the most complete expression of an essentially intellectual culture court. In Venice, a republic with a very different governmental structure, a different expression of the Renaissance appears.

Primavera, *1478*
Sandro Botticelli (c.1445–1510)
Tempera on panel 80×123in (203×314cm)
Uffizi, Florence

The Primavera *was painted by Botticelli as a commission for Lorenzo di Pierfrancesco de'Medici, a cousin of Lorenzo the Magnificent, for his townhouse in Florence. It is one of a series of allegorical paintings based in Classical mythology, but its true significance to Lorenzo or Botticelli himself is not entirely understood. Various theories have included that it is an illustration to contemporary poems, or to tales from Ovid, or that it represents ideas taken from Platonic philosophy. At the right of the picture Zephyr, the wind god, pursues the nymph Chloris, and at his touch she is transformed into Flora. In the center of the painting stands Venus, with Cupid overhead, and to the left are the Three Graces and Mercury, the messenger god. The painting was probably completed just before Botticelli's visit to Rome, where he executed frescoes in the Sistine Chapel at the Vatican. Botticelli's stylized, linear forms became unfashionable and he died in relative obscurity. His work was among the models claimed by the Pre-Raphaelite artists of the 19th century, which led to a reassessment of his paintings and his place in art history.*

The Venetian State

There have been many attempts by painters, writers and poets to capture the peculiar magic of Venice. The city occupies one of the most remarkable sites in the world on a group of built-up islands at the end of a causeway over two miles (3.2km) long. Unlike any other city, the main arteries of traffic are by canal, the main artery being the Grand Canal which snakes in a reverse "S" through the middle of the city. From the Grand Canal a multitude of canals link together as the city's communication network. St Mark is the patron saint of Venice, the lion is the symbol of St Mark, thus at the hub of the city the Piazza San Marco fronts the Church of San Marco (built in the 11th and 12th centuries) and on top of a column in the small square (the Piazzetta) next to the Piazza is the sculptured lion of St Mark.

In Venice, water is always to be seen. It is the life-blood of the city but it also gives that extraordinary light to the city that has been noticed by so many observers through the ages. The sun bounces off the moving water as it does not do from solid road surfaces, casts flashes on the buildings and makes the architecture of the city look, in Shelley's words, "like fabrics of enchantment piled to heaven". Artists have been drawn to the city and one of the great painters of light in the 19th century, the Englishman Turner, gave the city in his many paintings an image of light and color not paralleled by the paintings of any other city.

The islands that form Venice are in a lagoon at the northern end of the Adriatic Sea, providing it with fine trade routes eastward, the lagoon bar protecting it from storms and providing good harbor. Flooding is the greatest and most destructive danger to the low-lying islands.

The Venetian civilization which developed is as unusual as the site itself. Sea trade and naval domination of

the Adriatic were the foundations of Venice's great mercantile empire, which expanded as far as the Black Sea. By 1381 Venice had overwhelmed its rivals in Genoa on the northwestern borders of the peninsula and this gave it a more or less free hand in the Near East for two centuries until the rise of the Ottoman Turks, who plundered its commercial outports, particularly between 1425 and 1430. Its position favored it in any Eastern trade since Venice was the most conveniently placed port to places east and for transport overland to the west of Europe. In the hinterland (the *terra firma*) expansion was spectacular in the early 15th century: Padua, Vicenza and Verona were absorbed by 1405, and by 1429 Crema was seized in the course of war with Filippo Maria Visconti, Duke of Milan.

The Republic was run by the most secret and exclusive government outside a prince's court in Italy, and appeared to observers at the time to be the most stable and splendid government of any of the great free states of Italy. It had eventually become a hereditary oligarchy of some 1500 families who controlled the Great Council. This body selected various public officials and, through a tediously elaborate procedure, elected the nominal head of government, the Doge, whose functions were mainly ceremonial, and who was elected for life. The all-powerful Senate comprised some 300 members, and operated together with a Council of Ten, which, among other matters, was charged with the detection and punishment of treason, and wisely held their meetings in the greatest secrecy.

The division between the governing nobility and the citizen class, however rich it might be, had a remarkable consequence in Venice – the *scuole*, or guilds. Of particular interest from the point of view of art were the type known as *Scuole Grandi*, lay confraternities that were established as offshoots of a self-flagellating religious movement of the mid-13th century. Their role became important as the political and charitable organizations through which the citizen class, who were excluded from government, could run their affairs. The *scuole* were financed by the benefactions and subscriptions of their members, and their wealth was sometimes prodigious because the members included the never-quite-respectable, non-noble merchant class. Rivalry between the guilds, coupled with their great wealth, produced some of the most splendid structures of Renaissance Venice. Their functional requirements were actually quite simple: they had to include two great halls, usually built one on top of the other, one for general assemblies of the guild, the other for the dispensation of charity to their own impoverished colleagues. In addition there had to be provision for a small assembly room upstairs where a committee who carried out day-to-day administration would meet.

The importance of the six major *scuole* as patrons was immense. Competitiveness in the arts, including music and various ceremonial functions, was such that by the middle of the 16th century attempts were made to cut down the expenditure on them. The Scuola Grande della Misericordia had a new building designed for it by Jacopo Sansovino (1486–1570) begun (but not completed) in 1532. The stupendous Scuola Grande di San Rocco was begun in 1515 and was substantially complete by 1549. The architecture of the façade is one of the last and grandest productions of local architects working in a local style. Inside are great cycles of paintings by Tintoretto of between 1564 and 1583. The Scuola di San Giorgio dei Schiavoni and the Scuola di Sant'Orsola contain a series of paintings by Carpaccio. The façade of the Scuola di San Marco was begun in 1485 and constitutes one of the glories of the inventive local architectural style. The paintings commissioned for this building were particularly rich and varied, and included *St Mark Preaching in Alexandria* by Gentile and Giovanni Bellini, Tintoretto's *The Miracle of the Slave* and, later, the *Finding of the Body of St Mark,* the *Transportation,* the *Saving of the Saracen at Sea.* Finally, the Scuola di San Giovanni Evangelista was provided with a celebrated staircase by the architect Moro Coducci (1440–1504), and incorporated paintings by Titian, Gentile Bellini and Carpaccio.

The Bellinis, Giovanni (1430–1516) and Gentile (*c*.1429–1507), were brothers and belonged to a Venetian family of craftsmen who played an important role in the development of Venetian art during the 15th and 16th centuries. Jacopo (*c*.1400–71), the father of Gentile and Giovanni, was himself the son of a tinsmith or pewterer and studied first under Gentile da Fabriano, who worked in Venice in the style now known as International Gothic. At this time Venice was not yet a center of great artistic activity and Jacopo followed Fabriano to Florence. The instruction he then received from the Florentine masters, Donatello, Masaccio, Ghiberti and Uccello, gave him a position of reputation and influence on his return to Venice in 1429. Both his sons became painters and his daughter married the Paduan painter Andrea Mantegna (1431–1506). The influence of this family in setting up the Venetian school cannot be overemphasized. Giovanni, who created the largest studio workshop in Venice, trained most of the next generation of painters, including the great figures of Giorgione and Titian. He was strongly influenced initially by his precocious

Madonna of the Meadow, c.1505
Giovanni Bellini (c.1430/40–1516)
Oil on panel 26½×34in (67×86cm)
National Gallery, London

*Giovanni Bellini and his elder brother
Gentile were both trained in the studio of
their father Jacopo (c.1400–70). Although
Gentile had set up work independently by
1459 there is evidence that all three
continued to collaborate until Jacopo's
death. The brother inherited his sketchbooks
and Giovanni used some of the drawings as
the basis of landscape backgrounds. This
Madonna and Child is one of a number of
smallscale devotional images that survive
from the output of a long and very
distinguished career, in which Bellini was
largely responsible for the development of
Venice as a center of the arts that could
rival Florence. Among Bellini's pupils were
Giorgione and Titian, both of whom also
became his professional rivals. Bellini
outlived Giorgione and matched Titian's
reputation through his own continued
energy and inventiveness. A measure
of the respect accorded to Giovanni
Bellini both in Italy and elsewhere is the
remark made by Durer after his visit to
Venice in 1505–7: "He [Bellini] is very old,
and still the best in painting."*

The Agony in the Garden, c.1460
Andrea Mantegna (1431–1506)
Tempera on wood 24×31½in (63×80cm)
National Gallery, London

*Mantegna worked initially in Padua and
there took part in a group dedicated to the
study and reconstruction of Classical culture
and civilization. In 1456 he was invited by
Lodovico Gonzaga to Mantua. Delayed by
his work in Padua, Mantegna finally took up
his appointment in 1460. The Gonzagas
owned a large library and gradually
established Mantua as a center of learning,
particularly well equipped for the study of
Classical art and philosophy.*

*The original form of the design for this
painting appears in Jacopo Bellini's
sketchbook and has some similarity to the
treatment of the same subject by Giovanni
Bellini. It has Mantegna's characteristic
definition of form with sculptural volume,
although the classical influence in his work
is apparent in his treatment of the soldiers in
the right background. The five winged putti
in the top right are carrying the instruments
of the Passion (column, cross, sponge and
spear), and Judas leads the soldiers in the
background.*

brother-in-law Mantegna, who, working in Padua, was influenced by Donatello to the extent that his passion for Classical sculpture appears in his paintings, the forms seeming to have been sculpted rather than painted.

The Venetian state, with its stable if illiberal government, was nevertheless wise enough to provide well for its citizens in addition to the general prosperity of the city. Venice was a city of pageant, carnivals and festivals (more than in any other Italian city), and revolt is difficult to organize when holidays are frequent. Gentile Bellini became painter to the Council of Ten and visited Constantinople to work at the court of the Turkish Sultan, returning to Venice rich, knighted and with a pension. His paintings of the pageants of Venice illustrate graphically the dress and customs.

In the development of painting the Sicilian artist Antonello da Messina (c.1430–79) appears to have had an influential, even crucial role. He is supposed to have visited the Netherlands, where he may have seen some work by Jan van Eyck, returning to Sicily in about 1465, moving from there to Venice in 1472, where he worked for the

187

Council of Ten. His importance stems from the probability that he introduced the oil painting technique (the Flemish style) into Italy, and its adoption by the Venetians in particular gave that school, in the works of Bellini, Titian, Tintoretto and Veronese, the freedom of color and technique that is its great glory. This is the traditional and probable, but not fully documented, story. What is clear is that Antonello introduced a visual delight in everyday things so attractive in Flemish painting.

The alacrity with which oil painting was adopted in Italy during the Renaissance says a great deal about the aspirations of the period. Oil painting is a "personality" method. The earlier techniques of fresco and tempera, however effective, did not, by the nature of their demanding and restrictive methods, lend themselves easily to the immediate expression of personality. It is not entirely the quality, it is also the anonymity of the fresco technique. It takes a Michelangelo to use fresco with individuality. In the Sistine Chapel it is the ceiling and the end wall that command – and anyone who has been there will know that it is not merely their famous reputation that evokes the command – our attention.

Another painter who was probably trained by Giovanni Bellini and is a contemporary of Titian is Giorgione (c.1477–1510). But Titian's long life, considered later, contrasts with Giorgione's early death, and thus Giorgione seems to belong to an earlier generation. Little is known of his life or background and very few paintings can confidently be ascribed to him (some authorities have limited the number to ten) but those that are show an accomplishment that has resulted in his being regarded as the stylistic link between the earlier Bellini and the later Titian. In spite of extensive later restorations, his *Castelfranco Altarpiece* has a radiantly remote presence.

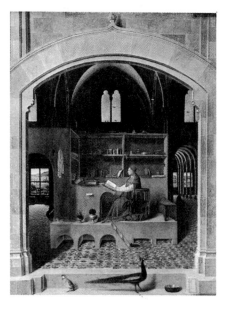

St Jerome in His Study, c.1460
Antonello da Messina (c.1430–79)
Oil on panel 18×14in (46×36cm)
National Gallery, London

Antonello was a Sicilian painter. The 16th-century biographer Vasari reported that he had been trained with Van Eyck; he showed evidence of the influence of a Flemish style of painting and was also an early master of oil painting technique in Italy. Vasari's proposal is unlikely to have been true, however, since Van Eyck was dead by 1441, when Antonello was only a child. It is more likely that Antonello was trained in Naples and there came across paintings by Van Eyck and Van Der Weyden. The first dated record of Antonello's activities is from 1456 but the earliest dated painting is from 1465. Much of his work was apparently .. destroyed in damage caused by earthquakes. He became more widely known during a visit to Venice (1475–6) where he executed an altarpiece for St Cassiano and was a popular portraitist, applying the Flemish convention of a threequarter view of the subject.

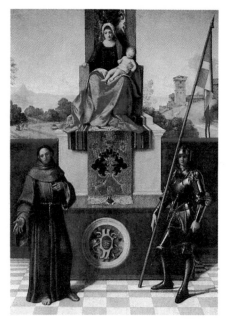

The Castelfranco Altarpiece: the Madonna and Child with Saints Francis and Liberale, c.1504
Giorgio Barbarelli, called Giorgione (c.1477–1510)
Oil on panel 78¾×60in (200×152cm)
San Liberale, Castelfranco

Nothing is known about Giorgione's early life. From an account mentioning his age during the plague year of 1510–11, his birth date has been traced back to 1477 or 1478. On his arrival in Venice in about 1500 he worked in the studio of the Bellinis. During his training he also became acquainted with the work of Leonardo and adopted similar methods of coloring, especially in background landscape. Giorgione's own pupil was Titian, but there was apparently a rift between the two artists when work by Titian was taken to be that of Giorgione and was widely praised; this started a rivalry that continued through their careers. It appears that Giorgione preferred private to public commissions. Much of his work is small in scale, as if intended for domestic shrines and private devotions. The Castelfranco Altarpiece was commissioned by General Tuzio Costanzo for the chapel of St George in the Cathedral of Castelfranco, where his son, Matteo, was buried.

Soon after the successful expansion of Venetian dominion over parts of northern Italy, a long war, lasting from 1463 to 1479, broke out in the eastern Mediterranean against Sultan Mehmet II, who had conquered Constantinople in 1453. In this war Venice lost Negroponte (Euboea in Greece) in 1470, and some of its territories on the Adriatic coast. The resulting peace treaty allowed the Venetians to maintain a trading quarter in Constantinople and various commercial privileges. In 1489 Venice acquired Cyprus, which proved to be a source of further friction with the Turks, but it was a vantage outpost in the Mediterranean of which the Venetians were inordinately proud.

The Republic did its best to maintain a cautious neutrality at the onset of the "Wars of Italy", which broke out on the invasion of Italy by King Charles VIII of France in September 1494. His seizure of Florence and Naples in February 1495 precipitated the formation of a league between Venice, Milan, the papacy and Spain. His successor, Louis XII, came back in 1499 to take Milan, and with Venetian collusion captured the city in September. Various complicated maneuvers led to the League of Cambrai, an alliance signed in December 1508 between Louis XII of France, the Emperor Maximilian I, Pope Julius II and Ferdinand of Aragon, officially to campaign against the Ottoman Turks, but in reality to tear off Venice's territories in northern and southern Italy. Venice wriggled out of this threat of annihilation when, after an initial defeat by the French, the allies fell out among themselves, and the League dissolved itself in 1510. The economic recovery of Venice after the draining of resources caused by its efforts to survive during the Wars of Italy and the onslaught of the League of Cambrai slowly allowed the city to turn its attention to cultural activities, particularly to building. In one sense

the catastrophic Sack of Rome in 1527 was the best thing that ever happened to Venice, for as a result Sebastiano Serlio (1475–1554), the important architectural theorist, and Jacopo Sansovino (1486–1570), the sculptor and architect, made their way to the island city. Sansovino had first gone to Rome in about 1506 and had absorbed the vocabulary of the great architect Bramante in particular. When he came to build palaces for the Venetian patricians these stylistic influences emerged.

The most commonly used building material in Venice was brick, the only one available locally, the usual technique being to coat brickwork with a stucco made of ground brick and marble burned in lime. In Venice any high-quality stone and marble had to be imported, and luckily a very white limestone was available at Istoria on the mainland, which could be transported relatively cheaply to the metropolis. This stone was easy to carve and, oddly enough, also very resistant to weathering, and therefore used for important details, such as capitals, bases and window frames. It was even used as a damp course from time to time. The characteristic red marble used in some buildings came from Verona. The Venetian love of color in building materials, exemplified by the Palazzo Dario, Santa Maria dei Miracoli, and the Scuola Grande di San Marco, was satisfied by the use of some extremely expensive materials such as verde antica (a dark green stone), oriental marbles (as in the Loggetta in the Piazza San Marco) and the hard red porphyry and hard green serpentine (as in the Palazzo Vendramin-Calergi).

Venetian palaces assumed a remarkably unchanging structure and layout throughout the period of momentous stylistic changes from medieval Gothic to Classical High Renaissance. A city house had to meet certain require-

ments: it had to have a gateway on the canal at water level for loading and unloading materials of all kinds. Away from the water, safe and dry, and therefore on the next floor above ground level, or piano nobile, were the living quarters. Usually there were towers incorporating staircases at either end of the façade. Land costs money, nowhere more than in Venice, so there was an increasing tendency to build high on narrow sites, as in modern cities, and this tendency was reinforced by the Venetian practice of all surviving generations of one family living together. Moreover, by the 15th century the city was running out of island space that offered solid foundations. This meant that houses had to be built on drained land on great wooden piles with a stone infill, which in part explains the predeliction for great arcades with colonnades and, usually, exotic tracery across the front of Venetian Gothic palaces. Arcades are much lighter than solid masonry walls with windows, and even builders with the most elementary knowledge of load factors knew it. One problem with the early type was the lack of light, due to the closeness of houses to each other, and it was found that an L-shaped plan with a courtyard at the back gave more light and allowed more space.

We can best observe the workings of the patronage of state in the development of the buildings on and around the Piazza San Marco. Building activities were run by committees, one of which looked after the upkeep and adornment of the great public structures, particularly the Church of San Marco and the Piazza in front of it. Of great importance in this system was the state architect, the Protomaestro, who was chosen by the Senate and was responsible for new building as well as the maintenance of existing buildings. The upkeep and maintenance of fortresses was a particularly important

part of the office, and the most significant architect employed was Michele Sanmichele (1484–1559), who worked for the Senate in Venice, Crete, Cyprus and Corfu.

The Doge's Palace, adjacent to the Church of San Marco on the small square (*Piazzetta*) and the home of Venice's political administration, was eventually reconstructed in the 1340s, and later alterations to its structure came after a catastrophic fire in 1483. The architecture of the new façade is a mixture of deference to the Gothic style of the older parts of the palace in its use of painted arches, and a variety of a more Classical style. Most of the internal decoration of the palace was destroyed by fires in 1574 and 1577, including paintings by the Bellinis, Carpaccio and Tintoretto. The Senate itself could also initiate religious building projects, the most spectacular examples being the Redentore (a votive church built to fulfill a vow in thanks for the deliverance of the city from plague in 1575–6), designed by Andrea Palladio, and Santa Maria della Salute by Baldassare Longhena (1598–1682) to thank the Virgin for deliverance after the plague of 1630.

Jacopo Sansovino, who was elected by the Senate as protomaestro in 1529, had, according to Vasari, been sent for by the Doge as the best architect to deal with the repairs required for the cupola of San Marco. The buildings produced by Sansovino for the Venetian state constitute a happy point of intersection between his Roman Renaissance style based on Bramante with the state's need for the most splendid possible structures for their most public place. Sansovino's Zecca, or Mint, was commissioned in 1537 and completed in 1545. The building had to meet several requirements: the lowest story had to incorporate various shops and the rest of the building was devoted to striking coins,

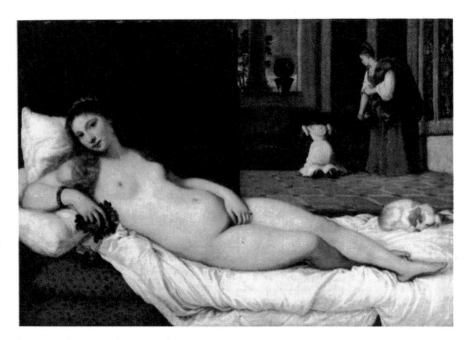

The Venus of Urbino, c.*1538*
Tiziano Vecellio, called Titian (c.1487–1576)
Oil on canvas 47 × 65in (119.5 × 165cm)
Uffizi, Florence

In 1530 Titian was introduced to the Holy Roman Emperor Charles V and was knighted and established as court painter. He continued to work for his patrons among the Italian nobility; he carried out commissions for the Gonzaga and Medici families. This Venus *was created for the Duke of Urbino, hence the title by which it is known. The identity of the model has proved a matter for speculation, as it was commonly believed that the painting represents the Duke's wife. Comparisons with Titian's formal portrait of the Duchess of Urbino tend to deny this possibility. The rumor may have arisen because Venus is here interpreted as a symbol of marital love and fidelity, rather than carnal desire. The pose is based on a painting by Giorgione known as the* Dresden Venus.

housing furnaces, and various storerooms for coal and so on. A mint needed to look impregnable, and Sansovino's heavy, muscular Doric order on the *piano nobile*, coupled with the blocks or lintels above the great windows certainly gave an impression of menace to contemporaries, one of whom called it "a worthy prison for the precious gold".

Sansovino's Loggetta at the base of the Campanile in the corner of the Piazza San Marco, begun in 1538, is another example of architecture as propaganda. It was an assembly point for the ruling noble class and was built with the most lavish and colorful materials: white Istrian stone, red Veronese marble, and dark green *verde antica*. Its form is that of a Roman triumphal arch reproduced in triplicate as a sort of porch to the Campanile – and the whole served as a vehicle for glorifying Venice by means of sculpture.

Sansovino's stylistic vocabulary had combined so authoritatively with the

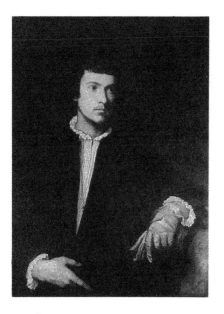

The Man with a Glove, c.1520–2
Tiziano Vecellio, called Titian (c.1487–1576)
Oil on canvas 39×35in (100×89cm)
Louvre, Paris

As a child Titian was apprenticed to a
master mosaicist in Venice and subsequently
trained as a painter in the Bellini workshop
with Giorgione. By 1510 he had become an
independent master painter and his
reputation was established by a cycle of
works on the miracles of St Anthony,
painted in the Scuola del Santo at Padua.
In 1516 he took over a large commission
from the Bellini's to paint a battle scene in
the Ducal Palace at Venice. This was not
finished until 1537 because Titian's rapidly
expanding reputation brought him many
more commissions. Portraiture was an
important part of his work throughout his
life. The Man with a Glove, in common
with many of Titian's early portraits, is of an
unknown sitter. The three-quarter view
marks a change of style; in earlier portraits
Titian adopted the device of placing the
the figure in a central plane with a
foreground ledge cutting across the figure
above waist level.

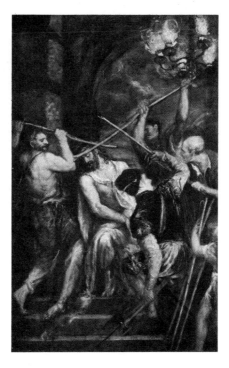

Christ Crowned with Thorns, c.1570
Tiziano Vecellio, called Titian (c.1487–1576)
Oil on canvas 110½×72in (280×182cm)
Alte Pinakothek, Munich

Titian painted two large versions of this
subject, the one shown here very late in his
life, and an earlier one, done probably in the
1540s. In the earlier version Christ rolls his
eyes upward toward Heaven, giving the
painting a melodramatic effect unusual in
Titian. In the later version, the eyes are cast
down, so that Christ wears the more
traditional air of resignation. And the more
muted, darker colors of the later painting,
where the brushwork is not so vigorous nor
the movement of the torturers so energetically
depicted, lend to the scene the somber calm
which is one of the hallmarks of Titian's
painting.
The sensitivity and strength of this late
work, together with its effective composition
and marvellous technique establish that
Titian retained his abilities to the end of
his life.

requirements of his patrons that he and
Sanmichele more or less killed off the
indigenous style that had been prac-
ticed by local masters. It also had the
effect of keeping one of the most
influential masters in the history of
architecture, Andrea Palladio (1518–
80), out of Venice for some consider-
able time.

The greatest glory of the Venetian
School of painting resides in the work
of the three 16th-century contem-
poraries. Venice is artistically the city
of Titian, Tintoretto and Veronese.

Tiziano Vecellio (c.1487–1576),
known as Titian, was born at Cadore
and lived an exceptionally long, fruit-
ful and almost entirely successful life.
He became rich and revered as almost
no other Renaissance artist. The range
of subject and the changes in his tech-
nique make it impossible adequately to
analyze his total output but in the
middle years of the century, until the
arrival of Tintoretto and Veronese, he
dominated Venetian painting. His
breadth of sympathy, the subtlety of
his technique, his uncompromising tem-
perament and dignified authority make
him one of the greatest painters in
Western art. His work celebrates the
High Renaissance in Venice. Assured
and technically brilliant, his ability to
create in such works as Sacred and
Profane Love, the altarpiece known as
the Pesaro Madonna, the Venus of
Urbino and his equestrian portrait of
the Emperor Charles V, images of
Renaissance variety and conviction is
unequalled.

It is difficult not to accord to Jacopo
Robusti (1518–94), known as Tinto-
retto ("the little dyer"), the same
qualities. He, too, was a man of
superabundant talent and almost un-
manageable energy. If anything, his
pictorial inventiveness was greater than
Titian's and the vigor of his technique,
the passionate movement of his figures,

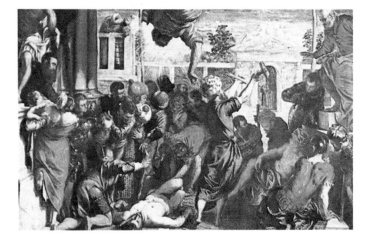

St Mark Freeing a Christian Slave, *1548*
Jacopo Robusti, called Tintoretto (1518–94)
Oil on canvas 161½×214½in (410×545cm)
Accademia, Venice

The Crucifixion, *1565*
Jacopo Robusti, called Tintoretto (1518–94)
Oil on canvas 211×482in (536×1224cm)
Scuola di San Rocco, Venice

The name by which Tintoretto is known
derives from his father's profession as a
dyer (tintore). For a brief period he trained
in the studio of Titian, but their relationship
was strained and it is not known where
Tintoretto completed his apprenticeship. It
seems he became occupied with a constant
stream of commissions although he never
became wealthy. He was not well liked
by fellow artists, owing to several occasions
when he obtained commissions by devious
methods. From a generous standpoint such
behavior could be dismissed as merely an
excess of enthusiasm, but among his peers
it was clearly interpreted as a sign of an
underhanded nature. A typical example was
the commission for the Crucifixion, part of a
cycle of works required by the Scuola di
San Rocco. There is no contemporary
equivalent of the Scuola; they were
religious and social groupings formed
around the possession of relics of a saint,
but not attached to a particular place of
worship. They acted as a support system for
members, providing finance or other
assistance where needed, and also made
donations to the state in the form of money
or fighting troops. In 1546 the Scuola di
San Rocco organized a competition, inviting
four artists to submit designs for the
decoration of their assembly rooms in

Venice. Tintoretto smuggled a completed
painting into position before the competition
was to be judged and, despite the hostility
of some members of the Scuola, his
strategy swung the balance in his favor. He
was accepted for the job by a vote of
thirty-one to twenty. The other artists were
angry with him for these tactics because the
commission was a large one; the San Rocco
cycle occupied Tintoretto from 1565 to
1587. The earlier painting shown here,
St Mark Freeing the Christian Slave, *was
also one of a series painted for the Scuola
Grande di San Marco.*

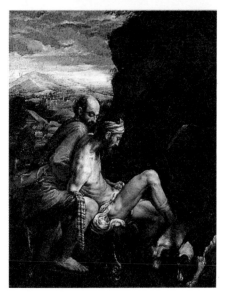

Finding of Moses, *1570–80*
Paolo Veronese (1528–1588)
Prado, Madrid

Born in Verona, Veronese's first works are
found in that city. His major work though,
was undertaken in Venice, where he settled
in 1553 and soon began to receive large
decorative commissions, the first being three
ceiling frescos in the Palazzo Ducale. His
enormous facility and luxurious use of color
are seen in such huge canvases as The
Marriage at Cana *and* The Feast in the
House of Levi *of 1573. The* Finding of Moses
*reveals his interest in splendid costumes and
rich settings; in keeping with the grandeur of
the Venetian state, rather than in any
revelation of the actuality of the scene.*

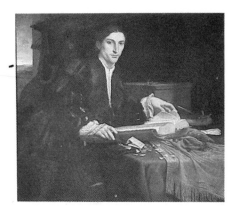

Young Man in his Study, c.*1528*
Lorenzo Lotto (c.1480–after 1556)
Oil on canvas 38⅝×43¾in (96×109cm)
Accademia, Venice

*Lotto was a Venetian and a contemporary of
Titian and Giorgione, and although his work
is not generally regarded to be of their
superior quality, his achievement as a portrait
painter has come, in the 20th century, to
receive the fullest recognition.*
*Lotto had a distinctive style. His colors were
usually more intense than Titian's. More
important, his portrayal of his sitter's
psychological and emotional states was far
more acute than that attempted by other
painters of his generation. In this painting
he employed, too, a boldly horizontal
composition which was rare for the times.
Lotto's individuality of manner cost him the
patronage of Venetian connoisseurs and
most of his work found its market in the
provinces.*

The Good Samaritan,
Jacopo Bassano (1510–92)
Oil on canvas 40×31½in (102×79cm)
National Gallery, London

*Jacopo dal Ponte, known as Bassano from
his native town, is the most important of a
family of painters. His work is mannerist and
although not explicitly Venetian, is within its
sphere of influence. The presentation of the
Good Samaritan in this painting emphasises
his supportive role, while for the priest and
the Levite in the left middle distance the
treatment, although mannerist, is more
realistic than in most of his work.*

gives his work a sense of physical life
that has no peer. He is perhaps
best seen in the Scuola di San Marco in
a series of paintings, most of which are
in their original positions since the
interior is the only one to have re-
mained still as it was originally de-
signed.

If we say that Veronese is perhaps
not quite of the stature of Titian and
Tintoretto in the pantheon of Venetian
luminaries it is not to diminish his
enormous talent and energy but rather
to emphasize theirs. Paolo Caliari
(known as Veronese) (*c.*1528–88), more
than a generation younger than Titian,
is the last of the great decorative
painters of the Renaissance. His great
canvases throb with life lived as a rich
pageant of eating and drinking, war-
ring and mourning over Christ. His
painting of the finding of Moses con-
tains figures in the richest of Venetian
Renaissance dress in front of a Renais-
sance city, the atmosphere almost
pagan in its luxury (Veronese did in
fact run foul of the Church for some of
his work.) This Renaissance rather
than Classical luxury is characteristic
of Veronese but it is accompanied by
most accomplished compositional care.
The combination in his greatest works
is unrivaled.

In Venice itself, which is spattered
with the works of these three great
figures in churches and museums
throughout the city, one can get almost
breathless and surfeited with their
power – the totality is overwhelming.
Lorenzo Lotto (*c.*1480–1556) was a
Venetian portraitist of great sensitivity
whose observation of qualities in his
sitters is delineated with a precision of
drawing and forthrightness that make
his later work among the finest in the
Venetian school.

Another painter of the mainland of
Venice was Jacopo dal Ponte (1510/
8–92), known as Bassano after the
town from which he came. He was a

member of a family of painters from
Bassano and his work is a subtle form
of Mannerism. His use of light is un-
usual and his drawing is fluent, and his
ability to create a sense of earthy reality
in his religious works, such as the *Ador-
ation of the Shepherds* is uniquely his.

Various factors that are still only
dimly understood in detail made a
considerable number of Venetians and
other rich men and nobles divert their
capital investment away from overseas
trade into the development of land. The
period of war from 1509 to 1515 had
naturally produced considerable physi-
cal and economic devastation. There-
after great sums of money had to be
diverted for fortifying towns on the
terra firma (such as Padua and Treviso
in 1517) and in various colonies. Most
building stopped in and around Venice
from then until the early 1530s. As a
bolster against the chaos wrought by
war and competition in Mediterranean
economies, it appears that the Venetian
nobility looked to more stable invest-
ments, particularly those that could be
created by reclamation and more care-
ful cultivation of land. In 1556 the
Senate created a Board of Uncultivated
Properties empowered to subsidize re-
clamation projects, and between 1510
and 1580 the resource from the taxing
of *terra firma* land quadrupled. The
nobility of nearby Vicenza in particular
became very rich in the years after the
recovery; not only did they have a
flourishing business in grain, cattle,
wine, fruit, and silk, but they had also
managed to prevent themselves from
being economically dominated by rich
Venetians trying to buy up their land.
Many of the nobles in the mainland
towns were highly educated, intellectu-
ally curious and interested in the arts.
This combined with their invigorated
interest in the countryside and every-
thing connected with it that could be
gleaned from the Classical writers to
lay the ground for the revolution in

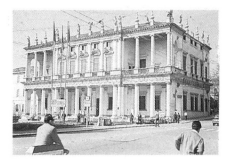

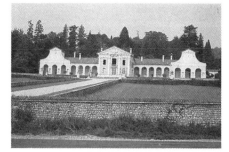

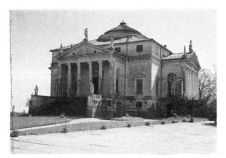

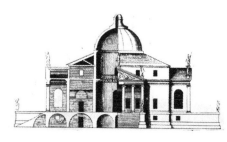

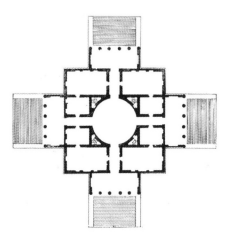

S Giorgio Maggiore, *1560–1580*
Venice, Italy
Palace of Girolamo Chiericati, *1546/49–1558*
(not completed until c.1680)
Vicenza, Italy
**Villa of Daniele and Marc'Antonio
Barbaro,** *1549/51–1558*
Maser, Italy
Villa Capra, *begun 1550*
View
Section and plan
Vicenza, Italy

Andrea di Pietro, called Palladio (1508–80)

*One of the signs of the increasing urban
wealth being accumulated in Renaissance
Italy was the building by merchant princes
and the like of large country houses, or
villas, to go along with their town palaces.
The villa commonly served a dual function.
as both the center of a working farm and a
summer retreat. By far the most important
designer of villas and townhouses in the
16th century was Palladio, whose domestic
architecture was done almost entirely in the
region around Venice known as the Veneto,
and in Vicenza. Vicenza boasts two of his
most famous buildings, the Palazzo
Chiericati (1550) and the Villa Capra
(c.1550–54, known also as the Villa
Rotonda). The Villa Capra exhibits both
Palladio's reliance upon Classical motifs –
the temple-like portico of the façade, the
colonnades, the pedimented windows – and
his freedom in using them to achieve a
wholly personal style. The villa is perfectly
symmetrical: the façade is repeated in every
detail on all of its four faces. It was especially
admired by English and American architects
of the 18th century, by which time domestic
architecture, still vying for supremacy over
ecclesiastical when Palladio was alive, had
become (along with the designing of public,
secular buildings) the chief activity of
master architects.*

country-house building that is associated with the name of Andrea Palladio (1518–80).

Palladio's special contribution to architecture lies as much in his influence as in his buildings. Although he was trained as a stonemason and only became known as an "architector" in 1540 at the age of thirty-two, his work in Vicenza and Venice has continued to inspire emulators and by the 18th century he was the model for a Classically inspired architecture throughout the world that has come to carry his name, Palladian, even in both the United States and Russia. Perhaps the most important factor in his preeminence is his published work *Quattro Libri di Architettura* (*Four Books of Architecture*), which combines an analysis of Classical humanist architecture and its tradition with practical patterns drawn from his own work, carefully and accurately illustrated (although only his best-known building, the Villa Rotonda on the outskirts of Vicenza, is built precisely as drawn). It is both the practical value as an architect's textbook and the justification for the Classical mode that makes the *Quattro Libri* of such central importance in subsequent Classically inspired architecture.

During Palladio's youth the hinterland of Venice, known as the Veneto, was becoming the busiest center of building in Italy and he had as inspiration Giulio Romano at·Mantua (following Alberti), Sanmichele at Verona and Sansovino in Venice itself. On his

Rome and the Church

return from a visit to Rome, Palladio became Vicenza's most important architect, where he built many great town houses and public buildings such as the Palazzo Chiericati. One of his most attractive works is the Teatro Olimpico, with its permanent Classical street-scene set, begun in the year of his death.

After 1560 he began to work for Venice and in 1570 he settled there. The Benedictine monastery and church of San Giorgio Maggiore, one of the dominating architectural features of the city, is his first great religious building. The interior is calm and clean with a remote and solemn atmosphere supported by the white and cool gray of its color. This calm clarity is characteristic of his designs and is what has made his work so attractive to subsequent observers. The *Quattro Libri* also contains, apart from the Villa Rotonda, drawings of the houses most popularly associated with him, the Villa Barbaro at Maser and the Palazzo Valmarana in Vicenza being the most important.

The decline of Venice

Although it was a slow process that was to last for a century or more, the decline in the importance of Venice had already begun before her greatest artistic achievements were completed. It is almost as if Titian, Tintoretto, Veronese and Palladio had to find a form for the glory of the most powerful and splendid of all Renaissance cities before it gave way to a sunset of decline.

The first and ultimately fatal blow to her dominance was the discovery of an easier route eastward by the Atlantic than via Venice, down the Adriatic to the eastern end of the Mediterranean and then overland. As this commercial threat increased, the wealth of Venice was undermined, and her resources were further reduced by wars against the Turks lasting into the 18th century.

During the Renaissance, Rome, which had once been the City of the Caesars, came into its own again as the City of the Popes. The city that gave its name to the greatest empire the Western world had known now gave its name to the Church that had dominated the Western world for a thousand years. Rome, which had always had a central place in politics, now reasserted its place as the focus of its faith.

As the course of the Renaissance flowed from the formative years in the 15th century to the maturity of the early 16th century the state of Rome became crucial. The papal court in Rome both provoked and resisted the expansion of its most damaging opposition force, Protestantism. The practices of the Church authorities in Rome – their sexual immorality, selling of preferments, favoritism of relatives, greed and the blackmail of churches all over Europe – so disgusted many people that during the 15th century protest grew, grievances were identified and published, and eventually resulted in the splitting off of great numbers of Christians in small church communities beyond the jurisdiction of Rome. The Roman Catholic Church, as the Church guided by the papacy was henceforth known, had a rival that quickly grew to threaten it.

At the beginning of the 15th century Rome was a run-down medieval city. Its buildings were huddled in the ruins of Classical Rome, the city in disorder and the economy bled by the dominant baronial families in their fortified towers. The popes had tried to re-establish themselves in Rome after their exile in Avignon. The process was marred at times during the late 14th century, when there had been not one but two rival popes – one in Avignon, the other in Rome. The city council of Rome, traditionally run by a few families with pedigrees going back a thousand years, recognized the danger

to their freedom and privileges if the popes returned. The struggle between them was continuous. From this time, despite incursions by enemies both Italian and foreign, revolts from within and periods of declining influence, Rome has remained the City of Popes and the focus of the Roman Catholic Church.

When in the 15th century the popes finally succeeded in securing Rome as their recognized headquarters, they proceeded to give it a facelift as a mark of their position of overriding power. Symbolic of the building program for restoration and rejuvenation of the city was the demolition and rebuilding of the ancient basilica of St Peter's, while large areas of the city were bull-dozed to make wide streets and exciting vistas.

The first popes in Rome's Renaissance (and here it really was a rebirth, since many old and revered buildings, churches among them, were destroyed and Rome took on its modern face) were all from the great Roman families, but later they came from other cities in Italy and from Spain.

The reestablishment of papal Rome was accompanied by the development throughout Italy of the Renaissance courts of culture, such as the Medici in Florence, the Gonzagas in Mantua and the Estes in Ferrara. Humanist culture came to Rome as elsewhere and the popes attracted scholars to their newly established court at the Quirinal and Vatican palaces. Humanism invaded the Church and contributed to the broader and more Classically focused activities of the churchmen in Rome that so disturbed the then faithful in the north.

The Church had great revenues and most of the popes lived richly. The cardinals, too, became increasingly rich, absorbing the great Church revenues, vying with each other for dominance both in the Church and in

society. They formed their own personal Courts of Culture and their rivalry included the wish to have artists attached to them as evidence of their cultural status because art is the visible expression of things otherwise intangible. Rome became a center to which the best artists were drawn and where artistic activity flourished.

Despite centuries of destruction much ancient building remained and with the increase in Classical interest during the 15th century attention was paid to the imperial remains that the Romans of the day had on their doorstep. Marble statues were dug up and, importantly, because they emphasized the relationship with Imperial Rome and the long history of the Roman Church, the early Christian catacombs were uncovered and explored. The Renaissance in Rome was closer to its Classical models than anywhere else, thanks to the inspiration of the ancient Roman remains which were all around for people to see. No other Italian city had such quantities of Classical ruins, and what they did have was often concealed inside medieval buildings.

Having established themselves, the popes' ambitions turned out from Rome and the Church to territorial ambitions and worldly matters. Some popes were energetic and cultured men who genuinely believed that the Church should be the secular as well as spiritual leader throughout Christendom. They were particularly interested in asserting their ascendancy in the Holy Roman Empire – where the name itself suggested a religious authority – and in Spain, which was the most devout of the Catholic flock. In neither instance did they succeed but the struggle was constant. Both France and Spain had ambitions of their own in Italy, and at the end of the 15th century the French under Charles VIII invaded. In 1527 Rome was sacked by Spanish and German forces of the Emperor Charles V.

It was not until the 16th century that Rome effectively established its new role and the Sack of 1527 was a setback in the expansive program of patronage undertaken by the popes. From the papacy of Pius II (1458–64) the process had been continuing. Alexander VI (known as the Borgia Pope, and father of Cesare and Lucrezia Borgia), whose historical image is not attractive, was the first to attempt to curb the great Roman families, such as the Orsini and Colonna, and to establish the supremacy of the Church. Being a Spaniard, he did not have the usual ties with the Roman aristocracy. But it was under Julius II (1503–13), who succeeded Alexander VI, that the greatest advances were made. Aggressive, strongminded and militant, he was also a dedicated Humanist. He led the papal troops in battle and founded the Vatican library, which was filled with Classical documents as well as religious works. He was also a great patron of the arts and had the first plans for the rebuilding of St Peter's drawn up. With the political situation in Florence at the beginning of the century extremely unsettled, many artists left Florence for Rome at the imperious call of Julius II. Among these were Michelangelo (1475–1564), Raphael (1483–1520) and Jacopo Sansovino (who, later, was on his way to France at the invitation of Francis I but only got as far as Venice, where his greatest work is found). At this time Rome became the great focus of artistic talent that it remained until the new St Peter's was completed at the end of the next century.

The movement of artists around Italy – and some outside Italy – meant a constant traffic of ideas to the advantage of the smaller courts such as those at Urbino, Ferrara, Mantua, Bologna, Perugia and Parma, where the same sophistication is found as in the more important such as Florence and Milan. Although Italy was politically divided,

culturally it was, generally speaking, one. Rome, however, was always something special.

The power of the papacy, the demands of the rebuilding of the city, the great riches concentrated in Rome and its special place as the Holy City of pilgrimage and spiritual authority, raised it above other cities. Protected by the belt of surrounding territories known as the Papal States, and nourished by the great demand for religious works of art, Rome turned into a city of artists whose work was admired by a reverent population.

Julius II was succeeded in 1513 by a Medici Pope, Leo X (1513–21), which helped the continuity of art in Rome since the Florentine artists, who might have been expected to go home when the onerous demands of Julius were ended, stayed on under the Florentine Pope's protection and encouragement. Leo was shortly followed by another Medici, Clement VII (1523–34).

The pontificates of these three great popes covered the great age of Roman Renaissance art, which was only cut short by the Sack of 1527. This period is the High Renaissance of Raphael and the maturity of Michelangelo.

The first plans for the rebuilding of St Peter's were made by Donato Bramante (1444–1514) for Julius II. Julius's intention, as one of the most powerful rulers in Europe, was to establish Rome as the capital of the world. If no previous pope had dared to demolish the early basilica built by Constantine over the burial place of St Peter, Julius felt no such inhibitions. He intended to raise the greatest church in Christendom to replace the old basilica, and he wisely chose Bramante to be the architect of this Classical building. Bramante had a real feeling and understanding for Classical Humanism, and could express it in a Renaissance rather than merely Classically imitative manner. His little circular Church called the

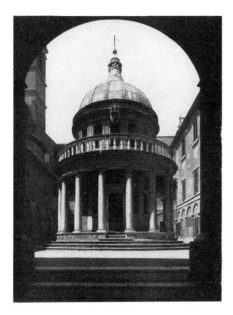

The Tempietto, *San Pietro in Montorio, Rome, c.1502–06*
Donato Bramante (1444–1514)

This small chapel, built at the wishes of Ferdinand and Isabella of Spain to stand in the courtyard of the Spanish convent of San Pietro in Montorio, was the first Renaissance building faithfully to revive the Classical Doric temple. Too small to serve any practical purpose, it took the Classical pagan memorial and adapted it to a Christian use, as a monument to honor the martyred apostle Peter. Its central plan became the model for church architecture of the High Renaissance, most notably in the plan for St Peter's which Bramante made either during or just after the building of the Tempietto.

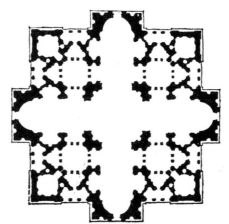

Plan of the basilica of St Peter's, *c.1508*
Donato Bramante (c.1444–1514)
Vatican City, Rome

Born near Urbino, Bramante undertook his first important commissions in Milan. There he met Leonardo da Vinci, who painted his Last Supper *in the Refectory of Santa Maria delle Grazie, where Bramante was remodeling the church. In 1499 Bramante moved to Rome and there he was made architect to the Vatican by Julius II. He produced the first plans for the new St Peter's in Rome on the form of the Greek cross.*

Tempietto at San Pietro in Montorio over the traditional site of the martyrdom of St Peter was the most completely Classical building erected up to that time (1502). Small as it is – and highly unsuitable as a church in consequence – with an internal diameter of only just over 14ft (4m), its proportions and handling of detail make it one of the architectural masterpieces of Rome. It is to be seen more as a monument than as a sanctuary, and externally rather than internally.

Bramante's design for St Peter's was planned on a Greek cross as a Classical building. It is noteworthy that it was thought entirely appropriate to erect a building in the heart of Christianity evoking architecturally, if anything, the splendor of the pagan Roman Empire. The interlocking of Humanism and Christianity in Renaissance feeling could hardly be expressed better.

Leonardo, Raphael, Michelangelo

The Renaissance achieves its highest artistic expression in the work of three artists whose combined work encapsulates its spirit and nature. The 15th and early 16th centuries in Italy were a time for genius. The enterprise and talents of a large number of painters, architects and sculptors are itemized with enthusiasm (if not always accuracy) by Giorgio Vasari later in the period of his fascinating *Lives*. His enthusiasms and prejudices are for all to see but his greatest enthusiasm is reserved for Michelangelo, while Leonardo and Raphael are also recognized as supreme geniuses. In giving these three prime importance we are not forgetting the great Venetian trio of Titian, Tintoretto and Veronese, each of whom made a major contribution to the character of Renaissance art; we are simply noting that the central position on the Renaissance stage is occupied by these three standing, like the medalists on an Olympic podium, as the focus of adulation. And it is justified.

It is particularly appropriate to the consideration of the work of the highest standard to remember that the value of any work of art is that which the individual observer attaches to it. A preeminence has been accorded to Michelangelo, Leonardo and Raphael by their contemporaries and by all succeeding generations, often with an undiscriminating excitement that will will not necessarily be shared by observers today. Indeed, although the ability of these three artists will be indisputably evident, affection for and enjoyment and understanding of it, may be harder to find. Personal and temperamental preferences affect our relationship with things that we know are important and valuable – the "I know it's good but I don't like it" response.

Leonardo da Vinci (1452–1518) personifies the Renaissance ideal of the Universal Man. His wide interests and

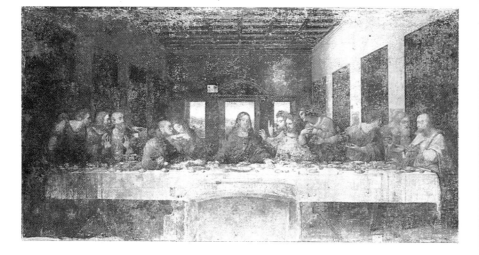

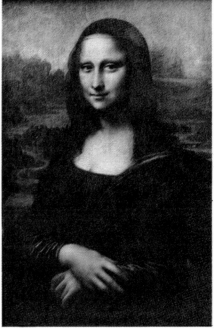

unbounded curiosity led him into science, medicine, botany and philosophy as well as those visual arts for which he produced paintings, designed and projected sculpture and made architectural designs. That he should have worked in all the visual arts was not as unusual in the Renaissance as it would be today, but that he should additionally have made a real contribution to the development of scientific studies marks him out as unique. There appears not to have been in history a more universally gifted figure. The Renaissance belief in the individual capacity of man to solve his own problems required that he be interested in an almost unlimited range of subjects. If additionally he might have physical attributes such as strength and beauty, even better. Vasari informs us that Leonardo was immensely strong, unusually tall and of attractive appearance. To add to this a gentle and caring temperament and friendly and unassuming manner is almost to define a perfect man of the Renaissance. His contemporaries thought him to be so and he was revered everywhere he went.

Born at Vinci near Florence, he is known as a Florentine painter, but he

The Last Supper, *1495–97*
Leonardo da Vinci (1452–1519)
Oil, tempera and fresco 13½ × 29ft
(4.2 × 9.1m)
Santa Maria delle Grazie, Milan

The Last Supper *formed part of the decorations for the convent of Santa Maria delle Grazie ordered by Ludovico Sforza. Leonardo had worked for Sforza for some years and his patron made use of his talents as artist and engineer. Leonardo wished to work more slowly than conventional fresco technique would allow and he experimented with adding oil and tempera mediums. The contemporary writer Bandello left a graphic account of Leonardo's acitivity: ''. . . he used to climb on the scaffolding early in the morning – because* The Last Supper *is somewhat high off the ground; he would keep the brush in his hand from sunrise to sunset and, forgetting to eat or drink, would go on painting. Then for three or four days he would not touch his work, but for one or two hours a day would stand and merely look at it, examine it and judge his own figures.'' Unfortunately Leonardo's technical innovations were often unsuccessful and the painting had already begun to deteriorate by 1517, a condition at the time attributed to dampness in the wall. In 1568 Vasari noted that it was ''only a muddle of blots''. Subsequent restoration attempts compounded the problem and although the fresco was improved in repairs to the chapel after bomb damage in 1943, it remains shadowy and imprecise.*

Mona Lisa, *c.1503–6*
Leonardo da Vinci (1452–1519)
Oil on panel 30 × 21in (77 × 53cm)
Louvre, Paris

From 1500 Leonardo became more and more involved with his studies in mathematics and engineering, and he gained a reputation for leaving paintings unfinished. He briefly traveled with the army of Cesare Borgia in 1502, acting as architect and engineer, but soon returned to Florence and was commissioned to paint a large fresco of the Battle of Anghiari for the Sforza family. This mural encountered technical problems and it was supposedly during the same period that he began work on the small oil portrait known as the Mona Lisa, *arguably the world's most famous painting. The origin of the portrait is disputed; there is no document proving how or when it was commissioned. It reportedly shows Lisa Gherardini, the wife of Francesco del Giocondo (the* Mona Lisa *is alternatively known as* La Gioconda*), but the only contemporary comment on the painting suggests that it was commissioned by Giuliano de'Medici. Although little is known about it, there has never been any doubt that it is attributable to Leonardo.*

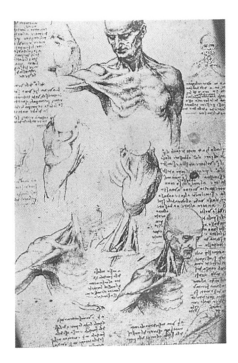

Anatomical drawing, c.1512
Leonardo da Vinci (1452–1519)
Pen and ink
Royal Library, Windsor, England

Leonardo started to study anatomy from about 1489, at first with the intention of acquiring knowledge that could be of use in his figure paintings, but gradually for his increasing interest in the subject for its own sake. He began practicing dissection and worked altogether on about thirty bodies, making hundreds of drawings including the earliest record of a child in the womb. Leonardo also studied animals, again making dissections and recording his findings in drawings. By a method of casting with wax and plaster he made models of internal organs and became particularly fascinated with the heart and the circulatory system. He constantly sought to find the center of vitality and debated with himself the relative importance of heart, brain and spine. Dissection of corpses was officially banned, but the rules were rarely enforced by the end of the 15th century. Leonardo's last few years in Italy were fraught with personal and political problems and he never completed a proposed treatise on anatomy. His drawings were safely preserved in 1516 when he went to live in France, where he died.

worked in Milan, Mantua, and Rome and visited many other Italian towns, being fêted wherever he went. He was thus an Italian rather than Florentine. Of all the cities in which he lived and worked, Rome was the least attractive to him and he stayed only two years, whereas he stayed thirteen years in Milan, working for Ludovico Sforza.

The universality of Leonardo's genius is best seen in the notebooks he made through his life to capture the constantly shifting focus of his interests. In thousands of pages of notes, diagrams and drawings he laid bare his mind. Almost every subject in nature fascinated him, he made careful anatomical studies, sketches, designs for buildings never to be built, and sketches for sculptures. The list is almost endless and it is through his sketchbooks rather than his finished works that he can best be approached. In fact, although he stopped working on most of his major paintings, his constant search went on so that it is difficult to say that any of his work is finished. Even his two most famous works the *Mona Lisa* and the *Last Supper* in Milan were never considered by him to be finished, indeed in the *Last Supper* he was as much interested in the technique he was exploring as with the completion of the painting. His one major sculptural project was also uncompleted. This was an equestrian statue of Francesco Sforza, the *condottiere* founder of the Sforza dynasty at Milan.

In his painting there is a quality of aerial perspective and solidity of form through the use of a technique called by the Italian term *sfumato*, which is associated with his name. This term describes the subtle blending of edges and outlines to create a sense of the form turning and thus blurring outlines (*sfumato* means smoky).

Raphael, from Urbino (1483–1520), equally fêted and adored, loved Rome

and worked most of his short life there. He was in Florence after 1504, where he conceived an admiration for Leonardo and on his move to Rome in 1509 he attempted, without complete success, to emulate the heroic style of Michelangelo. In him the three are thus linked and it is Raphael's achievement to have forged a personal art from the influence of his two greatest contemporaries. However, the most potent influences in the creation of his mature style were his study, with Bramante, of the antique and the opportunity to work with Bramante in Rome and to cooperate with him in the decorations of the Villa Farnesina, for which he painted the *Triumph of Galatea*.

In describing Raphael's work the words that spring to mind are grace, charm, assurance, authority. Words such as anguish and tension, which certainly might be applied to other artists, are inappropriate to him. In his short life he was so successful that he was followed everywhere as a film star might be today and worked publicly with many assistants. His drawing was impeccable and he rarely attempted more than he knew his considerable capacities would allow. Steeped in the Classically inspired Renaissance culture, he moved with ease in Classical references and one of his great works done in the Vatican for Pope Julius II, the fresco *The School of Athens*, epitomizes the Classical concerns of the Renaissance. That it should be found at the very heart of Roman Christian authority may be thought somewhat surprising until one reflects on Julius's passion for Classical learning. The grace and charm, the compositional assurance of Raphael's painting is seen in a number of Madonna and Child works – Classical in feeling, religious in sentiment.

Michelangelo was withdrawn, irascible, of unbounded talent, independent but demonstrably a creative genius

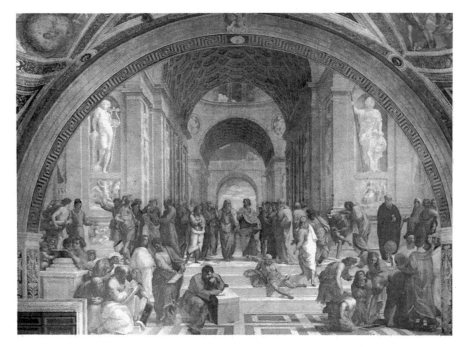

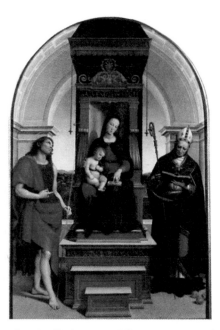

The School of Athens, *1509–11*
Raphael Sanzio (1483–1520)
Fresco: Width at base about 25ft (7.7m)
Stanza della Segnatura, Vatican, Rome

*Raphael learned much from his master,
Perugino, and, during his stay in Florence,
from his study of the work of older
contemporaries, such as Leonardo and
Michelangelo. He was nonetheless
relatively inexperienced when in 1508 he
was invited to Rome by Pope Julius II to
work on fresco decorations in the Vatican.
In fact when Raphael had begun the work
Julius was so impressed that he ordered
him to repaint frescoes already in place,
although they had been executed by
artists of better established reputation than
Raphael's own at that time. The School of
Athens forms part of a fresco cycle in the
Stanza della Segnatura, the room in which
ecclesiastical tribunals met and papal briefs
were signed. It represents Philosophy; the
other major works in the same room show
Theology, Poetry and Jurisprudence. When
these were finished Raphael began work in
the adjoining room where the Pope held
audience, the room now known as the
Stanza d'Eliodoro. Some of the figures in the
School of Athens have been identified as
portraits of Raphael's friends and colleagues,
and even a self-portrait*

The Ansidei Madonna, *1505*
Raphael Sanzio (1483–1520)
*Oil on canvas, transferred from wood
85×58½in (215.5×148cm)*
National Gallery, London

*Raphael was born in Urbino and lived there
as a child. His father was a painter, but both
parents were dead by 1494 and details of
Raphael's early career are scarce. He
probably trained with Perugino and worked
with him at Perugia, but by 1504 was back
in Urbino and was sufficiently well-known
to be commissioned for portraits of the
family of Duke Guidobaldo of Urbino. In late
autumn of 1504 Raphael moved to Florence.
His work of the following few years clearly
shows what an influence he found in the
wealth of artistic example in Florence. He
painted a large number of variations on the
theme of the Madonna and Child, in several
of which the basis of the composition can
be traced to sketches by Leonardo. The
Ansidei Madonna, showing the Virgin
enthroned between St John the Baptist and
St Nicholas, is named after the Ansidei
family of Perugia, who commissioned the
painting for the Church of St Fiorenzo.*

of unrivalled energy. The popes wanted
his work. Their power was unrestricted
and he chafed under their authority.
Although productive, it was never an
easy relationship. The characters of
Raphael and of Michelangelo were the
inverse of each other's and it is well
known that a personal antipathy ex-
isted between them – more positively
expressed on Michelangelo's part.

Michelangelo Buonarrotti (1475–
1564), born at Caprese near Florence,
was painter, sculptor, architect and
poet, and no figure in the history of art
has so captured the imagination as the
great artistic genius, the personification
of the artistic spirit, driven by its own
demands rather than by others. His
overriding genius was recognized by
all. Uncomfortable and discouraging
though it might be to have him working
for them, all the great patrons of con-
temporary Renaissance Italy vied for
his work. If one were to try to confine
such an expansive genius into one
simple description, it must be his
dominating creative strength. Every-

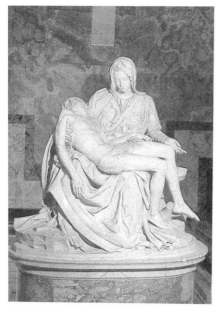

Pietà, *1497–1500*
Michelangelo Buonarotti (1475–1564)
Marble: Height 68in (172.5cm)
Saint Peter's, Rome

Michelangelo began work in Florence at the studio of Ghirlandaio but stayed only briefly with the painter before moving on to train at the sculpture school in the gardens of the Medici Palace. While there he attracted the attention of Lorenzo de'Medici. Before Michelangelo could become established, the character of Florentine life changed after the death of Lorenzo and under the powerful influence of Savonarola. Michelangelo left Florence in 1494; he went first to Bologna and then to Rome in 1496, where he took the opportunity to study Classical sculpture. The Pietà was commissioned in 1497 by Cardinal Jean Bilhères de Lagraulas, the French envoy to the papal court. It was intended for the French chapel at St Peter's. In the following year Michelangelo was in Carrara, quarrying marble for the sculpture. He worked on the carving for two years and though his patron died before the sculpture was completed, it was erected in St Peter's and established Michelangelo as a sculptor of outstanding ability. The Pietà is Michelangelo's only signed work; his name is carved into the sash across the Madonna's robe.

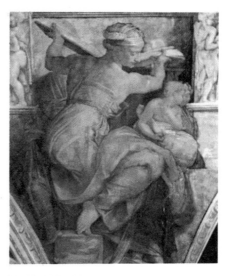

The Delphic Sybil, *the Sistine Chapel ceiling, 1508–12 (detail)*
Michelangelo Buonarotti (1475–1564)
Fresco whole ceiling 118×46ft (38.5×14m)
Sistine Chapel, Vatican, Rome

In 1508 Michelangelo received a summons from Pope Julius II to return to Rome from Florence. He expected to be able to resume work on the project for the Pope's tomb, but instead Julius insisted that he accept a commission to decorate the ceiling of the Sistine Chapel in fresco. Michelangelo's protest that he was not a painter met with no response. The first designs for the project included figures of the Apostles set in the pendentives of the ceiling and surrounded by geometric patterns. Michelangelo was not satisfied with this concept and, given free rein on subject matter, developed the grand series of scenes from the Old Testament scriptures, including figures of Hebrew prophets and pagan sybils. Michelangelo spent four years on the paintings, working almost single-handed, apart from assistance with menial tasks. He painted from a high scaffolding of his own design and the compositions are the more remarkable since his viewpoint must have been extremely awkward and the figures are often placed in direct opposition to the emphasis of the architectural structure. Michelangelo was uncomfortable and unhappy with the conditions of his work, but ultimately gained some satisfaction from having proved that he could be as inspired in painting as in his preferred medium of sculpture.

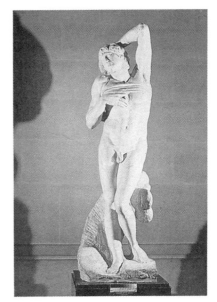

Atlas Slave, *c.1513–20 (detail)*
Michelangelo Buonarotti (1475–1564)
Marble height: 102in (259cm)
The Academy of Fine Arts, Florence

In 1505 Michelangelo was summoned to Rome by the newly appointed Pope Julius II, who wished to commission a grand project for the construction of his own tomb. The tomb was not completed until 1547, long after the death of Julius, and the work proved to be a burden to Michelangelo for more than thirty years. Eventually a smaller version of the tomb was completed in 1547, worked mainly by assistants. Of the sculptures included, only the Moses (1513–16) is Michelangelo's own work. Four statues of slaves were intended for the project: two finished works now in the Louvre and two partly formed figures firmly embedded in the original blocks, the Awakening Slave and the Atlas Slave. These show clearly the process of Michelangelo's carving technique, since the marks of chisels, particularly the toothed-claw chisel, are fully visible. The unfinished statues form a notable contrast with the highly polished Pietà (1499) in St Peter's at Rome, which shows the opposite extreme of Michelangelo's craft. The traditions of sculpture allowed for a major work to be enlarged mechanically from a smaller model. All but the final details of the final version were often carried out by workshop assistants.

thing that he did carries an authority that goes beyond his subject or his age. For him neither Classical Humanism nor devout Christianity inspired art – all his actions were drawn from an almost overwhelming life-force.

Raphael's supreme gifts and sweet temperament made him a pop star in an age of stars. His studio was capable of producing the best work without fuss or difficulty in the required contracted period. His Classical grace and his undoubted genius gave him a position of great influence. Michelangelo had no such following. He outstretched others so far that they recognized that only his manner could be used, not his creative intellect. Thus it was that he was not only the artistic mega-genius of the High Renaissance, but also the father of Mannerism, as we shall see. His work is in fact so demanding that, as we have noted elsewhere, other works seem pale and insubstantial in his presence. The Sistine Ceiling and end wall are perhaps his single most inspiring pictorial work, but his sculptures have become almost the typifying image for the whole of Western sculpture. In architecture, too, his achievements are monumental. The cupola of St Peter's, for which his designs supplanted those of Bramante, is the most accomplished of all Classically inspired domes and his designs for the Roman Capitol (the city hall) are the complete expression of Renaissance architecture. As with no other artist, it would be true to say that the removal of his work from the Renaissance would diminish it substantially.

With Leonardo, Raphael and Michelangelo the Renaissance reaches its culmination. Art and science in the unrivaled mind of Leonardo, the sure and complete grace of Raphael, and the unlimited creative range of Michelangelo makes the age one of the greatest in the art of Western civilization.

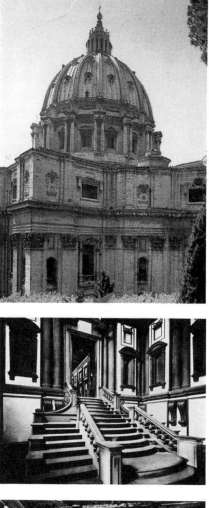

St Peter's, *Rome, 1558–60*
Michelangelo Buonarotti (1457–1564)

Rebuilding of St Peter's at Rome began during the 16th century to a plan drawn up by Bramante in 1505. The form of the building was to be a large Greek Cross with four equal arms as the apses of the church. The foundations were laid during Bramante's lifetime and after his death other architects were consulted to provide modifications, but no new design was adopted. In 1546 Michelangelo became architect to St Peter's. He redesigned the structure, adding a large western portico to extend the compact cross shape conceived by Bramante. Michelangelo proposed the idea of the great dome rising above the center of the building, which was completed by Della Porta after Michelangelo's death, and the facade was modified by Maderno when he added a long nave to the church.

The Laurentian Library, *anteroom and interior.*
Michelangelo Buonarotti (1475–1564)

In 1520 Michelangelo returned from Rome and began work for the Medici family, his first project being the chapel housing the Medici tombs. He undertook work on the Library in Florence on the instructions of Giulio de'Medici, elected Pope Clement VII in 1523. Michelangelo was not formally trained in architecture and the Library was his first architectural project to not have a heavy sculptural emphasis. In his austere design of contrasting gray and white he reversed a number of architectural conventions, such as the recessed columns that divide the walls. Construction began in 1524 and proceeded well, but was interrupted when Clement VII was forced into hiding after the Sack of Rome in 1527 and the Medici were expelled from Florence. Work resumed before the Pope's death in 1534 but by that time Michelangelo had returned to Rome and was no longer directly involved in the building of the Library. In 1559 he supplied a model for the staircase leading from the anteroom to the Library itself. This set a precedent explored more fully in Baroque architecture in that the staircase was treated as a major and elaborate form in itself rather than as a merely functional element. It was built according to Michelangelo's plan, although in stone, not wood as he had suggested, by Ammanati (1511–92).

Mannerism

Mannerism is a term fairly recently adopted by art historians to identify a particular development in the visual arts that started about 1510 and lasted for about fifty years. It has most often been used to describe mainly Italian artists working in Italy, but in addition Fontainebleau Mannerism is the outcome of the work of two expatriate Italians working at the French court in the 1530s, Giovanni Rosso (1494–1540) and Francesco Primaticcio (1540/5–70). There are Mannerist characteristics to be found in most European art around this time but such minor manifestations are a specialist pursuit of art historians and need not concern us here.

It is, however, useful to have some knowledge of Mannerism for two main reasons. Firstly, it isolates a type of art that has a number of common characteristics and thus, like most labels, has a shorthand value in saying something about a Mannerist artist. Secondly, its appearance says some important things about the nature of the society that produces it.

The word comes from the Italian word *maniera*, meaning style or stylish. Out of this comes the inference that the style with which a work is made is more significant than any message it may be transmitting. When something, no matter what, is done with style, panache, so that the way in which it is done is more important than what is done – when, for instance, table manners are more important than eating – then we are in the presence of a form of Mannerism. Translated into art that means that the individual characteristics are calculated to impress, and the style of the individual is what is admired.

Curiously, but perhaps not surprisingly, the three great masters of the High Renaissance, Leonardo, Raphael and Michelangelo, have a responsibility for the form that Mannerism took. The individual quality and impact of their work was unmistakeable and inimitable. The technique carries a message of unattainable quality – how do you follow that? One way is by not realizing what the content is and apeing the manner. The power of Michelangelo is so evident that, as he matured, his way of painting became almost a message in itself – so that later he seemed to become a Mannerist version of himself and an inspiration to "mannered" painters in the expressive exaggeration of his forms. Leonardo's *sfumato*, uniquely his, has the same inspiration to the Mannerists, an elegant personal grace in all he does that says clarity, charm and intellectual sophistication will give you all you need. In this sense Mannerism is stylishness, and *la bella maniera* was first applied with this connotation to the work of Raphael and his followers.

Although it is important to understand the term, it has more interest stylistically for art historians than anyone else. More significant here is to explain its occurrence than to trace its development from evidences in Leonardo, Raphael and Michelangelo through their Mannerist successors such as Jacopo Pontormo (1494–1557), Parmigianino (1503–40) and Bronzino (1503–72) in painting, Giovanni Bologna (1529–1608) in sculpture and Baldassare Peruzzi (1481–1536) in architecture.

The achievements of the High Renaissance masters are the culmination of a development that started in the later 14th century and was brought to its fullest expression in the early 15th century. Nearly 150 years separate the beginning of the Renaissance from Mannerism and during this time the cities and towns of Italy first became aware of the new spirit, learned, understood and applied the new philosophy to their modern lives, and achieved a confidence in themselves that was finally expressed in the grandeur of the works of these great masters.

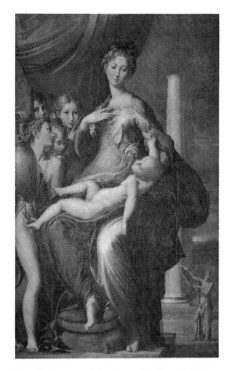

The Madonna of the Long Neck, c.*1535*
Francesco Mazzola, called Parmigianino (1503–40)
Oil on panel 85×52in (216×132cm)
Uffizi, Florence

Parmigiano was one of the most extreme artists of the late Mannerist period, developing a stylized, linear form of composition that was already evident in his early work in Parma and which he applied even to his portrait painting. He arrived in Rome in 1524, left for Bologna after the Sack of Rome in 1527 and returned to Parma in 1531. He began to work on frescoes for Santa Maria della Steccata but progressed extremely slowly. The so-called Madonna of the Long Neck was commissioned as a decoration for the Tagliaferri Chapel in Santa Maria dei Servi in 1534. It remains unfinished and was not put in place until 1542. Parmigianino apparently neglected painting in his later years and was briefly imprisoned for his failure to complete the fresco commission. According to the 16th-century biographer Vasari he wasted a good deal of time on experiments in alchemy. He started painting again shortly before his death and seemed to tone down the earlier stylistic exaggerations

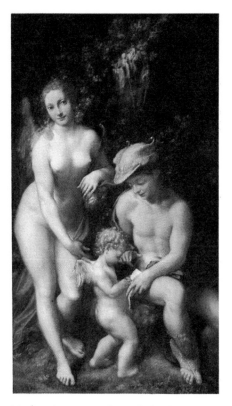

Mercury Instructing Cupid Before Venus,
c.1520–4
Antonio Allegri, (called Correggio)
(c.1489–1534)
Oil on canvas 61×35½in (155×91cm)
National Gallery, London

*Correggio is named for the town in which
he was born and brought up. This small
town was close to several large centers of
power and culture, among them Mantua,
Bologna and Milan. It is possible that
Correggio trained in Mantua with Mantegna,
but it was while working in Parma that he
found a kind of immediate fame. In this
period he painted two works on mytho-
logical themes for Federigo Gonzaga of
Mantua, one of these being the painting
shown here, popularly known as the* School
of Love. *He spent the last few years of his
life back in Correggio in the home of his
parents, living more quietly but still carrying
out work for the Gonzaga family. The*
School of Love *was sold to Charles I of
England from the Gonzaga collection in
1628.*

Where was one to go from there?
Italy was in the thrall of French
invaders or the Spanish troops of
Charles V, who seemed likely to
remain and dominate the peninsula.
Times were unsettled. More distrub-
ingly, it might perhaps have seemed
that there was nowhere else to go in
art. What really valuable thing could
be said? What, in a dissolving society,
was the point of saying it anyway? It
could produce an "inner tension" in
artists and there is evidence to suggest
that it did. Several were certainly
unstable: Jacopo Pontormo (1494–
1556) was an introverted hypochon-
driac and Francesco Parmigianino
(1503–40) became insane.

There was also the spiritual crisis
posed by the Reformation. Even the
cloak of the Church could not protect
people from the fear that this founda-
tion to their lives could be wrong. In
such circumstances it is not surprising
that there was a feeling of melancholy
and withdrawal, and that as an anti-
dote an almost aggressive self-display
should appear in defiance of it. It is
interesting to note that while in Renais-
sance paintings a frontal figure looks
confidently at the observer, in a Man-
nerist painting the figures look out with
a vacant withdrawn or introspective
air, often of melancholy. The treatment
of the figures also emphasizes forms
and poses, making them seem almost
impossibly athletic or anatomically
improbable.

The Courts of Culture in which the
Mannerists worked had by this time
become artificial and effete, concerned
with worldly appearance rather than
being, as in the Renaissance, centers of
real intellectual life. Mannerism re-
flects in art a society that had lost its
way, its spiritual certainties and its
intellectual enthusiasms.

A contemporary of Leonardo who
adopts and modifies his *sfumato*, and
in his early work is what may be called

a proto-Mannerist, is Antonio Correg-
gio (1489–1534). He takes his name
from his birthplace near Parma, where
he worked in his maturity. Like Par-
migianino, Raphael and so many other
of his contemporaries, he died rela-
tively young. The development and
reputation of Renaissance artists often
came early in their lives. It was a young
society in the arts, welcoming talent
and apparently with room for all. The
struggle of the artist to gain recog-
nition was, of course, not unknown in
Renaissance Italy but it was the excep-
tion rather than the rule and, despite
certain limitations imposed by guild
membership, it was encouragement
rather than exclusion that chacterized
the atmosphere of the cities and their
courts, however provincial. The age
must be seen as one of commercial,
political and artistic enthusiasm, of
energy and expectation.

Coming from as provincial a town
as Parma in the north Italian plain,
Correggio had only the influence of
Venice and Mantegna in his early years,
and must have felt the need of closer
contact with the Classical spirit – his
earlier work is certainly not imbued
with it – and it seems probable that he
went to Rome before finally settling in
his home town. All this is significant
because the influence of Raphael be-
comes apparent in his later work. The
subtle and sophisticated use of light
distinguishes Correggio from other
Mannerists and his painting has a
physicality that is not present in, for
instance, his Florentine contemporary
Bronzino.

Angelo Allori, known as Bronzino
(1503–72), who was born near Florence
and studied with Pontormo and with
Parmigianino, represents Mannerism
in painting. Pontormo's exaggeration
of form, emotion and gesture, together
with the somewhat obvious harshness
of color, represents the first stage,
which is softened in the extended ele-

gance of Parmigianino's painting to more sympathetic color and softer treatment of light. Bronzino's drawing has a clarity and precision, a self-conscious intellectualism, which reveals the Mannerists' personal idiosyncratic style at its height. There is accomplishment, personality, intellectualism, but a minimum of human feeling. This is nowhere more effectively expressed than in his so-called *Venus, Cupid, Folly and Time*, based upon an allegory of love. Its apparent sexuality is so carefully conceived that the figures have neither reality nor emotion, and the work has more of the aspect of painted, frozen statuary.

A contemporary of both Michelangelo and the Mannerists, and showing some influence from both, is Benvenuto Cellini (1500–71) who was born and died in Florence and was a metal worker and sculptor. This bald statement disguises the career of one of the more outrageous characters in the history of art who would be remembered if all we had of him was his energetic, bawdy, fascinating and informative memoirs, in which his self-assertive good opinion of himself is trailed through his adventures and amours (he claims to have personally killed the Duke of Bourbon leading the attack on Rome in 1527). He has, however, left gold and silver work and some sculptures, which show him to have been almost as talented as he claimed, and two of which at least are among the most representative Renaissance pieces to survive. The first is the famous salt cellar made for Francis I while he worked for him in France (although it was started in Rome), and the Classical bronze of *Perseus Holding the Head of Medusa* in the Loggia dei Lanzi in Florence. The easy accomplishment of this figure reflects the High Renaissance as much as the independent arrogance of Cellini's nature.

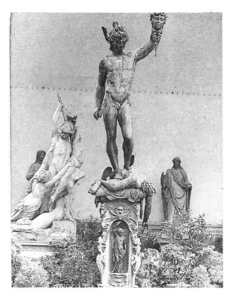

Perseus and Medusa, *1545–54*
Benvenuto Cellini (1500–71)
Bronze: Height 17¾ft (5.5m)
Loggia dei Lanzi, Florence

The ambitious bronze cast of Perseus is one of the major works of Cellini's period in Florence, where he settled in 1545. In earlier years he lived in Rome – only a few coins and medals survive from his work during that time – and he then moved to France, where he spent five years in the service of Francis I. There his talents as a goldsmith were put to work and he also completed a large mural painting. In Florence Cellini came under the patronage of Duke Cosimo I, for whom he created the Perseus. It was a large undertaking for a bronze cast and full of delicate detail, the length of the figure being increased by the outstretched arm. The body of Medusa was cast separately. Cellini's autobiography, written between 1558 and 1562, contains an entertaining account of the casting, telling how every possible disaster befell the project: there was a rainstorm, the workshop was set on fire, Cellini himself contracted a fever and the bronze curdled in the furnace. However, Cellini triumphantly related his ultimate success, the only problem was a slight blemish in the toes of the figure, where the bronze had not penetrated the mould, and this was easily retouched.

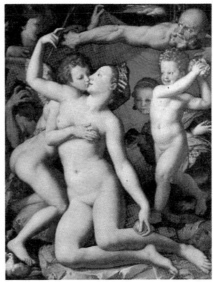

Venus, Cupid, Folly and Time, c.*1545*
Agnolo Bronzino (1503–72)
Oil on panel 57½×45½in (146×116cm)
National Gallery, London

Bronzino trained in the studio of Jacopo Pontormo (1494–1557) and thereafter continued to live and work in Florence. He became court painter to Cosimo de'Medici and received frequent commissions from Eleanor of Toledo, the wife of Cosimo, including frescoes in her personal chapel at the Palazzo Vecchio. She is recorded with her son in a portrait made at some time between 1543 and 1553 (Uffizi, Florence). A feature of Bronzino's style was his rejection of the looser painting techniques and variable focus adopted during the Renaissance, for example by Leonardo. Bronzino returned to a precise, technically excellent but impersonal style, evident in both portraits and the allegorical compositions popular among artists and patrons of the period. Venus, Cupid, Folly and Time probably represents a moral tale but at the same time expresses a licentiousness that belies its purpose.

An Age of Change: The Renaissance beyond the Alps

The European Renaissance and Reformation

The nature of the Renaissance and its origins in Italy were considered in the previous section. This section considers the extension of that movement into the rest of Europe and sees how the history of each state or region during the period – roughly 1500 to 1600 – affected the forms that it took. Each of the nations has a different history, interacting with the others, and also bringing its own national characteristics increasingly into play. Thus the "northern" Renaissance (which is the term generally used, although it includes France and Spain) does not have a simple coherent identity, but is much varied as it appears in each country.

There is however an important unifying consideration: looked at from a world perspective, there is, despite all differences, a common history and consistent course of development which can be called European, rather than, say, French, German, English or Spanish, and this stems directly from the first advanced cultures to appear on or spread to what we broadly call the European continent. There is a European culture which is greater, perhaps, than the sum of its parts, for it has, as a result of its expansion into other regions of the world, become the dominant world culture. It may be said that the last four hundred years saw the emergence of a Eurocentric world culture. Even the two powers which are politically dominant in today's world – the United States and Russia – have looked and continued to look to European culture for inspiration.

Russians consider themselves to be Europeans, and the source of the present Communist ideology is the thought of two Europeans, Karl Marx and Friedrich Engels. The United States, whose culture was created, as the country was settled, almost exclusively by Europeans, has always been a partner in that culture. Thanks to the United States' political and industrial power, it has become both the repository and custodian of European culture, and the symbol of its nature throughout the world.

So, although the Renaissance that took place in Italy came to be seen as playing the dominant role in the earlier development of European culture, Italy should really be seen more an early developer than as the main achiever. While Italy provided the first modern inspiration in the Renaissance, the full expression of Western culture may be found in the great varieties of development, of differing temperament and history elsewhere in the Western European states during the 16th, 17th and 18th centuries. Outside Italy, the Renaissance means not only Erasmus and Luther, but also Newton and Linnaeus who followed. It means Bach and Mozart as much as Palestrina and Monteverdi.

The history of this other Europe, that is to say all Europe outside Italy, is one of later development of the new Renaissance ideas, but accompanied by a surge towards unification of states not paralleled in Italy. The exception is in Germany, where a historical unity under the Holy Roman Empire had turned into a large number of practically independent states recognizing only the nominal authority of the Emperor. The late Medieval period lasted in northern Europe until about 1500, although by that time the new learning (as it was called) from Italy and the spread of Humanist philosophy had already begun in certain limited areas. It is very difficult to see any clear dividing line between the medieval world and the dawning Renaissance in the early part of this period. This becomes visible when one looks at the art of the period.

Symbolic of release from the Middle Ages is the departure from Europe's shores of Columbus and other explorers around the beginning of the 16th century. The enlargement of royal power in countries such as France, England and Spain promoted the beginnings of a search both for new and justifiable forms and sources of authority (Machiavelli's arguments of expediency and pragmatism giving a spur to this) and for the style consciously to be adopted to project that authority. Against the well-remembered background of the struggles between the church and state, the conflicting powers of the pope and king was debated (the doctrine of the Divine Right of Kings being one result). The dynamics of this search as much as the inspiration of Humanism (as authority for man's belief in his own capacities) provided the bases for growth and change in each of the Western European states.

The Reformation was another factor of great importance in initiating change and giving grounds for differing national development. From the middle of the 15th century, especially in the north, increasing disillusion with the state of the medieval Church was felt. A number of popular movements, which the Church establishment could brand as heretical – such as the Lollards in England or the Hussites in Bohemia – sprang up spontaneously. This grassroots discontent and spiritual hunger surfaced as Protestantism early in the 16th century in the lives and teaching of such passionate reformers as Luther and Calvin and in the subtle intellectual arguments of Erasmus.

From this ferment the Reformation was born.

It would be difficult to overstate the importance of the use of Protestantism in the formation of the modern world. Its rapid expansion during the 16th century was as dramatic as the spread of Islam a thousand years earlier. The Roman Church was obliged to look within itself and find new means of preaching its tenets. From the Council of Trent (1545–63) and through teaching orders such as the Jesuits of Ignatius Loyola (approved by Rome in 1540) came a new movement to combat the Reforms – the Counter-Reformation in fact. From this time, the teachings of Bible and Church came under examination with a freedom of thought and interpretation that led many independent Christians to form themselves into a great variety of dissident groups and congregations. Among the earliest of these were the Anabaptists, the sober English Puritans and the Calvinists of Geneva. There was "a surge of religious zeal and commitment" which included a consideration of what responsibility the individual Christian owed to his state or monarch. Faith and politics became entangled and scripture could be used effectively as political propaganda.

Thus, the 16th century saw the origin of modern states as they established themselves and sided with the forces of either Protestantism or Catholicism to support their own secular institutions: the wars of the 16th century were over the claims of either Church to be officially established in each country. Shaky though the newly united or liberated states might still be (Holland, England, France, Sweden, Russia), their rulers and courts, teeming with a privileged aristocracy whose power monarchs often with good reason feared, became increasingly ambitious to foster the intellectual life in much the same way as the still much admired Courts of Culture had done in Renaissance Florence, Urbino, Milan, Mantua and Ferrara.

The Reformation coincided with the development of the most potent force for the dissemination of ideas – the invention of moveable type and hence the possibility of rapid and cheap printing of texts for the widest distribution to all who could read. Literacy itself was put within the reach of almost everyone and became a door to real advancement, the clergy ceased to have a virtual monopoly on learning, the Bible, translated into the national language, became a book available to all, lay universities were founded. Poetry and literature flourished, and the theater became literature: Shakespeare could be read.

The nation state became the political framework for action. It was built upon a number of factors of which the foundation of dynasties, the improving power of firearms, the creative force of commerce leading to the concentration of capital in a few – and non-noble – hands were perhaps the most significant. The world itself enlarged. Westward from Europe a new continent had been discovered between Europe and the Indies – America. The western Atlantic seaboard replaced the Mediterranean as the primary route of seaborne trade and brought Spain, Holland and England to the fore. Spain, through the colonization of the middle Americas, became the richest and, through fortunate royal marriages and deaths, the largest power in Europe and the world, pouring her overseas wealth into her other European possessions, notably the Netherlands. Eastward to India and beyond, Portuguese, Spanish, Dutch, English and French explorers founded trading posts, and their rivalries provoked yet more internecine European warfare.

The only real threat to Europe as a whole came from Islam. Ever since the Muslims had with almost incredible speed swept across north Africa into Spain and France – checked only at Tours in 732 – and deep into Asia Minor, a great crescent of hostile and alien culture had hemmed in the south of Europe. The pathetic failure of the Crusades had left a legacy of anxiety in the heart of Christian Europe. Then, just as the reconquest of Spain from the Moors was gaining ground in the 15th century, thus pressing down, so to speak, the western horn of the crescent, its eastern end sliced up like a terrible blade into the Balkans and eastern Europe. This was the apparently unstoppable drive of the Ottoman Turks who, from about 1390 carried everything before them, capturing Budapest by 1541.

Once again, the Christians of Europe felt beleaguered, but with the difference that now they were divided in their religious allegiances. No longer could the pope's summons bring the warriors of Christendom into battle, as in the Middle Ages. Rulers were prepared to stab each other in the back – even the Catholic king of France allied himself with the Turkish sultan in the 1530s, as a precautionary balance to the power of the Habsburg Emperor. The last flicker of the medieval crusading spirit was manifeted at the battle of Lepanto (1571) when a Venetian and Spanish fleet – commanded by a Habsburg prince of Spain, Don John of Austria – defeated a Turkish fleet in Greek waters – but by that time, wars more important for the future of Europe were in the making in the west, where Spain's conflict with Elizabeth of England was soon to culminate in the sending of the Invincible Armada to its doom in 1588.

Philip of Spain's decision to invade England with a great Armada came at the end of a period of undeclared war between England and Spain. English seamen robbed the legitimate treasure fleets of Spain, English soldiers fought

the Spanish in the Netherlands and, as a final irritation to Catholic Spain, England was firmly Protestant. Philip's long-suffering patience failed and he sent a mighty fleet on a mission that he must have known could not succeed – the capture of England. The result was the total destruction of his ships, and the loss of most of his men, not killed in battle but drowned in the wreck of the ships around the coast of Britain.

The presence of Muslim kingdoms on the continent of Europe had a number of deep cultural consequences. In the west, it had once provided a channel for Classical science and philosophy – dressed up in an Arabic guise – to filter through to scholars in the monasteries and universities of medieval Europe who had been cut off from many of the original sources of the "pagan" civilization which preceded them. Not that the tolerant and cosmopolitan centers of Muslim Spain, such as the courts of Cordoba and Granada, were a permanent feature: waves of intolerant Muslim fanaticism swept north from Africa on several occasions, but without being able to stem the relentless pressure of the Christian reconquest. The struggle, not only for the victory of one faith or other, but for the identity of the peoples of Spain and Portugal themselves, left a bitter legacy for the future. By the end of the 15th century when Renaissance influences were spreading outward from Italy, the last Muslim stronghold, Granada, had only just fallen (January 1492) to Ferdinand and Isabella (the backers of Columbus, himself about to set sail seven months later). Spain was still a nation on a war footing, a fact which was to give her a unique destiny in the century ahead.

The legacy of Turkish rule in southeastern Europe was also of a negative kind for the conquered nations which eventually emerged into freedom and independence, for it can be said that

the Ottomans prolonged the Middle Ages in the Balkans until the very end of the 19th century. Their empire was medieval in character, and their Christian subjects were held in a deprived, servile status long after the Industrial Revolution had come to the West. This goes far to account for the ultra-conservatism of the Orthodox Church in those countries, for the almost feudal nature of their societies, and in consequence for the extremism of their revolutionary movements. Culturally, the peoples of Yugoslavia, Rumania, Albania, Bulgaria and Greece (and for a time, of Hungary as well) were long cut off from contact with a changing world outside, and took refuge in the traditions of their ancestors and the cultivation of mainly religious forms of art.

Francis I, King of France, c.1525
Anon. or possibly Jean Clouet (d.1541)
Oil on panel 37½ × 29in (96 × 74cm)
Louvre, Paris

Clouet's origins are obscure. A longstanding theory that he was the son of a Burgundian painter of the same name is now thought to be incorrect and he has also been traced less convincingly to French and Italian families. It is clear that he was not native to France, since his possessions passed to the crown on his death, as was the rule for foreigners, and were returned to Francis Clouet by Deed of Gift from the king.

An annual salary for the painter Jean Clouet was first recorded in the accounts of the French court in 1516. At that time he was ranked fourteenth among the court's artists and gradually worked his way up, attaining first position in 1532. The last evidence of his activity is a record of a fee paid to his wife for bringing paintings to the king for approval in 1537. It is not clear whether this implies anything about the state of the painter's health, in that he could not be present in person. Jean Clouet's activities at court were unusual in that he seems to have concentrated solely on portraiture, whereas other artists at the court were expected to play a more varied role in its formal and cultural life.

The Renaissance in France

The first European country to assert and maintain its authority as a state was France. She was ideally placed: protected from the most feared eastern threat, that of the Ottoman Turks, by the Austrian defense of Vienna, and distant from Ottoman expansion in North Africa, she lay at the center of the web of Europe. She had good communications with her neighbors and particularly with Italy. France was by 1477 under Louis XI more or less a consolidated kingdom but with a large and unruly nobility still enjoying their feudal privileges of the Middle Ages, and a foreign policy that was torn between Catholic inclinations and political and commercial needs. Throughout the 16th century, France suffered from sectarian and dynastic strife and the Protestant Huguenot uprisings later in the century subjected the people to constant disturbance. Only at the end of the century, with Henry IV, did France achieve domestic peace.

French invasions of Italy continued into the 16th century, with the ironic result that close cultural links with, and the enthusiastic absorption of the Italian Renaissance spirit were forged.

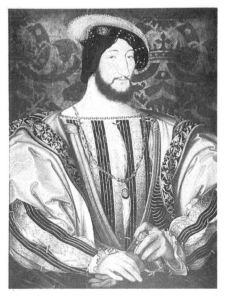

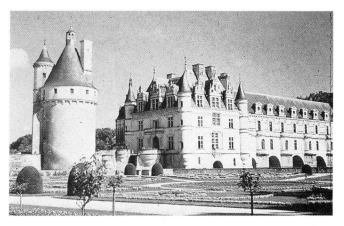

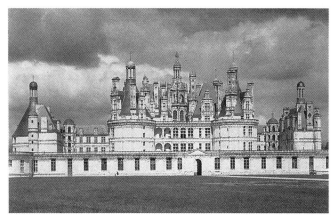

Francis I, patron and supporter of Leonardo da Vinci, was France's first Renaissance prince, and at the same time the epitome of traditional French chivalry. His importance for the arts was enormous, as a leader of fashion, the chief patron of the arts and his court the focus of aristocratic life. Gradually the dominant role of the nobility in governing the country was diminished, although they remained bound to the crown by a strict hierarchy and system of privileges. From the beginning of the 16th century the fortified manor house (*château fort*) of the nobility gave way to the country retreat surrounded by pleasure gardens (*château de plaisance*). The chateaux in the Loire Valley were built by flamboyant aristocrats and by the monarch during the first decades of the century and reflect the increasing sense of security in the realm. Blois, to which Francis I added Chenonceaux, Aza le Rideau and the extraordinary Chambord, were built at this time. These chateaux are more medieval, with their castle characteristics, than Renaissance or Classical in feeling. At Blois, Francis I's outside open staircase may have a veneer of Classical detailing, and at Chambard it is the massing of detail and ornament without feeling or understanding that makes it so extraordinarily inappropriate – as a sort of hat –

to the simple, castle-like building.

Fontainebleau, the royal residence, was the center of great artistic activity, with Francis I initiating its rebuilding and redecoration (largely by Flemish and Italian artists). His initiative was carried on by Henry IV towards the end of the century, by which time Fontainebleau was recognized as one of the great palaces of Europe.

With the close contacts with Italy there is a much livelier intellectual curiosity in France than in its sister Catholic country Spain. With a monarchy firmly committed to playing a dominant role in the politics of Italy and the papacy, and with kings dedicated to the patronage of Italian artists during the first half of the 16th century, it is not surprising that France was the most assiduous of European states in emulating the achievements of the Italian Renaissance. Francis I was not only a truly Renaissance patron (he bought the *Mona Lisa* by Leonardo, which is why it is now in the Louvre, Paris), but he invited a number of Renaissance artists to France to work, among whom was Leonardo to whom he gave the Castle of Cloux near Amboise, where Leonardo died. Other artists invited were Andrea del Sarto (1486–1530), who accepted and stayed a year, and Fra Bartolommeo (c.1474–1517), who declined. The architect

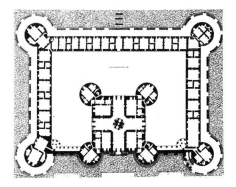

Château of Chenonceaux, *1515–56*
Loire, France

Chenonceaux is a characteristically 16th-century French château. It was extended by De l'Orme in 1556 in a more classically restrained style than the rest of the building.

Château of Chambord, *view and plan, begun 1519*
Domenico da Cortona (?)
near Blois, France

Built by Francis I ten miles east of his château at Blois, Chambord remains intact.

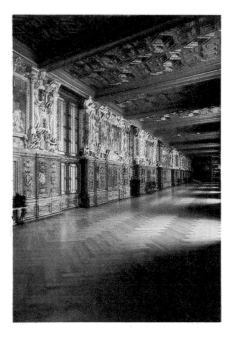

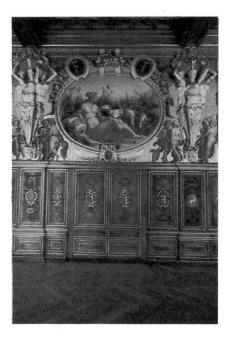

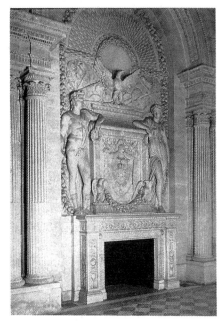

Gallery of Francis I, *general view and detail, 1533–40*
Giovanni Rosso (1491–1540) and Primaticcio (1505–70)
Château of Fontainebleau, France

Although Fontainebleau was very largely remodeled in the early 19th century under Napoleon's influence, the gallery of Francis I remains the most accomplished 16th-century decorative mannerist scheme, and retains

most of its original character in paintings, although such stucco decorations were copied throughout Europe.

Fireplace, room of Cariatides, *c.1550*
Jean Goujon (1510–c.1564)
Louvre, Paris

Although restored in the 19th century this fireplace, surmounted by relief figures, indicates the quality of Goujon's modeling and retains the essential features of his work. The figures on the exterior of Lescot's wing of the Louvre, are also by Goujon.

Jacopo Sansovino (1486–1570) was also invited but was persuaded to stay in Venice while on the way to the French court. Francis I was also responsible for bringing Giovanni Rosso (1494–1540) and Francesco Primaticcio (1505–70) to work on the palace at Fontainebleau, where their work had the greatest effect in changing the character of French court art into a full Renaissance style. The work done there, or influenced from there, is collectively known as the School of Fontainebleau and it is purely Italian Mannerism transplanted to France. At Fontainebleau the combination of wood paneling, stucco-molded plaster-work and painted panels was a new development which added richness to the feeling of the interior. Francis also employed the energetic and extrovert artist Benvenuto Cellini, whose celebrated sculptured gold salt-cellar (although started in Rome) was completed in France.

The most notable native figure in sculpture was Jean Goujon (active 1540–62). He worked with Pierre Lescot (1500/45–78) on the Louvre and with Philibert de l'Orme at Anet. His Classicism is accomplished and he was clearly aware of Roman examples.

As well as painters and sculptors, Italian architects also visited or settled in France. Sebastiano Serlio (1475–1554), theorist and historian of archi-

tecture as well, arrived about 1540 and exerted considerable influence. The court of the rebuilt Louvre palace, designed with restraint and care by Pierre Lescot is an early example of his influence. Another and greater architect, l'Orme, had studied Classical ruins in Rome and published his analysis of architecture in 1567. Both in the treatise and in his accomplished buildings he begins to presage the French individual form of Classicism which found its full expression later in the Palace of Versailles. His masterpiece is perhaps the Chateau of Anet built for Diane de Poitiers, mistress of Henry II of France, for whom de L'Orme also worked as chief architect.

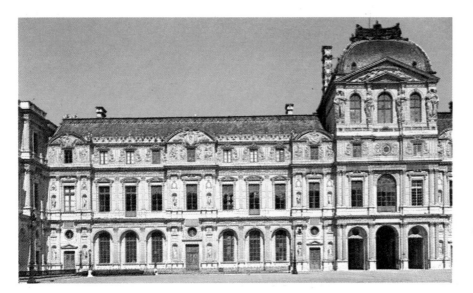

Louvre Palace, west façade courtyard,
begun 1546
Pierre Lescot (c.1510–78)
Paris

Although a somewhat shadowy figure in his origins, Lescot inherited a title and enjoyed a privileged position at Court. His reputation rests largely on being the architect who introduced the new language of classical form into France, and his court at the Louvre remains an impressive memorial. The original design was intended to be of two stories, but he added a third, probably to relate more comfortably with the greater height of the Pavillon du Roi opposite. The inscribed date of 1556, suggests the date of completion.

Later in the century devastation and insecurity stalked the land in the wake of the religious and civil wars, for which the baleful influence of France's Italian queen and queen mother, Marie de Medicis is heavily answerable. Among the disastrous events for which she must bear the responsibility is the massacre of Protestants in Paris and the provinces which was initiated on St Bartholomew's Eve, 1572. Not until later in the 17th century did France assume the central position in the European arts scene that she was to maintain until the 20th century.

Château d'Anet, entrance gatehouse,
1548–55
Philibert de l'Orme (c.1510–70)
Annet, France

Born in Lyons, l'Orme spent three years in Rome where met Dianne de Poitiers who became his most notable patron. During his time as Superintendant of Buildings for Henry II, l'Orme wrote two impressive treatises on architecture. His best known work is the Château d'Anet, of which the gateway survives and is a simple, symmetrical, classic structure, with an entirely French flavor.

Spain in the 16th Century

As the Atlantic seaboard became increasingly important at the expense of the Mediterranean as the main trading route and outlet for emigration to the Americas during the 16th century, Barcelona declined as a port to be replaced by Seville and Cadiz. Through these convenient ports the great silver imports and produce from the new Spanish possessions were brought in to be distributed through Spain's European possessions. In consequence, the direction of Spain's interest and influence shifted from her lands in the Mediterranean basin, especially southern Italy, to the potential of the New World and to the northern parts of occupied Flanders and hostile England. During the century she was at her greatest, feared and envied throughout the world.

Of course, Spain has a long and varied history and has participated in most of the developments in European history. Some of the finest examples of prehistoric wall painting are found in Spain – at Altamira, for instance. The Romans colonized, as did the Visigoths, who organized Christian kingdoms in the country. In the 8th century the Arabs conquered most of the peninsula and surged on briefly into France. The Moorish capital at Cordoba became one of the most important centers of culture in Europe and gradually the Muslim, Christian and Jewish populations became closely dependent on each other.

The end of the medieval period is signaled by the reign, starting in 1479, of Ferdinand and Isabella, and together they reigned over more of the land than any rulers for some centuries. At this time the Church had become wealthy and powerful, firstly because the people were intensely religious – as indeed they have remained – and because only Spaniards could hold office in the Church, being also subject to the crown. The Church was supported by

the throne, who was its master. At the beginning of the century the Jews held power through money (usury) and there was still a large population of *Moriscos* (Moors converted to Christianity). At this time (1480) the Inquisition was instituted to deal with heresy and control Jews and Moors alike. The Inquisition has always received exceedingly bad reports, being credited with the most horrific forms of torture and repression, and doubtless most of it carries some truth, but it is also true that the representatives of the Inquisition in local situations acted in some ways like justices of the peace and local magistrates in England. In spite of coercion, conversion did not make much headway, and by the beginning of the 16th century, both the Jews and the Moors had been expelled from Spain and Portugal. The Moors went either to Turkish dominions, such as Crete or to North Africa, while the Jews went in large numbers to the more tolerant environment of Holland, where they formed the basis of the brilliant and wealthy Ashkenazi community to which Spinoza belonged.

In 1516 Charles I came to the throne and, since he also inherited the title of Holy Roman Emperor, ruled for forty years as Charles V, the most powerful ruler in Europe. During his reign the great conquests in the Americas were completed. They had begun in 1500 with Venezuela, followed by Cuba in 1511, and the famous – or infamous – conquest of Mexico by Cortez was carried through between 1517 and 1524. Successively the Philippines, Florida, Ecuador, Bolivia and Chile were added to the Spanish Crown, the conquests concluding in 1543 with Pizzaro's victory over the Incas of Peru. The conquerors (*conquistadors*) threw themselves energetically into mining the riches of first gold and then silver which were returned in great treasure fleets to Cadiz and Seville. Spain's treasure galleons were the envy of Europe and the exploits of the English pirates, such as Drake and Grenville, often with tacit royal approval in seizing them wherever possible, is one of the legends of sea adventure.

During the whole century Spain was a strong and centralized monarchy, with unchallenged authority, which could and did stamp out all opposition, whether political or religious. It was the unswerving mutual support of state and church in Spain – another continuing factor and important as recently as in Franco's Spain – that gave her a stability unknown in the rest of Europe. The effect of the Reformation, dramatic and far-reaching in most of Europe, was confined to small and isolated communities widely dispersed and easily suppressed.

During the reign of Charles V, Spain was able through his person to claim sovereignty over more than half of Europe, and as the century advanced, became ambitious to control the whole of it – only France (although Catholic, Spain's principal rival) and England (a natural Protestant adversary) stood in her way. The power and attraction of his court and that of his successor Philip II, was such that all culture centered around it. Dominated by a stiff formality of conduct, pious, austere, blinkered, secure and arrogant, the Spanish court sponsored a somber and dignified style. However, the political ambitions and religious enthusiasm of the monarchy were more absorbing than literary and artistic culture, and although there were some Humanists in Spain, there was no parallel to the Courts of Culture in Italy.

The real destruction of Spain's power under Philip II late in the century was of her own making. Overtaxed and underproductive, she engaged in widespread warfare which was ruinous, while the vast silver imports in the long run put the final seal on her decline, through inflation, to repeated bankruptcies of the exchequer.

Painting and Sculpture in 16th-century Spain

As France was the expatriate home of Italian and Flemish artists in the middle years of the 16th century, so Spain, because of Charles V personal links with Flanders, attracted Flemish artists, the most important of whom was Anthonis Mor, known as Antonio Moro (1517–76/7). His refined and subtle portraits done for the court have a forthrightness and assurance which sets the precedent for the founder of what is known as the Madrid School, Sancho Coello (1531–88), who as court painter to Philip II was the one important native Spanish painter of the 16th century. His portraits of the court figures look forward to those of Velasquez in the next century and seem to bridge time with the same formal dresses in both centuries, as evidenced in the extraordinary clothes worn by the little Infanta in paintings by both artists.

In sculpture the most important master was Alonso Berruguete (1486–1561), who was thoroughly Italiante, and had trained in Italy, where he knew Michelangelo. His work is Mannerist, for example his St Sebastian in Valladolid Museum shows that elaboration and exaggeration of gesture which is characteristic of all Mannerist work as well as that recurring Spanish agonizing passion and intensity which is already seen in early medieval painting. In Toledo Cathedral his sculptured *Transfiguration* almost anticipates the elaborate Spanish Baroque of the *Transparente* by Narciso Tomé in the same cathedral. A comparison of Berruguete, Tome and Bernini's *Ecstasy of St Teresa* will clearly show not only Mannerist and Baroque

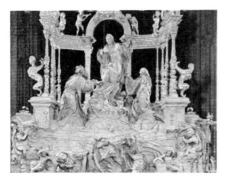

Transfiguration
Alonso Berruguete (c.1485–1561)
Alabaster
Toledo Cathedral, Toledo, Spain

*Berruguete was the son of the first great
Spanish Renaissance painter, as well as
being a sculptor, painter and architect in his
own right. He studied in Florence and Rome
before returning to work in Valladolid. His
great* Transfiguration *in Toledo Cathedral
dominates the throne, the strong carving and
sentiment in the work make it a powerful
sculptural expression of the Spanish
Renaissance.*

Immaculate Conception, *c.1607–13*
Oil on canvas 127½ × 65⅜in (323 × 167cm)
Museum of Santa Cruz, Toledo

View of Toledo, *c.1600*
*Domenicos Theotokopoulos, known as El
Greco (1541–1614)*
Oil on canvas 47½ × 41in (121 × 106cm)
Metropolitan Museum of Art, New York

*Although properly regarded as a Spanish
painter, El Greco was born in Candia, Crete
and studied in Venice, probably as a pupil of
Titian. At about the end of 1576 he moved to
Toledo – with which he remains particularly
associated – and died there in 1614, leaving
his strong personal mannerist view of the
city as one of the most famous landscapes in
Renaissance art. El Greco undertook many
commissions for churches in and around
Toledo, and in the Church of San Vicenze,
he painted four works;* The Visitation *for the
vault,* St Peter and St Ildefonso *for the side
altars, and the* Immaculate Conception *as the
main altarpiece. Work on the church was not
completed until a year before his death. The*
Immaculate Conception *is sometimes known
as The* Assumption of the Virgin, *and is
perhaps the most complete expression of El
Greco's art.*

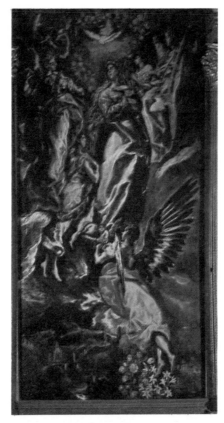

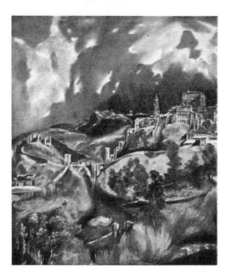

characteristics but also the suavity of
the accomplished Italian Baroque in
comparison with the more ornately
sentimental Spanish variety.

It is this quality of intensity that
characterizes the work of El Greco –
"The Greek" – (1541–1614). Born
Domenikos Theotokopoulos in Can-
dia, Crete, where he received his first
training as a painter, he moved to
Venice as a pupil of Titian in his late
years, and there are elements of late
Titian in his paintings, both at that
time and later. The peculiar subtlety of
Titian's paint surfaces with their many
thin superimposed layers (glazes) is not
found in El Greco, but the tautness of
his figures and the tonal qualities are
present. There are also qualities in El
Greco's work which have been des-
cribed as Byzantine. Byzantine icon
painting exhibits a formality and re-
moteness which is part of El Greco's
style. In 1577 he moved to Toledo
where he lived and worked for the rest
of his life. He was not favored by Philip
II, and although highly regarded was
able to work out his own unique
pictorial style without the limitations
of the formality of the court. In some
ways it is difficult to characterize his
work except to say that it is one of the
most personal in the history of paint-
ing. There are almost writhing tensions
in his line, a harshness in his tonal
relationships (his use of light and dark
is often highly personal and non-
naturalistic) and sharp oppositions in
his use of colors that make his painting
remarkably distinctive. Stylistically he
may be called a Mannerist, but in his
swirling and ascending forms he comes
near to being Baroque. He was the only
dominating figure in Spanish painting
in the 16th century, and as will be seen
from his dates he leads into the art of
the 17th century.

Architecture in 16th-century Spain

At the beginning of the 16th century Spain was virtually a post-war society still having a strong medieval tradition and no tradition of the liberal Humanism to be found in Italy at the time. A highly ornamented Gothic style of Spanish art and architecture known as *mudejar* (an Arabic word used to designate the art developed by Muslims working under Christian direction after the reconquest) had developed. In *mudejar* art we can see the Church acting as the traditional focus of a society coming to terms with an alien culture. Although during the middle decades of the century the newly fashionable Italian elements were attached to architecture or introduced into painting and sculpture, it was done with no real feeling for or understanding of its Humanistic nature. The result was often bizarre.

Spain, with its strong regional character (eg., Castile, Navarre, Aragon) continued to produce works with local rather than national features. Even when imperial Habsburg resources were used, as in the royal palace of the Escorial (1563–97) and its furnishings by Philip II, there was no consistent, overriding Italian influence – indeed the principal artistic interest of Philip II was with imported Flemish art (his father had been born and brought up in Flanders and it was a rich part of his possessions). His enthusiasm for Hieronymus Bosch (c.1450–1516) accounts for the major collection of Bosch's work in Madrid. Nevertheless, the interior of the Escorial was decorated by imported Italians. All of which indicates that there was no clearly Spanish indigenous art before the decorative style known as Plateresque (from *plateria* – silverware, because its finely made ornament resembled the work of silversmiths). This was the earliest expression of Renaissance influence and is characterized by

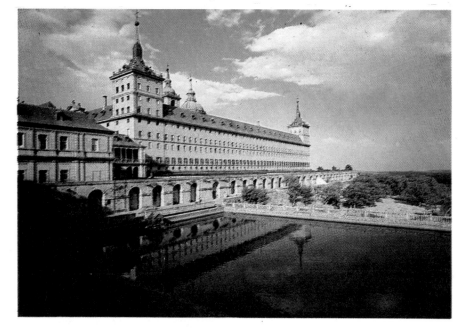

the application of elaborate ornamentation to essentially simple structural forms, with little or no regard for the structures themselves. It was soon eclipsed by the Italianate influence introduced by Charles V, the most important example of which is the Escorial built by his son Philip II. The Escorial was built on the most lavish scale and yet austere and remote – perhaps the most complete expression of the spirit of the Spanish monarchy during the 16th century. Other buildings by Juan de Herrera (c.1530–97), who completed the Escorial, were the Alcazar at Toledo and the first designs for the cathedral at Valladolid.

El Escorial, *Spain, 1563–84, view and drawing Juan de Toledo (d.1567) and Juan de Herrera (1530–97)*

"Escorial" means "slag-heap" in Spanish and this vast royal complex of buildings, comprising a mausoleum, a monastery and a church, is indeed a massive pile of granite, as severe and forbidding as its surroundings in the Guadarrama foothills 30 miles (48km) northwest of Madrid. Its frigid monumentality expresses rhe turning away from the lavish grandeur of the Spanish Renaissance under the influence of the Counter-Reformation. Commissioned by the ascetic and deeply religious Philip II, it was begun by Juan de Toledo, but on his death the supervision of the building passed to his assistant, Juan de Herrera, who is rightly regarded as the true architect. The whole complex, which covers an area of about 12 acres (5 hectares), is rectangular in shape and is pointed at its corners by unadorned square towers surmounted by the "Austria" spires which were to become a distinctive feature of Spanish architecture. The massive front facade, stretching 670ft (204m), bears embryonic traces of the Baroque, but the prevailing note is struck by the deliberate absence of decoration, the estilo desornamentado of Herrera, which was the official style encouraged by Philip II.

The Netherlands in the 15th and 16th Centuries

In the 15th and 16th centuries, the area of Western Europe we nowadays call Holland and Belgium was known as the Low Countries ("Nether-lands") – a term that well describes the largely flat geographical features of the land on both sides of the mouth of the Rhine. It was still within the borders of the Holy Roman Empire, but was divided up into a large number of provinces, some ruled by bishops, other belonging to a variety of different feudal dynasties including the House of Burgundy. The greater part of the population spoke a dialect that has grown into the Dutch and Flemish languages of today, and was called in those days, "Low Dutch" or "Low German" (as distinct from the "High German" spoken elsewhere in the Empire) – the words "Dutch" and "German" once having been interchangeable. This is the origin of the modern word with which we describe the people and language of Holland.

After the Reformation, the Low Countries, or Netherlands, were split by the changes of religion into a southern half, consisting of Flanders and Brabant, which remained predominantly Catholic, and was subject to the Spanish Habsburgs and open to influences and pressure from France; and a northern half, which adopted Protestantism with great firmness, and broke away from the authority of the Holy Roman Emperor (who, as we have seen, also happened to be the king of Spain). This group of independent northern provinces, grouped around Holland, the strongest of them, called themselves the United Provinces of the Netherlands, or United Provinces for short. In this way we can place the birth of the two modern states, Belgium (out of the "Spanish Netherlands") and Holland or the Netherlands (out of the "United Provinces"), in this confusing period.

The art of the whole area in the 15th century is known as "Netherlandish", but as the 16th and 17th centuries advanced, the Flemish art of the Spanish Habsburg south and the Dutch art of the United Provinces moved in different directions. The medieval prosperity of the great towns of Bruges and Ghent faded, and they ceased to be the dominant centers of trade and financial power that they had been. In the case of Bruges, it was partly due to the silting up of what had been the main port of Flanders – by about 1500 Bruges ceased to be able to handle sea-going vessels. The rich and art-loving Burgundian dukes, who for a time were ruling an almost independent country wedged between France and Germany, lost much of their lands to the revived vigor of the French kings, determined to assert their rights over the whole of the kingdom. What was left of Burgundian property in the Low Countries passed, by one of the most dazzling pieces of international marriage-broking in the history of Europe, to the House of Habsburg: in 1477 the future Emperor Maximilian I was married to the Burgundian heiress at Ghent – and some twenty years later their son was in turn to marry the heiress of Ferdinand and Isabella, monarchs of Spain.

These dynastic wheelings and dealings left the people of the Low Countries dissatisfied subjects of a vast conglomerate empire, and the 16th century was a troubled one in this area. Charles V, King of Spain and Holy Roman Emperor, had been born in Brussels and brought up in Flanders, where as a youth he was popular. On his accession to the Spanish throne in 1516, he spoke no Spanish and was more at home in the company of Flemish speakers who accompanied him to Spain. Thus began the close interlocking of Spanish and Netherlandish history for nearly two centuries.

Under Charles's son, Philip II, who took over in 1556, the relationship deteriorated disastrously. The influence and teaching of Calvin was so strong in the Low Countries that Philip determined that the Inquisition should be introduced to suppress Calvinism which disaffected both nobles and common people. Uprisings led to the dispatch of the Duke of Alva to the Netherlands with a repressive army of professional Spanish soldiers. A bloody and divisive struggle ensued which lasted until the early 17th century. In the outcome, the United Provinces had won their independence, only Flanders and Brabant remaining under the Catholic Crown.

Netherlandish art in the 15th century

It is sometimes suggested that when the Renaissance spread from Italy through France to the rest of Europe, it became available as a sort of new intellectual and artistic coat to be bought and worn over old medieval armor, transforming the wearer into a modern man in the process. That it spread from Italy and was absorbed subsequently throughout Europe is true but that it transformed all who "wore" it certainly is not. Indeed, in some ways, the Renaissance idea was itself transformed by its contact with other than Italian countries. The Renaissance in northern Europe is essentially northern, and is later than in Italy, but the arts outside Italy were not exclusively or even predominantly backward-looking. Although the Middle Ages persisted in the art forms in the north until the end of the 15th century, buildings such as King's College Chapel, Cambridge, in England and the art of the Van Eycks in the Netherlands show that an inventive and competent art was developing independently of any inspiration that might be coming from contemporary Italy. It can be said that Europe, when looked at as a whole and taking into account the special phenomenon of

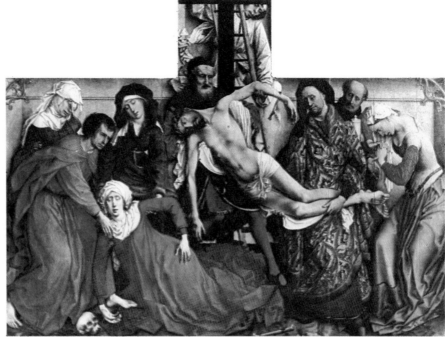

Italy, was showing a common spirit of enquiry that was not necessarily inspired by Classical models. To this extent, although what was happening in the north should not be described as a renaissance ("rebirth" is an inappropriate term), intellectually and artistically it was a changing world.

It is, in fact, in the Netherlands during the 15th century that the most creative surge can be seen. The work of Jan van Eyck (c.1390–1441) and Robert Campin (1378–1444) is outstanding, and there is a number of Netherlandish painters of quality who are their contemporaries or who succeed them. Of these Rogier van der Weyden (1349–64), Dirck Bouts (c.1415–75), Hans Memling (c.1430–94), Hugo van der Goes (d.1482) and, later, Gerard David (d.1523) are the most significant. Hieronymus Bosch (1450–1516), whose work is full of an arcane and now largely indecipherable symbolism, spans the 15th and 16th centuries.

The earliest of the Flemish masters is Robert Campin (who has been identified with the Master of the Flemalle Altarpiece) came from Tournai and he must be credited with the first masterpieces of the new Flemish School. Flanders was a wealthy and prosperous area, and artists were called upon to produce small panel paintings for the interiors of the houses of the rich and merchant class of Bruges, Ghent, Antwerp and Brussels. Independently of Italian inspiration, they discovered, more by a process of trial and error than by theorizing, the means by which the visible world might be represented convincingly. Linear perspective and aerial perspective, local color and the effect of light and shade in constructing a sense of volume, were all discovered and used by them. The tradition of painting was of illuminated manuscripts and miniatures rather than of large-scale wall paintings and the

Flemish artists developed a technique of meticulous attention to detail, together with a brilliant and lustrous use of color which makes all the paintings of the School marvelously attractive. Being also much concerned with methods and materials, their works have remained brilliant and in fine preservation, and it was in their search for an effective technique that the oil painting method was developed.

That such a significant school and form of painting could emerge from the Low Countries at this time is not at all surprising when we remember the traditional settled wealth of the region and the intellectual vigor of the Netherlandish people. What is perhaps surprising is how little is known of the lives of these figures. They are not easy to know about apart from their works and the anecdotes that surround the Italian masters (through the often apocryphal stories of Vasari) are absent. The appeal of such stories (however inaccurate they may be) sheds a life-like light on the artist and his work and since this is absent from Flemish art, the real nature of the school remains rather shadowy.

The Deposition, c.1430–5
Rogier van der Weyden (c.1400–64)
Oil on panel 86½×102in (220×260cm)
Prado, Madrid

A great deal of study has gone into the identification of the early Flemish masters. van der Weyden, for example, signed none of his work and there are no papers making specific reference to the paintings. Identification and dating has been done on the style of the paintings alone. Van der Weyden ran a large workshop and many copies of his compositions have been found, suggesting that they were popular with contemporary society. There is a copy of The Deposition *dated 1443, but it is thought that the original was completed some years earlier. A record of Rogelet de la Pâture is thought to refer to Rogier van der Weyden. This shows that he entered the workshop of Robert Campin at Tournai in 1427 and left as a master painter in 1432. This constitutes a late apprenticeship and it is clear that there was some mutual influence between the two artists. In 1435 van der Weyden was appointed painter to the City of Brussels and spent most of his life there, apart from a visit to Italy in 1450.*

Robert Campin, whose life apart from his birth at Tournai is obscure (and even his birthplace is not certain) is a case in point. It seems likely that his work is often ascribed to the so-called Master of Flemalle (a term used to describe an artist who is only known by the one work it nominates). His most famous work is the *Merode Altarpiece.* The careful painting of the interior, the precision of the forms and the sharp angularity of the folds in drapery are characteristic of the Flemish school.

Also from Tournai was Rogier van der Weyden and a student of Campin's. It is possible that he visited Italy but his work shows no evidence of it and his *Deposition* with typically Flemish precision treats a number of figures in an almost frieze-like expression of the anguish of the scene. The drawing of the body of Christ has a strong sense of physical presence as well as anatomical authority.

Jan van Eyck worked mainly at Bruges. His work, like that of Campin, shows the influence of the miniaturist and there is an almost startling quality of detail in his work which has hardly been equaled. Both the *Arnolfini Wedding Portrait* and *The Madonna with the Chancellor Rolin* reveal in the details of the background of each work a minute clarity, in the first of an interior and the second of a distant view across the clean, busy town.

The difficult and enigmatic work of Hieronymus Bosch has engaged the attention of students of both art and the occult. His work is an early example of that form of fantasy and imagination that we now call Surrealism. Of course, although he is one of the most dedicated of such painters (few of his paintings do not contain obscure and fantastic elements), he lived in an age when obscure symbolism was commonplace and his paintings have now acquired

an interest which derives not so much from what they were intended to say when they were produced, as from a power of psychological imagery which has not been equaled. The small reliquary with painted panels by Hans Memling, another painter of Bruges, has all the delicacy of a miniature.

Architecture and such sculpture as there was does not show the same creative quality as the painting, being firmly fixed in the Gothic tradition.

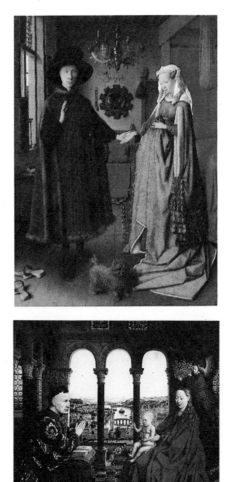

The Arnolfini Wedding Portrait, *1434*
Jan van Eyck (d 1441)
Oil on panel 32×23½in (82×60cm)
The National Gallery, London

The Madonna with Chancellor Rolin, c. *1435*
Jan van Eyck (d 1441)
Oil on panel 26×24½in (66×62cm)
Louvre, Paris

There is no recorded detail of the early life of Jan van Eyck and first evidence of his activity as a painter dates from 1422. In 1425 he entered the service of Philip the Good, Duke of Burgundy, and thereafter was frequently sent on diplomatic missions on behalf of the Duke, for example, to Spain and Portugal in 1429. By 1434 Van Eyck was married with one son and had bought a house in Bruges, where he settled. He was receiving a salary from Philip the Good; documents exist to show that in 1435 he had some difficulty in persuading the authorities to release the money, a matter that was settled by the Duke's own intervention. Van Eyck's marriage portrait of Giovanni Arnolfini, a silk merchant, and Giovanna Cenami stands as a witness to the ceremony. It is inscribed Johannes van Eyck fuit hic *("Jan van Eyck was here") and dated 1434. It is supposed that the portrait represents Arnolfini, though this cannot be proved conclusively, and a later single portrait (Staatliche Museen, Berlin) shows the same man. The marriage souvenir is more complex than a simple portrait record, being full of symbolism relating to the vows and customs of marriage. The detailed imagery in the mirror reflection shows two other figures, thought to include the painter.* The Madonna with Chancellor Rolin *is a fine example of the custom of painting portraits of officials in association with religious scenes, as celebration of their value in both the religious and secular affairs of the time. Van Eyck's portraits are notable for the detail and characterization he achieved, owing much to the subtlety of his technique. For many years Jan van Eyck and his brother Hubert (d. 1462) were popularly credited with the invention of oil painting techniques. Their contribution was in fact to perfect a medium that had been tried relatively unsuccessfully over centuries. It allowed far more depth in the coloring and modeling of form than had been possible with the tempera medium previously in widespread use.*

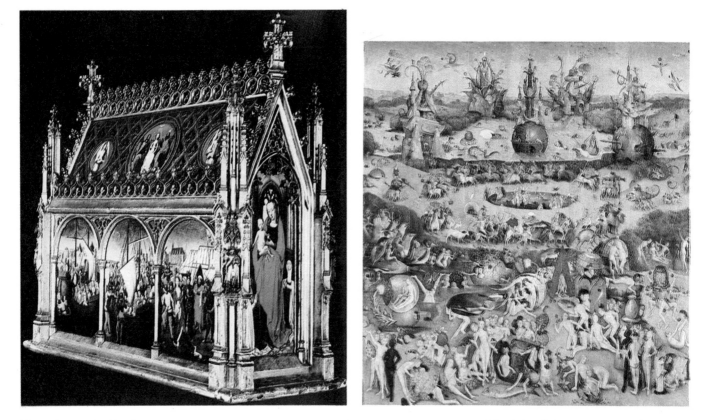

The Reliquary of St Ursula, *completed 1489*
Hans Memling (1430/35–94)
St John's Hospital, Bruges
34¼×35¾×13in (87×91×33cm)

*It is thought that Memling, although of
German origin, trained in Brussels with
Rogier van der Weyden. The first official
record of Memling dates from 1465 when
he acquired citizenship of the town of
Bruges. Possibly Memling decided to move
there from Brussels after the death of van
der Weyden in 1464; certainly his style
derived more from Flemish than from
German traditions. Tax records show that
Memling became extremely affluent – his
patrons were from the leading families of
Bruges, wealthy merchants and bankers.
Several major works were commissioned for
donations to St John's Hospital in Bruges.
The reliquary of St Ursula was commissioned
by two sisters, who appear beside the
Virgin and Child in a panel at one end of
the shrine. The main panel shows the
Legend of St Ursula and the eleven thousand
virgins.*

Garden of Earthly Delights, *center panel,
1505–10*
Hieronymus Bosch (1450–1516)
Oil on panel 86⅝×78in (220×195cm)
Prado, Madrid

*Little is known of the life of Hieronymus
Bosch; no letters or diaries remain and such
detail as can be authenticated is taken
mainly from references in municipal records
of the Dutch town of s'Hertogenbosch,
where he apparently spent his whole life
and from which he took his name. His
family name was Jeronimus van Aken and
the first reference to his adoption of Bosch
as surname occurs in a commission for an
altarpiece for Philip the Handsome, Duke of
Burgundy, of 1504. Other members of his
family were involved in the arts and were
members of the Brotherhood of Our Lady,
through which Bosch received commissions
for church decorations. All of his extant
paintings are undated, making it difficult for
historians to unravel the progress of his art.
Critical and academic studies of the* Garden

*of Earthly Delights have attempted to
decipher the complex and unembarrassed
symbolism of the large triptych, with its
peculiar forms and overt sexual references.
Theories that it related to a heretical
underground sect, while providing much
colorful speculation, have been discounted
mainly on the grounds that Bosch's known
patrons were generally quite conventional
figures. It is rather thought that the pictures
are a personal embroidery of accepted
medieval allegories and proverbs later
forgotten. When the two wing panels are
closed, the outer surface of the work shows
a representation of the creation of the world,
contained within a crystal sphere, far more
restrained in color and figuration than the
inner scenes.*

Netherlandish art in the 16th century

The same lack of creative development or understanding of the Renaissance (although its forms were used in such buildings as the Town Hall of the Hague, derived from the earlier town hall at Antwerp), is found in 16th century architecture as in the previous century. The influence of Italian art is evident in the work of the bronze sculptor Adrien de Vries (*c*.1560–1626), but his work is found mainly in Germany and Bohemia. His *Hercules Fountain* at Augsburg, where he lived, is his most notable work.

It is hardly necessary to remind ourselves that the Reformation and its aftermath dominated the century. It has impinged on all that we have had to say in almost every country. Protestantism gained strength in the Low Countries and while Quentin Massys, or Metsys (14650–1530) and Jan Mostaert (*c*.1475–1556) produced work of some interest, the most important artist of the 16th century in the tradition of Netherlandish realism, but also with a sense of fantasy, is Peter Breugel the Elder (*c*.1564–1638). His disgust with humanity finds a concomitant of sympathy never far from the surface of his work.

One last painter should be mentioned. The great age of Dutch landscape painting, and indeed of Dutch painting generally, was to come in the 17th century, but a curious and endearing early example of a basically landscape painter of the early 16th century is Joachim Patenir (d.1524). Although landscape painting was not an acceptable form until later in the 17th century, a passion for landscape reveals itself. For Patenir the romance of rocky landscape calls, but in the flatness of Holland he had to invent it for himself. The result is some charming and strange paintings; the strangeness, indeed, of Bosch, Breugel and Patenir.

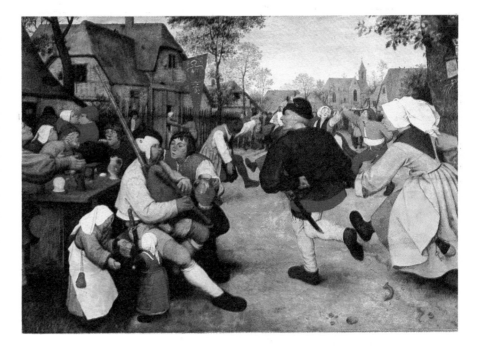

Peasant Dance, c.*1557*
Pieter Breugel the Elder (1525–69)
Oil on canvas 44⅞×64⅝in (114×164cm)
Kunsthistorisches Museum, Vienna

One of a family of painters, Breugel worked first in Antwerp and later in Brussels. With Bosch he is the greatest of the 16th-century Flemish painters, and his genre paintings express the peasant life of the Low Countries in an emotionally realist way. This picture is one of the finest large-scale figure compositions of peasant life. Most of his works have a moral lesson to teach, and the viciousness underlying peasant life can be seen in the quarrel which has broken out.

Hercules Fountain, *1602*
Adriaen de Vries (c.1550–1626)
Bronze
Augsburg, Germany

De Vries was a pupil of Giovanni da Bologna and became court sculptor to Rudolph II. The Hercules group shows Bologna's powerful influence.

The Renaissance in the German Lands

When we consider Germany and Austria we are talking of the area, roughly, of the Holy Roman Empire north of the Alps, and including Bohemia (now part of Czechoslovakia). Italy lay to the south, the Low Countries and France to the west and Poland and Hungary to the east. Although it is often maintained, and with some truth, that well into the 16th century Germany retained many characteristics of a medieval society, two of the greatest representatives of German Renaissance painting were working early in the 16th century – Albrecht Dürer (1471–1528) and Hans Holbein the Younger (1497–1543).

Both were contemporaries of Luther and lived through the birth of the Reformation. We have noted elsewhere the importance of the religious dissensions at this time and that this greatly significant development in Western society was initiated in Germany where it had an important effect on the arts. In such a collection of small semi-independent states and cities, the responsibility for choice in faith was as personal a matter in Germany as anywhere in Europe. Nowhere was individual faith so tested or subject to so much questioning. Religious belief was a more important factor in everyone's life in Europe in the 16th century than it usually is today. Life was founded in either Protestantism or Catholicism for everyone. The choice confronted artists in the same way that it did everyone else, but for them it would be manifest in their work – and their work would be in some ways directed by their faith. In Germany, these crises of conscience were allied to a national seriousness of nature which has sometimes been seen as harshness. The result has been that among the Germans the problem of the nation state has seemed to evoke more anguished emotional responses than is observable

in other societies. Neither the heart-searching nor its expression in art is, of course, restricted to the issue of Protestantism versus Catholicism, and in the case of German art it has produced a general lack of what might be described as felicity even in the most admirable artists, such as is Dürer. The consequence is that German art is often not naturally likeable when it is most effective.

The beginnings of a real German style can be seen in the work of the north German artists influenced by the Flemish artists Van Eyck and Campin, such as Martin Schongauer (d.1491) and Konrad Witz (c.1400–44), whose place between a medieval realism and Renaissance consciousness can be seen in such works as Witz's *Miraculous Draught of Fishes*, where the landscape and the figures are lit by a rich sunlight which is modern in feeling. Indeed, Witz has been credited with the first modern landscape.

The interest in landscape shown by Witz is found in other artists in the century such as Albrecht Altdorfer (c.1480–1538), whose paintings of the upper Danube valley establish him as an early landscape painter of importance, although his most famous work is his *Battle of Alexander and Darius* (1529).

The extreme of emotional expression is found in the work of Matthis Grunewald (c.1470–1528), the disturbing visual violence of whose painting is seen most dramatically and completely in the panels of the *Isenheim Altarpiece*. The Crucifixion panel is one of the most anguished works in the whole of European painting. Its inspiration is medieval, while its execution shows the beginning of a Renaissance technique. The greater part of his work was completed before the Reformation but it most clearly indicates the intensity of spiritual feeling that permeated Germany at the time. The expressionist

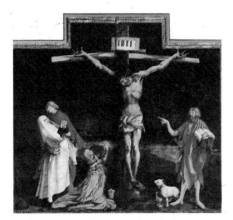

The Isenheim Altarpiece, *completed 1515*
Detail – The Crucifixion
Mathis Neithardt-Gothardt, called Grunewald, (c.1470/80–1528)
Oil on wood panel 106×120in (269×307cm)
Musée d'Unterlinden, Colmar, France

The Isenheim Altarpiece is the best known work of the artist commonly called Grunewald, the name mistakenly attributed to him by a 17th-century biographer, Joachim von Sandrart. At the time when the altarpice was painted Grunewald was employed as painter, architect and superintendent of works to the Elector of Mainz, and evidence suggests he remained in this situation until 1526 (his career is not fully documented). The altarpiece was undertaken on commission for Guido Gersi, the Sicilian administrator of the convent and hospital run by the Antonite Order at Isenheim in Alsace. The Crucifixion is the central panel of the work and is flanked by wing panels depicting St Anthony and St Sebastian. A lower panel shows the Entombment of Christ.

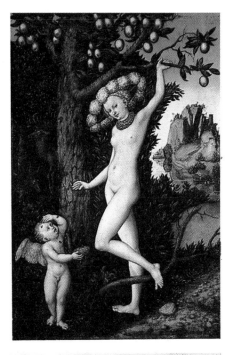

Miraculous Draught of Fishes, *1444*
Konrad Witz (c.1400–44)
Oil on canvas 52×60in (132×154cm)
Museum of Art and History, Geneva

Witz was a Swiss painter who produced his major works at the time of the Basle Councils of the Church. This picture, set in a spacious landscape studied from Lake Geneva, is the most effective of his strongly naturalistic work.

Cupid complaining to Venus, *1532*
Lucas Cranach (1472–1553)
Oil on wood 32×21½in (81×54.6cm)
National Gallery, London

Cranach worked originally in his birthplace, Kronach, from which his name is derived. After a period spent in Vienna he was invited to become court painter to Frederick the Wise, the Elector of Saxony. Cranach settled in Wittenberg, where he set up a large and busy workshop. His sons, Hans and Lucas the Younger, joined him there as assistants. In 1508 Elector Frederick gave Cranach his own coat of arms and from this he derived a special symbol – a winged snake –which appeared with his monogram on all his paintings. Cranach prospered in Wittenberg and, in addition to his activities as court painter, he became joint owner of a bookshop, printing works and paper mill. After the death of Frederick he continued in the service of the successive Electors, John the Constant and John Frederick the Magnanimous.

This painting shows Cupid, stung after raiding a bees' nest, complaining to Venus.

The Piece of Turf, *1503*
Albrecht Dürer (1471–1528)
Watercolor and gouache on paper
16×12½in (41×31.5cm)
Albertina, Vienna

Particular to Dürer's talents was an incessant curiosity and patience in recording all sorts of visual impressions, strengthened by his complete mastery of a variety of painting and drawing techniques. Unusually for the time, many of his outstanding pieces were executed in watercolor. Some, like the records of his return journey from Italy at the end of the 15th century, are broad sketches of landscape, and others, as in The Piece of Turf, *are extremely delicate records of detail of apparently insignificant objects. This same precision was applied to his woodcuts and engravings. In general, the traditions of the time relegated landscape to a decorative background role in figure compositions, where it was subject to a number of pictorial conventions. Dürer was one of the first artists to give landscape a major role and to study it carefully for its own sake.*

qualities in his paintings may be seen as something of a national characteristic since, four centuries later, the work of the modern German Expressionists and other modern German painter reflects the same intensity.

The most important painter directly affected by the Reformation and a devote friend and admirer of Luther (he was at Luther's engagement fsstivities and painted his portrait) was Lucas Cranach the Elder (1472–1553). His work incorporates something of the views of Luther, but who is also a curious and instructive mixture of many different strands of influence. There is firstly his strong Gothic attachment and in his early pre-Reformation religious works the medieval spirit is dominant; there is also something of the charm of the International Gothic in his work. There is also the influence of the Renaissance in his paintings of mythological subjects, particularly in a number of nudes he painted, as for instance the *Venus* at Frankfurt. There is a naivety and freshness as well as something of Mannerism (similar to the French Mannerism seen in the Fontainebleau School). But it is his portraits, which show a genuine human sympathy as well as accomplished draftsmanship, that reveal his art at its finest.

In the work of Dürer and Holbein the highest point in German Renaissance art is reached. Both Dürer and Holbein are sometimes seen as representative Reformation artists, and while they were affected by the growing religious dissension, Dürer's art is pre-Reformation in time (he died in 1528), and Holbein removed himself from the scenes of controversy – first to Basle in Switzerland, where Erasmus was a figure of great Humanist influence and, later, to London. Both were centers of Protestantism.

Albrecht Dürer stands supreme as a representative of the northern Renais-

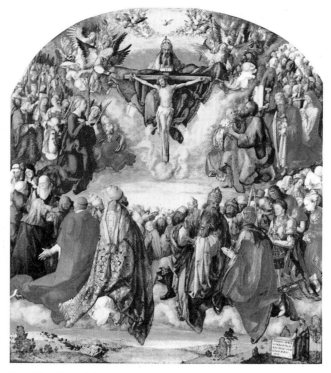

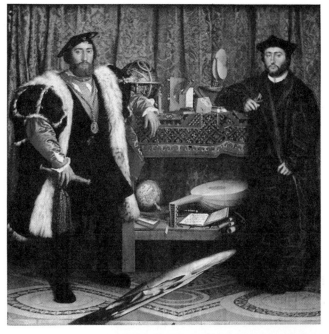

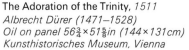

The Adoration of the Trinity, *1511*
Albrecht Dürer (1471–1528)
Oil on panel 56¾×51⅝in (144×131cm)
Kunsthistorisches Museum, Vienna

Dürer was already known locally in Nuremberg before his second visit to Italy in 1505, and on his return in 1507 he became something of a celebrity. The work was constantly in demand. The altarpiece showing the Adoration of the Trinity *was commissioned in 1508 by a coppersmith named Matthäus Landauer as a decoration for the chapel of an old people's home that he had endowed. Dürer was considerably occupied during the following period. In 1509 he bought a house in Nuremberg where he installed a printing press and began to produce new editions of his engravings and he was reluctant to accept a commission that demanded a heavy commitment of time and energy, but the drawing presented to Landauer as the proposal for the work shows his careful preparation; he conceived it from the start in conjunction with an elaborate frame and constructed the work as a whole. The design was modified and the frame itself is now exhibited separately at the Germanisches Museum in Nuremberg. The painting of the altarpiece was completed in 1511..*

The Ambassadors, *1533*
Hans Holbein the Younger (1497/8–1543)
Oil and tempera on panel 81½×82½in (206×209cm)
National Gallery, London

Holbein settled permanently in London in 1532 where he became acquainted with Thomas Cromwell, minister to Henry VIII. Through Cromwell Holbein obtained the commission for this double portrait of the French ambassadors to London, Jean de Dinteville and Georges de Selve, Bishop of Lavour. The painting is crammed with symbols pertaining to the contemporary debate between Humanism and religion, and contains one of the most famous examples of anamorphism – the depiction of an object so distorted that it can only be seen in proper perspective from one viewpoint – in the elongated skull across the foreground. In 1536 Holbein became court painter to Henry VIII. Unlike his famous patrons More and Cromwell, both of whom were executed after incurring the displeasure of the King, Holbein contrived to maintain a good relationship with Henry.

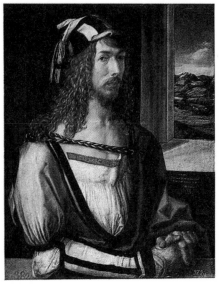

Self Portrait, *1498*
Albrecht Dürer (1471–1528)
Oil on panel 20½×16⅛in (52×41cm)
Prado, Madrid

This powerfully direct self-portrait, is one of the earliest independent assertions in art of the artist as a personality in his own right.

sance and is one of the greatest creative figures in Western art. Although in his later years much affected by the religious conflict around him, his early work is the result of his travels through Germany, the Netherlands, and, most importantly, northern Italy. Like most of his contemporaries who visited Italy, he was deeply responsive to the relaxed atmosphere of sophisticated accomplishment that he encountered on his first visit to Venice in about 1494/5. His *Self Portrait at Twenty-Seven*, in which he paints himself in fashionable Venetian dress, is a confident expression of his wish to be associated with the Renaissance. Dürer shows the interest of the universal Renaissance man in his range of subject matter, his technique, his intellectual curiosity and his self-confidence. His studies of landscape and animals, beautifully rendered in watercolor, have little of the medieval feeling found in most of his contemporaries and his great religious paintings, although with something of the German harshness, may be

compared with the Italian religious paintings in accomplishment.

Perhaps his greatest achievement is in the large number of engravings that he produced through all his working life. Sensitive and fluent draftsmanship reveals his mental stature and wide range of interests.

Late in his life he planned a number of religious works which he never completed – the Protestant embargo on religious representation overtook him. The Protestants determined that their forms and places of worship should not be like the Catholic's. They desired clarity rather than obscurity and saw in the highly decorated Catholic Churches a sentimental departure from the reality and simplicity of the life and teachings of Christ. They therefore banned the decoration of churches, giving rise to simple interiors without the representation of religious images.

The work of Holbein, which reflects another aspect of the northern Renaissance, is best seen in his portraits. He was one of the greatest portrait painters

in Western art. In some ways portraiture is an essentially Renaissance activity and indicates the aspect of Humanism which emphasizes personality and capacity, individuality. The portrait identifies, it destroys anonymity, it offers a single person for universal scrutiny. The portraitist analyses and evaluates, selects and, in the process, makes judgements and revelations. At its worst portraiture can be wretched face-copying of undistinguished sitters. At its best – in the hands of a Holbein or Rembrandt – it can be a revelation of the depth of feeling and all the emotions that humanity is capable of. In the process of studying one sitter the artist may say something about all sitters. William Blake, a 19th century English poet and painter, asked in a side note, "Of what interest is it to art what a portrait painter does?" This irritated comment is a reflection of a continuing embarassment that is often felt in front of inferior portraits, but the work of such artists as Holbein establishes that it need not be so. His portrait of *Erasmus*, the leader of the return to dignified human achievement, is here shown with such simple means in a composition that lays emphasis on the head (mind), hands (action and writing), which must evoke the calm creative force of this great thinker in any viewer's mind. His painting of the *Ambassadors of France* shows the extraordinary quality of his draftsmanship, which is also seen in the many drawings of English court figures that he has left. It is the subtlety of his drawing, its apparent simplicity that leaves the deepest impression.

The architecture of Germany during this period is, as might be anticipated, a divided and unsettled area, with no developing unified philosophy such as one encounters in Italy. It looks back more to the medieval than forward to the Renaissance.

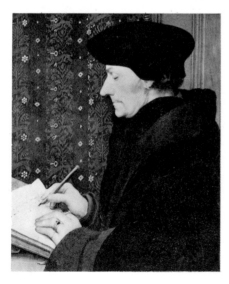

Erasmus of Rotterdam, *1523–4*
Hans Holbein the Younger (1497/8-1543)
Oil and tempera on wood 16⅞×13in
(42.6×33cm)
Louvre, Paris

Hans Holbein was the son of a painter of the same name living in Augsburg. He received his early training in his father's studio. At an early stage he began to work as an illustrator and became acquainted in Basle with the printer Johann Fröben. Holbein set up a practice independently in Basle, joined the painters' guild and worked on a variety of commissions including portraits, murals and religious decorations. During this time he also produced his famous series of woodcuts The Dance of Death. *The Dutch scholar Erasmus settled in Basle from 1521 and stayed at the home of Fröben. Holbein's portrait shows Erasmus at work, standing at his desk to write, as was his habit. Holbein arrived in England in 1526 and was able to find work quickly thanks to an introduction through Eramus to Sir Thomas More.*

The Renaissance in England: The Age of Shakespeare

Along with the Netherlands, England was in the early 16th century becoming one of the principal trading countries of Europe. As a Protestant country during most of the century, religious art was eliminated and one of the main sources of patronage as well as inspiration was removed. Perhaps it is thus not surprising that painting in England is not comparable to that in Catholic countries, even though the whole art of Europe was not at its best in this period!

The crown was now the only alternative to the Church as a patron and Henry VIII, if not an easy and relaxed Renaissance figure, was nevertheless a conscious enthusiast and he imported a number of artists from Protestant countries – most successfully, from Switzerland, the German Hans Holbein the Younger, who not only made the most famous likeness of the King but provided some inspiration to indigenous painters, such as John Bettes and the miniaturist Nicholas Hilliard (c.1547–1619), who in his turn was to produce the most notable portrait of Queen Elizabeth I. Queen Mary before her, in the midst of attempting to convert the country back to Catholicism, sat to the Dutchman Antonio Moro (c.1517–77), who also worked for her husband, Philip II of Spain. Another Dutchman, Isaac Oliver (d.1617), was a competitor of Nicholas Hilliard at the end of the century. In sculpture, too, the most important figures are foreign, the Florentines Giovanni da Maiano (1438–78) and Pietro Torregiano (1472–1528). It should also be noted that in the late medieval chapel of King's College, Cambridge, there is perhaps the finest example in England of Renaissance stained glass (showing Flemish influence) as well as a fine carved rood screen and wooden choir stalls in the new style.

It is however in literature and in architecture that the Renaissance spirit finds its fullest expression in England. It is not far-fetched to say that William Shakespeare (1564–1616) is, as poet, courtier and man of action, the summation of a Renaissance man. If he was perhaps not a man of the court in the full sense, and if his life of action on the stage did not have the chivalric glamor of the deeds of Queen Elizabeth's favorites, such as the poet and soldier Sir Philip Sidney (1554–88), the recklessly ambitious Earl of Essex (1566–1601) or that patron of the theater, the Earl of Leicester (1532–88), yet in his comedies (1592–1604) Shakespeare gives us the perfect reflection of the Italian Courts of Culture and their Humanist outlook, tinged with his own deep wisdom and understanding of human nature. He makes us so familiar with the character of the cultured, moody Italian duke – the poetic Orsino in *Twelfth Night*, Vicentio in *Measure for Measure*, the Duke of Milan in *Two Gentlemen of Verona*, the exiled duke in *As You Like It*, for example – and the mannered, dependent yet unruly entourage, that it is surprising to realize that Shakespeare probably never visited Italy. He absorbed its Humanism (expressed in his plays) and his Classical imagery (expressed in his poetry) from printed books and the atmosphere of the times.

In building, of which there was a great deal going on in the English countryside, the same Humanist and Classical models prevailed. The selling-off of monastic lands to the landed gentry under Henry VIII between 1536 and 1540 resulted in a demand for the construction of country mansions, especially once the possibility of a restoration of the Catholic Church under Mary (1553–8) had receded. Many large houses were built during the 16th century, from the early Suffolk Place (1521–27) to Wollaton Hall (1588) or Hardwick Hall (1590–7), said to be "more glass than wall", but

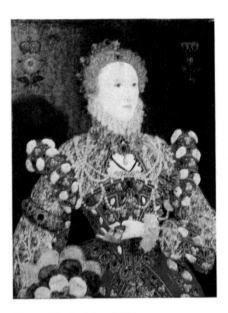

Queen Elizabeth I, c.1575
Nicholás Hilliard (c.1547–1619)
Oil on canvas 30¼×23½in (76.8×59.9cm)
Walker Art Gallery, Liverpool

Nicholas Hilliard was the son of a goldsmith and he and two brothers took the profession of their father. In 1556 Hilliard was sent to live in the home of a rich merchant in Exeter, England, and he accompanied the family to Geneva when they fled the new Catholic regime instituted by Queen Mary. On his return to England in 1562 Hilliard was apprenticed to Robert Brandon, a goldsmith and jeweler working for the court of Elizabeth I. By 1569 Hilliard was able to set up his own business and entered royal service. Apart from a brief visit to France in 1577 he continued work from his house and shop in London for thirty-five years, assisted in later years by his son Lawrence. At some stage in his training Hilliard had learned the art of limning, or miniature painting, and produced a number of portrait miniatures for members of Elizabeth's court, as well as larger scale portraits. He also completed a treatise on the art of limning. By 1617 Hilliard had a contract to the court of James I for all miniatures and engravings that might be required. However in the following year he was imprisoned briefly after standing surety for another person's debt and died soon after.

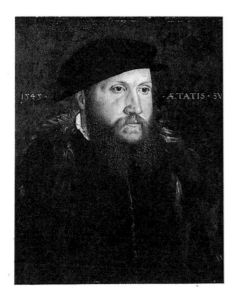

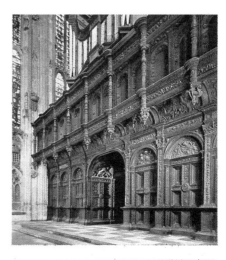

Man in a Black Cap, *1545*
John Bettes (active 1531–c.1576)
Oil on panel 16⅛ × 18½ in (40×47cm)
Tate Gallery, London

The influence of Holbein on English painting in the later 16th century is evident in this study of an unknown subject. Bettes was one of a number of painters who portrayed English Tudor society with a keen and meticulous eye.

Rood Screen, *c.1530*
Carved wood
King's College, Cambridge

This fine carved screen is one of the earliest examples of Renaissance wood carving. The Renaissance first expressed itself in the decorative arts through the work of French and Dutch craftsmen, and this screen is possibly an example of French workmanship.

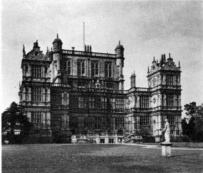

Wollaton Hall, *1580–88*
Robert Smythson (c.1556–1614)
Nottingham, England

Longleat, *1554, rebuilt after fire 1568–75*
Wiltshire, England

Hardwick Hall, *begun 1590*
Robert Smythson (c.1556–1614)
Derbyshire, England

These three buildings, from the first great monument of Elizabethan architecture Longleat, to the later Wollaton and Hardwick Halls, represent both extraordinary house-building and the establishment of a domestic-style Renaissance, that has no parallel elsewhere. The character of all these houses, the similarity of decoration on the roof-line, and in the strap-work, gives an extraordinary dignity which is repeated internally, and is also found in smaller and less pretentious Tudor houses.

the greatest, Longleat – probably rebuilt by the most important architect of such fabrics, Robert Smythson (c.1556–1614), also responsible for Wollaton and Hardwick – remains the most impressive and largest monument of Elizabethan architecture.

Tudor country houses followed the central court plan, derived from the castle, which, in England, has always been the Englishman's home. The change from fortifications of practical use to the defensible house, set sometimes in an ornamental and usually dry moat – to the large house defended only by its inaccessability in its own extensive lands, is the pattern of development from the 13th to the 16th century.

During this century an attractive style of domestic architecture, the Tudor wood-frame structure with infill panels of wattle and plaster, became popular and widespread, deriving from the earlier cruck construction. So popular has it remained that it still appears as a decorative veneer on a great number of suburban housing developments.

The Expansion of Europe: The Seventeenth Century

The Background to 17th-Century Europe

In the second half of the 16th century Europe was dominated by the religious and political consequences of the Reformation. By the 1550s Protestantism could no longer be seen as a short-term heretical movement nor one that had only religious significance. The divisions within Christendom caused by the Reformation were politically useful to rulers wishing to increase their power. For this reason the religious wars in Germany were encouraged by princes who saw an opportunity to gain greater autonomy within the Holy Roman Empire. The political nature of these wars was reflected in the Peace of Augsburg of 1555, whose terms established that the religion of a state – whether Protestant or Catholic – would be decided by the ruler, whose subjects, whatever their personal preferences, were expected to follow suit. Therefore Protestantism was accepted as an alternative to Catholicism and could not be eliminated on the grounds of combating heresy.

At the time it must have seemed possible that Protestantism had the potential to oust Catholicism across the whole of Europe. The Catholic Church recognized the need for internal reform and a clarification of its position in a Europe that now had an alternative form of Christianity; it also required a combative element to win back areas lost to Protestantism. This formed the basic elements of the Counter-Reformation. After initial attempts at reconciliation the papacy veered toward a more stringent orthodoxy. At the same time in Europe there was a call for a general council of Christendom to find a common ground between the two groups, which resulted in the Council of Trent (1545–63).

While the Council did not reach a settlement between the Catholic and Protestant causes, it did clarify definitions of Catholicism, thereby opening the way for a concerted assault on heresy.

Religious orders, especially the Jesuits, applied this newly established orthodoxy against all deviants. Founded in 1540 by St Ignatius Loyola, the Jesuits were an elite group and responsible only to the pope. They were trained with thoroughness and dedication to one purpose: to fight Protestantism. One of their main strategies was to use education toward this end and by 1600 they had founded at least 372 colleges, winning back new generations of Catholics for Rome. The Jesuits had early successes in Austria, Hungary and France.

The balance between Catholicism and Protestantism did not always lean toward the former. Italy, Spain and Celtic (non-English) Ireland adhered consistently to the Catholic Church, but there was no other state that could with certainty be called permanently Catholic or Protestant. Although parts of France remained Catholic, the country was divided by religious wars for most of the period between 1550 and 1600, and endured a succession of regimes that could neither embrace Protestantism nor eradicate it. England reverted to Catholicism under Mary I in 1554, only to become more deeply Protestant under Elizabeth I in 1558. Scotland was for a while pulled between the Catholicism of the royal family and the Protestantism of the preacher John Knox, and a similar uncertainty hung over much of the rest of Europe. By 1600 the Counter-Reformation had reclaimed Bavaria and the southern Netherlands; Poland returned to Catholicism under Sigismund III; Catholicism began to dominate Austria and Germany, and France had appeared to become more stable under Henry IV, who had converted to Catholicism in 1593.

Nevertheless, Catholic rulers in nearly all of these countries had to make concessions to strong Protestant groups, allowing them political freedom and degrees of autonomy. Meanwhile, Scandinavia, Scotland, England, the United Provinces and parts of Switzerland and Germany were resolutely Protestant. As the Catholic Church was organized for a bold attempt at reconverting these firmly Protestant states, the period between 1600 and 1650 was another era of religious wars.

Religion, politics and economic factors were perhaps more strongly linked during the period 1550–1650 than in any other, largely because religious issues were mixed into existing dynastic and national tensions to generate even greater conflict. The political weakness of France during the Wars of Religion meant that France could not counterbalance activities of Habsburg Spain – its traditional enemy – leaving Italy dominated by it. Only in the 1590s did peace in France to some extent restore the balance of power in Europe. Relations between England, Spain and the Netherlands were symptomatic of the indissoluble tie between religion and politics. In the eyes of the Spanish government, the United Provinces' struggle for independence as a Protestant nation was both the revolt of a subject state and the rise of heresy. Similarly, English aid to the United Provinces, however small, was politically and religiously distasteful to Philip II of Spain, and resulted in the Spanish Armada being sent to England in 1588 and continued warfare in the Netherlands.

The general economy of Europe

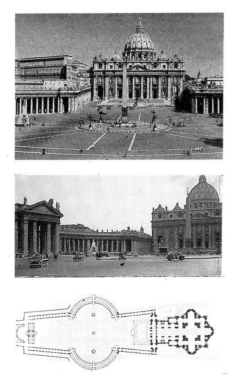

The Piazza before St Peter's, *Rome, 1656–7*
two views and plan
Gianlorenzo Bernini (1598–1680)

Bernini was fully restored to his position as architect to St Peter's on the accession of Pope Alexander VII in 1655. His major project of the following year was the design of the Piazza in front of the church, where the faithful gathered on ceremonial days to hear the blessing of the Pope. Bernini created a vast oval surrounded by colonnades, open at the approach from the town and linked to the church at the opposite side by a trapezoid courtyard. Maderno's modification of the facade of St Peter's was felt to be too wide and low, owing to the inclusion of lateral extensions intended to form the bases of bell towers. Bernini failed to erect the towers in an earlier project, but with the Piazza succeeded in correcting the apparent proportions of the church by keeping his own structures low in relation to the facade. He regarded the curving colonnades as symbolic of the arms of the church embracing its believers. The original plan continued the colonnade towards the town, drawing in the exit from the Piazza, but this section was never built.

experienced inflation throughout the 16th century and the fact that prices increased faster than wages caused food riots among the urban poor, which often embraced religious issues as well. Europe was also affected by substantial growth in population throughout the century. In 1500 only four cities, including Milan and Paris, had a population exceeding one hundred thousand; by 1600 London, Amsterdam, Palermo, Lisbon and Seville were added to that category. Growth was equally prevalent in smaller cities: the populations of Strasbourg, Vienna and Hamburg rose from 20,000 in 1500 to 40,000 in 1600. The English population rose from three and a half million to five million in the same period, while the Holy Roman Empire increased from twelve million to twenty. This increase put an unprecedented demand on food supplies, which could not be met and resulted in widespread famine in Spain, Italy and parts of France. The famines were an indication that the Mediterranean countries could no longer feed themselves, and from the 1590s grain imports from northern Europe became essential to sustain the increased population. This trade was most successfully served by the Dutch and British, and the Venetians began to lose their former commercial pre-eminence in Europe.

Rome

The uncertainties of the 16th century led princes to want to increase the effectiveness of their rule in all areas, especially in matters of taxation. This was also true of the popes who were both temporal and spiritual rulers in their dealings with the Campagna, the lands politically subject to Rome. The popes had also lost a large amount of income from the Protestant secession and began to look for alternative sources of revenue. To a certain extent both goals were achieved. Taxation in

the papal states increased ten-fold between 1500 and 1600, outstripping inflation, while so many ecclesiastics were appointed to administrative posts in papal lands that it led to fears of tyranny. In 1570, as another means of increasing revenue, Pope Clement XIII began to investigate the title deeds of all barons holding lands as fiefs of Rome, resulting in numerous castles being claimed by the papal government. This caused a rural aristocratic revolt, which lead to widespread banditry, while famine and economic disasters in Europe contributed to political unrest. It was only in the 1590s that systematic policing began to curb this violence. Meanwhile, the popes were busily attracting the nobility away from their lands to a new and desirable Rome.

The embellishment of Rome in the 16th century increased as various popes threw themselves optimistically into creating a city that was to be the figurehead of the Counter-Reformation. Rome grew from thirty thousand to many times this figure during the century, due partly to its reconstruction by successive popes. The re-planning of the city began before the Reformation with the rebuilding of St Peter's. The Sacking of Rome in 1527 by the troops of Charles V, and the insecurity of the papal position as the Protestant revolt gathered momentum, halted progress until the Counter-Reformation and the Council of Trent restored the determination of the papacy to make Rome the center of the Catholic revival. As the Puritanical element of the Counter-Reformation relaxed from the 1570s onward, luxurious decoration and ostentatious display were deliberately fostered as a manifestation of papal confidence. Rome became a visually magnificent magnet for tourists and pilgrims, manifesting itself as the capital city of Catholicism. Tourism became the city's

The Nature of Baroque

livelihood; attempts to introduce manufacturing industries failed. In 1600 Rome was able to accommodate half a million pilgrims and live off their money, supplemented by the expenditure of cardinals resident in the city.

The replanning began in earnest with the reconstruction of the Capitol from plans by Michelangelo in 1564. This was followed by a systematic destruction of medieval Rome by successive popes, especially Sixtus V (1585–90), to create impressive vistas, façades and buildings suitable for the image the papacy was fostering for its capital city. Squares were designed all over Rome with obelisks and statues to act as focal points. Provincial nobles of the Campagna and clerical officials resident in Rome vied to glorify themselves in a way that simultaneously advanced the prestige of Rome.

The creation of a monumental new Rome as a reflection of the resurgence of papal power and confidence was in many ways similar to Louis XIV's building of Versailles in the 1670s in that both were manifestations of a desire to impress Europe with displays of grandeur that underlined the prestige of their creators. Unlike Versailles, where all of the magnificence was dependent upon the king, Rome in the late 16th and early 17th centuries benefited from its impact on its admirers and so grew further.

Baroque Rome, in its architecture, painting and sculpture, was the initial creation of the Counter-Reformation's effect on the papacy. It continued as such through much of the 17th century with Rome as the sole patron, drawing artists from the now declining centers of the Renaissance, such as Florence, Milan and Venice.

Culturally the Counter-Reformation period witnessed a shift southward, away from Florence and Venice to Rome where the extensive rebuilding of the city, generated by Pope Sixtus V attracted artists, sculptors and architects. Baroque art was the creation of artists in response to the demands of the Counter-Reformation Catholic Church and the potential of art to enforce religious orthodoxy was recognized. The Council of Trent decided that "by means of the stories of the mystery of our Redemption portrayed by paintings or other representations the people be instructed and confirmed in habit of remembering and continually revolving in mind the articles of faith". Subsequently, an artistic code of conduct was created by theologians and rigorously supervised by the religious authorities. The Council dictated that artists depicting religious events had to ensure the Biblical accuracy of their paintings and that the paintings had to be as realistic as possible so that they could be understood by even the simplest of worshippers to stimulate religious piety. While the immediate results of this close supervision of works of art had none of the rich and dramatic intensity characteristic of the Baroque, art as an instrument of propaganda was now used to greater effect to glorify God, promote the Catholic faith and heighten the religious and emotional experience of the devout and dedicated believer.

During the Baroque period, as in the Renaissance, the Church was a ubiquitous patron and courts and the aristocracy remained another important source of commission. The Bible and classical mythology were the primary subjects in painting; churches, palaces and great houses in architecture; and tombs and personal monuments in sculpture. As the period advanced, new subject matter, reflecting a shift in taste and demand, appeared in painting and sculpture, but essentially the arts followed the pattern established in the Renaissance.

The 17th century beckoned to an age of accomplishment for which the 15th and 16th centuries had laid the foundation; the world of the 17th century seemed larger through geographical explorations and intellectually more complex. The Renaissance had inspired a strong and lasting search for truth in Western societies overlaid by a thousand years of increasing Christian spiritual dominance which, in the 17th century, became characteristic of the age. Science flourished as did the arts, and from this time on, for the educated and the privileged, life was to be filled with intellectual exploration, the fanciful or serious elaboration of ideas, displays of talent and the recognition of individual genius. These concerns lead to piety and scientific knowledge, as well as to a love of excess, theatricality and artificiality.

There were, of course, still difficulties, not the least being that the values offered by the Catholic Church, couched in inspiring and mystical terms, did not fit comfortably with the ideas of Humanism; God and Man could not both be at the center of creation. But with the new intellectual freedom, supposedly inviolable truths could be examined and perhaps a compromise reached. In some measure the Baroque may be seen as an expression of the compromise of faith with intellectual freedom; it may express the conscious confinement of God within man's created institutions. The aspiring nature of the Baroque is expressed in the facility of the artist: he creates the sentiment and thus it is his creation rather than God's, in the way that the dome created by the artist represents and contains the heavens, at one time believed to be created by God.

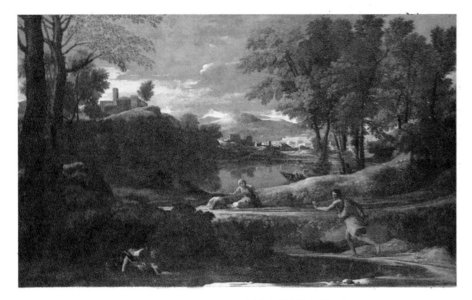

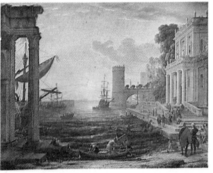

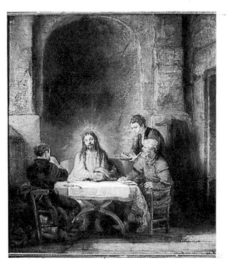

Landscape with a Man Killed by a Snake,
c.1648
Nicolas Poussin (1593/4–1665)
Oil on canvas 47×78¼in (119.4×198.8cm)
National Gallery, London

The French painter Poussin settled in Rome
at the age of thirty. He arrived in the city
with an introduction to Cardinal Francesco
Barberini, but this potential patron was away
on a papal mission and Poussin's early years
in Rome were a struggle for recognition.
In 1629 he took lodgings with the Dughet
family. The sons, Gaspard and Jean, were
both artists; Gaspard became a pupil of
Poussin and later took his surname as a
mark of respect. In 1630 Poussin married
Gaspard's sister, Anne Marie. He was by
then better established, having carried out
his first public commission, an altarpiece for
a chapel in St Peter's, in 1628. His paintings
of the 1630s and 1640s were mainly of
religious and mythological subjects. The
Landscape with a Snake *is thought to have*
originated from a local incident that occurred
probably in about 1641. The painting
represents a very prolific period in
Poussin's career and is one of several
landscapes painted in the same year.
Poussin's working method was described in
biographical methods: to create the correct
impression of space, form and light in large
compositions he constructed small
"theaters" in which he placed wax models
representing the figures. He habitually made
drawings from these models before
embarking on a full-scale composition.

The Embarcation of the Queen of Sheba, *1648*
Claude Lorrain (1600–82)
Canvas mounted on wood
58½×76¼in (148×194cm)
National Gallery, London

Claude Gellée, known as Le Lorrain, was,
like Poussin, an expatriate Frenchman
living in Rome. He arrived there at an early
age and initially earned his living as a pastry
cook until he established a reputation as an
artist. In 1625 he returned to France for a
period of work at Nancy, but in 1627
settled permanently in Rome. He attracted
some important patrons, including Pope
Urban VIII. Claude was a close friend and
companion of Poussin and the two artists
were in the habit of making sketching tours
in the countryside. In 1635 Claude began
the drawings for his Liber Veritatis, *a*
pictorial record of all his major works that
has proved invaluable in identifying and
dating the paintings made from them.
Claude's work remained extremely popular
throughout the 18th and 19th centuries and
had a profound effect on the development
of landscape painting.

Christ at Emmaus, *1648*
Rembrandt van Rijn (1606–69)
Oil on panel 27×26in (68.5×66cm)
Louvre, Paris

The 1640s were a period of decline for
Rembrandt. Commissions were few and far
between after the Night Watch of 1642 and
he suffered a personal and financial loss
after the death of his wife, Saskia, in the
same year. In 1648 he was sued by
Geertghe Dircx, his housekeeper since his
wife's death, who claimed that Rembrandt
promised to marry her. Rembrandt was
considerably harassed by her behavior and
in 1649 was ordered to pay her two hundred
guilders compensation. His problems were
not over as she was later committed to an
asylum and he had to contribute to her
upkeep there. However, during this same
period he became acquainted with
Hendrikje Stoffels, who took care of his
life and his business affairs during his later
years. During this period he was busy with
drawings, etchings and paintings on
mythological and religious themes, (the
subject of Christ at Emmaus appears more
than once) and also produced etchings of
himself and his environment, for example,
compositions based on the artist and model
in the studio and an etched portrait of
himself at work on a drawing.

If the Baroque could be identified only with this new religious sentiment and energy, its analysis would be relatively clear-cut, but the expansion of Europe was also expressed in intellectual enquiry, a consideration of proper forms of government and colonialism. In the arts this was reflected in Realism, the presentation of the appearance of a subject that ranged from highly illusionistic sentimental 17th century Spanish polychrome sculptures to the subtle, penetrating paintings of Rembrandt van Rijn (1606–69). It is in Michelangelo Caravaggio (d.1610) that this truth to appearance – or as will be seen later, apparent truth to appearance – is given its first powerful impetus. Classicism, a recurrent preoccupation in Western culture, reflects another aspect of the age, and is seen in the work of such artists as Nicolas Poussin (1594–1665) and Claude Lorrain (1600–82), as well as in the architecture of Versailles.

At the beginning of the Renaissance the artist had been a craftsman – usually uneducated, often ignorant and sometimes illiterate. He came largely from the artisan class and accepted his role as a paid worker who had to be worthy of his hire in giving satisfaction to his employer; he might have been carving meat instead of sculpture. By the 16th century his status had so improved that rich patrons vied for his work; he was outside the continuing struggle for social recognition, he was educated and cultured and, most importantly, his individual genius was recognized and revered. What the artist might do or think had become one of the acknowledged determinants of the cultural character of the society.

From this time forward the artist was his own man and it was his personal, particular view of the world, his artistic philosophy and his unique style that patrons sought. Within this independence, however, lay the seeds of excess leading to vanity, conceit, arrogance and, of course, self-deception. It is easy to see oneself as a genius if everyone expects you to be one; a certain arrogance and complacency are common elements in the Baroque.

There were also those who enjoyed, valued or whose vanity was satisfied by association with artists. The "superiority" of the artist – something that has often engendered social snobbery even where there is little artistic ability – became a feature of Baroque society with manners becoming more important than matter, and form replacing content. It was not easy for those in awe of the artist to distinguish the one from the other and attitudinizing and elaboration became a feature of the age. The exaggerated modes of greeting, the piled and curled hair styles and the colorful luxuries of dress were the social expressions of this spirit: the sword, which in the Renaissance had been a necessary part of dress, became a theatrical prop. The artist began to live outside convention and it was accepted that he should. In this we recognize the modern "bohemian" artist and it is interesting to note that Caravaggio has been described as "perhaps the first consistent bohemian".

In Baroque art the first and most important element is the expression and manipulation of space. As we have already seen, the artist – as architect, sculptor or painter – is or may be involved with the illusion or indication of space. In the case of architecture this involves the creation of a three-dimensional object in space. The sculptor creates a space-filling object and may, by grouping figures or associating them with architecture, imply the use of space-linking elements. In painting, space between the elements creates the illusion of three dimensions.

The Renaissance artist was concerned with building a balanced and ordered space to satisfy his desire for a Classical type of control. The Baroque artist manipulated space and made it an emotional factor in the expression of his curiosity. There was, in fact, a preoccupation with what today we might call hyper-emotionalism. The idea of ecstasy – a trance-like, spiritual or mystical state – appealed to the sentiment of the period. The intellectual curiosity of the age looked outward and upward in its search for the immutable truths. In Baroque art space flows, is piled up and escapes like the spirit of Baroque man. Everything is flux and movement manipulated by the spirit of the artist; the spirit and the mind can be seen looking upward together. This soaring movement is particularly evident in the rising vertical compositions and the upward glances of figures in painting and sculpture, even when not religious in content. In Baroque architecture the upward emphasis has a particular and revealing expression: the dome with surmounting lantern, a small turret with windows all around that crowns a roof or dome.

As we have seen, Renaissance architecture emphasized the horizontal. The Renaissance dome or cupola, which replaces the unequivocally vertical medieval spire, is the exception. The dome moves upward, expands and controls, representing the heavens as a confined form, suggesting, perhaps, that the heavens are part of man's control. In the Baroque period the lantern has the effect of turning the dome into a suggestion of a spire, as can be seen on St Peter's in Rome. Guarino Guarini's (1624–83) spire in Turin and Francesco Borromini's (1599–1667) rising drum and lantern on St Ivo in Rome introduced a typically Baroque elaboration of this.

The double reverse curve is another identifying characteristic of Baroque art. Extended it becomes the serpentine line, and expressed in three dimensions it becomes the spiral. Its attraction

might have been anticipated: as a form it carries all the implications of the curiosity, elaboration, energy and spatial implication that we have encountered as characteristic of the Baroque. Whereas the straight line – vertical in the medieval period, horizontal in the Renaissance – expresses a directness, unequivocal, purposeful and inflexible, the double curve moves this way and that before arriving at point B from point A. Taut or loose, it implies the space it explores on either side of its direct route, and in three dimensions expresses energy and freedom.

Perhaps the most significant development in 17th century European history was the consolidation of the nation state. This process had begun much earlier in two important regions – Germany and Italy – and was not to be completed for another two hundred years. Nevertheless, by the end of the Thirty Years War in 1648 the map of Europe west of the Rhine and north of the Alps had taken on much the shape that it bears today.

In previous centuries European affairs had been largely determined either by the ambitions of powerful individuals and families or by mass movements associated with differing religious beliefs. In the 17th century the unit of power and focus of allegiance was the nation. The turning point was the Thirty Years War, which began as a religious war to reclaim successfully for Catholicism the Protestant lands of Bohemia and the northern Netherlands, where the attempt was scarcely tried. It ended as a war between states, from which France emerged as the strongest European power. Spain and the Holy Roman Empire – the former champions of the Catholic cause – were humbled proportionately, and the papacy, which had tried in vain to bring about peace, lost almost all political influence. Germany had been the scene of most of the fighting and was devastated for a generation; indeed the war counteracted any movement toward unification by confirming the conversion of what had once been a federal empire into a loose federation of many separate states. Meanwhile, the United Provinces successfully resisted Spanish troops massed along their frontier to the south and enjoyed a Golden Age. Although they had effectively freed themselves from Spanish domination at the end of the 16th century, the formal recognition of the United Provinces as an independent sovereign state was one of the main provisions of the Treaty of Westphalia in 1648.

National assertiveness within the boundaries of Europe was matched by greater security from non-European enemies and expansion overseas. In 1683 Turkish forces besieging Vienna were driven back into Hungary and then into the Balkans in the early 18th century. At the same time Turkish sea power was eliminated in the Mediterranean. Beyond Europe, the Spaniards and Portuguese, who had begun colonizing North and South America and exploring the Far East in the 16th century, were now rivaled by France, Britain and the Netherlands. The 17th century thus witnessed the establishment of European dominion over large parts of the world, which was to reach its peak at the time of World War I.

The nation states became stronger and more cohesive through the centralization of bureaucracy, improved systems of taxation and justice, and the elimination of sources of power that threatened the central authority. Power was very often concentrated in the hands of a single, absolute ruler (hence the term "absolutism"), who was aided by a skillful chief minister. While philosophical justifications of this arrangement varied, most political thinkers of the period were united in proclaiming the advantages of a strong centralized state that abhorred rebellion. Basing their case on the Bible, traditionalists argued in favor of the divine right of kings: the Prophet Samuel, acting on God's command, anointed David king of a united Israel; all legitimate kings therefore derived their authority directly from God. By the same analogy, while they were answerable to no one for their actions, kings had a religious duty to care for the safety of their subjects. As the French theologian Jacques Bossuet stated: "You are the children of Almighty God; it was He who established your power for the good of mankind." From this Bossuet distinguished between absolute government – responsible and conformable to reason and tradition as well as to God's will – and arbitrary government, which was irresponsible and wicked.

A different and essentially materialistic defense of absolutism was advanced by the English philosopher Thomas Hobbes, who argued that the power of the ruler derived from fear rather than from benevolence. According to Hobbes, all men fear violent death and to avoid that fate the individual willingly surrenders all rights, with the exception of self-preservation, to a central authority, which becomes invested with almost unlimited power. This was the "great Leviathan", the subject of Hobbe's principal book, *Leviathan*, published in 1651. The Leviathan need not be a monarch: a strong assembly or senate would serve equally well. Hobbes believed that rebellion was wrong whether it succeeded or failed because it disturbed the peace. The preservation of internal peace was the goal of government, and the worst condition of a nation was civil war. However, because no power existed superior to the nation state, it was inevitable that states would periodically go to war with one another. It is not surprising that, like his prede-

cessor the 16th century Italian states-man and political theorist Niccolò Machiavelli, who also recommended a pragmatic and amoral rather than idealistic theory of government, Hobbes was suspected of atheism.

A third argument for giving absolute power to the state was propounded by the Jewish philosopher Baruch Spinoza. Although Spinoza's conclusions were similar to both those of the exponents of divine right and of Hobbes, he started from a different premise. In his *Tractatus Theologico-Politicus*, written in about 1600, Spinoza presented democracy – majority rule at meetings of equal citizens – as the "most natural" form of government. However, this might have dangerous consequences for, like Hobbes, Spinoza had a deep fear of anarchy. In the late 1660s he became an admirer of John De Witt, who represented the views of the great Amsterdam merchants and whose assassination in 1672, after Louis XIV's invasion of the Netherlands, he had apparently witnessed. De Witt's – and the merchants' – views were far from democratic and this, coupled with the spectacle of absolute monarchy triumphing over an oligarchic republic, perhaps persuaded Spinoza that the intellectual freedom he cherished would be best protected under a stronger form of government than any democracy that the 17th century was likely to produce.

What all of these arguments for autocracy have in common is not only a conclusion but also a motive: a desire for peace. After more than one hundred years of civil and religious strife and external wars, the longing for peace in Europe was nearly universal. Wars had come to seem uncontrollable and a government that held out the hope of ending them had a natural appeal, as well as justifying a ruler's actions, whether these were in the interest of his subjects or not. Wars of trade, wars

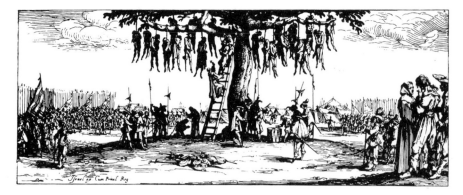

of aggression, wars to preserve the balance of power in Europe and wars between rival colonial powers overseas all erupted periodically in the later 17th and 18th centuries.

Civil war, however, subsided, as did religious persecution, and armed rebellion was a rarity until the American and French Revolutions in the late 18th century. By that time a new theory of government had gained intellectual respectability among the middle and upper classes. In part this was the revival of an old theory in a new form. In the 1640s the English Parliament had justified rebellion against King Charles I on the grounds that his rule was no better than an arbitrary tyranny and offensive to the consciences of Protestant Englishmen. When the King's son, the Catholic James II, sought to impose a similar tyranny forty years later, resistance was sufficiently widespread to compel him to abdicate. A legitimate successor was available in King Charles I's daughter Mary and her Dutch Protestant husband, William III. The Glorious Revolution of 1688–9 was effected without a shot being fired.

The spirit behind this event was formulated in 1690 by the English philosopher John Locke in *A Treatise of Civil Government*. According to Locke, a social contract founded on reason was the basis of the relationship between ruler and ruled. Human beings obey the natural law, and subjection to

Les Grandes Misères de la Guerre, 1633
Jacques Callot (1592/3–1635)
Etching

Callot's last great work, the six Petites Misères de la Guerre *and the eighteen* Grandes Misères, *was inspired by Richilieu's invasion of Lorraine in 1633. After serving at the Medici court at Florence from 1611 to 1621, Callot had made his name with his etchings of common life and scenes drawn from the* commedia dell'arte *done in the grotesque manner fashionable in the reign of Louis XIII. The* Misères *(which served as a source for Goya) depicted the cruelty and wanton destructiveness of war, the first such unromantic treatment of the subject in European art. Callot introduced the technique of covering the copper plate with a varnish of mastic and linseed oil, thereby producing a hard ground capable of being scratched with very fine lines and resistant to flaking off in the acid bath. His etchings therefore display a virtuoso mixture of lightly and deeply etched lines.*

natural law confers natural rights, therefore he may be deposed. It was this theory that lay behind the American and French Revolutions. In Hobbes' system human rights were willingly yielded to the state in the interest of securing peace; ironically, by the end of the 18th century the defense of human rights was the chief cause for which men and nations went to war.

France and Absolutism

The country that best exemplifies autocratic government in the 17th century is France, where the system later to be known as the *ancien régime* was created. From the Protestant Henry IV's declaration, on compromising with his Catholic opponents to gain control of his kingdom in 1594, that "Paris is worth a Mass", to Louis XIV's identification of the interests of the state with his own, "L'Etat, c'est moi" ("The State, it is I"), the consistent aim of French internal policy was to unite the nation around the king. To accomplish this the power of the nobility had to be destroyed and royal appointees excluded from government.

The king governed with the aid of a small council, of which his chief minister was the head, and the States General, or parliament. The latter was composed of the higher clergy, nobility and representatives of the people and, significantly, never sat from the late 16th to the late 18th century. The process of undermining the nobility begun under Henry IV was continued under Louis XIII by his powerful and gifted chief minister, the cardinal and statesman Richelieu.

Richelieu and the rise of nationalism

From 1624 until his death in 1642 Richelieu best expressed the unity and power of 17th century France that was to culminate in the reign of Louis XIV. Richelieu's name has come to be associated with guile and ruthlessness, and in fact he is one of the few statesmen to openly have avowed his admiration for Machiavelli. Like Machiavelli, Richelieu held that the interests of the state sometimes justified actions otherwise reprehensible in private conduct. Unlike Machiavelli, who merely offered advice, Richelieu was in a position to put this doctrine into practice. Instead of attempting to wipe out the nobility, which was not his objective, Richelieu intimidated them by executing those

caught plotting against the king. Although belonging to the minor nobility himself, Richelieu never allowed the great nobles any part in the central administration of the state.

Richelieu's skills showed themselves even more clearly in foreign policy. Whenever possible he used diplomacy and bribery rather than armed force. By subsidizing the opponents of Spain and the Empire during the Thirty Years War – even when, as in the case of Gustavus Adolphus of Sweden, they happened to be Protestant – he gained advantages for France without costing the lives of French soldiers. On the other hand, in the early 1630s he dispatched a French army into Lorraine with the purpose of terrorizing the populace, the results of which can be judged from Jacques Callot's brilliant and moving series of contemporary etchings, *The Horrors of War*. Finally, under Richelieu French troops delivered the final blow to the Spanish and Imperial armies in the concluding stages of the Thirty Years War.

During this time increasing pressure was being put on the French Protestants, or Huguenots. In 1598 the Huguenots had been granted freedom of worship by the Edict of Nantes as part of Henry IV's desire to heal the religious divisions of France. An attempt by the Huguenots in 1628 to seize political control of La Rochelle on the west coast of the country was defeated under orders from Richelieu in 1629. For a time the Huguenots were allowed to worship in their own way but were deprived of all political rights. Richelieu's suppression of Protestantism was facilitated by the rise of Catholic piety in France, brought about by the activities of the papacy in Rome. New religious thinkers appeared, new orders were founded and the revival of Catholicism continued throughout the century; in Paris alone forty religious orders were founded and twenty

churches begun between 1610 and 1660.

Besides weakening and dividing the nobility and destroying the political independence of the Huguenots, Richelieu reduced the powers of provincial governors and enforced the collection of taxes, which, with other financial measures, greatly strengthened the state treasury. One such measure was the sale of government securities, which in times of special need paid high rates of interest, thus attracting a constant flow of speculators. Another measure that was used extensively under Louis XIV was the sale of government offices. Although the great offices of state were filled by appointment, almost every other office in central and local government and in the law could be bought. These offices conferred privileges and perquisites, including a commission on taxes collected from the poor. That there were taxes that weakened the poor while enriching the bourgeoisie and lesser nobility suited Richlieu's purposes very well.

The rise of the central power was accompanied by the rise of the officer class and coincided with increased religious uniformity. This condition is very much reflected in the arts of the time. Henry IV's main artistic activity was the rebuilding of much of Paris as a fitting capital for the newly peaceful France, in the same way that Rome was being rebuilt as the center of a unified Catholicism. In Paris new works were typified by a simplicity of style; the Pont Neuf, for example, was originally intended in the 16th century to support buildings and triumphal arches but was completed without either. Other projects included the building of squares, such as the Place Royale (today the Place des Vosges), the Place Dauphine and the never-completed Place de France. All were designed, with their accompanying buildings, in a simple, Classical style creating a strong sense of unity. It was in these squares that Henry

for the first time combined the styles of the large, symmetrical squares of Italy and the Flemish tradition of groups of small houses. The cheapness of materials, royal impetus and artistic success of the squares ensured that they were copied across France throughout the century.

Grandiose projects were also undertaken under Louis XIII. Construction of the Luxembourg Palace, for example, began again using a severe, Classical style rather than the exuberant Baroque style popular in Italy at the time. Some historians feel that the Classical style was chosen because, in its insistence on uniformity and order as prescribed by the ruler, it reflected the tenets of absolutism to a greater degree than the fluent if undisciplined Baroque.

Most major architectural projects between 1630 and 1660 were made for the growing bourgeoisie which was more dependent than the nobility on the government, and therefore more susceptible to its dictates of taste. At the same time, the bourgeoisie lacked the huge resources necessary for the building of elaborate Baroque palaces, and consequently the major architects of this period built many private houses in Paris for them. The architects used were those in royal favor, for example Jacques Lemercier (1585–1654) had been used extensively by Cardinal Richelieu at Rueil and Richelieu, and then built many bourgeois projects. François Mansart (1598–1666) was commissioned by the crown at Blois, but worked mainly for bourgeois officers, for example at the Château of Maisons. Louis Le Vau (1612–70), who later came to prominence under Louis XIV, was favored by members of the *Parlement*, a major legal body.

As in other Catholic countries, the reestablishment of Catholicism in France meant that the Church became a major patron of the arts, requiring new buildings and sculpture and paintings to decorate them. At the same time a prevailing religious sentiment in French society also provided a secular market for religious works of art, especially painting. Until 1650 church architecture reflected the same restraint noticeable in secular building and Lemercier and other architects applied an Italian Classical style used in secular works to French churches.

The Church of the Sorbonne in Paris was commissioned by Richelieu. His patronage of this most impressive building meant that his taste was highly visible in the capital and offered an example for other church building. The façade of the Sorbonne, with its large Italianate dome, perpetuated the century Italian styles. However, unlike contemporary Italian churches, French churches were not decorated as ornately; painting was more restrained and less theatrical, sculpture more modest and less often used. This restraint reflected the sober form of Catholicism current in France at the time, which was less emotive and ecstatic than in southern Europe. A lesser influence on French church design was the use of the Gothic style, as seen in the late 16th century Church of St Eustache, Paris. The French Jesuits, while responsible for the introduction of an Italian motif in some of their churches, were also susceptible to the Gothic tradition, but this was more often found in the provinces than in Paris.

As a patron of culture, although he was far outshone by Louis XIV, Richelieu was largely responsible for the most spectacular building campaigns of the early 17th century and commissioned paintings from Nicolas Poussin (1594–1665), whom he brought, unwillingly, to Paris to decorate the Long Gallery of the Louvre. More importantly, he created the basis for the development of French Classicism

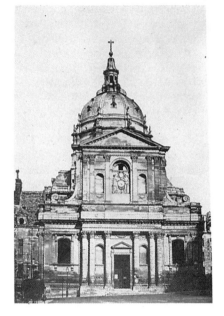

The Church of the Sorbonne, *Paris, 1635 Jacques Lemercier (c.1580–1654)*

The Paris skyline owes much to the intrusion of Italian Baroque motifs, especially the domes of Les Invalides and the Church of the Sorbonne. The latter is the more restrained, but it has the same emphatic ribs of the drum, rising across the line of the dome to the lantern, where, instead of being rounded off by a cupola, they are drawn forcefully upwards to a short spire. Lemercier spent about seven years in Rome between 1607 and 1614 and this church — together with the chateau and new town at Richelieu, begun 1631, and the Palais Royal, begun 1633 — introduced the academic Roman style of Giacomo della Porta (c.1537–1602) to France. The Roman front, with its two superimposed orders, was taken directly from della Porta's S.Maria Monti; the overall plan of the Church, with its central dome separating a nave and choir of equal size, was modeled on Rosato Rosati's S. Carlo ai Catinari, begun in 1612 when Lemercier was still at Rome. Like the Les Invalides chapel, the building combines Classical proportion with chaste Baroque decoration in the French manner. So delighted was Richelieu with the effect that he ordered the Place de la Sorbonne to be cleared in order to give a proper view of it.

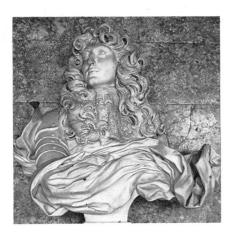

Louis XIV, *1665*
Gianlorenzo Bernini (1598–1680)
Marble
Palace of Versailles, France

*In 1665 Bernini was invited to Paris to discuss plans for the completion of the Louvre palace. During his visit he was accompanied by a guide and interpreter, Paul Fréart, who left a descriptive account of the visit in a lengthy diary. Soon after Bernini's arrival it was suggested that he might carry out a bust of King Louis XIV, and the commission was officially confirmed in June of 1665. Bernini began by sketching the King as he went about his business, and then made clay models (*bozzetti*) of the intended pose. The form of the bust was roughly blocked out in marble by an assistant and Bernini commenced work on the detailed carving. As the portrait progressed the King allowed thirteen sittings of one hour each. The completed bust was not considered a true likeness, but rather a symbolic representation. Bernini's view of the problem of portrait sculpture was recorded by Fréart: "If a man whitened his hair, beard and eyebrows, and — were it . . possible — his eyeballs and lips, and presented himself in that state to those very persons that see him every day, he would hardly be recognized by them. . . . Hence you can understand how difficult it is to make a portrait, which is all of one color, resemble the sitter." The bust was the only material outcome of Bernini's trip to France. His plans for the Louvre did not suit French taste or practicality and the palace was completed by French architects some time after his return to Italy.*

by founding the most distinguished of all literary academies, the Académie Française, in 1635. Richelieu's policies were successful in uniting France, and the country experienced a growth in nationalistic feeling. Artistically this was reflected in a desire to produce a more uniform national style. The Classical sobriety found in French architecture came to be the key characteristic of religion, theater, literature and other aspects of culture and became increasingly an especially French quality.

On his deathbed, the State that Richelieu had created was bequeathed by him to the care of Cardinal Mazarin, who guided it during the minority of Louis XIV and the regency of his mother, Ann of Austria, Louis XIII's widow. Under Mazarin the nobility were further humbled during the troubles known as the *Fronde* (1648–53) from which the middle class emerged with heighted power and as chief supporters of the crown. While Mazarin committed more blunders than Richelieu, he redeemed them by using even subtler diplomatic methods and it was therefore a compliant nation that the rulers of France delivered to the 22-year-old Louis XIV on his assumption of power in 1660. To complete the process of disarming the nobles, Louis was to attract them away from their country estates and give them the most expensive of all toys to play with – the Court of Versailles.

The Sun King

Louis XIV, also known as the Sun King, and the embodiment of French national glory, was born in 1638 and was trained for kingship almost from that moment. He succeeded his father in 1643 and reigned for seventy-two years. Perhaps more than any other monarch in modern history except Napoleon, Louis XIV believed that kingship was a highly specialized occupation requiring

constant application and a shrewd knowledge of men. His days were passed in a routine of official business, beginning in his bedroom at five in the morning. According to Louis XIV, a monarch saw his country from an eminence shared by no one and therefore he was best qualified to decide between competing interests. As Louis, or rather his ghostwriters, declared in his *Instructions pour le Dauphin* in 1666, "holding as it were the plan of God, we seem to participate in his wisdom as in his authority; for instance, in what concerns discernment of human character, allocation of employments and distribution of rewards."

Louis XIV was no mere national figurehead as his father had been; none of his ministers exercised as much power as Richelieu. Yet not the least of Louis's abilities was his capacity to surround himself with competent, and in some cases, brilliant men, of whom Jean-Baptiste Colbert is the best known. A bourgeois by origin, Colbert was less an initiator of policies – that was left to Louis – than an efficient administrator. In one field, however, he was an innovator: the encouragement of industry and commerce, an area that had not interested Richelieu nor Mazarin. During Louis XIV's reign, every activity from the army and navy to tapestry-weaving was reorganized and improved, and all were designed to serve the interests of the state and the greater glory of the King. This applied in full measure to the visual arts. The Royal Academy of Painting and Sculpture in 1663 was reorganized under the directorship of Charles Lebrun (1619–90) and vigorously supported by Colbert. A national art style was in this way enforced to the extent that even the French Academy in Rome, founded three years later, ensured similar control over French artists in Italy. In the nationalistic art of

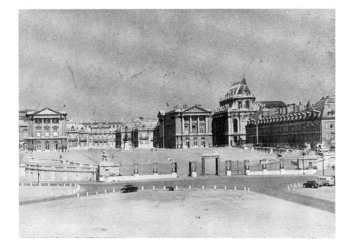

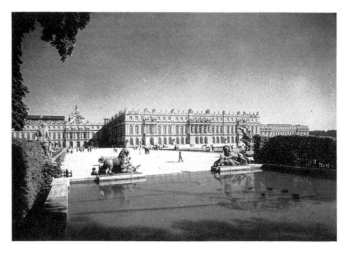

The Palace of Versailles,
17th century
*Louis Le Vau (1612–70), Jules Hardouin
Mansart (1646–1708) and André Le Nôtre
(1613–1700)*

In 1624 a simple hunting lodge was built at
Versailles for Louis XIII consisting of three
wings around a courtyard. In the late 1660s
Louis XIV became interested in the idea of
transferring his court's activities from Paris
to Versailles and gave orders that the
original lodge should be pulled down and a
grander edifice be constructed. His architect,
Le Vau, produced a plan for rebuilding
that incorporated rather than replaced the
old structure. The courtyard frontage was
left exposed but on the garden side the
building was extended and given an
elegant façade of twenty-five bays marked
by pilasters and columns. The central
section was recessed behind a terrace at
first floor level. Le Vau also designed the
interiors of the palace, in collaboration with
the King's painter, Charles Lebrun
(1619–90). Le Vau's work at Versailles was
drastically altered in later modifications and
of the interiors the only remaining evidence
is in the apartments of the King and Queen,
decorated in stucco and paint.

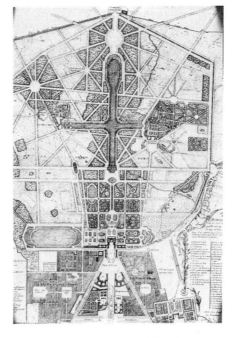

The Gardens of the Palace of Versailles
Plan

Garden front, *Versailles, begun 1669*
Louis Le Vau (1612–70)

In 1678 Le Vau's design of the palace at
Versailles was completely transformed by
the work of Jules Hardouin Mansart. The
Palace was given extended wings to either
side of the central structure and in
remodelling the garden front, Mansart
filled the recessed first floor area to create
space for the Hall of Mirrors, one of the
most famous interior features of Versailles.
The staterooms within the buildings opened
one into another as if to form a long gallery,
the Royal apartments remaining the center
of the enlarged design. As the Palace was
extended, the formal gardens were designed
and laid out by Andre Le Nôtre, with the
low flowerbeds immediately outside the
garden front leading down through a radial
pattern of walkways to the cruciform canal
in the center of the park. At one end of the
canal stands the Grand Trianon, also
redesigned by Mansart to replace an earlier
structure by Le Vau. The Trianon was
intended as a retreat for the King, separate
from the general activities of the court. In
1685, at the height of the work arranged by
Mansart, 36,000 men and 6000 horses
were employed on the site, working on both
gardens and buildings. The final length of
the Palace itself is over one-third of a
mile (0.5km).

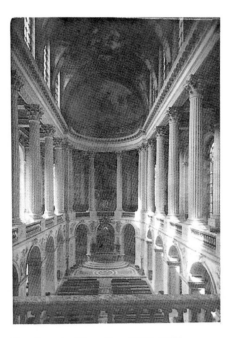

The Chapel at Versailles, *1689–1703*
Jules Hardoúin Mansart (1646–1708)

This chapel was the last of the buildings designed for the royal palace at Versailles by Mansart, whom Louis XIV placed in charge of the extensive additions to the palace in 1678. The stables and orangery were completed in 1686, the Grand Trianon a year later. Work began on the chapel in 1686, the Grand Trianon a year later.
Work began on the chapel in 1689, but it was almost immediately interrupted by the War of the League of Augsburg. Construction took place between 1699 and 1703 and the interior decoration was completed by 1710. Its high proportions, reminiscent of the Gothic style, derive from the King's insistence that the chapel have two stories, with the royal pew on the upper story connected directly to the King's apartments. The contrasts of depth and light in the first story colonnade lend the interior a mysterious, distinctly unClassical air, but the chapel's most Baroque feature is the illusionist ceiling fresco (1708–9) painted by Antoine Coypel.

this period noble, elevated subjects, which by observing the rules of order and harmony were designed to appeal to the educated mind, were advocated in preference to more emotive qualities; the ancients and masters, such as Raphael and Poussin, were to be followed rather than, at this stage, the Venetians and Rubens.

This restrained Classicism was slightly modified to serve Louis's requirements for what was undoubtedly the most important and influential building project of the 17th century: Versailles. Versailles epitomized Louis's and Colbert's artistic reasoning that the arts should glorify the monarch and reflect his supreme position both within France and abroad, and an ensemble of artists of unparalleled splendor was created. The decorative analogy used throughout the magnificent staterooms of Versailles is that of Louis as Apollo, the Sun King, presiding majestically over an allegorical world; even the surrounding gardens were conceived as elaborate settings for royal ceremonies and theatricals.

The architect Le Vau, the painter Lebrun and the landscape gardener André Le Nôtre (1613–1700), all of whom had previously worked together, were responsible for the overall conception of Versailles. In the work of all three the style was Classical rather than Baroque, indicating that the French were determined to regard Italy only as a contributor, rather than the sole arbiter, of artistic taste. Accordingly, courtyard squares were composed without Baroque curves, using instead the plain massing of areas with trophies decorating the roof lines to achieve monumental effects of grandeur.

Versailles consumed much of France's finances and artistic talent. As building interiors dominated the field of contemporary French decorative painting, Le Nôtre's gardens dominated the development of sculpture. For most of the 17th century French sculpture had occupied a relatively minor position. However, Louis's policy of self-aggrandizement now offered sculptors, such as François Girardon (1628–1715) and Antoine Coysevox (1640–1720), opportunities for dramatic and flamboyant compositions.

In other areas too the artistic geniuses of France were content to serve the King and were generously patronized by him: the poet and dramatist Jean-Baptiste Racine, the dramatist Molière, the leading literary theorist Nicolas Boileau, the theologian Jacques Bossuet, the composers Jean-Baptiste Lully and François Couperin, to name only a few.

In foreign affairs Louis XIV shone conspicuously, and it was here that he eventually over-reached himself. More aggressive than his predecessors, Louis conducted brilliant military campaigns in Flanders and Franche-Comté, territories of Spain and the Holy Roman Empire, respectively. Almost everywhere French generalship was superior to the opposition. Yet after initial successes, Louis's invasion of the Netherlands in 1672 ended in defeat. In the 1690s he tried again and his armies also made repeated forays into western Germany.

Louis's greatest war – the Spanish Succession – although it ultimately gained the objective Louis sought, only did so at enormous cost and was not even necessary. The last sickly Habsburg king of Spain, Charles II, finally died in 1700. Having no heirs, he bequeathed the throne to a grandson of Louis XIV, the Duc d'Anjou, with the condition that the French and Spanish crowns should remain separate. Instead of quietly accepting his good fortune, Louis made as much noise about it as possible, thereby arousing the hostility of Austria, the Netherlands and Britain, all supporting other claimants to the throne. A British army in alliance first

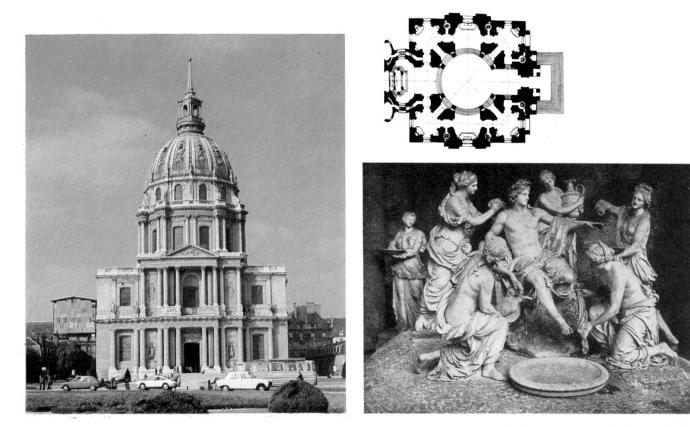

The Church of Les Invalides, *Paris, 1680–91*
Jules Hardouin Mansart (1646–1708)
View and plan

As superintendent of public works in France from 1699 until his death, Mansart left his mark on Paris with the two large squares, the Place Vendôme and the Place des Victoires, and the church for the military hospital, Les Invalides. The church exhibits a highly original fusion of Classical and Baroque elements. The basic design follows the traditional form of a Greek cross with circular chapels in the four openings; the heavily-broken facade of the west front and, inside, the upward thrust of eight free-standing Corinthian columns surmounted by a deep, curving entablature break with orthodox Classicism. The richly gilded dome is one of Paris's most prominent Baroque skymarks. Unfortunately, the grand vertical symmetry of Mansart's original building was distorted in 1843, when a deep well was cut into the ground directly beneath the central dome to accommodate Visconti's tomb of Napoleon.

Apollo Tended by Nymphs at Thebes
François Girardon (1628–1725)
Marble
Versailles, France

Girardon was the sculptural counterpart to the painter Charles Lebrun in the great decorative enterprises of the late 17th century in France. He was specially interested in Hellenistic sculpture, and there is a romantic softness about his treatment of the figures in this, his most famous work, which is set in an atmospheric grotto.

with the Austrians and then with the Dutch defeated the French in a series of battles between 1704 and 1709, bringing recognition to Britain as a European power for the first time since the Middle Ages. It was not until 1715 with the Treaty of Utrecht, by which time the war had swung in favor of the French, that the Duc d'Anjou was able to ascend the Spanish throne as Philip V; ironically this was also the year of Louis XIV's death.

Louis XIV's last years were clouded by costly wars, a decline in the quality of his ministers and an atmosphere of gloom imposed at Versailles by his last mistress, Madame de Maintenon. Louis, however, continued his policy of self-aggrandizement, which now found artistic expression in the Church of Les Invalides. In contrast to Versailles's earlier Classicism and awesome interiors, Les Invalides reflects strong

The Netherlands in the 17th Century

Baroque influences in keeping with the court's, and therefore the nation's, devout Catholicism. The revocation of the Edict of Nantes in 1685, expelling thousands of Huguenots from France, monitored the religious atmosphere during this period. In architecture, Italian Baroque was tempered by the French tradition of Classicism clearly noticeable in the Place des Victoires and Place de Vendôme, designed to provide accommodation for Louis's officer class and indicative of their importance throughout the century. Both display absolutist Classical restraint while at the same time incorporating Baroque motifs, as can be seen, for example, in the dome of Les Invalides. Artistically, the dome fresco paintings by Charles de La Fosse (1636–1716) at Les Invalides are a triumph of Venetian warmth over Lebrun's preference for Poussin and the Classical arts, and indicate the course that French painting was to follow over the next few decades. The subject of the same fresco – St Louis presenting Christ the Sword with which he has vanquished the Church's enemies – both pays tribute to Louis's famous ancestor and conveys his new-found religious enthusiasm. The coloring is rich and warm, its design closely modeled on Correggio, but the disposition of figures around an open sky hints at the beginnings of a forthcoming lightness in art.

French manners and fashions, French art and architecture and French literary theory held sway almost everywhere and remained so for a century to come; only Britain and Italy were, in different ways, partial exceptions. France ought to have proved that an autocratic government was the necessary condition, so far as the 17th century was concerned for national unity and development. Yet matters were not quite so simple, as the history of the Netherlands makes clear.

In contrast to Louis XIV's desire for centralization and an absolute monarchy, the United Provinces represented government by wealthy merchants within a federation of provincial states. To contemporaries, Louis was the epitome of the idea of the divine right of kings and French nationalism, while in the United Provinces a strong merchant class meant commercial success and enlightened toleration. Apart from the very end of the 17th century, when Dutch art reflected French Classical influences – ironically, when the two countries were at war – the political antithesis of France and the United Provinces is paralleled in Hyacinthe Riguad's (1659–1743) portraits and Versaille's grandeur contrasting sharply with the quiet introspection of Rembrandt van Rijn (1606–69) and the ordered serenity of Dutch interiors.

The north

Although the seven United Provinces of the Dutch Republic – Holland, Zeeland, Utrecht, Gelderland, Friesland, Overijessel and Groningen – were not officially recognized until the Treaty of Munster (1648), their independence from Spanish control and political separation from the rest of the Netherlands had actually been in existence since the Twelve Year Truce (1609). The seven provinces had originally formed the northern section of the seventeen provinces of the Netherlands. With Charles V's death in 1555, his son, Philip II of Spain, became the new ruler. The opposition to his rule – the Revolt of the Netherlands – began in 1565 and was marked by riots that involved the destruction of·religious objects. It was primarily a struggle for independence by a politically weaker, and later physically, smaller power against the excessive taxation and religious persecution of a larger power, Spain.

The new republic was one of contrasts and contradictions. An oligarchy of merchants coexisted with a hereditary ruler, or Stadholder, filled from the house of Orange, who resided at The Hague. The theoretical federation of seven equal states came to be dominated by the commercially superior Holland and, if Holland's religion was officially Calvinist, unofficially other religions and sects were tolerated. Public Catholic worship was banned but private worship flourished, and Amsterdam's large Jewish community – many of whom were Rembrandt's neighbors and models – were granted public worship as early as 1597. As a contemporary remarked: "I believe in this street where I lodge, there be well near as many religions as there be houses, for one neighbor knows not nor cares not what religion the other is of, so that the number of conventicles exceed the number of churches here. And let this country call itself as long as it will the United Provinces, one way I am persuaded in this point there's no place so disunited".

Unlike Catholic Italy, the Calvinist clergy did not commission works of art for their churches, whose clinically sparse interiors, depicted by Pieter Saenredam (1597–1665) and Gerrit Berkheyde (1638–98), provided the perfect setting for the sermon-based Calvinist service. Royal and aristocratic patronage, another important source of commissions, was similarly diminished, removing to a large extent the demand for large-scale decorative or historical commissions, although the history and religious paintings of Rembrandt, Gerard van Honthorst (1590–1656) and Hendrick Terbrugghen (1588–1629) suggest that there was still a small demand for such paintings. These traditional sources of patronage were largely replaced by a prospering middle class, although, if contemporary reports are accurate, all levels of Dutch society could afford and

Interior of the Domkerk, Utrecht
Pieter Jansz, Saenredam (1597–1665)
Oil on panel 23¼×19in (58×47.5cm)
National Gallery, London

Although as early as the 15th century Van Eyck brothers were using church interiors for the settings of religious paintings, it was not until the 17th century that Dutch painters began to paint buildings for their own sake. Above all, they painted church interiors, although street scenes also became popular. Because he painted church interiors with the deliberate intention of giving them a minutely accurate, realistic representation Saenredam became known as the "finest portraitist of architecture". About fifty of his paintings are known and each one of them was painted from a meticulously drawn sketch of the building. The sensitive tones of his palette and his delicate handling of light and shade convey wonderfully the awesome stillness of empty churches.

An Interior Scene, *1650s (?)*
Pieter de Hoogh (1629–after 1684)
Oil on canvas 29×25in (74×65cm)
National Gallery, London

De Hoogh represents the solid mercantile, Protestant class in Dutch 17th-century society, concerned with order and a devout life. His paintings express the solid virtues of life in a way that contrasts most strongly with those of the peasant life in the paintings of Adriaen Brouwer (1606–36) and Adriaen van Ostade, such as the Alchemist below.

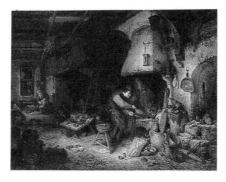

An Alchemist, *1661*
Adriaen van Ostade (1610–85)
Oil on wood 13⅜×17¾in (34×42.5cm)
National Gallery, London

Adriaen van Ostade was born in Haarlem, where he spent his entire life. The son of a weaver, he learned painting as a pupil of Frans Hals and became well known for his genre paintings, in which no attempt is made to romanticize the quality of life among the poor and peasant classes. Although many copied his style, it is reckoned that over eight hundred paintings are attributable to Van Ostade. Genre paintings were a source of interest and amusement to the more affluent classes of society and were much in vogue. Alchemy was also a favorite subject among painters; the fruitless search for a means of making gold was used as a symbol of human stupidity and greed although the practice continued well into the 18th century. Van Ostade's portrayal of the alchemist is imaginary and was interpreted in terms of the characters and surroundings common to his everyday observation.

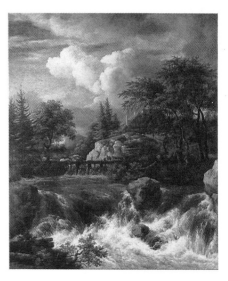

A Waterfall in a Rocky Landscape, *not dated*
Jacob van Ruisdael (1628/9–82)
Oil on canvas 38¾×33½in (98.5×85.1cm)
The National Gallery, London

Ruisdael was born in Haarlem but settled in Amsterdam in 1657, where he remained for the rest of his life. He had been raised in the traditions of painting; his father was a dealer and frame-maker and his father's half-brother was the painter Salomon van Ruysdael (c.1600/2–70). Ruisdael's early landscapes were very much in the style of other Dutch paintings of the period, but he seemed naturally to favor a more dramatic style of composition. Soon after moving to Amsterdam he became interested in the work of Allart van Everdingen (1621–75), a Dutch painter who had visited Scandinavia in 1641 and executed a series of paintings of waterfalls. It is also possible that Ruisdael himself visited Germany in 1650 and saw at first hand a more rugged landscape than that of his native environment. This experience and the influence of Everdingen were quickly reflected in his work. Of Ruisdael's character little is known but that he remained a bachelor and was apparently a withdrawn and isolated figure. In about 1676 he trained as a doctor and thereafter practiced as both surgeon and painter, but his latest dated work is from 1678, four years before his death.

took an interest in art. An English traveler in 1640 wrote that "many times blacksmiths, cobblers, etc will have some pictures or other by their forge and in their stall. Such is the general notion, inclination and delight that these country natives have to painting."

The attitude that works of art were things to live with and enjoy is reflected by the paintings of interiors of the period which show paintings on walls and glimpsed through doors into rooms beyond. These scenes, or genre paintings as they are called, are probably the most characteristic of all Dutch paintings of this period. At their most obvious they record everyday elements of Dutch life and leisure, furnishings and costumes. Pieter de Hooch's (1629–c.1684) earlier works recreate the characteristic order of black-and-white tiled interiors, while the works of Adriaen van Ostade (1610–84) depict life much lower down the social scale. The descriptiveness of these paintings, however, is not strictly literal, and broken pipes, extinguished candles, keys, playing cards and open bird cages contain double meanings pointing out morals in a context that was easily recognized by a public attuned to the use of allegory.

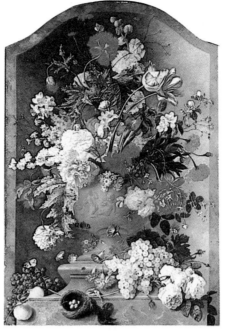

Flowers in a Terracotta Vase, 1736–7
Jan Van Huijsum (1682–1749)
Oil on canvas 29×25in (74×65cm)
(134×92cm)
National Gallery, London

This late example of Dutch flower painting represents a genre that was popular from the early 17th century. It produced, during the great period of Dutch art, some most luxurious and popular flower, fruit and still-life works. All such paintings delight in the meticulous observation of form and the precise rendering of surface texture, as well as the delicate and evanescent quality of the fruit and flowers that are represented in profusion in such works. Often, as in this case, some small unexpected detail like an insect, butterfly, or as here, a birdnest with eggs, appears.

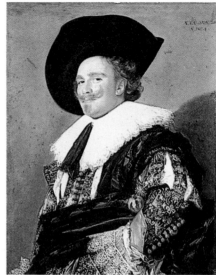

The Laughing Cavalier (Portrait of an Officer), 1624
Frans Hals (1581/5–1666)
Oil on canvas 33×26½in (84×67cm)
The Wallace Collection, London

There has been some disagreement over the number of works that can be truly attributed to Frans Hals, but there are certainly well over 200, and of these 195 are portraits. The earliest known work by Hals is dated 1611 and there is no evidence of his activity prior to that date, although he was by then between twenty-five and thirty years old. After that time he appears to have attracted a steady stream of portrait commissions. The artist himself left no letters or papers, so his personality and preoccupations have remained a matter for speculation. A reputation for drunkenness and disorderly living was wrongly attached to his name. A record of a Frans Hals brought to book for drunken behavior and wife beating in fact referred to a different man of the same name and living in the same town, but was originally thought to refer to the painter Hals. He has often been identified with the subjects of his portraits, particularly the famous example known as the Laughing Cavalier. However, this title was not given to the painting until late 19th century and the sitter remains anonymous. Hals himself was recorded as a member of the St George Militia of Haarlem and from 1644 was an officer of the Guild of St Luke. This suggests that he was a responsible and well respected member of his community.

Three Ships in a Gale, 1673
Willem van de Velde the Younger (1633–1707)
Oil on canvas 29×37in (75×95cm)
National Gallery, London

The Dutch have always been a mercantile sea-going people and the growth of the Dutch commerce had the effect of creating a demand for marine paintings. Among the most important of the 17th-century painters of such works was Van de Velde, and his rendering of the power of the sea and of ships contesting with the ocean is well expressed in this painting of a man-of-war and another ship showing the Dutch flag, with a third in the background.

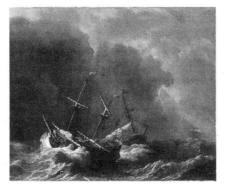

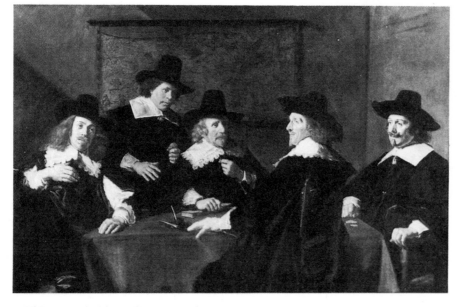

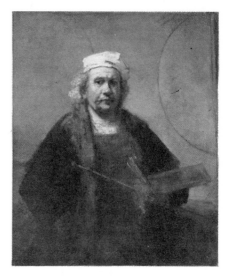

This remarkable realism extends to other aspects of Dutch painting. Landscapes by Meindert Hobbema (1638–1709) and Jacob van Ruisdael (1628–82) accurately portray the Dutch countryside, and the marine pieces of the Van de Velde family (1636–1712, inclusive) depict the Dutch coastline and the source of Dutch naval and commercial superiority. The single and group portraits of Frans Hals (1581/5–1666) and Rembrandt record wealthy merchants and city magistrates whose civic pride and social concern permeated many aspects of Dutch life. Native products, such as cheese, fish, glass, silver and Delftware china dominate the still-life compositions of Pieter Claesz (c.1597–1661), William Heda (c.1593–1680) and Willem Kalf (1619–93), and the decoration on the walls of Jan Vermeer's (1632–75) interiors underline the country's tradition of cartography and its new boundaries.

But Dutch 17th-century painting is dominated by one of the most admired of European painters, whose present reputation parallels that of Leonardo, Michelangelo and Rubens as one of the

Regents of the Old Men's Almshouse, c.1644

Frans Hals (1581/5–1666)
Oil on canvas 67⅞×98⅝in
(176.5×256cm)
Frans Hals Museum, Haarlem

In the last years of his life Hals became so poor that he was obliged to appeal to the municipal council for aid. In 1662 he was given a small pension, increased in 1664 and supplemented by a gift of peat for fuel It is possible that this painting and its companion piece showing the Regentesses of the Women's Almshouse were commissions awarded as a form of charity, to provide the painter with some money while keeping him employed on worthwhile work. Hals was by this time in his eighties and the style of the paintings is somewhat less dexterous than earlier group portraits, but they nonetheless occupy an important place in the cycle of his life's work.

Self-Portrait, c.1660
Rembrandt van Rijn (1606–69)
Oil on canvas 45×37½in (114×95cm)
Kenwood House, London

Rembrandt left more than one hundred self portraits in paintings, drawings and etchings. These form a highly descriptive visual biography of the painter, but this was not necessarily Rembrandt's prime intention. Many of the portraits show him in costume, or may represent studies of facial expressions, and it may simply have been a convenient device to employ himself as a model. This self-portrait is unusual in that Rembrandt represents himself as a painter, and his expression is in no way posed or contrived. Its precise date is uncertain, but the portrait is one of many recording the painter's old age. Rembrandt lived with, and finally outlived, his common-law wife Hendrikje Stoffels and his son Titus. His first wife, Saskia, had left her money for the upbringing of Titus on condition that Rembrandt should not marry again. However, it was a business partnership between Hendrikje and Titus that kept Rembrandt after 1660, since he had never recovered financial stability after his bankruptcy of 1656.

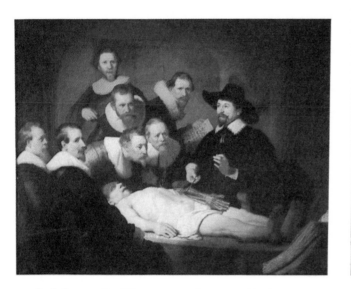

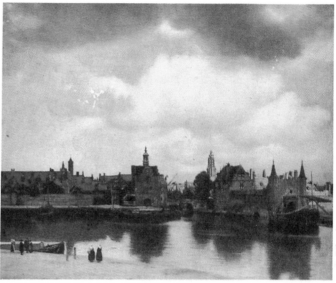

seminal figures in Western art. Rembrandt Harmensz van Rijn was born in Leyden in 1606 and died in Amsterdam in 1669. Thus his life covers the main creative period of Dutch 17th-century painting and the establishment of the United Provinces as a separate Protestant state. His subject matter ranges from Biblical and mythological to landscapes, genre scenes, subject paintings and perhaps his finest achievement, a range of portraits, including over fifty self-portraits from youth to old age. These last – taken in totality – are perhaps the most moving visual survey of the development of a human life ever to have been recorded in paint. They show a depth of self-analysis, a quality of human sympathy, which is unrivaled. His Biblical and subject paintings have the same human sympathies and he developed a marvelous technique, deriving in some measure from Caravaggio's *chiaroscuro*, which enabled him to express the spirit of the deeply devout Calvinists of Holland. The treatment of light, with mysterious, luminous darks and small areas of light give an almost reverent atmosphere in all his religious paintings, particularly

The Anatomy Lecture of Dr Nicolas Tulp, *1632*
Rembrandt van Rijn (1609–69)
Oil on canvas 65×86½in (163×217cm)
Mauritshuis, The Hague

This was Rembrandt's first important group composition and shows Dr Tulp (1593–1674) demonstrating the structure of the forearm with the assistance of the famous anatomy book by Versalius propped at the foot of the body. A great deal is known about the individuals represented in the painting, including that of the corpse, a noted criminal. The painting, although an early work, shows a dramatic intent in the composition which is absent from the bravura painting of Franz Hals's Regents of the Old Men's Almshouse. Nevertheless, there is an inconsistency in the poses of the onlookers and the stiff, formal stance of Dr Tulp himself.

Despite that, it is a remarkable work for a young painter of 26 confronted by a demanding contract.

View of Delft, *c.1658–60*
Jan Vermeer (1632–75)
Oil on canvas 38½×46¾in (8.5×117.5cm)
Collection of the Académie, Louvre, Paris
Mauritshuis, The Hague

Lack of documentary evidence about his life and Vermeer's own habit of leaving his paintings undated have caused some difficulties with the identification of his work and the sequence of the paintings. Vermeer's career seems to have been uneventful and not especially successful; his widow was declared bankrupt in the year following his death. His work was neglected until rediscovered and popularized in the 19th century, but only about forty paintings have been positively attributed to Vermeer. The View of Delft is one of only two townscapes. It shows the two old gates of the city of Delft on the river Schie. From contemporary plans a house has been identified that could have provided a studio for Vermeer while he worked on the painting. The Music Lesson is more typical of Vermeer's oeuvre, showing an interior scene with figures. This popular title has become attached to the painting although the scene itself shows no evidence that this was the true subject. On one wall of the interior is a picture in the style of Caravaggio, similar to one known to have been in the possession of Vermeer's mother-in-law, who also lived in Delft.

evident in the simple, but moving *Supper at Emmaus.* Another important part of Rembrandt's oeuver is the large number of etchings and drawings which reinforce the subtlety of his treatment of light, while also revealing the high quality of his draftsmanship.

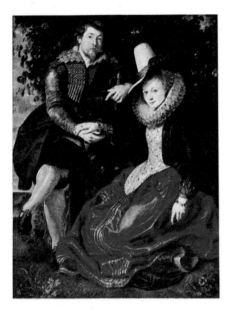

Rubens and Isabella Brandt, *1609–10*
Sir Peter Paul Rubens (1577–1640)
Oil on canvas 70½ × 53½ in (174 × 132 cm)
Alte Pinakothek, Munich

This painting, although it is almost a stiff and formal "wedding portrait" in the mannerist style which Rubens had adopted whilst in Italy, nevertheless carries the beginnings of the characteristic Baroque flourish of his later work. The sophisticated and elaborate dress of both Isabella Brandt and Rubens himself is in great contrast to the sober and serious nature of his Dutch Calvinist contemporaries.

The south

Although it is tempting to see these boundaries as dividing the Netherlands into a Protestant north and Catholic south, the division of 1609 depended initially on geographical rather than linguistic or religious considerations. In both the north and the south lived people who spoke Walloon and Dutch, and Protestants and Catholics lived side by side. Helped by its natural terrain and sea defenses, the north maintained independence and became predominantly Calvinist. The more vulnerable south reverted to Spanish control and Catholicism and was ruled from Madrid by the Regent the Infanta Isabella (Philip II's daughter), and her husband, Albert. Spain dictated the character of the court at Brussels and its foreign and domestic policy.

Having established the support of the nobility, the reestablishment of Catholicism as the official religion became an overriding issue, just as in the north the Synod of Dordt (1618) aimed to enforce a more extreme Calvinism. While not the persecution of former times, public Catholic observance was rigorously enforced: Sunday attendance and church observance was compulsory; there was strict supervision of all levels of religious education and tight censorship placed on printers and booksellers. Unlike the north, art was seen as an essential means to emphasize Counter-Reformation Catholicism. It therefore seems extraordinarily appropriate that one of the artists best equipped to do this, Sir Peter Paul Rubens (1577–1640), would have returned to his native Antwerp the very year the Truce was signed and the south returned to Spanish control.

Antwerp had been left economically and commercially weak by the closure of the river Scheldt in 1585 and by Spain's self-interested control, but artistically it was an important source of civic and religious patronage. Religious patrons ensured the decoration of churches, whose original Gothic framework and interiors were rapidly transformed into rich Baroque settings. Ruben's experience in Rome and his devout Catholicism equipped him to produce works of rich and emotional intensity for cathedrals and the Jesuits, injecting a characteristic warmth, color and dramatic movement into Biblical events. In Rubens's exuberant statements of faith and Rembrandt's quiet contemplation the essential differences between Catholicism and Protestantism are beautifully and clearly juxtaposed.

The Brussels court, like its European counterparts, ensured a more consistent aristocratic patronage than in the Republic. As Archduke Albert of Austria and Isabella's official painter, Rubens produced elegant portraits as well as large-scale decorative works, in particular that depicting the lavish, triumphal entry of Isabella's successor, the Cardinal-Infante Ferdinand of Austria in 1635. The years after Ferdinand's arrival witnessed the flowering of Flemish painting – seen in the work of Jordaens – plus a degree of artistic interchange with the north. The second half of the 17th century was a pale reflection of the first. During a period when traditional custom once more played an important part in the country's administration, Flemish painting had become provincial and produced no latter-day Rubens. Politically these years were marked by French threats of invasion and, with little support coming from a weakened Spain, the south was forced to accept military assistance from the Dutch republic. The association with the Austrian branch of the Habsburgs, which had begun with Albert's regency in 1596, continued in the governship of Ferdinand and Leopold Wilhelm. By the Treaties of Utrecht (1713) and Rastatt (1714) the southern Netherlands were officially declared Austrian territory.

**Virgin and Child with St Zacharias,
St Elizabeth and John the Baptist,** c.1620
*Jacques Jordaens (1593–1678)
Oil on canvas 45×60in (114×152cm)
National Gallery, London*

*A follower of Rubens after whose death he
became the leading figure painter of the
Southern Netherlands.*

**Autumn Landscape with a View of Het
Steen in the Early Morning,** c.1636
*Sir Peter Paul Rubens (1577–1640)
Oil on panel 51⅝×90½in (131×229cm)
The National Gallery, London*

*During the later years of his life Rubens
tired of his busy career and attempted to
retire from commissioned work and his
diplomatic connections. In 1635 he bought
the country mansion of Het Steen, near
Malines, and for the last five years of his
life spent as much time there as possible
with his second wife, Hélène Fourment,
painting for his own enjoyment. The high
horizon and broad perspective of this
landscape suggest that it was intended to be
hung with the base at eye level to give the
full effect. Despite the appeal of his peaceful
life in the country, Rubens failed to free
himself from other responsibilities and was
working on a large commission for Philip IV
of Spain at the time of his death.*

The Coronation of Marie de Medicis,
*1622–5
Sir Peter Paul Rubens (1577–1640)
Oil on Canvas 155×116¼in (394×295cm)
The Louvre, Paris*

*Marie de Medicis, widow of Henri IV of
France and mother of Louis XIII, ordered
the building of a new palace for herself in
Paris in 1615, now the Luxembourg Palace.
in 1621 she commissioned Rubens to
provide a cycle of paintings tracing the
major events of her life, and this is one of
the 21 pictures resulting from the
commission. The fine reputation of Rubens
had come to her attention through his work
in Italy for her sister, the Duchess of
Mantua, and also because the painter was
engaged in designing tapestries for Louis
XIII. Rubens completed some work on the
Medici cycle in Paris; others he painted in
his own studio in Antwerp. He made full
use of his workshop assistants in preparing
the paintings but added substantial
retouchings when they were hung in 1625.
Such a large commission pleased Rubens,
who had a very matter of fact assessment of
his own capabilities: "I confess that I am, by
natural instinct, better fitted to execute
very large works than small curiosities.
Everyone according to his gifts; my talent is
such that no undertaking, however vast in
size or diversified in subject, has ever
surpassed my courage."*

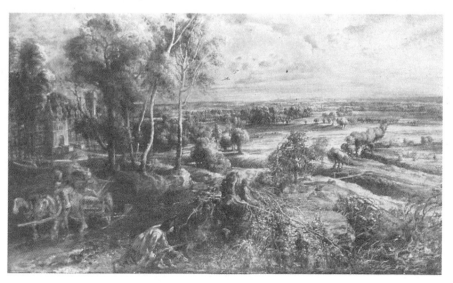

Italy in the 17th Century

Composed of numerous city-states, each with a long tradition of independence and civic pride, 17th century Italy played a far less powerful role in European politics than in the previous century. Spanish control' of Naples, Milan, Sicily and Sardinia, and French influence in Mantua, Modena, Parma, Piedmont and Monteferrat ensured both Habsburg and Bourbon interests for most of the century. Like Spain and parts of central Europe, Italy's levels of prosperity and population were lower at the end of the period than in 1600. Its northern textile industry suffered from the competition of the cheaper Dutch and Flemish markets, and a series of poor grain harvests resulted in a depressed peasantry and inevitable food riots. However, at the beginning of the 17th century there were signs that the earlier dangers from Protestantism had lessened; Catholicism had been reestablished in a number of European countries and many papal and clerical abuses of power removed during the Counter-Reformation.

At the beginning of the 17th century the earlier threat from Protestantism was not as great as before, but the threat of scientific enquiry to established values and principles meant that a visual support that emphasized Catholic orthodoxy was still needed. For this reason many beliefs central to the Catholic Church, such as the importance of good works and the cult of the Virgin and Child, were reflected in painting and sculpture. As the Baroque passed from its Early period (1600–30) into its High period (the mid-decades of the century) greater confidence within the Catholic Church was reflected in a more flamboyant and exuberant style of art now aimed at satisfying the aesthetic senses of the observer as well as Biblical accuracy by brilliantly incorporating spatial illusionistic devices to heighten and stimulate emotional response in the viewer.

There was one artist in particular who, while capable of arousing the spectator's emotional and spiritual response, offered viable alternatives to other 17th century artists: Michelangelo da Merisi (1573–1610), better known as Caravaggio.

In 1597 Caravaggio received a commission from the Church to decorate the Contarelli Chapel. The paintings, however, received a great deal of criticism. One charge was Caravaggio's depiction of a saint with "dirty feet". His *Madonna di Loreto*, painted in 1604 for another chapel, was criticized for a similar lack of decorum and a "disparaging treatment of certain elements which should have been handled with more respect in such an important work", and his *Death of the Virgin* was also attacked for portraying its subject "like some filthy whore from the slums".

While contemporary religious literature emphasized the nobility and beauty of the Virgin and the saints, Caravaggio emphasized the simple piety and nobility of the common peasant. The subjects of his paintings were portrayed within a familiar environment by making the figures large – and therefore nearer to the onlooker – and investing them with the physical defects of ordinary human beings. This same piety is present in Caravaggio's *Seven Acts of Mercy* (1606), which, by interpreting the events depicted in the painting in human, everyday terms, transmits the poverty and suffering of contemporary Naples.

Although continually in trouble with and misinterpreted by civic as well as religious authorities, and personally and artistically attacked, Caravaggio never lacked influential friends and patrons. His death at Port'Ercole at the age of thirty-seven was marked by the simple notice that "Word has been received of the death of Michelangelo Caravaggio the famous painter, re-

nowned in the handling of color and painting from life."

While still alive, Caravaggio had been in contact with a group of artists who later came to be known as the Caravaggisti because of their close contact with him. This included a small group of Italian painters of religious subjects who, in adopting Caravaggio's style of situating figures in an enclosed, semi-lit space, attracted a group of northern painters working in Rome soon after Caravaggio's death. On their return to Utrecht – a center of Catholicism – these northern artists formed the Utrecht school, producing religious works that combined Caravaggio's characteristic use of chiaroscuro tempered by native traditions.

By the 1620s most of the northern Caravaggisti had left Rome. After 1630, with the exception of the French painter Georges de La Tour (1593–1652), whose paintings were influenced more by the Utrecht school than by Caravaggio, Caravaggio's influence and artistic popularity declined.

While Caravaggio introduced a new and radical stylistic approach in 17th century painting that had long-term effects, he was still, through most of his career, dependent largely on the Church, showing that during this period the nature of Roman society, or more accurately papal society, was of central importance to the future development of Baroque art.

While politically independent, the 17th century papacy was frequently at the mercy of the European balance of power and as wary of absolutist as of Protestant tendencies. Like its 16th century counterpart, the papacy saw artistic patronage as a means of furthering the office of the pope as well as its own personal and dynastic interests.

Despite Counter-Reformation reforms, nepotism ensured substantial papal "families" and there was considerable artistic scope for private

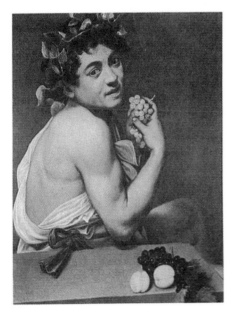

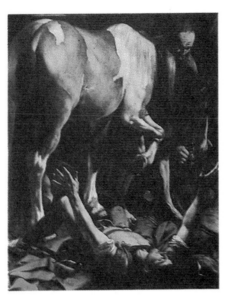

Bacchus, c.1596
Michelangelo Merisi da Caravaggio
(1573–1610)
Oil on canvas 37½ × 33½in (95 × 85cm)
The Uffizi, Florence

The Conversion of St Paul, 1600–1
Michelangelo Merisi da Caravaggio
(1573–1610)
Oil on canvas 90½ × 69in (230 × 175cm)
S. Maria del Popolo, Rome

Caravaggio is regarded as among the
greatest of 17th-century painters for the
originality of his work and its considerable
influence on the development of Italian
painting. His personal life and career were
equally extraordinary, being punctuated by
violent incidents illustrating his volatile and
aggressive temperament. After an early
apprenticeship in Milan, Caravaggio is
recorded as living in Rome by 1592,
although the exact date of his move is not
known. He became a workshop assistant,
painting details of still lifes, fruit and
flowers. Some evidence of this training can
be seen in the Bacchus of 1596. Attempts
to set up business on his own were not
initially successful, but eventually, with the
help of other artists, he became acquainted
with dealers and patrons, notably the
Cardinal Francesco del Monte, who gave
Caravaggio shelter, food and an allowance
and also bought several of the paintings
outright. In 1600 Caravaggio was

commissioned to make two large paintings
for the chapel of Monsignor Cerasi at
Santa Maria del Popolo in Rome. The
subjects were the Conversion of St Paul
and the Martyrdom of St Peter. Caravaggio
produced a version of each picture but these
first efforts were both refused. The work
was not wasted, as the paintings
subsequently were bought for a private
collection, but Caravaggio made second
versions of each and the final payment for
acceptance of this work was made in
November 1601. The Conversion of St Paul
shows an aspect of Caravaggio's work that
brought considerable criticism: his realism
in which saintly figures in the paintings
were modeled on ordinary people, observed
in minute detail and not elevated by
idealization. It also demonstrates the power
of Caravaggio's approach to composition,
with the dramatic chiaroscuro and fore-
foreshortening of forms.

patronage, for example in the decoration of family chapels in addition to official papal projects. The precariousness of papal politics – the death of a pope resulted in his "family's" immediate downfall – frequently led to frenzied periods of patronage in an attempt to outdo rival or preceding dynasties before power, and therefore money, ran out. Nationalistic considerations were also important, with successive popes giving artistic preference to fellow countrymen; Gregory XV, for example, extensively commissioned paintings from his fellow Bolognese, Domenichino (1581–1641).

A close examination of Pope Urban VIII in particular shows how, in bringing all of these factors into play, mid-17th century Italian Baroque art developed as it did. Maffeo Barberini, the future Urban VIII, had held the position of Papal Legate in France and, with his brother Carlo, had shown a characteristic interest in the arts. Inspired by the lavish patronage of Pope Paul V and his nephew Scipio Borghese, the first two decades of the 17th century saw a change in Italy from austerity to a richer and more sensuous style. Against this background Maffeo Barberini was elected Pope Urban VIII in 1623 and embarked upon a policy of artistic endeavor that used papal resources and occasional increases in taxation to employ on a grand scale fellow Florentines the architect/sculptor Gianlorenzo Bernini (1598–1680) and the architect/painter Pietro da Cortona (1596–1669). This resulted in works that far surpassed the splendor of Borghese patronage, glorified the Barberini family as much as the Catholic Church, and dictated the development of all of the arts for the next twenty years.

The end of Urban's pontificate in 1644 coincided with the final years of the Thirty Years War and the beginning of the French ascendency in Europe.

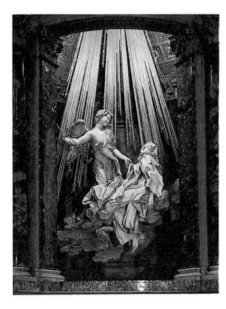

The Ecstasy of St Theresa, *1646–52*
Gianlorenzo Bernini (1598–1680)
Marble
Cornaro Chapel, Santa Maria della
Vittoria, Rome

When Pope Urban VIII died in 1644 Bernini gradually lost favor at the papal court. During the early years of the papacy of Innocent X, Bernini was commissioned for the full decoration of the chapel of Cardinal Federigo Còrnaro in the left transept of Santa Maria della Vittoria in Rome. The centerprice of Bernini's decorations is the sculpture of St Theresa in ecstasy, a faithful rendering of her account of her experience. As a devout and conscientious Catholic, Bernini was able to give his wholehearted imagination to the work. The walls of the chapel are faced with different colored marbles surrounding the central tableau. In the vaulted ceiling above, a host of angels is depicted in paint and stucco relief. Members of the Cornaro family are represented in sculptured boxes on the side walls, shown in animated realism as if discussing the vision. Because it is a shallow space the whole chapel was conceived for a frontal view. Although critics applied the term "theatrical", intending to disparage the work, it is appropriate to Bernini's conception and execution of the chapel as a unified experience.

Allegory of Divine Providence and Barberini Power, *1633–9*
Pietro Berretini da Cortona (1596–1669)
Fresco (sketch for)
Palazzo Barberini, Rome

Pietro da Cortona was originally apprenticed to a minor Florentine artist and accompanied his master to Rome in about 1612. Cortona gradually established his own reputation and became the major painter in the High Baroque style, as represented by his extraordinarily ambitious design for the ceiling paintings in the Barberini Palace. The ceiling is treated with an illusionistic architectural framework, apparently opening to the sky. The whole thrust of the composition is intended to simulate vertical height, including the poses and perspective of the figures. While working on the Barberini ceiling Cortona began work on frescoes in the Pitti Palace in Florence, where he incorporated stucco work with painted design to achieve a complex three-dimensional effect. The influence of his style spread to France and he was invited to Paris by Cardinal Mazarin, an invitation he refused. He gradually became more interested in architecture and was one of the architects invited to submit designs for the completion of the Louvre Palace in the competition won by Bernini in 1664

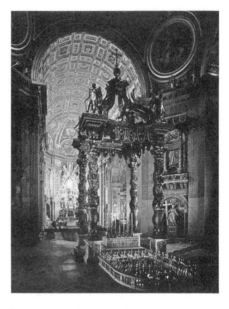

Baldacchino, *St Peter's, Rome, 1633*
Gianlorenzo Bernini (1598–1680)
Gilt bronze: Height about 100ft (30m)

Before starting work for Urban VIII, Bernini worked mainly on sculptures, but at the Pope's express wish he began to study painting and architecture. He apparently spent about two years almost solely occupied with painting, although few examples survive. His first architectural commission from Urban was the remodeling of the Church of Santa Bibiana, outside Rome. The first major work in St Peter's was the construction of the great baldacchino, or canopy, placed over the site of St Peter's tomb within the church. The work was ordered in 1624 and completion of the canopy took almost ten years. Bernini at first visualized a statue of the risen Christ above the central structure, but abandoned this in favor of a decorative architectural cover for the canopy, the edges being adorned with figures of angels and cherubs. As a personal tribute to the Pope, the symbolism of various elements relates to the heraldry of the Barberini family; the symbols include bees, the Sun and the Barberini laurel entwining the twisted columns.

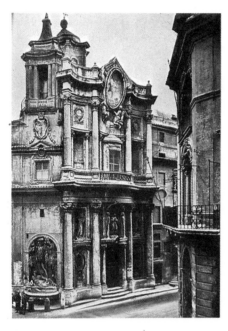

Church of S. Carlo alle Quattro Fontane,
Rome, 1638–46
Francesco Borromini (1599–1667)

This church, the crowning achievement of Borromini, spanned his working life, for the façade was not added until 1667. The decoration of the façade – a complicated series of bays, oval windows, Roman sacrificial altars and even a massive oval .portrait – is undoubtedly lively but has rarely been considered entirely successful. It is the interior that inspires awe. The church is so small that it would fit into one of the piers that support the dome of St Peter's. It is marked neither by sumptuous decoration nor by dramatic lighting; except for the altars the color is wholly gray and white. Yet so strong is the feeling of motion created by the interplay of the oval dome and the side and entrance chapels that the church seems to be spacious. The whole is a triumph of Borromini's view that architects must be painters and sculptors familiar with the human body, since only then would their buildings be true living forms. This organic principle was a vital ingredient of the Baroque and Borromini's buildings gave it its freest expression. But although he was in his own lifetime acclaimed with Bernini as the greatest architect of the high Roman Baroque just as the façade of this church was almost completed, he committed suicide.

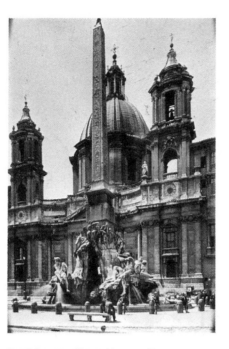

Sant' Agnese, *Piazza Navona, Rome, 1653–57*
Francesco Borromini (1599–1667)

As part of his ambitious project to remodel the Roman Piazza Navona, originally the stadium of Domitian (AD 92–96), and transfer the papal court there, Pope Innocent X decided to have the small shrine of Sant' Agnese entirely rebuilt. When Borromini took charge of the work in 1653, the foundations had already been laid and the crossing piers and façade begun to plans drawn up by the Rainaldi workshop. And since he quit the project four years later, only the façade and campanili up to the level of the main cornice are his. The ornamental austerity of the façade and the cross-rhythms of its curves are typical of Borromini's manner and of the Roman Baroque as a whole. Wren used the campanili of Sant' Agnese as sources for the twin west towers of St Paul's.

Although not so consistently extravagant nor so important as patrons, his successors Innocent X and, to a greater extent, Alexander VII, continued papal interest in the arts and allowed other artists, such as Francesco Borromini (1599–1667), the opportunities that Bernini's monopoly had prevented. There was also a relaxing of formerly strict attitudes and better financial support enabling the decorative completion of many churches belonging to various religious orders. Founded during the early period the Jesuits, Oratorians and Theatines had, like the papacy, all recognized the value of art as propaganda and had always been, in theory, a potential source of artistic patronage. In practice, however, limitations on imagery, particularly from the Jesuits, coupled with intermittant financial support usually derived from cardinal and noble families determined to exercise personal preferences, had kept many churches unadorned until the latter part of the century. Although many provincial artists traveled to and worked in Rome, centers such as Milan and Florence tended to develop along independent and regional lines. Naples followed this pattern for the first part of the century where a Caravaggio-like realism seen in the work of José Ribera (1591–1652) and Annibale Carracci (1557–1602) and a strictly enforced Counter-Reformation imagery dominated Neapolitan painting. By the third quarter of the 17th century the role of the papacy as a vital source of patronage was increasingly challenged by monarchs pursuing similar self-aggrandizement, most noticeably Louis XIV. Although Rome never lost its importance as a major artistic center, the emphasis clearly began to shift toward Paris.

The Decline of Spain

In the 17th century Spain declined as its rulers pursued a foreign policy impossible to support on the country's reduced revenues. During the period between 1600 and 1670 Spain was almost continually at war, its main adversaries being the Dutch United Provinces and France. These wars were long-lasting, widespread and extremely costly; furthermore, they failed. The war against the Dutch led to Dutch independence, and the war against France went on for decades, resulting in the loss of border provinces such as Artois and Roussillon and the cost was ruinous. Revenue from Spanish lands in the Americas declined over a long period of time – although expenditure did not – and the silver treasures that did arrive were sometimes already mortgaged so that on the one occasion when the Spanish fleet was captured by the Dutch, the effect on the Spanish economy was catastrophic.

Constitutionally Spain was a union of crowns that included the kingdoms of Catalonia, Valencia, Aragon, Castile and Portugal. Although each kingdom had its own privileges and tax-exemptions, it was Castile – the largest in both area and population – that had political dominance. In the 17th century, however, Castile's political power was not equaled by its economic strength. Early in the century the plague claimed half a million lives; the countryside was depopulated and urban industries collapsed, and by 1650 established industrial centers, such as Segovia and Toledo, were in noticeable decline. Moreover, the Church and aristocracy numerically made up a high percentage of the Castilian population and owned ninety-five per cent of the land, but were largely exempt from taxation and did not invest their income to stimulate the economy. The resulting decline in Castile's fortunes, as well as in the size of its population, meant that it had less and less to supply in revenue for the Crown. At the same time the Spanish obsession with nobility and the accompanying distaste for work of any kind meant that the small number of citizens who could have formed a merchant class had no wish to do so, despite occasional governmental decrees to encourage trade. In direct contrast to the towns of the United Provinces and France, which contributed to economic growth, Castilian towns lacked a vigorous merchant class.

For much of the 17th century the Spanish government was conducted by a succession of ministers. Gaspar de Guzman, count of Olivares, was the most notable and as minister to Philip III tried several times to reduce expenditure, encourage trade and curb the spending of the court and nobles, but was thwarted by the King's refusal to do anything that might admit reduction of Spanish power. Olivares's reforms, like those of Richelieu in France, aimed at strengthening the economy; however, unlike Richelieu, he never had a long enough period of peace in which to carry them out. The result was a permanently bankrupt country that stretched too few resources to too many fields of conflict. Eventually this situation led to revolt among the Spanish kingdoms, especially Catalonia and Portugal. Spain was so weak that Portugal managed to achieve complete independence.

If Spain was troubled by economic upheaval, it had no religious problems. Instead, the country remained unswervingly Catholic throughout the Reformation and Counter-Reformation, and saw itself as guardian of the papacy and Catholicism. Throughout the 16th century Spain dominated the papacy and, although this domination declined in the 17th century, the two parties have always recognized their close ties. The Jesuit order, for example, was always pro-Spanish and advanced the Spanish cause wherever it penetrated. The identification of the Spanish Crown with Catholicism was one of the reasons why Philip III refused to abandon war with the Dutch Protestants, seeing the suppression of heresy on an international scale as his scared duty. Church and Crown were linked in Spain to a degree not known elsewhere, and these two groups were the major patrons of art in 17th-century Spain.

The Church as patron

Unlike the Church in England and France, the Spanish Church's patronage of the arts was not interrupted by the Reformation and it continued to commission large-scale projects in painting and architecture. As in Italy, wealthy commissions by the secular population, in addition to religious organizations, ensured a steady source of religious patronage. The religious orders and the Church encouraged accurate depictions of important or fundamental Catholic beliefs, such as the Immaculate Conception of the Virgin. As at Trent, an artistic code of conduct was rigorously supervised.

Despite the close ties between the Spanish monarchy and the papacy, however, the quiet intensity of Spanish Catholicism resulted in a type of religious art singularly and essentially Spanish. In contrast to the more flamboyant affirmation of Catholicism in Rome, Spanish Catholicism was a combination of spirituality and the mysticism found in the writings of St Theresa and St Ignatius Loyola. Artistically this is echoed in a deeply personal vein in the work of El Greco (1541–1614). In many ways El Greco's intensely individual style sets him apart from the mainstream of Spanish religious painting, but his strong juxtapositioning of colors and handling of figures engaged in dramatic movement anticipates many Baroque tendencies. Emotionally, El Greco's interpretation

of a type of personal spirituality permeates later Spanish painting, in particular the work of Francisco de Zubarán (1598–1664), whose images of monastic contemplation reveal another, more private side of Spanish faith.

The Spanish court also had a long tradition of artistic patronage and Charles V's patronage of Titian (c.1487/90–1576) was eclipsed only by the building projects and collections of his son Philip II. The 17th century Spanish monarchy continued this tradition and consequently many artists flocked to the Madrid court. Despite, or possibly because, Spain had grown economically and politically weaker, 17th-century royalty in particular needed to project an image of strength and power. In Diego Velasquez (1599–1660) Philip IV found an artist who technically and tempermentally was more than equipped to convey the regal air of sober stateliness associated with Spain, at the same time never forgetting that the King and his family were human beings.

Commissions for portraits and religious works tended to dominate 17th-century Spanish painting, but by the middle of the century other areas were gaining popularity. Landscape painting, prompted by Philip IV, became increasingly popular, as did still-lifes and the work of Juan de Valdés Leal (1622–90). While poor internal communications and a lack of political unity ruined any chance of a national style, artists traveled between regional artistic centers, such as Seville and Madrid, studied works in private collections and had access to drawings and engravings from abroad. Foreign travel and visits from foreign artists, such as Rubens in 1603, and again in 1636, influenced native painters, while the importation of José Ribera's work from Naples – part of the Spanish empire – introduced Spanish artists to a Caravaggio-like realism and directness.

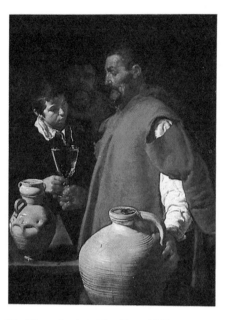

The Water Carrier of Seville, c.1619
Diego de Silva y Velasquez (1599–1660)
Oil on canvas 41¾×31½in (105.5×80cm)
Wellington Museum, London

Velasquez spent his early life in Seville and at the age of twelve was apprenticed to a local painter, Francisco Pacheco. Pacheco was also a writer and his home was a meeting place for the intellectuals of Seville. In 1618 Velasquez married Pacheco's daughter and began to gain a local reputation as an independent artist. Religious subjects appeared in his early paintings but he also developed a series of scenes of everyday life, subjects less well accepted in Spanish art of the period although genre paintings had become an accepted part of northern European traditions. The Water Carrier is typical of this early phase of Velasquez's work, particularly in the heavy chiaroscuro set against a dark background. Later the the painting was looted from Spain by Joseph Bonaparte, brother of Napoleon, and was confiscated from him after his defeat at the Battle of Vitoria. The Duke of Wellington attempted to return the painting to the Royal Collection of Spain but was instructed by the King to keep it, where it remains.

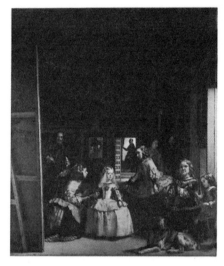

Las Meninas, *1656*
Diego de Silva y Velasquez (1599–1660)
Oil on canvas 125×108½in (318×276cm)
Prado, Madrid

Velasquez's first attempt to gain access to the Spanish court was unsuccessful, but in the following year, 1623, Philip VI succeeded to the Spanish throne. In the new court there were a number of Sevillians, including friends of his teacher Pacheco, were able to offer Velasquez hospitality in Madrid and introduced him to the King. Philip VI sat for Velasquez in the same year and the resulting portrait was very well received. The Painter was invited to remain at court and gradually established an important position there. In 1629 he was sent on a business trip to Italy that enabled him to view and buy paintings; during that visit he also made the well-known portrait of Pope Innocent X. Velasquez's figure group known as Las Meninas is from the later period of his career. It represents a complex spatial arrangement, showing the painter, surrounded by the Infanta and her servants, during work on a portrait of the King and Queen. They appear only as a mirror reflection in the background, and the viewer in fact stands before the painting in approximately the same relation to the figure group as would have been that of the painter's subjects.

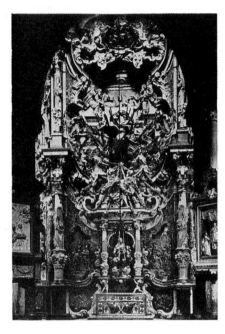

The Transparente, *Toledo Cathedral, Spain, 1721–32*
Narciso Tomé (c.1690–1742)

Tomé's ornate altar structure, placed in the Cathedral's ambulatory, was hailed at its completion as one of the wonders of the world. Today, after suffering in reputation during the Neoclassical revival, it is regarded as one of the surpassingly imaginative achievements of the Rococo. Its concave structure and illusionist lighting effects make it almost a chapel without walls. The whole massive structure appears to rest, in a playful manner typical of the Rococo, on two small angels standing on the altar table. The central image of the Madonna and Child is flanked by fluted, marble columns and surmounted by an alabaster rendering of the Last Supper, *above which the heavens, conceived in dazzling colors of jasper and glass, send down gilded rays of light. A magical effect is given to the altarpiece by hidden lighting from above, which draws the eye heavenward. This obscuring of the figures and ornaments, whose function is to contribute to the overall ensemble, is an example of the decline in the importance of sculpture in Spanish church architecture of the late 17th and early 18th centuries.*

The second half of the century was marked by continuing patronage by a monarchy financially unable to do so. Stylistically it is characterized on the one hand by the harsh, expressive intensity of Leal and, on the other, by the lighter and more sentimental religious works of Bartolomé Esteban Murillo (1617–82). Apart from these two, Spanish painting in this period, as in the Spanish Netherlands, is a poor reflection of the early 17th century.

Throughout the 17th century the Church, with its huge resources, was the main architectural patron and secular architecture declined. One impetus to building had been the demand for new churches in the lands reconquered from the Moors toward the end of the Middle Ages, resulting in large, early Classically-styled works such as the Valladolid and Granada Cathedrals. Such churches continued to be built into the 17th century, maintaining this style. The lack of a bourgeois or official class, as in France, removed a potential source of patronage. Even the Crown's contribution to architectural patronage was reduced, partly because it had no need for new palaces; Philip II's large complex, the Escorial partly by Juan Herrera (1530–97), was just completed in 1600 and satisfied the needs of the crown and court. A combination of monastery, mausoleum and palace, the Escorial is a striking manifestation of the strong ties that existed between the Church and crown in Spain, and the almost mystical identification of the monarchy with the cause of Catholicism. The severe Classical style of the Escorial predominated in Spanish architecture in the early 17th century.

As in other countries, the spread of the Jesuits in Spain brought a Roman style of architecture modeled on the plan of the Church of the Gesu in Rome, but the style of churches favored a Mannerist design rather than a full-fledged Baroque. This might appear unusual in a country with strong links with Italy, a loyalty to Catholicism and dominance by the Church, and can perhaps be seen as the continuing influence of Herrera's taste for severity.

The Baroque style first appeared in Spain in about 1660 in sculptured altarpieces where Catholic fervor could unleash fantastic theatrical designs that were meant to affect the onlooker, as at Compostella and in Andalusia. Sculpture was completely dominated by the production of religious works; the depiction of military and triumphal sculpture for squares and gardens was almost unknown. Castile especially evolved a sumptuous Baroque style, as seen in works such as the *Pietá* by Gregorio Fernandez (1576–1636).

The transference of Baroque design from sculptural compositions to church façades was first noticeable in Granada Cathedral in about 1660. Architecture and sculpture, still dominated by Church patronage, now rapidly became ornately Baroque, as shown by the high altar of the church of San Estevan, Salamanca, by José Benito de Churriguera (1665–1725), a designer whose name came to be associated with overwhelming ornamentation.

The continued economic and political decline of Spain at the beginning of the 18th century did not halt the Church's patronage; its command of so high a percentage of the nation's resources meant that grandiose projects could still be commissioned. One of the most important Baroque works of this period was the Transparente at Toledo Cathedral, a chapel inserted in the cathedral ambulatory between 1721 and 1732. In style, it is directly related to 17th-century works in Italy by Bernini, in which elements of architecture, painting and sculpture were used together with the aim of overwhelming the emotions of the onlooker with visual splendor.

England under the Stuarts

England in the 17th century was dominated by attempts by the Stuart monarchs (1603–49 and 1660–1714) to impose absolutist theories of government onto a country with a strong parliamentary tradition. Already King of Scotland, James I became the first Stuart king of England in 1603. His intention to rule with as much control as possible is reflected in his *True Rights of Free Monarchies*, written in that same year, stressing the Divine Right of Kings, legal sovereignty, freedom of executive action and responsibility only to God. Because Scotland was an impoverished kingdom and prone to political factions, and James anticipated a more luxurious court in England with ample funds for patronage, he spent freely. Elizabeth I's reign, however, had left England badly off and James's royal expenditures soon caused difficulties. It was only a lack of foreign wars that staved off a major financial crisis; the war with Spain, for example, was brought to a close and removed a potentially fatal drain on resources.

James I died in 1625 and was succeeded by his son, Charles I. Like his father, Charles was a firm believer in the Divine Right of Kings and consequently clashed many times with Parliament in his attempts to put his ideas into practice in relation to Church, government and financial matters. This finally led to the outbreak of the Civil War (1642–9), resulting in the Commonwealth of England under the rule of Oliver Cromwell (1599–1658), which lasted until the restoration of the monarchy under Charles II in 1660. During the Commonwealth there was no court, at least in the social sense, although Cromwell as the center of power attracted followers and admirers. After the restoration, Charles II's place in the constitution of the country was more limited than his father's and from this time onward

absolutism under an English monarch was not possible. The replacement of Charles II's successor, James II, by William III and Mary in the bloodless "Glorious Revolution" in 1688 shows that by this time Parliament had achieved a position of unassailable strength and England had become a constitutional monarchy in which policies of government were increasingly the province of Parliament rather than of the king.

The monarchy as patron

The history of the monarchy in 17th century England directly affected the history of English art. The Church of England, being Protestant, needed no devotional art, and few new buildings; what little church building took place was hesitant and unadventurous, exhibiting a survival of an earlier Gothic style. England lacked the great noble families of the power and wealth found in other European countries, and while there were noble patrons of importance, they were often individuals rather than members of a wealthy caste. For these reasons the monarchy came to be the greatest patron of painting, architecture and sculpture, and artists and architects were used to express its aims and aspirations. While Baroque art did not occur in England as in Italy, the tenets of its art and architecture came to be more fully understood through the artists employed by the monarchy.

The Stuart monarchs in particular were keen patrons of the arts. Charles I's collection of paintings and artifacts encouraged others to do the same, creating a court mania for art and the rise of Van Dyck in painting and Inigo Jones (1573–1652) in architecture reflect this.

Inigo Jones first achieved royal favor as a designer of masques and was later commissioned to create some of the masterpieces of English architecture.

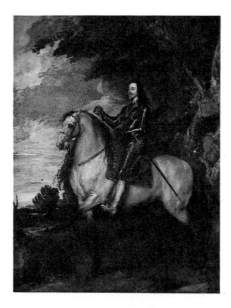

Charles I on Horseback, c.1638
Sir Anthony van Dyck (1599–1641)
Oil on canvas 144½×115in (367×292cm)
National Gallery, London

Van Dyck's great talent was recognized early in his native town of Antwerp and he had carried out one large commission before joining the Guild of St Luke in 1618. At about that time he worked with Rubens and made his first visit to London in 1621, where he came under the patronage of King James I. After several years traveling in Italy, Van Dyck returned to Antwerp, but from 1632 the remainder of his life was spent as court painter to Charles I of England, who rewarded his services with a knighthood. The King was well satisfied with Van Dyck's first group portrait of the royal family (1632), which was followed by the first equestrian portrait of Charles I (1633). Van Dyck's portraits of Charles I improved upon the subject, who was said to be small and unprepossessing; the King thus acquired an air of authority tinged with melancholy, which for many years afterwards was claimed to be a premonition of his impending martyrdom. In fact, Van Dyck was dead before any hint arrived of the political upheavals to come, so this view of the portraits is romantic. Nevertheless, Van Dyck succeeded in establishing an image of the court that is still instantly recognizable, and particularly of the King, one of the last English monarchs to rule in the belief of his Divine Right to office.

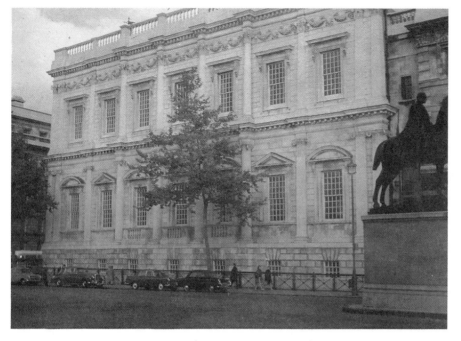

The **Banqueting House**, *London, 1619–22*
Inigo Jones (1573–1652)

When Inigo Jones was appointed Surveyor General of the King's Works in 1615 English architecture had scarcely been touched by the Renaissance. Jones himself, although skillful at architecture in wood and canvas, had almost no experience of monumental building in stone. The Queen's House and the Banqueting House – the one modeled on an Italian villa and the other on an Italian palace – introduced the Palladian style to England. Each was designed on the principle of the double cube, with rooms rising to two stories, the exterior elevation of each story having its own order and the front facade characterized by decorative pilasters and a slightly projected central bay surmounted by a pediment. The plans details are faithfully Palladian – with the exception of the cantilevered balcony on the lower order of the Banqueting House – the wide spacing of the windows gives the buildings a calm elongation in marked contrast to the upward agitation of Palladio's building, with their emphasis on the vertical piling-up of orders at the center. The plans for the Queen's House were drawn up in 1616, three years before those for the Banqueting House, so although it was not completed until 1635, it is considered to be the first Classical building in England. The idea of a double-house, linked by a first-story bridge, was Jones's solution to the problem of joining the garden at Greenwich to the park that lay across a road. The idea was taken from the Villa at Poggio à Caiano near Florence by Giuliano da Sangallo (1445–1516).

If Jones owed his first commissions to James, he owed the experience he used to produce them to Thomas Howard, Earl of Arundel. Lord Arundel, an exception to the general paucity of private patronage in England, was an avid collector and, more importantly, toured Europe to widen his appreciation of art. On one occasion he took Jones with him to Italy, giving the young architect the opportunity to see Classical and Renaissance architecture and to meet Italian architects. Most English architects had not visited the Continent and acquired their knowledge of Classical motifs through books of ornamental design. Therefore they had only a second- or third-hand acquaintance with the architecture current in southern Europe, and as a result they applied Classical motifs without a real understanding of Classical Italian rules of proportion. Largely because of his exposure to contemporary Italian Baroque styles, Jones was unique among English architects of his generation and his designs mirror this distinc-

tion. His Queen's House in Greenwich, commissioned by James I and built in the early part of the century, is a chaste, Classically styled villa with obvious Italian influences. Similarly, the Banqueting House, London, also commissioned by James I, strictly obeys Classical laws of proportion and design. Both works are very different from the type of buildings that were being erected in and around London at the time.

Painting received similar stimulus from Van Dyck, one of the foremost Flemish painters of the time. The artist first came to London in 1620, departing soon after for a period of study and employment in Italy and elsewhere and returning to England in 1632. Van Dyck, like Jones, owed his popularity to Lord Arundel and was heavily patronized by the Crown. Until Van Dyck's arrival, English painting reflected the Elizabethan style, seen in the stiff, formal portraits of that period. Working in England from 1632 until 1641, Van Dyck introduced a Baroque

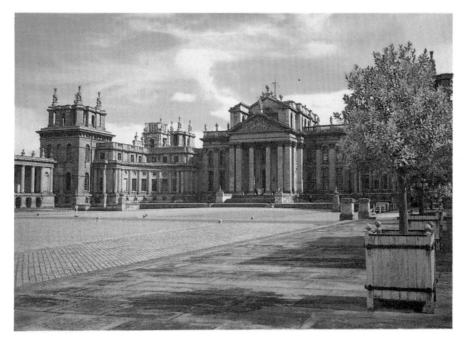

Blenheim Palace, *Woodstock, England,
1705–22*
*Sir John Vanbrugh (1664–1726) and
Nicholas Hawksmoor (1661–1736)*

*Blenheim Palace, a gift from the nation to
John, Duke of Marlborough in gratitude for
the victory over Louis XIV at Blenheim in
1704, is the most monumental expression of
the Baroque in England and the noblest
creation of the Vanbrugh/Hawksmoor
partnership. Vanbrugh was already famous
as a playwright when, in 1699, he suddenly
turned architect and undertook to design
Castle Howard for the Earl of Carlisle. Sarah,
Duchess of Marlborough, would have
preferred Wren as Blenheim's architect.
"I made Mr Vanbrugh my enemy", she
wrote, "by constant disputes I had with
him to prevent his extravagances." For the
Marlboroughs had to foot part of the bill.
The Duchess's tongue drove Vanbrugh
away – he left in a rage in 1716 never to
return – but she was unable to stop the
extravagance. Blenheim, as much castle as
palace, is on a scale far beyond that of any
other private residence in England. Built
entirely from local stone, it achieves an
heroic grandeur that brilliantly fulfils
Vanbrugh's intention to produce a lasting
evocation of military glory. It marked a
turning away from the simpler Classical
principles of Inigo Jones and Wren.
façade was not added until 1667.*

St Paul's Cathedral, *London, 1675–1710*
Sir Christopher Wren (1632–1723)

*Wren's most famous building, while it may
in a general sense be called England's only
Classical cathedral, is a blend of elements
entirely in keeping with his prevailing
tendency to eclecticism. The dome,
London's best-known skymark, is
quintessentially Classical, but the shape of
the church – a Latin cross – is the result of
Wren's capitulation to the conservatism of
English, and especially clerical taste. Wren
was forced to abandon his original design
in the shape of a Greek cross in order to*
*bring the Cathedral into conformity with
English expectations of a long nave leading
to a long chancel. The result is a plan nearer
to a Norman cathedral than to any Classical
model. The façade of the west front is also
more Baroque than Classical, all the more
so for the cross-rhythmed, fantastical
flanking towers, which were designed after
1700. The whole ingenious mixture of
styles was entirely the work of Wren, a feat
accomplished by few other architects in
history for a building of such size.*

style which was quickly adopted by the court of Charles I. These included innumerable portraits and studies never before done of the royal family, including his celebrated portrait of Charles I for the Italian sculptor Bernini, from which the sculptor was to model a bust of the King. The bust never materialized, but the project, like his commissioning of Jones, is indicative of Charles's desire to include the most current styles of art at his court. A further example of Charles's patronage was his commissioning of Rubens to paint the ceiling of Jones's Banqueting House in London.

With the Civil War, architecture ground to a standstill and painting declined; without a court and its money, the arts could not flourish. Yet the war affected the future of English art and patronage. During his nine years in exile in France and Holland, Charles II came into contact with the art and ideas of the Baroque. Upon his return to the throne in 1660, Charles's patronage, especially in architecture, reflected this and his admiration for Louis XIV, as seen in his schemes for Whitehall, Winchester, Chelsea and Greenwich, which show a desire for impressive buildings on the lines of Versailles and Les Invalides. For these Charles commissioned the architect Sir Christopher Wren (1632–1723). Wren was fortunate not only in being offered numerous royal projects, but in being given responsibility for the rebuilding of London after the Great Fire of 1666. Wren is best known for his numerous London churches and especially St Paul's Cathedral, which exhibits his inheritance of Jones's ideas and shows the beginnings of a Baroque style in England. Examples of this include the west towers of the Cathedral, built later than the original design. Wren's ideas were later exploited by Nicholas Hawksmoor (1661–1736) and Sir John Vanbrugh (1664–1726).

Central Europe in the 17th Century

In the 17th century France and England were unified countries; Spain and Italy were fragmented but composed of a few large states – in Spain's case united under one crown, in Italy's mainly ruled by the various Habsburgs. Central Europe, however, was composed of hundreds of semi-independent states, the most important including Austria, Bohemia, Moravia and parts of Hungary. These states in theory owed allegiance to the Holy Roman Emperor (traditionally a Habsburg), but in fact were autonomous. They varied in size from those large enough to be considered nations, such as Bavaria, to innumerable free cities – reminiscent of Greek city-states and Italian early republics, although much smaller – which consisted of merely a city and the land immediately around it. Of these, Nuremberg and Augsburg were among the most politically, commercially and culturally important. There were also many states ruled by prince bishops which were a combination of diocese and independent states, such as Cologne and Mainz. The largest and most powerful states were the traditional Habsburg lands of modern Austria and Bohemia, ruled by various members of this dominant family.

The religious divisions of Central Europe were as complicated as the dynastic ones. Protestant and Catholic states were scattered across the entire area; large groups of one religious persuasion often lived in a state where the official religion was the other. The Counter-Reformation therefore made Central Europe a potential battleground for the victory of either Catholicism or Protestantism and was seen as such by militant Catholic forces in the early 1600s. The Habsburg lands – because of Habsburg dominance in Italy – and those allied to them were physically, and politically close to Rome. Their rulers were therefore keen champions of the resurgence of Catholi-

cism, which would create an indissoluble link with their own political power. They also knew that any attempt to increase Habsburg power would have the backing of Spain, who had everything to gain from a strong Catholic presence in Central Europe acting as a threat to Protestant countries of the north.

In the light of this, in the latter half of the 16th century, many Catholic and Protestant states cautiously came together in leagues of defense. These alliances became more pronounced in the first two decades of the 17th century, when Habsburg activities against Protestants prompted the creation of the Protestant Union for Defense of Evangelical Religions and the retaliatory Catholic League. The threat to political stability was increased by the international support of both sides in German lands because any local conflict had the potential of becoming a major European war.

Such proved to be the case. Starting with a local dispute in Bohemia, the Thirty Years War broke out in 1618. Soon Spain, Sweden and, later, France became involved in a prolonged war that took place largely within modern-day Germany. The effect on the areas involved was extremely damaging. Before the war the economy and population of Germany and central Europe was comparatively stable and healthy, with farming and many rich trading cities populated with prosperous merchant classes. During the war most of Germany suffered a decrease in population from fighting and, more dangerously, from the effects of plague on an already weakened population. While parts of northern Germany were relatively untouched, Bohemia and Silesia lost about twenty per cent of their populations. Southern Germany was even more heavily affected: the population of Munich, for example, fell from 18,000 to 9000 inhabitants. Over-

all the German population shrank by forty per cent in the countryside and thirty per cent in the cities. The depopulation of the countryside destroyed the incomes of the nobility dependent upon it, for example in Bavaria, where officials and the Church acquired lands cheaply. Depopulation in towns adversely affected the economics of cities already facing stiff competition from the northern countries; and in the south the bankruptcy of the major banking families added further problems. Industry was interrupted by warfare and slow to recover. Politically, the war meant a decline in the power of the Emperor, and the Peace of Westphalia in 1648 favored his two enemies, France and Sweden. Later, the rise of the Hohenzollerns – aided by France – in Brandenburg created another source of opposition to Habsburg domination of Germany.

The Thirty Years War severely curtailed development in the arts, and particularly in the Baroque style, in Germany. Before 1618 close political and religious ties between southern Germany, the Habsburg lands and Rome had resulted in the spread of Roman ideas to those areas where Jesuits quickly became established, for example, Munich. In the arts Mannerism had become popular and consequently the use of Italian architects, painters and sculptors. Bavaria, Austria, Bohemia and parts of Hungary all developed late Mannerist and early Baroque styles in the early 17th century in both secular and religious art. Without the war, the development of an exuberant Baroque art in all fields would have been probable, closely allied to later Italian developments in Catholic countries. Parts of Protestant Germany would probably have evolved a town-dominated art similar to that of the United Provinces and also, perhaps, been influenced by the Classicism of France and England. While the inter-

national nature of art at this time meant that style was not totally dictated by religious or political affiliations, these considerations did play a large part in determining to what degree the Baroque did or did not develop in a given area.

After the end of the war a great deal of architecture and sculpture resulted from the need to restore buildings that had been damaged and to build new ones, especially churches, as a symbol of the war's end. As before the war, the prominence of Italian designers is noticeable, in Vienna especially. Development in Hungary was restricted by the occupying Turkish forces, who threatened to conquer all of Hungary and even Austria several times in the 17th century. Bohemia, in contrast, saw a spectacular development of Baroque art as the nobles who supported the Habsburgs, with their newly enlarged estates, began to build new palaces. The nobility's political aspirations to be as powerful as possible added an impetus to their displays of wealth and Prague became full of palaces and churches mainly designed and decorated by Italian artists and architects, reflecting the style of that country.

French influence was not restricted to architecture; absolutism, as practiced by Louis XIV, was eagerly imitated where and when possible. Absolutism for the Empire, however, had been an impossible concept even before the Thirty Years War. The constituent states had far too much power to be compelled to submit to an absolutist emperor, and the erosion of his position during and after the war confirmed this balance of power. As the individual states recovered from the war, their rulers evolved their own forms of absolutism, while in the Habsburg lands rule had been largely absolutist throughout the country. Coupled with this was the resurgence

of nationalism, kindled for the first time with the defeat of the Turks in the 1680s and 1690s, most noticeably after the defense of Vienna in 1684.

In art this was reflected in a decline in Italian dominance in architecture and sculpture as German designers came to prominence. Austria and Hungary also developed an appreciation of their own local talents in architecture, painting and sculpture which coincided with a monastic resurgence. The Church began to build and rebuild large monasteries designed by local architects, who developed a lush style independent of Italian Baroque schools. Some of these architects had trained in Italy but were sufficiently aware of their own talent to evolve a unique style that predominated from about 1680 until well into the 18th century. In secular building, small courts inspired by Louis XIV demanded imposing settings resulting in sumptuous Baroque palaces. These were now affordable as the effects of the Thirty Years War receded, farming and commerce provided a fruitful course for governmental revenue and warfare was largely avoided, except by expansionist Prussia. The main conflict of the late 17th century and early 18th centuries, the War of the Spanish Succession, was less damaging to central Europe and was fought with less ferocity. The Thirty Years War was the last religious war; thereafter war was political and dynastic and, although Austria, Bavaria and others were involved in conflicts, the burden was not so great as to halt artistic endeavors.

The Expansion of Europe: The Eighteenth Century

The 18th Century in Europe

The power struggles of the 18th century hinged mostly on the new ascendancy of France in Europe, and to a considerable extent also on the marshaling of the people of Prussia into the powerful nucleus of a future German state. These changes were the achievements of two absolute monarchs, Louis XIV of France and Frederick the Great of Prussia. Louis, therefore, can be held responsible not only for the War of the Spanish Succession (1701–14) during his own reign, but for the coalitions that were formed against France by her rivals in the War of the Austrian Succession (1740–48) and the Seven Years War (1756–63), and in a sense also for the international pattern of alliances against France in the French Revolutionary Wars (1792–1802), even after the French monarchy itself had disappeared from the political scene.

In the cases of the wars of 1740–48 and 1756–63 mentioned above, the immediate provoker – and ultimate beneficiary – was Frederick II, King of Prussia, better known as Frederick the Great (reigned 1740–86), whose ambitions led him into aggressive wars, principally against Austria and Russia, in which he established Prussia as the strongest German state. Yet in the wider perspective of the world balance of power, the true beneficiary of both wars turned out to be Great Britain (as the newly united kingdoms of England and Scotland were re-named after 1707). In North America the British won Quebec and the province of Canada from the French (1753–9), and supplanted them in India (1748–61), in a series of campaigns that won renown for General Wolfe in Canada and Robert Clive in India.

Looking still further ahead, the conflict between the British and French in America (in which Colonel George Washington served with distinction) in the 1750s started to draw the lines between revolutionaries and loyalists, in the run-up to the rebellion which was to break out in the thirteen colonies in 1774. The colonies of the United States which were to become the superpower of the 20th century, began to move toward independence in the repercussions overseas of France's struggle to maintain its position in Europe during the 18th century.

Other deep changes were making themselves felt in Europe. While the wealth, education and influence of the non-noble middle classes were increasing, most governments were in the hands of well-meaning but arbitrary rulers, the "enlightened despots", such as Frederick the Great, the Empress Maria Theresa (1740–80) and the Emperor Joseph II (1780–90) of Austria; Catherine the Great of Russia (1762–96) and Charles III of Spain (1759–88). Only in France and Britain were there two quite different situations. The fatal indecisiveness of King Louis XVI of France and the reactionary stubbornness of a privileged aristocracy blocked the necessary reforms which a stronger monarch might have forced through. In Britain, on the other hand, constitutional monarchy and responsible government were in the making. This had happened through the development of a special relationship between the ruling classes – Protestant in allegiance and increasingly mercantile in outlook – and the Hanover dynasty, brought over in 1714 to secure the Protestant succession. The three Georges (1714–27, 1727–60, 1760–1820), though far from ideal monarchs, did ease the transition from absolute to parliamentary rule which was to give Britain such political strength in the 19th century.

At the other, eastern, end of Europe, however, there was an absence of progress towards political freedom and responsible government during the 18th century. In Russia, serfdom was still being enforced and even lingered on in Prussia until as late as 1807. The absolute powers of the tsar (or empress, as in the case of Catherine the Great) were unchallenged. The strength of the Russian state, and the uniformity and obedience of its society, were the obsessions of its rulers. Russia's frontiers were pushed steadily southwards into Asia through wars with the Turkish Empire (1768–74, 1787–91).

To the west of Russia, the chaotic kingdom of Poland, lacking any natural geographical borders, was steadily gobbled up by its expansionist neighbors. In the partitions of 1772, 1793 and 1795, Russia, Prussia and Austria succeeded in blotting out Poland – although not without one of her doomed insurrections (that of 1794, led by Tadeusz Kosciuszko), adding another page of hopeless heroism to Polish history.

The whole of the 18th century in art reflects the two main characteristics of, on the one hand, continuing absolutism, and on the other, the questioning and scepticism fostered by what is called the Enlightenment. The extension of the Baroque into a highly decorative style known as Rococo, arising out of the French court, is a reflection of the continuing separation of the courts from the people, while the development of a new seriousness and moral purpose is reflected in a Classical style which begins during the life of Rococo, but achieves dominance as a result of the French Revolution.

The Age of Rococo

The term "Rococo", like other terms which have since acquired respectability, was originally disparaging and dismissive. It seems first to have been used in about 1796 as a slang epithet in Parisian studios for the "bad old style" – the style of the *ancién regime* – the heartless pre-Revolution aristocracy who were, it was believed, without moral standards or concern for others. To some extent this judgement of the term has dogged it even in the 20th century, for the Rococo is indeed a manifestation of irresponsible freedom, of "art for art's sake", and we tend to be suspicious of art that lacks an ideological structure. Those who disliked the painterliness and theatricality of the Baroque could reflect that, at least, it was a vehicle for the Christian faith; critics discouraged by the coldness of Neoclassicism could take comfort in its earnest belief in human progress. The Rococo sailed under no philosophies except, perhaps, escapism.

This is not to say that the Rococo lacked vitality. It was both a continuation of and a revolt against the Baroque; it retained Baroque interests in paint surfaces, color, spiraling movement and the supernatural, expressed in the ability of gods to hover on ceilings, something that was not regarded as absurd because it could not be tested. At the same time it reacted against the pomposity and artificial formality of 17th-century society by treating mythology playfully, by creating surroundings that were light, comfortable and decorative. Two important ideas of the 18th century – nature and the pursuit of happiness – underlie the Rococo. Shells, palms, flowers and birds were used by the Rococo artists and designers purely as decoration, but they are an aspect of the century's awakening to the minutiae of the natural world that, on a more serious level, the Swedish botanist Linnaeus (Linné) produced in his classification of plants in 1753.

The Rococo started in France at the beginning of the 18th century. In the second half of the 17th century, under Louis XIV, France had become the dominant power in Europe and the Duc de Saint Simon's memoirs, written at the time, convey the boredom and pettiness of a court overloaded with rigid etiquette and piety: "At last the King, growing weary of splendor and crowds, decided that he needed sometimes to have smallness and solitude." Hence privacy and intimacy were increasingly necessary in 18th century society. On Louis XIV's death in 1715 the Regent moved the court to Paris which lead to the building of many *hôtels* (what would now be called townhouses). These often had to be fitted into small, awkward spaces and in consequence rooms became smaller, ceilings lower and, to compensate for this, their shapes were more varied. When the court returned to Versailles on the accession of Louis XV in 1723, Paris remained the leader of taste.

Louis XIV's long series of wars, culminating in the War of the Spanish Succession had ruined the French economy which thereafter lurched from crisis to crisis with wild attempts at rebalance. While the majority of people suffered with each war, its attendant financial speculations made huge fortunes for a few opportunists financiers who then distressed the old aristocract with their lavish patronage of the arts. The spiral of greed and ostentatious display continued. The Rococo in France is therefore the art of a ruling class completely cut off from the social and financial realities of the nation – an inspiration for the Revolution which was to follow.

France was very aware of appropriateness and symbolism in its decorative schemes, for example Charles Lebrun's Kings Audience Chamber at Versailles depicts an iconographical progression of the planets with the last room dedicated to Apollo – alluding to Louis, the Sun King.

The Rococo in France was essentially a style of interior decoration. Seventeenth century French rooms had been divided into geometric panels of wood or marble, in robust, contrasting colors. Pillars supported heavily gilded cornices below ceilings painted with rich allegorical scenes painted to stimulate and arouse the emotions and intellect of the viewer. As manners relaxed under the Regency (1715–23), so did decoration, yet there was still a restraint and delicacy expressed in the early phase of French Rococo art. Mirrors were put on walls; pilasters became elongated, wooden panels carved in low relief often devoted to musical instruments and flowers. These alternated with tall and slim round-headed doors, windows and mirrors. Windows ran from cornice to floor and on ground floors access to the garden, creating what today we call french windows. Paneling was generally white and gold or sometimes unpainted light-toned wood. Decorative paintings were small and placed over doors that became increasingly irregular in shape. Architects, carvers, furniture-makers and painters all made an equal contribution and were equal in status, for painting had temporarily set aside its contempt for the decorative arts and abandoned its claim to superior intellectual significance.

In the late 1720s French Rococo decoration entered a phase that relied heavily on the use of asymmetry, greater fluidity and *rocaille*, or shell forms. Yet however asymmetric its surface decoration, a room had to have a basic underlying structure, for example the interiors of Nicolas Pineau (1684–1754) are composed of rectangular panels within which a subtle asymmetry makes play. The delight in surprise, expressed by the mature Rococo in its love of asymmetry, was also reflected in the jumbling together of disparate

elements, such as figures, animals and architecture in decorative schemes.

If the Rococo interior aimed at variety, the guiding principle of the exterior was simplicity. Contrasts of gold and light and the heavy porticos of the 17th century were abandoned in favor of light horizontals and rounded corners.

Rococo decoration sought to escape from the restraints of the 17th century and the same feeling pervades its painting. Jean-Antoine Watteau (1684–1721), who is the great representative of early Rococo, produced small-scale, unheroic subjects of people enjoying themselves in the countryside. Watteau was influenced by Rubens's delight in color, although not his bravura application of paint. In Watteau's figures, threads of color like the ribbing on a shell entwine to form a network of shimmering, three-dimensional contours.

What is new about Watteau's art is its private emotion and ambiguity. Watteau's people seem leisured and carefree yet one detects in them an

The Pilgrimage on the Island of Cythera, 1717
Jean Antoine Watteau (1684–1721)
Oil on canvas 50×76in (129×194cm)
Collection of the Academie, Louvre, Paris

The subject of this painting was drawn from a play by Florent Dancourt, Les Trois Cousines, *performed in Paris in 1700 and 1709. Watteau was early acquainted with the theater through his apprenticeship to Claude Gillot, a painter of theatrical scenes. In the play the central character, Madame Hortense, invites her companions to the island of Cythera (Cerigo) to visit the temple of love said to be the birthplace of Venus, where a single man or woman could find a wife or husband. An early version on this theme by Watteau, painted in 1709, has a staged effect and is probably a direct reference to the action of the play. In 1717 he produced this personal interpretation and presented it as his application for membership of the French Academy. For his reception to the Academy a special category was created to accommodate the painting – the fete galante. Another version of the subject painted in 1718 (Staatliche Museen, Berlin) closely follows the composition of this first large picture, but in the overall appearance is more emphatic in the drawing and brighter in color.*

Drawing of a Shell, c. *1710–15*
Antoine Watteau (1684–1721)
Red and black chalk, 11⅝×7⅜in (29.6×18.6cm)
Institut Néerlandais, Paris

While Watteau probably made this drawing for documentary purposes, it illustrates the period's fascination with and use of shell design in all forms of art. These include the irregular S-curve, asymmetry and a great interest in the natural world and the exotic.

underlying melancholy. Watteau celebrates human emotion and glorifies love, but hints at sadness, the passage of time and unfulfilled expectations. Watteau is so much a painter of all times that it is easy to forget that he was popular in his own day. He served a leisured society that preferred to ignore the unpleasant side of life; still contemporaries commented on his truth to nature in his acute sensitivity to the human heart and his meticulous draftsmanship that catches the essence of a figure's movement assembled from countless small life studies.

Watteau preferred to devise his own subjects and therefore sold his work through a dealer rather than through direct commissions. Dealers were a new Parisian trade who were available to fill the vacuum created by the decline of official patronage.

Unlike Watteau, there is no uneasy undercurrent in the work of the leading painter of the mid-18th century, François Boucher (1703–70). Exuberant, sensuous and composed of blues, seagreens, coral and pearly flesh tints, his work is the equivalent of the High Rococo. Whereas the 17th century had shown warring gods and heroic deeds – inspirations to France's more earthly campaigns – Rococo painting preferred an intrusive, lulling feminity. Shepherdesses appeared in porcelain, Marie-Antoinette played dairy-maid at Rambouillet and Boucher produced paintings of tumble-down picturesque cottages, shepherdesses and deep blue-green trees. The pastoral was a favorite theme of the century because it suggested a closeness to nature without the debasement of actually working on the land.

Boucher was outdone by the erotic energy of his pupil Jean-Honoré Fragonard (1732–1806), the last great Rococo painter whose life spanned the traumatic events of the French Revolution and the rise of Napoleon. He was over-

The Rising of the Sun, *1753*
François Boucher (1703–70)
Oil on canvas 126½×106½in (351×270cm)
The Wallace Collection, London

In 1752 Boucher was given a studio at the Louvre, the prerogative of the First Painter to the King. Boucher was a special favorite of the mistress of Louis XV, Madame de Pompadour, and the arrangement over the studio came about through his friendship with her brother, who was able to influence Boucher's advancement. Boucher painted several fine portraits of Madame de Pompadour over the years. She bought a pair of canvases, The Rising of the Sun *and its companion piece,* The Setting of the Sun, *when they were exhibited at the Salon of 1753. The paintings, extremely popular with the public if not with the critics, were intended as tapestry designs, although the tapestries were never executed. Boucher was often occupied with work for the Gobelins tapestry factory and became its director from 1755.*

The Swing, *1768*
Jean Honoré Fragonard (1732–1806)
Oil on canvas 32⅝×26in (83×66cm)
The Wallace Collection, London

The commission for this painting was passed to Fragonard by his contemporary Doyen, a painter chiefly known for religious subjects. The Baron de St Julien had approached Doyen with specific ideas for the composition. He wanted a painting showing his mistress seated on a swing, being pushed by a bishop, and with the Baron himself in such a position as to appreciate the disarray of his mistress's clothing caused by the movement of the swing. It is not clear why Doyen was thought suitable for the execution of this rather risqué theme, but though he declined the commission he immediately suggested it be given to Fragonard. Fragonard's career had been confused and he had seemed unable to settle upon the most suitable vehicle for his talents. He became an Associate of the French Academy in 1765 by the submission of a history painting, but judging by Doyen's recommendation he had acquired a reputation of a different kind by 1768. Fragonard agreed to undertake the Baron de St Julien's commission and completed the picture though without the figure of the bishop originally specified.

taken by the new taste stimulated by the end of the monarchy. It might be said that in cutting off the head of the King Louis XVI, the Revolution also killed the Rococo. Like Watteau, Fragonard used nature to express the state of mind of his subjects. He also produced genre scenes lightened with humor and aimed at a wide audience through the medium of engraving, like *The Swing*. Genre painting flourished in the Rococo as a result of 18th-century fascination with human behavior. The Rococo facility for witty yet tolerant social observation continued late into the century. It also produced informal portraits that delight in the textures of skin and dress, as seen in the work of Jean-Marc Nattier (1685–1726).

Pastel was invented at the beginning of the century and with its soft texture and light tones was an attractive medium to the Rococo artist. The singing blues and pale pinks of pastel are superbly used by the portraitists Maurice Quentin de La Tour (1704–88) and Jean-Baptiste Perronneau (1715–83), who invested his sitters with grave dignity while La Tour expressed the conscious charm of sparkling eyes.

In England the Rococo was very different from France and the rest of Europe. There was no court patronage on a large scale and in the first half of the century, little demand for history painting, even prettified mythology like that produced by Boucher. Far from emulating the headlong decadence of the French court that followed the death of the 77 year-old Louis XIV in 1715, England's adopted Hanoverian monarchs tended to be private in their tastes and increasingly given to bourgeois virtues like the quiet enjoyment of family life, particularly with the accession of George III, who was nicknamed "Farmer George" by the wits of London.

The English middle class attained much greater power and cultural influ-

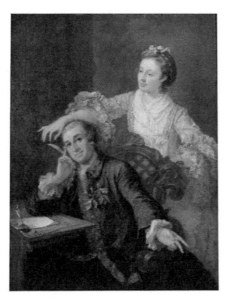

David Garrick and His Wife, 1757
William Hogarth (1697–1764)
Oil on canvas 52¼×41in (132·7×104cm)
Royal Collection, Windsor, England

Hogarth was trained as an engraver, but early in his career attempted to attract business as a portrait painter. This aspect of his work was never well regarded and he was better appreciated for his engravings and paintings of modern morality tales which formed a large body of his work. In 1756 he again returned to portrait painting in response to criticism of his written work The Analysis of Beauty, *published in 1753. Hogarth's detractors implied that he had no capacity to understand aesthetics and he determined to prove them wrong, by establishing himself in portraiture and history painting. He made several studies of the actor David Garrick in character, but this painting of Garrick with his wife was considered a particularly fine likeness. However, it appears that a quarrel arose between the painter and the actor during the sittings and Garrick never bought the portrait. After Hogarth's death his widow sent it to the Garricks without charge. From Mrs Garrick's possession it passed to a Mr Edward Hawke Locker. Mr Locker's son recorded in his memoirs that "this picture is so lifelike that as little children we were afraid of it; so much so that my mother persuaded my father to sell it. . . ." It was sold to George IV and remains in the Royal Collection.*

ence in the 18th century and was already growing in wealth and confidence through the effects of the Industrial Revolution. The most important English painter of the first half of the century, William Hogarth (1697–1764), was firmly rooted in the bourgeoisie. He was also, almost against his will, greatly influenced by the French Rococo. London had a flourishing French artistic community made up mostly of engravers and decorative artists, many of whom were Huguenots who had come to England as exiles after the toleration of Protestants in France was revoked in 1685.

Hogarth's suspicion of the Rococo stemmed partly from nationalism. In *O, the Roast Beef of Old England* (1748–9) he lampooned French poverty, clerical corruption and restrictions on personal freedom. The "modern moral subjects" series of pictures which show the progress of vice or, more rarely, virtue, are far removed from French Rococo amorality. The contemporary dress worn by the figures in these paintings drove home the point that corruption was a modern problem capable of resolution and that virtue did not belong merely to the Golden Age. The series of paintings, with their unfolding of a story and obsessive attention to significant detail, are akin to the new literary form of the 18th century, the novel. Hogarth's morality influenced the French painter Jean-Baptiste Grueze (1725–1805) when in the 1760s he responded to the French demand for subjects showing the family life of decent, simple folk.

Hogarth also developed the middle-class portrait, epitomized by his *Captain Thomas Coram* of 1740. Coram made his fortune in shipbuilding in America and set up the Foundling Hospital for unwanted and illegitimate children in 1739. Although there was still great stigma attached to illegitimacy, there was also the begin-

ning of sympathy for childhood, as Hogarth's many portraits of children show.

Hogarth suggested that artists should donate pictures for the Court Room of Coram's hospital, thereby associating themselves with a prestigious and honorable cause while gaining exhibition space. The plan produced several history pictures, exquisite landscapes by the young Thomas Gainsborough (1727–28) and a program of annual dinners which strengthened the bonds of the members of the artistic community which led ultimately to the foundation of the Royal Academy in London in 1768.

The use of theater and music in French art has already been noted and the 18th century was also the great age of play-going in England. There was likewise a vogue for theater genre-pieces, notably Hogarth's scene from *The Beggar's Opera* (1729), Gay's parody of Italian opera and satire on the corruption of Walpole's government.

Linked with an awareness of the theater was an exploration of human relationships and social behavior evident in England in the so-called "conversation-piece" – small pictures of family groups in characteristic domestic activities, such as taking tea or riding through their estates. Arthur Devis's (1711–87) work shows the English gentry stiffly posed in paneled rooms – scarcely in "conversation" but bound together by ties of family and class. His *Sir George and Lady Strickland* (1751), with a Rococo softness of coloring, has a genuine feeling for landscape that goes beyond the display of a gentleman's landed possessions.

Thomas Gainsborough (1727–88), like Hogarth, was an artist connected with the Rococo but not entirely confined to it. In his superb use of paint and ability to transform everyday settings

into something magical, he is closer to Watteau. Gainsborough was a keen observer of nature and in his early years was strongly influenced by 17th century Dutch landscape painting. Whereas Reynolds counted politicians and literary men among his friends, Gainsborough preferred actors and musicians.

In Gainsborough's portraits of women there is a melting softness and often a slight air of unknowability and melancholy – part of late 18th century indulgence of feeling. The faces of Gainsborough's mature portraits are painted with loose, flickering strokes, leaving the spectator to supply expression and likeness. With Gainsborough's death Reynolds paid tribute to his rival in 1789 by devoting the whole of the fourteenth Royal Academy Discourse to him, commenting that "all those odd scratches and marks, which, on a close examination are so observable in Gainsborough's pictures, and which even to experienced painters appear rather the effect of accident than design; this chaos, this uncouth and shapeless appearance by a kind of magic, at a certain distance assumes form, and all the parts seem to drop into their proper places."

Unlike earlier portrait painters, including Reynolds, who often painted only the face leaving the rest to drapery painters, Gainsborough was interested in all parts of his paintings. In his late pictures his figures are fully integrated with the landscape and derive their radiance from it reflecting this sympathy of man with nature beginning to be expressed at the end of the century.

Not surprisingly, in the conservative English atmosphere under the bad-tempered and domestic Hanoverian kings, Rococo does not express itself strongly in architecture. Other influences, such as medievalism and exotic styles derived from colonization (India) and trade (China) produced examples

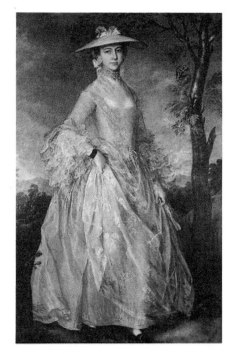

Mary, Countess Howe, *1763–4*
Thomas Gainsborough (1727–88)
Oil on canvas 96×60in (240×150cm)
Kenwood House, London

During the early part of his career Gainsborough made a reasonable living as a painter in his native Suffolk, England. In 1759 he moved to Bath, persuaded by his friend Philip Thicknesse, who, though Governor of Landguard Prison at Harwich, was accustomed to spend winters in Bath and knew that the clientele for a portrait painter would be wealthier and more widespread in that town than Gainsborough could find in Ipswich. Painters were allowed to hang their pictures in the Pump Room at the spa, a fashionable meeting place for visitors, so Gainsborough was able to publicize his work and soon received commissions for portraits. One such is this full length portrait of Lady Howe, the wife of a naval officer who served in the American War of Independence and later became a hero of the British fleet. Though many of Gainsborough's portraits are formal with a flat background, this example shows his ability to enhance the impact by using a landscape setting, a feature of his work that contributed to his success. Gainsborough also began to exhibit regularly in London after his move to Bath.

of strange, and in the English land-scape, inappropriate structures, such as the pagoda in Kew Gardens, London (1763) by Sir William Chambers (1723–96). There is, however, a curious English manifestation of the Rococo spirit seen in a passion for follies and sham ruins. These were erected in gardens and estates to be wondered at, to be posed against, sometimes to stay in, but always as a fantasy relief from the seriousness of the age.

The Rococo in Italy finds its main expression in Venetian painting, although in most parts of the country it was enthusiastically taken up in furniture design and book illustration. Rome was scarcely influenced by the Rococo and in the first half of the 18th century artistic expression was largely Baroque.

Venice's traditions lay with the brilliant color, free handling of paint, grandeur and confidence of Veronese and Tintoretto. By the 18th century Venice had lost much of her political power and, although a republic, was still ruled by an oligarchy now fossilized in its own institutions. Venice retained, however, the pagentry of a glorious past that bolstered confidence and was helped by the fact that there was always an audience of tourists. Conditions in Venice were thus similar to those in Rococo France, that is, a decadent aristocracy who preferred escapist art. To this was added a continuing demand for religious painting and a strong figurative tradition that produced the brilliant inventiveness of Gianbattista Tiepolo (1696–1770). In some ways Tiepolo could be called a Baroque painter in the grandeur of his treatment of religious and historical themes, but Tiepolo's involvement in an avowedly imaginary world is Rococo, which he shares with Watteau and Boucher, as well as his indifference to historical accuracy. Tiepolo's story of Anthony and Cleopatra and the 12th century marriage of

Frederick Barbarossa and Beatrice of Burgundy are presented in a fantasy of Italian dress and Oriental influences.

Tiepolo's pictures delight in miraculous occurences and wonderfully theatrical divine interventions. In his *Miracle of the Holy House of Loreto* (*c*.1743), heavenly beings appear good-humored and soaring within an effortless composition into scattered spirals. The sketches for seven altarpieces for the church at Aranjuez, Spain show a different aspect of Tiepolo's religious art appropriate to an ageing, self-exiled artist in an autocratic country still in the grip of religious fervor. The use of paint shows a wonderful freedom and Tiepolo's characteristic Rococo palette of sky blue, gold and white but with an intimacy and poignancy in the depiction of religious experience.

The prominence of "view" painting was unique to Venice and the result of her status as a scenic and historical attraction from which tourists took away painted views as souvenirs. There was, however, no such demand from Venetian patrons and artists such as Antonio Canale, known as Canaletto (1697–1768), although immensely successful, had to remain practitioners of what was then considered an inferior genre; Canaletto was not elected to the Venetian Academy until 1763, for which his reception piece was an acceptable architectural flight of fancy. Canaletto's early work displays Baroque richness of coloring and an acute observation of Venice's "mixed multitude of Jews, Turks, and Christians; lawyers, knaves, and pick-pockets; mountebanks, old women, and physicians". Later, his palette became lighter and brighter; he produced piercingly accurate, severly composed topographical views with radiant skies and tiny figures. Canaletto made use of Venice's waterways and the ceremonial journeys such as Ascension Day of the State Barge. To modern

Cleopatra's Banquet *before 1750*
Giambattista Tiepolo (1696–1770)
Fresco cycle
Palazzo Labia, Venice

The story of Antony and Cleopatra was a recurrent source of inspiration to Tiepolo in in the 1740s and he had already treated the subject in several paintings before he began to decorate the Palazzo Labia in c.1745. This fresco cycle, of which the two grandest elements are the Inventio di Antonio e Cleopatra *and the* Convito di Antonio e Cleopatra, *was the culminating masterpiece of Tiepolo's Venetian period (1741–50), before he went to Germany to decorate the Würzburg Residenz. It represents also the final flowering of fresco illusionism in the grand tradition, the perspective space of the paintings appearing to be a natural, almost seamless extension of real space. The Rococo elegance that Tiepolo added derived in large part from his revolutionary palette. This was dominated by cool silver tones, which imparted the effect of transparent daylight to his frescoes and allowed him to achieve startling contrasts without recourse to the dark tones of the 17th-century masters.*

eyes these pieces have a slightly mechanical air.

From 1746–55 Canaletto was in England and the cold light and unfamiliar architecture caused him to produce works of a naive stiffness which led British patrons to wonder if they had imported an imposter. Canaletto, however, responded superbly to the dance of London's church spires along the silvery Thames.

Canaletto's successor as a painter of Venetian views was Francesco Guardi (1712–93). Guardi's pictures contain the same elements of boats and buildings as Canaletto, but his composition and technique is looser with an infinity of sea and sky. Building façades are broken by light. Guardi had less of a desire to create a painting around an event and some of his most haunting works are tiny canvases consisting simply of a gondola floating in an expanse of lagoon. He also painted *capricci*, imaginary compositions of ruins adorned with thread-like grasses, tumble-down dwellings and a few raggedly poetic figures (an interest in ruins is an 18th century preoccupation).

Very different conditions fostered the development of the Rococo in Germany from those in France. The territories of the old Holy Roman Empire were nominally ruled by the Habsburgs but in practice were independent. At the end of the Thirty Years War in 1648 Germany was divided into over two hundred territorial units with fifty-one free cities and numberless estates. By the beginning of the 18th century Germany had recovered from the devastating effects of the war, the agricultural economy was again buoyant and in 1699, when the Turks were driven from Hungary and Transylvania, a long-standing threat to Vienna was removed. Rivalry and an envy of the court of Louis XIV among the princes led to building on a grand scale, paid for by the rents from agricultural

land and by the tolls levied on goods moving from state to state. From there magnificent churches and palaces were created, giving employment to many craftsmen.

Austria and southern Germany, unlike the still fervently Catholic north, had naturally adopted the Baroque with its elaborate dramatization of religious sentiment. German Rococo, particularly evident in church interiors, is an extention of the Baroque with stress on decorative rather than architectural values; an intensification of theatricality – with perhaps some loss of spiritual force combined with a Germanic tradition of craftsmanship and startling naturalism. The colored wood statues of Ignaz Günther (1725–75) are a curious mixture of Rococo sugariness and the German carver's realism and emotion.

German Rococo art has a quality of the unexpected and bold eccentricity not found in Italy and France with their Classical tradition. For example, Johann Bernhard Fischer von Erlach's (1656–1723) Karlskirche in Vienna startlingly grouped late Baroque and Classical elements in homage to the Habsburg Emperor. There is also in 18th century German art a pursuit of pleasure characteristic of the century, resulting in the building of French-styled pleasure pavillions.

French Rococo inevitably influenced Germany, as did the general atmosphere of the French Enlightenment. The Austrian Empress Maria Theresa and Frederick the Great of Prussia, who both came to their thrones in 1740, regarded themselves as "Enlightened" and under this banner made tentative reforms to consolidate their autocratic power in the face of the nobility. Frederick entertained the French philosopher Voltaire and owned a superb collection of Watteaus. Prussia's snatching of Silesia from Maria Theresa lead to the Seven Year's War

View of Venice with Sta Maria della Salute and the Dogana, c.1780
Francesco Guardi (1721–93)
Oil on canvas 14×22in (36×56cm)
Wallace Collection, London

After collaborating with his brother Gianantonio on altarpieces for about thirty years, Guardi turned to painting views in the manner of Canaletto in the late 1750s. These paintings found a ready market among wealthy Englishmen making the grand tour of the Continent, but Guardi was regarded as an inferior imitator of Canaletto and never enjoyed his financial or social success. Although Gianantonio was elected to the Venetian Academy in 1756, Francesco had to wait until 1780 to be accorded the honor. Only in the later 19th century, when the Impressionists discovered the play of atmospheric light that lent his paintings a shimmering tone and a shadowiness of outline quite different from Canaletto's firm drawing, was his originality recognized.

and buildings in the latest Rococo style were a direct result in the arts of Frederick's campaign to challenge Austrian domination in the Empire.

After 1726 Karl Albrecht of Bavaria continued French Rococo in Bavaria by employing the Fleming François de Cuvilliés (1695–1768) who had trained in France. Cuvilliés's best known building is the Amalienburg in the grounds of the Nymphenburg Palace, Munich, that marvelously demonstrates the effectiveness of Rococo on a small scale.

Although Germany did not produce any great Rococo painters, it surpassed

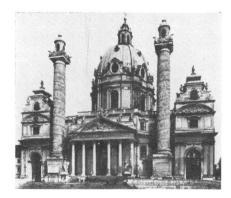

The Karlskirche, *Vienna, 1716–24*
Bernhard Fischer von Erlach (1656–1723)

*The flowering of the Austrian Baroque had
its culmination in the work of Fischer von
Erlach. The Karlskirche was built, in part, to
commemorate the victory over the plague in
1713, and the curious upward-spiraling
relief-bands on the minaret-like columns
that flank the central portico were intended
to represent the triumph of the Christian
faith over the disease. The unusually broad
expanse of the west front conceals the
building's essential structure: Fischer was
fond of the ellipse and here he used the
shape to spacious effect, both for the
central dome and for the vast well beneath
it, which is the heart of the building. So
varied are the motifs of the church's
exterior – including the pedimented portico
with its severely Classical columns and the
twin flanking towers with their whimsical
pagoda roofs and bases in the form of
triumphal arches – that the building almost
defies classification. The total effect,
however, is a miraculous blending of
elements to create the characteristic
dynamic tension of Baroque architecture.*

**London: the Thames and City of London
Seen from Richmond House,** *1746*
Antonio Canaletto (1697–1768)
Oil on canvas 41¾×46¼in (105×117·5cm)
Goodwood Collection, Chichester, England

*During the years 1730 Canaletto was well
established as a painter in Venice and much
of his work consisted of commissions for
English patrons. Some were obtained
through visitors touring Italy, but his
paintings were also promoted by Joseph
Smith, an English merchant and art
collector who settled successfully in Venice
and was appointed British Consul, thus
taking control of the export of paintings.
Canaletto was not much accustomed to . .
traveling and his decision to visit England in
1746, when he was already middle-aged,
may have been partly influenced by a desire
to establish his reputation there
independently of Smith's influence. At the
time there was also a decline in tourism
and trade due to the War of the Austrian
Succession and this had adversely affected
the market for Canaletto's work. The painter
arrived in England with a letter of
introduction to the Duke of Richmond and
this view of the Thames from Richmond
Terrace was one of his first commissions.*

France in combining interior archi-
tecture, stucco work and painting into
one magnificent whole, a form of
synthesis from the Baroque. Nowhere
is this more apparent than in the
Residenz at Würzburg (1720–44) with
architecture by Johann Balthasar Neu-
mann (1687–1753), stucco work by
Antonio Bossi (1720–63) and frescoes
by Tiepolo. Neumann's architecture is
monumental but inventive, and to
induce awe in the worshipper in the
presence of the heavenly host, was the
aim of painted church ceilings, al-
though few were executed with the
genius of Tiepolo. In German churches
and palaces there was a tradition of
collaboration between architect, stuc-
coist, painter and carver which was
often a family partnership, as in the
case of the Bavarian brothers Johann
Baptist (1680–1758) and Dominikus
Zimmerman (1685–1766) who built the
pilgrimage church of Die Wies (1746–
54). The Church, built of wood, takes
Rococo lightness – white, gold, pink,
pale blue curling forms – a step
further. There are still pilasters, but the
scrollwork of the Corinthian capitals
has a decorative life of its own. The
pulpit is more like a bower from an
opera set – a graceful, artfully random
assemblage of putti, garlands, palm
fronds, drapery and ribbed shells. Yet
the exterior of the church is simple and
set a little way from the village in
beautiful Alpine countryside. There is
thus a theatrical progression derived
from the Baroque, a calm preparation
of the mind before an interior glorifying
God burst on the dazzled senses. Die
Wieskirche (the Church in the Mea-
dows) is perhaps the masterpiece, in
the sphere of architecture, of the
German Rococo. Owing almost noth-
ing to French influence, it is at the
furthest possible remove from the
Baroque. By using coupled columns
standing away from the walls of the
oval "nave" and by continuing this

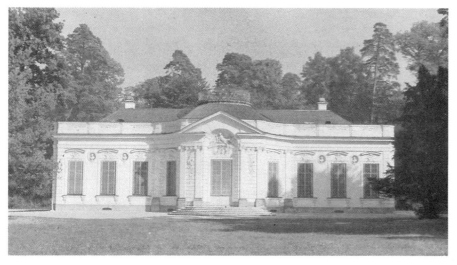

The Amalienburg, *1734–9*
François de Cuvilliès (1695–1768)

*The hunting lodge built in the grounds of
the Nymphenburg Palace, Munich, for the
Electress·Maria Amalia is a shining example
of Cuvilliès's gift for light Rococo
decoration. At the age of thirteen Cuvilliès
became court dwarf to the Elector Max
Emanuel, who in 1720 sent him to Paris to
train as an architect under François Blondel
the Younger. When he returned to Bavaria
in 1724 he brought with him the Rococo
style of ornamentation which he had picked
up in France. Hitherto the style had been
unknown in Germany. Much of the
Amalienburg – the curved walls, for
example, and the lavish use of mirrors in the
central hall – is reminiscent of the Hotel de
la Soubise, but in sheer riotousness
Cuvilliès went further than his French
contemporaries. Taking the Rococo to such
extremes became a peculiarly south German
passion, a development for which much of
the credit must be given to the volume of
engravings giving examples of architectural
ornamentation on which Cuvilliès worked
from 1738 until his death.*

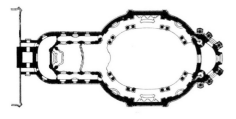

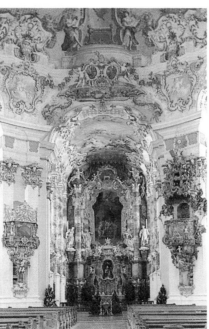

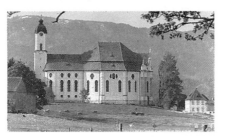

system with variations in the deep
chancel, Zimmermann creates a light-
pierced structure within a more nearly
intact shell (although that too is pierced
by windows). The result is almost like
a late Gothic church, except that the
detail could not be more un-Gothic.
The color is also unusual. Whereas
most German 18th-century churches
depend on white and gold, sometimes
with plum colored or yellow marble (a
hangover from the Baroque) Die Wies
includes pink and above all blue most
notably in the chancel columns. All
this is moreover flooded with light, a
sort of heavenly sunshine surpassing
even the natural sunshine outside. Like
other totally successful Rococo build-
ings, as has previously been remarked,
Die Wieskirche is quite small.

Another important German contri-
bution to the Rococo was the discovery
in 1708 of how to make hard paste
porcelain, previously known only from
imported Chinese wares. In setting up
the Meissen factory, Augustus the
Strong of Saxony led the way in
princely patronage of porcelain manu-
facture and porcelain joined tapestry
as a source of royal prestige.

Die Wies Church, *1746–54*
*Interior along the nave, exterior from the
south, and plan*
Dominikus Zimmermann (1685–1766)
Johann Baptist Zimmermann (1680–1758)

*The Zimmermann brothers worked
independently, but occasionally together, as
in the case of Die Wies, developing in the
church one of the finest expressions of the
southern Bavarian Rococo. The exterior of
the church expresses the almost elliptical
nave, and extended choir, and echoes the
silhouette of the Alps in its roof-line.*

*The simplicity of the exterior does not
however, reveal the extraordinary profusion
of stucco and painted decoration of the
interior.*

Enlightenment, Neo-Classicism and Revolution

It is possible to write about the Rococo with very little reference to the underlying ideas of the society that produced it; the same is not true of Neoclassicism, which was a state of mind as well as a style. Although diversely interpreted, it aimed at universality, appealing to all times as well as all nations by reinterpreting the spirit of Classical Greece and Rome, the "Golden Age" of art. Sir Joshua Reynolds wrote: "That wit is false, which can subsist only in one language; and that picture which pleases only one age or nation, owes its reception to some local or accidental association of ideas." Behind Neoclassical art is a ferment of ideas; these can only be understood by reference to the Enlightenment, the great spirit of questioning and discovery that swept across Europe in the 18th century.

The Enlightenment

The 17th century produced many brilliant scientific discoveries: the steam engine, used in industry by James Watt in the 1760s, had been invented by the Huguenot refugee Denis Papin in the 1690s. It was for the 18th century to apply such discoveries to explain and harness the physical world. Machines such as James Hargreave's "spinning jenny" (1767) led the way to the Industrial Revolution of the 19th century. Agriculture was improved by scientific methods, for example in England in the breeding of livestock. Lightning, once thought to be the voice of God, could be bottled in a Leyden jar and channeled by Benjamin Franklin's lightning rod of 1752. In 1800 water was first separated into hydrogen and oxygen. As the world became easier to understand, the presence of a mysterious Divine Mover seemed irrelevant. Man, supremely confident, could find out everything by reason and inquiry; progress tended toward perfection.

For the first time the possibilities of science fired the artist's imagination: Etienne-Louis Boullée designed a massive spherical monument to Newton and the Romantic artist and poet William Blake cast Newton as a villain, but nonetheless paid tribute to his intellect.

With exploration came the desire to classify. From 1749–89 the Count de Buffon produced thirty-two volumes of his *Natural History*, studying matter in motion without reference to God-ordained hierarchies. Chambers and Johnson produced dictionaries; Denis Diderot, Jean d'Alembert and their *philosophe* contributors examined every aspect of existence in a rational light, even providing engraved illustrations. Reynolds in his *Discourses*, Burke in his *Treatise on the Sublime and the Beautiful* examined how men responded to art and the natural world, and whether concepts like beauty were subject to some immutable law.

The 18th century discovered the ability to stand outside familiar institutions and reappraise them. Montesquieu's *Persian Letters* criticize contemporary French society by pretending to examine it through the eyes of two Muslims (itself a reflection of interest in the East and the realization that different societies had different viewpoints). It also became apparent that each period of history had its own *Zeitgeist*, or spirit of the times. Johann Joachim Winckelmann (1717–68) saw something dynamic in Classical Greece that later ages could learn from, because this spirit was embodied in Greek art. As society's deeper longings shifted in the Romantic period the spirit of other ages reflected the aspirations of the present – for example the German equation of the medieval period with national freedom and greatness.

This regarding of institutions in a critical light led to the realization that they changed – and that they should

Design for a Monument to Newton, c.1784
Etienne Louis Boullée (1728–99)
Wash drawing
Bibliothèque Nationale, Paris

Boullée is perhaps better known for works never built than for those constructed. He made a large number of project drawings throughout his career, many related to actual or proposed buildings of the period although others were purely imaginative. Boullée had originally studied both painting and architecture; he took up the latter against his own preference, under the persuasion of his architect father. In his early work Boullée built or remodeled a number of town houses in Paris. After his appointment as Controller of Buildings at the Hotel des Invalides, he hoped to become involved in public commissions. He produced a plan for the remodeling of the Chateau at Versailles and drew up a design for the partly built church of La Madeleine, but was not appointed to either project. His design for a cenotaph to Isaac Newton, the father of modern science and one of the greatly admired intellects in the Age of Reason, was among many drawings based on the models from earlier civilizations – Rome, Egypt, Nineveh and Babylon. It was in such ideas that Boullée was able to free himself from the practical problems of constructions and present a kind of architecture as yet scientifically impossible. The Newton Monument was designed as a complete sphere, pierced at the top to let in natural light, giving the impression of a night sky. The sarcophagus was to be placed at the base, leaving the entire space above free. Outside, rows of cypresses were planned as austere decoration for the base of the monument.

change if they had become corrupt. Neither the American nor the French Revolution would have occurred if a belief in the Divine Right of Kings had still been widely held. Since so much had been proved by science, there was scepticism as to what could not be proved, like the existence of God; Voltaire wrote "Faith consists of believing what our reason cannot believe." Established religion was not only authoritarian, it was frequently inhumane – in *Candide*, Voltaire spoke passionately for religious tolerance, and most *philosophes* upheld individual freedom through Deism, the worship of a higher Being without the church.

Not only religious freedom but freedoms of all kinds were energetically discussed. Each man was a rational being, equal to his fellow men, and had a right to "life, liberty and the pursuit of happiness". The condition of society was ameliorated not by repression but by humanity – the Marquis of Beccaria in *Dei diletti e delle pene* ("On Pleasures and on Punishment", 1764) wrote that crime was better prevented than punished and that its causes lay in social evils and used the phrase "the greatest happiness of the greatest number". The concern for penal and economic reform in his work was influential in enlightened rulers.

In *The Wealth of Nations* (1776) Adam Smith's recipe for prosperity was freedom from economic controls: man tends to improve his condition, every man acts in his own best interest, and the conjunction of private interests leads to public good. This was the perfect justification for the expansion of industry and capitalism. In his first work in 1776 Jeremy Bentham examined the conflict of interests bound to arise in society and stated that the aim of human action (and, more dangerously, the measure of right and wrong) was the "greatest happiness of the greatest number". It was the

attempt to turn the lives of the many from misery to happiness that inspired the French Revolution and even the Napoleonic Wars, as Napoleon saw (or presented) himself as a liberator by fire and sword of nations from tyranny.

The 18th century, for all its naivety about the perfectability of man, saw that there had to be some controls, made by man not God, in the form of education. In 1706 Locke wrote "Of all the men we meet with, nine parts of them are what they are, good or evil, useful or not, by their education." In novels such as Henry Fielding's *Tom Jones*, experience educates the hero into becoming a better – and shrewder – citizen. Art in the 18th century became didactic, even before the appearance of Neoclassicism, as has been seen in the work of Hogarth. There was a strain of realistic and didactic European art coexistent with the Rococo. In the work of the Brescian Giacomo Ceruti (active 1720–50) the realism lies merely in brutal, perhaps prurient, observation of poverty. By contrast Jean-Baptiste-Simeon Chardin (1699–1779) observed and taught the virtues of middle-class life: patience, cleanliness, industry, education and responsibility. The chain of duty is quickly assumed; the older child teaches the younger. The sincerity of Chardin's world extends to his technique – firm impasto, quiet coloring, clear boundaries and the use of profile – artistic qualities which became an expression of seriousness for the Neoclassicists as well. Jean-Etienne Liotard (1702–90) was akin to Chardin in the perfection of his technique and refusal to sentimentalize humble subjects, such as a maid carrying chocolate. Middle-class shrewdness, sincerity and common sense, as well as an exquisite eye for textures, are also found in the portraits of Allan Ramsay (1713–84) who came from from Edinburgh, an important center of the Enlightenment.

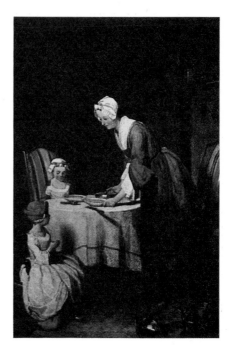

Grace, *1740*
Jean-Baptiste-Simeon Chardin (1699–1779)
Oil on canvas 19¼ × 15½in (49 × 41cm)
The Louvre, Paris

This genre scene set in a quiet interior is characteristic of Chardin's work in the 1730s and early 1740s. In the earlier and later years of his life he concentrated on still-life paintings; his reputation as a genre painter began only with the exhibition of sixteen canvases depicting bourgeois life at the Exposition de la Jeunesse in Paris in 1734. The mood and composition of those paintings drew on the work of the 17th-century Dutch masters, but by his unique use of paint he achieved a depth and subtlety of tone all his own. The popularity of Chardin's genre paintings, done at the time when Dutch cabinet pictures were fashionable in France, is a reminder that a naturalist tradition continued to flourish alongside the prevailing Rococo manner of French painting in the first half of the 18th century.

As can be seen from Chardin's work and the emphasis on education, there was an interest in children. It was not however, until 1762 with Jean-Jacques Rousseau's *Emile, où de l'Education*, that it was realized that a child's mind differed from an adult's or that education should encourage a child to think for itself rather than learn precepts by rote. Child portraits became increasingly lively toward the end of the 18th century, as in the work of Elizabeth Vigée-Le Brun (1755–1842) and Thomas Lawrence (1769–1830); Reynold's *Lady Spencer and Her Daughter* (1760–61) and George Romney's (1734–1802) *Mrs Carwardine and Child* (1775) are portraits of parental affection.

The child was fascinating to the late 18th century because it showed a primitive and innocent state of human consciousness – an idea further developed by the Romantics. The primitive was important for the Enlightenment: Homer and Ossian – the supposed author of Celtic poetry "translated", but in fact invented, by James Macpherson – were depicted in Neoclassical art because they were bards of very young, "pure" societies. As the Neoclassical blended into the Romantic, Rousseau wrote of the "noble savage" and in *Emile*: "Nature has created man happy and good, but society depraves him and makes him miserable". Neoclassicism depended as much on the idea of a higher previous state – located in Classical Greece and Rome – as did Christianity – with the difference that this Neoclassical state could be regained on earth by following historical example, rather than with Christianity waiting for the next life whose existence seemed increasingly unlikely.

Classicism and Neoclassicism

Neoclassicism can be described as a rejection of Rococo frivolity in favor of a new seriousness. Although Neoclassicism ultimately challenged the

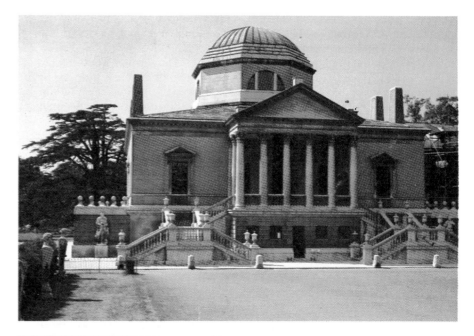

Chiswick House, *London c.1725*
Lord Burlington (1694–1753) and William Kent (1685–1748)

Richard Boyle succeeded to the title of third Earl of Burlington and a considerable fortune while still a young boy. After a classical education and a grand tour of Europe he became a valuable patron of artists and musicians, but was also determined to practice architecture. In 1719 he revisited Italy to make a careful study of the works of the Venetian architect Andrea Palladio (1518–80). He returned to England to promote the Palladian style of architecture in England and commissioned the Scottish architect Colen Campbell (d. 1729) to remodel the façade of Burlington House, making it the first Palladian style facade in London. In 1725, in collaboration with his protegé William Kent (1685–1748), Burlington designed a small house at his estate in Chiswick, an adaptation of Palladio's Villa Rotonda near Vicenza, Italy. Burlington's house was far more elaborate in detail than Palladio's style, possibly owing to the influence of Kent's study of the Roman Baroque. Chiswick House became a curiosity and drew much criticism, partly because it was considered unsuitable that a member of the aristocracy should engage in a professional practice like architecture. The house was regarded more as a showpiece than functional.

Petit Trianon, *Versailles, 1762–8*
Ange-Jacques Gabriel (1698–1782)

The Petit Trianon was built in the park at Versailles for Louis XV. It was designed by Ange-Jacques Gabriel, who had succeeded his father Jacques Gabriel (1667–1742) as architect to the king. Being of a later date than the main buildings at Versailles, it added yet again to the diversity of styles in architecture. The small, compact villa was given by Louis XVI to his wife, Marie Antoinette, and it was there that she received news in 1789 of the Parisian revolutionaries marching on Versailles.

The Oath of the Horatii, *1784*
Jacques Louis David (1748–1825)
Oil on canvas 130×168in (330×425cm)
The Louvre, Paris

The Oath of the Horatii, *painted by David during his second stay in Rome in 1784, has become the standard work of French Neoclassical painting. As a student David had disciplined himself to drawing, spending a whole year studying facial features and hands, working from life models and statues. In 1774 he won the Prix de Rome and in the following year traveled to Italy, where he stayed until 1781. There he absorbed the form and detail of ancient Classical sculpture at first hand and developed his Neoclassical style, a manner far more austere and clearly defined than the frivolity of French Rococo painting represented by his teachers and precursors. The choice of a Classical subject was not in itself unusual – the painting shows the three Roman Horatii brothers who engaged in combat with three brothers from the Curatii of Alba to settle the outcome of a war between the two states – but David's approach to composition, form and color constituted a revolution in painting. Despite the clean appearance of the picture, David's perfectionism is evidenced by considerable reworking of details. The painting was very well received, both in Rome and at the Paris Salon of 1785. The moral tenor of the subject, the dedication of citizen to state, seems in retrospect highly suitable to David's life and times.*

Rococo and the Baroque in its pomp and theatricality, the two movements coexisted for part of the mid-18th century. Historical events culminated in a stylistic victory for Neoclassicism attached as it was to become to the Revolutionary spirit in France. Classical art, rediscovered by the Renaissance, had influenced artists such as Poussin in the 17th century. Education in the 18th century included Classical Latin and Greek, not as dead languages but as vehicles for a vital philosphical and literary tradition. In the first half of the century there were revivals of Classicism in England that looked back to 17th century Classicism. The English revival of Classicism was chiefly concerned with architecture. It was known as Palladianism because British architects traced a tradition of Classical architecture through Inigo Jones (1573–1652) and Andrea Palladio (1508–80). Palladio personified the

Renaissance idea that the main goal of architecture was to recapture the splendor of Roman antiquity by going back to the first century BC Roman writer Vitruvius who defined the architectural orders. In 1715 Colen Campbell published *Vitruvius Britannicus*, a survey of 16th and 17th century architecture in Britain with a blueprint for the future. Campbell's book influenced the Earl of Burlington who went to Italy in 1719 to study Palladio. Some felt that Burlington betrayed his social standing by practicing as an architect, but architecture became one of the accomplishments of an Enlightened aristocrat, even of a ruler, as seen in Frederick the Great's building projects. Classical tendencies within the Baroque were developed by James Gibbs (1682–1754) particularly in his design of St Martin-in-the-Fields, London. The exterior has a Baroque feeling for movement provided by Classical elements.

Early Classicism in France was linked with Louis XIV's revival of the mid-century when Louis XV decided to boost his prestige by reference to his glorious ancestor. Even when fully Neoclassical, French 18th century architecture retained an elegance and attention to detail, especially in private buildings. An example of this is Ange-Jacques Gabriel's (1698–1782) Petit Trianon, near Versailles, austere in its block-like shape, perfect proportions and crisp exterior staircase, but more restrained than English Palladian buildings.

The interest in Classical art, and even the commissioning of paintings

showing heroes of Republican Rome, although attractive to those progressive in politics, was not confined to them. Both the *Oath of the Horatii* and *Brutus* by Jacques-Louis David (1748–1825) deal with episodes in the history of the Roman Republic, and were bought for the Crown. Indeed, despite the decadent lifestyle of the court, Louis XVI was the counterpart of George III who displayed bourgeois virtues of faithfulness and diligence. From the middle of the 18th century, an artistic education in Italy – primarily Rome – became essential but it was not until the 1740s that interest shifted from Baroque art to the abundant Classical remains in Italy. From then on there was a brisk trade in Classical sculpture and a lively enthusiasm for archeological enquiry and classification appropriate to the age. In 1738 Herculaneum was discovered and ten years later Pompeii, revealing a wealth of Roman objects and wall paintings from the first century. The delicate arabesques, bright colors and erotic subjects were something of a shock to the mid-18th century conception of an austere, Classical Italy. It was not until the end of the century that artifacts, furniture and even costumes from the sites were closely copied.

Thanks to systematic archeological investigation a picture of changing styles of antiquity began to emerge: the art of Pompeii was seen to be late Classical and comparatively decadent. In 1751 James Stuart and Nicholas Revett went to measure Greek monuments in Athens and attention was thus focused on the differences between Greek and Roman architecture.

Greek sculpture found its most influential champion in the German archeologist and writer on Classical art, Johann Joachim Winckelmann who never visited Greece and who wrote his first treatise, *Thoughts on the Imitation of Greek Works in Painting and Sculpture* in Rome (1755). Rome, of course, contained much Hellenistic sculpture and Roman copies of Greek originals.

In 1734, in accordance with the Enlightenment's desire to educate that led to the setting up of museums all over Europe, Pope Clement XII opened the first public museum of antiquities. To Winckelmann, Greek sculpture was the expression of a perfect society, the product of an ideal climate which led to physical beauty and a political system of an ideal reflected in "noble simplicity" and "calm grandeur" in art. The secret of Winckelmann's influence was his characteristically 18th century fusion of rational argument with sentiment. He recommended "imitation" – the recapturing of the Classical spirit – rather than slavish copying. Winckelmann's writings encouraged a renaissance of sculpture, particularly in the work of the Italian Antonio Canova (1757–1822) and the Dane Bertel Thorwaldson (1768–1844). In place of angels bearing the soul to heaven, Canova's monuments abound in Classically-dressed allegorical figures, such as Piety and Beneficence, even in his monument to Pope Clement XIV. Tombs are far from being mere trappings of antiquity and the Classical reliance on deeds in this world rather than expectations of the next is amply felt.

Classical sculpture also affected the work in France of Etienne Maurice Falconet (1716–91) and Claude-Michel Clodion (1738–1814), whose smooth, pure lines and simple compositions are tinged with Rococo eroticism.

Less successful than Winckelmann's encouragement of sculpture, painting, it was felt, should reflect antique statues and reliefs by borrowing poses, using a shallow, limited picture space, smooth sculpture-like modeling and clearly defined outlines of figures. This produced some very dull pictures except in the greatest of artists. Anton Raffael Mengs's (1728–79) *Parnassus* was produced in Rome to such a program with the addition of something of the sort of the Classicism of Raphael. Of other artists in Rome in the 1750s and 1760s, the American Benjamin West was Neoclassical and uninspired.

The sense of the power and weight of stone and the drama of huge, simple buildings is also characteristic of Neoclassicism, finding expression in the work and unrealizable projects of Claude-Nicholas Ledoux (1736–1806), Etienne-Louis Boullée (1728–99) and Sir John Soane (1753–1857). Giovanni Piranesi (1720–78), although trained as an architect, built little; the idealism – some would say megalomania – of Neoclassical architects was frequently bigger than practicality or purses.

Parnassus with Apollo and the Muses, *1761*
Anton Raffael Mengs (1728–79)
Fresco approx. 117×235in (3×6m)
Villa Albani, Rome

Mengs was the son of Ismael Mengs (c.1689–1764), Director of the Royal Academy of Painting at Dresden. He first visited Rome in the company of his father in 1741 and returned there to settle after a brief period as court painter in Saxony, where he had produced many pastel portraits of members of the court. In his ceiling fresco Parnassus with Apollo and the Muses, *Mengs broke with the tradition of* sotto in su, *a style of composition that used foreshortening of the figures to give the impression of a view upward through the scene. Mengs arranged his painting as if it were a conventional view from eye level. He was highly regarded in his own lifetime but the influence of his painting and writings declined rapidly after his death.*

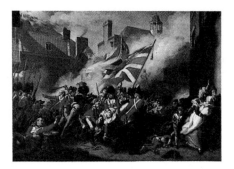

The Death of Major Pierson, *1783*
John Singleton Copley (1783–1815)
Oil on canvas 97 × 144in (242.5 × 360cm)
Tate Gallery, London

Like his fellow expatriate Benjamin West, Copley visited Italy before settling permanently in England in 1774. He gained a brief popularity by his history paintings, first winning recognition with Watson and the Shark, *exhibited at the Royal Academy in 1778. The Death of Major Pierson represented the high-water mark of his career. The Duke of Wellington later remarked that he knew no other painting that so convincingly conveyed the real feeling of battle. But before the 18th century closed changing taste left Copley high and dry and his last years were clouded by the harrassments of creditors. His reputation today rests chiefly on his early American portraits of public figures.*

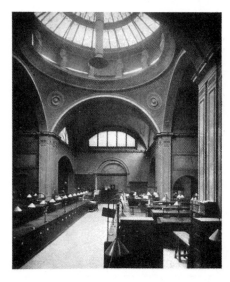

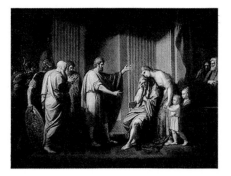

Cleombrotus ordered into Banishment by Leonidas II, King of Sparta, *1768*
Benjamin West (1738–1820)
Oil on canvas 54½ × 73in (123 × 168cm)
Tate Gallery, London

Benjamin West was born in America, but died in London where he had first established himself as a portraitist, though he wished to be regarded as a history painter. Eventually he achieved success and succeeded Sir Joshua Reynolds as president of the Royal Academy in 1772. His early neo-classical style became more Baroque in his later work, and in his Death of Wolfe *he produced the first "history" painting in modern dress.*

Consols Office, *Bank of England, London, 1794*
Sir John Soane (1753–1837)

Soane's influential work formed a link between the Palladian style of 18th century England and the Classical revival that followed. Soane was the son of a master builder, articled in 1768 to the London architect George Dance (1741–1825). In 1776 Soane won the Royal Academy Gold Medal for architectural design, entitling him to a grant for three years study in Italy. On his return to England in 1780 he took up practice in London and the eastern counties, but not until he started designs for the Bank of England did his reputation become fully established. He was chosen as architect to the Bank from fifteen competitors. His work started in 1788 and occupied him until his retirement in 1833, although he also took other commissions during that time. The Bank buildings included a complex arrangement of offices, halls, residential areas and courtyards.

Painting in England was in a state of ferment in the second half of the 18th century due to the changing status of the artist. England, painfully aware that France had enjoyed the prestige of an Academy since 1648, founded its Royal Academy in London in 1768. The first President was Sir Joshua Reynolds (1723–92). Reynolds's own work is ambiguous. His history paintings make light of their subjects while his portraits aggrandize sitters by not always discreet reference to Classical precedent. Apart from an excellent feeling for paint and an intimacy of treatment, he believed that human dignity could best be conveyed by calm expressions and poses.

It was left to two American painters who had studied in Italy to revitalize the history picture in England. In 1770 Benjamin West (1738–1820) painted the *Death of Wolfe* in contemporary dress, rejecting Reynolds's idea that he should show the participants in togas; he claimed instead that "the event took place on September 13th, 1759, in a region of the world unknown to the Greeks and Romans, and at a period of time when no such nations, nor heroes in their costumes any longer existed". In composition the painting is a curious mixture of Neoclassical and Baroque influences. The hero makes a good end in this world, and his immortality – in posterity's memory – is ensured by surrounding witnesses that includes an Indian. A similar instance of the Neo-classical attitude to death is shown in John Singleton Copley's (1738–1815) *Death of Major Pierson.* Although attention is concentrated on the heroic death, a note of universal misery is struck in the fleeing women and children. Modern dress history paintings scarcely appeared in France before reality overtook ideology with the onset of the French Revolution.

Neoclassicism was among other things a search for primitive purity and

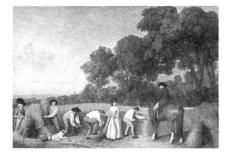

The Reapers, *1785*
George Stubbs (1724–1806)
Oil on wood 35½ × 53⅞in (90 × 136.7cm)
The Tate Gallery, London

George Stubbs is well remembered for his paintings of animals and anatomical studies, such as Anatomy of a Horse, *begun in 1758 and published in 1766. In his early years he had pursued a career as a portrait painter, traveling in the towns of northern England, but after his move to London in 1759 he attracted many commissions for paintings of racehorses and hunters, dogs and hunting scenes. Stubbs hoped to turn the tide of this practice and obtain a reputation for history painting and portraiture. He was unable to discard the well established associations with his work on animals, although he began to include some genre paintings, such as* The Reapers *and its companion piece* The Haymakers *in his oeuvre. By 1785 Stubbs was a member of the Royal Academy of Arts in London and exhibited these two works there in 1786. He had been largely self taught and throughout his career investigated a number of techniques for painting and printmaking. He learned etching and engraving for the anatomical studies; he executed large mezzotint copies of* The Reapers *and* The Haymakers *and also painted second versions of both subjects in enamels.*

nowhere was this better expressed than in line engraving, for example in the work of John Flaxman (1755–1826), who also designed reliefs. Britain was one of the most advanced European nations in scientific discoveries, a factor leading to the Industrial Revolution; the spirit of enquiry is evident in the work of George Stubbs (1724–1806) and Joseph Wright of Derby (1734–97). At first sight Stubbs seems to belong to a fairly recently established and modest British tradition – the horse painter – yet the clarity with which he organizes groups of horses into friezes against a background of green suggests an instinctive Neoclassicism. Helped by Josiah Wedgwood, he experimented with enamel painting on ceramic and with a complex type of printmaking that produces velvety shadows, always seeking to extend the expressive vocabulary of his art. He was also a scientist and published *The Anatomy of the Horse* (1766) which reflected the Enlightenment's thirst for knowledge.

England already had a Classical tradition in architecture with the Palladian movement. Palladianism however was mainly expressed in country houses and villas while some of the most interesting Neoclassical buildings of the last quarter of the 18th century and the beginning of the 19th were public buildings. This reflected an age of confidence, expansion and an increasingly complex society. Increase in, and better organization of, bureaucracy led to Sir William Chambers (1723–96) Somerset House for government offices and Sir John Soane's Bank of England. Increase in urban population produced Robert Adam's (1728–92) Adelphi Terrace and the planning of Regent Street and Regent's Park by John Nash (1752–1835).

Fear of free-thinking and radicalism among the urban poor resulted in the Churches Act of 1818 which released a vast sum for the building of new

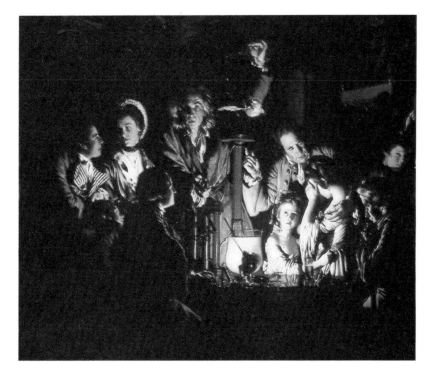

churches, many Greek in style, although reflecting a growing enthusiasm for Gothic. The Greek revival of the early years of the 19th century, expressed in the use of Greek Ionic and Doric and the copying of severe, monumental temple architecture, coincided with the institutionalizing of the Enlightenment reliance on education. William Wilkins's (1778–1839) Downing College and London University; Robert Smirke's (1781–1867) British Museum and Thomas Hamilton's (1785–1858) brilliant, dramatic Edinburgh High Schools are all Greek Revival buildings. The Greek revival in England emerged much later than Winckelmann's emphasis on Greek culture on the Continent. Architecture in England from 1750 to 1780 was dominated by Sir William Chambers and Robert Adam, both influenced by Piranesi in their preference for Roman architecture.

Experiment on a Bird in the Air Pump,
c.1767–8
Joseph Wright of Derby (1734–97)
Oil on canvas 72×96in (182.9×243.8cm)
The Tate Gallery, London

Wright's early training was as a portrait painter, under the London artist Thomas Hudson, who also taught Reynolds. In the late 1750s Wright settled in his native town of Derby, England as a portraitist and in 1760 was traveling around the towns of the English Midlands taking commissions. He later conceived his idea of studying the effects of artificial light through the medium of painting. He started work on a series of "candle light" paintings, the first being Three Persons Viewing the Gladiator *of 1765, which includes a portrait of the artist. Wright's work was highly original for the time, especially the dramatic compositions showing the use of scientific instruments, seen in this example; both the subject matter and the composition were quite unlike any other work among Wright's contemporaries. A study for* Experiment on a Bird in the Air Pump *exists on the back of a self-portrait by Wright.*

Robert Adam, like Chambers, had been to Italy and Asia Minor and contributed to the understanding of late, flamboyant Roman decoration with the publication of a treatise on the ruins of the palace of the Roman Emperor, Diocletian, at Spoleto. Adam concluded that much modern interior decoration was simply Roman exteriors transferred inside, for example the use of columns and pediments over doors in a purely decorative manner, and that real Roman interiors would repay study. He also observed that the rigid rules laid down by Palladio were, in fact, used with flexibility by the Romans. Adam also realized that there were different styles of Roman design that could be used to express the different character of forms. Like French Neoclassical architects he saw interiors as a progression of rooms of various shapes and importance.

John Nash's development ran from Carleton House to Regent's Park, creating a slightly irregular thoroughfare between fashionable Mayfair and slummy Soho. To purists John Nash was scarcely regarded as a Neoclassical architect. French Neoclassical architecture was more rigorously theocratic, to the extent that some of its finest expressions were never built and often impossible to realize practically. Yet the Neoclassicists of the day, their merit lay in flights of imagination, not practicality – or even the impulse to consider human needs.

The idea that a building should contain elements symbolic of its function was important to Neoclassical architectural theory and influenced the type of borrowing from Classical sources. Claud Nicolas Ledoux (1736–1806) carried the impulse for architectural symbolism to the point of genius. In 1775 Ledoux began the saltworks at Arc-et-Senans. A saltworks may seem an unlikely starting point for a symbolic masterpiece, but the salt tax, or

gabelle, was vital to the French economy, and so high that smuggling, violence and heavy penalties for illegal distillation explain the symbols of authority in Ledoux's design.

Austere French Neoclassicism was taken up in Prussia from the foundations laid by Frederick the Great, despite the setbacks of the Napoleonic Wars. Carl Langhans's (1732–1808) Brandenburg Gate of 1789 was one of the earliest Greek Revival buildings in Germany, based on the Propylaea in Athens. The short-lived Friedrich Gilly (1772–1800) produced some superb unrealized designs, including a monument to Frederick the Great (1797) in which a Greek temple is set on a pierced Roman podium. Karl Schinkel (1781–1841) was responsible for much town planning in Berlin. He was a typically early 19th century eclectic, being a painter, producer of panoramas and theater sets, and architect in the Gothic style, which he felt to be typically Prussian. However, his Altes Museum (1823–30) with its horizontal emphasis, row of Ionic columns and attic with sparse sculptural decoration is a careful Classical work.

A Neoclassical architectural style spread with Napoleon's armies to Italy and Spain. In France Neoclassicism was carefully fostered by Napoleon – specifically the Roman Imperialist so eloquent of Napoleon's ambitions and achievements – along with a vogue for Egyptian motifs inspired by the Nile Campaigns. Perhaps surprisingly the Napoleonic period as such (1799–1815) did not produce a spate of vast public buildings – one reason being that the First Consul, subsequently Emperor, was too busy – but the Empire style meant greater richness, the use of gilding, polychrome in exterior architecture, allegorical sculptural decoration; Imperial eagles and interiors draped like Eastern tents, as in Josephine's bedroom at Malmaison. Paris

was given a regular, Classical plan. All this was a brilliant foil for the figure of Napoleon, who dressed plainly and was depicted by David toiling over the Code Napoleon at four in the morning – "working while my subjects sleep", as the Emperor remarked upon seeing the picture, pleased at this icon of devotion to duty, the leader serving his people.

In France Neoclassical painting became great art in the figure of Jacques-Louis David (1748–1825). When David won the Prix de Rome in 1774 he expressed a determination not to be seduced by Classicism during his stay in the city. A meeting with a pro-Winckelmanian theorist revised his opinions with his painting *Belisarius*. The painting depicts stoicism in the face of adversity, the nobility of a great man even in old age, and the fleeting nature of human glory. This is an austere, difficult heroism. As in the *Death of Socrates*, David never pretends that it is easy to do what is right, and this is what lies behind the tense power of his art. David looked to Poussin for the bright, clear colors, linear treatment, smooth paint and deeply receding background in his painting.

David's *Oath of the Horatii, Brutus* and *The Intervention of the Sabine Women* epitomize three stages of the French Revolution, although it must be emphasized that the first two paintings were in advance of events and were not a specific reaction to them. David was deeply involved in Revolutionary politics and through his art can be seen the hopes and fears of France although he was far from being a mere popularizer. As a Deputy he voted for the death of Louis XVI, he was Chairman of the Convention and organized revolutionary festivals based on Roman rites using a cast of thousands of people rather than "elitist" trained actors. *The Death of Marat* records the death

of a secular martyr to the Republic cause, murdered by the Royalist Charlotte Corday (Marat himself had murdered hundreds, but as David saw it, for noble reasons). The austerity of Marat's life is hinted at in the homely materials, his devotion to duty, like Napoleon, in the fact that he continues to write for the good of the people when racked by a painful skin disease.

Napoleon was the man to whom France looked to extricate the country from the terrible turmoil into which it had been plunged. David's masterpieces – *Napoleon Crossing the Alps*, the massive *Coronation* and *Napoleon Distributing the Eagles* – bear witness to this cult. But David outlived Napoleon, and spent his final years in exile in Brussels, extending the naturalism apparent in the Seriziat portraits and his occasional landscapes into a piercing delineation of bourgeois mediocrity as in *The Three Ladies of Ghent*. Meanwhile, painting in France had taken a new direction – Romanticism.

The Consecration of the Emperor Napoleon and the Coronation of the Empress Josephine, *1805–7*
Jacques Louis David (1748–1825)
Oil on canvas 244½×385in (621×979cm)
The Louvre, Paris

David was initially cautious when Napoleon began to show him special favor and in 1800 he refused the title of Painter to the Government. Despite his shyness of official status, David undertook many commissions for Napoleon, largely to celebrate his successes in battle, and in 1804 was the natural choice when a grandiose record of the coronation of the Emperor and Empress was required. David undertook four paintings showing various stages of the celebrations. He was present at the coronation in Notre Dame and where possible made separate studies of the participants. The pope officiated at the ceremony, but Napoleon himself placed the crown upon his own head. It was judged more tactful politically to record the following moments of the ceremony when the Emperor turned to crown his consort, and it was generally agreed that this had been a particularly moving part of the proceedings.

America in the 18th and early 19th Centuries

The 18th and 19th centuries saw Europeans tame the continent of America and build it into a major industrial and political power. In the process they had a clean slate of cultural possibilities upon which to write, but American art did not acquire a national identity until the mid-19th century.

In the 17th and 18th centuries American art reflected the places of origins of its settlers, and to some extent continued to do so. The southwest had Spanish Baroque churches, as befitted an area of Spanish settlement and Jesuit missionary activity. Louisiana looked to the court of Louis XIV, Virginia to English aristocratic taste. The northeastern seaboard was settled by Dutch and English Protestants, who became the dominant group. America first broke away from Britain in 1775–83 during the War of Independence, and then slowly collected the various colonies into a federation of states, for its leaders realized that there would only be peace if the whole continent acted in common interest. Louisiana was bought from Napoleon in 1802, Florida acquited from Spain in 1819. Texas joined the Union in 1845, the Pacific northwest was taken by force from England in 1846, the southwest from Mexico in 1848 and 1853. The continental empire was completed by the purchase of Alaska from Russia in 1867. By then the importance of unity had been demonstrated by the 1861–65 American Civil War, fought to prevent the South seceding from the Union.

In the 17th century the eastern seaboard towns gradually became organized, comparatively secure from Indian attacks, and prosperous. In 1690 Boston had 7000 inhabitants, New York and Philadelphia 4000 each. The Protestant communities believed in hard work, shrewd business, piety and craftsmanship. As Puritans, they frowned upon religious painting, but many box-like wooden churches were built, designed so that no part of church proceedings would be obscured from the congregation, and with prominent pulpits for the all-important sermon.

Both Dutch and English had a strong tradition of portraiture, served in American by "limners" – painters without formal academic training who did other jobs as well, such as sign-painting. They tended to ignore perspective but captured minutely the appearance of objects so that the imagination, not the eye, provided the details. This was sometimes overlaid with a veneer of sophistication borrowed from imported prints. Naive painters sometimes expressed a strong feeling for character and environment, as in Winthrop Chandler's *Reverend Ebenezer Devotion* (1770), with its meticulous background of books.

Settlers who had come from upper-class English backgrounds, namely Southern plantation owners, imported Europeans like Charles Bridges and Gustavus Hesselius (1682–1755) to paint them. Although not always painters of the highest rank, these temporary immigrants introduced the 18th century "grand manner" in portraiture to America. John Smibert's (1688–1751) *Bishop Berkeley and His Family* (1729) is a sensitive essay in the manner of Kneller's group portraits – at once grand and informal, skilled in command of perspective and light, conveying family affection, intelligence and the sense of vision that animated so many American settlers: Berkeley planned a college in Bermuda for the education (and conversion) of Indians as well as colonists.

The period leading up to the War of Independence and the drafting of the American Constitution (1789) was dominated by Classically educated, cosmopolitan leaders like Benjamin Franklin, George Washington and Thomas Jefferson. Vigor, grandeur and a sense of history in the making

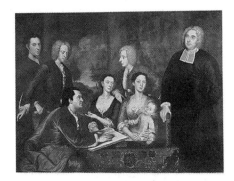

Bishop George Berkeley and his party, *1729*
John Smibert (1688–1751)
Oil on canvas 69½ × 94½in (161 × 236cm)
Yale Art Gallery

Of Scottish origins, Smibert left Edinburgh, where he was apprenticed to a house painter, for London, and there worked as a coach painter and studied art. After a short visit to Italy he left London in 1728 in the company of George Berkeley, who intended to found a college for Indians and wanted Smibert to teach art and architecture. Whilst in Newport, Rhode Island, he painted this, his most notable work. Smibert moved to Boston in the same year, where he became a well known portrait painter, and inspired other artists such as Copley and Peale. His single architectural work is the interesting Faneuil Hall (1742) in Boston.

George Washington, *1795*
Gilbert Stuart (1755–1828)
Oil on canvas
National Gallery, Washington

An American portrait painter, mainly known for his three portraits of George Washington, Stuart worked in Scotland and in London until his return to America in 1792. He practiced in New York, Philadelphia and Washington before settling in Boston in 1805. His portraits, which somewhat recall the work of Alan Ramsay, are clear and analytical with considered sensitivity of draftsmanship.

were characteristic of the painting of the period, although ties with England were still so strong that American artists continued to go there for education and patronage. Benjamin West also did subjects from American history, such as the *Treaty of William Penn with the Indians* (1771). West's pupil John Trumbull (1756–1843) did a series of paintings from the War: paintings that were Baroque in color and movement, but with a Romantic concern for atmosphere. American pride in its history, and awareness of struggle, ensured a long tradition of military painting, though as the nation became established in the 19th century this heroic period was overlaid with a veil of sentimentality, apparent in Emanuel Leutze's (1816–68) *Washington Crossing the Delaware* (1851).

John Singleton Copley (1738–1815) was also a superb portraitist, influenced by the limners in his clear, detailed painting, and portraying a late 18th century society that was simple but not crude, self-reliant, full of dignity and commonsense. Copley's famous portrait of *Paul Revere* (1768–70) epitomized the type of man who made the American Revolution; an articulate craftsman who felt himself the equal of anybody. The interest in the individual, characteristic of late 18th century America led to a fresh approach to portraiture, as in the case of West's follower Gilbert Stuart (1755–1828). His *Skater* (1782) is an informal, elegant action portrait, with an early Romantic freedom of brushwork derived from Gainsborough.

The early period of the Republic was dominated by patrician landowners who favored trade controls to protect their own interest, and felt economic and cultural affinities with Europe. Gradually, however, the separateness of America was defined. Jefferson remarked: "The European nations constitute a separate division of the globe ... they have a set of interests of there own in which it is our business never to engage ourselves". The population increased; immigrants arrived from Europe in the aftermath of the Napoleonic Wars, and settlement spread westward. Frontier townsmen were brave and enterprising, combating hostile nature and Indians, generally of humble, often non-English stock and with no interest in the elite culture of the eastern seaboard. Democracy had always been stressed in America, but the era of Andrew Jackson's Presidency (1829–37) was the era of glorification of the common man. This pushing, shoving, bumptious shouting-about-democracy era settled the West against enormous odds.

Concurrently there was an upsurge of genre painting; pictures of everyday life could not be regarded as inferior when everyday life was the nation's most precious asset, and security newly won from the wilderness. There was a strong folk tradition throughout America, evident in the work of the Quaker Edward Hicks (1780–1849), today recognized as a great naive painter. Hicks was trained as a sign-painter and did many versions of *The Peaceable Kingdom*, reflecting the central Quaker tenet of pacifism.

William Sidney Mount (1807–68) studied in New York and was influenced by engravings of European genre painting (the 17th century Dutch were popular). His own work portrays rural activities, with affection but without nostalgia, for country and town were not yet divorced in the American consciousness. George Caleb Bingham (1811–79) showed life on the Missouri River, then a major artery of trade and communication even before steamboats encouraged settlement along its banks. Bingham was actively involved in politics, running for State Representative and painting scenes of local elections that do not belittle the work-

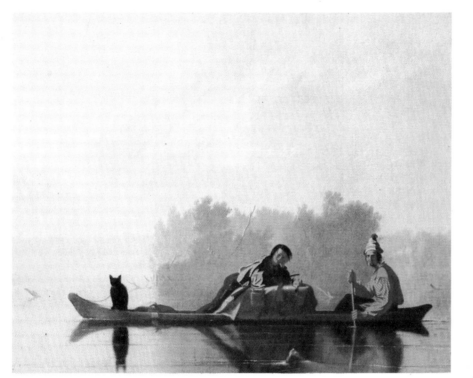

Chinese Blue Pie
John James Audubon (1785–1851)

Audubon was born in Haiti and at the age of four was sent to France where he studied drawing under David before going to America in 1803. By 1808 his principal interest in nature, especially birds, had already been established and from 1827–38, after some initial difficulty, he published his drawings of birds as The Birds of America. They have become among the most famous ornithological portfolios.

Fur Traders Descending the Missouri, *1845*
George Caleb Bingham (1811–79)
Oil on canvas 29×36½in (73.5×92.5cm)
Metropolitan Museum of Art, New York

From the age of eight Bingham lived in Missouri and he belongs to the so-called "west of the Mississippi school" of American landscape painting (as distinct from the Hudson River school). The school produced many highly energetic paintings on vast canvases depicting the epic grandeur of the scenery and the heroic courage of the men who opened up the West. Bingham is distinguished by the more painterly, almost Classical, calm of his approach. The Fur Traders, with its balanced composition of forms across the surface plane of the painting – having the figures all face outward is a device he learned from the work of William Mount – and its frozen, timeless quality, is a fine example of the care that he took not to allow the romantic subject matter of his paintings to interfere with his primary interest in light and shade, linear clarity and formal harmony.

ings of democracy at grassroots level, as the work of European genre painters was apt to do.

If the virgin territory of America supported new communities for artists to observe, the 19th century interest in geology and natural history had free range in a new continent. The artist Charles Wilson Peale (1741–1827) had a private natural history museum in Philadelphia, and painted *Exhuming the First American Mastodon* (1806–08) – note the national pride in the title. John James Audubon's (1785–1851) watercolors of American birds (1827–23) are imbued with a feeling of the grandeur of the natural world, both romantic and peculiarly American.

As the Indian threat receded, at least from eastern life, artists like Seth Eastman (1808–75) and George Catlin (1796–1872) set out to record the original inhabitants of the continent; as Catlin put it: "to rescue from

oblivion so much of their primitive looks and customs as the industry and ardent enthusiasm of one lifetime could accomplish". This enthusiasm was the 19th century heir of Enlightenment ideals about the "noble savage", and there is real poignancy (and guilt) in Catlin's before and after pictures of a

The Cavalry Charge
Frederic Remington (1861–1909)
Oil on canvas
Metropolitan Museum of Art, New York

Remington studied art at Yale and the Art Students League, but because of ill-health moved to the West where he became a clerk and eventually a rancher. By this time healthy and hard-living, and with considerable energy, he managed to produce a large body of paintings and sculpture in a short life. His work depicted life in the West in an illustrational and graphic style which partakes more of book illustration than of painting. Nevertheless, the strength of his drawings and his strong color made his paintings live and gave them a raw reality for his city clients.

The Oxbow (The Connecticut River near Northampton), *1836*
Thomas Cole (1801–48)
Oil on canvas $51\frac{1}{2} \times 76in$ (131×193cm)
Metropolitan Museum of Art, New York

Thomas Cole, who came to the United States from England with his family when he was nineteen, was the founder of the Hudson River school of landscape painting, a school whose "existence" may conveniently be dated from 1825, when Cole placed three views of the River for sale in a private New York gallery. Cole was working on The Oxbow *at the same time as he was completing his ambitious allegorical landscape cycle,* The Course of Empire. *Like the Transcendentalists in philosophy and literature, Cole sought moral inspiration and ethical instruction from the contemplation of nature because in nature was to be found the "inseparable connection between the beautiful and the good." In* The Oxbow, *the storm in the background has already refreshed the foreground landscape and around the dead tree trunk springs new growth, symbolic of the eternal renewal of nature. In the work of Cole and the other members of the Hudson River school, especially Asher B. Durand (1796–1886) and Frederick Church (1826–1900), American landscape painting, having played a supporting role in the history painting of Benjamin West and John Singleton Copley, found a theater of its own.*

young American Indian's trip to Washington. He returned to his tribe in a hideous parody of Western dress, and was eventually killed as a demonic medicine man. Late in the century, when life was even more stable and urban, Indian life (and indeed any frontier existence), was glamorized in the bronzes and paintings of Frederic Remington (1861–1909), inventor of the myth of the Wild West.

Apart from their dignity as human beings, all Americans had their landscape in common, and "All nature here is new to art". In America as in Romantic Europe, landscape painting was democratic in impulse; unlike history painting it did not need a Classical education to understand it, and the spectator responded to it according to his capacity for feeling, a quality more highly prized in the 19th century than the capacity for reason. As they discovered more of it, Americans grasped that their landscape was extraordinary by any standards, and the history of landscape painting in America shows that extraordinariness being made more and more overt. Following European trends, the march of science threatened traditional Christianity towards the middle of the

century. Seeing God, or spiritual release, in nature – the pantheism or transcendentalism of Emerson and Thoreau – was another reason for the popularity of landscape painting.

America's first great landscape painter was Washington Allston (1779–1843), who traveled widely in England and Europe and applied to American scenery the traditions of the historic landscape of Salvator Rosa (1615–73), Claude and Turner. Like early American architects who tried to outdo European Neoclassical buildings, Allston competed with Europe on its own terms in designing vast historical canvases (*Belshazzar's Feast* plagued him for twenty-five years), and setting significant, emotionally-charged events, like *Elijah Being Fed by the Ravens* (1818) in generalized American scenery.

The next generation of landscape painters, the Hudson River school led by Thomas Cole (1801–48), partook of the national awareness of the middle of the century and concentrated on the specific character of American landscape without an historical element. Hudson River school paintings are very bright, responding directly to local colors and eschewing the "brown landscape" European tradition, which still lingered on in European 19th century painting. The moralistic tendency in American life, the feeling of mission which pervaded the young nation, is reflected in Cole's painting of the cycles *The Course of Empire* (1836) and *The Voyage of Life* (1840), which also owe much in theme and style to Turner and John Martin (1789–1854).

After 1850 America rapidly became industrialized, and many living in the cities felt a great nostalgia for the open spaces. The nation, although large and comparatively unpopulated, was one of the first to realize that nature should consciously be protected from the encroachment of man: Yellowstone became the first national park in 1872.

The late Romantic landscape painting of Frederick Church (1826–1900), Thomas Moran (1837–1926) and Albert Bierstadt (1830–1902) reflects this nostalgia and concentrates on America's unassailable places, like the Rocky mountains. The canvases are huge, with a stress on the power of nature, as in Moran's *Big Springs, Yellowstone Park*. By the third quarter of the 19th century industrial progress had brought prosperity, and prosperous Americans were intrepid, insatiable travelers, eager to see the wonders of nature outside their own continent. Church supplied this taste by seeking out spectacular natural features in South America, the Arctic, and, even though accessible to many, Niagara Falls.

Architecture

America in the 19th century was an architect's dream, with a constant demand for new public and private buildings. Architecture in America took a course similar to the history of painting; European influences followed by the search for a national style.

The early settlers built very simply in wood, which was abundant, according to their national styles. In the early 18th century English settlers on the eastern seaboard emulated Georgian styles, with use of brick and white-painted wood rather than the stony severity of English Palladian buildings, and on a smaller scale.

Neoclassical thought caused America's first leaders to think of Republican Rome (as a model of democracy, not because of possibilities of empire) when setting up its institutions. Hence the choice of senators, capitols and the Roman eagle. It was inevitable that Neoclassical building should be seen as the best outward expression of democracy, especially for public buildings. Many of the ruling class of the early days of the Republic had made the grand tour of Europe and

The Rocky Mountains, *1863*
Albert Bierstadt (1830–1902)
Oil on canvas 73¼ × 120¾in (186 × 306.5cm)
Metropolitan Museum of Art, New York

Bierstadt was born in Germany but emigrated to the United States when he was two. This painting was completed in the year that Bierstadt made the second of his three journeys to the American West. The first of them took place in 1857 when he accompanied a government surveying expedition to the Rocky Mountains and the Yosemite Valley. The sketches which he made on those trips were the basis of his huge landscape canvases. Several aspects of Bierstadt's art may be faulted – his dependence upon conventional devices for rendering trees and clouds has received critical censure – but his grandiose treatment of mountain scenery caught the public mood of America in the 1860s and 1870s, when his canvases fetched exceedingly large sums.

had studied Greek and Roman buildings at first hand. Political ties with France – which had helped America against England in the Revolution – attracted French architects, who were in the vanguard of Neoclassicism, to the country, and Americans studied in France. Washington D.C. was laid out by the Frenchman Pierre Charles l'Enfant (1754–1825).

In a manner of characteristic of the Enlightenment, Thomas Jefferson considered all aspects of social organization, and possessed the energy to see his projects come to fruition. Politician, landowner and educationalist, he was also an architect by profession and could realize the outward symbols of the new society he was helping to create. His own house, Monticello

(1770–1809), combines Palladian and Roman influences, but has a charm and informality that derived partly from its combination of brick and white-painted wood. Education was vital to the young Republic, and Jefferson's design for the University of Virginia (1822–26) was again Neoclassical: porticoed, Roman-inspired buildings grouped around a lawn, with gardens behind. In keeping with the secular confidence of the Enlightenment, the central rotunda houses not a chapel, but a library.

With the help of the French architect Charles Clérisseau (1721–1820), Jefferson based the state capitol at Richmond, Virginia (1785–89) on the form of a Roman temple – a rectangle with a portico at the front, like the Maison Carrée at Nimes, which he much admired. The form was imposing, economical of space and building materials, and the portico unlike those on English Palladian buildings. Richmond inspired countless imitations, for public buildings, semi-official buildings like banks, and also private houses for wealthy eastern merchants, such as the house designed by Ithiel Town (1784–1844) and Alexander Jackson Davis (1803–92) for Samuel Russel at Middletown, Connecticut (1828). In keeping with the spirit of simplicity in early 19th century American life, and perhaps because of a lack of the appropriate craftsmen, there is little sculptural detail in American Neoclassical building. This lack of extraneous details is paralleled in the furniture of the period, which follows European styles with greater simplicity, and often greater elegance.

After about 1825, heavier Greek forms were preferred to Roman. Roman or Palladian architecture had come to be associated with gentlemanly elitism and Greek architecture with a more robust, and earlier, democracy. America was also influenced by

Greek revival in Europe. There was still a Neoclassical tendency for architecture to express the function of the building symbolically. The growth of Washington D.C. as a seat of power and the country's wealth necessitated a new Treasury Building. Robert Mills's (1781–1855) design (1836–42) included a long Ionic colonnade in imitation of a *stoa*. The Greek peristyle, or continuous colonnade, was ideal for a hot climate. In "Andalusia" (1836), built by Thomas Ustick Walter (1804–87), a Doric colonnade was married to a Georgian box house. Southern plantation owners, immensely wealthy in the first half of the 19th century by producing cotton cheaply by slave labor and selling it to the mills of northern England, flaunted their status by building. Porticoed Neoclassical houses were shady, and imitated the Palladian mansions of English aristocrats, with whom they felt most affinity. Toward the middle of the 19th century, strict Classical elements were combined with engineering inventions. The Naval Asylum, Philadelphia (1826–29), designed by William Strickland, had an Ionic, marble portico with iron columns and balconies in the flanking piazzas.

When Napoleons I and III redesigned Paris they had to knock down existing buildings that had grown up haphazardly over the centuries. By contrast Washington D.C. was a town planner's dream: a federal capital to be built from scratch. Despite the fact that New York, Philadelphia and Boston were the chief population centers, the new site was equidistant between northern and southern settlements on the eastern seaboard, and easily defended, situated as it was on the arms of the Potomac. L'Enfant had produced a rational, grid-like plan (1791) overlaid with round points from which avenues radiated – the plan of the gardens at Versailles elevated to a grand scale.

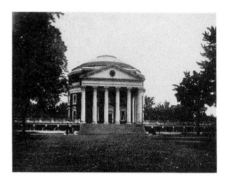

The Redwood Library, *University of Virginia, 1817–26*
Thomas Jefferson (1743–1826)
Charlottesville, Virginia

Jefferson successfully combined the roles of statesman and architect throughout his career and was therefore an important figure in both the physical and political development of the United States. He was from a wealthy family and college educated. As a student he first became interested in architecture. He absorbed the influence of Roman and Neoclassical architecture during a period as American Ambassador to France (1784–89). After his return to the United States he compared the development of buildings taking place there and criticized in particular the randomness of Virginian architecture. When he later designed the University of Virginia, for which he planned not only the buildings but the curriculum for the studies as well, he modeled the form of the library on the Pantheon at Rome, although he had not seen this building at first hand.

There was thus a characteristically American mixture of formality and liveliness. The Capitol (1793–1830) was designed by Charles Bulfinch (1763–1844) but considerably extended by T.U. Walter (1861–65), America's great increase in population and territory making this necessary. Bulfinch's lively use of Classical features, elements of Somerset House, London, and an imposing, Wren-like dome is better shown in his Massachusetts State House (1795–98); civic architecture which does not slavishly follow a Neoclassical formula.

Massachusetts State House, *1795–97*
Charles Bulfinch (1763–1844)
Brick, marble and stone
Boston, Massachusetts

There was no established architectural profession in the United States in the late 18th century and it is thought that Charles Bulfinch was almost entirely self-taught. He observed and learned the principles of Neoclassicism in the architecture of Europe during a visit prior to 1787, and on his return to New England began to produce his first designs for buildings. He worked initially on an amateur basis but as he gradually built a reputation tried to start a full time architectural practice. This involved him in considerable financial difficulties that dogged his career (he was bankrupted in 1796 and briefly imprisoned for debt in 1811). Preparations for the building of a new State House in Boston had begun in 1787 and a plan for this project was one of the first designs made by Bulfinch after his return from Europe. It was heavily influenced by his knowledge of English architecture, particularly the recently built Somerset House in London. The huge dome of the State House was originally shingled; subsequently it was covered with copper and eventually gilded in 1874.

Many immigrants had sailed to America to escape religious persecution. Forms of worship gave the various American communities their identity, and as they grew prosperous in the 19th century there was great demand for church building. In Baltimore, Benjamin Latrobe (1764–1820) designed the Roman Catholic cathedral (1804–21). He submitted both Neoclassical and Gothic designs, and his highly individual, severely vaulted

Neoclassical style, owing much to Sir John Soane, was chosen. Gothic building was popular from the mid-19th century, encouraged by Latrobe and Richard Upjohn (1802–78). Lacking Gothic ruins, American architects had to rely on engravings; but at first there was more interest in fantasy Gothic than archeological exactitude. Around the middle of the century American woodcarving skill was expressed in the fretwork of "Gothic" cottages, based on the illustrations in A.J. Downing's *Cottage Residences* (1842). In the east these "cottages" could run to thirty rooms, but the style was also adopted for humbler dwellings in the Midwest.

Upjohn's Trinity Church, New York (1839–46) and Grace Church (1843–46) by James Renwick (1818–95) in the same city, were serious Gothic edifices, built for a sophisticated, wealthy urban congregation and influenced by the piety and archeological accuracy fostered by Pugin. However, by the middle of the 19th century, Americans were tired of being straightjacketed by pre-

United States Capitol, *Washington D.C.*
late 18th to mid-19th century
James Hoban (c.1762–1831), Benjamin Latrobe (1764–1820),
Thomas Ustick Waiter (1804–87) and others

In 1792 Thomas Jefferson launched a competition to find a suitable design for a Capitol Building of the United States. Ten designs were received but none were thought appropriate to the monumental nature of the building. In the following year a design was presented by Willik Thornton (1759–1828). This was found acceptable and adopted, but as Thornton had only amateur status as an architect, supervision of the technical aspects of construction was undertaken by James Hoban, the architect responsible for the design of the neighboring Presidential residence, now known as the White House. Hoban was originally assisted by the French architect Etienne Hallet, who was replaced in 1794 by the Englishman George Hadfield (1763–1826). Work proceeded slowly and Hadfield's intervention was found unsatisfactory. In 1803 Benjamin Latrobe took charge of the project at Jefferson's invitation. Two completed wings of the Capitol were burned by British troops in 1814. Latrobe started restoration work, but two years later he resigned and the responsibility for continuation fell to Charles Bulfinch. Bulfinch repaired the damaged wings and erected the central section and the dome. The many different hands in the project are reflected in the mixture of styles contributing to the exterior form of the building. A further change was made in 1855 when Thomas Ustick Walter redesigned the dome. This was constructed of wrought and cast iron, a relatively new building material that later supplied the basis of a new approach to architectural structures.

cise architectural styles and the rather stale elitist philosophies that accompanied them. A joyous eclecticism set in, the buildings produced often being on a very large scale, as banking or railway monopolies made great fortunes. But by far the most exciting developments in American architecture by 1850 were utilitarian – the bridges, railways, stations, factories that were taming the continent – and turning America rapidly into a major power.

The Nineteenth Century

From the French Revolution to the Year of Revolutions

The history of these sixty or more years is essentially bound up with efforts by the rest of Europe to limit, or repulse, aggressive French expansion. The world-wide importance of the shattering events in France from the fall of the Bastille in 1789 through the life of the new republic to the fall of Napoleon in 1815 put events in France and her actions outside her boundaries at the center of importance and interest. Every eye was focused on France, and she was seen as either a shining example or a dreadful warning to all of Western society.

In 1789 the political condition of France was in crisis, and her economic condition demanded urgent and strong action by the government. Louis XVI's weak absolutism was incapable of coping with these problems. Progress was not unthinkable, but it would have meant breaking up the archaic system of privileges and exemptions for the aristocracy, whose vested interests opposed change. Yet, strange as it may seem, the ideas of the Enlightenment were shared by both the aristocracy and the middle class of lawyers, manufacturers and businessmen. They were all men and women of the age of Voltaire (1695–1778), whose satire had pilloried the absurd institutions of the old system (the *ancien régime*) and debunked the polite Christianity of the 18th century. The independence of America from the British, and the setting up of a squirarchical, secular republic, seemed to all of them to offer the perfect model for a modern nation. The Colonists' struggle was effectively supported by the king of France and his army and navy, as well as being hailed by the bourgeois élite. However, more radical libertarian aspirations, in

Europe and America, still remained to be realized. The radical shift is incarnate in the career of the Englishman Tom Paine (1737–1809), who arrived in America with high republican fervor in 1774, contributed by his writings to upholding the morale of the American revolutionaries at a critical phase of the war, and then departed for Europe to become actively involved in the French Revolution.

By 1789, economic pressures had forced the pace. The king had to agree to convoking a historic form of parliament, called the States-General, which had been dormant since 1615, long before the time of the great Louis XIV. It met on 1 May 1789 and rapidly took matters into its own hands. Within seven weeks it had turned itself into a National Assembly. Amid the rush of measures which ensued – such as the formal renunciation of the nobility's privileges on August 4th and the Declaration of the Rights of Man on August 26th – there occurred what is probably the most famous symbolic landmark in modern history: the Fall of the Bastille on July 14th, 1789.

The Revolution moved into radical top gear in the summer of 1792, when the wars broke out which were to continue one way or another for the next 23 years. Prussia invaded France, a republic was declared, atrocities in Paris and the provinces mounted up, the king and queen were guillotined, and by June 1793 power passed to the extreme faction led by Maximilien de Robespierre (1758–94). Their rule is known as The Terror and lasted just longer than a year, ending when their own heads fell on the guillotine. The remaining story of the French Revolution – the five-year period known as the Directoire – seems like a comparatively calm interlude to prepare for the dramatic ascent of General Napoleon

Bonaparte.

The force of the French Revolution had at first been directed against home targets – the stifling injustices of the old system. Once the European powers had tried, in 1792, to intervene and save the royal family, the Revolution turned outward. Animated by a missionary ardor, the revolutionaries challenged the political and religious values of the whole continent – and in so doing, knew that there were many thousands of foreign ears already attuned to their message.

In the year of the Bastille, Napoleon Bonaparte was a lieutenant of twenty. In 1799, when he returned from Egypt, seized power and made himself First Consul, he was a famous general. War with the powers began almost at once, and from that moment, French expansion was incorporated in Napoleon's extraordinary genius. He claimed to be the heir and executor of the Revolution and that in his person the highest ideals of the men of 1789 were represented. The contrary view – that Napoleon was the executioner of the Revolution and that in him its achievements were betrayed – is no less believable. Be that as it may, while it was as an autocrat that he ruled, it was to the incandescent spirit of the Revolution that he appealed in his soldiers when he needed them to march for him to war across the length and breadth of Europe.

Numerous Italians, Germans, Swiss, Poles and others believed Napoleon and his rhetoric at first. Dreams of national liberation and unity seemed to be on the point of realization. The abolition of crusty old feudal domains was promised. The reform of laws, constitutions and economies was the order of the day. Republics with Classical names (the Batavian, for the Dutch; the Helvetic, for the Swiss; the Cis-alpine, for the Piedmontese; the

Tuscan, for the Florentines; the Parthenopaean, even, for the Neapolitans) were inaugurated in the wake of his armies. Hopes were raised that were all too soon to turn sour. The infant republics were simply annexed to a bloated French empire, established in 1804.

Disillusion with Napoleon, once the idol of European nationalists and liberals (one recalls Beethoven's original dedication of the *Eroica Symphony*, composed in 1804, to Napoleon, and its erasure in disgust at his assumption of the title of Emperor), produced in reaction a search for traditional and ethnic values in opposition to the French. For Napoleon, the most disastrous example of this was the result of his ill-judged occupation of Spain and Portugal in 1807. Instead of welcoming the removal of an absurd, corrupt and fossilized court, the Spanish rallied to all their most antiquated, die-hard elements in order to fight the hated French invader. Sustained by the money and armies of Protestant Britain, the Catholic guerillas fought on. The so-called Peninsular War dragged on its costly course continuously until the last days of the Napoleonic Empire in 1813.

Perhaps Napoleon might have survived his Spanish disasters, and even have achieved some kind of stalemate with the British in spite of losing the struggle for naval supremacy to them at Trafalgar in 1805, had it not been for his Russian gamble. The roll-call of Napoleon's victories over his opponents in Europe – Austerlitz in 1805, Jena in 1806, Friedland in 1807, Wagram in 1809 – is drowned by the echoes of the calamity of 1812 and the retreat from Moscow. But he did not go down in one. His army may have melted away in the Russian forests, lukewarm allies may have deserted him, the Germans may have finally risen against him (Battle of Leipzig,

1813), yet he still fought a brilliant defensive campaign back to the heart of France. Exiled by his enemies to the island of Elba, he bounced back in 1815 for one last fling which collapsed on the battlefield of Waterloo, ending the First Empire in ignominy, while sowing the seeds for a Napoleonic revival some forty years later under his nephew, Louis-Napoleon, better known as Napoleon III (1851–70).

The old order in Europe appeared to be re-established, the old values restored. The pope was back in Rome, the Bourbons were on the thrones of France and Naples. But the Holy Roman Empire (abolished in 1806) was gone for good. Above all, minds had been deeply changed. Politically, the reactionaries were on top everywhere. The Austrian empire and the German states were "managed" for the next twenty years by Metternich, whose foreign policy was directed to maintaining a concert of Austria with the most reactionary powers, Russia and Prussia. Even the British government, while gradually distancing itself from affairs on the Continent, was engaged in a fight against trade unionism (the "Tolpuddle Martyrs", 1833) and electoral reform (Chartism, 1836–48). Wellington, the chief destroyer of Napoleon's military power, was called in as Prime Minister in 1828–30 to hold the conservative ranks, but by 1832 the Reform Act had opened the way to the modernization and eventual democratization of the British political system.

The year 1830 brought into the open the social and political changes which had been taking place behind the backs of the post-Napoleonic régimes in France and the rest of Europe. An uprising in Paris chased out the unbending Charles X and replaced him by the more liberally-inclined "citizen-king", Louis-Philippe. The new monarch's tastes and personality seemed to bring him close to the bourgeoisie

which was now coming into its own. Industrialization – pioneered by the British – was beginning in France and was appearing in Belgium and western Germany. The population was on the increase everywhere.

The political lessons of the French Revolution – including the Terror, the régime of Napoleon and the reaction that set in after his fall in 1815 – were being pondered by a new generation of intellectuals. On the right, Joseph de Maistre (1755–1821), following Edmund Burke, had sought for an alternative to the rationalistic principles which had inspired the leaders and propagandists of the Revolution in 1789, and found it in mankind's instinctive need for faith and order. On the left, the early pioneers of socialism and anarchism were defining their utopian ideas for the perfect society. Robert Owen (1771–1858) and William Godwin (1756–1836) in Britain, Charles Fourier (1722–1837) and Henri de Saint-Simon (1760–1825) in France paved the way for more radical and aggressive thinkers such as Louis-Auguste Blanqui (1805–81) and Louis Blanc (1811–82). Marx, Engels and Proudhon, the revolutionary writers of later years, were still young men who had not yet made a name for themselves.

Fifteen years of post-Napoleonic peace had accustomed people to relatively good times. The agitation in Britain, it is true, for the reform of Parliament had encouraged the supporters of liberalism and constitutionalism in other countries, but the nearest to real violence had been some ill-fated risings in Italy organized by the nationalist secret society, the Carbonari. The uprisings in Paris of March 1830 therefore sent a shock-wave through Europe. The mainly Catholic and partly French-speaking southern region of the Kingdom of the Netherlands split from the mainly Protestant

north to form the new state of Belgium. In November, the Poles staged a new insurrection, crushed by Russian arms within a year. Violence returned to politics. The Chartist movement in Britain (1838–50), although orderly, showed the political muscle of a mass movement, while agrarian discontent found an outlet in the "Captain Swing" and "Rebecca" riots of 1843.

A powerful combination of forces was building up which was to rock the establishments of Europe in 1848. Nationalists, from Ireland to the Balkans, were gathering strength among the young and the lesser bourgeoisie for the rights of self-determination, national identity and emancipation. Liberals in every European country drew on the support of the successful bourgeoisie and professional classes in their struggle to curb arbitrary government by means of constitutions and representative government, and to free commerce and industry from restrictions which favored the out-of-date privileges of the land-owning class. Socialists and anarchists were being armed with a body of increasingly sophisticated political and economic theory to guide their strategies and enhance their standing among progressive intellectuals and writers.

When the floor finally gave way under the post-Napoleonic structure of Europe that had been set up at the Congress of Vienna (1814–15) and presided over by Klemens von Metternich (1773–1859) as Austrian Chancellor, it was symbolic that he was one of the first to fall. Because of the risings in Paris and other capitals 1848 is often called The Year of Revolutions. It could as justly be remembered as the Year of Failed Revolutions.

The year began with a revolt in Sicily to which the king of Naples yielded with the grant of a constitution on January 12th. In February, Paris rose against Louis-Philippe and March saw the extraordinary climax when the streets came out against the court or the occupying power in Vienna, Berlin, Munich, Rome, Milan and Venice. Everywhere in Europe there was the excitement of change in the air that month. In Munich King Ludwig I had to abdicate and flee with his mistress, the dancer Lola Montez. The Hungarian parliament began to break the country's ties with Austria. The Czechs struck out for their autonomy. King Carlo Alberto of Sardinia-Piedmont led his army against the Austrian occupation forces in the name of Italian liberation. Even early Victorian London was affected: on April 10th a great Chartist demonstration on Kennington Common heard a radical speech by Fergus O'Connor. In May, an all-German parliament met at Frankfurt. The hopes of liberals and the horrors of conservatives electrified the ruling classes of Europe.

The ferment began to enter a new phase. The Italian war against the Austrians was soon lost. In many capitals, conservatives and reactionaries resumed control – in Vienna, in December, they replaced the doddering emperor with the eighteen-year-old Franz Josef I (who was to survive as a symbol of Habsburg conservatism until the middle of World War I). The enthusiasm of nationalists and liberals in Germany petered out ineffectively in the Frankfurt parliament. The only real fight left came from the republicans under Giuseppe Mazzini (1805–72) in Rome and the Hungarians under Lajos Kossuth (1802–94).

In November, the pope had abandoned Rome where a republic was then installed. Mazzini took over the defense of the city against French troops sent to restore the pope, and was not ousted until June 1849. In Hungary, the struggle ended in August, with the country being brought back under the control of Vienna by Russian armies sent in by the tsar to support his Habsburg fellow-monarch.

At the end of 1849 it could seem to the revolutionaries that all was failure, but the reassertion of much of traditional authority could no longer mean a return to the past. The decline of Austria was becoming apparent as the nationalism of the non-German peoples clashed with the Vienna government and with German nationalism inside the Austrian Empire. New men – the leaders of the later 19th century – were already mapping out their paths to power. In France, Louis Napoleon (1808–73) was elected president of the restored Republic in November 1848 – three years later he assumed the succession of the first Emperor of the French as Napoleon III. In Germany, the extreme right-wing Prussian member of parliament Otto von Bismarck (1815–98), was struggling to gain the political influence which was to become his, also three years later. Looking ahead we see these events already pointing to the modern, industrialized and imperialistic Europe of 1870. In that year the triumphant Bismarck, now chancellor of a German Reich united by Prussia, destroyed the empire of Napoleon III and so, indirectly, generated the French Third Republic of 1871–1940.

In the cultural and intellectual life of the West, the year 1848 made a deep impression. The *Communist Manifesto*, written by Karl Marx and Friedrich Engels in 1847, was published at the very beginning of 1848, and marks the official starting point of that seam of socialist doctrine on which the present-day Soviet Union and its satellites are founded. Major creative figures of Western music and literature were carried along on the revolutionary tide: Giuseppe Verdi composed patriotic melodies in *I Lombardi* and *Ernani* which brought audiences to their feet in opera houses throughout Italy in protest against

Austrian oppression, while as a result of a late left-wing flare-up in Dresden in May 1849, in which Richard Wagner was implicated, the German composer became a refugee abroad for twelve years.

Artistically, the first half of the 19th century could not make up its mind. Several different attitudes expressing themselves in ways that have attracted labels to themselves. Artistic labels are usually a convenient way of grouping strong strands in the complexity of artistic philosophies; attitudes harden into identifiable interpretations of the web of social ideas and feelings that make up a period. The French Revolution and its aftermath overturned so many established situations that uncertainty was common, and the herd instinct caused individuals with common ideas or programs to group together for strength, or for artists with sympathetic views to associate with.

Following, and arising out the Neoclassicism which had been the fashion from just prior to the French Revolution through to the end of the Napoleonic period, there appeared successively or concurrently in European art the movements named Romanticism, Romantic Classicism, Naturalism, Revivalism and Realism. During this time the role the artist had achieved in society by the 18th century had changed, the old aristocratic patronage never recovered, subject matter was widened as acceptance of previously despised subjects was allowed while much of the formerly admired categories declined, and a new relationship between the notions of what art might be and what it had been were developed.

From the 1850s onward, a new course was set which led directly to the present day.

Romanticism

As with Baroque and Rococo the origin of the label "Romantic" is difficult to establish. "Romantic" was used throughout the 18th century by English writers to describe wild scenery with mountains and waterfalls. The notion of Romantic art did not appear until the beginning of the 19th century in Germany to describe medieval subject matter used by a painter as "romances".

The optimism and scepticism, together with the belief in reason found in the 18th century, had rested on fragile foundations. The tragic Lisbon earthquake of 1755 could neither be predicted nor controlled by science and why would a good God allow such senseless destruction? And, if man was capable of reasoned moral action, he was also capable of great evil. The Romantics discovered the attraction of pitting oneself against God. Much Romantic painting was inspired by poetry which was felt to be the supreme art. The passion and wildness of Shakespeare's Tragedies was newly appreciated and Alderman Boydell in London commissioned a Shakespeare Gallery. The demonic energy of Goethe's *Faust* was brilliantly interpreted by the Romantic artist Delacroix in his angular and shadowy lithographs of 1828. The human brain had aspects that reason itself could not control; both Henry Fuseli's (1741–1825) *The Nightmare* (1782), with its sense of physical helplessness, and Goya's *The Sleep of Reason Brings Forth Monsters* make this same point.

In his *Critique of Pure Reason* (1781) and *Critique of Practical Reason* (1788), Immanuel Kant argued that the mind does not reflect the image of the things about it as Locke in the 17th century had assumed; rather, impressions from the outside world are molded in accordance with a set of ideas present in the mind before any experience, and which are indicative of a higher unknowable

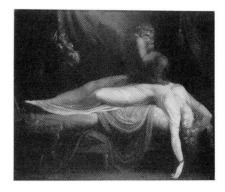

The Nightmare, *1782*
Henry Fuseli (1741–1825)
Oil on canvas
Kunsthaus, Zürich

The Sleep of Reason produces Monsters
Francisco Jose de Goya y Lucientes
(1746–1828)
Etching from The Caprices, published 1799

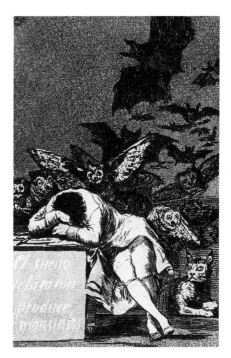

reality. This suggestion of a terrifying gap between the world and the mind and the power of the mind to reorganize sensations is behind what is a general Romantic anxiety. At its finest Romantic landscape may express this state of mind: Thomas Girtin's (1775–1802) *Storiths Heights* (1802) is imbued with desolation, Caspar David Friedrich's (1774–1840) *Meadows Before Griefswald* (c. 1825) with a quiet joy.

The turmoil of Romantic thought was a reflection of events in which hope and despair, enthusiasm and apathy alternated as man searched on for the freedom initiated by the Enlightenment. Liberalism in France turned into the Terror, the dominance of Napoleon and the glory and barbarism of the Napoleonic Wars. After Napoleon's defeat in 1815 the Bourbons were restored but the principle that bad governments could be replaced by revolution had been established, and nationalism and desire for reform led to uprisings all over Europe in 1830 and 1848. Especially in France where most of the fighting was done by the lower classes although the bourgeoise benefited from the moderate reforms made by new regimes, as they did in England with the bloodless extension of the franchise in 1832. By 1850 official art was reflecting the tastes of a confident and enriched middle class, calling for realism.

But in the brief peace of 1802 there is an undeniable fascination with Napoleon – a romantic, satanic figure who accomplished great feats at the expense of thousands. In France the cult of Napoleon, so well served by Jacques Louis David (1748·1825), was evident also in his pupil Antoine-Jean Gros (1771–1835) who was part of Napoleon's entourage and witnessed his campaigns. *The Plague House at Jaffa* (1804) shows Napoleon visiting a military hospital. The fact that large numbers of the army on the eastern

campaigns succumbed to disease says little for Napoleon's planning, but this is forgotten in the Emperor's heroism in touching the sore plague victim as his aids nervously cover their faces. Napoleon is willing to face not only conventional danger in battle, which can be prepared for, but the invisible threat of disease and there is in this a hint of the miraculous powers of great office.

The sense of the ambiguity of war – glory for one man and misery for thousands – is apparent in *Napoleon at Eylau* (1808), but is most striking for the realism of the frozen corpses.

The aspirations of Napoleonic France are apparent in Théodore Géricault's (1791–1824) optimistic, vigorous *Officer of the Imperial Guard* (1812). Géricault's *Wounded Cuirassier Leaving the Battlefield* of 1814 is on the same large scale, not strikingly different in mood. France was defeated; the Cuirassier glances back courageously but full of foreboding, the horse shies. Tragedy is expressed by gloomy colors, bold shadows, broad, flat areas of paint, cold light.

Géricault's defeated hero is still monumentalized and idealized, there is a desperate need to believe in something and for the post-Napoleonic artist the problem was one of replacing revolutionary and military subjects in a time of dull, ignoble peace. So insistent was the Romantic desire to create that artists like James Barry (1741–1806) bankrupted themselves with huge historical works that no one would buy. In 1816 Géricault left for Rome to escape the scandal of an affair with his young aunt-by-marriage. Géricault's great work was *The Raft of the Medusa*, exhibited at the Salon of 1819; once again a new interpretation of the history picture, combining sensationalism and political comment.

The upheavals of the Napoleonic Wars contributed to the darkness of the Romantic temperament – the swelling

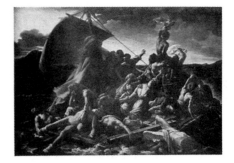

The Raft of the Medusa, *1819*
Théodore Géricault (1781–1824)
Oil on canvas 193×296in (491×716cm)
The Louvre, Paris

Géricault's desire to make a major painting of a contemporary event resulted in this large, striking canvas showing the survivor's raft of the wrecked ship Medusa, *sunk in 1816. The 149 people who took to the raft were at first taken in tow by lifeboats, but the cables snapped and the raft was left adrift on the sea for twelve days before a rescue could be effected. Only fifteen people remained alive at the end of the ordeal. The wreck caused a political scandal – responsibility was ascribed to the incompetence of the ship's captain and it was said that he had obtained his post only through the favor of the Bourbon regime. Two survivors, the ship's doctor and engineer, tried to sue for compensation, but the only result was that they were dismissed from government service. Géricault chose to depict an incident that emphasized the suffering of the victims – a moment of false hope caused by a passing ship that failed to sight the raft. He entered wholeheartedly upon his preparations for the painting. He interviewed survivors, including the doctor, Sauvigny, and constructed a model of the raft. To be sure that he could truly represent the physical horror he made studies of corpses in the Paris morgue, some of them mutilated. He hired a studio specially to house the large canvas while he worked. Delacroix saw the work in progress and described how it excited him so much that he ran wildly down the street. Another viewer remarked "How it seems to jut out from the canvas, especially in the parts still only sketched in . . . It was just like a fragment of sculpture in the preliminary stage."*

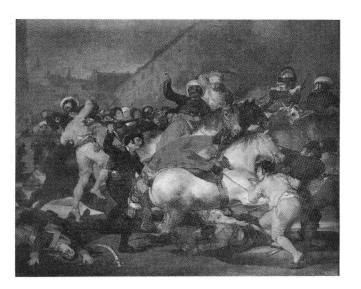

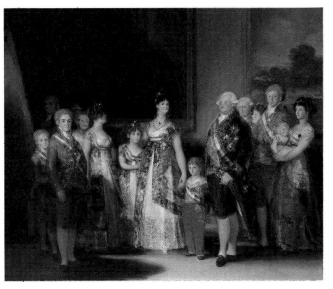

The Charge of the Mamelukes, *1814*
Francisco Goya y Lucientes (1746–1828)
Oil on canvas 106½×138in (266×345cm)
Prado, Madrid

Between 1808 and 1814 Goya executed a series of etchings taken from the Peninsular War and entitled Los desastres de la guerra. *Then, in 1814, he produced, on the same theme, his only two historical paintings done in oils, this one, known also as* The Second of May, 1808, *and* The Executions of May 3, 1808. *Both paintings take as their theme not only the eternal cruelty of war, but, more specifically, the dawning age of liberal nationalism (in 1808 the Spanish patriots were fighting for their national freedom against the French). And both paintings, containing, as they do, the pictorial representation of nearly every human emotion and presenting the narrative with a powerful, dramatic tension (achieved to a remarkable degree by the force of sheer brushwork), announce the arrival of Romanticism five years before Géricault painted* The Raft of the Medusa.

of insanity, violence, supernatural evils, the fall of empires; a pessimism summed up by the English painter Turner in an epic poem, *The Fallacies of Hope*, fragments of which accompanied his paintings. He depicted Hannibal overwhelmed by the elements on the eve of triumph, and both the rise and decadence of the Carthaginian Empire. It was a warning to over-confident Britain, developing rapidly as an industrial nation, as well as a comment on the fate of France. This apocalyptic trend in Turner was taken up by John Martin (1789–1854). Like "hellfire" preaching, Martin's Biblical pictures such as *The Great Day of His Wrath*, had an aspect of grisly entertainment, thus making Martin's fortune in exhibition fees.

The universal tragedy of war was expressed most fiercely in the work of Francisco Goya (1746–1828). Like many Spanish intellectuals, Goya welcomed the French Revolution and its challenge to autocratic governments, hoping that it would lead to reform of Spain's fossilized institutions. But when Napoleonic armies invaded Spain in 1808, a fierce nationalist movement

Charles IV and His Family, *1800*
Francisco de Goya y Lucientes (1746–1828)
Oil on canvas 110×132in (280×336cm)
Prado, Madrid

After several years of association with the Spanish court, Goya was named First Court Painter in 1799 and in the following year was commissioned to produce this portrait of the royal family. It is a traditionally formal figure composition, but the painter's inclusion of a self-portrait behind the royal group is a shadowy reference to Velasquez's Las Meninas *(1656), in which the painter and his canvas occupy a prominent place at the left of the painting beside his subjects, as if the whole were seen in large mirror. In Goya's painting the King and Queen are centrally placed with their youngest children. The figure in blue at left is the heir to the throne, later Ferdinand VII. The curious pose of the lady next to him, her head turned away from the viewer, has given rise to two different explanations. One is that she represents the consort of the future king, as yet unchosen. Another, less respectful, explanation has it that Goya found one of the King's daughters so plain that he could not bear to paint her face. The portrait is sometimes regarded as satirical, since Goya obviously made no attempt to flatter in his portrayal of the unprepossessing royal couple. However, there is no evidence that the King was displeased, but while Goya continued to paint for the court he never again portrayed the King or Queen.*

resisted them. Goya's *2nd of May 1808* (1814) shows the massacre by Spaniards, of Napoleons hated mamelukes, soldiers from Egypt, the *3rd of May* shows the reprisals, the execution of 5000 Spaniards. The free, glittering paint technique that Goya lavished upon royal portraits such as the *Family of Charles IV* (1800), serves to heighten the pathos of the *3rd of May*. Corpses mingle with the sandy soil, dead with no hope of salvation; a white-shirted figure is posed at the last moment of life, not heroic, merely bewildered. Goya's series of etchings *The Disasters of War* (1810–13, published 1863) do not take sides, simply show the hideousness of everybody's actions. An earlier series, the *Caprichos*, hoped to shame society out of its follies; in the *Disasters* Goya acknowledges that the Age of Reason is dead.

Romantic Classicism

Apart from the expression of violent events by strong color and free brushwork evident in the artists just discussed, there was a counter-current which sought to respond to Romantic tensions, while retaining some Neoclassical techniques – linear qualities, cool coloring, precise finish. In art as in other areas, innovation and tradition came into conflict during the period. The period of revolution and social turmoil of the late 18th century was followed by a return to solutions in various forms of monarchy – Napoleon, the Bourbons, Louis-Philippe, Napoleon III – for many felt that there was a validity in the Classical tradition that could face modern challenges, a resilience also believed to be present in the ancient institution of monarchy. Old solutions and arguments were also apparent in art.

In France the *Poussiniste-Rubéniste* argument developed into a battle of real rancor between the Classicists and the Romantics. Ingres, leader of the

Classical faction, deeply disapproved of Delacroix the Romantic. Conflicting Romantic/Classical tendencies could exist in a single artist. Keats is regarded as a Romantic poet, yet his emotionally charged poetry frequently interprets Classical themes.

Pierre Paul Prud'hon's (1758–1823) *Justice and Divine Vengeance Pursuing Crime* (1808, painted for the Palais de Justice), has robustly Neoclassical figures and striking use of an idealized nude, but the exploration of guilt is Romantic. Although the murderer is pursued by allegorical figures, his glance at the peaceful corpse suggests that the vengeance will be of his own creating, in perpetual unquietness of mind. The theme of the guilt-ridden criminal, to be both abhorred and pitied, was explored in Byron's *Cain*, in tales of the Wandering Jew and in James Hogg's *Private Memoirs and Confessions of a Justified Sinner*.

In the work of David's pupil, Anne-Louis Girodet-Trioson (1767–1824), Romantic Classicism was pushed to extremes, so much so that David, usually tolerant of the divergent interests of his students, declared that he did not understand it. Girodet's *Endymion* (1791) returns to Classical mythology, abandoned as frivolous since the Rococo, and simply concentrates on the creation of a beautiful mood, made the more unearthly by Mannerist distortions of the nudes in uneven light.

The Classical tradition of French art was most strongly upheld by Jean-Auguste-Dominique Ingres (1780–1867), who, after winning the Prix de Rome, was virtually in exile in that city from 1807 to 1824. One of the new breed of intensely status-conscious artists and determined to succeed through official channels, he returned to dominate the Academy and set a pattern for Academic thinking which continued until the Impressionists. However sterile Classicism may have

become in the hands of Ingres's followers, this was not the case with his own work. Ingres's early work was influenced by the Primitives, a group within David's studio who felt that his Classicism had not gone far enough. They wanted to return to even "purer" sources, such as archaic Greek vase painting, and admired the terse, linear expressiveness of John Flaxman (1755–1826). From this appreciation of archaic art Ingres learned how to make physical distortion convey emotion. In *Venus Wounded by Diomedes* (c.1805), the horses are taken wholesale from vasepaintings, but Venus, smooth, concise in outline, a creation of subtle, complementary curves, is a Classical figure overlaid with Ingres's own highly individual sensuousness. The curved neck and rubbery, expressive limbs reappear in *Jupiter and Thetis* (1811). The painting was criticized as "Gothic" (still a derisive term for flatness, "incorrect" drawing, and primitivism), but the distortion enhances the disturbing quality of the eroticism. The return to mythology has not the robust, good-humored eroticism of the Rococo, but a fever of sexual tension.

Ingres's women are not real people but superb animals charged with sexual energy, dangerous and beguiling. Nineteenth century society put women on pedestals and divided them sharply into domestic goddesses or "fallen women", making eroticism a dangerous area for the artist. Both Ingres and Delacroix found that the most acceptable way to express eroticism was by reference to Eastern societies where women were merely sexual objects; hence Ingres's odalisques and Delacroix's bored, sultry *Women of Algiers* (1834), painted after his trip to Morocco in 1832.

In this the artists reflected a taste for the exotic that grew steadily in the first half of the century. British colonization of India was well established,

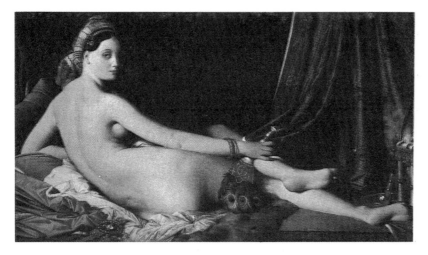

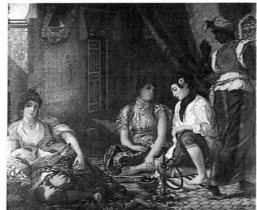

and imported products accustomed Westerners to an art that was neither European nor Classical. Brightly colored, intricately patterned shawls may have inspired the bold textile experiments of the Victorians, who could achieve such effects quickly and cheaply by machinery. "Indian" buildings like Sezincote (1803) helped contribute to the atmosphere of architectural eclecticism.

From India attention turned to Africa, which at the beginning of the 19th century was virgin territory for European colonization and power struggles. Napoleon's ambitions in north Africa were foiled, but Delacroix went to Algiers as part of a diplomatic mission; French influence there was beginning. It became as natural to travel to the Middle East in the 19th century as it had been to travel to Rome in the 18th century. For the Romantics, Islamic societies contained elements to which they could respond – color, violence, sensuousness – behavior which as the 19th century progressed was increasingly stifled in European manners, and could only be enjoyed vicariously, through alien cultures and history: hence the popularity of Browning's evocation of Renaissance Italy. The growth of Christian

The Grande Odalisque, *1814*
Jean Auguste Dominique Ingres (1780–1867)
Oil on canvas 36×63½in (91×162cm)
The Louvre, Paris

As a pupil of David, Ingres won the Prix de Rome in 1801 but was prevented from traveling immediately to Italy because the government delayed release of the money due to him. This was not supplied until 1806 and Ingres then departed for Rome, initially for a period of four years. When the prize money ran out he was able to obtain enough commissioned work to stay in Italy and in fact remained there until 1824. The Grande Odalisque was commissioned by Queen Caroline of Naples, as a pendant to a picture already in her possession, a nude study entitled Sleepers of Naples. *Ingres visited Naples in 1814 to carry out portraits of the Queen and her family. The completed Odalisque was never delivered to the Queen, but it was later exhibited at the Paris Salon of 1819, where the critics received it with hostility and incomprehension. The figure closely resembles a nude study for David's portrait of* Madame Recamier. *As a pupil and assistant to David, Ingres had himself worked on details of that painting. In the Odalisque he took liberties with anatomical details in order to create the linear rhythms of the composition, and it was this aspect that particularly aroused the wrath of his critics.*

Women of Algiers, *1834*
Eugène Delacroix (1798–1863)
Oil on canvas 70.9×90.2in (180×229cm)
The Louvre, Paris

This painting, exhibited at the Salon of 1834, was constructed from sketches made by Delacroix during a trip to Algiers in 1832. Through the influence of a friend, Delacroix had been able to gain access to a harem and by the report of those who accompanied him "seemed as though intoxicated by what he saw". The fascination of the subject for the painter is reflected in his remark "This is woman as I understand her, not thrown into the life of the world, but withdrawn at its heart, as its most secret, delicious and moving fulfilment". Using watercolour and pencil, Delacroix made sketches of the scene, including extensive verbal notes relating to color and the patterns of light and shade. He persuaded some of the women to sit briefly for portrait studies, here included in the final work. On departure, he took with him examples of slippers, scarves and other items that he could carry away as reference for details. Information used for the final painting was also taken from sketches made previously for Massacre at Chios *(1824). The theme of the cloistered women obviously interested him deeply and he returned to a reworking of* Women of Algiers *in 1848–9 and a single figure study,* Woman of Algiers in Her Apartment, *in 1857.*

piety in Victorian England, allied with a typically 19th century interest in archeological accuracy, led to traveling in Palestine. When the Pre-Raphaelite William Holman Hunt (1827–1910) painted *The Scapegoat* (1856), he spent agonized months in the Palestine desert by the Dead Sea evoking the correct state of mind through experience of physical conditions. (The scapegoat bore the guilt of the world in Biblical terms and Hunt wanted to paint Biblical scenes with accurate local settings).

In subject-matter, Ingres, like his age, was eclectic. The previous century's discovery that the Classical age had a living spirit that could be recaptured was extended in the 19th century to embrace any period, but particularly the Middle Ages. Historical tableaux suddenly became important, people wanted to know what it was like to be *there*. Ingres imagined Raphael with his mistress, Leonardo dying in the arms of Francis I, St Joan; all with great attention to historical exactitude, incorporating exquisite still-lifes of furniture, all with smooth, even modeling and gentle light. The desire to make history comprehensible, immediate, above all sympathetic, was also apparent in those who painted in the Romantic manner of loose brushwork and fiery color, like the English artists Sir David Wilkie (1785–1841) and Richard Bonington (1802–28). Bonington's *Henry IV Receiving the Spanish Ambassador* was inspired by Ingres's picture of 1817, although very different in handling. Both paintings show Henry playing with his children – an accessible, popular, humane King, the ideal of the bourgeois voter in a constitutional monarchy, while the stunned envoy of autocratic Spain looks on.

Ingres also drew on the sweet, balanced Classicism of Raphael, whose work captivated him while in Italy, as

Géricault had been powerfully impressed by the work of Michelangelo. The individual portraits in his subject paintings are striking, and Ingres's greatest achievement was perhaps in his depiction of contemporaries. The power of his portraits lies not in subtle interpretation of character, but in an intense response to physical beauty and a reduction of it to simple, perfectly balanced forms. In contrast to English portraiture, like that of Gainsborough and Sir Thomas Lawrence (1769–1830), where the heads are intensely alive and accessories generalized, Ingres's portrait of Madame Devaucay (1807) had the head reduced to beautiful essentials, flawless as a Raphael Madonna, while the textures of beads,

fan and shawl are transfixing in their realism. If Ingres's early portraits – sophisticated, elegant, a trifle pompous – are half-beguiled by Italian indolence, his late portraits equally reveal the ruling class of the Second Empire (Napoleon III was proclaimed Emperor in 1852): complacent immensely rich, heads of financial empires like the Rothschilds. European society was by this time controlled by owners of multinational industrial and banking interests, less interested in nationalism than profit, eager consumers of luxuries. Ingres's realism sharpens to cope with women so hung with jewels and textiles of intricate modern manufacture that they look like icons of materialism, but retain a feminine mystique nonetheless.

Portrait of Madame Moitessier, *1851*
Jean Auguste Dominique Ingres (1780–1867)
Oil on canvas 58¾×40in (146.7×100.3cm)
The Louvre, Paris

Ingres was first approached to paint a portrait of Madame Moitessier in 1844. Though he declined initially, he subsequently met the subject and agreed to the commission. He started work in 1844 on a painting showing Madame Moitessier seated with her young daughter Caroline by her side. Ingres found the child's behavior increasingly impossible; she was left out of the composition and the portrait was then abandoned altogether. He was again reminded of his undertaking in 1851 and agreed to resume work. This time he quickly completed this formal, standing pose. He took some care to arrange the detail of the black clothing and studied arrangement of pink roses. Prior to this Ingres had been distracted from his work by grief and depression caused by the death of his wife in 1849. By 1851 he had begun to recover his spirits and in fact remarried in 1852. His connection with Madame Moitessier was not yet over. In 1856 he returned to the portrait showing the seated pose and reworked the composition, again leaving out the daughter, who was by this time no longer a child. The 1856 portrait (National Gallery, London) is less formal and more colorful, showing all the rich detail of the subject's floral gown.

The Beginnings of Realism

Realism and Naturalism are terms much used in connection with 19th century art. They express the age's interest in the physical appearance of the world, and the concern with how to set it down. Artists approached this in different ways: by painting in the open air; copying objects in minute detail; using loose, expressive brushwork to convey intangible qualities, like wind moving leaves. There was also a feeling that art should tell the truth about modern life, and take subjects from the experience of the rural or urban working class, who according to utilitarian philosophy were the most important section of the population because greatest in number. Generally speaking, Realism and Naturalism are interchangeable terms, but are sometimes used in a more specialized way by art historians. In the latter case, Naturalism refers to art which is concerned to capture the appearance of nature, while Realism has political overtones: faithfulness to outward appearance which drives home a social message, as in the work of Courbet.

The 19th century increasingly concentrated on the physical world: greater scientific understanding led to new inventions, the past lay buried in the ground to be systematically uncovered, looking at how people lived might lead to an improvement in social conditions, nature's laws could be uncovered by observation. Despite the genuine religious revivals of the early part of the century, real faith lay in science, and science cast doubts on Christianity. There was a tendency to see the arts as somehow scientific. George Eliot, an agnostic, regarded her novels, which show the interaction of different strata of society, as natural history; John Constable, certainly a devout Christian, saw landscape painting as a "branch of natural philosophy, of which pictures are but the experiments".

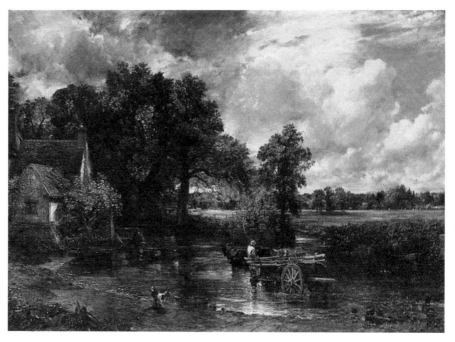

The Haywain, *1821*
John Constable (1776–1837)
Oil on canvas $51\frac{5}{8} \times 73$in (130×185cm)
The National Gallery, London

Science aimed to start without preconceptions and to prove things through observation and experiment. The first phase of Real)sm occurred in landscape painting, and tried to look at nature as it really was, not through artistic convention or tradition. For example, a Classical landscape was generally framed with trees on either side; Naturalist painters like Constable, Corot, the group who worked around Barbizon in France, and German Biedermieier artists preferred more open, random compositions. Strict compositional formulas had to some extent been abandoned by Romantic landscapists, but Naturalist painters eschewed stories set within landscape, like Turner's *Aeneas and the Sibyl*, and painted nature because it was there, and delighted the eye, not because a thunderstorm or gloomy woods could be made to symbolize human feeling. It was realized that calm fields and ordinary woods could be as interesting as sensational natural features, like mountains. John Constable (1776–1837)

A number of studies and at least two detailed oil sketches preceded the final version of this large composition, showing a view of the Stour near Flatford Mill. At the left is the house of Constable's friend Willy Lott, a favorite subject of the artist. In 1821 Constable was living in Hampstead in London, but the countryside of eastern England remained his major preoccupation and he could draw upon a large body of sketches and studies, supplementing his previous observations with occasional trips to Suffolk. The Haywain was probably conceived and executed within about five months during 1821 and in that same year was exhibited in the Royal Academy in London under the title Landscape – Noon. *With some reworking it was shown again at an exhibition of the British Institution, where it deeply impressed the French painter Géricault and was bought by a French art dealer. Constable suffered a lack of recognition in England throughout his career (he was not elected a full member of the Royal Academy until 1829) and* The Haywain *received far greater acclaim in France when it was shown at the Salon of 1824 and it was awarded a gold medal.*

went to the Lake District in England in 1806, but felt no affection for it; he preferred the flat East Anglian countryside where he had grown up, which carried associations of a happy childhood, and showed man in harmony with nature, but gently molding it by agriculture. Constable came from the conservative rural middle class, which abhorred industrialization and strongly resisted the Reform Bill of 1832; for them, extension of the franchise meant anarchy. Constable's paintings are not escapist in the way that Palmer's are, but they celebrate a way of life that many thought to be threatened – a reality worth preserving.

Constable's "science" and "experiment" lay in studying the changing face of nature and trying to make it real to his audience by expressing brushwork. A recent treatise had classified types of clouds, and Constable's cloud studies have notation of time of day, wind directions and cloud type; Constable wanted to understand and convey quite clearly what nature looked like at a particular moment. The 19th century was a time of expanding communications, scientific and historical knowledge. While large things, like distances, seemed to shrink, small things, like flowers, were discovered to be infinitely complex. Hence the validity of the artistic study in the 19th century; it was acceptable to make a picture out of a clump of flowers, or a patch of scrubby woodland without dramatic features.

The fundamental question of Naturalism was how physical reality should be conveyed. For Constable and Corot the problem was less one of minute description than capturing the effects of nature, which were "real" but difficult to convey in terms of paint. Constable's "snow" (flecks of white paint) intended to convey light glittering off every solid object. In his early work Jean-Baptiste-Camille Corot

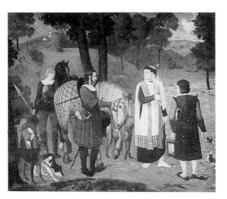

The Emperor Rudolf of Habsburg and the Priest, c.1809
Franz Pforr (1788–1812)
Oil on canvas 18 × 21½in (45.5 × 54.5cm)
Städel Institute, Frankfurt-am-Maine

Pforr was one of a group of six young German painters, of whom the leader was Friedrich Overbeck (1789–1869), called the Nazarenes (from their beards and long hair). They established a Guild of St Luke at Vienna in 1809 with the purpose of emulating the religious orthodoxy and communal spirit of the medieval brotherhood of St Luke. In 1810 they moved to Rome. In their paintings they sought to revive the representational purity of the early Renaissance, especially as they found it in the work of Perugino and the early Raphael. Their backward look to the Middle Ages links them to Romanticism and also, in England, to the Pre-Raphaelite Brotherhood, on whom they exerted a strong influence. Pforr's early death brought the first phase of the group's existence to an end, but it was strengthened by the recruitment of new painters, especially Peter Cornelius (1783–1867).

(1796–1875) saw objects as molded by light, so that solidity could only be conveyed by juxtaposing light and shade, abandoning the artistic convention that objects were bounded by lines, and instead building up a picture by color and brushstrokes – a vision that paved the way for the Impressionists.

The 19th century desire to pin down reality was approached rather differently by the Pre-Raphaelites and by William Powell Frith (1819–1909). Frith's genre paintings reflect the century's fascination with its own social make-up (evident also in the rise of the novel) and favorite pastimes – days on the beach, race meetings, railway journeys. Physical details are minutely described in bright, naturalistic colors; a cross-section of society is shown; large numbers of figures suggest the jumble, vitality and overpopulation of contemporary life. There is a desire to order this chaos by making the picture tell a story, or rather a series of loosely-interrelated incidents, which can be "read" rather like the complexity of a Dickens novel. Dickens's plots and Frith's compositions reflect on the idea, current in the mid-19th century, that the classes of society depend on each other: this gave impulse to education acts, provisions for better hygiene, and arguments against strikes in novels such as Mrs Gaskell's North and South:

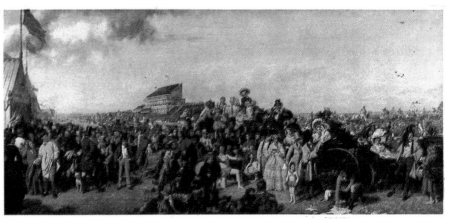

capitalists and workers stand or fall together.

In France around the mid-century Realism in art gained political import by referring specifically to the working class – the largest section of society and one that was becoming politically aware and capable of political manipulation. These Realists thought middle-class reality was unimportant, and to some extent Realism was associated with the unflinching depiction of misery, as in Zola's novels. The English Pre-Raphaelites also tackled the realities of lower class life. Dante Gabriele Rossetti (1828–82) and Holman Hunt (1827–1910) dealt with the problem of prostitution – rife in Victorian society with its sexual hypocrisy, and simply an easier living for poor women than working in factories.

The Pre-Raphaelites aimed to make art vivid to a modern audience without necessarily always depicting "the heroism of modern life" seen by Baudelaire as the century's most important subject. Like the Nazarenes, they looked to art before Raphael because it was charged with Christian fervor and observed objects with great clarity; in this

The Derby Day, *1858*
William Frith (1819–1909)
Oil on canvas 40×88in (100×220cm)
Tate Gallery, London

Frith was one of the scores of mid-19th-century painters, especially in England and France, who produced genre paintings forgotten today except by sentimental patriots for whom they retain a local nostalgic charm. Frith poured scorn on the suggestion that he was influenced by the Pre-Raphaelites, but in his three most famous genre canvases, this one, Ramsgate Sands *(1854) and* The Railway Station *(1862) he took the method of reproducing narrative scenes with fidelity to detail to an almost photographic extreme never attempted even by Holman Hunt. Frith enjoyed great commercial success in the 1850s and 1860s, partly thanks to the example set by Queen Victoria, who bought* Ramsgate Sands *in 1854.*

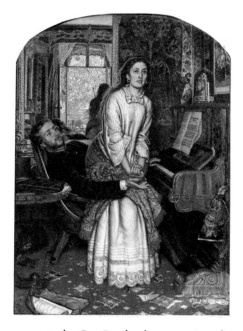

respect the Pre-Raphaelites continued the medieval revival. They took subjects from the Bible and literature, making them "real" (almost surreal) by obsessive description of physical objects: the same approach was applied to landscape. Nineteenth century manufacturing technique allowed artifacts to be made easily; until the invention of photography, a picture still required hard work as well as imagination. Holman Hunt took up the idea of craftsmanship, of physical as well as spiritual struggle in medieval painting, by inventing the very slow technique of painting on a wet white ground, rather like frescoeing wet plaster. If any mistakes were made, the whole area had to be repainted. The process was so arduous that Millais and Rossetti gave it up in favor of ordinary oil techniques. However, to the northern industrialists who collected Pre-Raphaelite paintings in the second half of the 19th century, the attraction lay in the evidence of hard work (the virtue by which they had gained their wealth); they also appreciated the clear narrative and delight in material objects. Ruskin's brilliant commentary on Hunt's *Awakening Conscience*

The Awakening Conscience, *1853*
William Holman Hunt (1827–1910)
Oil on canvas 30½×44½in (77.5×112.5cm)
Tate Gallery, London

Pre-Raphaelitism was one expression of the Romantic yearning for a golden past, for the more "natural" civilization of the Middle Ages rather than the early Industrial Age. Hunt, Millais and Dante Gabriel Rossetti formed the nucleus of the Pre-Raphaelite Brotherhood. It was formed in 1848 and lasted as a group until about 1853. It was Rossetti who first used the initials "PRB" on a painting, the Girlhood of Mary Virgin *(1848). The movement was dedicated to the twin artistic ends, only seemingly paradoxical, of social realism and Pre-Raphaelite manner. With its somewhat cloying religiosity (especially in the work of Hunt), its heroic pursuit of naturalistic detail, and its revival of the method of painting on a wet white ground to achieve a luminosity evocative of stained-glass, the movement was subjected to a torrent of cheap abuse. Its strengths were its feeling for the decorative use of color and its concern to draw from nature and for these, as well as for its ethical and religious impulse, it received the full approval of the arch-priest of High Victorian criticism, John Ruskin.*

(1852) demonstrated how the artist had used objects of furniture to point the moral, at once reveling in the age's materiality and ironically undercutting it: "there is not a single object in all that room – common, modern vulgar ... but it becomes tragical, if rightly read. That furniture so carefully painted, even to the last vein of the rosewood – is there nothing to be learned from that terrible luster of it, from its fatal newness; nothing there that has the old thoughts of home upon it, or that is ever to become a part of home?"

The art academies

In the 19th century the art academy reached the zenith of its power, especially in France. In the 18th century, academy exhibitions had become a social event. This continued in the following century as power shifted into the hands of the middle classes,

who preferred to buy pictures in the open market of the exhibition hall, rather than privately by commission. In this way they could confer with other viewers and read the opinions of newspaper art critics. The exhibitions were reviewed with increasing lavishness and the concept of the art expert who would guide taste was firmly established: Denis Diderot reached a large upper and middle-class audience with his *salons* in the 18th century, John Ruskin became a virtual dictator of the arts in the 19th century.

Thus for an artist to sell pictures, it was essential for his work to be shown at the Academy, and preferable for him to have attended an academy school. Because perhaps all institutions tend to become fossilized, the English and French Academies of the 19th century still taught in the manner set out at their founding, with emphasis on drawing the human figure from casts of Classical statues, and nude life studies. The hierarchy of subjects (in which history painting stood highest) was in theory upheld. Although academy exhibitions had room for lesser genres, the bulk of public attention (and reviews) were given to large, highly finished history pictures – hence the largeness of scale of Géricault's and Delacroix's Salon pieces. Around the middle of the century in France, when the impetus of Romanticism had burned itself out, it was no longer possible to paint modern battle scenes. Middle-of-the-road artists like Paul Delaroche (1797–1856) and Jean-Léon Gerôme (1824–1904) enlarged genre scenes of exotic or historical subjects. These pictures have very little serious content, but pleased a public which equated grandeur of thought with large areas of canvas, and spiritual truth with minute copying of outward appearances (a trick which ensured the success in England of Sir John Everett Millais's [1829–96] later work). Other painters,

The Garden of the Hesperides
Frederic Leighton (1830–96) – later
Oil on canvas
Lady Lever Art Gallery, Port Sunlight, England

The Princes in the Tower, *1831*
Paul Delaroche (1797–1856)
Oil on canvas 16⅝ × 19¾in (42 × 50cm)
Wallace Collection, London

Romans in Decline, *1847*
Thomas Couture (1815–79)
Oil on canvas
Louvre, Paris

The three paintings represent the varieties of academic painting in France and England during the middle years of the 19th century. Lord Leighton was a painter of great facility of draftsmanship, he studied widely in Europe and exhibited in the Royal Academy in 1855 with great success. In 1879 he became president of the Academy, and in later life took up sculpture.

One of the most successful of the 19th-century history painters, Delaroche exhibited in the salons of 1822 and became a great success. He completed a number of paintings of historical episodes, often from English history.

Couture studied with Baron Gros and Paul Delaroche, and like Delaroche he had early success, culminating in this, his most famous painting. He was appointed court painter to Napoleon III, although his principal claim to fame is perhaps that he was the teacher of Manet.

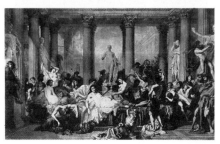

like Thomas Couture (1815–79) and Adolphe William Bougereau (1825–1905) in France; Frederick Leighton (1930–96), Albert Moore (1841–93) and Lawrence Alma-Tadema (1836–1912) in England, continued to interpret Classical subjects. Late 19th century academic Classicism had a genuine feeling for the Classical world, but it was used as a starting point for fantasies on mythology (an excuse for the glorification of idealized but fleshy nudes, as in Bougereau's *Nymphs and Satyr* (1873), or for purely decorative arrangements of figures, as in the work of Albert Moore. This kind of painting reflected a society that was pleasure-loving, indifferent to Christianity, wealthy, and yet which preferred to forget the sources of its wealth in industrial energy and squalor. Such academic painting had a rich appreciation of color and handling of paint, but its soullessness angered avant-garde artists to whom "academic" became a term of derision. The rigid screening process by which the French Academy controlled entry to its exhibitions was seen to undermine the artist's right to paint as he wished. In 1863 the *Salon des Refusés* organized by the Impressionists blew apart French Academic autonomy by allowing exhibition space to all-comers.

The Artist in Society

During the Middle Ages the artist was a craftsman laborer working as a paid employee and we have seen how his role changed during the Renaissance into a cultured and cultivated member of society courted and revered. It is also true that this role continued during the 18th century since the patronage of the Renaissance based upon the privileged, educated, aristocratic or royal continued through the 17th and 18th century. Although in some places and at some times a different situation obtained the artist remained as an accepted and valued member of the community. In 17th century Holland for instance, the rich and solid merchants provided the painters with an opportunity to examine their society from its depths of despair in the works of Adriaen van Ostade or Adriaen Brouwer, to the elegant security of the merchant drawing rooms.

Such acceptance of the artist depended on the security of wealth and privilege of patronage however it may have been gained. The artist was permitted to criticize or to fawn without threat to the established order.

But in the Romantic period in the early 19th century there was a widening rift between the sensitive artist and the new society. The momentous trauma of the Revolution in France had changed more than the nature of government. It had alerted the world to something to which the masters of society had given little attention – the numerical power of the general populace. All kings sat a little less securely on their thrones after the Revolution, the aristocracy looked at their servants and employers of labor looked at their workers with a new caution. To add to the religious reformation there were those who discerned the imperative need for social reform; they did not have far to look for many intolerable tyrannies. Slavery, child labor and virtual serfdom for the new industrial workers. The Industrial Revolution had provided cheaper goods and in doing so had drawn workers on the land into the dark and growing cities in housing and living conditions that were known to be scandalous – but then great fortunes were being made and until the Revolution it was assumed that the role of the workers was, if complaining, to work. The social reformers set about ameliorating the horrific conditions.

The artists felt keenly the situation and responded by identifying in their art the human implications of what was happening and realized too that there was a new audience for their work – the despised proletariat. Of course the process took time and its real arrival is signaled by the bourgeois art of the Impressionist.

However this anticipates events and the first division is well characterized by the attitudes of the artist-poet William Blake. Blake perceived at an early stage what the 19th century gradually discovered: that the Industrial Revolution forced upon men monotonous tasks that destroyed bodies and brains. Blake's contrast between "dark satanic mills" and "England's green and pleasant land" is unbearably poignant.

In his early drawings and poems Blake praised the French and American Revolutions and attacked social evils such as slavery (the *Little Black Boy* is one of the most effective protest poems ever written, and highly emotive lobbying of this kind was to lead Britain to abolish slavery in the 1830s). Later, however, Blake retreated into the world of imagination, where conflicts were played out in mythological dramas of his own devising. As if in reaction to England's increasing materialism Blake extended the boundaries of the imagination so that he saw no distinction between the physical and the imaginary. He claimed to have drawn his

Satan Arousing the Rebel Angels, *1808*
William Blake (1757–1827)
Ink and watercolor 20⅜ × 15½in
(51.8 × 39.3cm)
The Victoria and Albert Museum, London

In 1801 Blake received his first commission for illustrations to John Milton's Paradise Lost *and commenced work on a theme that occupied him frequently during the next fifteen years of his career. The original commission came from the Reverend Joseph Thomas of Epsom, but this drawing of* Satan Arousing the Rebel Angels *was completed in 1808 for Thomas Butts, a chief clerk of the war office in London, who was a good friend and conscientious patron to Blake for many years. Their association arose in part from a common commitment to the ideas of Swedish scientist and mystic Emanuel Swedenborg. Blake later rejected this path, while Butts remained a follower of Swedenborg, but this did not interfere with their friendship. Blake is unusual in the history of art for being equally well known as poet and painter. His choice of mystical and visionary themes, highly stylized personal manner and employment of graphic techniques in his major works set him apart from his contemporaries. He was able to make a living through his training as an engraver and by a certain amount of commissioned work but he also privately published books of his own poems, engraving the text and hand coloring the work.*

"visionary heads" from life; those watching saw him sketching from what to Blake was a model, to the onlookers thin air.

Rather a different, but likewise uneasy relationship to society was that of Eugène Delacroix (1798–1863). Delacroix was capable of commenting on contemporary events, as in *Liberty Leading the People*, which commemorated the fighting on the Paris barricades in the Revolution of 1830, after the failure of the restored Bourbon Dynasty under Charles X, and barricades were erected all over Paris. The Revolution lasted only three days (known as *les trois glorieuses*) but forced Charles to abdicate. The Revolution to the Parisians was the beginning of a new age under the "citizen King" Louis Philip, and the painting was bought by the government to be hastily stowed away in case it should give counter factions ideas. Delacoix also produced *Greece at Missolonghi* (1827). The female personification of Greece is not expiring (as is often said) after heavy defeat by the Turks in the Greek War of Independence (1821–29), but appealing to Europe to help her. In this picture Delacroix perfectly caught the spirit of his times. The Greek War of Independence, like the Spanish Civil War of the 20th century, was one of those emotive causes that united all liberals and prompted grand gestures, such as Byron's volunteering to fight for Greece, and his subsequent death. Like the opposition to slavery, it produced a glow of self-righteousness but was comfortably far away. In Delacroix's painting Greece is shown in a mixture of Classical and modern Greek dress.

Despite this engagement with popular causes, there was much in Delacroix's art that remained aloof. His fighting beasts, abductions and Sardanapalus indifferently watching the slaughter of his human possessions, point more to the acting out of private fantasy. Bright color and loose brushwork expressed the violence of his subjects (a violence, however private, that found an echo in the breast of his spectators), but Delacroix also experimented with color for its own sake, for example in deliberately juxtaposing complementary colors. He observed that the shadows on a yellowish skin were violet, and that red cloth had green shadows – looking at the worked not in terms of human interest, but simply of physical make-up. This was very different from the demand for storytelling of the 19th century public, although it did reflect the century's concern with science. Delacroix never abandoned "stories" (or at least Romantic evocations of mood), but his color experiments paved the way for the objectivity of the Impressionists, and widened the gap between the way in which the artist and the ordinary man perceived.

The discovery of nature

The origins of the English mastery of landscape painting lie in the 18th century, despite the continuing enthusiasm for Classical civilization. Unlike their French counterparts collected at Versailles, the English aristocracy spent much of the year on their country estates, personally supervising agriculture and enjoying country sports. They were thus aware of nature as actuality, and as the 18th century advanced, were increasingly likely to buy landscapes – particularly if, as in Francis Wheatley's (1747–1801), they showed a suitably sentimentalized and docile peasantry. There was also a strong 18th century tradition of British traveling, which alerted people to the range of possible landscape views: the grand tour for the very wealthy, England (toward the end of the century) for the middle classes. Better roads at home and abroad made traveling less hazardous, with more time to enjoy the

The Death of Sardanapalus, *1827*
Eugène Delacroix (1798–1863)
Oil on canvas 154×195in (392×496cm)
The Louvre, Paris

Delacroix drew the theme of this painting from a poem by Byron. Besieged in his palace, Sardanapalus, the king of Nineveh, prepares to die rather than be captured, and orders the slaughter of his entire entourage, wives, servants and even horses. In fact, Byron's poem does not supply this bloodthirsty detail and it is thought that Delacroix elaborated the theme from knowledge picked up from his own travels and possibly from the study of ancient Etruscan art. The ruins of Nineveh were discovered in 1842, so Delacroix's visualization considerably precedes the possibility of real reference to the time and place of the event. The composition was developed through many preparatory drawings and sketches. It was exhibited in the Salon of 1827, one of two pictures added to the ten by Delacroix already on display when it was decided to extend the exhibition into 1828. The painting was much criticized by both the public and the art establishment; the officer in charge of assigning state patronage to artists told Delacroix that he would be required to "change his manner" if interested in obtaining commissions. Delacroix's response was that he would adhere to his own manner "though the earth and stars were on the other side". He felt the criticism was unfair: in his own assessment he appreciated both the success and failure of his efforts, ". . . if there are things that I could wish improved, there are a good many others that I think myself happy to have done."

scenery. Scotland was opened up after the rebellion of 1745, Scots Jacobite against the English, when a network of roads was built to allow the military to police the country (much as for the same reasons the Romans had built their road network). Likewise Europe became more accessible in the 19th century through the road building for Napoleonic and other armies; and the advent of railroads presented landscape faster, in greater variety than ever before.

In England the use of watercolor derived from the 17th and early 18th century practice of making speedy drawings for military purposes. The portable equipment was useful for making drawings on more pleasurable journeys. By the end of the 18th century feelings that could not be contained within the framework of a Classical history picture – nostalgia, vague unease, yearning for freedom – were often expressed through landscape painting. Watercolor was a particularly appropriate medium, because of its associations of intimacy and the spontaneity with which natural effects could be captured. In both watercolor and oil Romantic energy, sensationalism and delight in using physical settings to express mood meant that hitherto ignored aspects of landscape were focused upon. Nostalgia for the past led to the inclusion of Gothic ruins in paintings. Awe at the energy and vastness of nature, which was quite indifferent to man, yet seemed a symbol of the vastness of his own imagination, was common to northern European Romanticism. It can be seen in Joseph Anton Koch's (1768–1839) thunderous waterfalls and John Robert Cozens's (1752–97) hazy mountains.

As has been seen in the work of Wright of Derby, the Industrial Revolution at first seemed an appropriate and optimistic subject for art, and indeed remained so in popular prints

(and later photographs). For the late 18th century landscapist Philippe-Jacques de Loutherbourg (1740–1812), subjects like *Coalbrookdale by Night* (1801) provided sensational effects and reflected public optimism in industrial advance, an excited sense that man was molding his environment and outdoing even nature in "special effects".

Nor did Joseph Mallord William Turner (1775–1851) eschew industrial scenes. He was interested in effects – whether made by nature, as in mist rising from the river at Norham Castle, or by man, as in the smoky trail from the tug pulling the Téméraire. Although celebrated as a landscapist, there is a feeling for contemporary life at the core of many of Turner's pictures. He depicts an England of maritime strength whose ruling class bought Dutch pictures, associating themselves with the seagoing, mercantile, Protestant Dutch; of burgeoning smoky cities, lingering rural customs, rich and visible history. Yet the landscape is not subordinated to mankind, as it is in Devis's backdrops for the landed gentry; rather, people are enveloped in the atmosphere of nature, semi-dissolved by it. Man cannot be separated from his environment and in Turner it is frequently a hostile environment – his people are at the mercy of the sea, avalanches, even the life-giving sun. The Enlightenment destroyed the belief in a God-ordered universe with man at the center of nature, and instead put humanity's destiny in its own hands. The failure of rational tenets to build a better society led the Romantics to turn to things outside man – but chaos and hostility lurked there too.

A desire to extend the bounds of experience is typically Romantic; Turner did this by exploring atmosphere and dissolving the form of things in the natural world. In his "color beginnings", areas of color stand for objects,

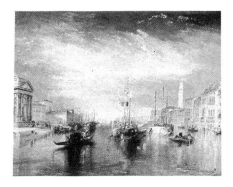

Venice: the Grand Canal, *1840*
Joseph Mallord William Turner (1775–1851)
Watercolor and ink 8 × 12⅜in
(21.5×31.5cm)
The Ashmolean Museum, Oxford, England

Turner made a life-long habit of traveling in England and Europe and would constantly sketch details of landscape and architecture in the places he visited. Venice and Switzerland were favorite locations and he made a number of trips to Italy after his first in 1819. Turner was not a good correspondent, nor did he keep diaries of his impressions during his travels, but his notebooks and sketches form a comprehensive pictorial record of his interests. Some of the Italian sketches formed the basis of illustrations and engravings, and many were used in the development of large painted compositions; but his watercolors also stand as important works in their own right. Over the years Turner used that medium frequently in his progressive investigations of the effects of color and light in nature.

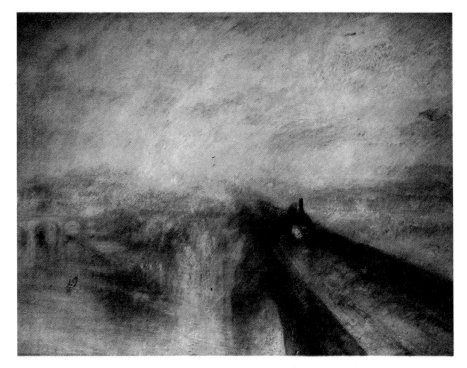

**Rain, Steam and Speed – the Great
Western Railway,** *1844*
Joseph Mallord William Turner (1775–1851)
Oil on canvas 35¾×48in (91×122cm)
The National Gallery, London

*Critics of Turner's later works often
ridiculed his style; his* Snowstorm *of 1842,
for example, was dismissed as "soapsuds
and whitewash", although Turner had
witnessed the storm while lashed to the
mast of a ship and nearly lost his life in the
attempt to observe reality.* Rain, Steam and
Speed *was also based on his acute
observation of an actual scene. A friend of
the art critic John Ruskin, who had
championed Turner's work in his* Modern
Painters, *published the previous year, was
able to describe the origin of the work.
Lady Simon had been traveling by rail from
Exeter to London and in the same
compartment was an ageing gentleman,
unknown to her. As the train passed
through a large town, he asked her
permission to lower the window and stood
for several minutes with his head and
shoulders thrust into the torrential rain
outside; he then sank back into his seat and
closed his eyes. On seeing the painting at
exhibition Lady Simon realized that the man
in the carriage had been Turner himself.*

The Cross in the Mountains, c.*1820*
Caspar David Friedrich (1774–1840)
Oil on canvas

*This painting is typical of themes that appear
in Friedrich's work, where a ruined abbey,
desolate forest and religious symbols are
inter-mixed into a romantic oppressive
atmosphere. Friedrich himself complained of
lassitude and the lack of desire to paint and
the mystical and haunted air in his paintings
reveals his withdrawn attitude. Friedrich
wrote "the artist should not only paint what
he sees before him, but also what he sees in
himself. If however, he sees nothing within
him, he should also refrain from painting
what he sees". All Friedrich's work suggests
a strong preocupation with his own
inner self.*

so composition and mood are achieved
without making forms explicit. How-
ever much pleasure we take in these
today for their own sake, for Turner
they were only beginnings – the captur-
ing of emotional response to a land-
scape, upon which form was worked
up in later drawings. In exhibited pic-
tures Turner usually put in enough
detail of objects to satisfy a society that
was obsessed with "finish" in art; they
equated finish with hard work and
"money's worth" for the buyer. Much
of Turner's work was after all topo-
graphical (concerned with "the por-
traiture of places"), however much he
presented familiar scenes in new atmos-
pheric light. In the 19th century the
public appetite for topographical and
other prints was insatiable; middle
class buyers regarded them as both
artistic and educational. Artists did not
need to work from the commission of
one patron, but could produce work
speculatively and live by the proceeds
of engraving. Thus to an extent they
were freer to follow their own subject-
matter; though there was the tyranny
of mass middle-class taste as against
that of single aristocrat. Turner built

up a considerable fortune which in his later years allowed him to remain aloof from public opinion. His contemporaries could make little of his freely-painted later work ("pictures of nothing, and very like" said Hazlitt even earlier). Yet *Rain, Steam and Speed* (1844) is a brilliant evocation of the excitement of the Railway Age, when people learned for the first time what it was like to see landscape very fast, blurred not detailed; George Eliot bewailed the demise of coach travel in *Felix Holt* (1866).

By the 1820s, when industrialization in England was already well advanced, nature and landscape painting could offer escape. In the 18th century writings of Thomson and Rousseau, man was encouraged to avoid the corruptions of society by living in the country. Artists like Samuel Palmer (1805–81) fled to the country to avoid the urban blight caused by industrialization, and many of the middle classes journeyed with him, if only in spirit. Palmer, like his mentor Blake, was not country born and saw rural England in idyllic terms – the atmosphere of man working within harmonious nature of Virgil's *Pastorals,* which Blake exquisitely illustrated (1820). English Romantic artists felt that they must separate themselves from the "great world" to produce sincere art, rather as the religious of the Middle Ages lived in separate communities to concentrate on God. Palmer's rural idyll was particularly fragile, and thus the more precious: hatred of machinery which destroyed rural crafts and jobs, inadequate food supplies, and agitation for the extension of the franchise, led to rural as well as city violence in these years.

In Germany the rôle of nature in spiritual expression was felt equally deeply, but the art produced in response was stylistically different from that in England. The German landscape of course looked quite different from that of England; fewer cultivated fields, like those depicted by Palmer and John Linnell (1792–1882); acres of virgin pine forest. Germany, like France, developed industry in the 19th century, but industrialization did not proceed at such a rate as in England, and in both countries the economy remained chiefly agricultural.

The German temperament inclines to philosophical analysis and use of symbolism in art. Nineteenth century Germany did not have such a strong tradition of naturalistic watercolor landscape or topographical painting as Britain, and German Romantic landscape appears more intense, less informal than its British counterpart. The work of Caspar David Friedrich (1774–1840) is a case in point. In contrast to Turner's expression of nature's grandeur and terror by blurring forms and abandoning naturalistic color, Friedrich approached nature in the utmost detail, with very crisp, formal compositions. He however avoided the disturbing clutter that the Pre-Raphaelites produced when they set down everything they saw, because he was concerned to convey an intense spiritual mood. The forms of nature were outward symbols of a religious state of mind. Friedrich was of his age in being able to express religious exaltation best through depictions of nature – free from "organized religion", especially abhorrent to the Protestant mind, and more so to the Romantic, with his distrust of authority. Friedrich painted an altarpiece for Count Thun's private chapel at Tetschen (1808), which consists simply of a mountain Crucifix catching the glow of the setting sun, the source of light being hidden from the spectator by tree-clad rocks in the foreground. The scene is both realistic, and symbolic of Christ's mediation between God and man, as we see the Crucifix bathed in light, but not the sun directly. There is a sense of unbearable yearning, characteristic particularly of German Romanticism. The wayside cross, which becomes a re-enactment of the Crucifixion in a northern setting, was a familiar object in the German landscape, and indicative of a simple, folkloric, rural faith that survived there, whereas in England by the beginning of the 19th century religion was largely a matter of social observance, rather than profound conviction.

German intellectuals were leaders in the expression and definition of Romanticism, and there was considerable interchange between artists and literary men, natural in a country which had always placed stress on ideas and education. One of the most ambitious intended fusions of idea, symbol, nature and art was the *Times of Day* (c.1803) project of Philip Otto Runge (1777–1810), like Friedrich a north German Protestant trained at the Copenhagen Academy. Large paintings of *Morning, Midday, Evening* and *Night* were to be displayed in a special Gothic building, where poetry would be recited by Ludwig Tieck to music by Ludwig Berger. The project was never realized, but the object was to create a *Gesamtkunstwerk* ("total art work") which went far beyond the total art work of south German Rococo churches, which combined visual arts only. The idea of fusing different arts was characteristic of European Romanticism generally. Whereas the 18th century defined and compartmentalized, social upheavals of the early 19th century resulted in the breaking down of barriers, including the traditional ones between the arts. Hence the concern of Romantic music with visual qualities, like the dancing peasants of Beethoven's *Pastoral Symphony*, and the rise of opera, a mixture of spectacle, play and music, which culminated in Wagner's late Romantic "music-dramas".

Revivalism

The 19th century was both acutely conscious of its place in history and obsessed by history generally. It both projected its own feelings on to historical personages, as is shown in historical genre painting, and increasing concern for correct chronology in the historical styles. Alexandre Lenoir's (1762–1839) medieval Museum of French Monuments and the Classical Glyptothek, Munich, display art as a progression. It was realized that history stretched back a great deal further than had previously been considered; age succeeding age could be viewed in the fossils of geological strata, shattering the belief that a date could be set for the Creation. In the second half of the century Marx stood back from events sufficiently to predict how political movements would progress: though having observed the flux of history, he made the now evident mistake of saying that proletarian revolution would usher in a Golden Age, after which all change would cease.

Although in a sense there was more history available than ever before, the early 19th century was dominated by its fascination with medievalism, and particularly with its northern manifestation, Gothic. This was largely because three northern nations – Britain, France and Germany – grew in power, political rivalry, and national consciousness during the period, and each claimed Gothic as their own invention (whereas in fact it was a particularly homogeneous international movement).

In Germany Gothic was regarded as the style which had united the German states in the medieval period and could do so again; during the Napoleonic Wars it represented the opposite of the Classicism adopted by the hated French. When Napoleon invaded Germany in 1806 there was a strong nationalistic resistance and many German liberals hoped that from this might be welded a new German democracy. By 1814 Napoleon was defeated and Classicism to some extent replaced medievalism, especially in militaristic Prussia, where it seemed better capable of reflecting the empire-building ambitions of the leaders.

Despite the failure of liberal aspirations, medievalism continued to be used in Germany as a symbol of national pride, pugnacity, artistic tradition and craftsmanship. A German folklore was also apparent in the fairytale paintings of Moritz von Schwind (1804–71) and Adrian Ludwig Richter (1803–84). It led moreover to a revival of woodcut for book illustration. The medium had associations of popular art, which appealed to the democratic tendencies of the 19th century, but had also been a vehicle for genius in the work of Dürer.

So deeply embedded was Classical learning and Italian art in northern cultures that the north-south dichotomy had somehow to be reconciled, to achieve art of new moral and religious intensity. The Nazarenes blended the style of the great period of German painting, the 15th century, that of Dürer, with elements of Italian painting before Raphael – a time which they felt had been concerned with simple faith and the true observation of nature in flat, bright colors and linear techniques. Franz Pforr (1788–1812) and Friedrich Overbeck (1789–1869) founded the Brotherhood of St Luke (the patron saint of painters) at Vienna in 1809 and extended the idea of the monastic apartness of the artist by moving to Rome in 1810. It was there that their secular-monastic group, living an austere life, dressing in quasi-medieval fashion, became known as the Nazarenes. In 1813 Overbeck converted to Catholicism; for intellectuals all over Europe, the Catholic church offered a refuge for souls troubled by the collapse of the En-

Strawberry Hill, *Twickenham, Surrey, remodelled 1750–53*
Horace Walpole (1717–97)

Fonthill Abbey, *1796–1807*
James Wyatt (1746–1813)

The Gothic Revival of the second half of the 18th century, however much it may have pointed to Romanticism and been a foretaste of the true 19th-century Gothic Revival, cared little for the real forms of Gothic architecture. It sought rather to exploit certain features of medieval architecture – pinnacles, pointed arches, assymetrical composition – to satisfy the need which some men felt for the picturesque. Strawberry Hill, a villa bought by Walpole in 1747, was Gothicised in a deliberate attempt to get away from the monotonous regularity of the prevailing Palladianism of the age. Fonthill Abbey, designed for the London eccentric, William Beckford, was even more the fulfilment of a fantasy. It was a true folly, built to be a ruin – and it duly (although not in keeping with Beckford's intentions) collapsed in 1807. "One must have taste to be sensible of the beauties of Grecian architecture," Walpole allowed: "one only wants passion to feel Gothic."

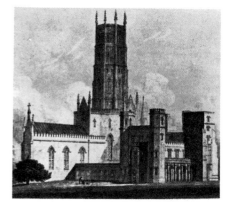

lightenment. The Nazarenes straggled back to Germany after Pforr's death and encouraged a revival of Biblical painting in medieval dress; they even, as a spiritual as well as an artistic challenge, mastered the medieval technique of fresco.

Gothic revival in England had parallels to that in Germany. As in Germany, there were many surviving Gothic buildings associated with national pride and kept in the public consciousness by the drawings of picturesque travelers. Horace Walpole's house near London called "Strawberry Hill" was a playful Gothic alternative to Palladianism. At the beginning of the 19th century Gothic provided a new means of expression for a newly rich commercial class, which had little sympathy with the Classical tastes of long-established aristocracy. William Beckford's enormous wealth came from West Indian sugar plantations, and this largely spurious pedigree went right back to medieval kings. His house, "Fonthill" (1795–1807), though built by the Classically-trained architect James Wyatt (1747–1813), was far more convincing as a medieval edifice than "Strawberry Hill", although based on church rather than secular architecture.

This phase of conscious eccentricity was succeeded by archeological analysis of Gothic architecture: the labels for styles ("Early English", "Decorated" and "Perpendicular"), set down by Thomas Rickman in his book *Attempt to Discriminate the Styles of English Architecture* (1817), are still used. In Europe similar interest led to feasts of reconstruction. The medieval plans of the incomplete Cologne Cathedral were found, and the building finished. In France Eugène Viollet-le-Duc (1814–79) made a complete career out of medieval restoration, notably his work on Notre Dame.

As early as 1802 Châteaubriand in *The Spirit of Christianity* urged a return to the old religion as a way of healing France's divisions. The idea was taken up by Napoleon, who made peace with the pope and restored the Church, seeing in it a useful "opiate of the masses", another way of keeping order. But as in Germany, the sufferings of the Napoleonic period produced a genuine yearning for the comforts of religion.

In England the uncertainties of the early 19th century – economic fluctuation, pressures of growing population on food supplies, evils of industrial conditions – led likewise to religious revivalism. Protestant movements were linked with political radicalism and concentrated on the plight of the poor, but the English established Church also strove to put it house in order. The Oxford Movement connected spiritual renewal with a greater attention to ritual; some of its members moved right over to Rome, like John Newman, who later became a cardinal. Gothic architecture became the symbol of a purer, more intense era of religious faith, and as such was championed by the Catholic convert Augustus Welby Northmore Pugin (1812–52). Like Winckelmann and Ruskin, Pugin's success was the result of superbly impassioned rhetoric, but he argued that Gothic was functionally ideal for church building. Classical churches (useful as 18th century preaching boxes), said everything about paganism and nothing about Christianity. Gothic architecture imitated natural forms – the idea of rib vaulting was supposed to have come from interlocked tree branches – yet was "honest", in that all parts of its structure were visible (for example buttresses), and decoration arose from the structure (crockets looked elegant and were useful as counterweights to the side thrust of arches). Thus in his "functionalism" Pugin was really arguing for the Gothic that its associations created the ideal environment.

The Houses of Parliament, *1840–1867*
Sir Charles Barry (1795–1860) and Augustus Welby Pugin (1812–52)
Magnesian limestone, wood and cast iron
Westminster, London

A competition for a design for the new Houses of Parliament was set up after the original building was burned in 1834. The rules demanded that the new design should be of Elizabethan or Gothic style. Of the ninety-seven entries, all but six were Gothic and the proposal finally selected in 1836 was that of the architect Charles Barry. The design was not universally liked and its opponents went so far as to petition Parliament to overturn the decision, but it was agreed that the principle of competition must be upheld and that Barry had fairly won. The design follows a basic cruciform layout and Barry's own preference was for Classical styling. The complex Gothic exterior that gives the building its full character was the work of the expert medievalist Pugin, who was invited by Barry to design the ornamentation.

In 1834 the medieval Houses of Parliament burned down and Parliament, which increasingly controlled the lives of British citizens, seized the opportunity to build much larger premises – specifically in a style appropriate to British dignity, Gothic or Tudor. Sir Charles Barry's (1795–1860) design was given Perpendicular detailing by Pugin, and the "ancient" art of fresco was revived (disastrously) for interior decoration. In his own work, like St Augustine's, Ramsgate (1846), Pugin

followed medieval precept in plan as well as detail, and preferred "purer" Decorated (c.1250–1350) styles.

Pugin stressed how much Gothic stylistic associations created the character of a building; other architects realized this could apply to any period, and played a variation of notes accordingly. There was much 19th century public building, as it was a collectivist age – political decisions took place in assemblies, social life had a focal point in the theater, people gathered to hear lectures. Barry used the Renaissance Palazzo style, with its associations of wealth and learning, for the Travelers' (1829) and Reform Club (1837), as appropriate for urban gatherings of the ruling class, who met to discuss politics and art, and relax away from stifling domestic decorum. Charles Garnier (1825–98) made the Paris Opera House (1861–74) a bizarre Imperial palace, reminiscent of the lavishness of Roman entertainments. William Butterfield (1814–1900) produced a polychrome medieval style, simple and yet rich, for All Saints, Margaret Street, Keble College, Oxford and Rugby – an example of that great Victorian institution, the public school. In architecture of the mid 19th century anything went, provided it was rich enough in associations.

The Opéra, Paris, 1861–75
Jean-Louis-Charles Garnier (1825–98)

When the Empress Eugénie asked Garnier whether his new Opéra was in the style of Louis XIV, Louis XV or Louis XVI, he answered, "C'est du Napoléon III" ("It is of Napoleon III"). Between 1850 and 1870 Napoleon gave Paris a radical facelift that included wide boulevards, expansive squares, planted gardens and glittering public buildings. In 1857 he announced a competition for a new opera house. The competition was won by Garnier and eighteen years later the building was formally opened. In its opulent, elaborate, distorting mixture of Classicism and the neo-Baroque, the new building appealed to the uneducated taste of the prosperous, civic-proud bourgeosie that was asserting itself. One contemporary critic dismissed it as "looking like an overloaded sideboard." And, indeed, its most eye-catching feature, the vast, winding staircase, is, like the whole building, something of a fraud. For its lavish (some say garish) trappings in polychromic marble and onyx are not structural at all but mere hangings from a hidden steel framework – the coarse, vulgar materials of the new Industrial Age dressed up in the tasteful clothing of the past. Still, Paris is in Napoleon III's debt and Garnier's Opéra ranks, after the new Louvre, as the second marvel of his era.

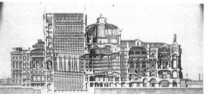

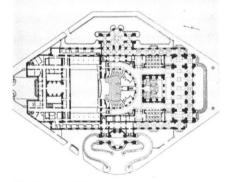

The Dance, 1865–69
Jean-Baptiste Carpeaux (1827–1875)
Stone
L'Opera, Paris

The Dance, commissioned for the façade of L'Opera in Paris, was the finest of these major works, though it was not well received and its uninhibited exuberance caused a public scandal.

Realism, Impressionism and the Industrial World

The 19th century does not move gradually like the 18th towards one great climax. Indeed, from our present perspective the French Revolution begins to resemble the first premature surge of an age that was to be shot through with progress, reaction and turmoil at every level. The rising force of the masses, the ruthless preservation of power by the bourgeoisie and the calls to reason, science and order were significant factors about the time of the French Revolution, and they in turn became increasingly pressing issues as the 19th century unfolded. The events of 1830, 1848 and 1870 have led to its apt description as the "century of revolutions". In each instance France was again the principal, although by no means the exclusive, focus of activity, pointing to its volatile position in the social network of Europe.

Yet it should be remembered that the status quo, despite huge resistance in France and elsewhere, remained essentially unchanged throughout the 19th century. Some countries even managed to avoid the specter of revolution altogether. Russia did so by lagging behind the times with a feudal system, and England took the opposite approach through advocating comparatively advanced, liberal reform. After 1789, in fact, any complete and lasting reversal in the political structure of a major European nation would not occur until 1917, although it was France probably more than any other country that expressed the mood of the times by appearing over and over again to reach the brink of just such upheaval.

The year 1848 was a microcosm of the century. Revolution spread from France to the rest of the continent on a massive scale and for a while it looked as if violent conflict would finally end the old regimes and give birth to new and lasting aspirations. Yet when a typical cycle of revolt – fleeting left-wing rule and brutal repression by conservative elements – was enacted, a familiar pattern was vindicated: regimes were restored and only aspirations abided. Nonetheless, 1848 endured as a potent symbol of rebellion and – outside of France – of patriotic fervor, which was continued in the nationalist struggles of emergent states such as Italy and Hungary. Other already independent countries such as Britain and Prussia sought military strength and empires, leaving France relatively free to fulfill a peculiarly energetic cultural role in Europe. One of the first and most vital expressions of that role was seen in the ascendancy of an entirely new artistic climate in the later 1840s that challenged the accepted conventions of both Classicism and Romanticism. The approach that this aesthetic revolution embodied is usually given the name of Realism.

Realism, meaning in simplest terms the translation of the outward appearances of reality into an artistic medium, has been an element of art from the very earliest time. Never before, however, did it include an entire movement, spanning different disciplines, which regarded the accurate depiction of reality as an end in itself. Belief in tangible facts now became absolute. The visible world was no longer, as it had been to a Van Eyck or Vermeer, a facade beyond which lay some greater truth. This major shift is closely connected to the changes in human thought that had been gathering momentum in European society from at least the advent of the French Revolution.

A vital lesson of that first revolt was that the world could be dramatically and directly changed by immediate action; there was no immutable hierarchy bequeathed from God through a monarch that could not be altered. While this was hardly a new discovery, it had neither been supported before by a rationalist philosophy nor demonstrated on such a wide and efficient scale. The revolutions of 1830 and 1848 made it brutally clear that the character of reality was very much a question of how it was controlled by whatever group or class held power over society.

At the same time in the first half of the century the extraordinary advances in science that the Industrial Revolution had inspired were accelerating at an unprecedented rate. The structure of matter was being determined by physicists such as Herman Helmholtz and James Joule; in natural science Charles Darwin seemed to have uncovered the laws through which humanity had originated; Karl Marx and other socialists believed that they, too, had revealed analogous forces behind the formation of society and in man's control over his own material destiny. Mechanical progress had turned manufacturing into the outcome of an objective industrial process, rather than of individual craft. Space itself was being conquered by the spread of the railway, the invention of the telegraph and the growing use of steamships. All of these innovations were directly or indirectly the result of the scientific grasp of reality and the scrutiny of material fact.

In the context of such changes it is not surprising that Romanticism – with its emphasis on subjective emotion, the spiritual and the exotic – was in decline by the end of the 1830s. Even Classicism, still alive as an official style in the art of the Academy and in evidence at the great social gathering of the annual Paris Salon, had a new and growing body of opponents by this time because its entire attitude was naturally based upon the antique and the ideal – not the present and the real. On the other hand, protest came from so fundamentally a romantic a temperament as the French poet Charles Baudelaire, who was now moved to exclaim about

the Salon of 1845 that the modern world, in all its detail, was worthy of artistic treatment: "It will be painting, true painting, which can extract from the life of today that which is epic and can make us understand . . . that we are great and poetic in our cravats and our polished boots."

Already, in fact, the "great" and "epic" spectacle of modern man in contemporary society was being depicted in the crowded panoramas of the social novel. In the psychological probing of writers such as Stendhal (the pseudonym of Marie Henri Beyle) and Gustave Flaubert, in the enormous family histories of Honoré de Balzac and slightly later Emile Zola, and, outside France, in the sprawling narratives of Charles Dickens and Leo Tolstoy we encounter the most sustained and searching manifestations of realism in literature. At their best these books scan amazingly diverse levels of contemporary life and the equally varied human types that it creates. Through artifice they fashioned an art that had the ring of truth, the feeling of a whole world experienced, studied and faithfully recorded.

In painting the growth of realism was similarly inseparable from an urge to show modern man and his conditions in an unadorned and direct manner. For Jean Francois Millet (1814–75), Honoré Daumier (1808–79) and, especially, Gustave Courbet (1819–77) the choice of subject was often no longer a question of inherited traditions, a desire to sanctify the present with some fantastic quality, as it had been predominantly to painters as different as David and Delacroix in the previous generation. Their art is probably among the first in European history to make an epic but realistic hero of the common laborer and his secular existence.

Millet's rural peasants, Daumier's urban proletariat and Courbet's provincials are partly a response to the gathering prominence that such classes had acquired in the social upheavals of recent French history. But they are also, above all, an expression of a new secularization in the attitude of the artist: these were simply the specimens most immediately available for his sympathetic or dispassionate study. The cartoons of Daumier show the artist as a commentator on every foible and twist in the day-to-day life of the nation. Courbet sought to include a cross-section of society in his consummatory masterpiece of 1855, *The Painter's Studio*. Intellectuals and artisans, the rag-pickers of the world and the bourgeoisie are all represented here; they are the human clay of Courbet's art. Whether a stimulus or threat to his vision, they are nonetheless the teeming mass who remain its focus. This need for comprehensiveness was basic to Courbet's outlook, as he wrote in his manifesto – one of the first of many in modern art – accompanying the Pavilion of Realism that he personally organized in 1855 as an alternative to the Salon: "To be able to represent the customs, the ideas, the appearance of my own evaluation; to be not only a painter but a man as well: in short, to create living art, that is my aim."

The lack of condescension and the sympathy that these three artists extended to their plebeian subject matter are impressive innovations. Millet and Daumier at times afford their humble figures the grandeur and monumentality that had formerly been reserved to the actors of mythological, religious and historical painting. The mourners of Courbet's *Burial at Ornans* (1850) perhaps hint at a recollection of the gods and citizens of the Parthenon frieze. These qualities, however, suggest the continuities of Realist art with tradition rather than with revolution.

To a greater extent than Millet or Daumier, Courbet now looks a peculiarly modern personality to us. Although he tended to equate realism, that is, artistic honesty, with social truth and democracy, he seems particularly relevant to our own century for his shifting allegiances. At one moment he is the man of the people, at the next a bohemian and poseur. He plays the self-conscious role of the artist to the hilt but then appears to sympathize with the cause of revolution. Such ambivalent positions are a foretaste of the engagement and alienation between which many modern artists have traced a difficult path.

The lasting effect of Courbet's work, and indeed of Realism in general, is one of an art dominated by the immediacy of the here-and-now. From the 1850s onward Realism quickly became a dominant mode in French painting and by the same time had emerged in the work of the Pre-Raphaelite Brotherhood in England. These artists attempted to bypass the overtly sophisticated High Renaissance models that they felt had been responsible for the dullness of the academic tradition in favor of the clarity of earlier Italian painting. Despite the Pre-Raphaelites choice of subject matter that included historical and moralizing themes, the sense of a deep fidelity to the material world still radiates from their work with its exact and tangible detail. In fact, even when Realism spread beyond Europe to the United States and was developed by painters such as Winslow Homer (1836–1910) and Thomas Eakins (1844–1916), its essential characteristics persisted in their determined, objective handling and the solid, palpable surfaces they created.

Only a deep-rooted need to capture something of the vitality and sprawl of life itself can explain why we encounter so many crowded, slightly awkward compositions in the art of the period. From the Pre-Raphaelite William Holman Hunt (1827–1910) and his densely-peopled depiction of the English laborer

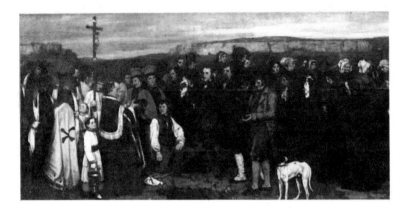

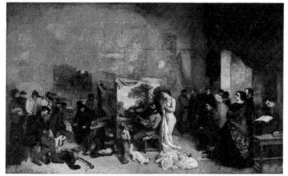

Funeral at Ornans, *1850*
Gustave Courbet (1819–77)
Oil on canvas 124×261in (314×663cm)
Louvre, Paris

The Painter's Studio, *1855*
Gustave Courbet (1819–77)
Oil on canvas 124×235in (361×598cm)
Louvre, Paris

Courbet submitted these large paintings to the jury of the International Exhibition at Paris in 1855 and both were rejected, whereupon he set up his own pavilion and exhibited forty-three paintings under the title "Le Réalisme". We know something of what he meant by the term: "The art of painting should consist only in the representation of objects which the artist can see and touch. No period should be reproduced except by its own artists. . . . It is for that reason that I reject history painting when applied to the past. History painting is essentially contemporary." He added that painting was "essentially a concrete art and can consist only of the representation of real and existing things." The Funeral at Ornans, *set, like many of his paintings, against the landscape of his native Ornans, gives us some idea of what his words mean,*

The Woodcutters, *1848*
Jean François Millet (1814–75)
Oil on canvas 22½×39in (57×81cm)
Victoria and Albert Museum, London

Following the Revolution in Paris in 1848 the Salon was declared open entry and every painting was hung. Millet's painting The Winnowers *won approval and he was given a state commission, he started work on a Biblical scene. The story goes that he abandoned this work on hearing a chance remark, "a man . . . who never paints anything but naked women", that brought him to realize the small basis of his reputation as an artist. He determined to give up his popular style and concentrate on subjects that he felt worthwhile. From then on he developed the composition of workers and peasants for which he is remembered. In 1849 Millet and his family left the city, where there was further political upheaval and an epidemic of cholera, to settle in the Barbizon, where he studied at first hand the rural life depicted in* The Gleaners *(1857) and* The Angelus *(1855–57).*

Prisoners from the Front, *1866*
Winslow Homer (1836–1910)
Oil on canvas 24×38in (61×96.5cm)
Metropolitan Museum of Art, New York

Northeaster, *1895*
Winslow Homer (1836–1910)
Oil on canvas 34½×50in (86×125cm)
Metropolitan Museum of Art, New York

These two paintings – the one done only four years after Homer first used oil paints, the other major work of his last period – reveal the distance that he traveled as a painter. The first has lingering traces of Homer's early career as a lithographer. Homer was at the front during the Civil War (1861–5) where he served as an illustrator for the New York magazine Harper's Weekly. *In its two-dimensional composition and lack of narrative drama,* Prisoners *introduced a new style into American genre painting. On a visit to England in 1881–2 he lived in a fishing village on the craggy North Sea coast, and from that date the strength and mystery of the sea became a recurrent theme in his paintings. When he returned to the United States he settled at a barren spar of land on the Maine coast. There he painted his final, epic works.*

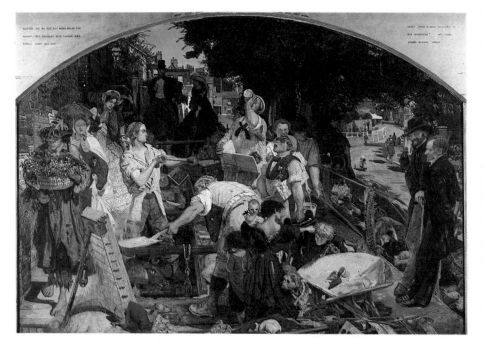

(1855) and the academic W. P. Frith's (1819–1909) scenes of Victorian leisure and business, this thread runs through otherwise very different pictures. Indeed, the fact that a great deal of the official and second-rank art of the latter half of the 19th century is simply more naturalistic and detailed than before is an indication of how far-reaching the climate of Realism had become as its radical connotations gave way to respectability. It was again, however, a relatively small group of painters in France who took Realism to its logical conclusion by analyzing the very way in which we perceive the world through sight, and seized upon the impressions of color and light that are our most vivid contact with reality.

From Realism to Impressionism

The official and public condemnation that Courbet's work had often provoked continued against the nucleus of the most important painting done in France in the second half of the 19th century.

Work, 1852–65
Ford Madox Brown (1821–93)
Oil on canvas 53×77¼in (133×194cm)
City Art Galleries, Manchester

Brown was born at Calais and settled in England in 1845. Before then he had studied in Rome and met the group of German painters called the Nazarenes, whose interest in religious subjects and primitivist manner link them to the Pre-Raphaelites. Rosetti introduced Brown to the Pre-Raphaelite Brotherhood in 1848 and, although he remained on the periphery of the movement, he was greatly influenced by it. Work, his most famous painting, follows in its meticulous recording of social detail Ruskin's advice to beginners: "Go to nature, rejecting nothing, selecting nothing, and scorning nothing". It is also faithful to Holman Hunt's creed that a painting acquires "truth" in direct proportion to its accumulation of incident and minute dilineation of forms. The pointed contemporary reference of the painting is reinforced by the foreground figures, Thomas Carlyle and Frederick Maurice (the Christian Socialist founder of the London Working Men's College), who are depicted as mere onlookers.

This happened despite the fact that a number of the artists involved were no longer conscious revolutionaries and, in fact, in many cases sought popular acceptance. The initial history of the period is therefore that of a repeated conflict with the academic tradition and its expression through the outlet of the annual Salon. Because the Salon offered the only public exhibition of artists' work, its jury had enormous power. Its strict academic tradition, stemming from the 17th century, meant that those artists with anything but a conventional, Classical approach were generally refused entry. At the time of Courbet there was therefore a split between those artists who adhered to long-established and "safe" subject matter treated in styles based on past models, and those who were attempting to depict the contemporary scene in realistic and – for their period – increasingly experimental ways. Almost by definition these innovators were comparatively isolated and few in number. Since their aims and techniques were in advance of the practice of the time, they have become known as the avant-garde, a military term given to a small group that explores ahead of the main body of an army.

The enormous popularity and affection that the paintings of Édouard Manet (1832–83) enjoy today is an ironic example of the abrupt changes in the relationship between the artist and his public that we have come to Manet and the Realists represented the avant-garde and their efforts were met with widespread hostility and incomprehension. The relatively few pictures they produced have long since acquired their own perspective and are far more important than the legions of academic paintings they once challenged.

In part, the change of emphasis is understandable when we consider the weight of conservatism that characterized French society after 1871. Any

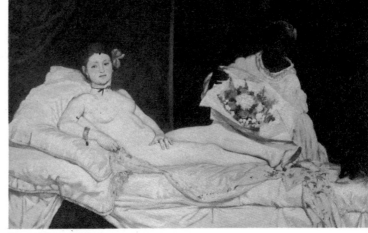

The Cart – Souvenir de Santry, *1874*
Camille Corot (1796–1875)
Oil on canvas 18½×20in (47×56cm)
National Gallery, London

This late work by Corot shows how fresh and vigorous his painting was, even up to the time of his death. He was born in Paris and from 1825 ro 1828 was traveling in Italy, working out of doors. He revisited Italy twice and achieved gradual success, becoming a member of the Salon Jury. His work has been associated with that of the Barbizon group of artists, although he himself was not fully one of them.

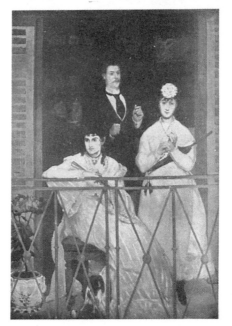

Olympia, *1865*
Edouard Manet (1832–1883)
Oil on canvas 51¼×74¾in (127×188cm)
Louvre, Paris

The Balcony, *1868*
Edouard Manet (1832–83)
Oil on canvas 66½×48⅞in (169×124.5cm)
both Louvre, Paris

Manet submitted Olympia *to the Salon in 1865 and, like the* Déjeuner sur l'Herbe *of two years earlier, it was rejected. The painting was aggressively provocative, being a modern, unidealized rendering of a nude, a deliberate updating, so to speak, of Titian's* Urbino Venus. *The harsh, even lighting, the two-dimensional composition and the daring use of solid blocks of color drew the fire of its critics. Not until 1874 did Manet produce his first Impressionist painting,* The Boating.

The idea for The Balcony *came to Manet from a scene noticed on a visit to Boulogne in 1868 and he combined this with a study of Goya's painting* Woman on the Balcony *(Prado, Madrid). The model for the woman on the left was the painter Berthe Morisot, who had been introduced to Manet for the first time in that year. The painting was exhibited at the Salon of 1868 and met with hostile criticism. Manet was no stranger to critical ridicule, having caused a scandal with his showings of* Déjeuner sur l'herbe *in 1863 and* Olympia *in 1865. In 1867 he had been driven to construct his own exhibition pavilion to ensure a showing of his work. In response to* The Balcony *the critic Louis Estault remarked that Manet "specializes in horrifying the bourgeois".*

state that was prepared to eliminate twenty thousand people for the cause of reaction – as happened during and after the Paris Commune – was hardly likely to prove sympathetic to a tiny group of painters who were openly critical of the artistic establishment. On the other hand, the techniques evolved by Manet and the Realists demonstrate how avant-garde art was already beginning to run ahead of the canons of acceptability and understanding of its period. Where the average 19th-century eye saw only the lack of classical, historical and religious references and a crude blur, we per-ceive a warmly acceptable vision of city and country depicted in terms at once realistic and yet with a satisfying poetry in their unexpected colors and forms. Time alone educates perception and bridges the gap between us and the avant-garde, allowing us to see the world as they did.

It is a strength of Édouard Manet's work that, although it stems partly from Realism and anticipates Impres-

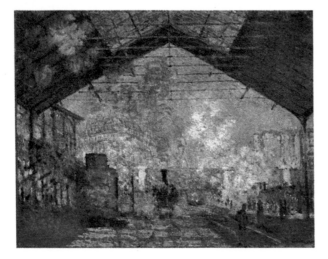

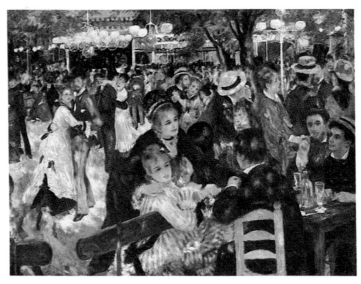

Gare St Lazare, *1877*
Claude Monet (1840–1926)
Oil on canvas 32½×39¾in (82×101cm)
Louvre, Paris

*Monet's series of paintings of the Gare
St Lazare in Paris were begun in 1876 and
finished in 1878. He exhibited seven of
the canvases in the Third Impressionist
exhibition of 1877. Monet had used the
motif of a moving train in previous paintings,
but in a landscape setting. The decision to
concentrate on the station as his subject
stemmed from the general principle of
working in the context of everyday life,
rather than relying on traditional subjects of
academic art. But it was also Monet's
answer to critics who still refused to
recognize the aims and achievements of the
Impressionists, and who had scoffed
particulary at Monet's paintings because
they were "foggy" and obscure; Monet
decided that he would give them paintings
of fog, the smoke and steam of the great
railway engines. In this period of his life
Monet was suffering from considerable
financial problems and the illness of his
wife, Camille. It is said that Renoir savored
an amusing reminiscence of the poverty-
stricken Monet putting on his best suit and
introducing himself to the station master
as a painter of some importance, in order to
obtain a free run of the station to achieve
the effects he wished to paint.*

Le Moulin de la Galette, *1876*
Pierre Auguste Renoir (1814–1919)
Oil on canvas 51½×69in (131×175cm)
Jeu de Paume, Louvre, Paris

*The second Impressionist exhibition was
held in 1876 and it met with no more
critical success than had the first in 1874.
One critic wrote of a nude painting by
Renoir that it looked like "a mass of
decomposing flesh" because of the way the
colors were applied. However, the year was
in other respects a turning point in Renoir's
personal career. In 1875 he had met Victor
Choquet, a customs officer, who was
prepared to act as a patron, and in 1876
Renoir was taken up by the publisher
Georges Charpentier, who commissioned
portraits of his own family and introduced
the painter to other patrons. This relative
security enabled Renoir to work more freely.
In keeping with Impressionist principles of
representing everyday scenes, he started
work on this lively view of the Moulin de la
Galette, an open-air dance hall where on
Sundays could be found groups of young
working people enjoying the leisure of a free
afternoon. Renoir placed his canvas close to
the scene and painted from life. While he
persuaded his friends to act as male models,
he preferred to choose the female figures
from among the girls on the dance floor. A
smaller version of the painting exists also
dated 1876. This was probably commissioned
by Choquet, who admired the original but
found it too large for a domestic setting.*

sionism, it cannot be attributed to either movement because of its originality and contradictions. Manet's subjects are frequently rooted in the elegant affairs of contemporary Paris, the life of the café and the conservatory, yet he deliberately drew upon the compositions of the Old Masters for inspiration. His paintings possess a clarity and precision that at first look truly realistic, but he seemed intent upon making this very objectivity the basis for an artificial style. The bright, even lighting reduces shapes to flat areas of color so that the puzzling novelty of his approach seems somehow to lie in its sheer frankness.

Although Manet sincerely desired official acclaim, it was possibly this factor that, on the contrary, brought him repeated censure and estrangement in his attempts to reach a public ill-tuned to his aims. When *Le Déjeuner sur l'herbe* was shown in 1863 at the Salon des Réfusés, (organized for those who had been rejected by the Salon proper), it earned the ultimate denigration of Louis Napoleon and, two years later, *Olympia* encountered a storm of criticism at the Salon. The Third Republic was unwilling to accept the

female nude in so unadorned a fashion or, in the case of *Le Déjeuner*, beside men in contemporary dress; and it was Manet's lack of comment or apology that fueled outraged responses. It was precisely these characteristics that in turn recommended him as a kind of hero to the youthful group of painters who eventually became known, disparagingly, as the Impressionists.

A cool, objective attitude was not, however, unique to Manet. It had already gained ground less obtrusively in the observation of nature by the painters who were active around the village of Barbizon in the forest of Fontainebleau from as early as 1830 onward. Their feelings were still nonetheless colored by a romanticism that is less evident in the landscapes of Eugène Boudin (1824–98), the Dutchman Johann Jongkind (1819–91) and Camille Corot (1796–1875). Corot executed large, conventionalized landscapes with the requisite classical figures meant to be seen at the Salon. He and other artists, however, also produced small, relatively sketchy canvases, sometimes out of doors (*plein air*), that emitted a luminosity quite out of keeping with the accepted standards of the day. The artistic period known as Impressionism drew its inspiration from this alternative method of painting and from the knowledge that there remained one fundamental element in nature that had not been fully analyzed nor captured by even Realist art up to that time: light. In the mid-1860s this realization was shared by figures such as Claude Monet (1840–1926), Auguste Renoir (1841–1919) and Camille Pissaro (1830–1903).

The training that the Impressionists Monet, Alfred Sisley (1839–99) and Renoir received in the studio of the unconventional academician Charles Gleyre may have helped in making them aware of the potential of the sketch done in the open air and its

capacity for creating an impression of vividness and movement denied to more elaborately worked and "finished" compositions. To give their paintings heightened luminosity, the Impressionists soon came to eliminate the the dark, usually brownish ground used to prime a canvas, which was widely thought indispensible at the time, substituting a white or subtle tint that enlivened the tonalities of color they chose to use over this. Because most of their canvases were executed rapidly out of doors, they lacked the traditional finish that resulted in a uniform, refined paint surface where individual brushstrokes were no longer visible. The small, rapid dabs of the brush they used in preference to this "finish" began to suggest the fleeting, broken effects of light upon the myriad of surfaces that the eye encounters out of doors. The final innovation of the Impressionists was to grasp the astonishing diversity of hues of color that are present, if one looks hard enough, in nature. Water, snow and even shadows were at last shown for what they are: not monotonously colored areas but a play of tints and hues affected by the atmosphere, reflections and the proximity of other colors.

The quintessential Impressionist painting is an image of transience, a record of the artist's visual sensations in the face of a passing moment of weather, light or the bustling life of the city. This explains the recurrent fascination of the Impressionists, particularly Monet, with water, a substance that is optically inexhaustible, ever-changing and elusive. That Impressionism should have made a permanent transcription of what is only fleetingly experienced in life remains part of its charm for us today. It is also a prime reason why it was so unpopular in an age when the highest function of art was still thought to be its ability to convey eternal truths expressed through

ideal or historical figures. Political, literary and emotional preoccupations are generally absent from Impressionist paintings, allowing them to speak with a directness that is instantly appealing to a public that has perhaps too often been distracted by these obtrusive topics. Although the Impressionists witnessed the disruption of the Franco-Prussian war, their work continued to be remarkably untroubled and deeply Gallic in feeling. The faith in a benign domestic existence or a smiling Nature usually remained uppermost. There is a poignancy about the classic period of Impressionism in the 1870s that owes a great deal to its involvement with a vanished way of life; the relatively serene and rural mood of France at that time was soon to be darkened permanently by a series of political scandals and the grim spread of industrialization.

Beyond Impressionism

By 1880 almost every member of the Impressionist group was either unable or unwilling to sustain the poise and tranquillity that had been manifested in the work of the 1870s and the movement began to undergo a crisis. A series of seven exhibitions, starting in 1874, had established the Impressionists as a distinct faction active outside of the Salon. Yet these shows met with little financial success and few alternative patrons were found. The dilemma that Impressionism confronted was encouraged not only by social disappointments and a need to obtain greater official recognition, but from some of its basic artistic premises. By the early 1880s Monet, Pissarro and Renoir began to feel that their art had serious shortcomings, not least of which was a lack of solidity, permanence and emotional commitment. The one member of the circle who failed to grasp this was Alfred Sisley. The repetitive landscapes that he con-

311

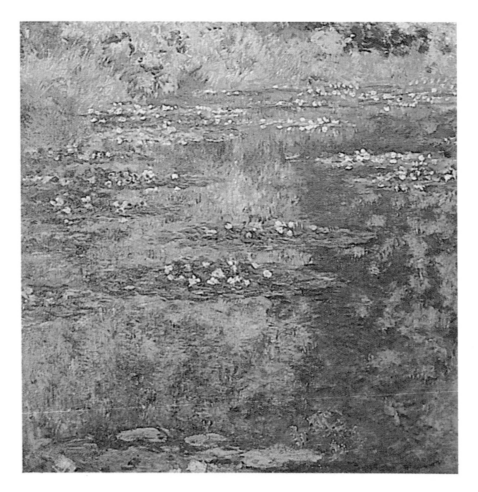

Water-Lilies, c.1921
Claude Monet (1840–1926)
Oil on canvas 79×237in (197.5×592.5cm)
Private collection, New York

Monet began to build a water-garden near his house at Giverny in the 1890s and his first paintings on the theme were exhibited in 1900. Three years later, having greatly enlarged the garden's pond, he painted the first of his famous series of water-lily canvases, forty-eight of which were exhibited in 1909. By then Monet already had in mind the idea of a vast, continuous lily-pond decoration to envelope a whole room. This was the germ of the huge canvases which he painted from 1916 almost until his death. "I no longer sleep because of them," he wrote in 1924. "In the night I am constantly haunted by what I am trying to realize. I rise broken with fatigue every morning." So elusive is the treatment of perspective in these late canvases that only the water-lilies establish the surface of the pond; yet the composition of the painting shown here, at first sight haphazard, is actually a painstakingly worked-out balancing of diagonals, verticals and horizontals.

tinued to paint until his death perhaps demonstrate what would have happened to Impressionism if its more self-critical adherents had not revised their methods and ideals.

In their separate ways, the leading Impressionists started to pursue more imaginative and monumental goals. Pissarro moved toward substantial figural scenes realized in a highly systematic style, while Renoir returned to the study of his favorite Old Masters, also stressing the importance of the human figure in a painstaking, classical manner. Monet, always the crux of the movement and its most steadfast champion, became so obsessed with the slightest changes in nuances of light and atmosphere that he was led to create series of paintings of the same motif under varying conditions – a haystack, Rouen cathedral and, finally, the sumptuous lily pond of his own garden. In his later works any recognizable subject receded from importance as Monet ruminated and delved into his perceptions of the flux of light, color and texture divested from material objects.

Edgar Degas (1834–1917) was the only major figure to have been associated with the social activities of the Impressionists from the early days who managed to avoid the crisis of the 1880s. This probably betrays the fact that, like Manet, his approach had at heart little in common with the essence of the movement. He once remarked to the Impressionists that, "You need natural life, I artificial life", thereby summarizing his most fundamental difference. In preference to open-air landscape, his favorite themes were extracted from a modern urban milieu of café-concerts, horse races, ballet and, particularly, the female figure in an interior. For the colors of nature he substituted the greater opulence that came when people, clothes and decor were observed under artificial lighting. Thus he replaced the emphatic brushstroke of the Impressionists with a concentration upon line and a more extensive use of unorthodox techniques in pastel and other graphic media. Degas's approach was inquisitive and clinical to the point of ruthlessness and is perhaps best experienced at its most forceful when compared with an artist of very dif-

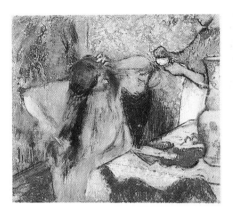

Woman at her Toilet, c.1894
Edgar Degas (1834–1917)
Pastel 37⅝ × 43⅜in (93 × 108cm)
Tate Gallery, London

Degas' sophisticated Parisian character, together with his acute draftsmanship, gave his artistic preoccupations – dancers, laundresses, horses and women at their toilet – a distinction to which his masterly use of the pastel added a vibrant immediacy.

ferent temperament upon whom he exerted considerable influence, the American painter Mary Cassatt (1845–1926). While Cassatt's female subjects and domestic scenes undeniably reveal Degas's legacy, they are permeated with a tenderness and humanity alien to the Frenchman's work, where the figure is, in his own words, examined with brilliant dispassion as "the human animal busy with itself".

Post-Impressionism

The label "Post-Impressionism" is usually taken to indicate work done by artists immediately following Impressionism. But from the first use of the term by the English art critic Roger Fry in 1910 it has carried strong overtones of the aesthetic differences between the two schools. As the Impressionists were changing course in the 1880s, certain younger French artists were starting to explore an entirely different attitude to some of their innovations, and contributed perspectives that would have been anathema to the original circle.

Henri de Toulouse-Lautrec (1864–1901), a dissolute although extremely perceptive aristocrat crippled by a riding accident at the age of fourteen, typifies the continuity and change in French painting at this stage. His subjects maintain the tradition established by Manet and Degas, but their impassive stance is ousted by a personality that evidently absorbed and relished the seamier, more grotesque side of Parisian life. The restraint of earlier French art is abandoned as Toulouse-Lautrec swings between sympathy and revulsion for the cabarets, circuses and brothels he frequented. Concern for the objective beauty of color and line gave way to an urge to exploit their expressive properties through caricature and unnatural, lurid dissonances. The painter was no longer a well-bred observer; he became a participant in a disordered, frenetic bohemia that turned his art into protest and comment. The reverse of Toulouse-Lautrec's position was to disengage painting from the social level of reality and to ponder its formal significance. This alternative was developed by four artists: Paul Gauguin, Vincent Van Gogh, George Seurat and Paul Cézanne, all of whom offered the strongest challenge to Impressionism.

Paul Gauguin (1848–1903) resembled Toulouse-Lautrec in his disaffection from the increasingly vulgar, prosperous and materialistic French society of the 1880s. In this case, however, the retreat was not toward the subculture of entertainment and night-life. Instead, Gauguin abandoned his family and a career as a stockbroker and fled civilization altogether for the lure of the primitive, found at first in the peasant hinterland of Brittany and then in Tahiti. Initially, Gauguin was influenced by Impressionism, but soon criticized both its spirit and methods when he came to believe that painting should express inner emotions and ideas. To Gauguin, the life of the mind and soul was to take precedence over the senses, important as these were in their ability to make poetry out of the everyday world. In his rejection of external appearances Gauguin felt that a painting ought to assume a decorative beauty of its own. This caused him to adopt flat, unnatural colors and ponderous figures that suggested symbolic meaning and something of the crude, heavy forms that he admired in pre-Renaissance and exotic art.

To the Dutchman Vincent van Gogh (1853–90) art could never yield its full significance if the wonder and beauty of the external world was totally denied, and so he was more affected than Gauguin by the delight in nature that Impressionism had discovered. This decision was animated and even jeopardized by Van Gogh's essentially emotional and religious point of view. Consequently, his treatment of nature was deeply subjective and gained in intensity as his own life moved from crisis to crisis, culminating in suicide. In Paris in 1886 Van Gogh came in contact with Impressionism, Seurat and Japanese prints, which liberated his handling of color and pictorial structure. The broken brushwork and bright palette of Impressionism were transformed into a style of utter individuality: direct and vibrant yet imbued with a touching humility before the most commonplace landscapes and people. When Van Gogh moved to

the south of France with its brilliant Mediterranean light two years later, his paintings gradually began to resemble a magnetic field of scintillating dashes of color. In the last tragic months of his life he produced paintings with enormous speed, dominated by heavy brushwork and surging forms that hint at an externalization of Van Gogh's inner turmoil. Through still-life, portrait and landscape, which remained recognizable in his work to the very end, he traced the turbulent, convulsive patterns of his own psyche.

A quite different course of Post-Impressionism was evolved by Paul Cézanne (1839–1906) and Georges Seurat (1859–91). By separate routes both reached the conclusion that Impressionism might be made into a force as monumental and enduring as the work of the Old Masters. Seurat's studiously intellectual outlook had close affinities with the philosophy of his time, known as Positivism, which supposed that reality could be analysed solely by the aid of precise scientific laws. For Seurat there seemed to be formulas that might be used to translate light, color and even particular emotional moods onto

Sunday Afternoon on the Island of
La Grande Jatte, *1884–6*
Georges Seurat (1859–91)
Oil on canvas 81 × 120⅜in (202 × 300cm)
Art Institute of Chicago

The Models, *1886–8*
Georges Seurat (1859–91)
Oil on canvas 79 × 99in (197 × 248cm)
The Barnes Foundation, Philadelphia

These two paintings are the masterpieces of Seurat's art, which opposes the impressionist freedom with a discipline of pictorial construction and a demanding pointilliste technique. The Grande Jatte *is a composition of the most taut and convincing balance, and of the* Models *Roger Fry wrote, "one cannot move a button or a ribbon without disaster to this amazingly complete and closely-knit system. Since Poussin surely no one has been able to design in such elaborate and perfect counterpoint." Seurat himself was perhaps not entirely happy with it. He was already fretting at the number of painters who were adopting pointillism, thereby making his work seem to be less original. "I am thinking very much of how to do without the dot", he wrote to Pissaro in September 1888, and whether for that reason or because the canvas he used changed the colors of* The Models *within a matter of days, he painted a smaller version (about one-sixth the size) later that year in which his brushwork is much more free. In both versions his "squashing" of perspective is striking, being more pronounced than in his earlier paintings.*

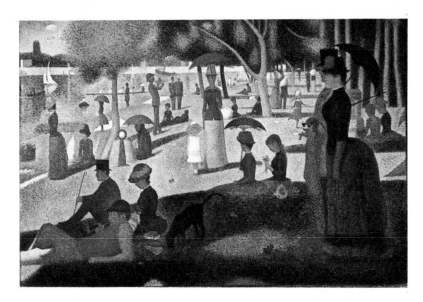

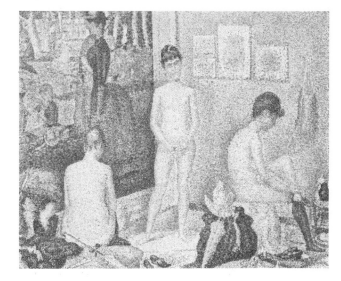

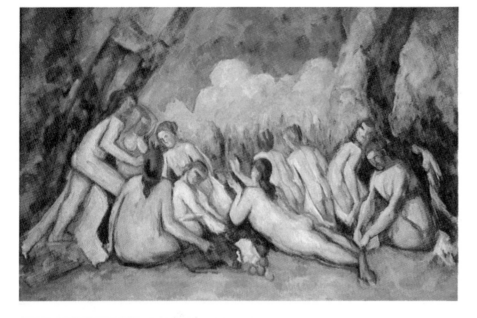

Bathers, 1900–1906
Paul Cézanne (1839–1906)
Oil on canvas 51¼ × 76¾in (130 × 195cm)
National Gallery, London

Pistachio Tree in the Courtyard of
Chateau Noir, c.1900
Paul Cézanne (1839–1906)
Watercolor and pencil 21¼ × 16⅞in
(54 × 43cm)
Art Institute of Chicago

Despite increasing fame and appreciation for his work in the later years of his life, Cézanne became increasingly withdrawn, tending to avoid contact with other painters and frequently falling out with friends over apparently trivial matters. Throughout his life he showed a continuing attachment to his birthplace, Aix en Provence, and many of the motifs in his best known paintings are features of the landscape in that area. By working mornings, in the studio and going out in the afternoons to study the landscape, he was able to divide his time between the several subjects that obsessed him. There are many studies and paintings on the Bathers theme. In a letter of 1904 to Emile Bernard, one of the few friends whom Cézanne did not alienate, he expressed the frustration of being unable to paint such a subject from life, pointing out the problems of finding a suitable location and models willing to pose, and the practical difficulties of working outdoors on a large canvas. He therefore was obliged to produce the Bathers as a studio work "where everything has the brown coloring of feeble daylight without reflections from the sky and the sun". In his isolated state he singlemindedly pursued his researches, essentially fulfilling the promise expressed in his last letter to Bernard; "I have sworn to die painting."

a two-dimensional surface. His own system is termed Pointillism and grew from the Impressionists' discovery that small touches of pigment (*points*) set side by sid e on a canvas could blend optically, when viewed at a suitable distance, into a third and more vibrant tone. Seurat planned his mural-like compositions in meticulous detail and brought to them a deliberation that had been consciously played down by the Impressionists. The results are curiously personal and transcend Seurat's own modest, mechanical estimation of his technique. His followers included Paul Signac (1863–1935), who wrote *D'Eugène Delacroix au Néo-Impressionisme* in 1899, a theoretical justification for the system of dividing colors into small touches of hues, and thus the subsequent term Divisionism. In the hands of Signac and other painters less original than Seurat the application of the method was liable to triumph over its aims. A number of painters in the 20th century have nonetheless resorted to techniques that can be traced to Divisionism.

The course of Paul Cézanne's (1839–1906) career ran from the impact of the Impressionists' study of landscape to a conviction that the artistic transcription of reality was infinitely complex; that art was not mere imitation but rather "a harmony parallel to nature". Like Seurat, Cézanne seized upon the implications of the Impressionists' brush-stroke and from it developed not a tiny dot of color but a block-like touch that was used to construct a mosaic of interconnected facets. These resembled the bricks of a pictorial architecture, shifting and tilted where necessary yet solid in their overall structure. Unlike Seurat, Cézanne felt that order need not be imposed upon the chaotic surfaces of everyday life through the imposition of predetermined aesthetic laws; to some extent it resided there already as an underlying framework

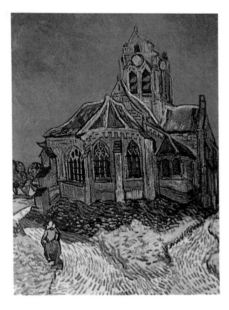

Church at Auvers, *1890*
Vincent van Gogh (1853–90)
Oil on canvas 37×29¼in (94×74cm)
Musée Jeu de Paume, Louvre, Paris

*The last two years of Van Gogh's life were
an unhappy and turbulent time for the
artist. Soon after the famous incident when
he quarreled fiercely with Gauguin and cut
off part of his ear, Van Gogh was
voluntarily admitted to an asylum at St
Remy, where it was hoped his inter-
mittent attacks of depression and insanity
could be controlled. These were inter-
spersed with periods of lucidity and he
continued to paint while at the asylum. The
Olive Grove constitutes a reply to Emile
Bernard, who had written describing his
current engagement with a new painting,
Christ in the Garden of Olives. Van Gogh,
ever the champion of what lay before his
eyes, replied that he would rather paint the
olive trees outside his own window than
some imaginary vision. On leaving St Remy,
Van Gogh settled at Auvers sur Oise in
May 1890. He painted the local church
during the first two weeks of his stay and
the brief Auvers period continued to be
extremely productive. However, his mental
state was beyond control and on July 27,
1890 he shot himself while out painting.
He died two days later. Van Gogh had been
bitterly conscious of his lack of success as
an artist and it is especially ironical that
1890 was also the year when he made the
first and only sale of a painting.*

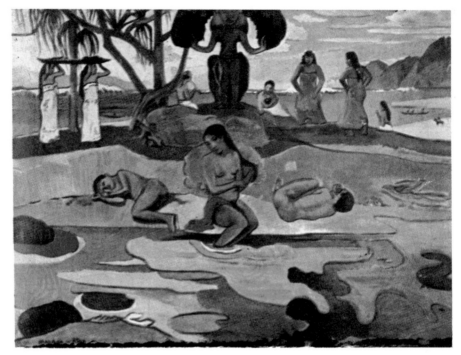

The Day of the God, *1894*
Paul Gauguin (1848–1903)
Oil on canvas 26×34½ (66×91cm)
Art Institute of Chicago

*Escape from bourgeois Western civilization
was an object sought by many artists in the
late 19th century – the* fin de siècle *of the
French Symbolists and the "mauve decade"
of the English aesthetes. Gauguin visited
Tahiti from 1891 to 1893 and returned in
1895 to live there until his death. Although
he was disappointed by the extent to which
the island had already been Westernized, he
lived in a bamboo hut away from the capital,
took a native wife, wore native clothing and
tried as best he could to disencumber
himself of his European inheritance.*

that had only to be revealed and grasped
by the artist's painstaking search.
Cézanne spoke to his friend and fellow-
artist Émile Bernard (1868–1941) of the
necessity to "see in nature the cylinder,
the sphere, the cone", an idea that be-
came a point of departure for later
abstract painting such as that of Mon-
drian and the Cubists, who attempted
to extract some inner, formal essence
from beneath the outward show of
visual appearances. The importance of
Cézanne has much to do with the
balance he achieved between these two
requirements. In his greatest com-
positions the immense diversity of
nature coexists with the sense of order
we expect from art.

The Vision After the Sermon –
Jacob Wrestling with the Angel, *1888*
Paul Gauguin (1848–1903)
Oil on canvas 28¾×36¼in (73×92cm)
The National Gallery of Scotland, Edinburgh

During the period 1886–8 Gauguin began to shed the influence of Impressionism, a strong presence in his early career as a painter, through his friendship with Camille Pissarro, and developed characteristics of style that formed the basis of his later work. On a visit to Pont Aven in 1886 he worked closely with the painter Émile Bernard (1868–1941) and confronted ideas that were in direct opposition to the stress on observation and naturalism promoted by the Impressionists, such as the Symbolist notion that art should "clothe the idea in a perceptible form". In 1888 Gauguin made another visit to Pont Aven, having traveled to Martinique during 1887, and was much struck by a simple design by Bernard, a painting called Breton Women in a Field. *This seems to have been the initial inspiration for* Vision After the Sermon, *giving Gauguin the idea of using Breton peasants in their traditional dress as the medium for portraying a symbolic religious experience. The use of flattened shapes and bold colors was partly derived from interest in Japanese prints – the wrestling figures are probably based on a print by Hokusai. The style adopted by Gauguin and Bernard was referred to as* cloisonnisme, *the bright colors and strong linear emphasis being reminiscent of cloisonné enameling. When the painting was finished Gauguin offered it for display in a local church, anxious to see its effect in such a setting, but it was refused by the priest.*

Fin-de-siècle

As the 19th century drew to a close capitalism in Europe and the United States continued to prosper and expand at a remarkable rate. Its success is seen in the progressive rise of an affluent middle class, the extensive development of colonial enterprise throughout the the world, the growth of consumer markets at home and the widespread escalation of industrial production. Cities grew relentlessly and the metropolis became the focus of both wealth and deprivation, witnessed in the extraordinary upsurge of Chicago, a village in 1820 but by 1900 a city rich with skyscrapers and rife with slums. Since cities and individuals alike were equally keen to purchase recognition and beauty with their newly acquired wealth, art was affected by this boom. It is therefore hardly surprising that the decorative arts, civic sculpture and the works of the various salons and their alternatives or descendants experienced unusual levels of activity in the latter part of the century. Quantity, however, took its toll on quality and this was made worse by the vulgar or ill-informed tastes of the middle class and *nouveaux riches.*

On the artistic and intellectual scene, the final quarter of the century saw a variety of challenges to Realism. Philosophers such as Friedrich Nietzsche argued that the behavior and conventions of civilization masked the raw, inexplicable striving of man's will to power. To the French philosopher Henri Bergson the facts of reality, analyzed so assiduously by the tools of science, were deceptive because they might simply be a dynamic flux that could only be experienced intuitively. The revolt against the certainties of everyday life took its most extreme form in the final manifestations of the doctrine of aestheticism, the belief in the supremacy of art over nature.

This flight from reality had first sur-

"Alcazar Lyrique", poster for Aristide Bruant, 1893
Henri de Toulouse Lautrec (1864–1901)
Color poster 50×36½in (127×92.5cm)
Bibliotheque Nationale, Paris

Toulouse Lautrec established himself in a studio in Montmartre, Paris in 1885 and thereafter exhibited work regularly and received commissions for illustrations and graphic work. He was not fully at ease in the company of other artists and preferred to spend his time amid the night life of Montmartre, in the cafés, cabarets and brothels that became the main subjects of his paintings and drawings. By 1886 he was a regular visitor to Le Mirliton, the cabaret owned by the singer Aristide Bruant. Lautrec exhibited some work there and made posters and illustrations for the cabaret magazine. In June 1892 Bruant asked him to design a poster for the singer's appearance at the café concert Les Ambassadeurs. During the following year Lutrec made two more posters for Bruant, all in the same bold style, partly influenced by his keen interest in Japanese prints. Lautrec had taken up lithography in 1891 and many of his posters were made by this technique; his work has remained an important example of the successful combination of traditions of graphic and fine arts.

A L'Innovation Department Store,
Brussels, 1901
Baron Victor Horta (1861–1947)
Iron and glass façade

Little is known of Horta's early career; he was practicing as an architect by 1885 and evidence suggests that his first buildings were Neo-Renaissance in style. His design for the house of Professor Tassel in Brussels (1892–3) was the first major Art Nouveau building in Belgium. Horta made use of an iron frame for the façade, much of it covered with stone. Developing the use of iron in both structural and decorative functions, he later designed the Hôtel Solvay (1895–1900) and the Maison du Peuple (1896–9). The latter, a theater in Brussels, was the first example of a full use of an iron and glass facade, repeated in subsequent buildings including the A L'Innovation store. (Both of these structures have since been demolished.) The elaborate style of Art Nouveau in Belgium was influenced by work from England published or exhibited in Belgium, including design by William Morris and Arthur Mackmurdo, drawings by Aubrey Beardsley and the paintings of the Pre-Raphaelites.

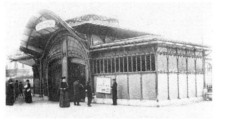

Entrance to the Métro, *Place Bastille, Paris, c.1900*
Hector Guimard (1867–1942)
Iron and glass

Guimard was the leading exponent of Art Nouveau in France, his first notable building in this style being the Castel Beranger, built in Paris (1894–8). The facade was not particularly flamboyant, but the elaborate ornamental character of Art Nouveau was evident in the detail. Guimard, however, is best remembered for his station entrances to the Paris Métro, carried out in 1899 and 1900. These were the basis of his popular reputation and several still exist. They vary in form, some consisting only of ornamental railings and light fittings while others are enclosed shelters of iron and glass. The elegant linear structures are derived from plant forms, a device typical of Art Nouveau, which became known in France also by the label Le Style Métro, *in tribute to Guimard's designs.*

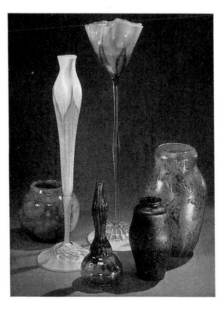

faced in Romanticism but flowered again and reached its limits toward the end of the 19th century. In French this period is called the *fin-de-siècle*, a phrase connoting a mood of over-refinement and irrationalism pursued to the brink of decadence. In fin-de-siècle art the banal and pedestrian is very often avoided by recourse to ornament or decoration. This is as evident in the exquisite, arabesque harmonies of Claude Debussy's music as it is the glasswork of Louis Tiffany (1848–1933), the paintings of the Viennese Gustav Klimt (1862–1918), or the architecture of the Belgian Victor Horta (1861–1947). After 1890 the one style that cut across national boundaries was known as *Art Nouveau* in England, France and the United States, *Jugendstil* in Germany and *stile Liberty* in Italy. In all cases it was essentially decorative.

Perhaps because it was novel and the only major art style of the century that was not merely a revival of an earlier manner, Art Nouveau achieved rapid and international popularity. In architecture it ranged from a use of ornament as a veneer on the surface of buildings to a principle so integral that it helped determine their very structures.

Louis Comfort Tiffany *(1848–1933)*
Selection of work in the Metropolitan Museum of Art, New York

Tiffany trained as a painter in his native United States and in France before taking up stained-glass making in 1875. The turning-point of his career came in 1889 when he saw the glass work of the Art Nouveau French designer, Emile Gallé, at that year's Paris Exhibition. Almost immediately he began to experiment with blown glass-work in the Art Nouveau manner, and within a few years he made internationally famous his own style of glass-work, which he called favril *(from the Latin* faber *for "craftsman"). The style was distinguished by its iridescence and by the free lines of its shapes; the glass was sometimes combined with metals or metal alloys, as in the lamps which he began to make after he organized the Tiffany Studio in New York in 1900.*

Despite its originality, Art Nouveau nonetheless had many sources, including the intricate networks of Gothic architecture, the decorative patterns of the English Arts and Crafts movement, Celtic illumination and the serpentine curves employed by Van Gogh and Gauguin. Through its seemingly endless, flowing undulations, Art Nouveau also suggested organic processes of growth. Tiffany's irridescent glasswork evoked flower and plant forms; Hector Guimard's (1807–1942) Métro stations in Paris resembled metallic copses sprouting from the streets; and Antoni Gaudi's edifices had at times the bizarre presence of pulsating organisms. The linearity of Art Nouveau lent itself naturally to graphic design and found sophisticated pictorial expression in the drawings and posters by artists such as Toulouse-Lautrec in France and Aubrey Beardsley (1872–98) in England. The appeal of Art Nouveau was pervasive enough for its influence to be felt throughout the arts, lending itself as readily to painting and architecture as it did to applied crafts such as furniture, jewelry and book design. Today it seems to typify an era of elegance and luxuriousness, but in its emphasis on the more abstract side of design it was a significant precursor to some types of 20th century art.

Symbolism

The escape from Realism in painting culminated in the Symbolist movement of the 1880s and 1890s. This, like its contemporary tendency Art Nouveau, was an international phenomenon without rigid boundaries, loosely held together as much by shared attitudes and themes as by specific doctrines. Its origins can be traced at least to the 1850s and especially in France to the poet Charles Baudelaire, who had called for writing to be rooted in imagination, suggesting mood and the play of abstract thought rather than fact. From

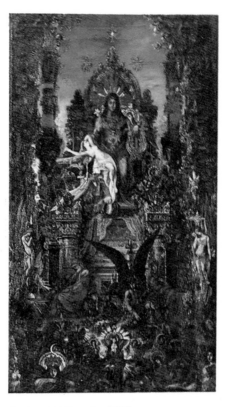

Jupiter and Semele, *1896*
Gustave Moreau (1826–98)
Oil on canvas
Musée Gustave Moreau, Paris

During his visit to Italy in 1857 Moreau was deeply impressed by the Venetian colorists of the Renaissance and their work remained the most potent influence throughout his career, from the Oedipus and the Sphinx *of 1864 to this, his last, painting. Like the other painters with whom he was linked by the Symbolists – Puvis de Chavannes, Odilon Redon and Eugène Carrière – Moreau has fallen into obscurity, although the Surrealists paid attention to him. Moreau was out of step with the*

a different standpoint, photography had diminished the effectiveness of Realist art by the mechanical ease with which it rendered accurate likenesses.

In England there had been an early and powerful stimulus to escapism in

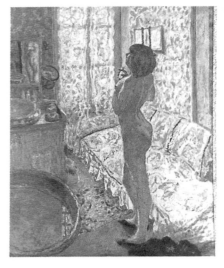

L'Eau de Cologne, *1908*
Pierre Bonnard (1867–1947)
Oil on canvas 50×43½in (124×108cm)
Musées Royaux des Beaux-Arts, Brussels

In the 1890s Bonnard was associated with the Nabis, a group that included Vuillard and Maillol and expounded the idea "that a picture . . . is essentially a flat surface covered with colors assembled in a certain order." To this end his painting had the blurred edges and the strong formal element of color which were the peculiar contributions of the Nabis to Post-Impressionism. Unlike the Fauves, the Nabis, and Bonnard in particular, were concerned to represent psychological and emotional states on their canvases. For Bonnard this led to a preoccupation with the minor episodes of domestic life. Hence he was sometimes called, along with Edouard Vuillard (1868–1940), an "Intimist". Bonnard may thus be considered one of the last direct descendants of 19th-century Realism. Bonnard later remarked, "We had wanted to take the same direction as the Impressionists, but to go farther than they did in the rendering of color as it actually exists in Nature . . . And then progress came upon us faster than anyone expected, and the public was ready for Cubism, and even for Surrealism, before we had realized our intentions completely."

the romantic poetry of Alfred Tennyson and, especially, the writing of Walter Pater, who eulogized the exquisite refinement of music and distant cultures such as the Renaissance. As already noted, the Pre-Raphaelites pursued visual realism, yet there was another side, exemplified in the art and theory of artists such as William Morris (1834–96), Edward Burne-Jones (1833–98) and Dante Gabriel Rossetti (1828–82) that was attracted to decoration and the lure of remote Classical or medieval legend. After his move to London in 1859, the ex-patriate American James Abbott McNeill Whistler (1834–1903), by using the example of Japanese art to stress the formal arrangement of color and shapes alone, also showed how the aims of Realism could be subverted.

By the 1880s the mood of Europe was ripe for widespread revulsion against the here-and-now and naturalism. The further reaches seemed to be attained when for example, French poets such as Stéphane Mallarmé retreated completely from life to mold the perfection of a handful of immensely refined poems. A key book of the fin-de-siècle is Huysmans' significantly titled *Against the Grain* (1884) in which the decadent anti-hero, Des Esseintes declares, "The age of nature is past; it has finally exhausted the patience of all sensitive minds by the loathsome monotony of its landscapes and skies."

Three of the main French Symbolist painters were Odilon Redon (1840–1916), Pierre Puvis de Chavannes (1824–98) and Gustave Moreau (1826–98). The "symbol" for them meant a visual analogy to the artist's inward poetic sensations. In the case of Moreau and Puvis de Chavannes all contemporary references were avoided in favor of obscure mythological and fantastic subjects. Redon, like Moreau, suggested the occult and depicted a twilight realm of strange sub-human creatures influenced by Darwin's ideas on the origins of life. As a whole, fin-de-siècle imagery is peopled by mythic and monstrous beings, and its most recurrent type is the *femme fatale* – from Rossetti's Pre-Raphaelite vamps to Redon's *Red Sphinx* (1913) – all of them, in some respects a sinister return to both the unattainable female of Romanticism and the whore who replaced her in the Realism of the mid-century.

In France a group known as the Nabis (Hebrew for "prophet") appeared in the 1890s. Some of its members followed Gauguin's example and adopted occult or mystical religious themes, but Édouard Vuillard (1868–1740) and Pierre Bonnard (1867–1947) chose to depict the intimate interiors of bourgeois Parisian life. In keeping with the fin-de-siècle taste for decoration, they also produced prints, posters, book illustrations and stained glass. Post-Impressionism taught them the value of sensuous color combinations, and from the Japanese print they took flat patterns and unexpected compositional techniques that helped imbue their commonplace subjects with a quiet, mysterious aura that owes much to Symbolism.

Outside France two important artists, the Belgian James Ensor (1860–1949) and the Norwegian Edvard Munch (1863–1944), were affected by Symbolism and created hugely powerful works that reflect the spiritual crises that troubled European society in the late 19th century. Both responded in their different ways to the estranged state of the sensitive artist in a hypocritical and mundane social framework. Ensor took the shimmering color and broken brushwork of Post-Impressionism and set it at the service of a bedevilled self that loathed both the vulgarity of the working class and the hollowness of petit-bourgeois culture. In the *Entry of Christ Into Brussels* (1888) we see Ensor's search for a genuine religious faith amid a Socialist parade and a *danse macabre* of masked and skeletal figures. Munch also evolved his flaming, impassioned style from a study of Post-Impressionism and applied it to the themes of anxiety and doubt that philosophers such as Friedrich Nietzsche and Søren Kierkegaard had discerned as the plight of modern man, a spiritual soul set adrift in a materialist hell.

Late 19th century sculpture

The bulk of sculpture created during the 19th century reflects the desire of the age to see itself perpetuated in a monumental, lasting form. Funerary and civic sculpture flourished as never before in the Victorian period; the heroic, prestigious and the merely wealthy all wished to be recorded in stone and metal for the present and for posterity. Buildings required sculpture not just as decoration to emphasize their importance, but to instruct about their function; for example, the busts of famous artists who usually adorn a typical 19th-century museum. Despite the second place that sculpture took to painting in the academies of the time, it became the ultimate public symbol, epitomized in the Statue of Liberty. Yet the sheer popularity of sculpture, not surprisingly, eroded artistic standards and the large audience it had to reach reduced style too often to an issue of dull, acceptable naturalism.

At first, a strong dependence on official commissions made it risky for sculptors to emulate the abrasiveness of Realist painting and ideal or conventionalized nude figures continued to be staple academic fare well into the 1870s and 1880s. In a specialized field such as tomb statuary the situation was different in that vivid details could drive home the facts of mortality and the noteworthy characteristics of the departed.

Realism, Impressionism and the Industrial World

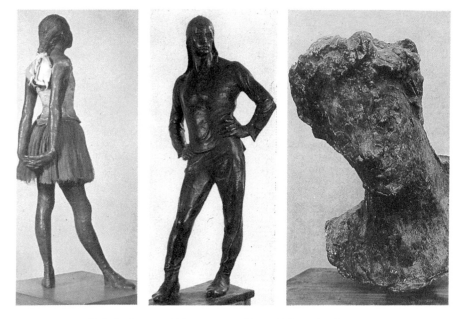

Fourteen-year-old Ballet Dancer, *1881*
Edgar Degas (1834–1917)
Bronze, height 39in (99cm)
Tate Gallery, London

Porter, c.*1900*
Constantin Meunier (1831–1905)
Bronze, height 90in (225cm)
Kunsthistorisches Museum, Vienna

This appealing, even elegant sculpture of a child dancer in a gauche posture reveals Degas' aristocratic sensitivity and his considerable ability to capture movement and activity. His figures contrast and complement the sturdy forthrightness of the realist figures of Constantin Meunier.

Meunier's earlier work had been of religious subjects painted in a traditional academic style, but in the late 1870s he became preoccupied with the mining and industrial country around Liège. Towards occupied him for the rest of his life. Towards the end of his life he proposed a great monument to labor which was later erected in Brussels.

Yvette Guilbert, *1894*
Medardo Rosso (1858–1928)
Wax over plaster. Height 16¼in (41.3cm)
Galleria Nazionale d'Arte Moderna, Rome

The work of Medardo Rosso is often described as "Impressionist sculpture", though not directly connected with the Impressionist group of painters, because of the fluid, semi-abstract style that, unusually for sculpture, seems to refuse to focus on specifics of form. Between 1884 and 1895 Rosso worked in both Milan and Paris. His work had a profound effect on Rodin and is thought to have later influenced Rodin's approach to his modeling of the figure of Balzac. Rosso's portrait sculpture of Yvette Guilbert was made at the start of her singing career in Paris. She was working at the Théâtre d'Application, an experimental theater nicknamed La Bodinière, where in 1893 Rosso put on an exhibition of his sculptures in the foyer.

Some of the more overstated touches occur among the numerous funeral monuments found in France, England and, especially, Italy. By the 1880s, however, not only death but also the worker – another cornerstone of pictorial Realism – was such a topical issue in European society that even mainstream sculptors were finally prepared to commemorate him in a contemporary rather than antique guise. The Parisian laborers of Jules Dalou (1838–1902) and the miners and dockers sculpted by the Belgian Constantin Meunier (1831–1905) are belated responses to themes established thirty years previously by Courbet and Millet. These stocky models, sometimes captured in the midst of their occupations, are a sincere break with Salon mythologies and the ruling classes usually ennobled by the public statue. Yet although Dalou, Meunier and others brought democracy into the scope of their profession, it was hard for them to escape the conservative idioms in which they were trained.

Only a few disparate artists appear to have created sculpture of real importance and interest in the second half of the century. Edgar Degas translated his preoccupation with the movements of the human body into a series of wax studies of dancers and nudes that revitalized the vocabulary of naturalism. There is a freshness and desire to eliminate outworn conventions here that recalls the vivacious portrait busts done by Daumier in the 1830s. In both instances the function and qualities of the sketch have been carried over into a tangible, three-dimensional medium. The Italian Medardo Rosso (1858–1928) pushed sculpture even further toward the fluidity of painting in his studies of individuals and groups that suggest the Impressionists' concern with the dissolution of matter when seen through the shifting veils of light and atmosphere.

321

It was left to Auguste Rodin (1840–1917) in France to link the great sculptural achievements of the Renaissance and Baroque eras to the plastic revolutions of our own century. Insofar as he imbued the structure and surface of his figures with a passionate life and energy, Rodin was a realist. Yet he also experimented with ideas such as the fragmented body, rough, unfinished modeling and the representation of violent action that were to emerge as major themes in modern sculpture. The mood of his work was nonetheless very much of its time. The *Balzac* (commissioned in 1893) is a public monument to the hero of Realism; the *Gate of Hell* (commissioned in 1880) recalls the interweaving patterns of Art Nouveau and many of Rodin's figures are symbols of spiritual states. Rodin gave physical form to many of the best tendencies of his period and for the most part avoided its worst excesses, although he remained a modeler in clay rather than a carver of stone. Through his searching, inventive approach he managed to cast a powerful influence over a wide variety of later sculptors.

Balzac, *1897*
Auguste Rodin (1840–1917)
Bronze: height 118in (299.7cm)
Paris

Rodin's long involvement in the creation of a monument to the writer Balzac was the stormiest episode of a controversial career. Commissioned by the Société des Gens de Lettres, the sculpture was originally intended for erection in front of the Palais Royal in Paris. In 1891 Rodin traveled in the region of Tours, the writer's birthplace, making clay sketches of anyone he could find who bore a good resemblance to Balzac. On his return to Paris he worked on nude and clothed studies for the figure. After 1893 he developed the idea of using a draped robe, a reference to Balzac's habit of working swathed in a heavy dressing gown. Rodin's first contract had agreed delivery of the sculpture by January 1893. Rodin eventually settled on the idea of a robed figure and himself produced a four-foot (120cm) model, enlarged by his assistants to full size, but this plaster version of the work was not finally exhibited until 1898, when it was shown at the Paris Salon. It caused an outcry. The progress of the sculpture and the controversy surrounding the commission was already a favorite story in the press and at its height almost eclipsed public interest in the Dreyfus affair. Following the unveiling of the sculpture, which was not approved by any of those officially concerned with the commission, Rodin was ridiculed by public and press; small plaster caricatures were sold on the streets outside the exhibition. Rodin had been completely dedicated to the project. He had made seventeen major studies and called the Balzac "the sum of my whole life, result of a whole lifetime of effort, the mainspring of my esthetic theory": Rodin removed the work from the exhibition after the public fuss and took it to his home in Meudon, outside Paris. His defence to the Société declared that the Balzac was "none the less in the line of demarcation between commercial sculpture and the art of sculpture that we no longer have in Europe. My principle is to imitate not only form but also life". The affair won Rodin extra support from his admirers and many fellow artists, but criticism was extremely harsh from many other quarters.

The Gate of Hell, *1880–1917*
August Rodin (1840–1917)
Bronze 248×57in (600×142.5cm)
Musée Rodin, Paris

Rodin first gained patronage in 1880 when, in spite of the outcry against his Age of Bronze (1876) – a standing, life-size male nude exhibited at the Salon in 1887 that drew the bizarre accusation that it had been cast from life – the French government asked him to design a large bronze door for the proposed new Museum of Decorative Arts. The Museum was never built, nor did Rodin ever finish the door, but it lies at the very heart of his life's work. From its 186 figures sprang most of the large sculptures for which he is famous, none more so than the Thinker (1888), found in embryo here as the huge figure of the poet, Dante, who sits on the lintel at the top and muses upon the swirling, tormented Inferno beneath him. It was from Dante's great epic that Rodin gained the inspiration and the title for the door. The range of emotions depicted in it and the sureness of its technical handling recall the power of Michelangelo, whose work Rodin saw on a visit to Italy in 1875 and of which he said that it effected his "liberation from academicism".

Architecture in the Industrial Age

The development of architecture in the 19th century can be viewed as a contrast between the revival of earlier styles and the quest for new types of expression. Despite the enormous technical inventiveness that had altered the entire face of European society since the advent of the Industrial Revolution, no comparable transformations had taken place in the architectural field by the middle of the century. It is therefore not surprising that when change finally arrived it was due predominantly to the pressures exerted from the outside by sociological and technological progress. In the 19th century industry and population had expanded as in no other epoch in Western history, and they required buildings and constructions different from anything previously envisaged. Stations, steel bridges, mammoth exhibition halls and skyscrapers were all triumphs peculiar to the time. Often they were realized with such assurance, grace and power that by the end of the century it seemed as if, perhaps, one of the greatest achievements of the age was to have raised engineering to the status of architecture.

By 1850, however, architecture was yet to be revolutionized from without. Blatantly functional structures such as bridges and factories were still a task for engineers, and "true" architecture was the province of comparatively important buildings that demanded a "style" rather than the mere structures determined by their use. Since the age had so far invented no new styles, the available choices had to include a revival of traditional ones, and therefore the term Revivalism. Because each style had its particular champions, the Battle of the Styles ensued.

In both Victorian Europe and the United States every style told a story. The Baroque, for example, spoke of opulence and ostentation, expressed in hedonistic edifices such as the Paris Opéra, built during the Second Empire. In the United States, Classicism was associated with Greece and therefore admirably suited the Capitol (1835) of a burgeoning democracy. Gothic was deeply rooted in the splendors of English faith and Tudor prosperity and was therefore chosen as a national style for the new Houses of Parliament, begun in 1840. The spread of the Gothic Revival in England after this date inevitably caused considerable speculation and controversy about the implications of the style and revealed a great deal about the aesthetic attitudes of Victorian society.

To A. W. N. Pugin (1812–52), a co-designer of the Houses of Parliament, Gothicism was a symbol of Christianity, as opposed to the inherent paganism of Classicism. Consequently, morality was a force present from the start of the Victorian interpretation of architecture. This approach was developed in the influential theories of John Ruskin (1819–1900), who extended it to the criticism of society itself. For Ruskin industrialization, with its hideous effects on design, environment and man, called for an antidote that he thought could be found in a renewal of the study of nature and a return to the supposedly unforced labor and noble creativity of the Gothic era.

Ruskin's theories found their practical application in William Morris (1834–96) and the Arts and Crafts movement, where they naturally mingled with socialism – another response to the degrading effects of industrialism. Morris taught the value of an approach to craftwork that respected simplicity and the qualities of the material involved. In the Red House (1859–61) that Philip Webb (1831–1915) built for Morris these principles bore their first architectural fruit. Against the bombast of the moment it represents a predominantly unorna-

The Crystal Palace, *1851*
Sir Joseph Paxton (1803–65)
Cast iron and glass
Sydenham, London (now destroyed)

Paxton's original design for a glass conservatory to house the collection of the forthcoming Great Exhibition of 1851 was first sketched on blotting paper during a business meeting in June 1850, where he was representing his employer The Duke of Devonshire. A competition had been set up by Prince Albert to find a design for the building, but no suitable ideas were discovered by this method. Paxton's sketch was presented at Buckingham Palace and immediately accepted; work began in July and by January 1851 the building was completed ready for the exhibition.

mented, direct conception that looks back to the homely relationship between a building and its setting found in the English vernacular of manor and cottage, and to the popularity of the cottage-type residence and garden suburb which began in late Victorian times and continues today.

Nevertheless, industry thrust deeply into Victorian architecture, especially in the new materials and construction techniques that it made available. The industrial products shown at the Great Exhibition of 1851 themselves demanded a housing structure of unprecedented size admitting maximum light. The solution was Joseph Paxton's Crystal Palace, a landmark in rapid engineering procedures and the introduction of new materials – iron and glass. Slightly later, in France, Henri Labrouste (1801–75) erected the vaults of the Reading Room

of the Bibliothèque Nationale in cast-iron. After the invention of the Bessemer process in 1855 steel became invaluable for those great constructions that still stand as monuments to the age, such as the Brooklyn Bridge (1869–83), Eiffel's viaducts and his Tower (1888), and the vaults of the Victorian railway stations, commanding and fixed across an ever-sprawling London like the fingers on an open palm. In London's King's Cross (1851–2) and St Pancras (1865) stations are embodied two contrasting worlds of 19th-century architecture. Both serve similar needs but the first reveals its function with a bold facade announcing the vaults behind, while the second screens them in the towering shrine of a neo-Gothic hotel. It was, ironically, the earlier functional answer that anticipated one mainstream of modern building, a path that was to be epitomized pre-eminently in the progress of the skyscraper in the United States and, specifically, Chicago.

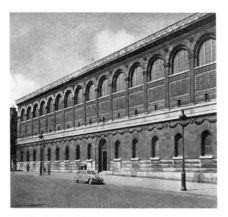

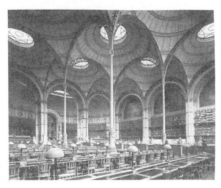

Bibliothèque Nationale, *exterior and Reading Room, Paris, 1861–69* Henri Labrouste (1801–75)

When Labrouste came to design the reading room of the Bibliothèque Nationale, he was an experienced architect who had already, in the Bibliothèque Sainte-Geneviève (Paris, 1845–50), built one of the first noteworthy buildings of the Age of Iron. Although the conventional masonry of its Neoclassical exterior clothed the metal structure, inside the ironwork of the vaulting was exposed. With the Gare de l'Est (1847–52) it ranks as one of the two early triumphs of French iron-and-glass architecture. In the reading room of the later period, Labrouste used the new materials to even greater effect. Its many light domes, supported by slender iron arches and columns, and its four stories of metal book stacks, with grid-iron floors to allow light to pass from one story to another, were a demonstration of the elegance and grace that metal-framed architecture could achieve.

The Eiffel Tower, *Paris, 1889* Gustave Eiffel (1832–1923)

Eiffel was an engineer, not an architect, and his tower for the Paris Exhibition of 1889 is not really a building. When he came to design it, he already had experience in working in metal and the structure of the tower is based on his earlier efforts – the Douro bridge (1875), the Garabit viaduct (1884) and the pavilion for the Exhibition of 1878. What distinguished Eiffel from most of his contemporaries in the Age of Iron was his readiness to leave the metalwork visible. By contrast, as late as 1893 the metal buildings at the Chicago World Fair were cased in real or artificial masonry facades. Eiffel's decorative flourishes in an Art Nouveau style rarely came off; the curved arches, of no structural function, that link the four pylons at the base and the barely visible ornamentation elsewhere contribute little to the beauty of the Tower, whose effect derives from its sheer height and the graceful continuity of its curved outline. Although the Tower, rising to 984ft (323m), was the world's tallest tower until the building of the Empire State Building nearly half a century later, in one important respect it looked backward rather than forward: it was made of wrought iron, which was already being replaced by steel, the primary material of the Skyscraper Age, about to be born.

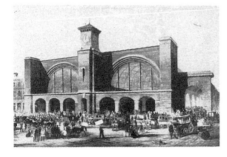

King's Cross Station, *London, 1851–2* Lewis Cubitt (1799–1883) Brick, glass and wood

Cubitt had already designed a large rail terminal for the South Eastern Railway in south London when he was commissioned to work on the fifth main London station for the Great Northern Railway. While there was already a temporary terminal, in 1851 the railway board acquired the right to build a permanent station at King's Cross on the site of a former smallpox hospital. Cubitt followed the same type of plan used for the earlier terminal: a screen frontage of masonry built across the passenger sheds.

Chicago was a classic instance of the urban explosion of the 19th century and the new architectural requirements that it demanded. In 1831 there was a fort with a few log cabins at the mouth of the Chicago River; by 1900 Chicago had almost two million inhabitants and a welter of unprecedentedly tall buildings that marked the recognition of steel and glass as respectable materials. In the intervening years a city in an entirely modern sense had come into being, a focus for transcontinental railways, commerce, industry and a spiraling populace, located between the agricultural Plains, the waterways of the Great Lakes and heavy industry to the east. A fire in 1871 had razed most of the old town and provided free rein for a new metropolis rising from the order of a grid plan.

Some of the earlier buildings in the rebirth of Chicago displayed a Revivalist approach, but with a difference. H. H. Richardson's Trinity Church, Boston, for example, adopted the Romanesque style, and his influence in the study of solid forms and use of colored stone, struck a new note. Richardson's innovative approach influenced Louis H. Sullivan (1856–1924), the genius of what became known as the Chicago School of Architecture. Sullivan was not the first to employ a steel frame, rather than masonry-based construction, as the strongest method for creating the high buildings necessary to contain an expanding business workforce accompanied by rising land prices. He did, however, bring a brilliant logic and refinement to the demand to build vertically. Sullivan stressed that "form follows function" and his works beautifully express his doctrine, turning the outdated masonry wall into a curtain of glass held within the stability of an underlying steel grid. After Sullivan the marriage of engineering's precision and the traditional harmony of architecture ceased to be one of convenience

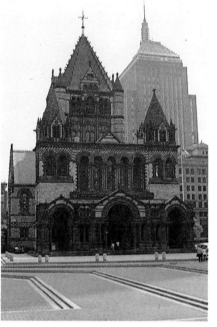

Trinity Church, *Boston, 1873–77*
Henry Hobson Richardson (1838–86)
Pink granite trimmed with brownstone

Richardson's design for the Trinity Church in Boston gave him his second success in architectural competition, his first being the commission for a State Hospital at Buffalo, won in 1870. The tower of Trinity Church was, at Richardson's own suggestion, modeled on that of Salamanca Cathedral and this gives the building its Romanesque character, although the influences of other styles can also be detected. The accepted notion that Richardson was responsible for a Romanesque revival style in American 19th-century architecture indicates only one area of his lasting influence. Richardson's reputation was confirmed by the building of Trinity Church and the design was taken as a model for church architecture in the United States for many years following. The structure illustrates the architect's preference for a heavy massing of forms, further expressed in the choice of stone as the material. The original plan also included stained glass made in the workshops of William Morris in England. Richardson was responsible for the main structure and character of the Church although additions, mainly decorative, were later made by other designers to the porch, chancel and western towers.

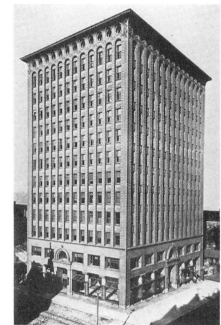

Guaranty Building, *1895 Buffalo, New York*
Dankmar Adler (1844–1900) and Louis Sullivan (1856–1924)
Steel frame, brick and terracotta

The partnership of Adler and Sullivan began in 1881 and they became important figures in the development of modern American architecture. Sullivan, having academic and practical training, was the originator of the aesthetics of their designs while Adler, trained as architect and engineer, made the major contribution to administration of the practice and was able to solve the technical problems of increasingly complex construction methods. Multi-story building had already been established using masonry construction, but in Chicago in the late 19th century architects such as Adler and Sullivan began to make full use of building techniques using a load bearing metal frame, following the pioneering work of William Le Baron Jenney (1832–1907). Sullivan's basic tenet was that "form ever follows function". In his design of the exterior he marked the changing functions of successive levels, the broad area for reception and shops on the lower floors, the unbroken line of offices rising above, topped by the service areas directly below the roof with rounded windows breaking the pattern of the façade.

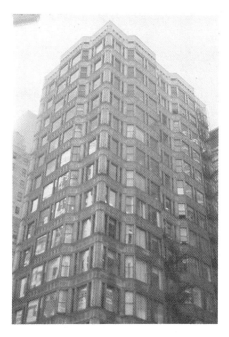

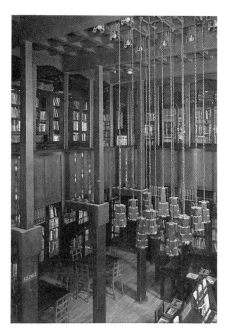

The Reliance Building, *1890–95, Chicago, Ill.*
Daniel Burnham (1846–1912) and John
Wellborn Root (1850–91)
Steel piers sheathed in terracotta, glass

Within a year of first working together as
draftsmen in a Chicago architectural practice,
Burnham and Root formed their own
partnership in 1873. Their collaboration was
complementary, like that of Adler and
Sullivan, in that Root preferred to remain
fully occupied with designing the buildings
while Burnham took responsibility for dealing
with clients and managing the business. In
1889 they designed the Monadnock
apartment building in Chicago, the last tall
building to be made with load-bearing
masonry. In the Reliance Building, however,
the exterior was designed around a steel
frame; Root was keenly aware of the
relationship of design and new construction
methods: "So vital has the underlying
structure of a building become, that it must
dictate absolutely the general departure of
external forms".

The Glasgow School of Art, *1896–1909*
Charles Rennie Mackintosh (1868–1928)

Mackintosh was only twenty-eight when he
won the competition to design the new Art
School in Glasgow in 1896. The committee
asked for a "plain" building. It got what it
asked for: a building so soberly geometrical
in its almost unbroken lines and uniform
windows that it became one of the most
notorious and celebrated buildings of the
dawning Modern Movement in architecture.
The main part of the building, of square-cut
stone, iron and plate-glass, was built
between 1896 and 1899. The designs for
the west wing, containing the library, were
made in 1907 and the addition was
completed in 1909. The library bears traces
of Art Nouveau, which Mackintosh, more
successfully than any other architect of the
period, had a few years earlier brought to
the design of the interiors of two Glasgow
tearooms. But even here the glitter and the
feeling for space that is the hallmark of
Mackintosh's style is, despite Art Nouveau
details on the balustrades, a matter of straight
lines and unyielding right angles.

and became an ideal for our century.

Sullivan's reply to the problem of what to do with decoration was to confine intricate iron filligree within the predominantly austere framework of his facades. At the same time in Europe these curves and spirals were being allowed to take over almost the entire surface of buildings. In typical Art Nouveau works, such as the houses, stores and hotels of Brussels designed by Victor Horta, ornament, far from being restrained, became the essence of architecture. This approach was taken to its limits in Spain by Antoni Gaudi (1852–1926), who drew upon many different styles, especially Gothic and Islamic, to fashion a personal idiom that resembles Art Nouveau in its overwhelming decorativeness and organic inspiration. Beneath Gaudi's fantastic undulating surfaces there in fact lies a profound understanding of structural design. This was shared by another European architect who extracted from the premises of Art Nouveau works that would be seen as a new spirit in architecture – the Scotsman Charles Rennie Mackintosh (1869–1928).

For his most important commissions Mackintosh, whenever possible, assumed command of every aspect of design from the basic plan to the smallest details of decoration and furniture. In the great façades of the Glasgow School of Art (1898–1909) Mackintosh combined glass and stone as though they were the masses of some abstract sculpture. On the outside decoration is confined to slender wrought ironwork, and within, especially in the famous Library, it takes on a highly modern, geometric quality inseparable from the design of the room itself. The School of Art remains among the earliest and certainly most successful responses to that search for a balance of functional structure and visual beauty that began in the first stirrings of the machine age and continues to motivate architects today.

The Modern World

The 20th Century

To any educated person living at the end of the last century it must have been obvious that the future would see extraordinary changes in the fabric of Western civilization. Predictions about the form it might take became popular in the years up to 1900 and were fostered by the seemingly admirable and rapid increase of technological expertise. Enormous advances in engineering, for example, enabled writers to envisage the development of existing inventions such as the automobile and to anticipate others as yet unrealized, such as television and powered air travel. Even a new literary genre devoted to prophecies of the future – science fiction – emerged in this period and found a ready audience. Despite a few gloomy or dissenting estimates from wary intellectuals, the general attitude toward the coming age was therefore on the whole optimistic and, as 1900 approached, it appears that the last Victorians had little idea of the world they were so earnestly creating.

The death of Queen Victoria in 1901, however, sounded a symbolic knell. Although Great Britain enjoyed the height of imperial prestige, there were signs, most notably in the South African Boer War that ended the following year, that its position could not be maintained indefinitely without serious challenge or bloodshed. The nastiness of this war was tempered by the fact that, like almost all previous colonial conflicts, it was waged at a safe distance from Europe, even if the participants were no longer significantly divided into "civilized" invaders versus "savage" natives. At the same time, the rise of Germany began to suggest that imperialism could precipitate internal European rivalries as easily as remote wars of subjugation. The struggle for the control of the seas between these two nations soon became an arms race as each attempted to outdo the other's naval capacity. Politics were being shaped by the ominous demands of a military-industrial complex, and Japan's surprising victory over the Russian fleet in 1905 further proved that the sophisticated hardware of aggression could be successfully wielded by non-Western races. If such power was able to pass beyond old and once secure confines, then Europe's days at the political center might be numbered.

Yet as long as a preeminence of Western cultural attitudes continued, combining a basic belief in progress with a sense of superiority and a clear lead in technology to support the idea of progress, the West could continue to view itself as an overall guiding force of civilization; a small part of the globe with a monopoly of intellect and undimmed cultural vitality. In this respect there had been few disruptive challenges from half-savage or exotic races, for science and learning continued to represent supreme monuments to European integrity, despite the growing weight of the "white man's burden" in other spheres. As scientific knowledge and its train of inventions proliferated on an ever-widening front in the early part of this century, it looked as though the promise of man's absolute control over his environment, which began with the Industrial Revolution, was within sight of fulfillment; Victorians from Marx to Darwin had declared that environment was the key to the success of society and man.

If such thinkers now appear to have come close to being false prophets, we should remember that at no other time in human history has our ability to understand and regulate the world equaled the past hundred years. The spread of electrical power and of every method of communication from the telephone to the satellite, the development of versatile means of transport, the capacity of industry to produce on an undreamed-of scale through mechanized assembly-line techniques and to dominate the land by agricultural prowess have all changed material existence beyond recognition. The very span of man's life and his relationship to suffering and death have been transformed in this age by discoveries in medicine and chemistry.

While the winds of change brought progress without tears, there was little suspicion that every gain over resources, time and existence might be a Faustian bargain that would carry its particular hell in the wake of its rewards. In 1903, when the first powered aircraft was flown by the Wright brothers, who at the time imagined that this achievement would become the scourge of life in Guernica, Dresden or Hanoi, as well as affect the habits of world unity? Did discoveries about the structure of the atom at first presage a bomb capable of world annihilation? When Henry Ford introduced the conveyor belt to his factories in 1913, was it rejected as a soulless threat to the more human aspects of work? The history of the 20th century demonstrates that human expectations have never been raised to such heights – nor been so damaged by progress.

By the turn of the century religion was already a casualty of progress, and finished as one of its ultimate victims. The assault on spiritual faith launched by the down-to-earth certainties of materialism was given an unexpected twist with the scientific upheavals of the new era. In the last resort many could still discern the actions of a god of sorts, albeit thoroughly rational and de-mythologized, behind the stable laws of natural evolution, Marxism or the old physics. Yet within a mere thirty

years or so after 1900 even these secular convictions were permanently unsettled.

The Viennese psychologist Sigmund Freud had proposed compelling arguments to suggest that mysterious, irrational forces from the depths of an unconscious previously barely acknowledged were active in human behavior and the formation of social structures. His theories seemed to be reinforced in 1914 when self-destructiveness convulsed the "civilized" West and the veneer of culture disintegrated into the brutish absurdity of bloody aggression. To some philosophers of the period as well the moral laws that had sustained the Victorian age no longer looked self-evident or unquestionable. The English philosopher Bertrand Russell saw absolute truth only in the abstract propositions of mathematics; the influential Austrian thinker Ludwig Wittgenstein found it in the forms of communication rather than the physical world; and for the American philosopher William James truth was simply what "works" for us in our everyday lives. Rational scepticism or outright disbelief shook the long established climate of confidence.

Even matter was reeling under the impact of a scientific revolution unequaled since the transition from the medieval world-view to that of the Renaissance. The Austrian physicist Max Planck had demonstrated that energy did not really move in continuous forms but in weirdly irregular packets, or "quanta", that are apt to consist of mysterious, unpredictable particles. After 1925 his successors in quantum mechanics abandoned completely the venerable picture of the atom as a tidy, reassuring whir of orbiting bodies. In fact, it appeared that matter was largely composed of nothing whatsoever and the speed of a sub-atomic particle such as the electron could never, for example, be deter-

mined simultaneously with its position, as the nuclear physicist Werner Heisenberg claimed in his famous "indeterminacy principle" of 1927. Reality was receding as science advanced, undermining the foundations on which the great minds of the past had built.

The central figure of this revolution was, of course, Albert Einstein. In his *Special Theory of Relativity* (1905) he had altered a view of the universe that had prevailed since the age of Newton. According to Einstein, space and time were not absolute, fixed frames of reference: they were entirely relative rather than independent of one another. The shock of Einstein's discoveries lay in the subtle but enormous shift they caused in the idea of reality. There had been previously an undeniable reassurance in the concept that basic categories such as space and time were somehow regular and unchanging, existing outside of us, for ever and always, rather like God himself. But Einstein exposed this as only one way of looking at space and time, not a statement of how they actually are. It is more accurate to say that both flow together into a fourth-dimensional continuum. Space is not really rectilinear, an hypothesis almost universally assumed since Euclid, but curved; and time can slow down under certain circumstances, for example, when a body approaches the speed of light.

If the strictly scientific implications of Einstein's researches were vast, at the less specialized, popular level their effect proved equally radical. For many educated people "reality" before and after Einstein and what he came to symbolize was quite simply "different". Although there still might be a god behind the baffling cosmos of post-Einstein science, he had become a far stranger and more remote presence.

From the beginning of the 20th century the hopes and passions once attached to religion were seriously in

decline and faith in progress was further emasculated by two World Wars. How and where did spiritual aspirations continue to find expression? In the West it appeared that they were frequently shifted to the field of art and culture, while throughout the globe political ideas sought, and often gained, people's attention. Disillusion with the existing order of things has repeatedly caused modern art to transform or destroy old conventions with fervid expectations being aroused in some novel reality, a millenium or alternative to replace the dullness and failings of the present. Dissatisfaction, however rooted in economic exigency, has played a large role in the fascist revolutions in Europe and the socialist uprisings of Russia, China and the Third World. A common thread of utopian dreams and their aftermath can, perhaps, be traced in modern history, appealing to architect and politician, to both the informed elite of the West and the scarcely literate masses of the East. It is significant that in recent times propaganda – that curious hinterland that transforms the messages of politics and commerce into a palatable guise – has become perhaps the most all-encompassing type of discourse. We meet its blatant, persuasive tone in the gargantuan monuments of Communism and, far more subtly, in the manifold images of our own media and advertising.

The sheer complexity of events during the last eighty years, and the range in our awareness of what can be achieved, both in terms of destruction and creation, have been reflected in the changing microcosm of 20th century art. Its graphic scope is illustrated in the rise of the cinema, a new art form whose massive audiences compare only with those once gripped by religion. Like religion too, the symbols of the film world exert an almost overwhelming hold on the popular imag-

ination, and they required at most a few decades, not centuries, to work their spell. The speed with which the sophisticated techniques of the cinema – its reorganization of time and space through editing, close-ups and other devices – have been assimilated at all levels of society is another measure of the urgency behind modern culture.

However, this always had its less tasteful side and in the last century the masses were already responding to the growth of a kind of "low" art, today termed *kitsch* (meaning, approximately, "in bad taste"). In the cheaply printed reproduction, the penny-thriller or romance and the music-hall song were the germs of what would evolve into television, paperbacks and pop music – doubtless epidemics, yet thoroughly vital, inventive and addressing what some have likened to a "village" of almost global proportions that signifies their democratic origins. It is revealing of our era that photography, in essence a mechanical technique, should have been, on the one hand, raised to a refined art of observation, and, on the other, lowered to the accessibility of anyone within reach of a newspaper or an inexpensive camera.

The restless, searching mood of modern art has been the motivation behind its many attempts to challenge or transform reality; efforts that by turns have disclosed singular strengths and foibles. The totalitarian consequences of revolution, whether from the Left or the Right, have exposed the vulnerability of artists at the hands of the State. When deprived of the comparative freedom of bourgeois democracy, their personal funds of creativity have usually withered or been annulled from outside. But modern artists – from Salvador Dali to Mick Jagger – have been especially active in their efforts to subvert the social order in the name of higher principles, greater freedom or plain old bohemianism. Like the Surrealists of the 1920s and 1930s, who demanded a crisis in consciousness but were unable to weather the political currents of their day, they may sometimes confuse the limits of artistic independence with what can be expected from society, bound by its rules and transcending them only through imagination in paint, sound or print.

Although modern artists may have been thwarted when their aims became too ambitious, their revolutionary zeal still guaranteed incessant conflict on their own ground with established norms and traditions. In music, for example, since 1900 we find alternatives in the so-called atonal sound patterns of a Schoenberg or jazz improvisation to the entire system of harmony and rhythm that has been its time-honored language since the late Renaissance. Literature has witnessed huge transformations in the novel, beginning with writers such as James Joyce, whose *Ulysses* (1922) and *Finnegan's Wake* (1939) dispensed with traditional conceptions of plot. Poets, such as Ezra Pound and T. S. Eliot, were only the first of many to question the structure of poetry by using words to conjure sequences of images and associations rather than to unfold any strict narrative.

Possibly the most momentous of these breakthroughs came when Western painting ceased to mirror the external world. This was accomplished through the use of abstraction, the term used for images having no visible equivalents in what we see around us. Sculpture also abandoned ancient conventions in the pursuit of new materials and subjects, redefining ends and means that had gone unquestioned since the Classical era. Nowhere was this search for forms that would be at one with the mood of the times more acutely experienced than in modern architecture. In this century the architect has sometimes had to assume the role of social engineer, planning new cities and programs of existence and reducing buildings to "machines" to serve the needs of society.

The logic that led to atonalism in music, abstraction in literature and painting and unornamented buildings has been placed under the heading of Modernism to denote a conspicuous trend within the entire sweep of modern art. Although modern art has proved enormously important, and rich and diverse in masterpieces, it should be remembered that it does not necessarily include all art done during the modern period. Revolt creates its own orthodoxies and there have been many dissenting voices that belong neither to blind traditionalists nor artistic defectors from the present. Pablo Picasso never abandoned the use of figuration and for this was hotly attacked by modernist advocates. For other experimentalists, such as the Soviet film director Sergei Eisenstein, there have been conservative counterparts, such as the American director John Ford, who, although he did not break new ground, magnificently exploited the Hollywood convention that he accepted without question. Finally, even if Modernism once represented a powerful vanguard, the fact that it has also been the target of bewildered rejection by the layman perhaps implies that it contains meanings yet to be deciphered and styles requiring study and understanding within a broader perspective. As we reach a point where an escalating rate of change confronts every aspect of our lives, the need for such a backward glance is perhaps more urgent than ever before.

The Early Art Movements

Fauvism

The arts of the 20th century suffered a slightly belated start because for the first years after the turn of the century the aesthetic climate of Europe and the United States was still dominated by the standards of the *fin-de-siècle*. Elegance, taste and refinement remained highly-prized qualities, not only in the art nouveau style, which continued to influence architecture and design, but also, for example, in the exquisite harmonies of Symbolist painting and the polished prose of a novelist such as Henry James. This is felt equally in the languishing characters of Anton Chekhov's plays and the yearning anguish of Gustav Mahler's last symphonies. When such a degree of sophistication is reached, there is usually some inevitable loss of momentum and verve. One of the first signs of a new and aggressive attitude came in painting with the birth of the movement now known as Fauvism.

When a critic at the Paris Salon d'Automne of 1905 saw a room in which a classically styled bust was surrounded by the paintings of Henri Matisse (1869–1954) and his colleagues, he exclaimed, "Donatello among the wild beasts" (*fauve* is the French word for "beasts"). The half-serious remark stuck and the work of Matisse, André Derain (1880–1954) and Maurice Vlaminck (1876–1958) entered art history under the stylistic heading of Fauvism. The subjects of their art, however, were neither particularly wild nor beastial. Derain's *Houses of Parliament* (1905) shows exactly the scene chosen by Monet a few years earlier, yet its style is very different. Today, Fauvist paintings continue to impress us with their brilliant colors and the harsh, quick handling of the paint. This effect, however, is softened because our 20th century vision has long since grown accustomed to encountering every hue of the spectrum in the most common-

place of circumstances, from color television to the reproductions in this book. Eighty years ago bright tones were more a thing of nature than culture, and for people only just beginning to adjust to the high-keyed but comparatively sedate palette of Impressionism, the Fauves' use of color must have seemed outrageous.

The origins of Fauvism lay in the unnatural colors chosen by Gauguin; the fiercely impetuous technique of Van Gogh (at whose 1901 Paris retrospective Derain had introduced Vlaminck to Matisse); and the fragmented strokes used by the Divisionists. These artists and others exploited to the full the strong, synthetic pigments developed from the coal-tar industry of the mid-19th century, sometimes applying the paint in heavy layers straight from the tube as though it had a vitality that did not warrant the intervention of brushes. By 1906 the Fauve movement approached a point that made even works such as Derain's *Houses of Parliament* look timid. Color schemes reached a pitch of wild frenzy with trees turning scarlet and chrome, shadows pure ultramarine blue and compositions that were frequently conceived as heavily flattened designs. In Fauvism we sense a delight in raw sensation, a kind of calculated barbarity that anticipates the earthy dynamism that would soon feature in the early music of Igor Stravinsky and the novels of D. H. Lawrence. Of this period, Derain later wrote that "No matter how far we moved away from things . . . it was never far enough. Colors became charges of dynamite. They were supposed to discharge light. It was a fine idea in its freshness, that everything could be raised above the real." In their explosive emotional qualities the Fauves were heir to Post-Impressionists such as Gauguin and Van Gogh. Their attempt to "raise painting above the real" was the first

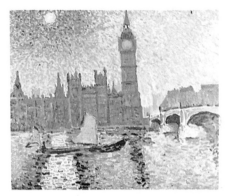

The Houses of Parliament (Big Ben), *1905*
André Derain (1880–1954)
Oil on canvas 31⅛×38⅝in (79×98cm)
Private collection, Troyes, France

André Derain and Henri Matisse first worked together as students at the Académie Carrière. In 1905 they spent some time together painting in the south of France and later that year were leading figures among the group of painters exhibiting at the Salon d'Automne in Paris who were given the name Fauves ("wild beasts") for their uninhibited use of color and energetic brushwork. Derain's first trip to London was also in 1905 and this painting is one of a series of London views in the exaggerated colors typical of Fauvism, although Derain's commitment to this style was short-lived. The paintings of London were probably commissioned from Derain by the art dealer Ambroise Vollard as a complement to an earlier London series by Monet. These had been the subject of a successful exhibition arranged by Vollard in 1904.

of many 20th century efforts to establish the primacy of color and free it from the limitations of the natural world. Nowhere was this liberation more subtly or pervasively expressed than in the work of Henri Matisse, Matisse was involved with Fauvism throughout their short life-span and then continued on his own path to pursue a career comparable only to Picasso's in its length and exuberance. Unlike Picasso, however, Matisse remained the most prudent of revolutionaries, seemingly unruffled by personal anguish or social unrest and secure in his knowledge of

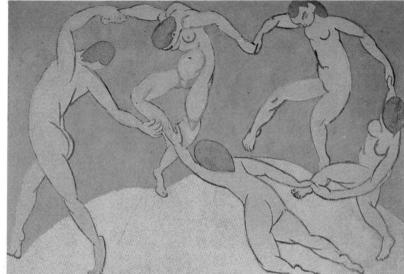

By the Seine, *1906*
Maurice Vlaminck (1876–1958)
Oil on canvas 21¼ × 25⅝in (53 × 63cm)
Collection of Guy Roncey, Paris

This typically Fauvist painting shows both the influence of Van Gogh and all the vitality of Vlaminck's nature.

what art should, and should not, achieve. For Matisse the sovereign value of art was its ability to convey those sensations most wanted, but too often most absent, from our ordinary lives; feelings "of balance, of purity and serenity", as he wrote in *Notes of a Painter* (1908). True voluptuousness without the burden of pretentious meanings was therefore the key to Matisse's luxuriant universe.

From the time of Matisse's early Fauvist landscapes of the south of France, the heart of this world was the Mediterranean and its associations: dazzling light, *joie de vivre* (the title of an important painting of 1906) and a delight in grace and beauty as ends in themselves. In 1910 these qualities were given unconventional form in two huge decorations for the palace of Serge Schchuchin, a wealthy Muscovite industrialist. The elemental themes of *Music* and *Dance* here represent an

absorption in primitive ecstasy, expressed through an equally basic language of outline and almost unmodulated fields of color. This "archaic" clarity Matisse was to refine at crucial points in his development, most strikingly perhaps in the compositions created from torn sheets of paper, (dyed beforehand) with gouache that the artist made when otherwise too ill to paint at the end of his life.

Matisse's complement to these expansive vistas was the modern ambience of his own Mediterranean rooms and studio with their elegant decor, female models and sunlit nature glimpsed beyond the bounds of a window or terrace. In these subjects he applied the lessons learned from a study of the intricate patterns of Indian and Persian miniatures and explored space through chromatic relationships rather than linear perspective. Matisse sought to recapture the exalted status that decoration had held in the East, for example, but too often lost in Europe, where it took second place to literary or anecdotal concerns. He showed that, at its finest, decoration may well amount to the essence of picture-making and does not need to be justified, glorying in its own renewal of invention. Through sheer resourcefulness Matisse avoided superficiality.

The Dance, *1909–10*
Henri Matisse (1869–1954)
Oil on canvas 102⅜ × 153⅝in (260 × 391cm)
Hermitage, Leningrad

The Dance is one of two paintings commissioned from Matisse by Sergei Shchukin as decorations for the large stairwell of his Moscow home. Following the original idea for the commission Matisse produced a study for The Dance and agreed with Shchukin to make a second large panel titled Music. In 1909 Matisse found his teaching activities in Paris were distracting him from his own painting and decided to move from the city. With his family he spent the summer at Cavaliere on the Mediterranean coast. He worked on preparatory figure paintings for the two panels, whenever possible taking his models outside to work. Also in 1909, he bought a house in the country at Issy les Molineaux and constructed a large wooden studio to house the large paintings. The Dance and Music were Matisse's only exhibits in the 1910 Salon d'Automne. They made a considerable impact and alarmed Shchukin, who thought they were not suitable for display in his home. He suggested that Matisse should retouch them or paint smaller versions of both subjects; these requests were refused by Matisse. Matisse had plans to visit Spain in November of 1910 and Shchukin Has to return to Moscow. At the last minute he agreed to accept the paintings and they were shipped to him on the artist's return from Spain, early in 1911. Later that year Matisse visited Moscow to discuss the hanging of the paintings, although it is not clear whether or not they were already in place.

Cubism

By the end of 1907 the Fauves' revolutionary use of color was largely complete, although it continued to exert a strong influence over succeeding generations of artists, not least through Matisse's prodigious career. Yet beyond the stunning tones there was something slightly traditional in even the most powerful Fauvist paintings. Their attitude to form and subject matter – largely confined to landscape, figures and a flattened, decorative space – was not unlike that of the more advanced later 19th-century artists. The world of 1907 was, however, a very different place. Already racked with social unrest – erupting in the violence of numerous political assassinations, bombings and the unsuccessful Russian Revolution of 1905 – its conception of time and space, as we have seen, would have been shaken as well by Einstein's *Theory of Relativity*. The cinema, with its irresistible immediacy, was proving a popular medium and newspaper photographs were becoming commonplace. Motorized taxis were on the streets of London and electric trains sped passengers along the subway networks of New York and Paris. The machine was affecting the life of even the ordinary person: he or she traveled faster, communicated over greater distances and learned of events with a speed impossible in the previous century. The world was smaller, more simultaneous, and life more complicated. Things were on the move and the shock of change found its artistic parallel in the advent of the movement called Cubism.

Like Fauvism, the term Cubism stemmed from the early and rather inaccurate descriptive remark of a critic. As a movement it was first ushered in by one artist and one painting: Pablo Picasso's (1881–1973) *Demoiselles d'Avignon*, begun at the end of 1906 and perhaps left unfinished the following year. Although this painting was not a true Cubist work, it initiated a revolution in the handling of space and form that flowered in the Cubism proper of the succeeding eight years. The *Demoiselles* startled Georges Braque (1882–1963) to such an extent that he dropped his Fauvist style completely and embarked on paintings in a radical new manner. What, in fact, was so extraordinary about the *Demoiselles*?

The painting originated as a relatively conventional nude scene representing the girls and male clientèle of a Barcelona brothel in the Calle d'Avignon. In the course of its development Picasso eliminated the men and any references to the evils of illicit sexual activity. It finished as a strange, alarming scene that reflects Picasso's impulse to break from not only the Western tradition of figure painting but also its entire mode of observation. Up to this date even Fauvism had clung to a not-too-distant and recognizable version of that ingenious way of recording the world from a fixed viewpoint that had been the continuing legacy of the Renaissance. According to the laws of traditional perspective, an illusion of solid forms in recession has to be created, but the *Demoiselles* is all density, all interaction yet without illusion. There is no recession, and "space" is created by flat, tangible wedges of color that jostle the masses of the figures. Indeed, they are now a compilation of surfaces rather than volumes and the overall effect might be likened to the facets created by a crumpled although unbroken sheet of aluminum foil. The image is, therefore, no longer the product of one fixed viewpoint, but a composite derived from different angles assumed by the artist. The substitution of African masks for ordinary heads on some of the figures further stresses the loss of Classical unity, since their simplified, hatchet shapes introduce primitive alternatives to Western ideals of beauty.

The art of Paul Cézanne also influenced Picasso's *Demoiselles* and the work that followed. Cézanne had inferred the existence of a type of geometric skeleton beneath the outward flesh of nature, and in his later paintings appeared to be translating this inner structure into a network of relations expressed by faceted brushstrokes. At times he also contradicted the principles of linear perspective in an attempt to render a more comprehensive account of a solid object than would be possible from a single stance. For example, a fruit dish might be shown almost in profile but with its interior depicted as if seen from slightly above. Such ideas deeply impressed Picasso and Braque, who sought ways of translating three-dimensional vision onto the flat picture plane without depending on the established devices of modeling and vanishing points. In the landscapes of Braque and Picasso from around 1908–9 we confront the very building-blocks of nature: severe cubes, cones and other masses that ascend the composition vertically rather than recede backward, as if all aspects of the scene were equally accessible to the painter's gaze. Since interest in structure is paramount, colors are simple and restricted. The idea of the painting as an imaginary stage set had finally gone; instead, its immediate reality as a flat surface predominates in an almost crystalline relief.

Between 1909 and 1911 Picasso and Braque, working in close collaboration, took their analysis of the pictorial syntax to an extreme, so that their approach during this period has been termed Analytical Cubism. Different sides of a form are included in one composition and thus the knowledge that the viewer's mind compiles from the information seen at successive points in time and space becomes part of the end result. This analysis led

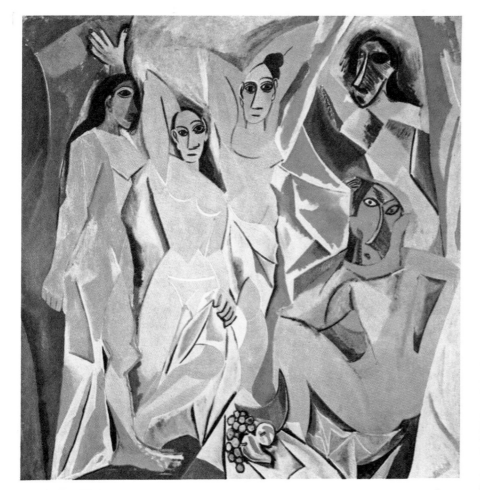

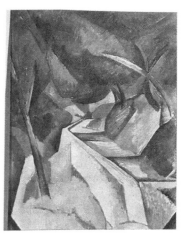

Landscape at L'Estaque. *1908*
Georges Braque (1882–1963)
Oil on canvas 31¾×25½in (81×65cm)
Kunstmuseum, Basle

In 1907 Braque, following the example of
Cézanne and Derain, went to L'Estaque,
near Marseilles, to paint in the Mediterranean
light. He was then in his brief Fauve-
influenced period and the 1907 painting of
the L'Estaque landscape has the violent
color-blocks of that School. In the interval
between painting it and starting the 1908
canvas, Braque met Picasso and saw the
Démoiselles d'Avignon. He quit the Fauvist
style abruptly and in 1908 produced the
paintings which led Matisse to coin the
word "Cubism". The painting shown here
announced several elements of the Cubist
style: a lack of surface depth, an absence of
foreshortening, the shifting perspectives of
geometric planes and a semi-monochromatic
palette. The change was not well received;
Matisse was a member of the jury that
refused all of Braque's submissions for that
year's Salon d'Automne.

Demoiselles d'Avignon, *1907*
Pablo Picasso (1881–1973)
Oil on canvas 96×92in (244×234cm)
The Museum of Modern Art, New York

During 1905 and 1906 Picasso worked on a
number of figure paintings and the nude
gradually assumed major importance in his
work. In March 1907 he acquired two
Iberian sculptured heads, and began to
include stylized motifs derived from them,
and from African masks and sculpture
seen in Paris, in his paintings and
drawings. Also in March he visited the Salon
des Independants and saw the boldly
executed nudes exhibited there by Matisse
and Derain. Two months later he started
work on this large composition, based on
sketches using the theme of a brothel. In
earlier versions Picasso included, with the
women, the figures of sailors and details
such as flowers and fruit. These were
discarded for the final version, except for
the small section of fruit remaining at the
bottom of the canvas. The painting was
finished by July 1907 and was seen at
Picasso's Paris studio by many friends and
acquaintances, causing a considerable stir
for its new treatment of the human form.
It was not exhibited publicly until 1916,
when it acquired the title by which it is now
known, a reference not to the town of that
name, but to a "red-light" district of
Barcelona.

to the disintegration of masses into a shifting irregular array of planes frequently connected, as in Braque's *The Portuguese* of 1911, by a supporting framework of lines around which floats a delicate ochre mist of brushstrokes. At this point Picasso and Braque faced a paradox. The degree to which they broke down recognizable forms meant that the subject of the picture nearly disappeared amidst the abstract, hidden structures they revealed. To afford glimpses of recognizable elements – sources not in art but in happenstance – fragments of stencilled words or numbers and convincingly drawn objects were sometimes added. These small clues pulled the imagery back from complete abstraction toward a suggestion of the everyday environment.

In a still-life of 1912 Picasso followed the next logical step and affixed to a painting a piece of oil cloth commercially printed to resemble chair caning. A bit of the "real" world was thus suddenly stuck onto art but, being *mock* chair caning, it was already a kind of painting in itself and an illusion meant to deceive. Braque and Picasso continued to utilize an increasing variety of such fragments, snippets of plain and textured papers, newsprint and so forth, making "collages" – an assembly of glued sheets (from the French *coller*, to glue). Subject matter now ceased to be broken down into tiny shards or facets; instead, a collage such as Picasso's *Bottle, Glass and Guitar* (1913) began with relatively large pieces of various papers that were then trimmed, arranged and drawn over to represent objects. These are therefore synthesized from abstract layers, hence the term "Synthetic" used by art historians to indicate this period of Cubism as distinct from its earlier stages based on forthright analysis.

Style usually means a particular way of transposing reality into a given framework, and it was a tacit assump-

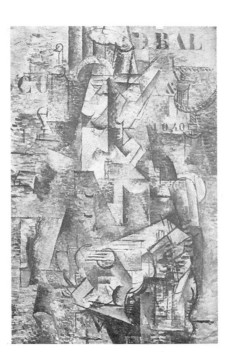

The Portuguese, *1911*
Georges Braque (1882–1963)
Oil on canvas 46×32in (116.5×81.3cm)
Kunstmuseum, Basle, Switzerland

Braque's first major painting of 1911, The Portuguese, *was supposedly based on a guitar player seen in a bar at Marseilles. Musical instruments were a subject frequently included in Cubist still life and figure paintings and* The Portuguese *is one of a series of half-length figure paintings by Braque.*

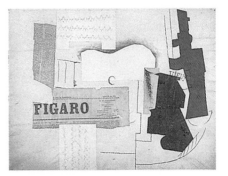

Bottle of Vieux Marc, Glass, Guitar and Newspaper, *1913*
Pablo Picasso (1881–1973)
Mixed media 18⅜×24⅝in (46.7×62.4cm)
Tate Gallery, London

In 1913 Picasso had moved into a new studio in Paris and spent the summer working at Cérèt in the south of France. This painting is one of many still life studies produced during the year. Picasso and Braque were together involved in intensive work developing the principles of Cubism and adding new formal elements to the paintings – such as Braque's use of stencilled lettering also taken up by Picasso in the still lifes, and the first appearance of collage in Cubist works. Paper stuck to the canvas introduced new textures and the artists played games with reality and illusion by sticking down cloth or paper patterned with a printed texture or adding pictures, for example of real fruit, to embellish a still life.

tion before Cubism that art had to be consistent in this respect. Cubism questioned and made a witty commentary about the world, unfolding it as a dynamic process working at different, simultaneous levels. For the first time these levels were combined in one image, so that in the *Bottle, Glass and Guitar* for example, the viewer must decipher diverse means of representation, ranging from pure line to flat cut-outs, from drawn words to printed ones. Cubism exposed the Western tradition of perspective as only one of many alternative systems of viewing the world. To the question "What is

truth?", Cubism answered "Reality".

One of the more remarkable aspects of the Cubism evolved by Picasso and Braque until the outbreak of World War I was, therefore, that it distilled, for the most part unconsciously, something of the questioning spirit of the new age. Yet there were almost no references to the more obvious contributions of the period, such as machines or fast travel, that had helped to make existence "modern" in the early years of the 20th century. These became important only when Cubism started to make an impact outside France and was developed at home by artists such

as Fernand Léger (1881–1955) and Robert Delaunay (1885–1941), who made the Eiffel Tower, a preeminent symbol of the First Machine Age, the theme of much of his work, which was christened Orphism by Apollinaire because of its lyrical and poetic character. Even when the Spaniard Juan Gris (1887–1927) was admitted by Picasso and Braque to their circle, he respected their narrow vocabulary of motifs and took the austere geometries of still-life as the major focus of his searching, tragically brief career. The fact that Cubism could change the course of art in the modest observation of a few objects on a table or a single figure is a measure of how profound was the visual revolution that had been achieved. achieved. Others who wished to deal with the complexities of modern existence in terms of process and fragmentation now had a language to meet their needs.

La Ville de Paris, *1912*
Robert Delaunay (1885–1941)
Oil on canvas
Musée d'Art Moderne, Paris

Delaunay's most important contribution to the development of Cubism was his use of color. "In purely colored painting," he wrote, it is color itself which by its interplay, interruptions, and contrasts forms the framework, the rhythmic development, and not the use of older devices like geometry".

States of Mind: The Farewells, *1911*
Umberto Boccioni (1882–1916)
Oil on canvas 27⅞×37¾in (72.4×90.2cm)
Private collection, New York

The Farewells is one section of a triptych entitled States of Mind, the other two paintings being Those Who Go and Those Who Stay. They were preceded by an earlier version of the work and several studies. Boccioni had spent much time during 1911 formulating the idea of paintings representing states of mind. He described his work, in a lecture to the Circolo Artistico in Rome, as an effort to depict pure sensation, "the acutest synthesis of all the senses in a unique, universal one. . .". This stemmed partly from the philosophy of Henri Bergson, a considerable influence on the development of Futurist theory, who regarded changes of perception as "an interpenetration of past and present not a mathematical succession of states". Boccioni chose to use the scenes and impressions at a railway station as the basis for the paintings, in keeping with the declared Futurist principle of celebrating the speed and mechanized efficiency of modern life. The States of Mind were the focal point of his submissions to the Futurist exhibition of 1912. Boccioni produced a number of paintings in his brief career, cut short by a fatal accident during World War I, but his sculptures of dynamic form, begun in 1912, are his best known works.

Futurism

The tide of change, which was soon taken for granted in the more technically advanced parts of Europe early in the 20th century, was slow to find acceptance in Italy. Industrialization and the widespread use of machines arrived far later there than in France or Germany, and in fact Italy's unification as a nation dates only from 1870. Apart from opera, Italy had made little contribution to the arts of Western Europe since the time of Tiepolo in the 18th century. Large sections of the population remained tied to an archaic, rural lifestyle and the conservative power of the Roman Catholic Church was substantial. This situation meant that when Italian intellectuals finally confronted modern culture they reacted with a vehemence that would probably have been less exaggerated in a more precocious and liberal country. The first explosive sign of this meeting appeared in 1909 when a young Italian poet, Filippo Tommaso Marinetti, published the manifesto of a movement that he christened Futurism in the Paris newspaper *Le Figaro*. His declaration was inflammatory. It spoke in a rhetoric of action and violence that would be-

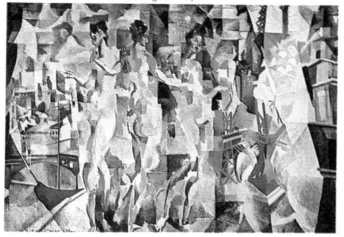

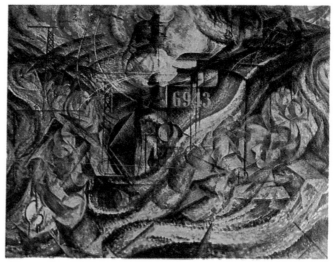

come essential for modern artists who wished to change art and life; at least until politicians drove home comparable messages with far greater effectiveness than they had to date.

In breathless prose Marinetti announced Futurism's intent to destroy the past and its stifling traditions, glorify war as an instrument of progress and exalt the masses in the Age of the Machine: "We will sing great masses agitated by work, pleasure or revolt . . . the slippery flight of airplanes whose propellers have flag-like flutterings and applauses of enthusiastic crowds."

The painters attracted to Marinetti's ideals included Umberto Boccioni (1882–1916), Giacomo Balla (1871–1958) and Gino Severini (1883–1976), whose initial dilemma was to discover a pictorial language in step with their aesthetics. In early paintings such as Boccioni's *The City Rises* (1910–11), a swirling mêlée of workmen and horses on an urban construction site, the Divisionist technique of broken brushstrokes was used to create a shimmering excitement. Yet to convey the noisy, engulfing tumult of the contemporary city something extra was needed; that something was found in 1911 when Severini introduced them to Cubism.

Once Parisian Cubism was adopted by the Italian Futurists it ceased being a delicate, intellectual tool used for the analysis of space and substance. It went on the streets, becoming a rowdy, exuberant weapon whose cascading planes and multiple viewpoints no longer dealt with the guitar, glass or reticent sitter, but themes such as the riot shown by Carlo Carrá (1881–1966) in *The Funeral of the Anarchist Galli* (1911), or the disruption wrought by Severini's *Suburban Train Arriving at Paris* (1915). The Futurists added new filips to Cubist methods such as imperious, darting strokes, called "force lines", that suggested velocity and probably derived from photo-

Dynamism of a Dog on a Leash, *1912*
Giacomo Balla (1871–1958)
Oil on canvas 35½×43¼in (91×110cm)
Albright-Knox Art Gallery, Buffalo

Soon after Filippo Marinetti published the Founding and First Manifesto of Futurism (1909), with its strident declaration that "there is no beauty except in struggle" and its glorification of war, Balla, like Carrà and Boccioni, was drawn into the Futurist movement. They, with Severini and Russolo, drew up their own Manifesto of the Futurist Painters, *which was announced in Turin on March 8, 1910. Rejecting the decadent art of the past, it called for a new art to celebrate "the frenetic life of our great cities and the exciting new psychology of nightlife; the feverish figures of . . . the Apache and the absinthe drinker." It rejoiced, too, in a world about to be "splendidly transformed by victorious Science." Yet the Futurists, for all their exaltation of the raw, modern world, retained painterly qualities derived from Neo-Impressionism and were preoccupied with the representation of movement. Both of these aspects are prominent in* Dog on a Leash, *the first and best-known of a series of paintings of movement that Balla painted in 1912.*

Drawing of an Airport, *1914*
Antonio Sant'Elia (1888–1916)

In his savage blast against the International Style, From Bauhaus to Our House, *the American writer Tom Wolfe speaks drily of "another unique phenomenon" of the modern movement in architecture: "the famous architect who did little or no building." His chief target was Le Corbusier, but he had in mind also Sant'Elia, perhaps unfairly, since Sant'Elia died very young. Sant'Elia's reputation rests entirely on the drawings in which he tried to produce a Futurist architecture, to build, as he put it, "the modern city . . .", a city "similar to a gigantic machine", made of concrete, glass, iron, "without painting or sculpture". Between 1912 and 1914 he made a series of drawings of his City of the Future – factories, airport hangars, railway stations, worker-housing skyscrapers – which, however daring in what has been called their "sheer Expressionism", bore no relation to the actual mechanics of erecting buildings.*

graphs of bodies moving at high speed leaving an extended blur of lines in their wake. Balla's *Dynamism of a Dog on a Leash* (1912) and similar compositions also revealed the influence of the sequential photographs of figures in motion taken by Etienne Marey, Eadweard Muybridge and others in the 1880s. Emphatic, clashing colors, perhaps metaphors of noise in the modern metropolis, replaced the atmospheric monochromes favored by Picasso and Braque. Boccioni in particular took his experiments into three-dimensions with a series of sculptures that investigated

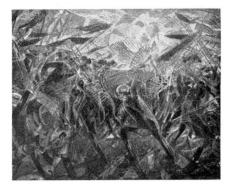

Funeral of the Anarchist Galli, *1911*
Carlo Carrà (1881–1966)
Oil on canvas 102½×73in (260×185cm)
Museum of Modern Art, New York

In 1911 Carrà and Boccioni, two of the original Futurists, visited Paris in order to study Cubist paintings. From the beginning Futurism was seen as a branch of Cubism, but a Cubism taken onto the streets, hence the subject of this painting. Angelo Galli was killed in street-fighting during the general strike in Milan in 1904 and at his funeral a riot that broke out between anarchists and the police nearly knocked his red-flagged coffin off its catafalque. Futurism had a political intention foreign to Cubism, but in this painting the influence of Cubism is strongly felt. Carrà's Futurist phase was short-lived. In 1915 he met De Chirico at Ferrara and with him led the ephemeral Metaphysical Painting movement in 1917.

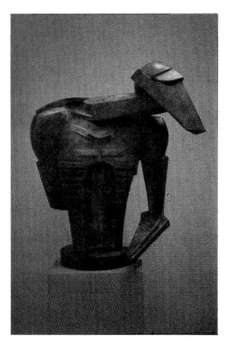

Rock Drill, *1912–13*
Jacob Epstein (1880–1959)
Bronze Height 28in (71cm)
Tate Gallery, London

Epstein, with Henri Gaudier-Brzeska (1891–1915), is the only sculptor whom it is useful to attach to the Vorticist movement. A drawing for this sculpture was printed in the first number of Blast, *the Vorticist journal; and Ezra Pound, the poet closest to the movement, named a set of his* Cantos *after it. The sculpture represents only a fleeting phase in Epstein's career and he soon lost the interest in machinery and modern mechanization which obsessed the Futurists and the Vorticists. Indeed, when the work came to be cast, he dropped the second-hand drill on which his "machine-like robot", as he called it, was to be mounted, so that the finished product lost the mixture of art and gadgetry which was its original inspiration. It retains, nevertheless, something of Epstein's original intention: "Here is the armed, sinister figure of today and tomorrow. No humanity, only the terrible Frankenstein's monster we have made ourselves into."*

the expression of kinetics in solid materials.

As an inventive phenomenon Futurism was short-lived, soon declining toward repetition and cliché, but its iconoclastic energy was infectious and influenced others even when its own ambitions failed. Antonio Sant'Elia (1886–1916), for example, produced drawings for Futurist buildings that were never constructed but whose sleek, soaring forms infiltrated many later architects' visions of the city of tomorrow. In England Futurism helped shape a closely related movement that assumed the name of Vorticism, from the vortex, a symbol of violently concentrated motion. Its leaders included the expatriate American poet Ezra Pound and the painter Wyndham Lewis (1884–1957), whose harsh, machine-like compositions were still more impersonal and lacerating than those of the Futurists. The deaths of Boccioni and Sant'Elia in the very war they had welcomed as a cleansing agent of civilization should, however, have been a warning of the darker implications of Futurism. When Marinetti, Lewis and Pound became attracted, in various respects, to fascist beliefs, the latent bankruptcy of these ideals, once they left the bounds of the artistic arena, was exposed. Yet Futurism proved deeply influential exactly because its demonstrations, pamphleteering, riotous theatricals and calls to action suggested that art could do more than just hang on a wall or decorate a museum. By striking a pose of aggressive militancy, its tone often unknowingly came to lurk behind the behavior of the avant-garde whenever they wished to admonish or simply frighten the complacent bourgeoisie. At moments as remote as the anti-Establishment protests of Dada during World War I, the shock tactics of Futurism found a new lease on life.

Abstract art in Russia

Initially, the breakthroughs of Cubism and Futurism led to particularly exciting conclusions in Russia. Backward and isolated to the point of half-savage feudalism, Russia sported a tiny nucleus of intellectuals who were surprisingly well-attuned to European affairs. Rayonism, a method invented by Mikhail Larionov (1881–1964) and Nathalia Goncharova (1881–1962) in 1911–12, which distorted objects into angular patterns of lines, evidently under the impact of light rays, was one of the first Russian responses to Cubism. Not long afterward Kazimir Malevich (1878–1935) began fusing objects, letters and fragmented figures into collage-like tableaux that owed something to the abrupt juxtapositions practiced by the Futurists. Malevich, however, misinterpreted the outwardly abstract look of Parisian Cubism, since in some of these paintings their enigmatic, blank planes of color obliterate rather than synthesize the subject. Malevich seems to have been drawn to conclude that it was these abstract shapes that best embodied the emotions that the artist felt in the face of the jarring forces of modern existence. In his book *The Non-Objective World*, Malevich observed that "The more active the life, the more intensive and consistent is the creation of dynamic form. The Futurist should by no means portray the machine; he should create new abstract form."

In 1913 Malevich designed the sets for an experimental Futurist opera, *Victory Over the Sun*, dealing with man's technical conquest of nature, in which one of the backdrops consisted of only a large black and white square. Malevich was to claim that such designs influenced the extraordinary change that took place in his work around 1915, when he exhibited a number of stark, utterly abstract paintings, including one with nothing but a

Nocturne, c.1913–14
Mikhail Larionov (1881–1964)
Oil on canvas 19½×24in (49×60cm)
Tate Gallery, London

Larionov first exhibited work in the style which he called Rayonism – paintings composed of Cubist-like representations of rays of light – at Moscow in 1913. By then the paintings that he had been producing since 1909, paintings which were roughly the Russian equivalent of the work of the Blaue Reiter *group in Germany, had established him, with his close friend and pupil, Natalia Goncharova (1881–1962), as the leading figure in Russian Modernism. There was never a coherent Rayonist Movement: Larionova and Natalia were the only painters to produce Rayonist paintings and Larionov had bandoned the style by 1915.*

black square on, or within, a white ground. Malevich called his new style Suprematism, to indicate what he now felt was the supremacy of pure feeling in art. He had left behind the celebration of appearances that motivated Cubism and Futurism and had turned his gaze inward where, it seems, only the purity of the most abstract geometric emblems could express intangible patterns of thought and sensation. The paintings of this period are both an end and a beginning. With their aura of mystic clarity they silenced the hubbub of all figurative painting, but in the Suprematist compositions from 1915

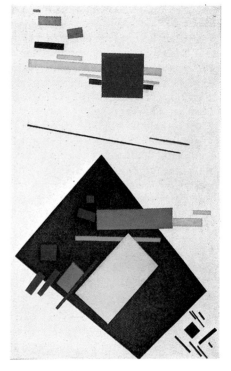

Suprematist Composition, c.1915
Kasimir Malevich (1878–1935)
Oil on canvas 23×19in (58.4×48.3cm)
Museum of Modern Art, New York

Malevich was a leading figure in Moscow art circles between 1910 and 1920. By 1912 he was keenly aware of the development of Cubism and Futurism in Europe, but the key stimulus to his invention of the wholly abstract Suprematist style is thought to stem from his development of designs for an opera, Victory Over the Sun, *in 1913. In this set he first utilized the black square that became a crucial element of his painted compositions. In 1915 he participated in an exhibition in Petrograd arranged by a group of ten painters; it was titled "0–10: The Last Futurist Exhibition". Malevich exhibited thirty-nine completely abstract canvases and began to explain his Suprematist theory in the catalog entry for his work. These ideas were expanded in his book* The Non-Objective World. *The importance of abstract art in Russia was relatively short-lived, however. Although Malevich was an influential figure with a notable role as a teacher in Moscow, he was badly affected by the reaction against abstract art after the Russian Revolution.*

Monument to the Third International,
1919–20
Vladimir Tatlin (1885–1953)
Wood and glass model
Russian Museum, Leningrad

Tatlin, the moving spirit of Russian Constructivism, visited Picasso in Paris in 1913 and was probably shown examples of the constructed reliefs that Picasso was then making. By 1915 Tatlin was making abstract relief sculptures out of various materials, and his first "corner-reliefs", free-standing, metal and wire spatial constructions to fit into corners of rooms, were shown at the St Petersburg exhibition of 1915–16 at which Malevich launched his Suprematist movement. In 1919 Tatlin, although not trained as an architect, was commissioned to design a huge structure to project over the Neva River in Petrograd (formerly St Petersburg and now Leningrad) as a monument to the Third International after the Bolshevik triumph. Meant to soar higher than the capitalist West's Eiffel Tower, and to spring out of the earth, pointing forward like the prow of a ship, the monument was intended to symbolize man's eternal aspiration to progress. It was to be built of steel and glass and its three internal, rotating cells were to house the Third International's assembly and secretariat.

onward the design at times shattered into waves of rectangles that floated through a white void like emissaries from outer space. In certain works these mass into simple crosses and shafts recalling the religious icons of earlier Russian art, purged, however, of all the natural associations that made them relics of the past.

When Lenin engineered the Revolution in 1917 history itself seemed to be purged as Old Russia suddenly faced the prospects of a fresh order of social consciousness. The vision celebrating the renewal of the spirit already belonged to Malevich, but the theories of Marxism-Leninism required that mysticism vanish in the dialectics of social struggle. Vladimir Tatlin (1885–1953), Alexander Rodchenko (1891–1956) and El Lissitsky (1890–1941) were quick to set non-representational, geometric configurations into a harder-hitting and more practical context than Malevich had sought. If Cubism was able to transform what we see into a self-governing visual microcosm with its own logic and momentum, could not its principles become the symbol of man's ability to reconstruct reality at large?

In the brief and astonishing period of experimental optimism that followed the October Revolution it seemed as though an affirmative answer to this question was possible. Tatlin and others grasped that the non-objective qualities that Cubism had helped liberate in painting – rectangles, circles, lines and emphatic flatness – were positive elements for a new dialectic. For every bit of the Old World that had been lost to abstraction, a novel, exciting set of shapes capable of expressing complex relationships had been constructed. Since society itself was being rebuilt, this element of "construction" assumed an urgent moral value. For some six years or so after 1917 Russian culture surged forward under the vigorous

banner of Constructivism. The people inherited a style that had once been the exclusive right of the avant-garde. Not only painting, sculpture and architectural schemes but also mass-produced placards, theater sets and even proletarian parades were designed on Constructivist lines. In a famous poster by Lissitsky made in 1920 a white circle symbolizes political reactionaries being scattered by the red wedge of the Revolution. The very ideology of Constructivism, its call to grapple with materials – to weld, rivet, compose fundamental geometric units into meaningful objects – seemed to echo Lenin's vision of continuing communist effort as the physical task of assembling our own futures.

The work that epitomized Constructivist aspirations also foretold its demise since it was never completed: Tatlin's *Monument to the Third International*, designed in 1919. The model of the piece is built of wood, but the conception it offered represented the apotheosis of Constructivism, involving vast planes of glass and iron, soaring shafts, spirals and arcs. In practice, however, the scale was impossibly ambitious, for it was to be taller than the Empire State Building and contain three enormous revolving chambers. As a symbol of transcendent effort it was supreme; as a real edifice it was absurdly impractical, particularly in a country ravaged by famine and civil war. When the Revolution was endangered, creators were forced to lower their sights. At first this meant fewer impractical plans, but as the doctrinaire policies of Stalin, who succeeded Lenin in 1924, began to take effect in the later 1920s, it became clear that there was no future for modern art in Russia. Since the working-class was considered the vanguard of society, no group could advance beyond it and the avant-garde was literally eliminated. Realism became the official style.

European approaches to abstraction

Simultaneous with the Russian experiment two painters in Europe – the Dutchman Piet Mondrian (1872–1944) and Wassily Kadinsky (1866–1944), an émigré from Russia and resident in Munich – were searching for an alternative to the entire Western tradition that held that art should reflect, or at least suggest, something of the external appearance of nature. Both artists worked independently of each other and pictures such as Kandinsky's searing compositions from around the time of World War I and Mondrian's serene *Composition with Red, Yellow and Blue* are totally different. Yet the two men were driven by similar convictions about the purpose of art and its capacity to redeem man: spiritual versions of the social Constructivist faith. In their case, however, religious hopes and fears replaced political fervor. Kandinsky was deeply attached to Russian Orthodoxy and Mondrian inherited a Dutch Calvinist leaning of long ancestry.

Yet by the turn of the century Christianity was losing its exclusive claim on many intellectuals and other systems were being proposed, ranging from the pragmatic ideas of Marxism to the mystical faith of theosophy. Both Kandinsky and Mondrian were passionately interested in theosophy for, inspired as it was by Hinduism, it was comparatively free of dogmatic details. It was thus an ideal stepping stone for any artist attempting to give form to religious impulses, but aware that the figurative traditions of the past were hopelessly inadequate to contemporary needs. Beset by materialism and unnerved by the pace of scientific thought, modern man, they imagined, was the victim of spiritual malaise. According to Kandinsky and Mondrian, an era would soon dawn when man would make peace with his psyche. Here was the appeal of theosophy, which taught the existence of universal harmony beneath the chaos of physical being. The individual could reach this superior realm of awareness by contemplating the abstract rather than the particular and by absorbing the purity inherent in music,

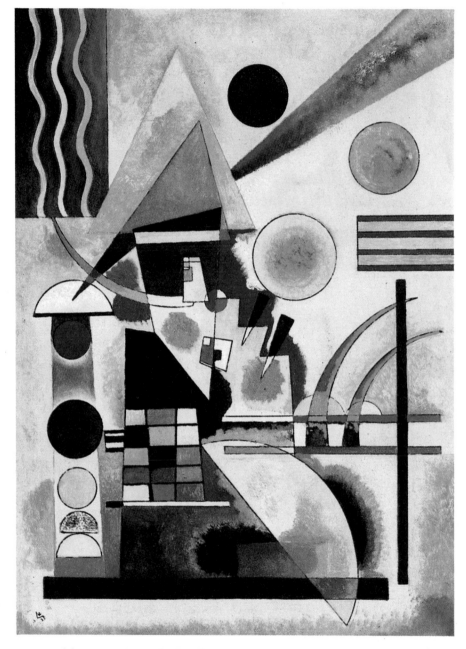

Swinging, *1925*
Wassily Kandinsky (1866–1944)
Oil on cardboard 27⅝ × 19⅝in (69 × 49cm)
Tate Gallery, London

Composition with Red, Blue and Yellow,
1930
Piet Mondrian (1872–1944)
Oil on canvas 137½×305¾in (351×782cm)
Private collection, New York

were awakened by a certain hue: "Color harmony must rest ultimately on purposive playing upon the human soul" (1911). In the landscapes Kandinsky was painting at the time great bursts of vermilion, ultramarine and other colors expand and float away from barely identifiable contours of mountains and fields, horses and riders. At the same time, in Paris and then at home in Holland, Mondrian employed the fragmenting vision of Cubism to extract from landscape a counterpoint of linear relations. The masses of a tree, church or breakers on the barren northern seashore gradually dissolved as the forces behind their physical existence took on the form of a grid for some transcendent crossword whose clues were matter and spirit.

As World War I raged, the two painters seemed to find proof that they were facing the terror of the last days, whose dissolution would announce a renewal of faith, an "epoch of the great spiritual", when only abstract art could do justice to the reign of existential truths. Despite the mystical sound of such ideas, they did propel their work toward a definitive stage. Kandinsky freed his images to the extent that whirlwind flashes of pigment and snaking black lines overwhelmed any visible subject. For Mondrian, on the other hand, calm triumphed in pictures that represented a Classical balance between what he discerned as the essential rationale of all visual phenomena: the vertical/horizontal impulses and the three primary colors. These he manipulated with endless subtlety, conjuring symbols of the inward equilibrium that lies behind the imbalance that man alone sees in nature. Through such responses to the problem of what painting could mean and do once it had abandoned likeness, Kandinsky and Mondrian became two of the most important sources of inspiration for subsequent abstract art.

color and the interaction of line – all extracted from the dross of commonplace situations. This argument was as old as Plato, and although Idealist philosophers had long known of its merits, painters had been all too human in accepting the outward charms of the visible world.

Consequently, in their earlier work both Kandinsky and Mondrian attempted, in different ways, to heighten abstract, universal qualities such as color and the rhythmic attributes of line at the expense of precisely defined forms. Kandinsky interpreted the spectrum as an index of spiritual states and felt that emotions, and even sounds,

Dada and Surrealism

The pioneers of abstraction were all believers whose faiths varied from the cult of the Machine (the Futurists) or the Revolution (the Constructivists) to that of the Spirit (Kandinsky). Yet when World War I demonstrated that civilization involved the destruction of large sections of humanity for the sake of senseless causes, many artists preferred to believe in nothing rather than failed principles. This nihilistic attitude erupted in different places almost simultaneously and took its name from the group of disaffected poets and painters who congregated in neutral Zurich in 1915. Their rallying cry was "dada", a word probably chosen because it had no meaning apart from its ring of childlike absurdity. Dadaism denounced everything held sacred by the bourgeoisie: polite society, reason and especially Art, the most highly-prized of our civilized commodities. The Dadaists waged a war against war and the German poet Hugo Ball, who was at the center of the Zurich movement, later wrote: "The Dadaist fights against the death-throes and death-drunkeness of his time. . . . He knows that this world of systems has gone to pieces, and that the age which demanded cash has organized a bargain sale of godless philosophies."

Since Dada was an attack on conventional values, it attempted to shock or take unexpected guises. In his cabaret performances Hugo Ball mocked language by reciting nonsense syllables; a Dada "exhibition" in Cologne had its entrance through a public lavatory; and works of "art" were made whose intended fate, sometimes realized by a furious public, was to be destroyed. If society was visibly rotten, then some Dadaists thought that it should return to the uncorrupted innocence of nature. Hans Arp (1887–1966) started to make paintings, collages and reliefs that were composed at

Celebes, 1921
Max Ernst (b. 1891–)
Oil on canvas 50×42¾in (125×107cm)
Tate Gallery, London

Ernst called this painting Celebes, *but it is now almost universally known as* The Elephant Celebes. *It is one of his last Dada works, painted just before he left Germany and followed Jean Arp to Paris in 1922. Arp had spent the years between 1919 and 1921 in Cologne, and he and Ernst, nicknamed "Dadamax", dominated the Dada movement there. On his arrival in Paris Ernst discovered that Dadaism was dying. Surrealism was about to be born and Ernst – for all that his entire lack of formal training makes him a singular figure among modern painters – was to become one of its first and finest exponents.*

Dada Relief, 1916
Jean (Hans) Arp (1887–1966)
Wood 9½×6in (24×150cm)
Kunsthaus, Basle

The Dada movement, as a movement, began in 1916 with the founding of the Cabaret Voltaire in Zürich by Hugo Ball, the German poet, musician and stage producer. By 1918 the movement had spread to Berlin, Cologne and Paris, which became the real Dada center. New York, too, where Duchamp presented his famous urinal Fountain *in 1917 got in on the act. Indeed, the Dada-like review 291, spawned by the group who associate themselves with Man Ray and the Alfred Stieglitz Photo Secession Gallery, had been founded in 1915. Dadaism sought to knock "high art" off its pedestal, to obliterate the very notion of art by declaring that any object could be regarded as art and that any method could be used by the artist. It denied the objective reality of ideas such as beauty, idealism of form, or truth of expression. It also owed something to the unprecedented slaughter of World War I. "Dada was not a 'made' movement," George Grosz (1893–1959) wrote; "it was an organic product, which began as a reaction against the head-in-the-clouds attitudes of so-called high art, whose disciples brooded over cubes, and over Gothic art, while the generals were painting in blood."*

random, determined mainly by chance without conscious control. Arp soon realized, however, that his inherent instincts for organization could not be suppressed. Still, the soft, vulnerable curves that increasingly dominated his work took on a special meaning, for

they echoed the organic pulse of nature, the flowing contours found in a piece of fruit, a hill or the human body. This style became known as Biomorphism (from the Greek: *bio*, meaning "life", and *morphe*, "shape") and was often to be used by modern artists wishing to symbolize natural processes of growth, as opposed to the artificiality associated with the machine.

As the embodiment of everything that was impersonal and progressive the machine was the constant butt of Dadaism. In Cologne Max Ernst (1891–1976) made drawings and collages of ludicrous, terrifying contraptions and Berlin Dadaists, such as George Grosz (1893–1959), satirized the Prussian

The Bride Stripped Bare by Her Bachelors, Even (The Large Glass), 1915–23
Marcel Duchamp (1887–1968)
Oil, lead wire and other media on glass
109¼×69in (277×176cm)
Philadelphia Museum of Art

The original concept of The Large Glass *first came to Duchamp in 1913. Bored with the traditional forms of painting, he was inspired with the idea of working on glass when looking at the colors on a glass palette from the wrong side. In his first experiments he tried to etch shapes on glass with acid, but abandoned this because of the fumes, and instead of the etching "drew" the shapes with a piece of lead wire. He gradually accumulated different aspects of the work, based on previous paintings or worked out through new forms and techniques that occurred to him as he experimented. While still in France, until 1915, Duchamp built up a body of notes for* The Large Glass *and stored them in a green cardboard box, moving on to make a full-scale drawing with the arrangement of forms mapped out in detail. On his first visit to New York in 1915 he took the drawing with him and started the project there, supported financially by the art collector Walter Arensburg, who was promised the finished work in exchange. For a year Duchamp worked on the top section of the glass and the form of* The Bride. *During the following year he constructed the* Bachelors, *in the lower half of the work. Duchamp returned to Paris in 1919 and stayed there until 1922, leaving* The Large Glass *in New*

York. During these years he became involved with the Dadaists and, having renounced painting, produced his ready-mades and motor driven constructions. On his return to New York in 1922 he resumed work on The Glass, *following the original plan but with some amendments; for example, he glued down some of the dust that had settled on the glass plates during the period of inactivity. In 1923 Duchamp made a decision to leave the work in a state of "definitive incompletion". The original notes and computations for the project were later published as a limited edition,* The Green Box. *The work itself was exhibited in Brooklyn, New York in 1926 and was damaged in the return journey, although this was not discovered immediately, as it remained in storage. Duchamp partially restored it in 1936 but considered the accidental shattering of the glass integral to the final look of the work. The long period of development of* The Large Glass *is legendary, but Duchamp illustrated his irreverent attitude to making art in his description of the early years: "It took so long because I could never work more than two hours a day. You see, it interested me, but not enough to be eager to finish it. I'm lazy, don't forget that. . . . It was my first visit, remember, and I had to see America as much as I had to work on my* Glass.*"*

petit-bourgeoisie as automatons. To Europeans, however, it was the United States, and especially New York, that represented the brave new world of technology, and Dada activities there were fittingly spearheaded by the Frenchman Marcel Duchamp (1887–1968). Before his departure from Paris in 1915, Duchamp had been involved with Cubism, depicting forms caught in such a blur of speed that they became anonymous and looked more like robots than humans. Duchamp felt that sexuality remained the one sacred enterprise whereby modern people could still be themselves, undisturbed by competition with the assembly line, and so, in an ironic mood, he began investing his mechanical dramas with erotic qualities. Moreover, Duchamp was also becoming cynical about the value of painting, thinking that after some four hundred years it had long since played most of its trump cards. As a consequence he began to designate ready-made objects such as a hat-rack or urinal as "works of art". His master-piece, *The Bride Stripped Bare by Her Bachelors, Even* (1915–23), is a compendium of Duchamp's doubts about art and alternative approaches. Assembled on large sheets of glass and left deliberately unfinished, it includes an accompanying set of notes so that the spectator may try to unravel its scenario – involving a "female" machine and her unfulfilled coupling with a "bachelor" apparatus – in his own mind.

If Dada was to follow its own logic, it had to end in either total absurdity or self-destruction, and discontent with this impasse contributed to the emergence of Surrealism, announced in 1924 by the young French poet André Breton. After the anarchy of Dadaism, Breton's call to order not only continued the revolt against bourgeois standards but added the idea that art might help people reach a revelatory way of looking at the world, which we normally

attain only in rare flashes. For example, when an individual experiences a sudden, extreme shock, a moment of wonder before any strange or astonishing phenomenon or, above all, the state of dreaming, wherein the mind is jolted into a consciousness different from anything known in ordinary circumstances. To Breton these were insights into another dimension of being, a sur- or super-reality, hence the movement's label, Surrealism.

In the writings of Sigmund Freud, and especially his study *The Interpretation of Dreams* (1900), Breton found a rich store of ideas concerning the unknown region within man – the subconscious. Freud had discussed the necessity for man to conquer the irrational fears and desires of his unconscious in the name of civilized reason. Breton, ever the romantic, thought otherwise, claiming that the subconscious was superior to conscious thought. It had to be liberated and, once freed, our minds could be immeasurably expanded and a super-reality, where fantasy and fact merged, would be attained. Breton agreed with Freud that the two areas of human thought that contained the strongest charge of subconscious energy were sexuality and the dream state. These became the preoccupations of the artists who gathered around Breton in Paris during the 1920s and resolved to allow – or provoke – their subconscious to dictate the imagery and form of their paintings.

The most disquieting evocation of the domain of dreams had nonetheless been captured by the Italian painter Giorgio de Chirico (1888–1978) some ten years before the inauguration of Surrealism. De Chirico's paintings (1910–19) unfold a haunted landscape of piazzas and arcades seen in a light too sharp, a perspective too extreme to pass for waking vision. Incongruous objects, such as a box in the foreground and a train in the distance, appear as mute witnesses to an unfathomable logic. It is not surprising, therefore, that De Chirico's renditions of an impossible reality had a profound influence on young Surrealists such as the Belgian René Magritte (1898–1967), the former German Dadaist Max Ernst and the Spanish painter Salvador Dali (b. 1904). From the mid-1920s onward the Surrealists conjured bizarre combinations, monstrous hybrids of man, beast and thing, and nightmarish disruptions of scale in a deadpan technique that earned their work the label of Veristic Surrealism, the intention being to paint the unreal truthfully. Dali took Verism to the point where he described his paintings as "hand-painted dream images". They are drenched with a peculiarly modern and Freudian atmosphere of sexual psychosis where every firm hold on reality turns into something nauseatingly viscous, and every creature falls prey to perverse urges to cannibalize, defecate or ravish – if not the other, then itself.

The alternative to these candid illustrations of the psyche's depths was to allow its uncontrollable forces to guide the artist's hand. Max Ernst showed that drawings and paintings that grew from the chance textures when a rough object, for example heavily grained wood, was placed beneath the picture surface could lead to greater abstraction of the image. This technique, which Ernst called *frottage* (from the French *frotter*, "to rub against"), was elaborated so that textures would suddenly metamorphose into identifiable passages and then regress into the background, encouraging an air of deliberate hallucination. The Spaniard Joan Miró (b.1893) at times forced himself to abandon conscious control, working in a near-hypnotic trance and only afterward superimposing provocative emblems: "I begin painting and as I paint the picture begins to assert itself, or suggest itself, under my brush.

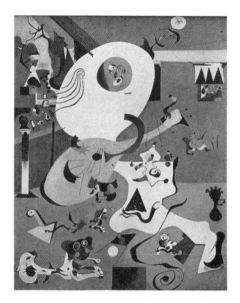

Dutch Interior I, *1928*
Joan Miró (b.1893)
Oil on canvas $36\frac{1}{4} \times 28\frac{3}{4}$ (92×73cm)
Museum of Modern Art, New York

This is one of four paintings that Miró produced from 17th-century Dutch masterpieces after visiting Holland in the spring of 1928. He was so taken by the meticulous detail of Dutch genre paintings that he brought back with him to Paris postcards of them from which to make his own. Dutch Interior I is a playful transformation of Hendrik Sorgh's c.1611–70 The Lute Player (1661), a sober, quiet interior scene which Miró turned into a chaotic, dancing one. Only the dog, looking outward from the canvas, retains the calm attitude of the original. So deliberate a method of painting may seem to obviate Miró's statement that his paintings were "always born in a state of hallucination, provoked by some shock or other, objective or subjective, for which I am entirely irresponsible".

Autumn Cannibalism, *1936–37*
Salvador Dali (b.1904)
Oil on canvas $31\frac{1}{2} \times 31\frac{1}{2}$in (79×79cm)
Tate Gallery, London

Dali's meticulous paintings of dream-like and hallucinatory images draw upon religious, political and personal themes. The fascination of these paintings rests partly in the precise and highly finished rendering of each element of the bizarre compositions.

Threatening Weather, c.*1931–32*
René Magritte (1898–1967)
Oil on canvas 27½×39½in (69×98cm)
Penrose Collection, London

Most of Magritte's paintings after 1931 present a highly personal rendering of illusionistic space. Objects hang over simple landscapes in the disoriented manner characteristic of dreams. Dreams were the very stuff of Surrealism. André Breton, in the first manifesto of Surrealism (1924), stated his belief that "in the future the two apparently contradictory states — dreams and

reality — will merge into an absolute reality, a surreality." Without Freud would Surrealism have been impossible? Yet Magritte was essentially anti-Freud. Like Chirico, his avowed master, he drew on the Symbolist movement of the late 19th century.

La belle jardinière, *1939*
Paul Klee (1879–1940)
Oil and tempera on canvas 37⅞×27⅝in (96×70cm)
Klee Foundation, Berne, Switzerland

In 1933 Paul Klee entered upon the final stage of his career when he was forced to leave Germany because the Nazi regime took power and closed the Bauhaus, where he had been a teacher for many years. He returned to his birthplace, Berne, and obtained a studio apartment. In the summer of 1935 he began to show signs of the illness that ultimately killed him and his health was poor from that time to the end of his life. He thus lived relatively peacefully, but his work was well known and highly regarded and was shown in various exhibitions in Europe and the United States during the 1930s. In Germany, however, it was suppressed, although paintings by Klee were included in the exhibition of "Degenerate Art" in Munich in 1937. While La belle jardinière *is in keeping with the style of his final works, its title suggests a more peaceable concept than some others of that period.*

The form becomes a sign for a woman or a bird as I work. The first stage is free unconscious. But the second stage is carefully calculated."

Automatism, the name linked to this method, gave Miró the freedom to drench his canvases with great washes of color that evoke a primordial ocean. Primitive creatures resembling amoeba float in engulfing fields, making us witnesses to a glimpse of genesis, of rudimentary sexual stirrings and form-giving amidst chaos. Although other Surrealists rarely matched Miró's poetic heights, the movement kept its popularity on an international scale throughout the 1930s. Not only did it provide a major alternative to what many shunned as the sterile atmosphere of geometric abstraction. It also offered a romantic outlet for fantasy, rebelliousness and dreams during a decade and a half that passed from the superficiality of the Jazz Era to the menace of totalitarianism.

Expressionism

Ambitious art movements have tended to dominate the stage of modern painting and at times exact a toll of conformity without which even their most independent members could share no common ground. Numerous painters have avoided allegiance to partisan circles, especially in those countries beyond the influence of a Paris that has often marked their birthplace. Since the general drift of most of these movements, with the exception of Veristic Surrealism, was towards the abstract, such outsiders were inclined to renew figurative traditions, extracting from them unexpected and modern patterns of significance.

Vienna in the 1900s, capital of a European empire larger than France, was an early example of this alternative to the so-called School of Paris. It had its own avant-garde in the Secession group, which had split ("seceded")

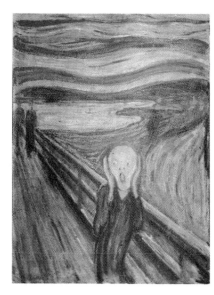

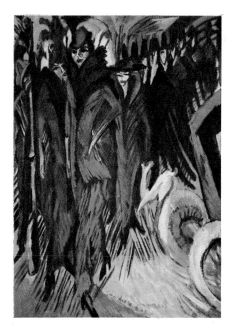

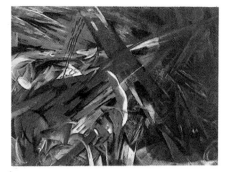

The Scream, *1893*
Edvard Munch (1863–1944)
Oil on canvas 35¾×28¾in (91×73cm)
The National Gallery, Oslo

The basis of much of Munch's work
throughout his career was his grand idea of
the Frieze of Life, *a series of paintings that
should form a coherent sequence and would
ideally be hung together in one location.
Many of Munch's individual subjects were
approached as part of this scheme, although
they followed no consistency of size or
proportion. These included recurring themes
such as* The Scream, The Kiss, The Dance
of Life *and* The Death Room. *No one could
be persuaded to issue a commission for the
Frieze and the works were gradually sold off
separately and scattered. Munch's work
attracted attention, though not always of
the right kind. In 1892 an exhibition of his
work opened in Berlin, at the invitation of
the Association of Berlin Painters, but
caused an uproar and was quickly closed
down. In the following year Munch painted*
The Scream *and a second version was
produced as a lithograph in 1895. A
description of the painting published by
August Strindberg in 1896 described it as
"a scream of terror in the presence of nature
flushed with anger and about to speak
through storm and thunder to the petty,
hare-brained creatures posing as gods, but
without a god-like appearance."*

Berlin Street Scene, *1914*
Ernst Ludwig Kirchner (1880–1938)
Oil on canvas 49¼×35¾in (125×91cm)
Staatsgalerie, Stuttgart

Street scenes were a recurring theme
throughout Kirchner's work and on his
move to Berlin in 1911 he developed a
fascination with the life of the city that
resulted in a series of paintings of the street
made through 1913 and 1914. This period
also marked the end of his association with
the Die Brúcke group of painters, leading to
a more isolated position in his artistic
career. However, his work was well
recognized and he received and he exhibited
regularly. The street scenes were depicted
in paintings and boldly executed woodcuts,
a medium that took a prominent place in
his oeuvre. Kirchner's career was
subsequently interrupted with the outbreak
of World War I, when he volunteered for
the army. In 1916 he suffered a breakdown
and in 1938 committed suicide.

Fate of Animals, *1913*
Franz Marc (1880–1916)
Oil on canvas 76×102in (195×263cm)
Kunstmuseum, Basle

Marc was a founder member with Kandinsky,
of the Blue Rider group in 1911, however his
career as a painter ended when he joined the
army and was killed during the First World
War. His work is characterized by an intensity
of color and line inspired by Cubism. He
sought to reveal the structure of creation and
the order of the natural world through
degrees of abstraction to which he gave
spiritual values. The use of 'blue' in the title
of the group came from his equating blue
with the masculine principle; yellow
representing the gentle serene, feminine
principle.

from the academies in 1897. The Secession leader, Gustav Klimt (1862–1918), had specialized in jewel-like, decorative portraits, and it was this most conservative of genres that began to reflect extreme unconventionality in the hands of two younger painters whom he influenced: Egon Schiele (1890–1918) and Oskar Kokoschka (1896–1980). Their Vienna was the permissive but morbidly self-conscious city of Freud, Adler and Krafft-Ebbing – researchers of eroticism and the abnormal – and in vignettes of patrons, aristocracy and intelligentsia both artists represented their sitters as though trapped before a psychoanalytic searchlight. Anxious poses and traceries of lines like nerves turn the figures into specimens of fear and trembling. The portrait, formerly a record of pomp, circumstance and status, was now a casebook of the soul.

In the stifling mileu of the pre-war Germany of Wilhelm II defiance of the academies produced loose artistic confraternities that set more store on individuality than collective rigor. The first of these was founded in Dresden in 1905 by Ernst Ludwig Kirchner (1880–1938), Erich Heckel (1883–1970) and Karl Schmidt-Rottluff (1884–1976) under the banner of Die Brücke, signifying the "bridge" between man's present and his impending hopes. Their manifesto proclaimed that "As youth, bearers of the future, we want to achieve freedom to live and work in opposition to old, established forces. Everyone belongs with us who, directly and without dissimulation, represents that which drives him to create."

This conviction that the artist is "driven to create" by inner necessity is not only characteristic of Die Brücke, but recurs constantly in German culture until Hitler's rise to power. The motive for this drive was felt to lie in the creator's innermost being, his ego. Kandinsky, as we have seen, sub-

scribed to a similar train of thought but was exceptional insofar as he permitted the "Spirit", another word for intuitive vigor, to pull him toward abstraction. Kirchner, his friends and indeed most Teutonic painters for the next two decades arrived at the opposite conclusion, relying on the human figure as an echo of themselves, which varied from an ideal to an alien, an enemy. The foremost aim of Die Brücke and subsequent German artists was therefore to express their states of mind through the representation of the world they inhabited, hence the category Expressionism, often applied in this context and denoting an outlook as much as any single program or doctrine.

Expressionism relied on distortion because it is in the gap between the everyday picture of the world and the special form bestowed on it by the artist that we may take the measure of the artist's emotional temperature. In Kirchner's *Street Scene* (1913) the bright colors of Fauvism reappear, yet they are singularly bereft of joy; a shrill tension prevails as the prostitute and her entourage rush towards us in a dagger of sharp silhouettes. This undertow of trauma and unease, embodied in jarring contrasts or spiky rhythms, is a leitmotif running the length of German Expressionism, from Die Brücke and its sister group Der Blaue Reiter, founded by Kandinsky and Franz Marc in Munich in 1911; through the stage sets of *The Cabinet of Dr Caligari* (1919) to the dissonances of Alban Berg's opera *Wozzeck* (1925). Even in the work of Paul Klee (1879–1940), who was initially associated with Der Blaue Reiter and went on to become a theorist and art teacher of considerable renown at the Bauhaus, we can trace its persistence in a far more cosmopolitan climate. Klee was a typical Expressionist in his idea that art uncovers hidden essences. As his famous *Creative

Credo* (1920) explains, "Art does not reproduce the visible; rather, it makes visible."

In an oeuvre of almost ten thousand predominantly miniaturist works, Klee freely combined abstract and representational approaches. His Swiss roots seemed to place him midway between France and Germany for his wiry, incisive line is as Nordic as a Dürer engraving, whereas the translucent and lyrical mosaic of color that he favored owed much to Parisian movements such as Fauvism and Cubism, especially the so-called Orphism of Robert Delaunay. In Klee's later paintings the sense of scale became more monumental as he fashioned brooding figures that resemble silent yet watchful hieroglyphs.

After World War I German society was confronted with successive cataclysms that pushed artists back to a more brutal kind of representation, with Klee's work of the period remaining the one lone retreat of delicate sensibility. Max Beckmann (1884–1950), George Grosz and Otto Dix (1891–1969) exemplify Expressionism's adherence to a contorted but undeniably figurative tradition. They were appalled by the horrors of the war, the brutal suppression of the 1919 Socialist uprisings and the rampant inflation and hypocrisy in the ensuing Weimar Republic. Nonetheless they stood convinced that the only antidote to such mayhem lay in a clinical ruthlessness, earning them the accolade of The New Objectivity (Die Neue Sachlichkeit). Grosz and Dix dealt with repellent themes, such as mutilated war veterans, prostitution and the greed of bloated Junkers. Beckmann, slightly less topical, took their cruel, knife-edged style to its limits. In *The Night* (1918–19) we confront an allegory of repression shown in a space that exerts unremitting pressure on the protagonists, who, with limbs akimbo, are by turns per-

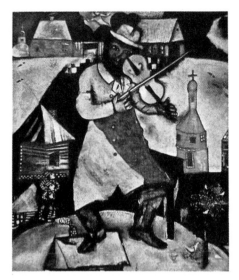

The Musician, *1912–13*
Marc Chagall (b.1889)
Oil on canvas 74×62½in (188×158.5cm)
Stedelijk Museum, Amsterdam

The French theorist and critic André Breton said that in Chagall's paintings from 1911 "metaphor made its triumphant entry into modern painting". The Musician was painted two years after Chagall's arrival in Paris, where he spent most of the rest of his life, from his native Russia. Hailed from the time that he painted the famous I and the Village (1911) as a forerunner of Surrealism – it was in Chagall's studio that Apollinaire, his breath taken away, is supposed to have muttered "surréel" – Chagall himself was always at pains to deny one, at least, of the Surrealists' claims, that spontaneous expression of the subconscious could produce art of the highest order. Automatism, he conceded, might have given birth to some good paintings but "as a conscious method, automatism engenders automatism".

The Night, *1918–19*
Max Beckman (1884–1950)
Oil on canvas 52⅜×60¼in (134×154cm)
Kunstsammlung Nordrhein-Westfalen, Düsseldorf

Beckmann was trained in 1900–03 in Weimar and during the early years of this century began to build a successful career as a painter, especially after his move to Berlin in 1907. His life and work were subject to profound changes through his experiences in World War I. He enlisted voluntarily as a medical orderly in 1914, serving first on the Russian front and subsequently in Flanders. Beckmann continued to draw while in military service, but was deeply shaken by the horrors of war and in October 1915 suffered a breakdown resulting in his discharge from the army and remained withdrawn and preoccupied. This was not eased after 1918 as he was highly conscious of the violence and poverty in postwar Germany. In Confession, written in 1918 (published 1920) he described his identification with the prevailing mood: "Just now, even more than before the war, I feel the need to be in the cities among my fellow men. This is where our place is. We must take part in the whole misery that is to come. We must surrender to the dreadful screams of pain of the poor disillusioned people . . . Our superfluous, self-filled existence can now be motivated only by giving our fellow men a picture of their fate and this can be done only if you love them". It was with these feelings that Beckmann painted the large canvas The Night, putting into the scene of torture and despair details from drawings made in the operating room at Flanders. The style of Beckmann's paintings became uncompromisingly grotesque in his efforts to pictorialize the intensity of his perceptions.

secutor and victim. With such paintings The New Objectivity proved how close it was to Expressionist currents of suffering and dread.

As long as Germany retained a semblance of democratic institutions through the 1920s, similar indictments were tolerated, but the Nazi takeover in 1933 meant that the State gained absolute control over culture. The more liberal artists were silenced, persecuted and driven to flee the country, and Expressionism in particular was branded as degenerate by Nazism, and its products destroyed or sold. We are today allowed a better perspective by which to grasp why Expressionism posed a special threat. Its concept of man as a vulnerable creature exposed the ever-confident and robust figures that became the staple fare of German painting during the Third Reich. Such stereotypes would only thrive on the collective imagination, and the center of Expressionism was the individual as a sentient being.

England and France

Until the end of World War II England remained largely insular, an informed observer rather than a full participant in the history of modern painting. Vorticism, the sole important British contribution to abstractionist art, had flowered and dissipated at an early date. The absence of radical challenges to academic molds in the later 19th century meant that the innovative links stretching from Post-Impressionism to the school of Paris were, as a rule, missing. Moreover, England did not possess an overtly authoritarian society and had experienced no worse political violence than the discontent surrounding the General Strike of 1926, and so Expressionist outcries remained largely a foreign trend. There was, however, a pastoral tradition extending from Pre-Raphaelite landscapes to Samuel Palmer (1805–81) and John Constable (1776–1837) that merged in the later 1920s with the influx of Continental modernism.

Ben Nicholson (1894–1982), probably the greatest of British abstract painters, typified this dialog with Europe in his sleek reliefs, which profited from a study of late Cubism and Mondrian. Nonetheless, arabesques floated over his paintings that suggested still-life and the coastal landscape of Cornwall where he settled in 1939. Paul Nash (1889–1946) and Graham Sutherland (1903–80) also brought an intimate contact with rural scenery into their compositions, using Surrealist fantasy to transform rock, tree and field into surrogates for the human figure, to which Sutherland returned in his later years with numerous devastatingly observed portraits, including *Winston Churchill*, destroyed by the sitter's wife. Yet perhaps the most original image of man during the 1920s and 1930s in Britain came from Stanley Spencer (1891–1959), who remained independent of the mainstream of modern painting. His sources, including early Renaissance murals and the Pre-Raphaelites, were at the time unfashionable but contributed a painstaking clarity that has some superficial kinship with German New Objectivity. Nonetheless, Spencer was a genuinely Christian visionary in an eccentric British mold that goes back to Blake and the Metaphysical poets of the 17th century whose habit of uncovering the Divine will in the most predestrian surroundings is evident in panoramas such as *The Resurrection, Cookham* (1923–27).

Any account of the alternatives to abstraction on the one hand and Surrealism on the other must acknowledge that Paris remained the global capital of modern art between the two wars. Consequently, it proved a veritable storehouse of divergent artistic attitudes to figuration. These can be broadly separated into two major tendencies: the first tended to pursue self-expression at the expense of restraint; the second was devoted to an ideal of disciplined order. Georges Rouault (1871–1958), Chaim Soutine (1893–1943) and Marc Chagall (b.1887) were notable exponents of the Expressionist strain. Soutine painted some of the most wildly agitated oils of this century, heaving his paint into frenzied forms that described landscapes, dead animals and twisted figures. Rouault also projected a despair with existence in his glowing, encrusted canvases, whose imagery was drawn from a deep Roman Catholic obsession with Sin and Redemption. In contrast, Chagall, like Soutine, was a Russian Jewish émigré based in Paris who absorbed something from almost every modern movement, but subscribed to none. He knew of the prismatic colors that Robert Delaunay had brought to Cubism and also of Russian folk art and its icons. Although Chagall's seemingly haphazard compositions have a whimsical abandon that at times approaches sentimentality, he was inspired by Hebraic themes – during one of the most anti-Semitic periods in European history – to create moving statements of religious passion, of which *The Musician* is a notable example.

Whereas we are now able to appreciate the nuances that separate Expressionism and Surrealism, in the 1920s there were those who regarded them both as being symptoms of romantic ferment. The demand for a return to classical severity was an alternative which arose also partly as a reaction to the war and came under the popular catchphrase of a "call to order". Yet order meant different things to different people. For some it was a reenactment of a less complicated past, such as T. S. Eliot's devout, reactionary politics, Stravinsky's Neo-classical phase and the 1920s vogue for Greek fashions. Others found sufficient order in contemporary industrial civilization. This could prompt pessimistic ideas about man as a cog in a conveyor belt universe, as satirized by Charlie Chaplin in the film *Modern Times*, but more commonly it entailed an optimistic celebration of the gains, not the losses, of modern life. It was Fernand Léger, a stalwart Cubist, who gave superb pictorial form to this mood from the early 1920s onward with monumental figurative paintings in bold colors that convey sincere enthusiasm for existence in a technological environment. His people have the honed contours of precision-made machines at ease in a mass-produced setting, heroic testaments to a social contract that failed to survive beyond the hopes of the Popular Front.

The presiding genius of the school of Paris was still considered by many to be Picasso. As the inventor of Cubism and a charismatic personality in his own right, he was already assuming a legendary aura between the wars that

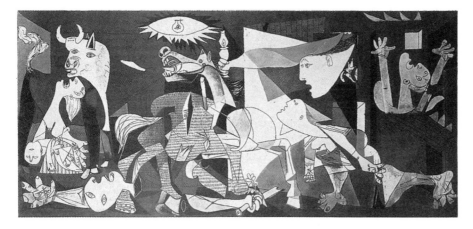

Guernica, *1937*
Pablo Picasso (1881–1973)
Oil on canvas 137½ 305½in (351×782cm)
Prado, Madrid

In 1937 the Republican government of Spain commissioned Picasso to execute a mural for their pavilion at the forthcoming World's Fair, to be held that year in Paris, where the artist had been living since the early years of his career. Picasso was busy with other projects and had not started the mural by April 1937. At the end of that month the Basque town of Guernica was bombed. Within days Picasso had assembled a body of sketches for a mural to commemorate the victims of the attack and he started work on the full composition in May. Each sketch was dated and Picasso arranged that his friend Dora Maar would photograph every stage of the full work in progress, providing a unique record of the evolution of a painting. Mixed with the images of women and children killed in the bombing are motifs familiar from Picasso's earlier work. The horse and the bull had first appeared in early studies of bullfights and over the years developed an abstract and symbolic form as his style evolved. The composition was sketched out on the huge canvas in line and gradually blocked in with black and white. Although the rough form had been decided in the preliminary sketches, the grouping of figures and details changed as the work progressed. Color was a feature of the preparatory drawings, but was eliminated from the final version. The painting was hung at the World's Fair in July 1937. In 1939 it was sent to the United States to take part in various exhibitions, including a retrospective of Picasso's work at the Museum of Modern Art in New York. After Franco's victory in Spain and the outbreak of World War II, the painting remained safely in New York. Guernica was not returned to Spain until after the death of General Franco and Picasso himself preferred a self-imposed exile from the country of his birth.

subsequent publicity would further accentuate. To the layman, certainly, Picasso and "modern art" seemed synonymous, although a curious irony exists in the fact that he eschewed total abstraction. Instead, during the 1920s and 1930s he coined an incredible variety of styles, searching into the numerous possible changes that he could extract from figuration. At times he appeared to anticipate, even contribute to, a direction such as Surrealism, although he would never join, preferring to avoid all stereotypes.

Around 1915 Picasso began to draw and paint delicate, realistic portraits and soon undertook his own "call to order" with serene Neoclassical works, perhaps inspired by the domestic security he enjoyed after his marriage in 1918 and the birth of a child three years later. Yet he was also ready to adapt earlier Cubist discoveries with a strongly geometric approach, seen in paintings such as *The Three Dancers* (1925), where the overtones of some sinister ritual start to emerge. By the late 1920s these combined with monstrous anatomical distortions as his liaison with his first wife crumbled. Playful Cubist ambiguities passed into powerful renderings of violent sexual acts or were transmuted into images wherein the outward mask of a face or

object seemed to contain a shadowed, half-glimpsed inner being. To an already wide repertoire Picasso added subjects from Greek myths and delved extensively into the potentials of etching. Despite his flamboyant reputation and the pronounced autobiographical note in his work he was sensitive to external political issues in the 1930s, and when civil war erupted in his native Spain – involving the annihilation of the ancient Basque capital of Guernica – Picasso countered with a gripping statement of innocence convulsed by horror. *Guernica* (1937) is perhaps the most famous painting of the 20th century. It combines complex symbols of suffering, aggression and inhumanity with a style that draws on many of the experiments Picasso had made in fragmentation and expressive distortion since the *Demoiselles d'Avignon*, exactly thirty years before. What began as a cool analysis of the world ended as a grave and impassioned record of its dismemberment on the eve of World War II. After *Guernica*, the reality of disaster spoke for itself. Significantly, Picasso's highly fecund postwar output was at its best when it avoided political commentary altogether, meditating rather upon the artist's private realm, his relation to tradition and quest for spontaneity in old age.

Sculpture 1900–1945

If the Paleolithic Venuses, Michelangelo's *David* and Rodin's *Balzac* have anything in common, it is the assumption that sculpture deals with the human figure. This comes from humanity's natural instinct to perpetuate its own image in some substance more permanent than flesh and blood. Of all the arts, with the exception of architecture, sculpture is literally the most tangible, for it occupies the space that we ourselves inhabit. Hence there is an eternal fascination in the act of making a replica of ourselves. The sculpture of our century is unique in so far as it has ceased to be satisfied with that one function and, although we have not been eliminated as its subject matter, our forms have had to contend with a previously unequaled number of rivals for its attention. This could be linked to an age that surrounds us with more artifacts than any other in history. Certainly it is an outgrowth of the explosion in modern man's investigation of everything about, beyond and within him – from his awareness of space, time and motion to his use of machines and invention of synthetic materials.

There is a certain lesson to be learned from the paradox that a considerable proportion of the most exciting sculpture since 1900 has been created by people who were primarily, or additionally, painters. But sculpture, unlike painting is not solely addressed to him and stands before us as a material thing, and matter is static, solid and real. Consequently, much of the sculpture made by modern painters has transformed these qualities in a daring manner that previous sculptors – hindered by narrow assumptions about their medium's conventionality – never attempted.

We have already seen that early modern painters were preoccupied with the machine as the epitome of a new sensibility, and felt that contemporary life was governed by interaction and flux. Among the first important sculptures of this century are therefore various efforts to fuse a brutal mechanistic mood with the humanistic subjects of the past. In 1914 the Frenchman Raymond Duchamp-Villon (1876–1918) fashioned *The Horse*. The animal was as time-honored a choice as the clay bisons found in Paleolithic caves or the horses on the Parthenon frieze, but Duchamp-Villon's creature resembles a spiraling engine part, a piston in bronze. A similar metamorphosis was applied to the human figure by the English sculptor Jacob Epstein (1880–1959) with *The Rock Drill* (1913–14), which presents a sinister armored torso, half man, half robot, that was to be mounted on a pneumatic drill, an alarming substitute for the usual plinth or pedestal. Even more aggressive was the Futurist concept of sculpture, for in 1912 Umberto Boccioni insisted that it deny its own gravity and become the embodiment of speed, renouncing marble and bronze in favor of new substances such as glass and wire. In a sequence of works that are now lost he put these ideas into practice, but his masterpiece, *Unique Forms of Continuity in Space* (1913), is an odd amalgam of the gracious past Boccioni hated and the on-rushing present that he worshiped. The Futurist Manifesto had observed that "A racing motor car, its frame adorned with great pipes like fiery snakes, which seem to run on shrapnel, is more beautiful than the Winged Victory of Samothrace." Yet it is these twin symbols of ancient poise and metallic violence that the imperious figure of *Unique Forms* appears to straddle. With its head like a radiator grill and limbs that burst outward into space, it strides away from the Classic nude toward a future moving so quickly that solid mass appears to fly in its wake.

Because Cubism broke down the outer skin of matter it was bound to raise fundamental questions about sculptural form, and in this respect Picasso again took the initiative. In 1912, the same year as Boccioni's call to use new materials, Picasso had made a guitar that was not "sculpted" but constructed, being cut and assembled from flat sheets of metal. The insight that simple planes could be translated into a three-dimensional representation came from Cubist painting and was extraordinary enough, yet from the guitar's center – meant to be the sound hole – emerged an open-ended cylinder taken from a stove pipe. In one gesture Picasso had destroyed three of Western sculpture's most cherished traditions: devotion to the figure, to modeling (or carving) and to solidity. Space was now put to use in a positive sense rather than remaining a void surrounding the object. Afterward Picasso started constructing pieces such as the *Still Life* of 1914 that looked as though a Cubist composition had jumped from its frame. Nothing here is what it seems to be and everything is rich in double meanings. The glass shows its insides while the table top leans downward implying that it is viewed in perspective; painted wood becomes bread and slices of sausage that lie upon a "tablecloth" that ends in a real upholstery fringe. These and similar inventions by Picasso in the heyday of Cubism, such as the 1914 bronze *Glass of Absinthe* – crowned by a genuine silver spoon balancing a painted plaster sugar lump – parodied the pompous grandeur that had threatened to stultify 19th-century sculpture. From the dull blocks on plinths that passed for public monuments and heroes, sculpture had become a witty assemblage of unexpected parts.

Picasso's assemblages proved beyond doubt that sculpture needed neither lofty subjects from myths or history to be profound, nor living ones to look lively. Thus he opened two sets of possibilities for succeeding sculptors. One

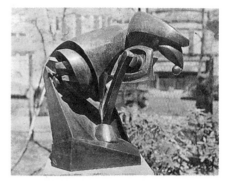

The Horse, *1914*
Raymond Duchamp Villon (1876–1918)
Bronze, height 40in (100cm)
Peggy Guggenheim Museum, Venice

A brother of Marcel Duchamp, his cubist work from 1912 shows a naturalist vitality which is well exemplified in the Horse *of 1914. He died during war service in 1918.*

The Gift,
Man Ray (1870–1976)

This destructive treatment of an everyday object of which the smooth surface is the most important aspect, is a typical example of the surrealist ability to focus attention. The title emphasises the reduction of the object to a useless present.

involved a manipulation of abstract entities – space, texture and color – the equivalent to breakthroughs in contemporary painting; the other led to the examination of what shapes mean, the associations they arouse and the identities they can assume. The first alternative was taken up eagerly in Russia, where Vladimir Tatlin and others started to make the Constructivist technique the basis of an entire ideology, using whatever materials were available for non-representational assemblages. These "counter-reliefs", as Tatlin named them, were sometimes hung from the ceiling or affixed high in a corner so that they appeared to float freely in space. Sculpture had transcended its own weight and taken to the air. It is characteristic of this freedom that Tatlin's *Monument to the Third International*, which we have already encountered as a design, can also be interpreted either as architecture or sculpture.

Constructivism, as we have seen, soon succumbed to the political and

Still Life, *1914*
Pablo Picasso (1881–1973)
Painted wood with upholstery fringe
10×19×4in (25.5 47.5×10cm)
Tate Gallery, London

In November 1913, in the first number which he edited of the review Les Soirées de Paris, *Apollinaire printed four reproductions of Cubist constructions by Picasso which were received with such disapproval by subscribers that the review nearly went out of business. The application of color to sculpture was of an ancient inheritance, but Picasso's constructions, of which this* Still Life *is an example, offended two artistic canons: that paintings should be two-dimensional and that everyday materials should not be made the ingredients of "high art". Picasso was happy to use any material which served his purpose, including fragments of newspaper, string, tin and cardboard. His "bas-relief" constructions, which may be seen to grow naturally out of the Cubist collage, or at least out of the Cubists' preoccupation with our perception of forms, attest to the unity of Picasso's work. His drawings so frequently look like sketches for sculpture that in the end it makes little sense to draw a sharp line of distinction between his paintings and his sculptures.*

economic exigencies of post-Revolutionary Russia, but two of Tatlin's associates, the brothers Naum Gabo (1890–1977) and Antoine Pevsner (1886–1962), refused to capitulate and left the country. Their sculpture, they declared, was neither representation nor political, it was simply *real*. In the Realistic Manifesto of 1920 Gabo stated his aims: "We affirm that the tone of a substance, i.e., its light-absorbing material body, is its only pictorial reality. ... We affirm the line only as a direction of the static forces and their rhythm in objects...."

These ideals had a direct impact on their work in the subsequent thirty years. Movement was introduced in one construction by the use of a piece of wire set vibrating by an electric motor; time was implied by transparent plastic and glass areas, allowing otherwise unseen sections to be visible simultaneously; meshes of wire like an exquisite cat's cradle encircled emptiness and glinted as they caught the light.

But could sculpture still be modern while respecting ancient materials such as stone, wood and bronze? An answer was provided by artists in Paris such as the Italian Amedeo Modigliani (1884–1920), and the Romanian Constantin Brancusi (1876–1957). The Russians had turned sculpture into a shimmering, translucent interaction of forces; Modigliani and Brancusi returned to its roots in primitive, expressive shapes. Modigliani's heads, hewn out of coarse stones, possess the archaic simplicity of Easter Island monoliths. Partly under the influence of African carvings, Brancusi hacked blocks of wood into enigmatic reminders that the totem, stark and implacable, had preceded the niceties of finish that academic sculptors used to conceal their weaknesses. He sought to remove all superfluous detail and go straight to the universals: "It is not the outward form that is real, but the essence of things. ... It is im-

possible to express anything real by imitating the outer surface of things."

When we contemplate the origins or the core of existence we tend to envisage primal simplicity, unconsciously remembering perhaps the featurelessness of an embryo or an egg. Complementing his brutish wooden pieces, Brancusi polished bronze and ground away at marble until it had a look of acute self-containment. In works such as *The Beginning of the World* (1924) and *Blond Negress* (1933) he attained ovoids of such perfect poise that they seem the alpha and omega of shape, from which nothing could be removed – nor added – without complete annihilation.

Unfortunately, in the untidy, everyday routine that for most of us passes for "life" the immaculate beauty of a Brancusi or a Gabo is rarely encountered, unless we happen to be millionaires or museum-goers. Instead, the accident is common property and the objects that we normally handle, from household appliances to workday tools, are prone to wear out, break and even kill. Artists sympathetic to Dadaism and Surrealism believed that this kind of awareness was more sharply graven in our consciousness than any curve or plane of plastic or alloy. When they resorted to sculpture, it was more often than not to undermine its hallowed rules, bringing humor, nastiness and surprise where formerly these would have been considered beyond the bounds of respectability.

The American Dadaist Man Ray (1890–1977) made one of Duchamp's ready-made commodities into an uncomfortable joke at the viewer's expense with his *Gift* (1921), in which he placed a row of nails, points outward, on the base of a flat-iron. Clearly this was meant as a painful rebuttal to all those smooth contours that generations of sculptors had invited their public to touch and caress. At the same time

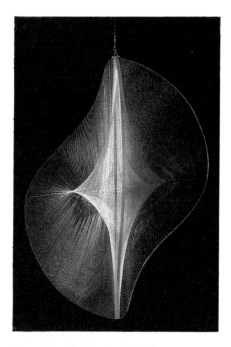

Linear Construction No 2, 1949
Naum Gabo (1890–1977)
Plastic and nylon height 36in (91cm)
Stedelijk Museum, Amsterdam

The record of Gabo's work shows a consistent development from the early aims of the Constructivist movement, founded by Gabo and his brother Antoine Pevsner (1886–1962) in 1917: to use the materials and concepts of the Industrial Age to discover a new attitude to form in sculpture. Gabo traveled widely in his long career and became an influential figure internationally. Gabo and Pevsner first worked together in Moscow and Berlin; in 1926 Gabo's work was first exhibited in New York; he lectured at the Bauhaus in Dessau in 1928 and was active in Paris from 1932 to 1935. He then lived in England until the mid-1940s and after 1947 settled in the United States, becoming an American citizen in 1952. Linear Construction represents Gabo's point of view clearly expressed in a statement on sculpture of 1937: "Up to now the sculptors have preferred the mass and neglected or paid very little attention to such an important component of mass as space. Space interested them only in so far as it was a spot in which volumes could be placed or projected. It had to surround masses. We consider space from an entirely different point of view. We consider it as an absolute sculptural element, released from any closed volume, and we represent it from inside, with its own specific properties".

Merzbau, *Hanover, begun 1923*
Kurt Schwitters (1887–1948)

Rejected by the Berlin Dada groups for allegedly being too unpolitical and too bourgeois, Schwitters invented his own branch of Dadaism called Merz, *taken from the middle of the word "Kommerzbank", from a letterhead which he used in a collage of 1920. In 1923 Schwitters began to publish his own review, also called* Merz. *His Dadism, in theory at least, was thoroughly nihilistic: "Everything the artist spits," he once said, "is art." The first of his* Merz *buildings was his own house in Hanover which he began to decorate in a Dada style in 1923 and was destroyed in 1943. Here, as in the houses that he later decorated in England and Norway, Schwitters put together materials of all kinds, more or less at random, to create a* Merz *environment. Yet the style may have sprung from personal yearnings deeper than Dadaist whimsy; Schwitters entitled one section of the Hanover house the "cathedral of erotic misery".*

Kurt Schwitters (1887–1948) was rummaging through Hanover garbage heaps in search of flotsam to fill the secret corners of his house, which grew over the years into a sordid yet poignant cathedral of rubbish with memories of what had been rejected and cast out by society. Perhaps Schwitters was enticed by the way chance takes over – think of any junkshop's wonderful assortments – as soon as an artifact loses its purpose. The Surrealists used this to uncover the inexplicable alarm we experience before the uncanny; the accidental meeting of categories ordinary enough in themselves yet horridly incompatible as partners, such as the *Fur-Covered Teacup* of Meret Oppenheim (b.1913). The drawback is that once the engaging affront to the senses wears off, pedestrian identities return and the reign of wonder stops as suddenly as it began. In this respect Picasso was again among the few to press forward into uncharted ground when, in the late 1920s, his friend Julio

Gonzales (1876–1942), a former worker at the Renault car factories, instructed him in welding techniques. A sequence of constructions followed that subjected iron to every imaginable gesture as it was wrought, forged, pierced and bolted into a variety of shapes. Although the individual components are unassuming, Picasso juxtaposed them with relentless variety. A colander in *Woman's Head* (1931), for example, shifts magically from a kitchen utensil to a part of the cranium. Nor does our interest soon fade; every section forces unseen encounters between ovoid and disk, spike and sphere, reminding us that to combine eloquent form with poetic content is still one of sculpture's oldest and most rewarding tasks.

Architecture 1900–1939

Buildings give us both a measure of a civilization and its monuments. Unlike painting or sculpture, buildings are a necessity and when architecture is meager – as in the Dark Ages – we tend, rightly or not, to interpret it as a sign of primitive backwardness. They may also, of course, recount the history of a society's ambitions and stand as physical symbols of man's relationship to the space he inhabits. Indeed, certain epochs, for example the medieval or Renaissance, are popularly identified with their predominant architectural style.

What would an archeologist of the future make of the last century and our own? He or she might conclude that the one century contained many important edifices reminiscent of previous discoveries but perhaps the other would appear to contain many structures different from anything previously encountered. Whether the archeologist could discern continuities behind the differences between the two is hard to say, but certainly most people today – whatever their knowledge of architecture – know that they see, use and possibly live in buildings that are, for better or worse, unique to our own century. Yet many probably have only a vague awareness of why this uniqueness takes the forms it does or where it originated, although those old enough to remember might add that there was scarce evidence of it in the early 1900s.

At the start of this century there were, broadly speaking, four major directions in architecture. Firstly, Revivalism expired in a blaze of glory, with the hope that the values of the past could be maintained in the present. The British architect Sir Edwin Lutyens (1869–1944) typified this trend with the New Delhi Viceroy's House (1912), a grandiose classical testament to the proud but waning authority of the British Empire. Secondly, in the United States the Woolworth Building (1913)

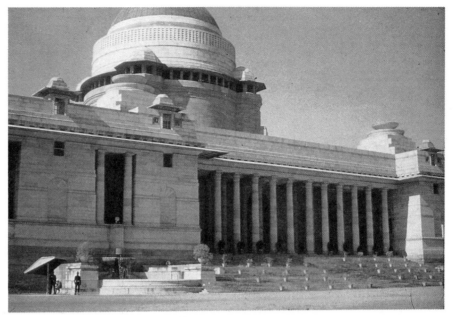

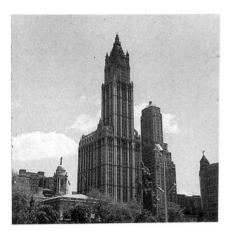

The Woolworth Building, *New York,*
1911–13
Cass Gilbert (1895–1934)

The first American skyscrapers, those of the
Chicago school led by Louis Sullivan,
tended to reflect Sullivan's dictum that
"form follows function." The buildings of
the 1890s were simple, accurate
representations of their frame structure.
Reinforced concrete, the characteristic
material of the skyscraper before the glass-
wall era, is able to cover a large area
without support and architects were
therefore freed from the vaulting that was
the structural basis of all previous European
architecture. Verticals were replaced by
horizontals laid one on top of another.
When the fashion moved to New York from
Chicago, a new generation sought to
embellish skyscrapers by sculptural modeling
and fancy ornamentation. The best-known
and tallest building of this kind was the
sixty-story Woolworth Building, done in
what the Swiss art historian Sigfried
Giedion later called "Woolworth Gothic."
The last important building of the type was
William van Alen's Chrysler Building, New
York (1930). By the time it was completed
architects were returning to the original
style, trusting to the upward sweep and
repetitive design of windows of the
skyscraper to give it its elegance.

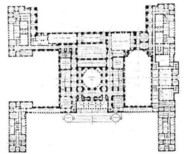

and the old Pennsylvania Station (1902–
10) were likewise highly imposing
efforts to cloak skyscraper and ter-
minus, respectively, in Gothic and
Roman molds. Thirdly, the continua-
tion of regional vernacular styles was
common and followed cottage-type
designs in particular. Then, by con-
trast, the two approaches we have
noted already – European Art Nouveau
and the steel-frame methods of Chicago
– broke away from historical models.

Yet how did these last two alterna-
tives relate to a moment whose mood
was voiced by the Italian Futurist archi-
tect Antonio Sant' Elia in 1914? "The
problem of modern architecture is not a
problem of rearranging its lines. . . . But
to raise the new-built structure on a

Viceroy's House, *New Delhi, 1912–31*
Sir Edwin Landseer Lutyens (1869–1944)

It is one of the great disappointments of
recent British architectural history that
Lutyens's Catholic Cathedral for Liverpool,
England was never built. We must look
elsewhere, to the Vice-Regal Palace (now
the President's House) at New Delhi to see
the masterpiece of his brilliant rehandling of
Renaissance Classicism. Lutyens made his
reputation chiefly by his country houses.
His Neoclassical period dates from 1910 and
includes the Cenotaph, London (1922) and
the British Embassy, Washington D.C.
(1926). The Viceroy's House was his
grandest and noblest work, the last
monumental architecture in the world
inspired by Classicism. The Indian
Independence movement was just
beginning to acquire force when Lutyens
was given the commission to design the
new capital at New Delhi in 1912, and he
had to overcome the opposition of officials
who dreaded the effects on native opinion
of imposing a Western tradition of
architecture on an Asian colony. In the
end, the Viceroy's House, made of luminous
red and buff-white sandstone, was
remarkable for integrating into its essentially
Classical composition and orders certain
prominent Eastern features, such as the
Mogul chujja *(the thin, projecting cornice*
that runs around the building) and the
smooth dome taken from the Great Stupa
at Sanchi.

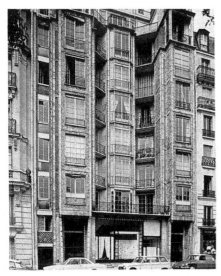

Apartment Building, *3 Rue Franklin Paris, 1903–03 Auguste Perret (1875–1954)*

While architects in the United States at the turn of the century were leading the way in the development of steel-frame architecture, France, in the work of Perret and Tony Garnier (1869–1948), was making an equally important contribution to the Modern movement in designing the first houses of a genuinely concrete character. The eight-story apartment building on the rue Franklin, in which Perret lived, has been called the first major 20th-century building. using a reinforced-concrete frame, Perret allowed the essential structure of the building to be plainly visible, so that even the ceramic infilling panels with relief foliage do not detract from the bold horizontal and vertical prominence of the beams and girders. The spatial ambiguities of the façade, with its recesses or bays (depending on which surface is taken as the true facade) are reminiscent of Mackintosh. Exposed concrete, internally and externally, remained the hallmark of Perret's style, which found its most satisfactory expression in the church at Le Raincy (1922–23).

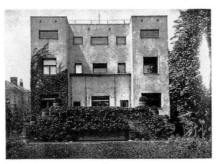

Steiner House, *Vienna, 1910 Adolf Loos (1870–1933*

In 1897 and 1898 Loos wrote a number of articles in which he derided the prevailing Art Nouveau style – known as the "Sezession" style in Austria – for its superfluous frivolity and declared that henceforth the modern world would receive its culture from engineers. From 1893 to 1896 Loos had lived in the United States, where he admired the simplicty of Colonial architecture, and his theory owes much to the functionalism of Louis Sullivan. "To find beauty in form instead of making it depend ornament or softening curves, remained humanity is aspiring." In all his buildings Loos practiced what he preached, nowhere more astringently than in the Steiner House. Its reliance on the pure cube, its stark use of contrasting straight lines, and its horizontal single-paned windows were all far in advance of the time. For twenty years Loos's geometric style, stripped of all ornament or sofetning curves, remained largely unimitated, so that today the Steiner House gives the appearance of having been built in the 1930s, the decade when Loos's influence on domestic architecture came at last to be strongly felt.

sane plan, gleaning every benefit of science and technology . . . establishing new forms, new reasons for existence . . . I affirm that the new architecture is . . . of cold calculation, temerous boldness and simplicity; of reinforced concrete, iron and glass. . . .''

Sant'Elia named the issues that were in the air just before World War I when progressive architects felt that contemporary life was increasingly ruled by mechanization and the need for rational simplicity. Chicago skyscrapers' regular steel frames were perfectly in keeping with this climate and so was the use of iron and glass in Art Nouveau. Yet while Chicago's example soon became the blueprint for numerous modern buildings, Art Nouveau vanished along with Revivalism. One explanation could be that the steel grid was a functional device, whereas the essence of Art Nouveau lay in complex ornament.

Ornament came under attack from all sides because it had nothing to recommend it to the Machine Age. For the Viennese architect Adolf Loos (1870–1933) ornamentation was to architecture what tattoos were to the human body: a sordid violation. The answer, therefore, rested upon a return to basic elements that had, in fact, been anticipated by one artist in Holland, Piet Mondrian, whom we have already encountered as a herald of abstract painting. In 1917 the painter Theo van Doesburg (1883–1931) founded a group around him that incorporated Mondrian and the cabinetmaker-turned-architect Gerrit Rietveld (1888–1965). Their ideas grew from a utopian belief that Art – the traditional provider of order and harmony – would no longer be necessary once man attained genuine unity with his environment. To gain this end the environment itself had to possess a unified style, hence the name of their movement, De Stijl (The Style).

Following Mondrian's aesthetics, De Stijl proposed that certain forms and their relationships contained universal validity because they were elemental. These included the clean edge of a straight line, the rectangle – established when horizontal and vertical meet – and the three primary colors plus black and white. In terms of design De Stijl was crystallized in a work such as Rietveld's exciting, virginal and clear-cut conception for an ideal residence, the Schroeder House in Utrecht (1924). Although it resembles a Mondrian painting extended into three

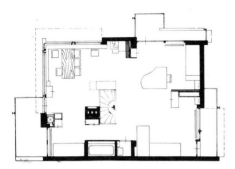

Schroeder House, *Utrecht,*
The Netherlands, 1924
View and upper floor plan
Gerrit Rietveld (1888–1964)
Concrete, brick, steel and wood

Rietveld had originally trained as a cabinet-maker, following his father's trade, and learned architectural design by studying at night school. At first Rietveld worked mainly on designs for furniture and interior domestic fittings. In 1917 Rietveld joined the newly formed De Stijl group, which promoted the principles of an approach to art and design based on theories of geometric abstraction. In 1921 he remodeled the interior of a house for Mrs Truss Schroeder and in 1924 she commissioned him to build her a new house on the outskirts of Utrecht, a site at that time having direct access to the countryside although it has since been overtaken by urban development. The house was a remarkable result of collaboration between Rietveld and his client, illustrating Rietveld's later expressed view that "Functional architecture must not just slavishly satisfy existing needs; it must also reveal living conditions." The upper floor formed the main living area; the lower housed study and recreation rooms. Upstairs the were no inner walls but sliding partitions, allowing the large open-plan area to be converted into four private rooms. Mrs Schroeder suggested that each "room" be equipped with cooking and washing facilities. This made the house extremely flexible functionally, with potential use as an open family home or as small apartments. The external design followed the principles of Neoplasticism in its planar arrangement of forms. The construction is basically steel-frame and brick; the bricks were rendered over and painted white and gray, giving the impression of pre-formed concrete slabs. The large rectangular windows on the first floor open fully outwards, linking the captive interior space with the exterior implications of space.

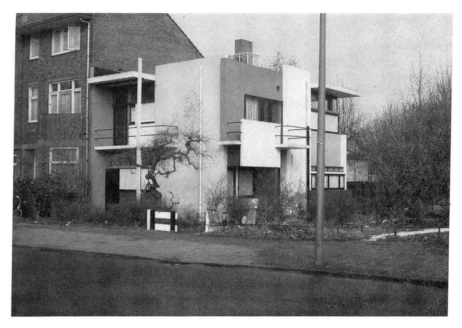

dimensions and has a measured, even rudimentary feel, it is not static. Instead, every component – walls, floor-slabs, canopies, balconies – appears to intersect, project and hover in space. Despite its small scale the Schroeder House offered a spectacular demonstration of airiness and open planning, contrasting with the dim, haphazard dwellings that the majority of the population then, and today, still inhabit. Whether humanity preferred comfy and relative squalor to ennervating precision was hardly a question raised by the optimistic generation of the 1920s, for whom happiness was a clean, well-lighted place.

The advocate of this vision was the French-Swiss Charles-Édouard Jeanneret (1887–1965), more popularly known as Le Corbusier. In his influential book *Towards a New Architecture* (1923) he outlined the sources, techniques and criteria for a science of building that he believed could reform society out of the chaotic jumble of the 19th-century city, a hotbed of disease and alienation. In its place would rise orderly townscapes full of mass-produced, flexible and beautiful structures. Mass-produced because man now had the Machine at his command and the house could, theoretically, be assembled with the ease of a factory-made automobile – provided, that is, that the correct materials were chosen. The bold feats of engineering and industry had vindicated those materials nominated by Sant'Elia in 1914: iron, glass and, especially, reinforced concrete. The last was of tremendous value because when steel rods are set into concrete, a very strong, tensile compound is created that far surpasses what can be achieved in stone or masonry. Reinforced concrete bridges, the 220 foot (73m) diameter dome of the Breslau Century Hall (1913) by Max Berg (1870–1947) and the ingeniously organized Paris apartments on the Rue Franklin (1903) by Auguste Perret (1874–1954) were all examples of reinforced concrete's potential. Le Corbusier realized that ferro-concrete could permit a building to have a skeleton, creating a framework so dur-

able and self-supporting that walls and windows became mere in-filling, curtains to be opened and drawn at liberty.

What character would Le Corbusier's ideal accommodation assume? Ornament implied clutter and so it was eliminated. Proportion, on the contrary, was vital and Corbusier studied the geometric outlines of machinery, which he likened to the hard, pure architectonics of Classical Greece and the Parthenon. Whiteness became a necessity insofar as it allowed volumes to be understood for what they were, devoid of cosmetic improvements. The conclusions of Le Corbusier's theories arrived during the 1920s in a series of plans for new cities that were never realized, and individual buildings that were. Both display faults peculiar to brilliantly ambitious schemes. The 1925 *Plan Voisin* visualized the destruction of all but a handful of key Parisian monuments in favor of high apartment buildings above streamlined highways that liberated the remaining ground for schools, parks and recreation. Hindsight, however, has shown that such schemes can create as many problems as they solve and cities conceived according to the Corbusier ideal, especially Brasilia, tend to feel at best unlived in, and, at worst, uninhabitable. Similarly, villas such as the *Savoye* at Poissy (1929) cost so much that they were within reach of only the wealthiest patrons and, as a consequence, soon deteriorated into unacceptable shabbiness. On the other hand, raising the upper cubic living area on stilts (*pilotis*) caused the villa to float miraculously over the landscape as no previous house had done. Internal ramps fluidly connected the floors; the roof space became a garden, and the walls, ceasing to bear loads, could be punctured as grace demanded by glazing. Since the days of Palladio a Classical edifice had scarcely inhabited its place in nature with such

beautiful, unassailable economy, and although Le Corbusier's style was not as practical as he claimed, it quickly passed beyond local criticisms to international recognition by the avant-garde. In this respect it helped form a vanguard movement in conjunction with the advanced and often more industrialized architecture and theory that had arisen in Germany from the early 1900s onward. Indeed, Le Corbusier was by no means alone in his insistence that an architect's work should fulfill its functions with the exactitude of a machine.

With its technological assets and industrial productivity Germany about 1900 had moved into the forefront of European nations. High standards of scientific education were established, and the large capitalist concerns required factories and design centers to meet their expanding needs. One of the biggest electrical corporations, AEG, commissioned Peter Behrens (1864–1940), a teacher of Le Corbusier, to design a sequence of factories that were landmarks in architecture insofar as this particular type of building had not previously been given much attention. The Turbine Factory (1908) proved especially influential on account of its enormous windows, providing much-needed light to the workers, and simple outlines. At its corners Behrens had nevertheless stood massive masonry piers, which Walter Gropius (1883–1969) demonstrated were unnecessary with the Fagus Shoe factory (1911). Instead, continuous windows running around corners replaced the piers, contributing to an effect of lightness. Gropius was at the time a socialist who shared with Le Corbusier the conviction that architecture did a great deal to determine man's social behavior. The design school in Weimar that he was appointed to direct in 1919 was renamed the *Bauhaus*, in reference to the medieval builders' workshop

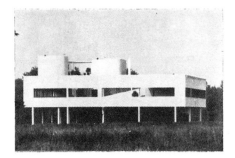

Villa Savoye, *1929–31*
Le Corbusier
(1887–1965)
Concrete, stucco and glass
Poissy, France

The Villa Savoie is one of a number of private residences designed by Le Courbusier after he had established the studio in the Rue de Sèvres at Paris that remained his working base for the rest of his career. It demonstrates several elements that formed the fundamental basis of Le Corbusier's design principles. The building is virtually a concrete box, raised on pilasters to give access to space underneath the living area, here used as a garage and entrance hall. Ribbon windows around the building give a clean view of the surroundings, like a natural mural. A raised patio area corresponds to the "garden in the sky" concept that Le Corbusier applied to high rise architecture. In some areas the concrete skeleton remains exposed while elsewhere the stucco finish adds pastel or neutral color to the exterior design. The effect of the exterior was unfortunately spoiled by rapid deterioration of the stucco and the building was further damaged during World War II, remaining in a dilapidated state for many years.

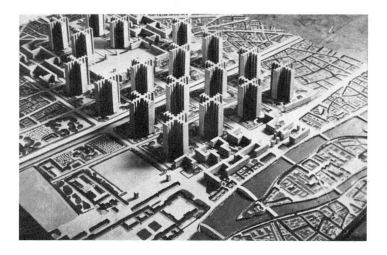

The Voisin Plan for Paris, *1925*
Le Corbusier (1887–1965)

With Frank Lloyd Wright, the most influential and informative architect of the first half of this century was Le Corbusier, whose energy, ability and forceful personality have imprinted themselves on a vast oeuvre of designs and a number of completed works in a variety of architectural modes. His vision was comprehensive and his schemes on a vast scale included the model of a plan for Paris in an annex of the Paris International Exhibition of the Decorative Arts in 1925. This scheme would have replaced much of the Right Bank beyond the Rue de Rivoli with the pattern of cruciform skyscrapers and living apartments seen in the illustration.

The Fagus Factory, *Alfeld an der Leine, 1911*
Walter Gropius (1883–1969)

Almost immediately after leaving the office of Peter Behrens, Gropius was commissioned to design this factory for the AEG Company. It was his first major building and it revealed how far, even so early in his career, he had gone beyond his teacher in the pursuit of modernity. The unapologetic use of the cube had been seen a year earlier in Loos's Steiner House, but, leaving aside the Crystal Palace in London and similar "greenhouse" structures, the Fagus Factory was the first building to have a façade made almost entirely of glass. Its corners, unsupported by girders, were to become a conventional device in the interwar years. The result was to destroy the

sharp distinction which traditional architecture had always maintained between interior design and external façades, thereby achieving a transparency which, despite the unyielding functionalism of the building, allows the building to serve as an example of what Frank Lloyd Wright meant by the "etherealization" of architecture.

The AEG Turbine Factory, *Berlin, 1909*
Peter Behrens (1868–1940)

In 1907, the year of the founding of the Deutsche Werkbund — an association of architects and designers whose aim it was to bring the artist into industrial production — the AEG electrical company appointed Behrens as its architect and industrial design consultant. By then Behrens had sloughed off the habit of Art Nouveau which he had acquired as a student painter in the 1890s — for example in 1901 he designed a new typeface which eliminated curves entirely. All Behren's important buildings between 1907 and the outbreak of World War I were done for AEG and his turbine factory is the most famous of them. It incorporates an iron three-pin frame on a massive scale and, although the building relies on stone, most notably for the sculpted rounding of its corners, there is no attempt to conceal its metal frame. The two-story wing has the flat roof and repeated oblong windows characteristic of the nascent International style

The Bauhaus, *Dessau, 1925–6*
Walter Gropius (1883–1969)
Ferro-concrete, brick, glass and stucco

*In 1919 Gropius gave up private practice as
an architect to become Director of the
Bauhaus, formerly the Academy of Weimar.
Under the influence of his ideas and
personality the school became a major
innovative force in modern art and design,
but Gropius' talents as an architect were
necessarily neglected. In 1926 the Bauhaus,
under increasing pressure from the Weimar
authorities, was invited to Dessau and
Gropius accepted responsibility for the
design of the new buildings. The agreement
included not only the design of the school
building but also separate accommodation
for the Bauhaus staff and a model district of
workers' dwellings in a nearby suburb.
Collaboration was a keynote at the Bauhaus,
but the design of the main school building
was entirely the inspiration of Gropius and
expressed his view of the needs and
possibilities of modern architecture. The
basic plan of the Dessau Bauhaus was of
blocks forming two interlocking L-shapes.
The connection was made by a bridge
above and crossing the access road,
containing a corridor and administration
offices, and linking classrooms and
laboratories with the main block of
technical workshops. In this area Gropius
used glass "curtain" walls on two sides of
the block that wrapped around the corners
of the building. Attached to the workshops
were an auditorium, stage and dining hall
and beyond these a six-story block for
student accommodation. The distribution of
levels marking the functional sections of
the school creates a complex silhouette
that changes radically from each successive
view around the building.*

(*Bauhütte*), symbolizing the ancient
unity of the arts and crafts under the
primacy of architecture. At first they
gave woodwork courses and the like,
but Gropius soon found that the
Machine Age demanded an under-
standing of industrial techniques.
Thereafter the school's slogan became
"Art and technology: a new unity."

After moving to Dessau in 1925 the
Bauhaus gathered together a multi-
national array of artistic talent, who
researched design possibilities in up-to-
the minute fields such as mass-
produced housing, typography and
furniture, besides the less industry-
oriented efforts of painters such as
Kandinsky and Klee, who were also on
the faculty. The quintessential Bau-
haus "look" stressed efficiency, sleek-
ness and materials suited to commercial
production. Its success, perhaps, can be
gauged in one small example: the
tubular steel-frame chair, long the
resting point of millions of posteriors
throughout the world, originated with
a Bauhaus student. In architecture the
work of Gropius, epitomized in the
Dessau Bauhaus complex itself, was by
1932 seen to have many qualities in
common with the achievements of Le
Corbusier and the De Stijl group among
others. Plain white surfaces, rectilinear
profiles, large windows, designs em-
phasizing functional requirements and
ferro-concrete became ideals for numer-
ous architects, regardless of national
loyalties. Consequently, their buildings
were described as suggesting an Inter-
national style. Once this had spread
from Europe to the United States, it was
regarded as nothing less than a symbol
of the mainstream of modern architec-
ture, influencing everything from sky-
scrapers to municipal housing projects.
Although the International style and
its outgrowths never transformed our
lives to the extent its pioneers imagined
it would, they have had a deep effect on
countless aspects of our environment

that we would not accept as "modern"
without their presence.

Nonetheless, no mainstream could
be defined unless it flowed among cross-
currents and it would be a mistake to
assume that the International Modern
style accounted for all architecture
between 1900 and 1939. Terrace houses
and cottage estates were still built in
England and across Europe; tenements
in many styles continued to rise in the
United States. Civic monuments –
whether the Lincoln Memorial (1917)
or Westminster Cathedral (1903) –
often adhered to past models and the
man in the street did not find them
wanting. Totalitarianism resulted in
Nazi and Stalinist bans on the Modern
movement at an official level to enable
the return to Neoclassicism. Yet there
were also those who forged challenges
to the International style without re-
course to the past. Some German
architects, for example, avoided the
impersonal aura of the Bauhaus and
because of their individuality have at
times been classified as Expressionists.
In place of standardized geometry they
substituted the fragile shimmer of the
mineral world, exemplified in Bruno
Taut's (1880–1938) sketches for dia-
mond-like glass structures and the
almost crystalline stalactite ceiling in-
side the Berlin Grosses Schauspielhaus
(1919) by Hans Poelzig (1869–1936).
Another prospect existed in the curving
rhythms that had vanished with the
demise of Art Nouveau. During the
earlier phase of his career Eric Mendel-
sohn (1887–1953) gave a new dimension
to this in the famous seven-story
Einstein Tower (1917) at Potsdam. In
this laboratory crowned by an ob-
servatory Mendelsohn externalized the
sweeping energies of contemporary
science to which it was dedicated. This
was not, however, accomplished by
machine-contoured units, but in or-
ganic volumes that look sculpted rather
than stamped out on a press.

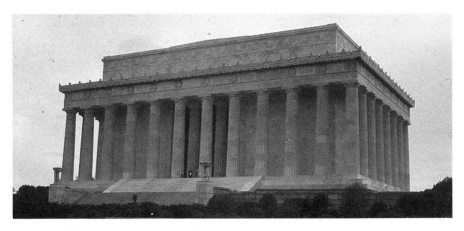

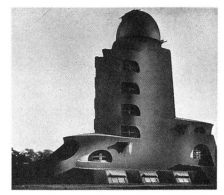

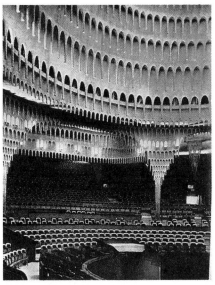

Grosses Schauspielhaus, *Berlin, 1919*
Hans Poelzig (1869–1936)

*Alongside the development of what became
known as the International style in Germany
after 1918 – associated, above all, with the
rectilinear puritanism of Mies van der Rohe –
there occurred sporadic experiments to find
an architectural mode of the Expressionist
movement in painting and sculpture.
Before the war Poelzig had employed the
chaste lines of the new industrial architecture,
but in the vast, structure-concealing,
"stalactited" ceiling of the Schauspielhaus,
which hangs like a huge dome over a
circular stage, he used reinforced concrete
to create one of the few successful
monuments of Expressionist architecture.*

The Lincoln Memorial, *Washington D.C.,
1914–22*
Henry Bacon (1866–1924)

*In the 1880s an academic reaction in
American architectural circles, fostered
notably by the firm of McKim, Mead &
White, brought into fashion a somewhat
superficial revival of "Classical",
"Renaissance" and "Georgian" styles. The
movement was strongest on the eastern
seaboard, where it continued to thrive long
after Frank Lloyd Wright and the architects
associated with the so-called Chicago
school were making the Midwest the cradle
of modernity. The Memorial – Bacon's
Greek doric temple – of white marble and
crowning high attic, stands at the end of
Pierre Charles L'Enfant's (1754–1825)
elegant mall and is the last noteworthy
building in the complex of Neoclassical
buildings which adorn the capital.*

Einstein Tower, *Potsdam, near Berlin,
1920–21*
Erich Mendelsohn (1887–1953)
Brick and concrete

*Mendelsohn was occupied with projects for
new buildings even while on active service
in World War I. In 1917 he sent home from
the Eastern front sketches that included
designs for airport and station buildings. He
had been encouraged by his teacher to
pursue ideas through drawing, perhaps as a
suggestion that his practical abilities were
less confident than his imagination, and
continued this habit when he commenced
practice as an architect in 1918 immediately
after leaving the army. Drawings of
observatories by Mendelsohn had been seen
by Professor Finlay Freundlich, a colleague
of Einstein, and it was he who suggested
Mendelsohn as architect when the German
government decided to build a study center
where Einstein's theories could be
explored. Mendelsohn's Tower was
conceived for construction in reinforced
concrete. Owing to delays in the delivery of
cement the proposal was modified and the
Tower built of brick covered with a concrete
layer. Despite construction problems the
completed building answered Mendelsohn's
conception of an organic and monumental
design.*

Another critic of the International Modern style's limitations had been, paradoxically, a precocious and original contributor to its beginnings: the American Frank Lloyd Wright (1869–1965). Due to his apprenticeship with Louis Sullivan of the Chicago School, Wright had a head start when it came to reducing architecture to strict fundamentals. The Larkin Building (Buffalo, 1904) and Unity Temple (Chicago, 1906), composed of almost Egyptian slab-like walls, strongly impressed the architects of De Stijl. Wright also inherited Sullivan's structural engineering skills, for example the whole of the Unity Temple is fabricated from poured concrete cast in molds. Wright was also among the first architects to appreciate that the Machine, and all it represented, was here to stay, yet, unlike some European Modernists, this knowledge did not turn him into a puritan who rejected decoration and everything superfluous to a building's bare function. Instead, Wright felt architecture ought to take its place in nature as an organic presence. He explored this theory in a series of residences in the Midwest that were sympathetic to what Wright thought was the quality of the surrounding landscape, as he observed in 1908: "The Prairie has a beauty of its own and we should recognize and accentuate this natural beauty, its quiet level. Hence . . . sheltering overhangs, low terraces and out reaching walls, sequestering private gardens."

Wright's darkly dramatic Prairie houses are low-slung and open outward into their environment, recalling his admiration for the loose, spreading organization of Japanese architecture. They also contain echoes of an early interest in the English Arts and Crafts movement insofar as Wright insisted on designing every feature of the interiors to match the outside and often integrated traditional rustic surfaces of wood and coarse stone. The summit of

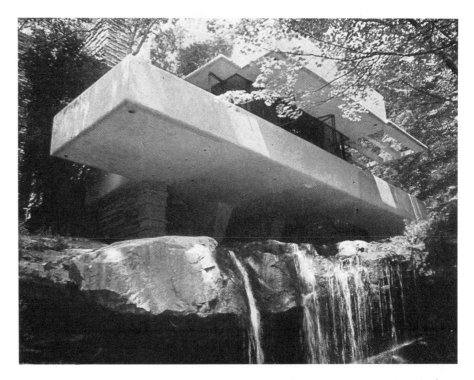

this Organic Architecture, as Wright called it, came in the 1936 Kaufmann residence, poised on a rocky ledge that emerges from the living room floor as a central hearth and with balconies suspended over a waterfall. Here was a stunning fusion of habitation and site, a return to the wilderness fulfilled and, in truth, only feasible with the carefully calculated use of up-to-date materials such as glass and ferro-concrete. Like the rather different mechanistic utopias of European Modernists, Wright's Organic Architecture offered another solution to the perennial question of how technology should deal with nature. If the ageing garden city, high-rise apartment buildings or merely suburbia have been the circumstances that many have long since tolerated, then perhaps they prove that the answers are slightly less grand and more susceptible to economic vagaries than the prophets of modern architecture imagined.

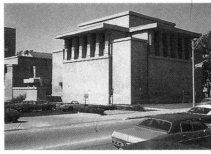

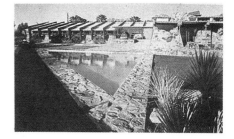

Art and Architecture since World War II

The Kaufmann House "Falling Water",
1936–9
Near Bear Run, Pennsylvania

The Unity Church, *Oak Park, Illinois, 1906*

The Prairie House, *Taliesin, Arizona, 1911*
Frank Lloyd Wright (1869–1959)

Wright's achievement in architecture is difficult to assess. It covers the first sixty years of this century from his early housing in Oak Park, Chicago, to large-scale projects late in his life.

Of all his work "Falling Water", set among trees and with rocks and small waterfalls, most typifies his romantic "natural" attitude and has captured the imagination of the public. The combination of sand-rendered cement slab with rough masonry, applied both internally and externally, is handled with sculptural mastery and a sensitivity to relationships of materials that is peculiarly Wright's.

Unity Church, a prototype of many later designs in the style of "functional Cubism" and one of the early sources of the De Stijl movement, was one of the first buildings in the United States to have a structure made of reinforced concrete. In keeping with Wright's devotion to the texture of surfaces, the pebble aggregate is left exposed on the interior walls. The external feature that most readily identifies the church as a Wright building are the piers which rise from the high podia to support a cantilevered roof. Wright was to repeat and extend this device in later houses, such as the Robie House, Chicago (1909) and the Coonley Playhouse, Riverside, Illinois (1912). The block-like form of Unity Church was a radical break with traditional church design, and is also a splendid example of Wright's genius in creating an architectural monumentalism scaled down to meet everyday human needs.

World War II represents a watershed in the development of Western society since it changed the balance of power between nations in ways that still influence the world today and the culture we experience. Perhaps one of its most striking effects was to reveal the United States as a country of extraordinary global power and importance whose only rival in terms of resources and political convictions was the Soviet Union. Although the origins of the war lay mostly in the rise of fascism in Western Europe, its outcome – the polarization of the Continent resulting from decisions made by Stalin and the Allied leaders at Yalta and Potsdam in 1945 – suggested that future conflict was more likely to be between capitalism and communism; less a question of internal Western struggles than of a major, and possibly irreversible, split with Russia and the East. The division of Germany itself, begun in 1945 and completed four years later, came to symbolize this breach, which was further intensified by China's Communist revolution. The end of the world war could therefore be seen equally as the start of a Cold War, a term first used in 1947 to describe the less open but more lasting hostility between the two opposing political systems that were to dominate future global relations.

Under the leadership of President Harry S. Truman, who succeeded Franklin D. Roosevelt in 1945, the United States began to evolve a distinctive image of itself and its role in world policy. It wanted to be recognized as the guardian of individual freedom and integrity against the kind of totalitarianism that perhaps not unjustifiably, it attributed to Communism. At the same time it refused to regress into its old policy of "splendid isolation", and began to increase its aspirations toward becoming a fully-fledged imperial power, engaging in remarkable technological advances at home that coincided with often ruthless programs of economic domination abroad. The popular concept of the United States and its people as symbols of material abundance, self-confidence and individualism was one that was greatly, and knowingly, boosted after 1945. Hence the United States could call the tune on many different cultural levels in various postwar societies throughout the world. In the mid-1950s an American, or Yankee "style" was something that could be identified as easily in cars, food or movies as in political beliefs. Whether this presence was welcomed, ignored or decried hardly altered its conspicuousness. The United States was something to be reckoned with in politics, art and life as it had never been before. In the eyes of an exhausted Europe or the impoverished Third World, the future, for a while, was seen to be working.

This shift of focus began in the 1930s, when fascism forced large numbers of creative people to leave Europe for either temporary or permanent exile in the United States. Among them were the composers Igor Stravinsky, Bela Bartók and Arnold Schoenberg, writers Thomas Mann and Bertolt Brecht, scientists such as Albert Einstein, and a galaxy of painters ranging from Mondrian to Léger and Ernst. Architecture profited in particular as leading European modernists settled in a country whose materials, capital and manpower provided an ideal arena for the spread of the International style. Thus American culture received a tremendous boost, reciprocated by a thriving economy that had survived the Depression, helped finance the Allied victory and continued to boom in peacetime. Given the initial stimulus from Europe, native talents overcame the provincialism of the 1920s and 1930s and went from strength to strength. Moreover, they were increasingly backed by manifold sponsorship from large corporations,

rich individuals and the government itself, especially from the Kennedy years (1960–3) onward. Consequently, the United States is very much in the fore of the history of postwar art.

However, there have been changes since 1940 that, although often attributed to American precedents, outgrew national boundaries. Partly through renewed patronage, museums have risen greatly in prestige, becoming strongholds not only of Old Masters but of contemporary artists and trends as well. Simultaneously, the art market has expanded to match spiraling demands from public and private sources and as a result works of art have acquired the charisma of deluxe commodities. Insofar as the status quo supported advanced trends on a relatively lavish scale, it gave an official seal of approval to the avant-garde, otherwise long-established as a thorn in the flesh of the conservative bourgeoisie. Never before have so many radical artists reaped such immediate social rewards as in the recent past. By the 1960s newness was a tradition usually greeted with enthusiasm rather than hostility by dealers, museums and connoisseurs. Some creators still presaged revolution, but audiences were usually stimulated rather than repelled by their threats. This perhaps explains why political commitment in painting has lost its venom: it thrived on active opponents, but liberalism bred tolerance and the avant-garde, having begun in the spirit of an attack, ended as an official institution.

Yet what characterizes the art of the 1940–80 era? Certainly not compromise or stagnation. Quite the reverse, because new directions have succeeded each other with a breathless momentum, always pushing toward extremes, testing every available limit. One outgrowth of this was that the distinctions between the different arts began to blur. Paintings approximated environmental proportions, sculpture investigated color and light, and staged events – known as "happenings" – became popular with the avant-garde. By the late 1960s no single style could safely be ascribed to the moment, for "pluralism" – the coexistence of multiple, divergent trends – was the order of the day. Culture itself was global. Unless you happened to be in a backward or repressive nation television, magazines and the cinema beseiged you at a glance with scenes and information from the most distant parts of the world. These, and the photographic reproductions of any well-illustrated book, could recreate remote eras with an intimacy previously unimaginable. Daily life had become a living "museum without walls". News and fashions passed from one continent to another almost overnight and the same pop music might be heard simultaneously in Tokyo, Los Angeles and Liverpool. Politics no longer dealt exclusively with national interests, but revolved instead around the cut and thrust of enormous superpowers. Indeed, apocalypse now proved a commonplace topic since many doubted whether humanity itself would survive another war, provided, that is, pollution and dwindling energy supplies permitted a long-term view at all.

Could art possess unity or true coherence in such a complex, unstable universe? The works encountered today and even those of twenty years ago are too near at hand for us to formulate comprehensive answers, and we must, as ever, rely on the primary evidence of our senses. But if we can grasp at least some of the driving problems and breakthroughs from which they sprang, then the thrill of tracing continuity within apparent confusion should rarely be altogether lost to the present.

Autumn Rhythm, 1950
Jackson Pollock (1912–56)
Oil on canvas 105×207in (267×527cm)
Metropolitan Museum of Art, New York

Jackson Pollock had achieved considerable attention by 1950 as a leading figure in a new generation of artists. Autumn Rhythm *was completed during the middle period of Pollock's famous "drip paintings". Pollock was not only a major figure in artistic circles, he also attracted much public attention for both his unconventional painting techniques and his "bohemian" lifestyle, which included some heavy drinking and open displays of wild behavior. This combination contributed to the assumption that his style of painting was equally abandoned. In a film showing his working methods, made in 1951, Pollock was able to explain his approach to technique: "when I am painting I have a general notion as to what I am about. I can control the flow of paint: there is no accident, just as there is no beginning and no end".*

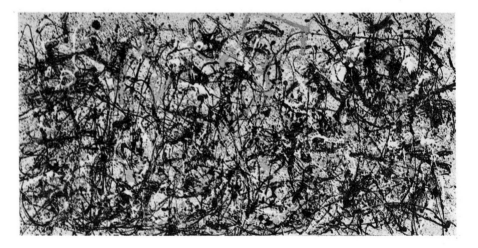

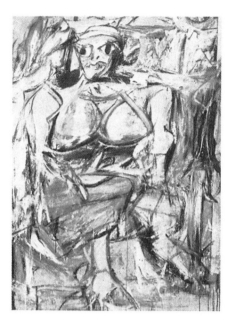

Woman I, *1950–2*
Willem de Kooning (b.1904)
Oil on canvas 75⅞×58in (192×148cm)
The Museum of Modern Art, New York

This is one from a series of paintings on the theme of Woman that formed the body of work in De Kooning's second one-man exhibition in New York, 1953. Of the post-war generation of American artists grouped under the title Abstract Expressionists, De Kooning was the only one to pursue a figurative theme, while developing the abstract interpretation and gestural technique that gave the painting of that period its remarkable impact on the progress of 20th-century art. The critical reaction to De Kooning's women was relatively hostile because, at the time, there was a general trend to emphasize the formalist analysis of paintings rather than subject matter. But De Kooning, Dutch by birth and fully aware of the European traditions of painting that he sought to reinterpret, described his approach in an unequivocal statement on the Woman series: "The women had to do with the female painted through the ages, all those idols, and maybe I was stuck to a certain extent; I couldn't go on. It did one thing for me: it eliminated composition, arrangement, relationships, light – all this silly talk about line, color and form – because that [the women] was the thing I wanted to get hold of."

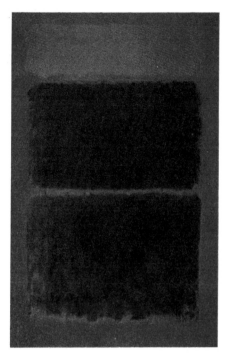

Light Red over Black, *1957*
Mark Rothko (1903–70)
Oil on canvas 91⅝×60in (233×153cm)
Tate Gallery, London

After painting figures in cityscapes in the 1930s and amalgams of organic forms reminiscent of Miró in the war years, in 1947 Rothko turned to the color-field paintings on which his reputation chiefly rests. The use of the word "field" to describe his painting is appropriate for they seldom yield any central point of attraction. The serenity of the paintings derives from more than their ordered composition; it is also a question of the soft, luminous palette which Rothko favored and of his method: the application of layer upon layer of thin washes of oil or acrylic paints which were allowed to soak into the canvas, thus giving the rectangles their blurred edges. Calm the paintings are, but the calmness has a foreboding intensity. "All art," as Rothko once said, "deals with intimations of mortality." He committed suicide in 1970.

Painting

The exodus of artists from Europe to the United States contributed to the replacement of Paris by New York as the artistic capital of the world. To a rising generation of New York painters such as Jackson Pollock (1912–56), Mark Rothko (1903–70) and Willem de Kooning (b.1904) the presence of leading European Cubists and Surrealists was a reminder of the limitations inherent in the realism of American art prevalent during the 1920s and 1930s. Yet the Americans were also acutely aware of the grimness of the postwar scene, shadowed by world-wide devastation, the hostile McCarthyite climate and the ultimate horror of the atom bomb. In a 1947 verse-play the expatriate English poet W. H. Auden aptly entitled the period "The Age of Anxiety". Philosophers, notably the Frenchman Jean-Paul Sartre, argued that existence was painful and absurd, given meaning only to the extent that man's acts defined what he was capable of achieving. Against this background the New York painters understandably sought to combine the most advanced type of abstraction with a tragic content that the Cubist tradition had felt little need to express. The synthesis of these two extremes in the late 1940s became known as Abstract Expressionism.

In the face of ominous external circumstances Jackson Pollock was among the first to attempt to externalize the forces within himself without recourse to conventional methods. During the 1930s he had experimented with a primitive imagery influenced by Surrealism as well as the big, crowded murals of David Alfaro Siqueiros (1896–1974), José Clemente Orozco (1883–1949) and others done in the wake of the Mexican Revolution. Yet Pollock went beyond even their dynamic manner and completely abandoned the use of brushes in 1947, instead dripping the paint in streams directly onto canvases

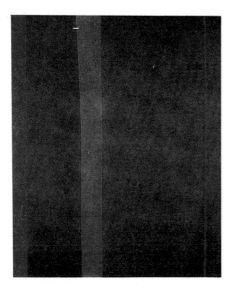

Adam, 1952–52
Barnett Newman (1905–1970)
Oil on canvas 95½ × 80in (242 × 203cm)
Tate Gallery, London

Newman was the most articulate of the
color-field painters of the New York School
and one of the words which repeatedly
turns up in his writings is "gesture". "My
idea," he once wrote, "was that, with an
automatic move, you could create a world."
In this painting the vertical stripe may be
interpreted as a representation of man's first
creative gesture, which Newman described
as "a poetic outcry", a cry of "awe and
anger at his tragic state . . . and at his own
helpness before the void". The single stripe
against a color ground is the most
frequently recurring motif in Newman's
paintings, although in many of them, such
as Vir Heroicus Sublimis (1950–51), a
number of stripes appear. The sublime, as
Newman and other Abstract Expressionists
picked up from Burke's Ideas of the Sublime
and the Beautiful, is rooted in fear and pain.
The infinite void, mysterious, frightening,
sublime, into which man is tossed for his
brief span, is what Newman intended to
express by his vast, undifferentiated color-
fields.

1953, 1953
Clyfford Still (1904–1980)
Oil on canvas 92⅞ × 68½in (235.5 × 174cm)
Tate Gallery, London

Of all the artists of the Abstract Expressionist
group, Clyfford Still proposed the most
uncompromising and radical move into
abstract art. Critical analysis has attempted
to identify the elemental forms of American
landscape in Still's work, or to relate the
flickering vertical shapes to tongues of fire.
But Still tried constantly to eradicate the
traditions of representational painting and
even the newer, more abstract styles, such
as Cubism, from his manner. He regarded the
past as literally a dead weight, ". . . a body of
history matured into dogma, authority,
tradition . . . The homage paid to it is a
celebration of death. We all bear the burden
of this tradition on our backs, but I cannot
count it a privilege to be a pallbearer of my
spirit in its name". Still's time in the 1950s
was divided between teaching and painting
and while his work made a strong
impression on the art world he was not
drawn into the kind of public image that
attached itself to Jackson Pollock when his
work became known. Earlier abstract works
by Still had titles suggesting physical or
emotional associations, but after 1947 he
adopted the habit of titling the paintings
only with the date of completion, sometimes
referenced by a letter of the alphabet, as if
refusing to define the work as other than its
own material existence.

laid flat on the floor. The results were
compositions of scintillating webs of
pigment; labyrinths whose unending
lines seemed to be a transposition of
Pollock's own whirlwind gestures and
psyche, but abstract because they
emerged only from the farthest recesses
of his inner self. A note by Pollock gives
an insight into his work: "Organic
intensity . . . energy and motion made
visible. . . . Memories arrested in
space. . . ."

Since Pollock's handling utilized the
whiplash motions of his entire body as
he elaborated the painting from all
sides, it was described as Action Paint-
ing, implying that the picture was a
record of the very process of the violent
yet skillfully controlled acts that had
brought it into being. To give full rein
to his gestures Pollock had to work on
an epic scale that in turn tends to engulf
the viewer as well, drawing him into a
space both shallow and mysteriously
unfathomable.

Willem de Kooning shared Pollock's
explosive, gestural attack on the canvas,
but retained the brush and, sometimes,
recognizable subjects, as seen in the
series begun by Woman I (1950–2), an
iconoclastic tribute to the sex-symbol-
cum-idol dear to the American Dream.
De Kooning's ferocious strokes hurtle
and collide across the painting's sur-
face, conveying the nervy, emotional
anxiety of the artist. Their influence on
younger painters throughout the 1950s
was extensive, for the slashing, im-
provisatory accents appeared a perfect
metaphor of urban tensions.

Another side of Abstract Expres-
sionism emerged with Mark Rothko,
Barnett Newman (1905–70) and
Clyfford Still (1904–80). Their aim was
to stir an awesome, almost religious
charge in the observer akin to the
exalted state of mind that the Roman-
tics had designated a "sublime" level of
consciousness. Hence they manipulated
grandiose fields of color that invite the

Spotted Cow, 1954
Jean Dubuffet (b.1901)
Oil on canvas 35×46in (89×117cm)
Private collection, New York

Dubuffet's art brut (the title of his 1949 Paris exhibition) was one of the seeds from which Pop Art grew. In a speech of 1951, called "Anticultural Positions", he stated his aesthetic position: "The notions of beauty and ugliness are Occidental concepts, unknown to primitive peoples. The notion of beauty is spurious . . . It would be desirable to get rid of this notion." Dubuffet chose subjects not usually thought worthy of serious artistic endeavor – hence the series of paintings of cows which he produced in 1954. He also used all manner of materials as "paint" – plaster, cement. sand, straw, vegetable peels, bread, string – and of tools as "brushes" – spoon handles, pens. In the famous Hourloupe *paintings of the 1960s he brought the materials of painting down to the most ordinary household items: felt-tip pen on paper and vinyl cut-outs on canvas.*

onlooker to contemplate absolutes of light and darkness, void and presence. Color had not been so closely linked to supernatural mystery since the shimmering mosaics of Ravenna or the stained glass in dim Gothic cathedrals. Clyfford Still's canvases are even more overtly dramatic and their rugged contours have been compared to the crags and wastes of the Badlands in the Canadian province of Alberta where he homesteaded as a youth. His walls of paint exude an uncanny vitality due to their solid, encrusted texture and are pitted against vertical flashes that are distant remnants of the upright figure,

a symbol of man's strength to survive in a desert both real and psychological. Certainly there was enough spiritual emptiness in a country whose materialism only added weight to Abstract Expressionism's struggle to discover visual equations for subjective truths.

Outside the United States painting frequently took second place in terms of quality to other artistic activities during the immediate postwar years. The advent of excellent cinematic movements in Italy and Japan, Dmitri Shostakovitch's music in the Soviet Union or the plays by the Irish dramatist Samuel Beckett, for example, are more memorable than any of the painting done in their respective countries. French artists found difficulty in escaping the elegant craftsmanship inherited from the prewar School of Paris – but now out of place – and were substantially affected by both Sartre's Existentialist theories and American Abstract Expressionism. Diluted variants of Action Painting tended to alternate with obvious references to brutality or alienation, as in the abstract reliefs of torn and burned sackcloth by the Italian Alberto Burri (b.1915). The Frenchman Jean Dubuffet (b.1901) came over as a more convincing Existentialist with his primitive figures composed of such rough, unprepossessing substances – earth, leaves and so forth – that they prompt us to wonder how far mankind ever really departs from the earth to which it must finally return.

One of the few British artists to achieve international stature in the early 1950s was Francis Bacon (b.1909). He, too, exploited the Existentialist fear that man under stress is prone to regress into animalistic cravings. Bacon draws on sources, such as medical textbooks and photographs of people in extreme situations, that uncover the sinews beneath the façade we normally observe. His style is as visceral as his

Study for a Pope, 1955
Francis Bacon (b. 1909)
Oil on canvas 60×46in (152.5×117cm)
Private collection, London

In the work of Francis Bacon the figure of the pope is a recurring theme from the early Velasquez's portrait of Pope Innocent X, a painting greatly admired by Bacon, who collected as many reproductions of the portrait as he could find. He denied particular religious significance in the choice of image, although the isolation and elevation of the pope's uniqueness seems emphasized by Bacon's use of linear framework containing the subject. This structure, however, is a feature of many of Bacon's figure studies, including the Pope series of 1951, 1953 and 1961–2. By the 1950s Bacon was well established as an artist, although little remains of his early work because he destroyed almost all of his output up to 1942. By his particular vision and technique he has escaped categorization in any of the major art movements of the 20th century, remaining a powerful individual presence throughout his long career. Photographs and reproductions have always been an important source of imagery for his work. Another frequently recurring image is a reinterpretation of the photograph of the wounded nurse from Eisenstein's film The Battleship Potemkin *(1928), and this has sometimes been fused with the Pope taken from Velasquez.*

themes, emphasizing the quirks that oil paint – handled fast and with respect for its own gritty or fluid properties – makes when it translates the unexpected flash of a face or a limb onto a grained support. Bacon's disturbing but paradoxically sumptuous style proves that representation can still comment on the human condition without descending to naive parables or anecdotes, while matching the sort of gut response to color that Abstract Expressionism nearly monopolized in the early 1950s.

Nonetheless, once the decade matured, anxieties blended into the comforts of the "affluent society", the title of J. K. Galbraith's 1958 study of the Western economy. It appeared that even The Bomb might be lived with, if not exactly loved, and Existentialist gravity was undermined by the surfeits of consumerism gushing outward from the United States. The lofty bias of Abstract Expressionism found itself open to parody in the frivolous rock 'n' roll era, and Jasper Johns (b.1930), for example, gave it a sly dig by depicting ultra-deadpan motifs such as bull's-eye targets, numerals and maps with the frenetic bravura of a De Kooning: the medium was forced to contradict the message. On the other side of the Atlantic the verve of Americana – from space travel to Elvis Presley and household gadgetry – was simply irresistible. Richard Hamilton (b.1922), Peter Blake (b.1932) and others observed that the entertainment devoured by the working and middle classes was "transient". So why shouldn't art follow suit?

Pop Art was a thought-provoking marriage between two realms previously considered mutually exclusive: high- and low-brow culture. Until about 1960 there lingered an unspoken, although near universal rule, dividing them. Art with a capital "A", for example, belonged to the former, the mass media to the latter and never,

Zero through Nine, *1961*
Jasper Johns (1930–)
Oil on canvas 54×41¼in (135×62cm)
Tate Gallery, London

Johns' paintings of numbers, flags and targets began in the 1950s and although they caused offence to a number of people, the reaction was against what is essentially cerebral art which operates on a number of visual, intellectual and punning levels. Not the least of the intellectual elements in Johns's art is his obvious pleasure in the quality of paint, which adds a further dimension of interest in emphasizing that whatever the subject of the work, it remains a painting. The ambivalence of his art has certain elements of the surrealist desire to create an insecurity of response. The art historian John Russel has remarked that "we shift to and fro, involuntarily, between the kind of recognition which is owed to a flag or to a target, and the kind of recognition which is owed to art".

Marilyn, *1967*
Andy Warhol, (b.1928)
Silkscreen from an edition of ten 35⅞×35⅞in (91×91cm)
Tate Gallery, London

Portraits of Marilyn Monroe were among the paintings which established Andy Warhol's reputation as a Pop artist in the early 1960s. He first gained notoriety with his hand-painted Cambell's Soup Cans *of 1962, but adopted the silkscreen printing technique for the film star portraits that followed. Silkscreening allowed him to repeat the images exactly and produced a bland, impersonal surface texture typical of Warhol's work, although the artist's imprint is sometimes seen in particular color effects and occasional hand-painted additions to the printed works. Warhol has carefully cultivated a public image as a leader of fashion, not only in his art, and his apparently disinterested approach to his paintings was originally quite controversial. Following his first successful exhibition in New York in 1962 he set up a studio called The Factory, where art was mass-produced, mostly by silkscreen technique. The Marilyn portraits recurred continually during the 1960s and 1970s. This example is from an edition of ten silkscreen prints with color variations. In earlier work he produced some block images of the face repeated twenty or twenty-five times. There are similar series based on photographs of Jackie Kennedy and Elizabeth Taylor, also dating from the early 1960s.*

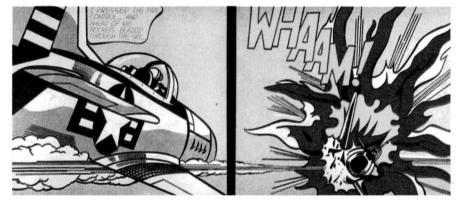

Whaam!, 1963
Roy Lichtenstein (b.1923)
Oil and acrylic on two canvases
68×106in (172×269cm)
Tate Gallery, London

After an early career as an Abstract
Expressionist, Lichtenstein began to use
comic strips and images from advertising in
his paintings in 1960, the same year that
Andy Warhol, independently, started to do
the same. Within two years Lichtenstein had
risen to fame on the Pop Art wave, depicting
on a huge scale the cardboard emotions of
"true romance" comics and the violence of
war comics. Lichtenstein stressed that he
wanted the finished product of his art to look
programed, but although metal stencils with
regular holes were used to produce the dots
(painted with a toothbrush), the drawing is
comparatively free, as is the painting of the
color-block areas. The result is more than an
enlarged copy of a comic strip. As one critic
has written, Lichtenstein makes "abstractions
out of the figurative, without losing the
content of the subject matter . . . a tension is
set up between recognizable image and the
formal design almost to the point where both
become one, thus solving the argument of
figurative versus abstract".

unless surreptitiously, did they meet. Somehow however, this distinction gradually broke down. Perhaps its erosion stemmed partly from a more egalitarian social structure; from the ease with which ideas and images defied class barriers in the era of rapid communications. Before a cinema screen or television all men were equal, almost. Whatever the reasons, Pop artists fused vulgarity and erudition. Peter Blake brought the astute touch of a Manet to whimsical pin-ups and teen idols. In the United States the contradictions multiplied with commercial methods such as photography and silkscreen printing used in an intellectual context. Roy Lichtenstein (b.1923) painstakingly took comic strips as a basis for monumental tableaux that resemble the great "machines" of the Baroque crossed with a Superman serial. The high-priest of chic banality emerged with Andy Warhol (b.1930), emblem of a moment and a world view as surely as Kennedy or The Beatles. In the early 1960s Warhol immortalized that strange "underground" that embraced the tortures of a dehumanizing capitalism – repetition and boredom – with open arms. His inscrutable *Marilyn* (1965), like every other subject he

paints, is infinitely superficial, repeatable and worrying as a mask that is never removed: "The reason I'm painting this way is because I want to be a machine. I think it would be terrific if everybody was alike."

Such stances represented one point of no return in the mid-1960s. Another came out of the color-field wing of Abstract Expressionism. Rothko, Still and Newman stripped away inessentials to concentrate on the emotive associations of color. By 1960 some Americans judged that they had not gone far enough and Clement Greenberg, a leading critic, claimed that painting had to rid itself of all excess baggage. This meant imagery, depth – because a picture is in the last analysis two-dimensional – and symbolism. What was left after this purge was the bedrock of vision: pure color. Kenneth Noland (b.1924), Frank Stella (b.1936) and Morris Louis (1912–62) put this logic into practice by employing simple configurations of circles, lozenges and bands, because these were the least obtrusive carriers for their chosen colors. Aims this narrowed could be pursued with the total devotion that a Vermeer had brought to the minutiae of his world. No shade or tint, no nuances of translucence or opacity escaped. Louis diluted his synthetic paints enabling them to soak directly into the unprimed support so that all tactile reminder of pigment evaporated; in *Alpha-Phi* (1960) colors are perceived as disembodied torrents framing a central void. Maximum vividness comes from a minimal amount of form. If Pop had approached a threshold where nothing was too familiar to warrant exclusion, here was its polar opposite rejecting all but the most refined of sensations. Both stood on brinks that would propel the 1970s toward the dilemma of how painting could adapt itself to a definition of art that had never been less static.

Sculpture

A lasting memory of World War II is the staggering scale of violence perpetrated against the human body. After the human debris of Auschwitz and Hiroshima, any statement about our physical selves acquired almost automatic pathos. This added another layer to the international postwar acclaim that greeted the Franco-Swiss sculptor Alberto Giacometti (1910–66) and the Englishman Henry Moore (b.1898). Both had profited from Surrealism in the late 1920s and 1930s, but were not swayed by the current interests in unconventional materials, relying on bronze, wood and stone to parallel their preoccupation with the equally traditional theme of the figure. From the early 1940s onward Giacometti tackled the Existentialist thesis of life's vulnerability within a hostile ambience. The trembling, stick-like individual of *Man Pointing* (1947) typifies Giacometti's attempt to express isolation; its hand delving into nothingness. This creature is so attenuated that its residue tells of masses abandoned to space, of the precarious line that stands between our dissolution and survival.

Henry Moore's monumental sculptures have not changed substantially since about 1950, possibly because of his profound attachment to two major concepts: the reclining figure and the interlocked mother and child. At an early stage Moore insisted upon the innate beauty of the solid materials that a sculptor handles and consequently stressed the importance of directly carving stone and wood. This went against the "professional" method of making small preliminary models that were merely enlarged or cast by assistants. The undulating curves he tirelessly explores at once evoke anatomical volumes and the tenacity of pebbles, ancient rock statues and mountains long since weathered

smooth by nature. This is so even if he has now returned to the use of bronze and to the preliminary sketching he once rejected. One has only to think of the magnetism of a cave's opening or the recesses of the body itself to comprehend something of the positive function that the hole has played for Moore and his contemporary, Barbara Hepworth (1903–75). It is significant that there is a strong urge to run our hands over and within their works. To grasp a Giacometti would be a sharp lesson in the brittleness of matter, but when even the gaze scans a piece such as Moore's *Recumbent Figure*, endurance and its timeless stability is felt.

American sculptors meanwhile had been resourceful in exploiting European breakthroughs from before the war. Alexander Calder (1898–1976) gave a witty dimension to the Constructivists' former interest in movement with his "mobiles" – metal sheets hung from the ceiling on wire and rods that allowed them to dance at the least disturbance in the surrounding air. It was David Smith (1906–65), however, who used the oxyacetylene welding torch so that industrial steel could be mastered with fluency and this, together with the geometric color abstractions of Kenneth Noland, revealed new possibilities in Britain during the early 1960s to Anthony Caro (b.1924).

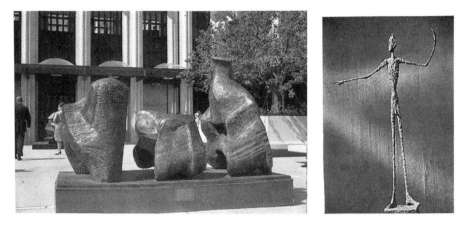

Three Piece Reclining Figure No 1, 1961–62
Henry Moore (b.1898)
Bronze, from an edition of seven. Length 113in (287cm)
Los Angeles County Museum of Aft

As one of the most prolific and influential figures of 20th century art, Henry Moore has pursued his career since 1945 amid a catalog of major commissions, awards, exhibitions and honors. His reclining figures of the early 1960s followed a series of standing and totemic figures developed throughout the 1950s. The forms are continually adjusted and refined in each succeeding piece and figurative references gradually reduced to the bare essentials. Moore is a master of many different techniques and materials of sculpture and much of his work has been cast in bronze. This is a process that leaves the sculptor at one removed from the finished work, as described by Moore himself: "In doing your sculpture you have imagined a certain quality in the bronze. No sculptor works direct in bronze: you can't take a solid piece of bronze and cut it to the shape you want, so all the sculptors who intend having their work in bronze are working with a mental idea of what it is going to look like, while they make it in some other material". Another aspect of his work which interests Moore greatly is their eventual locations. Many are monumental in scale and intended for open-air sites. There is an interesting contrast between the leafy landscape setting of the Three Piece Reclining Figure in Los Angeles and the austere geometry of the buildings of Rochester Institute of Technology in New York, where another cast of the same work is on display.

Man Pointing, *1947*
Alberto Giacometti (1902–66)
Bronze, height 69½in (177cm)
Tate Gallery, London

Giacometti, a Swiss painter, sculptor, draftsman and poet, studied sculpture in Geneva and Italian painting. From 1922 he was in Paris as a student of Bourdel. His early work was sur:ealist, but from 1935 his familiar stick-like figures appeared and they remained a preoccupation for the rest of his working life.

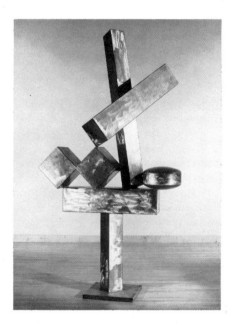

At first glance Caro's constructions may seem disconcertingly crude yet they are actually rich with structural inventiveness. Consider, for instance, how Caro manages to balance girders that we know to be fearsomely heavy as if they were the lightest of sticks. While we walk around a Caro, its entire organization alters; a line seen from head-on that appears to be a long beam or flat plane is really a parabola. And what has happened to that old nuisance, the pedestal? Caro abolishes it and instead the shapes unfold spontaneously without a core, tilting away

Cubi *XIX, 1964*
David Smith (1906–1965)
Mild steel sheet 112×58×40in
(284.5×147.5×101.5cm)
Tate Gallery, London

As a young man Smith learned much about the properties of steel from his work in an automobile factory and in 1937, inspired by the work of the Spanish sculptor, Julio Gonzales (1876–1942), he began to make welded sculptures. Fame came only in his last years, with the small groups of linear steel sculptures to which he gave the title Sentinel, *done in the late 1950s, and finally, with the series of monumental, free-standing stainless-steel* Cubi *which he produced between 1961 and 1965. Smith intended most of his sculptures to stand outdoors against a landscape, and the steel is usually coarsely ground to enable it to catch and reflect glints of sunlight at various angles.*

Early One Morning, *1962*
Painted steel 114×244×132in
(289.5×620×335.5cm)
Tate Gallery, London

The major influence on Caro's development was a visit to the United States in 1959, where he briefly met the sculptor David Smith. Caro also learned welding on his return to London and began to develop his own concept of sculpture in metal, working at first in a confined space of a garage. His complete rejection of sculpture "on a base" was a new idea and his influence in Britain and the United States was considerable, both through his work and his teaching activities.

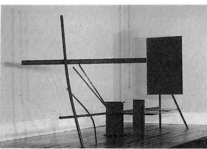

or plunging toward the onlooker, distinct beneath their skin of bright paint, yet a part of his landscape.

Although we can relate to the space a Caro sculpture inhabits because of its size and openness, the materials and elements themselves could never be confused with objects we might use or know. That particular opportunity fared better in the United States. Laden with material goods and subcultures. The random and thus bizarre impressions absorbed by the city-dweller were a mine for Robert Rauschenberg

Giant Hamburger, *1962*
Claes Oldenburg (b.1929)
Painted canvas filled with foam and cardboard
Art Gallery of Ontario, Toronto

In 1961 Oldenburg opened a "Store" in New York City where he sold simulated items of goods found in any grocer's shop – perhaps the most direct assertion of the Pop Art movement's assault on the special status of art. The idea came to him while driving down a street crowded with shops: "I saw in my mind's eye a complete environment based on this theme. Again it seemed to me that I had discovered a new world. I began wandering through stores – all kinds and all over – as though they were museums. In 1962 Oldenburg exhibited for the first time his giant sculptures, such as this seven-foot (2½m) long Hamburger. *"I am for an art," he had proclaimed in 1961, "that is political-erotical-mystical, that does something other than sit on its ass in a museum . . . an art that imitates the human, that is comic if necessary, or violent or whatever is necessary . . . that twists and extends and accumulates and spits and drips and is heavy and coarse and blunt and sweet and stupid as life itself."*

(b.1925), who combined junkshop wares, personal belongings and painted sections in his work. His "combines", a self-explanatory label, are kaleidoscopes that are best read sequentially, like a book, for their storehouse of memories, than interpreted by conventional standards. The life-size tableaux of George Segal (b.1924) and Edward Kienholz (b.1927) are more disturbing because the spectator can wander through them, meeting silent mannequins amid bric-a-brac lifted from the sleazy underside of the American Dream. In the 1960s the excesses of Pop offered splendid opportunities for further subversion in this respect, as Claes Oldenburg (b.1929) demonstrated through his soft plastic parodies of normally hard objects such as toilets, fans and typewriters. Like Oldenburg's projects for cigarette stubs and clothespins at skyscraper heights, these deprive the most ordinary objects of their accepted purpose and, by apparently simple alterations, conjure jokes and warnings from what would otherwise be prosaic throw-aways; scissors the size of the Washington Obelisk could be as imperious as they are amusing.

The Butcher Shop, *1965*
George Segal (b.1924)
Plaster, wood, vinyl, metal and plexiglass
94×99¼×48in (235×249×120cm)
Art Gallery of Ontario, Toronto

Segal began to make life-size paintings, (or sculptures, or assemblages – call them what you will) with figures rough-cast in wet plaster in 1961. Of one of the first, Man at a Table *(1961), he said that it was meant to be "a kind of Dada joke". But his isolated figures, always placed in a setting of real, everyday objects, have a timeless poignancy which, despite the absence of coloring (they were always left in the natural white of the plaster) or illusionistic modeling of the surface, raises them to a level of realism which recalls the work of Courbet. Segal's method was to cast his figures – from outside the negative mold, not, as in traditional casting, from inside – by applying cheesecloth soaked in wet plaster to live models and then working the surface with his hands. He permitted himself to make small alterations after the plaster had dried.*

Reservoir, *1961*
Robert Rauschenberg (b.1925)
Oil, pencil, fabric, wood, metal on canvas;
two electric clocks, rubber tread wheel,
spoked wheel rim 85½×62½×14¼in
(214.5×157×36cm)
National Collection of Fine Arts,
Washington, D.C.

Rauschenberg, the father of American Pop Art, produced a number of combine paintings in the early 1960s. Their chief novelty – the use of electrical equipment which was to be turned on – may be said to have inaugurated the "kinetic" art movement. His First Landing Jump *(1961) exhibited an electric cable joining a light bulb to a wall socket, the first instance of his incorporating wiring as a visual element of the painting itself. The two clocks in* Reservoir *contain (although the information is hidden from the viewer) the record of the length of time that it took Rauschenberg to complete the painting: the clock on the upper left was set when he began work on the painting, the one on the lower left when he had finished.*

Toward the end of the decade some sculptors moved beyond the object entirely, countering the demand that their work should be permanent or even containable in a gallery. To transform their surroundings became their goal and was partly the climax of the modern drive to relate sculpture directly to the spectator's physical frame of reference. It also coincided with a new interest in ecology and a flight from artificial urban conditions back to grassroots. The *Spiral Jetty* (1970) by Robert Smithson (1938–73), built on the great Salt Lake in Utah, is one such "earthwork", a domain extracted from the geological strata of the land. Should we see it at first as mere novelty, perhaps it is worthwhile recalling that man's original dialogues with his environment included concentric primitive settlements and circles of stone such as Stonehenge. The vortex here is an amalgam of pathway and maze, respectively ancient symbols of direction and enigma, implying human projection into undefined natural space.

Architecture since World War II

Postwar reconstruction radiated outward from the United States, which had escaped bombardment and was able to offer economic aid to less fortunate nations throughout the world. The prosperity of the Eisenhower and Macmillan years went hand in hand with the success of big business and multinational corporations. Their prestigious offices rose first in commercial meccas such as New York and soon spread across the world. High-powered organizations called for buildings of commensurate efficiency and this perhaps explains why the architecture of Mies van der Rohe (1886–1969), especially after his 1937 emigration from Germany to the United States, was emulated almost wherever capitalism flourished. Van der Rohe had briefly been director of the Bauhaus, and his personal brand of International Modernism stressed an unerring precision that fired a generation of architects, including Philip Johnson (b.1906) and the firm of Skidmore, Owings and Merrill, responsible for many of the best-known American commissions today. Van der Rohe's famous aphorism "less is more" expressed his belief that an edifice gains in quality as it eliminates unnecessary features. The crystalline rectangles of his Manhattan Seagram Building (1957) pursued this counsel of perfection and established a prototype for thousands of less accomplished descendents. Sheer tinted glass walls are held by a regular bronze frame so that exactitude harmonizes with materials of an elegance matched only by their cost. If the Seagram Building is a skyscraper nobly endowed with the Parthenon's geometric purity, its anonymous and chilly facade is also an expression of the bureaucracy it serves.

A human face in modern architecture also blossomed in the 1950s. In rural Finland, Alvar Aalto (1898–1976), for

The Seagram Building, *New York, 1958*
Ludwig Mies van der Rohe (1886–1969)
Steel, glass and bronze 520ft (160m)

"I hope you will understand that architecture has nothing to do with the invention of forms. It is not a playground for children, young or old. Architecture wrote the history of the epochs and gave them their names. Architecture depends on its time. It is the crystallization of its inner structure, the slow unfolding of its form. That is the reason why technology and architecture are so closely related. Our real hope is that some day they grow together, that some day one will be the expression of the other. Only then will we have an architecture worthy of its name: architecture as a true symbol of our time." This ideal was expressed in a lecture given by Mies van der Rohe in 1953. In the following year he was commissioned to design the Seagram Building, a structure that does seem to stand as a symbol of its time. The impact of the tall skyscraper, by day or night, depends upon the bronze glass curtain walls, their panels either reflecting or transmitting light. This rich and apparently fragile façade was made possible through the use of load bearing steel frame as the basis of construction, a technique fully exploited in the construction of high-rise office

buildings of the 20th century. No expense was spared for the Seagram Building, expressed in the fact that half of the site was left free as a pedestrian piazza, giving unobstructed access to the building and a clear view of its impressive façade. Valuable materials – bronze, copper and marble – were used and no detail, including doorknobs and faucets, was excluded from the overall plan. The interior design was in part the responsibility of Philip Johnson, who had been invited by Van der Rohe to collaborate on certain aspects of the project.

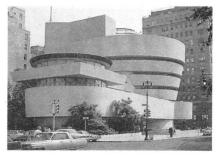

The Solomon R. Guggenheim Museum,
New York, 1946–59
Frank Lloyd Wright (1869–1959)

Circular and spiral shapes became prominent in Wright's work after the mid-1930s, although their use was first adumbrated in the Gordon Strong Automobile Objective of 1925. Wright favored them above all his non-residential designs, such as the Johnson Wax Company, Wisconsin (1936–39), with its lily-pad columns; and the spiraling, reinforced-concrete Guggenheim Museum, which was incomplete when he died. Wright's search for an "organic architecture" led him to the curve and spiral, for curves express far more poignantly than the rectilinear severity of the International style the recurring rhythms found in nature. The spiral structure allowed Wright to emphasize the space which the walls were enclosing, in effect returning in a highly sophisticated way to the cave dwellings of primordial man. More than any other of his buildings the Guggenheim gave substance to one of Wright's fundamental principles: "Space. The continual becoming: the invisible fountain from which all rhythms flow and to which they must pass. Beyond time or infinity."

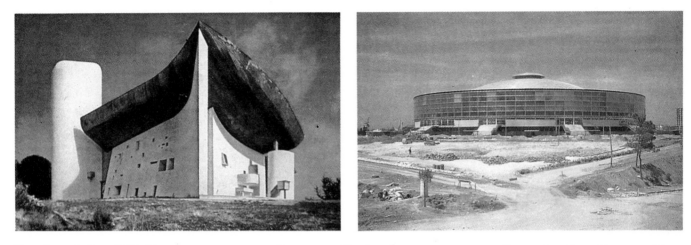

Notre Dame du Haut, *1950–55*
Le Corbusier (1887–1965)
(1887–1965)
Concrete and stone
Ronchamp, France

By 1950 Le Corbusier was an established figure with an international reputation and able to be selective about the projects offered to him. When he was invited to design a chapel of pilgrimage at Ronchamp he at first declined the commission. His previous proposals within the sphere of church architecture had been unsuccessful – his concepts had been criticized and their practical applications left unrealized. But through the mediation of a priest who was a personal friend and respected by Corbusier, he was persuaded to accept the work and was able to make his own conditions on the contract. In 1950 he spent some time visiting the site at Ronchamp and in the same year produced his first model for the chapel. In the event he produced a highly unusual building, but one that has proved extremely popular with the pilgrims visiting the chapel. The site was sloping and Corbusier allowed the floor to follow the incline of the land. The ceiling was 32ft (9.75m) at the highest point and fell to 14ft (4.25m) at the lowest. The curiously curved roof is supposedly based on a crab shell picked up by Corbusier on a visit to the United States and kept beside his drawing board throughout the designing of Ronchamp. A masterly effect in the building is the 6in (15cm) gap running all around the structure between roof and walls, visible from inside the chapel as a continuous line of light.

example, gave meditative character to the International style by re-introducing masonry, timber and discreet curves. More grandiloquent was the white concrete helix Frank Lloyd Wright designed for the Solomon R. Guggenheim Museum in New York (1959), which he described as an "unbroken wave". Although a "machine aesthetic" pioneer, Wright evidently now wanted to create a temple from a secular institution, and the Guggenheim has been revered at times as a latter-day *ziggurat* nestling in a mercantile jungle. However, the master of the renaissance in sculptural volumes was Le Corbusier. The roofscape of his monolithic Marseilles apartments, the *Unité d'Habitation* (1952), anticipated the entire Ronchamp Chapel of 1955. Seemingly molded by hand, it converses with the stark surrounding countryside and the exterior concrete presents the humble, rough texture of a peasant dwelling. Ronchamp diverted attentive postwar builders away from the mechanistic International Style as surely as Le Corbusier's earlier theories had precipitated it. What makes this chapel so special to even atheist and layman? Its masses may somehow awaken symbols in us – folded doves' wings, a human palm, a brow of hills – without ever

actually naming them. Few are able to remain deaf when an architect aspires to talk to us in this universal language.

More practical minds nonetheless asked whether habitations should not just meet daily requirements and leave poetry to the "artists". Critics observed that until about 1930 building technology had roughly kept pace with engineering but subsequently tended to fall ever further behind. Where was the house with a jet engine's proficiency or the constructional advance that equaled the discovery of nuclear power? Buckminster Fuller (b.1895) articulated the ultra-rational verdict that we disregard architecture for the virtues of science. His Dymaxion House, exceptionally advanced in 1927, was a module of lightweight, prefabricated metal hung on a central mast providing services to the inhabitants. Fuller next invented the geodesic dome: honeycomb vaults easily and cheaply erected over almost any area in numerous materials. Their potential uses were infinite, ranging from arctic radar covers to bubble-dome cities. With the recent population boom and energy crisis they sounded like brilliant discoveries, but did many people actually want to live in them? In Italy a less soul-destroying alternative could be discerned in the

Palazzo dello Sport, *1958*
Pier Luigi Nervi (1891–1979)
Rome

After 1945 no country was more adventurous than Italy in attempting to break down the ascendancy of functionalism and restore curvilinear, sculptural qualities to reinforced-concrete architecture. Nervi, an engineer, first revealed his speciality – domes with displayed concrete ribs over huge spaces – in the Turin Exhibition Hall (1947). Such departures from the orthodoxy of the International style became known as the "Neo-Liberty" movement, a reference to the era of Art Nouveau, which in Italy had been called Stile Liberty *after the London shop which specialized in Art Nouveau prints and furnishings.*
The Palazzo dello Sport, covered by a dome 328 feet in diameter, followed the pre-fabricated Palazzetto dello Sport, built a year earlier. The Palazzo (Sports Palace), built for the 1960 Olympic Games in Rome, followed the same techniques as the Palazzetto. The building additionally revealed the sculptured columns and floor slats with corved ribs that became characteristic of Nervi's later work. In such examples as the Pirelli Building in Milan and the Place Victoria tower in Montreal, his imaginative use of reinforced concrete in delicate rib structures has produced some internal forms of great sculptural and architectural beauty.

structural feats by Pier Luigi Nervi (1891–1979), achieved with concrete for roofing and supporting purposes. Although ferro-concrete may be, and has been, widely used for large-scale domestic schemes, Nervi's own landmarks are mainly in such fields as sport stadiums and exhibition halls. Significantly, Nervi sees himself as a civil engineer, not an architect.

During the 1960s even die-hard advocates of the Modern style had to face up to its many practical drawbacks. Such architecture consumed impermissible quantities of energy for heating, ventilation and so forth. Beyond the business sector, its application to public housing had also produced disillusionment. Le Corbusier's 1920s apartment building designs and, subsequently, his Marseilles apartments prompted many metropolitan estates to be built in the 1950s and 1960s. Too often they fell far short of utopias. Undecorated and clinically ordered surfaces encouraged vandalism; high-rise planning simultaneously crowded and isolated families; basic human desires for a garden or the smallest touches to differentiate one unit from the next were overruled. The style born of scientific optimism and social reform was dying far from the masterpieces of Gropius and Corbusier. Simultaneously, civic edifices ran into trouble. Unless they too maintained the heritage of the Modernist masters the sole option lay in revivals fram a rather jaded past. Despite their huge dissimilarities, the "people's palaces" behind the Iron Curtain, New York's Lincoln Center, and Coventry Cathedral share this dubious faith in their own grandeur. Already we are loath to accept them as the Chartres and Acropolis of our century.

Recent architecture yet does seem truly exciting when it refuses to be hamstrung by a single rigid tradition or theory. While opinions conflicted about whether the Modern style was a living

doctrine or had passed into history, there were signs in the later 1960s of a new freedom, logically christened Post-Modernism. The name might well be premature, but some architects certainly now tended to avoid fixed answers, preferring to solve problems as they arose individually. Sources from the past were neither denied nor glorified and Post-Modernists appeared ready to combine what had once looked incompatible. The Willis Faber Office in Ipswich, England (1974), for example, reconciles the precise glass walls of the Seagram Building with Ronchamp's flowing outlines. Its reply to an awkward site is both simple and unorthodox, curving to follow the irregularities, simultaneously mirroring older neighbors. Innovation glides alongside tradition. A similar flexibility could be noticed in town planning as the prewar calls for wholesale erasure have lately ceded to more modest reforms. Although the dangers of the contemporary city remain obvious, the sometimes extravagant variety of its buildings and layout can become a rewarding experience against the standardization that otherwise often threatens our routine. On the other hand, pessimists in the 1970s suspected that Post-Modernism disguised anarchy or, conversely, that capitalism was breeding a vulgar chaos whose unending suburbs – for better or worse – make a single town center redundant. Another widely discussed possibility was to give the individual, rather than the Establishment, more share in the decisions shaping his environment. Whatever the many hopes and obstacles for the future of modern architecture today we may at least be certain that they are inseparable from the forces that determine our society.

Elements of Art

These comments on the basic tools of artistic creation will be helpful to the understanding of the nature and quality of works of art, as well as enjoyment of them. A number of obvious elements goes into the design or making of paintings, sculpture and – to some extent – architecture, but their importance in the structure of art is not always easy to recognize or evaluate.

LINE: Any descriptive gesture with the hand or arm (such as showing size or pointing out a distance) is a drawing in space that can be read as such by the observer. The drawn line, whether to form an outline or to build up an area of color or dark and light is the artist's method of securing the gesture in more or less permanent form and the pencil, pen, brush, charcoal or any other marker that he uses is the tool of his gesture. With it he makes his statements of intention. Line is thus an expressive factor in the creative process. Since the gesture produces the line all painting and drawing involves in the broadest sense the use of line. Its possibilities are wide. Line may be used to bound or outline a form. Used in this way part of its nature is revealed: for although it conveniently defines the form, the line itself does not exist. A form does not itself have a line round it, but an edge or termination. Thus the line in art is an expressive convenience, suggesting its subject, much as the gestures that are made during speech, only in a more permanent way.

There is a child's remark which has become famous: when asked how she drew, she said "I think and then draw a line round my think". The artist's ability to use line itself in a subjectively emotive way has led to the suggestion that all art is drawing. In another famous comment, the 20th-century painter Paul Klee described drawing as "taking a line for a walk".

TONE: Although the outline of an object is identifiable and can be expressed in line, the object itself can only be seen when light falls on it. The expression of the degree of light and dark is described as the *tonal value* and tone is the term to denote the degree of light and dark on the gray scale from white to black. The perception of form, whether of a familiar or unfamiliar object, is achieved through the viewer's sensitivity to tonal values. The black-and-white (monochrome) photograph or movie shows how effective a purely tonal image may be in establishing a perfectly acceptable and comprehensible representation of vision. The degree of light and dark can be an adequate element in the expression of vision in art.

But, of course, light and dark and tonal values have an existence independent of any subject. To be expressive they do not have to represent a visible subject. Like line, tonal relationships may have an expressive and emotive effect in artistic expression. A great deal of 20th-century art has depended upon the manipulation of tone as the means to an artistic end.

During the 17th century, most notably associated with the artists Caravaggio and Rembrandt and their followers, the term *chiaroscurist* was applied to a number of artists whose work seemed, for their own artistic reasons, to be concerned with the dramatic and emotional effect of strong light-and-dark treatment of their subjects. Chiaroscuro (from the Italian *chiaro* – clear, bright, plus *oscuro* – dim, shaded) is a familiar art term used to describe or identify light-and-dark effects in, particularly, paintings, although it is appropriate to the description of all such effects.

COLOR: While line and tone may be used to express form, nature is perceived in terms of color as well. The perception of color and its visual and emotional effect has been the subject of considerable study both scientifically and psychologically. We can note that it is one of the most personally expressive weapons in the artist's armory, and one that has become an increasingly significant and conscious factor in the expression of 20th-century artists' intentions.

The degree of intensity (color saturation) of any color is known as its *hue*, which is a term further used to express the movement of the color away from its pure form: of a blue one may say it is of a greenish or purplish hue. The term *tint* is used to describe the degree of adulteration of the hue with white: a tint is any color mixed with white. The term *shade* describes the degree of adulteration with black. Tints and shades describe the place in the scale from white to black that any adulterated hue occupies.

Color response is personal – as has been stressed in the Introduction. The artist uses color sometimes as a pure hue but more often in subtle combinations of tints and shades in an almost endless variety of juxtapositions, sometimes with conscious intention and at other times in an intuitive and subjective impulse to achieve his ends. The result may seem to him to be utterly successful in expressing this. However, color response being, at least to some degree, subjective, he can never know the effect of his color on others.

FORM AND SHAPE: *Form* is a term frequently encountered in art and, simple though the word itself is, its application in art is complicated. "Art is form" suggests its all-encompassing use and in this sense it describes the way in which the content of a work of art is created. Form arises out of the artist's organization of his subject, so that the form becomes the work. Out of this comes the term "significant form"

to identify the (supposedly) meaningful quality of form in any work.

A more useful meaning perhaps, which concerns itself with the masses, forms and groupings that one encounters, whether in a representational, traditional work or in a modern abstract, is *shape*. Shape states the limit of any form, identifying it from any other.

TEXTURE: The term expresses the tactile nature of a surface in a work of art. It may describe the sense of the surface represented – such as the difference between the surface characters of silk and stone – or it may describe the actual surface of the work itself, the use of paint or other artist's material to achieve an emotive response that relates to the artist's understanding of the content of the work. Paint may, as for instance in tempera painting, be applied smoothly and achieve a luminous and unbroken smoothness or, in oil painting, be applied so that it rears up to catch the light and produce deep shadows in the hollows, giving softness and varying luminous effects.

COMPOSITION: When all the basic elements that the artist uses in the creative process have been considered – line, tone, color etc – the actual creation still involves a number of other equally, if not more, important factors. These came under the general heading of *composition*.

In a painting, the area that has to be covered, or the three-dimensional space that has to be occupied by a sculpture, must be organized, or, at least, stated. More or less consciously, the artist has traditionally considered some or all of the following elements and the work reflects the way he incorporates them into a single identity.

Unity: However apparently disparate the matter included in the work, there must be an overall unity between form,

content, color, texture in their treatment which will allow them to "live" together in the composition. In music, as Whistler observed, a Symphony in F does not consist of the constant repetition of the note F, so in a painting the "notes" may differ but they must be in the same key – or if not in the same key, be used for specified effects that will not destroy or disguise the underlying unity of subject treatment.

Balance, harmony, rhythm, repetition, contrast: In achieving his effect, the artist will be concerned with certain intangible elements which in themselves are difficult to identify, but are missed when absent. *Balance*, for instance, in the disposition of color, tone, line, etc over the surface of a painting, becomes most apparent when it is absent. The result is frequently an awkwardness and visual tension which *usually* the artist does not intend. It can be interesting to see how balance is achieved in terms of a composition by looking at the work in a mirror. This reveals certain aspects that are not always noticeable because in the correct view they do not cause certain tensions that the reversal reveals. The western habit of reading from left to right produces in us a tendency to experience visual phenomena, including works of art, from left to right too. Balance in the composition very often depends on an unconscious habit like this which is shared by the artist and the viewer. The Chinese or Japanese artist who uses an ink-laden brush both to write characters from top to bottom and to paint a landscape on a vertical scroll is operating in a kind of visual complicity with his viewers, who also write and read in the same direction.

Likewise with harmony. In a harmonious use of color the incompatible use of line will produce an uncomfortable emotional response. Unless the intention is to create a sense of disharmony,

an artist will seek relationships that are compatible between the basic elements of line, tone, color etc. To achieve this he may repeat color combinations or employ an interpenetrating rhythm of repeated parts. Whatever he does, he will be concerned with the overall coherence of the work in terms that he will see as satisfactory. In this century, for reasons which are explained in the text, artists frequently ignore or deny some of the traditional compositional precepts.

In sculpture further elements come into play: volume, space and spatial relationships – not illusionistically, as in two-dimensional pictures, but actually. Sculpture inhabits space in a more or less defined form. In some instances it may not obtrude into the surrounding space, in other instances (both traditionally and in this century) it is deliberately designed to imply the incorporation, within the composition, of space that it does not actually occupy. Thus the actual volume – the volumetric content – of a work of sculpture is not necessarily the limit of the space it inhabits. An example of what this means can be seen in Bernini's *David* (page 31), which so obviously implies the existence of another, to us invisible, figure toward which the youth is looking, and so incorporates the space between them. Anyone experiencing sculpture has found that one wants to move in relation to the work to comprehend it fully.

There is another important element in painting which requires some consideration, the limits of a painting. The frame (if it is framed) or (if it is not) the edges of the board, canvas or wall are determining factors, and the relationship of parts within the work to those edges is always highly significant.

There is a number of ways in which proportions may be determined in relation to a line. For instance, one can divide it in half, or divide it with one

very long part and one very short part, or divide it at some point in between. The point where a line is divided is very significant in creating the qualities of balance, tension, harmony etc, and there is a traditional proportion known as the Golden Section or Golden Mean which is supposed to evoke special satisfactions in response to it. This division is such that a Point C is fixed on a line AB, so that the relationship AB to AC is the same as CB to AC. As it is often phrased, "the shorter goes into the longer as the longer goes into the whole". This division is not, of course, confined to a straight line or to one plane, and a canvas composed of sides in the Golden Section ratio may, if the traditional authorities are right, provide a particularly pleasing proportion. At all events, the deliberate relating of part to part, of scale to scale, of light to dark, of line to area, of color to color, results in a composition, in a painting.

In most Western art, at least over the last few hundred years, there has been a preoccupation with effectively representing the visual appearance of objects, and a great deal of experiment and effort has gone into it. How the recession of space as we see it could be convincingly expressed in painting is one of the most important of these. The system which was devised and is called *perspective* is based on certain rules which enable us to identify the proportions of things or spaces in the way in which we actually perceive them. Pictorial perspective depends on the identification and use of what is known as the eye-level plane – the supposed position from which the representer decided to view his subject. The eye-level plane determines how much can be presented visibly in the area chosen, so that, for instance, if the eye-level is placed in a low relationship with the area of the canvas, nearly all that can be presented lies above the level of the

eye. The viewer automatically assumes the eye position of the original artist, regardless of where the viewer happens to be standing in reality in relation to the picture.

If in painting the decision is taken by the artist, and viewer has to accept it as final, in sculpture the relationship is different. Here the viewer's decision is final: he chooses the positions from which to look at the sculpture, in the same way as the painter looks at his subject – as a solid form.

SUBJECT: Historically, the artist presented a subject which had already acquired certain clearly defined forms in the time or culture in which they appeared. At various times, and with greater or less emphasis, the artist's main (but not exclusive) preoccupations have been with:

Religion: The artist has intended to induce awe, reverence, respect, piety, guilt or even fear on the part of the observer, or to project visually the teachings of a religion, the sacred stories that support it, and the relative importance of various figures or spirits. The artist uses his observation or his imagination to present a religious event or situation in a way that will convince the viewer of its truth and importance. On occasion, the artist may present a religious subject that ridicules what he sees as a heresy, or depicts the full horror of some evil force.

Politics and Propaganda: From the earliest times, a great deal of the world's art has been produced to support a particular social or political system, whether to affirm the right and validity of a cause or a dynasty, to undermine any thoughts of opposition or rebellion, or to stir up emotional responses of loaylty and obedience that may verge on fanaticism in their intensity.

Natural Delight: The visible world and the extraordinary range of its manifestations has stimulated the imagination and creative urge of artists throughout history, and led them to express their own responses to the physical environment. A vast amount of work has been produced, ranging from minute observations of natural forms to broad panoramic representations of Nature in all its varied expressions. This includes the human response to other humans in the form of portraiture, and in the representation of people engaged in pleasurable, pathetic or disturbing activities. The widest range of subject matter can be found in this general category.

Symbolism: The requirements of some cultures, and the preferences of certain artists, have led to forms of art in which the representation of the subject is meant to be read through the interpretation of certain symbols or design elements of an allusive character. Such subjects – of which Islamic abstract decoration is a simple example – will be apprehended to the full only the informed and initiated.

Glossary

Abstract art: A type of art in which there is form and color but no subject matter. Its modern development occurred in the years immediately preceding the outbreak of World War I, although it had always existed in its geometric form in oriental, Islamic and primitive patterning.

Abacus: A flat slab, square, round or polygonal in shape which separates the top of a capital from the base of an arch or horizontal beam which it supports.

Academy: The name of Plato's philosophical school in Athens, revived in 15th-century Italy. It described any formal, higher education institute. The Academic system flourished in Europe in the 17th century and 18th centuries; in art it provided a formal artistic education in an approved style, so rejecting the old apprentice-based artisan tradition.

Acanthus: A type of prickly-leafed plant used in a conventionalized form to embellish Corinthian capitals. Used in the Classical order and wherever the Corinthian Classical order has been revived.

Acropolis: The fortified citadel of a Greek city enclosing sacred precincts, the most famous example being at Athens.

Acrylic: A modern, synthetic base for paint which has some properties of both watercolors and oils.

Action painting: Splashing and dribbling paint over a canvas. Although it is claimed to go back to the days of Leonardo da Vinci, the term is generally used in reference to 20th-century painters, such as Jackson Pollock.

Aerial or atmospheric painting: A technique used to portray depth in a two-dimensional picture by suggesting recession through lightening of tones of more distant objects in a scene also known as aerial perspective. See Perspective.

Agora: A place of assembly, especially a market place in the center of a Greek city.

Aisle: The part of a church flanking the nave from the west front to the transept. Usually two in number but occasionally five.

All' antica: A term used to describe any works of art which imitate, or are based, on, works of Classical antiquity.

Altarpiece: A construction, normally of wood, placed upon an altar and as a type of art, painted or carved and gilded. Particularly important during the Middle Ages and the Renaissance, its subject matter was the representation of sacred persons or scenes associated with the saint on whose altar they rested.

Ambulatory: A square, semicircular or polygonal aisle enclosing an apse or straight-ended choir. Often chapels open from, or are part of, this aisle.

Amphitheater: A type of building developed by the Romans from Greek theaters, usually oval in shape, with banks of seats rising one above the other.

Apse: Commonly a semicircular or polygonal termination to the chancel, chapel, or occasionally the transept of a = church. An apsidal chapel is one that terminates in an apse; usually applied to projections from an ambulatory or the east side of a transept.

Arcade: A range of arches carried on piers, columns or shafts. It may be free-standing or attached to a wall.

Arch: A semicircular or pointed structure which spans the distance between two uprights. It is constructed of wedge-shaped stones which are often decorated. Arcuation is a technique of construction using arches.

Baluster, Balustrade: A row of balusters, or small pillars, supporting a horizontal element, for example to surround a balcony or roof.

Baptistry: A building or part of a building, often round or polygonal, in which the Christian rite of baptism is enacted.

Base: The architectural element that forms the transition between an upright (column or pilasters) and the plinth on which it stands. Normally the same shape as the upright above.

Bay: A repeated unit in the interior of a building derived by divisions marked on the side walls or ceiling, or externally by buttresses.

Bema: The raised floor of an apse or chancel of a Classical building.

Buttress: A mass of masonry projecting from, or built against, a wall to give it extra strength and stability. In medieval architecture, a counterweight to the thrust of vaults. A flying buttress is a type used in Gothic architecture where the counterweight stands away from the wall and the two are connected by a half arch.

Calligraphy: The art of fine handwriting and penmanship.

Camera obscura: A device known from the 13th century by which an arrangement of lenses and mirrors in a darkened space reflect an image of an object outside onto a surface in a box or darkened room. This allows the accurate copying of details, particularly useful for topography.

Capital: In architecture, a feature which surmounts a pier, column or shaft. It serves as a visual transition from the shape at its neck – the shape of the upright – to the larger abacus above. The abacus' shape is often tailored to the arch or beam above it.

Caravanserai: An enclosed, rectangular courtyard surrounded by stables and accommodation used as a stopping post for camel caravans, particularly in the Middle East.

Cartoon: In art historical terms, a preparatory sketch for a painting or tapestry, of the same size as the finished work. Cartoons are often transferred directly to the surface which will be painted.

Cartouche: A type of ornament derived from scrolls of paper or papyrus.

Caryatid: A sculptured full-length female figure employed in place of a column.

Chancel: The area in a church which contains the altar. Generally used to describe the whole of the east end of a church.

Chapterhouse: A place of assembly for members of a monastery or canons of a cathedral in which to discuss business.

Chiaroscuro: A method for modelling forms in pictures by using light and shade.

Choir: The area of a church where the service is sung. Either a part or all of the eastern extension of the nave of a church.

Cire perdue: A method of casting metal in which a mold is formed around a wax model which is then melted away.

Classical: Pertaining to the Greek and Roman civilizations from the 6th century BC to the 5th century AD and to any phase in the evolution of a style which seeks to emulate Greek and Roman ideals or an architectural adaptatin of the elements of Greek and Roman models.

Clay: An impermeable mud which when dry forms a hard material. It has many uses, such as brick-making, pottery and modeling.

Clerestory: The highest story of a church's internal elevation. Normally pierced by windows and often accompanied by an internal or external passage.

Cloister: A quadrangle, adjacent to the nave and west of the transept on the south side of a great church, surrounded by roofed or vaulted passages. Originally derived from the peristyle of a Greco-Roman country house, it was later intended to link together all the functioning parts of a monastery.

Codex: A manuscript in book form which gradually replaced scrolls from the first to the 4th century AD due to the use of parchment leaves instead of sheets of papyrus.

Coffering: The decoration of a ceiling or vaulted roof by recessed polygonal panels.

Collage: An art form constructed of fragments, usually applied to scraps of paper or fabric attached to a canvas or picture surface.

Colonnade: A series of columns placed at regular intervals, supporting arches or horizontal members.

Column: A load-bearing, cylindrical upright generally made of stone or metal.

Concrete: A building material formed by mixing gravel, sand, rubble and mortar. Known in the ancient Near East but first consistently exploited by the Romans in their architecture.

Contrapposto: The posing of the human body with the weight on one leg so that it forms an s-shaped curve to maintain its balance.

Corbel vaulting: The roofing of a structure by covering the space with a series of horizontal layers of stone, each projecting further than the one below.

Cornice: In Classical architecture the projecting section at the top of an entablature or, more generally, any horizontal form around a building especially beneath the roof.

Crocket: A decorative ball-like leaf form sprouting from any surface, but particularly Gothic capitals and spires.

Cruck: A curved piece of timber. Two facing each other form an arch. In medieval building, a simple structural device to support a main roof from which name a type of medieval house derives.

Crypt: An underground chamber, usually vaulted, beneath the east end of a church. Crypts functioned as a place of burial and provided additional chapel space. Often they are used to raise the east end above the nave.

Cuneiform: A form of writing originally produced by pressing a wedge-shaped stick onto a clay tablet, later carved in stone. Used by the Sumerians, Babylonians, Assyrians and Persians.

Cupola: A small dome on a circular or polygonal base, crowning a roof or a turret.

Diptych: A painting consisting of two parts, usually hinged together like a book. A triptych is a three-part painting with a center panel and two hinged wings usually half meeting on the centerline of the center panel. A polyptych is a multipanel painting.

Dome: A form of roofing which is usually hemispherical circular in plan and whose section may be pointed or bulbous as well as semicircular.

Drum: A vertical, three-dimensional form, square or polygonal in plan, whose function is to support a dome or cupola.

Emulsion: A liquid in which oily and watery constituents are combined through a natural agent which is composed of both watery and oily characteristics, such as the yolk of white of egg, casein, etc.

Encaustic: A painting technique in which pigments mixed with wax are combined with a porous surface through the use of heat.

Entablature: The horizontal, uppermost part of a Classical order. Its top section is the cornice, its middle the frieze and its lowest the architrave.

Entasis: A curve in the vertical profile of a column originally introduced as an optical refinement to counteract a tendency for parallel sides to appear to narrow in the middle.

Façade: The wall terminating the body of a building, usually containing the principal entrance and often elaborately decorated.

Finial: A small decorative feature found at the top of buildings, particularly medieval churches, but any terminal vertical carved feature. May also be applied in furniture and metalware.

Flying buttress: See Buttress.

Foliation: A form of decoration of an object using forms derived from leaf stalks and buds.

Foreshortening: The aspect of drawing which gives the effect of recession within a pictorial image.

Formal: The analysis of a work of art based on the appreciation of its design or composition.

Fresco: Wall painting employing a transparent paint. *Fresco secco* is the application of paint to dry plaster and true fresco (*buon fresco*) is painting on wet plaster so that after drying the plaster is colored by the pigment.

Frieze: Any horizontal band containing sculptural or painted representations, especially where individual scenes are related to each other.

Fugitive: Any non-permanent color.

Genres: The categories of art, especially painting, which are defined according to subject matter, such as landscape, still-life or history painting. Genre painting in the common usage of the term is the depiction of everyday life and events.

Gesso: A dense white ground composed of plaster and size which is applied to panels to provide a suitable base for oil or tempera painting.

Gilding: The application of a thin film of gold to a surface for ornamental purposes.

Glossary

Glazing: (1) The filling of a window or the covering of a surface with panels of glass. (2) The application of a glass-based chemical to pottery before it is finally fired in a kiln to protect the color by providing a thin layer of glass over all the surface; it also provides a non-porous surface.

Golden Mean: Also known as the Golden section, this is a proportion applied to a line, so that if divided, the ratio of its shorter part to the longer is the same as the longer to the whole.

Gouache: A method of watercolor painting using an opacifying agent such as barite to remove the usual transparent nature of watercolor painting.

Graffitto: A drawing, scratching or piece of writing on a wall, especially of a less formal nature (see Sgraffitto).

Grisaille: A monochromatic painting executed in shades of grey, often used as a base guide for an oil painting.

Groin vault: See Vault.

Grotesque: A form of decoration consisting of medallions, foliage, sphinxes, figures or similar elements applied in strange and awkward combinations.

Hieroglyph: A character which stands for a word, sound or syllable and is used as a "building block" for writing, as in ancient Egyptian.

Hippodrome: A prepared track for horse and chariot racing in Classical antiquity.

History painting: A type of painting using subject matter based on Classical antiquity, mythology and later Christian themes usually to express noble emotions and high moral concerns.

Hypostyle: An interior space, like a hall, in which the roof rests on rows of pillars or columns.

Icon: A painting of Christ or a saint on a panel; also any single image. Iconography is the study of subject matter and its sources in art. Iconology is the knowledge of the meaning behind images in art or the study of icons.

Illuminated manuscript: A lavishly illustrated manuscript particularly associated with the Middle Ages.

Illusionism: See Trompe l'oeil.

Imprimatura: A ground, often colored, which is laid upon a canvas or panel as the basis for painting.

Incunabula: Early printed books, usually defined as existing before 1500.

Intonaco: The final layer of plaster applied to a wall in true fresco.

Iwan: In eastern Muslim buildings, a tall vaulted or roofed hall which is open at one end.

Limner: The executor of a miniature portrait painting on vellum or playing cards. Also used to describe any painter of manuscript illuminations.

Linear: Pertaining to line or involving the use of lines.

Lintel: A horizontal beam in the post and lintel form of construction (trabeation). The horizontal feature of a doorway.

Loggia: A covered gallery, often facing a garden; characteristically Italian.

Lunette: Any semicircular opening or shape.

Madrasah: An Islamic theological college together with a mosque in one building complex.

Maestà: An Italian word meaning "in majesty" to describe a scene of the Madonna and Child surrounded by saints and angels.

Mandala: A circular symbolic representation of the universe.

Mandorla: An almond-shaped light or force enclosing either the Resurrected Christ or the Virgin. Used in painting and sculpture as a lozenge-shaped containing feature for representations of Christ and the Virgin.

Manuscript: a handwritten book comprised of sheets of papyrus, paper or vellum; the medium of literary culture from late antiquity until the invention of printing in the 15th century.

Maquette: A preparatory model in clay or wax for a piece of sculpture.

Mausoleum: A building, often centrally planned, which was to house the tomb of an important personage.

Medium: Any liquid used to hold color to form paint. The main ones include egg yolk, acrylic, oils, water and gum arabic.

Megaron: The principal hall with a central hearth in a Mycenaean palace, providing the original plan for the Classical temple.

Mihrab: The niche, chamber or slab in a mosque indicating the direction of Mecca.

Minaret: The tall tower beside a mosque from which the faithful are summoned to prayer.

Minbar: An Islamic equivalent of the pulpit in a Christian Church.

Miniature: A small painting, applied to illustrations in manuscripts and 16th-century portraits.

Module: A standard or unit of measurement used to build up a design; it may be as simple as the brick used in construction.

Monolith: A single, often large upright stone.

Mosaic: A decorative technique using small, usually square pieces of colored glass, marble or stone (*tesserae*) set in cement on a floor, a wall or a vault to form a pattern or pictorial image.

Mosque: The building in which the Muslims congregate to pray and listen to reading from the Q'uran.

Mural paintings: Any type of painting on a wall.

Naos: In a Greek temple the chamber inside the colonnades.

Narthex: The area at the west end of a church if it is more than one bay deep.

Nave: The principal and central aisle extending the length of a Christian church, from the western entrance to the choir or transepts.

Niche: A space hollowed out of a wall, often concave and containing sculpture.

Oeuvre: The collected works of any one artist.

Pagoda: A Far Eastern, especially Burmese, temple or more specifically its tower. Usually pyrimidical in form.

Pantocrator: Literally "ruler of all", this is the portrayal of Christ as the ruler of the universe, usually full or half-length, seen holding an open Gospel Book and blessing with His right hand.

Papier mâché: A mixture of paper pulp and some form of liquid adhesive used to imitate wood or plaster.

Pastiche: A work of art in imitation of the style of another artist.

Pavilion: (1) A Middle Eastern tent, round or square and with the cover drawn onto a central raised point. (2) An essentially ornamental, small-scale architectural structure.

Pediment: In architecture, a triangular frontispiece supported by columns.

Pentimento: Underpainting covered during the execution of an oil painting but which subsequently strikes through the overpainting, becoming visible under the transparent form of the overpainting.

Perspective: The technique of drawing objects on a surface so that they appear to be solid and located in three dimensions, as in nature. This can be either aerial perspective or mathematical perspective in which a scene is located on a grid of lines drawn on the picture plane.

Piano nobile (Italian): The floor containing the largest and most lavish rooms of a house.

Picture plane: The frontal limit of any space created in a pictorial image parallel to the viewer at the surface of the picture.

Pier: A non-columnar, load-bearing upright.

Pigment: A colored substance, usually in powder form, that is the color constituent of a painting method.

Pilaster: A rectangular shaft, partly projecting from and partially built into a wall, which is decorative not structural in nature and is thus a kind of relief sculpture.

Pinnacle: A small, often ornamented turret with a conical or pyramidical top.

Plinth: In the architecture of Classical antiquity, the rectangular block under the base of column. In medieval architecture it also refers to a projecting band at the top of the foundations.

Podium: In architecture the overall base on which a building is set.

Portal: A doorway with some form of architectural and sculptural embellishment.

Portico: A rectangular projection supported by columns often surmounted by a pediment.

Predella: A painting in a compartment along the base of an altar or the platform on which the altar stands.

Presbytery: The area of a church reserved for officiating priests; usually part of or all of the east end.

Primer: The preparation coat applied to a painting surface.

Propylaeon: The building or buildings with gates which act as entrances to the sacred enclosure of a Greek temple.

Pteron: The Greek word for "wing", it denotes the colonnades flanking a Classical temple.

Pylon: A gate or gate tower flanking the entrance to an Egyptian temple.

Qibla: The direction that the Islamic faithful face while praying, that is, toward Mecca.

Relief: A type of sculpture in which limited depth is given to two-dimensional images.

Reliquary: A receptacle designed to contain the sacred remains of holy persons.

Repoussé: A form of relief decoration on metal which is achieved by hammering the underside so that the surface which is seen has the projecting ornament on it.

Rose window: A circular medieval church window, usually of a large diameter, filled with stone tracery radiating from the center and stained glass to produce rich and radiant internal light.

Rubenisme: An artistic movement in France at the end of the 17th century climaxing with the work of Watteau. An argument between the Poussinistes, who centered their views around the work of Poussin, and the Rubenistes on the importance of color in painting. The Rubenistes believes that color was the most convincing means of achieving naturalism.

Rustication: The use of recessed masonry joints that are deliberately emphasized by the stone blocks having their surfaces roughened.

Salon: In the 17th century exhibitions by members of the French Royal Academy were held in the Salon d'Apollon in the Louvre, from which the term is used to describe exhibitions of official art, usually selected by a jury. In 1863 protests over the number of works rejected caused Napoleon III to order a special exhibition known as the Salon des Refusés which initiated non-jury exhibitions providing alternative outlets for exhibitions of non-official art.

Sarcophagus: A stone coffin, often ornamented and inscribed.

Scalloped: Fluted, fan-shaped form derived from the sea shell.

Screen: A partition in a church to separate the ritual choir from the nave, usually of wood and highly carved.

Scumble: A thick opque layer of oil paint applied to a painting to soften specific hard lines or features.

Sfumato: An Italian word for the gradual transition of tone from light to dark, often giving a smoky effect. Particularly associated with Leonardo and Correggio.

Sgraffito: A design produced by scratching on a plaster surface to allow a darker color underneath to show through.

Shuttering: A mold formed from wooden or metal beams in which concrete is poured in to produce a desired form.

Squinch: The supporting arches built across the angle of a square or polygonal compartment to support a circular or eliptical dome or spire.

Stanza: The Italian word for room, especially a large, grand one.

Stele: An upright stone slab or tablet that is sometimes covered with inscriptions and sculptural decoration.

Stoa: A covered walkway consisting of a roof supported by two parallel colonnades, with a wall or open booths along one side.

Stupa: A hemispherical mound or a building with a stone canopy, often surrounded by railings.

Stylobate: A continuous low wall that supports a row of columns. If it supports a portico the stylobate is usually in a stepped form.

Tel: An Arabic word for a manmade mound that usually covers the ruins of an ancient city.

Tempera: A form of painting using an emulsion as a binding agent of great durability. Such painting is usually on a wood or composition panel.

Index

Acknowledgments

Reproduced by Gracious Permission of H.M. The Queen 199, 262. Amsterdam: Stedelijk Museum 348, 353. Athens: Acropolis Museum 73, 75; National Museum 69. Basle: Kunstmuseum 333, 334, 342, 362. Berne: Klee Foundation 345. Bruges: St John's Hospital 218. Brussels: Musées Royaux des Beaux Arts 319. Buffalo, New York: Albright-Knox Art Gallery 336. Cairo: Egyptian National Museum 63, 64. Chantilly: Musée Condé 124. Chicago, Illinois: Art Institute of Chicago 314, 315, 316. Chichester: Goodwood House 266. Colmar: Musée d'Unterlinden 220. Darmstadt: Hessisches Landesmuseum 97. Detroit, Michigan: Detroit Institute of Arts 287. Dijon: Musée des Beaux-Arts 123. Dresden: Gemäldegalerie 300. Dublin: National Museum 98; Trinity College 97. Düsseldorf: Kunstsammlung Nordrhein-Westfalen 348. Edinburgh: National Gallery of Scotland 317. Florence: Academy of Fine Arts 31, 201; Museo Castagno, Sant'Apollonia 181; Museo Nazionale 179; Galleria degli Uffizi 185, 190, 203. Frankfurt/Main: Städel Institute 221. Geneva: Musée d'Art et d'Histoire 220. St Gallen: Stiftsbibliothek 100. Haarlem: Frans Hals Museum 242. The Hague: Gemeentemuseum 32, 33; Mauritshuis 243; Museum Meermanno-Westreenianum 126. Heraklion: Archaeological Museum 67. Leningrad: State Museum of the Hermitage 331; Russian Museum 339. Liège: St Paul's Cathedral 127. Liverpool: Walker Art Gallery 224. London: Architectural Association 104, 109, 114, 118, 225, 270, 274, 275, 355, 361, 374; Bridgeman Art Library 23, 36, 57, 88, 97, 98, 124, 130, 183, 185, 187, 192, 190, 203, 205, 217, 219, 220, 243, 260, 287, 289, 300, 302, 304, 307, 308, 314, 317, 338, 346, 350, 366; The British Library 98; Trustees of the British Museum 25, 62, 64, 69, 88, 96, 111, 151; (Museum of Mankind) 163, 164, 165, 169, 170, 171; Trewin Copplestone 20, 21, 22, 24, 25, 28, 34, 35, 72, 78, 82, 85, 87, 92, 121, 125, 130, 180, 181, 194, 205, 209, 213, 227, 232, 248, 254, 267, 270, 283, 304, 309, 324, 325, 326, 356, 360, 373; Robert Harding 135, 138, 142, 255; Michael Holford 23, 31, 34, 56, 61, 69, 72, 81, 82, 84, 85, 96, 101, 103, 107, 108, 121, 136, 169, 202, 209, 210, 214, 218, 222, 227, 244, 251, 266, 279, 289, 297, 307, 309, 342; Kenwood House (The Iveagh Bequest) 242, 263; Trustees of the National Galleries 25, 26, 27, 183, 187, 188, 200, 204, 205, 217, 222, 229, 240, 241, 245, 253, 293, 309; Felicity Nock 167; Percival David Foundation, University of London 152; Penguin Books Ltd 71, 78;

Penrose Collection 345; Dr Philip Rawson 148; Scala/Vision International 192; Trustees of the Tate Gallery 27, 35, 225, 273, 274, 294, 295, 313, 321, 334, 338, 340, 341, 342, 345, 348, 352, 365, 366, 368, 369, 370; Victoria and Albert Museum 23, 143, 146, 149, 158, 297, 307; Wallace Collection 241, 261, 265; Wellington Museum 251. Los Angeles, California: Los Angeles County Museum of Art 370. Madrid: Prado 192, 218, 251, 289, 350. Mainz: Römisch-Germanisches Germanisches Zentralmuseum 81. Manchester: City Art Galleries 308. Moscow: Tretyakov Gallery 94. Munich: Alte Pinakothek 31, 244; Antikensammlung 73. Naples: Herculaneum National Museum 83. New York: Metropolitan Museum of Art 61, 213, 279, 280, 281, 307, 314, 364; Museum of Modern Art 34, 35, 333, 337, 338, 344, 365; Walter P Chrysler Collection 312. Olympia: Archaeological Museum 79. Oslo: National Gallery 346; Viking Ship Museum 101. Otterlo: Kröller-Müller Museum 32. Oxford: Ashmolean Museum 299. Paris: Musée d'Art Moderne 335; Bibliothèque Nationale 268; Musée de Cluny 102; Musée de l'Homme 53; Musée du Louvre 23, 34, 73, 99, 184, 191, 198, 210, 217, 223, 229, 245, 269, 276, 288, 291, 298, 307, 309, 310, 316; (Collection de l'Académie) 260; Musée Gustave Moreau 319; National Museum of Art 22; Institut Néerlandais 260; Musée Rodin 322; Collection of Guy Roncey 343. Philadelphia, PA: Barnes Foundation 314; Museum of Art 343. Rome: Villa Albani 272; Galleria Borghese 31; Galleria Nazionale d'Arte Moderna 321; Museo Capitolino 83; Museo Nazionale 83; Museo Nazionale delle Terme 89; Museo Nazionale di Villa Giulia 81. San Marino, California: Huntington Library and Art Gallery 26. Siena: Museo del Opera del Duomo 127. Stuttgart: Staatsgalerie 346. Toledo: Museo de Santa Cruz 213. Toronto: Art Gallery of Ontario 371, 372. Tucson, Arizona: University of Arizona Museum of Art 365. Vatican City: Vatican Museums and Galleries 76. Venice: Accademia 193; Peggy Guggenheim Museum 352; Palazzo Labia 264. Vienna: Albertina 221; Kunsthistorisches Museum 219, 321; Naturhistorisches Museum 56. Washington, DC: National Collection of Fine Arts, 372; National Gallery 278. Yale, New Haven: Yale University Art Gallery 277. Zürich: Kunsthaus 287.